MODERN ART AND AMERICA

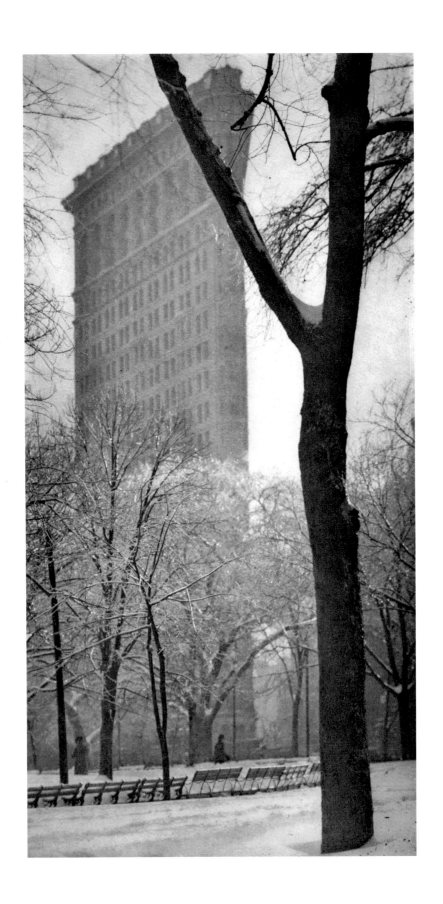

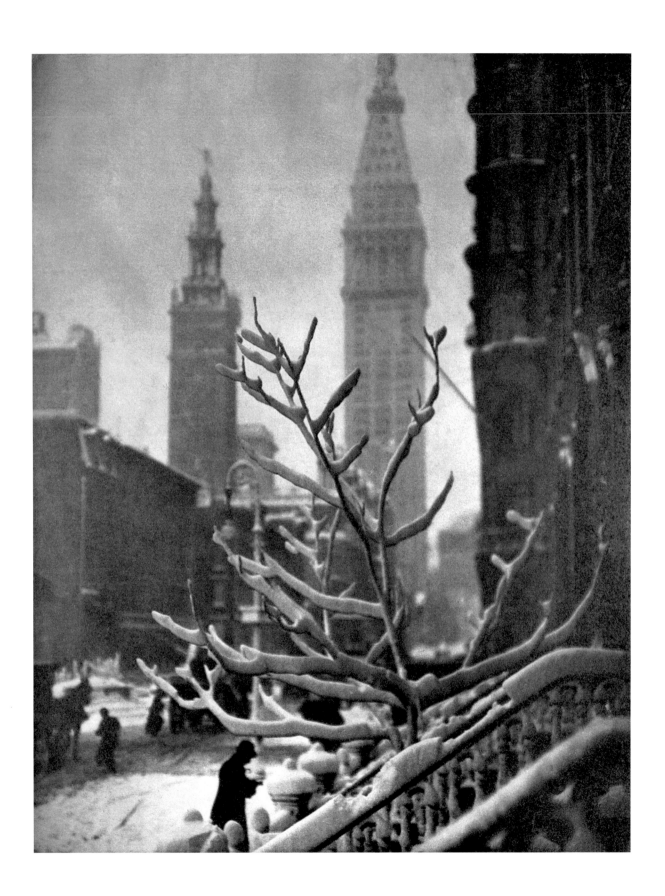

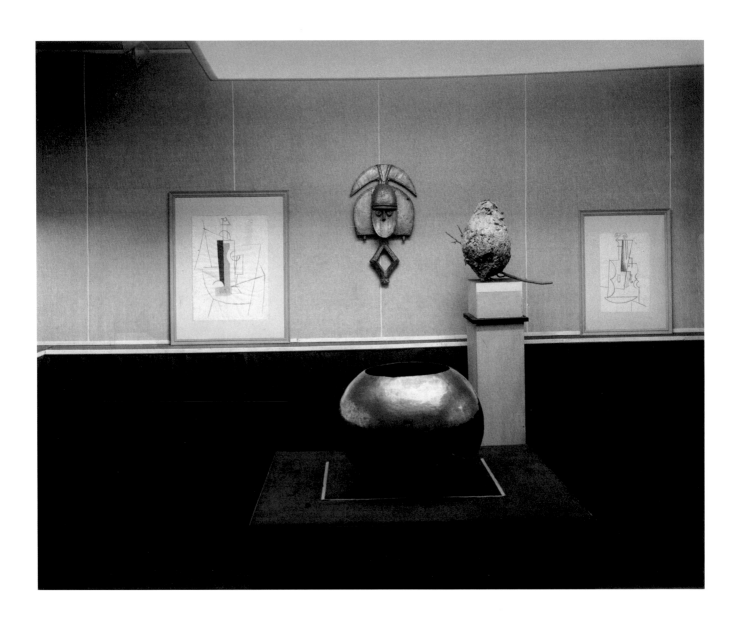

MODERN ART AND AMERICA

ALFRED STIEGLITZ

AND HIS NEW YORK GALLERIES

MODERN ART AND AMERICA

ALFRED STIEGLITZ

AND HIS NEW YORK GALLERIES

Sarah Greenough

with essays by William C. Agee, Charles Brock, John Cauman,

Ruth E. Fine, Pepe Karmel, Jill Kyle, Barbara Buhler Lynes,

Townsend Ludington, Anne McCauley, Bruce Robertson,

Helen M. Shannon, and Ann Temkin

NATIONAL GALLERY OF ART
WASHINGTON

BULFINCH PRESS
LITTLE, BROWN AND COMPANY
BOSTON NEW YORK LONDON

Deutsche Bank and Deutsche Banc Alex. Brown
are proud to sponsor the exhibition.

The exhibition was organized by the National Gallery of Art, Washington.

Exhibition Dates
National Gallery of Art, 28 January—22 April 2001

The book was produced by the Editors Office, National Gallery of Art.
EDITOR-IN-CHIEF, Judy Metro
SENIOR EDITOR, Mary Yakush
EDITOR, Susan Higman
PRODUCTION MANAGER, Chris Vogel

Designed by Lindgren/Fuller Design, New York, NY

Duotone separations by Robert J. Hennessey, Middletown, CT

Index prepared by Marshall Indexing Services, Silver Spring, MD

Typeset in Filosofia and Spartan Classified

Printed on Aberdeen Silk by Amilcare Pizzi, S.p.A., Milan, Italy

FRONTISPIECES: page 2, Alfred Stieglitz, *The Flatiron*, 1902, photogravure on Japanese tissue. National Gallery of Art, Washington, Alfred Stieglitz Collection; page 3, Alfred Stieglitz, *Two Towers, New York*, 1911, photogravure on Japanese vellum. National Gallery of Art, Washington, Alfred Stieglitz Collection; page 4, Alfred Stieglitz, *291—Picasso-Braque Exhibition*, 1915, platinum print. National Gallery of Art, Washington, Alfred Stieglitz Collection; page 6, Marsden Hartley, *Portrait of a German Officer*, 1914, oil on canvas. The Metropolitan Museum of Art, Alfred Stieglitz Collection, 1949; page 14, Alfred Stieglitz, *Self-Portrait*, 1907, gelatin silver print. National Gallery of Art, Washington, Alfred Stieglitz Collection

First Edition

Library of Congress Cataloging-in-Publication Data

Modern art and America: Alfred Stieglitz and his New York galleries / edited by Sarah Greenough
 p. cm.
Catalog of an exhibition held at the National Gallery of Art, Washington, D.C., Jan. 28—April 22, 2001.
 Includes bibliographical references and index.
 ISBN 0-89468-283-0 (paper)
 ISBN 0-8212-2728-9 (cloth)
 1. Modernism (Art)—United States—Exhibitions. 2. Art, Modern—20th century—United States—Exhibitions. 3. Stieglitz, Alfred, 1864—1946—Art patronage—Exhibitions. I. Greenough, Sarah, 1951— II. National Gallery of Art (U.S.)
N6512.5.M63 M6 2000
709'.04'0074753—dc21 00-048178

The clothbound edition is published by Bulfinch Press. Bulfinch Press is an imprint and trademark of Little, Brown and Company (Inc.).

CONTENTS

FOREWORD

Alfred Stieglitz (1864–1946) is well known through his remarkable photographs such as *The Steerage*, 1907, and his later studies of his wife, the celebrated painter Georgia O'Keeffe. His name appears in almost every study of the development of modern art in America. Yet this is the first systematic look at his multivalent talents as photographer, gallery director, publisher, impresario, and cultural force. Included here are many of the same works of art presented from 1908 to 1917 at Stieglitz's Little Galleries of the Photo-Secession, known as 291; from 1921 to 1929 at the Anderson Galleries and the Intimate Gallery; and from 1929 to 1946 at An American Place. In the modest rooms of his New York galleries a rich, intense, intellectual dialogue ensued, at first sparked by the avant-garde art and ideas of an array of Europeans and Americans and later reflecting the ideals of a smaller, close-knit group that he called "Seven Americans." *Modern Art and America: Alfred Stieglitz and His New York Galleries* presents those works by Rodin, Picasso, Matisse, and Duchamp, as well as Marin, O'Keeffe, Strand, and Demuth, that helped to inspire a dramatic transformation in American art and photography in the first few decades of the twentieth century.

In 1949 Miss O'Keeffe, executor of his estate, chose the National Gallery of Art as the repository of the largest and most important holding of Stieglitz's own work—almost 1,600 photographs representing his entire career—because she saw the then-new museum as an important symbol of the place of art within American society, situated as it was at the foot of the U.S. Capitol. In the half-century since Miss O'Keeffe's gift, the Gallery has extensively explored the contributions that the Stieglitz circle made to modern American life and art through numerous exhibitions of Stieglitz's own photographs and those of his colleagues such as Paul Strand, as well as by exhibitions of the art of Georgia O'Keeffe and John Marin, and through research and scholarly publications.

To Georgia O'Keeffe, therefore, the Gallery owes an enormous debt, both for the initial confidence she placed in a fledgling institution and for her subsequent gifts and support. The Georgia O'Keeffe Foundation, headed by Raymond R. Krueger, chairman, has continued to give assistance in myriad ways. We are especially indebted to Juan Hamilton, Georgia O'Keeffe's representative for the Alfred Stieglitz Collection at the Gallery, not only for the works he has lent to this exhibition, but most especially for guiding and inspiring us, over many years

and with great generosity, by his commitment to the legacy of both Stieglitz and O'Keeffe.

Sarah Greenough, the Gallery's curator of photographs, has spent several years working on this project, aided immeasurably by research associate Charles Brock. Their research and perceptive analysis of the art and activities of Stieglitz and his circle have shed new light on this fertile period in the development of modern American art and photography.

We would also like to express our deep appreciation to Deutsche Bank and Deutsche Banc Alex. Brown for so generously supporting this exhibition and extend special thanks to John A. Ross, chief executive officer, Deutsche Bank Group—The Americas, and to George P. Stamas, vice chairman of the board, Deutsche Banc Alex. Brown.

Our greatest debt of gratitude is owed to our many lenders. Without their enthusiastic support and their willingness to part with their often fragile and always treasured works of art, this exhibition could not have been possible.

EARL A. POWELL III
DIRECTOR

LENDERS TO THE EXHIBITION

Addison Gallery of American Art, Phillips Academy, Andover, Massachusetts

Albright-Knox Art Gallery, Buffalo

Amon Carter Museum, Fort Worth

The Art Institute of Chicago

AXA Financial, Inc., through its subsidiary The Equitable Life Assurance Society of the United States

The Beinecke Rare Book and Manuscript Library, Yale University, New Haven

Mr. André Bromberg

Brooklyn Museum of Art

Canadian Centre for Architecture, Montreal

The Cleveland Museum of Art

Courtauld Gallery, Courtauld Institute of Art, London

Dallas Museum of Art

Mr. Dimitris Daskalopoulos

Des Moines Art Center

Mr. and Mrs. Barney A. Ebsworth

Fisk University Galleries, Nashville

The Frances Lehman Loeb Art Center, Vassar College, Poughkeepsie

Frederick R. Weisman Art Museum, University of Minnesota, Minneapolis

Georgia O'Keeffe Museum, Santa Fe

The J. Paul Getty Museum, Los Angeles

Solomon R. Guggenheim Museum, New York

Anna Marie and Juan Hamilton

Hirshhorn Museum and Sculpture Garden, Smithsonian Institution, Washington

Jack S. Blanton Museum of Art, The University of Texas at Austin

Kunsthaus Zürich

Hope Haviland Leizear

Mr. and Mrs. Meredith J. Long

Myriam Lunn and The Estate of Harry H. Lunn Jr.

Mrs. Norma B. Marin, Courtesy of Richard York Gallery

Barbara Mathes Gallery, New York

May Family Collection

The McNay Art Museum, San Antonio

The Menil Collection, Houston

The Metropolitan Museum of Art, New York

Deborah and Halsey Minor

Musée National d'Art Moderne, Centre Georges Pompidou, Paris

Musée Rodin, Paris

Museum of Fine Arts, Boston

The Museum of Modern Art, New York

National Gallery of Art, Washington

National Portrait Gallery, Smithsonian Institution, Washington

Mr. Francis M. Naumann

New Jersey State Museum, Trenton

North Carolina Museum of Art, Raleigh

James and Barbara Palmer

Philadelphia Museum of Art

The Phillips Collection, Washington

Private Collections

The Saint Louis Art Museum

San Francisco Museum of Modern Art

Sheldon Memorial Art Gallery and Sculpture Garden, University of Nebraska, Lincoln

Museo Thyssen-Bornemisza, Madrid

The Toledo Museum of Art

The University of Iowa Museum of Art, Iowa City

Wadsworth Atheneum Museum of Art, Hartford

Washington University Gallery of Art, Saint Louis

Whitney Museum of American Art, New York

Worcester Art Museum, Worcester, Massachusetts

Yale University Art Gallery, New Haven

PREFACE

I have always been a revolutionist
if I have ever been anything at all.

STIEGLITZ, 1935

A lfred Stieglitz played a seminal role in the introduction of modern European art to this country and sparked a revolution in American art. He was a man of enormous intellect and passionate, often radical convictions. Yet, ironically, within the last thirty years he has been incorporated into the very establishment he once decried.

Stieglitz, though, was correct in his assessment of himself: he was, at the very core of his being, a revolutionist, and it was this characteristic that propelled him to a preeminent position in American art. Throughout his life he presented himself as a passionate individual who refused, even as a child, to play games according to prescribed rules but made new rules and even new games. An iconoclast who could not accept things on face value but insisted on challenging conventions, Stieglitz was intensely ambitious and highly competitive: he wanted, as he once admitted, to "beat everybody on earth," but once victorious, he lost interest and moved on to other things. "Whenever I feel success coming," he declared in the 1920s, "I walk around the corner." His defiance of tradition, his willingness to experiment, his faith in the efficacy of radical action, and his desire to work outside of accepted structures won him supporters among avant-garde artists and intellectuals. Moreover, his restless nature, coupled with his incessant need to subvert expectations, endowed him with the ability to discover fresh, more compelling causes in the wake of old ones, and thus to repeatedly reinvigorate his mission by bringing new ideas and new converts into his fold.

Charismatic, willful, and mesmerizing—his acolytes in the 1920s and 1930s called him a "prophet" and a "seer"—Stieglitz conducted a public performance—he termed it a demonstration—that lasted almost forty years. His stages were first the Little Galleries of the Photo-Secession at 291 Fifth Avenue, and later, the Anderson Galleries, the Intimate Gallery, and An American Place. His plays were the art he exhibited, and his audience included not only the galleries' visitors but readers of his influential periodical *Camera Work* and others interested in American art and culture in the early years of the twentieth century. Fiercely anti-commercial and

anti-materialist, he used his own income to finance his revolution and made do with the materials available. The modern European objects he presented at 291 between 1908 and 1917 were not imposing masterpieces but small, portable works that could be easily packed in a trunk or carried in a valise. Even the American paintings he showed in the 1920s, 1930s, and 1940s were of a scale that would fit into a cramped New York apartment. The exhibition spaces were modest: the Intimate Gallery took its name not just from the quality of conversation he wanted to generate, but also the diminutive size of the room, twenty by twenty-six feet. The 291 gallery was even smaller (the main room measured about fifteen feet square) and was also cheek by jowl with the jumble of the modern city. Above stores that advertised "Foreign Novelties," "All Masterpieces at Ridiculously Low Prices," and "All Our Pictures will be Sold at Cost," 291's neighbors on Fifth Avenue were the headquarters of the "Save New York Committee" and the "American Girls Aid"(fig. 129). In this setting, which must surely have delighted Stieglitz's dada colleagues, and his other equally unprepossessing spaces, he orchestrated a series of exhibitions from 1905 to his death in 1946 that challenged Americans, as no one else of the time did so consistently, to ask new questions about both themselves and the modern culture they were constructing.

Despite their central importance in Stieglitz's career and in the development of American modernism, only a few of the more than 190 exhibitions Stieglitz presented from 1905 to 1946 have been documented and analyzed. Nor have the exhibitions been systematically examined as a whole and mined for the information they convey about the nature of the dialogue he initiated between European and American artists, critics, and intellectuals. Neither has the diversity of art Stieglitz exhibited—paintings, prints, drawings, watercolors, photographs, sculpture, as well as African and children's art—been analyzed to determine the ideas each raised within the context of Stieglitz's exhibition schedule and the ongoing theoretical discussions. Finally, the extent to which Stieglitz positioned photography at the center of the evolving discourse on modernism has been largely overlooked.

This book and the exhibition it accompanies seek to assess the impact of Stieglitz's program of exhibitions, by first examining the logistics, the organizers— whether Stieglitz or one of his many associates such as Edward Steichen, Marius de Zayas, or Paul Haviland, for example—and the purpose, content, and critical and artistic response of several shows presented at 291 between 1908 and 1917. We selected these groundbreaking exhibitions because they most succinctly summarized the ideas under discussion at 291; provoked the greatest controversy and thus elicited the widest range of debate; and inspired American artists to approach their work in new and challenging ways. Second, we study how Stieglitz's later exhibitions,

from 1921 to 1946, of the art of the "Seven Americans"—Demuth, Dove, Hartley, Marin, O'Keeffe, Strand, and Stieglitz himself—led to the creation of a modern American art. We analyze both group and monographic exhibitions Stieglitz mounted at the Anderson Galleries, the Intimate Gallery, and An American Place; the cooperative gallery structure he devised; the community of ideas explored by these painters and photographers; and the nature and importance of each artist's relationship with Stieglitz. By addressing not only Stieglitz's introduction of modern European art to America but also his less heralded yet no less important support for American art in the 1920s, 1930s, and 1940s, this two-fold approach seeks to evaluate his multiple contributions, as photographer, gallery director, and publisher, to modern American art and culture.

Few business records for any of Stieglitz's galleries have survived. While handwritten, typed, or printed checklists exist, the titles or descriptions of exhibited works are seldom specific. Oddly, installation photographs by Stieglitz or others are rare. Therefore, in order to understand precisely what Americans and in particular American artists saw, and when, we have reconstructed the shows at Stieglitz's galleries from a variety of sources. These include brochures, photographs, reviews, and other literature of the time, as well as evidence gleaned from records of the dispersal of Stieglitz's own collection after his death. Our catalogue authors and other scholars noted in the texts and acknowledgments offered invaluable assistance in the reconstruction efforts. The works in this exhibition are those that, to the best of our knowledge, were seen at Stieglitz's galleries (in exhibitions or informally), or reproduced in *Camera Work*. The paintings, drawings, and watercolors are the same objects Stieglitz himself showed; other prints of the photographs and lithographs and other editions of the sculpture are occasionally included. The most prominent exception is five paintings made by Hartley after he broke with Stieglitz in 1937. Although never shown by Stieglitz, they are the direct result of his decades-long support of the artist and his repeated pleas that Hartley tackle his native landscape.

When Stieglitz opened the Little Galleries of the Photo-Secession at 291 Fifth Avenue in New York in 1905, he had the audacious belief that America, as the most modern nation in the world, could and should be the world's preeminent cultural force. And he was certain that New York, the city of ambition, the place where the hand of man—and the hand of modern man—was writ large, should be its center. For more than forty years Stieglitz worked to achieve this goal, mounting exhibitions, publishing brochures and periodicals, and steadfastly staying "on deck" at his galleries, as he phrased it, proselytizing to all who would listen. That time proved him correct bears witness to the strength of his paradigm; it is also evidence of his vision.

Note to the Reader

Although during the period of his closest association with Stieglitz Edward Steichen spelled his first name Eduard, we have used the more traditional spelling he adopted after World War I. In addition, readers will note that Elizabeth Luther Cary's name is also spelled Elisabeth Carey. When her reviews were reprinted in *Camera Work* her name was often misspelled. Finally, all references from the large and important Alfred Stieglitz/Georgia O'Keeffe Archive at the Yale Collection of American Literature, Beinecke Rare Book and Manuscript Library have been abbreviated YCAL; those from the Center for Creative Photography, University of Arizona, have been abbreviated CCP.

SARAH GREENOUGH

WITH CHARLES BROCK

When finally I am to be judged I think
I'll have to be judged by my own photographic work,
by Camera Work, *by the way I've lived and by the way*
I have conducted a series of interdependent demonstrations
in the shape of exhibitions covering over forty years.

STIEGLITZ, JANUARY 1935

GALLERY 291, 1905–1917

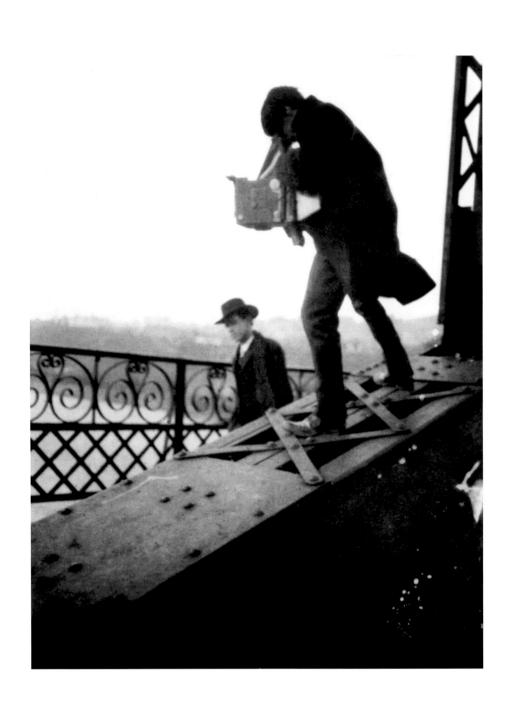

Sarah Greenough

ALFRED STIEGLITZ, REBELLIOUS MIDWIFE TO A THOUSAND IDEAS

*The Photo-Secession is an idea. It is the idea
of revolt against all authority in art, in fact
against all authority in everything,
for art is only the expression of life.*

STIEGLITZ, 1912[1]

I n 1902 when Alfred Stieglitz founded the Photo-Secession, in 1903 when he began to publish *Camera Work*, in 1905 when he opened The Little Galleries of the Photo-Secession at 291 Fifth Avenue in New York, and in 1907 when he began to exhibit art other than photography at this gallery, he had little conception of the ideas he would engender, the changes he would help to effect, or even specifically what he wanted to accomplish, except that he knew he wanted to shake the status quo. Many of the actions he took were in reaction to the activities—and often the perceived threats—of others around him. Many were prompted by his rebellious nature, his inherent distrust of conventionalism, and his need to defy expectations. Especially before 1907, his steps were not part of a planned, programmatic agenda, but were instead almost entirely improvised either by Stieglitz himself or his close associates, the result of their rich, free-spirited, wide-ranging, catholic, and uncensored debate. And yet, from these discussions and improvisations grew some revolutionary and influential ideas about art in the twentieth century: about the interrelationships between painting, sculpture, photography, and music; about abstraction versus realism; about Western versus non-Western art; about art by men versus art by women and art by children; about European versus American art; about the role of commerce and commercialism in art; and about the function of the machine and the place of nature in the modern age. Stieglitz himself did not give birth to all or even most of these ideas; in fact, in the early years of his involvement with modern art, his understanding occasionally lagged behind that of his colleagues. But he did recognize the profound need to establish a serious discussion

fig. 1 ANONYMOUS
Alfred Stieglitz Photographing
on a Bridge, *c. 1905*
gelatin silver print
Gilman Paper Company Collection

about art and to foster a situation in which experimentation, change, even radical actions were possible. With his fascination "in the idea of life, in the idea of the significance of art, the significance of people in relationship to each other and to art," he provided a place for artists and others to congregate and exhibit their work, and a journal in which to express and defend their thoughts and actions.[2] Perhaps most important, with a nimble, deeply inquisitive mind, an intense, passionate sincerity, and an almost blind faith that any new idea was worthy of investigation, Stieglitz produced intellectual sparks that ignited firestorms in those around him. During the first few decades of the twentieth century, Stieglitz became, as his friend Marius de Zayas aptly described him, "the midwife of ideas."[3]

The progress of the ages has been rhythmic and not
continuous, although always forward. In all phases
of human activity the tendency of the masses has been
invariably towards ultra conservatism. Progress
has been accomplished only by reason of the fanatical
enthusiasm of the revolutionist, whose extreme teaching
has saved the mass from utter inertia. What is to-day
accepted as conservative was yesterday denounced as
revolutionary.

STIEGLITZ, 1903 [4]

From 1902 through 1907 Alfred Stieglitz, at first unwittingly and then with increasing awareness, began to construct an environment that proved to be highly receptive to new ideas in photography and art. During these first few years of the twentieth century, he developed both a philosophical framework and the necessary supporting structures that enabled him and a growing cadre of supporters to initiate a dialogue among different kinds of artists and thus to launch one of the most influential challenges to the nature of American art in the twentieth century. No matter how far he seemed to stray into the other arts, photography—and particularly the intellectual concept of photography—was always central to his efforts. But with each passing year, his field of investigation widened, his circle of friends broadened, and his impact expanded and intensified.

The first critical element in this assault was the Photo-Secession, which he conceived of as a youthful, radical, elitist, modern organization, fired by passionate ideals and struggling against an older, more conservative and thoroughly entrenched photographic establishment. At the time, the photography community was divided

among many rival factions, but the pictorial photographers—those who sought to demonstrate that the medium was capable of artistic expression—were among the most vocal and contentious. With little consultation or input from its future members, Stieglitz founded the Photo-Secession in February 1902 to counter what he considered to be the pernicious impact of more conservative photographers who had gained control of both the Camera Club of New York, where he had been an active member for several years, and the prestigious Philadelphia Photographic Salon. But in addition he also wanted to consolidate his own position of leadership in American photography.[5] Modeled after other movements such as the Munich and Vienna secessions, which defied the entrenched academies, the Photo-Secession, Stieglitz declared, was "probably the most radical and exclusive body of photographers" in existence; it was a "protest," a "secession from the spirit of the doctrinaire, of the compromiser"; it was an attitude of "rebellion."[6]

While the philosophical stance of the Photo-Secession was clearly articulated, its organizational structure and membership requirements, and more important, its objectives and proposed methods of accomplishing its goals remained largely undefined. Reluctant to confine and proscribe something that was still evolving in his own mind, Stieglitz initially eluded many questions and even implied that it was a secret organization.[7] When he did issue a definition—and then only after considerable pressure from members of the Photo-Secession, especially Edward Steichen— he was intentionally vague. "The aim of the Photo-Secession," he wrote several months after its founding, was "to advance photography as applied to pictorial expression"; that is, it sought to promote photographs that aimed to be pictures rather than mere documents. The organization, he continued, would draw together not only practicing American photographers, but also others "interested in the art" and would hold from time to time in varying places exhibitions "not necessarily limited to the productions of the Photo-Secession or to American work."[8] Following the incendiary nature of Stieglitz's initial pronouncements proclaiming the birth of the Photo-Secession and its philosophical stance, the neutral tone of this statement is noteworthy, as is its open-ended nature. Its primary aim was not a definable goal—for example, to convince American art museums to hold regular exhibitions of photographs alongside the other arts—but almost conceptual in nature: to examine photography as a means of expression. Moreover, further ensuring that this investigation would be as wide-ranging as possible, Stieglitz did not limit this inquiry to any one school or photographic group, nor did he constrain either the Photo-Secession's membership or its exhibition policy. Although he may not have been aware of its full implications at the time, his vague statement endowed the Photo-Secession with the ability to change and grow over time, making it, as he

would often say a few years later, more of an idea or an attitude than a codified entity.

From 1902 through 1904 the Photo-Secession gradually took shape. Its members came to include many but by no means all of this country's leading artistic photographers: in addition to Edward Steichen, Frank Eugene, Gertrude Käsebier, Joseph T. Keiley, and Clarence H. White, later Alvin Langdon Coburn, Anne Brigman, and George Seeley joined its ranks. Stieglitz ran the Photo-Secession primarily as an exhibition society, mounting shows of members' work that were presented at camera clubs, as well as art museums, international fairs, and other venues in both the United States and Europe. Fully cognizant of the power of the written word, Stieglitz also knew that both he personally and the Photo-Secession in general needed a journal—a mouthpiece for their cause—to reproduce notable photographs, frame ideological issues, refute criticisms, and garner wider support.[9] Thus, in January 1903 Stieglitz, greatly assisted by his friend and occasional collaborator, the lawyer Joseph T. Keiley, published the first issue of *Camera Work*. Ensuring its independence, Stieglitz himself, not the Photo-Secession, edited and published *Camera Work;* it owed allegiance only to "the furtherance of modern photography," and to those with "faith in photography as a medium of individual expression." Devoting "all profits to the enlargement of the magazine's beauty and scope," Stieglitz expected that *Camera Work*'s "friends" would contribute both "moral and financial" support.[10] Moreover, from its inception Stieglitz considered *Camera Work* as a forum where a variety of viewpoints would be discussed. Early issues included not only analyses of the work of the Photo-Secession but also articles on scientific or naturalistic photography, while later ones published both plaudits and harsh criticisms of the exhibitions Stieglitz organized.

By 1905, though, Stieglitz found himself in a difficult position. Although both the traveling exhibitions of the Photo-Secession and *Camera Work* had been received with great acclaim, his position of leadership within the photographic community had been seriously eroded the year before when Curtis Bell, a professional photographer and president of the American Federation of Photographic Societies, organized an exhibition titled "The First American Photographic Salon," held at the Clausen Galleries in New York in December 1904. With a jury of distinguished painters including William Merritt Chase, Kenyon Cox, and Robert Henri, the show, which presented both American and European photographs, received considerable attention and was perceived by many as a direct challenge to Stieglitz's supremacy. His reputation was still further abraded in 1905 when he failed to establish a rival international society of pictorial photographers and host an exhibition of their work.[11] Just as he had been forced to take a decisive action in 1902 to secure his

position of prominence within the photographic community and therefore ensure the perpetuation of his ideas, so too in 1905 did he need to take a bold step to separate himself and the Photo-Secession from what he perceived to be the mediocrity and complacency that threatened artistic photography. With the spirited urging of his trusted young protégé, the photographer and painter Edward Steichen, Stieglitz rented three small rooms on the top floor of a building at 291 Fifth Avenue in New York to use as a gallery. Initially, Stieglitz and Steichen thought they would use the space to show, in successive installations, selections from Stieglitz's aborted international exhibition. Yet their great ambition and delight in risk-taking quickly led to other ideas and other plans. Because Stieglitz feared there would not be enough good photographic work to sustain a gallery, and because both men passionately believed in the need for photography to be seen in comparison with the other arts, they proposed to exhibit not only the "very best" photographs from around the world, but also other art that "the Council of the Photo-Secession can from time to time secure."[12] They hoped that by exhibiting paintings, drawings, or sculpture they would draw artists and critics into their space and thus initiate a dialogue about the relationship between painting and photography. To further stimulate a spirit of shared community and encourage a lively exchange of ideas, they also envisioned that the rooms would serve as an educational facility, making available "art magazines and publications, foreign and American," and would become a meeting place for "all art lovers."[13]

Stieglitz and Steichen also originally conceived of the gallery as a commercial space and proposed that it would "negotiate sales in behalf of the owners of the pictures exhibited, charging a commission of 15 percent for the benefit of the Photo-Secession treasury."[14] This dual agenda would prove to be a major point of contention. With his dislike of commercialism and his distaste for financial discussions, coupled with his own personal income, Stieglitz came to see sales, at best, as a barometer of the American public's knowledge, appreciation, and commitment to modern photography or art (or lack thereof) and, at worst, as a form of prostitution. Understandably, both artists and their potential patrons were frequently baffled by his posture that pictures needed to "find homes instead of owners" and frustrated by his often wildly inconsistent prices.[15] As his secretary Marie Rapp Boursault later recalled, if Stieglitz thought someone was treating a work of art as if it was a commodity, "he might double the price of the painting."[16]

When the Little Galleries of the Photo-Secession at 291 Fifth Avenue opened on 25 November 1905, they did much more than provide Stieglitz with a platform on which to demonstrate the merit of his cause (fig. 2).[17] To a very great extent, the Little Galleries, or 291, made Stieglitz both the artist and the force in modern

American culture that he came to be. At 291 the restless, impulsive photographer could respond quickly to ideas, issues, events, and criticism, and, if necessary, change direction. More important, 291 pushed Stieglitz out into the larger world. As he stood watch at the gallery, as he phrased it, day after day for at least six months of each year from 1905 through 1917, 291 brought him into contact with different kinds of people, many of whom had radically new and, for him, highly stimulating ideas. At the gallery he talked endlessly, as he himself readily admitted.[18] Yet, as evidenced by the rapid evolution of his understanding of art at this time, he also listened intently to his colleagues. He studied their work and absorbed their ideas, and, in turn, frequently became the most vocal and passionate champion of both. Several of Stieglitz's coworkers from the time remarked that he was as interested in the ideas provoked by the art, as the art itself. "The 'work of art' was never...of much interest to Stieglitz," Hutchins Hapgood recalled several years later, "it is what the work of art symbolizes, what is behind it that counts."[19]

After a year of exhibiting American and European photographs at 291, Stieglitz, Steichen, and Keiley came to believe that the ideas behind the fine art movement in photography were drying up; that it was time, as the critic Charles Caffin counseled Stieglitz, to "shift your attack."[20] The elusive, evocative, and often ethereal work of the Photo-Secession that only a few years earlier had seemed to Stieglitz so revealing of the photographer's "character, his emotions, his intellectual powers," now appeared stilted.[21] Moreover, as pictorial photographers such as

MODERN ART AND AMERICA

Frank Eugene or Robert Demachy became increasingly concerned with manipulation rather than meaning and created works that looked nothing like photographs, Stieglitz's prior belief that the photographer must create "a picture...unhampered by conventionality—unhampered by anything—not even the negative," seemed suspect and his interest in revealing the plastic nature of the medium dissipated.[22] Finally, he felt that the Photo-Secession was becoming too codified, too much of an established unit, and losing its radical edge. To rattle this growing complacency, Stieglitz exhibited paintings and drawings by the symbolist artist Pamela Colman Smith at 291 in January 1907 (fig. 3). Defending the exhibition, he defiantly proclaimed that neither he nor the "Secession Idea" were the "servant" of any one medium or group. While he initially showed Smith's work primarily to pique the Photo-Secession, he found it was indeed highly instructive to compare drawings and photographs in order to judge photography's "possibilities and limitations."[23] In fact, the exhibition was so successful in his estimation that for the next ten years he continued to exhibit, with ever increasing frequency, paintings, drawings, prints, and sculpture.[24]

The early exhibitions at 291 of non-photographic works were a varied mix, including such obscure artists as Willi Geiger, a German painter who studied with Franz von Stuck and was shown in 1908; Donald Shaw MacLaughlin, a Canadian etcher who was shown in 1908; Eugene Higgins, an American painter influenced by Millet who depicted labor and the poor, shown in 1909; or Gordon Craig, an English theater designer and draftsman who had an exhibition in 1910. Yet interspersed with these shows were exhibitions—often the first in this country— of Auguste Rodin (1908, 1910), Henri Matisse (1908, 1910, 1912), Henri Rousseau (1910), Paul Cézanne (1911), and Pablo Picasso (1911), as well as presentations of younger American artists, including John Marin (1909, 1910, 1911) and Marsden Hartley (1909, 1910). The seeming lack of focus of the early exhibition program clearly reflects the evolving understanding of modern art by Stieglitz, Steichen, and others responsible for exhibitions at 291 at this time, including Paul Haviland, a businessman and later a photographer, Max Weber, the painter, or Marius de Zayas, the Mexican artist. Stieglitz himself was most likely responsible for several of these early exhibitions, including those of Smith, Geiger, and MacLaughlin, while Paul Haviland, who began to assume an active role at 291 in 1908, undoubtedly proposed the exhibition of Higgins.[25] Steichen's commitment to modern art was ambivalent too. While he was responsible for some of the most important early

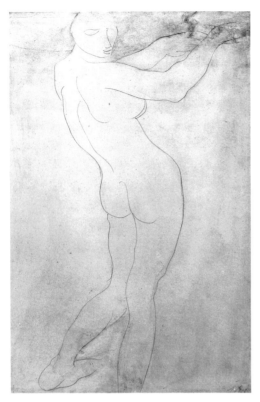

fig. 4 AUGUSTE RODIN
Nude Study, *1890*
watercolor and graphite
The Montreal Museum of Fine Arts,
F. Cleveland Morgan Bequest
EXHIBITED AT 291, 1908

fig. 5 GEORGE SEELEY
The Burning of Rome, *1906*
platinum print
The Metropolitan Museum of Art, Alfred Stieglitz Collection, 1933
EXHIBITED AT 291, 1907

shows at 291—Rodin and Matisse, for example—he also championed the late sym-
bolist art of Gordon Craig.[26]

This odd mixture of exhibitions, though, was largely the result of Stieglitz's
and Steichen's belief that they needed to rotate advanced work with what Steichen
referred to as "understandable" or more conventional art, and photography. As he
explained in a letter to Stieglitz in June 1908, "I think we should[,] if we have two
shows[,] have one !!! and the other an 'understandable' one. I had thought some of
Charles Shannon's lithographs or drawings by Gordon Craig.... As for the red rag I
am sure Picasso would fill the bill if I can get them but he is a crazy galloot[,] hates
exhibiting etc. however we will try him."[27] Especially during the early years at 291,
he and Steichen rotated "red rags" with exhibitions of both photographs and "under-
standable" art. Thus, for example, in 1907 and 1908 Stieglitz strategically opened
the season at 291 with an exhibition of photographs by members of the Photo-
Secession, followed by a highly provocative show of Rodin's spontaneous, minimal,
and, at the time, shockingly sexually explicit drawings. Next came an exhibition by a

fig. 6 HENRI MATISSE
Back View of Nude with Necklace, *1906*
lithograph
The Baltimore Museum of Art, Blanche Adler Memorial Fund
POSSIBLY EXHIBITED AT 291, 1908

fig. 7 ALFRED STIEGLITZ AND CLARENCE WHITE
The Torso, *1907*
waxed platinum print
The Metropolitan Museum of Art, Alfred Stieglitz Collection, 1933
REPRODUCED IN CAMERA WORK, JULY 1909

young newcomer to the Photo-Secession, the photographer George Seeley, followed by a group exhibition of works on paper by Geiger, MacLaughlin, and Smith. The season ended with Steichen's more recent photographs and another controversial exhibition of Henri Matisse's simplified etchings, drawings, watercolors, and one small oil painting. Stieglitz and Steichen's aim, though, was not simply to pace their shows or humor their audience to ensure their continued visitation and it was not merely to find what Steichen later referred to as "an antidote" for more radical work.[28] Rather, both wanted to set up a dialogue that would enable 291 visitors to see, discuss, and ponder the differences and similarities between artists of all ranks and types: between painters, draftsmen, sculptors, and photographers; between European and American artists; between older or more established figures and younger, newer practitioners. While these 1907–1908 shows were photographic and non-photographic, conventional and controversial, commercial successes and failures, all shared a common theme: all included numerous depictions of the female figure, often nude (figs. 4, 5, and 6). Thus, over the course of five months, visitors to

291—both artists and the public alike—could compare and contrast photographs, paintings, drawings, and prints, all depicting the female form, by such diverse artists as Rodin, Seeley, Smith, and Matisse. Perhaps not coincidentally, this was also a subject that was of particular interest to both Stieglitz and Steichen at this time, as both had recently made several photographs of the nude (fig. 7). In later years, as Stieglitz became increasingly fascinated with the ideas posed by modern art, he was less scrupulous about alternating between exhibitions of photographs and the other arts or between predictable and provocative work. Nevertheless, the 1907–1908 season clearly demonstrates both the dialogue Stieglitz and Steichen wanted to engender and the issues they wished to address.

Stieglitz himself benefited enormously from the varied program and his understanding of modern art grew exponentially from 1907 through the summer of 1911. Although when he first saw Cézanne's work in the large exhibition at Bernheim Jeune in Paris in the summer of 1907, he scoffed, "there's nothing there but empty paper with a few splashes of color," by 1911 he assuredly proclaimed to a New York critic that "without the understanding of Cézanne ... it is impossible for anyone to grasp, even faintly, much that is going on in the art world to-day," and in 1913 Francis Picabia anointed him "the man best informed in this whole revolution in the arts."[29] In addition to the 291 exhibitions, his teachers at this time were Steichen, Max Weber, who was immensely knowledgeable about the latest developments in modern European art, and Marius de Zayas, whose great intelligence, wit, and unbridled curiosity was deeply appreciated by the older photographer. Stieglitz's voracious reading, as well as his frequent trips to Europe, were also highly instructive: when he was in Paris in 1909 he met Matisse and the influential American collectors, the Steins—Michael, Sarah, Leo, and Gertrude—while during his 1911 trip to France, as he recounted in a letter later that year, he had "long most interesting sessions with or at Picasso, Matisse, Rodin, Gordon Craig, Vollard, Bernheims, Pellerin's."[30] His letters and published interviews from the time also indicate that the Picasso exhibition at 291 in March and April 1911 was a revelation for him. That show, coupled with de Zayas' article on Picasso in the April–July issue of *Camera Work* and his trip to Paris that summer, gave him a new appreciation and understanding of modern art.[31] Describing the show as a "tremendous experience," and "possibly the most interesting yet held there," Stieglitz wrote later that fall that it made him "realize what the seven years at '291' had really done for me."[32] He purchased Picasso's *Standing Female Nude*—one of the most recent and abstract drawings in the show and one that Picasso himself greatly valued—and he delightedly referred to it as "a sort of intellectual cocktail" (fig. 14).[33] While later that year he praised both Matisse and Picasso as "giants," Picasso, he con-

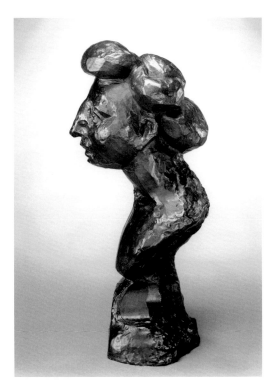

fig. 8 HENRI MATISSE
Head of Jeannette III, *1911/cast 1966*
bronze
*Hirshhorn Museum and Sculpture Garden, Smithsonian
Institution, Gift of Joseph H. Hirshhorn Foundation, 1972*
PLASTER CAST EXHIBITED AT 291, 1912

cluded, was "the great force who in the plastic arts will bring art back to its true expression."[34]

During these years Stieglitz also grew increasingly sophisticated about the entire exhibition process. Through trial and error, he came to believe that it was highly important to focus an exhibition so that it either presented new ideas, what he called a *"positive advance,"* or was "a *summing up"* and clearly elucidated the development of an artist's work. Otherwise, he concluded, a show was "nothing more than a market-place for the mediocre or the parading-ground for the stupid vanities of the small mind."[35] In addition, from Steichen's example he became increasingly sensitive to the role that design, installation, framing, sequence, and juxtaposition play in an exhibition. From his intimate, daily contact with an exhibition, he came to appreciate ever more keenly how these seemingly small details affected not just the look of a show, but also the ideas it engendered, and he discovered that these things alone could provoke new ideas and new associations far beyond those originally intended by the artist. Through his love for verbal gymnastics and Socratic dialogue, he became increasingly adept at dealing with both the press and the general public, and he realized that he could attract visitors who were as interested in hearing his unconventional, iconoclastic ideas and his highly unpredictable views of the world as they were in the art itself.[36] Finally, from experience, Stieglitz learned that he could incite the most provocative discussions— those that addressed the broadest range of issues—by presenting the most radical art. Describing the 1908 Matisse exhibition, he tersely wrote, "here was the work of a new man, with new ideas—a very anarchist, it seemed, in art. The exhibition led to many heated controversies; it proved stimulating."[37]

This more mature, nuanced, and layered understanding of modern art and the exhibition process itself was evident in both the 1911 Picasso exhibition and the 1912 Matisse show. Selected by de Zayas, Steichen, Frank Burty Haviland (Paul Haviland's brother) and the artist himself, the Picasso exhibition was a "demonstration of development," as Paul Haviland noted in *Camera Work*, intentionally designed to present to the American artists and the public "the different stages leading to his latest productions" (fig. 14).[38] As all involved undoubtedly anticipated, this exhibition, Picasso's first in this country, incited a storm of discussion and Stieglitz seems to have taken great pleasure in confounding critics by telling them that the works

they believed to be "the gibberings of a lunatic," he found "as perfect as a Bach fugue."[39] The 1912 Matisse exhibition was not retrospective but was the first public presentation anywhere that exclusively focused on his sculpture, which Stieglitz, on the advice of Leo Stein, considered his most innovative and challenging work (fig. 8).[40] Selected by Matisse and Steichen, this exhibition presented "the principal steps of Matisse's evolution as a sculptor," as Haviland again noted in *Camera Work*, and displayed both portraits, including the plaster versions of his celebrated series *Jeanette*, as well as figure studies (pl. 15).[41] It too was greeted with bewilderment and derision, described by one critic as "impossible travesties on the human form ... which make one grieve that men should be found who can by any chance regard them with other than feelings of horrible repulsion."[42]

Above all else these two exhibitions at 291 drew attention to what was for many one of the most disturbing and perplexing aspects of modern art: its attack on conventional notions of beauty in the human form. Within the space of one year Stieglitz presented some of the most radical challenges to these conventions that would be witnessed in the entire twentieth century. Moreover, although unintentional, as he was dependent on both what was available and what could be easily shipped, because he primarily exhibited drawings, small plaster casts, terra-cottas, and a few bronzes, he delivered these challenges in their most bare, unadorned, and provocative form, without the allure or distraction of color, scale, and, in most cases even patina. In this way, these exhibitions were fundamentally and profoundly educational: they provided a means of communication between one artist and another; they were intended not to sensationalize, and not simply to shock, but to instruct and provoke, to allow one artist to speak to another about the creative process.[43] And they were, at their very core, conceived as a Socratic dialogue, where new, even revolutionary ideas were introduced by the comparisons that were made and the questions that were posed, in order that artists and the public alike were empowered to reach their own conclusions.

Stieglitz also discovered that *Camera Work* could be an effective if somewhat deceptive tool in his arsenal at this time. Although unforeseen, because *Camera Work* reproduced everything—paintings, prints, drawings, sculpture, and photographs—the same size and in the same limited tonal range, it allowed photography more easily to engage the other arts in a serious discourse that Stieglitz could then push in other directions.[44] Stieglitz did just that in 1911 and 1912 when he expanded the ideas about the depiction of human form raised by the Picasso and Matisse exhibitions into a discussion of portraiture in both the pages of *Camera Work* and his own work. In order to demonstrate how "in portraiture," as he wrote, "the camera had the advantage over the best trained eye and hand," he devoted the January 1912 issue

fig. 9 DAVID OCTAVIUS HILL AND ROBERT ADAMSON
Principal Robert Haldane, *c. 1843*
The Scottish National Portrait Gallery, Edinburgh
REPRODUCED IN CAMERA WORK, JANUARY 1912

fig. 10 ALFRED STIEGLITZ
Arthur G. Dove, *1911–1912*
platinum print
National Gallery of Art, Washington, Alfred Stieglitz Collection

of *Camera Work* to reproductions of David Octavius Hill and Robert Adamson's simple but direct and emotive portraits made at the dawn of photography in the 1840s (fig. 9).[45] Also at that time, he began to photograph his friends and colleagues at 291. The earliest works in this series, such as *Arthur Dove*, 1911–1912, often depict single figures emerging from a dark background, showing a strong influence of Hill and Adamson (fig. 10). When making these portraits, his intention was not simply to document those artists whose work he exhibited, but to illustrate the profound differences between photographic portraiture and contemporary drawings or sculpture that also depicted the human form.

The April–July 1911 issue of *Camera Work* included de Zayas' important discussion of Picasso—the first extensive analysis of his art in America—as well as reproductions of Rodin's drawings of nudes and Steichen's photographs of Rodin's sculpture *Balzac* (figs. 11, 12). Contrasting the older sculptor's innovative pencil, watercolor, and gouache explorations of lithely flowing female figures with the young Steichen's interpretations of a monumental and firmly rooted statue, this

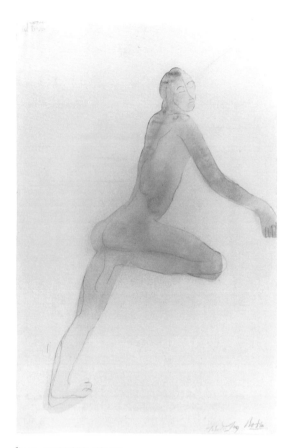

fig. 11 AUGUSTE RODIN
Leaving the Earth, *c. 1900–1905*
watercolor and graphite
The Art Institute of Chicago, Alfred Stieglitz Collection
EXHIBITED AT 291, 1910

fig. 12 EDWARD STEICHEN
Balzac—The Open Sky, 11 pm, *1908*
gelatin-carbon print
The Metropolitan Museum of Art, Alfred Stieglitz Collection, 1933
EXHIBITED AT 291, 1909

number of *Camera Work* called forth a profusion of questions and ideas, not just about the relationship of photography to sculpture and drawing, but also about gendered depiction, stasis and movement, the eternal and the ephemeral, youth and age, and innovation and interpretation. In October 1911 Stieglitz reproduced sixteen of his photographs in *Camera Work*, far more than in any previous issue, many made only the year before, and an illustration of Picasso's *Standing Female Nude.* It has been suggested that Stieglitz wished to demonstrate the visual similarities between his own work and Picasso's (fig. 13 and 14).[46] While Stieglitz's photograph *Spring Showers* and Picasso's *Standing Female Nude,* which followed immediately, share formal connections, his aim was surely broader. Because he conceived of each issue of *Camera Work* an "addition" to preceding ones, he certainly intended to compare his affinity with Picasso—the young rebel who was "the great force" in modern painting—to Steichen's appropriation of an older, more established, romantic sculptor.[47]

Further, by contrasting what he had come to call his "snapshots" with what he termed Picasso's "pure" works—beautiful not because of their relationship to anything else but "singly by themselves"—Stieglitz may also, immodestly, have wished to suggest that just as the future of twentieth-century art was embedded in the ideas explored by Picasso, so too did the future of twentieth-century photography lie in the lessons demonstrated in his own photographs.[48]

Certainly Stieglitz was also drawing attention to one of the major theoretical discussions that took place at 291 between 1908 and 1913. At this time, just as Picasso, Matisse, and others were constructing a new language of form and color, so too were the artists and critics associated with 291 formulating a critical vocabulary

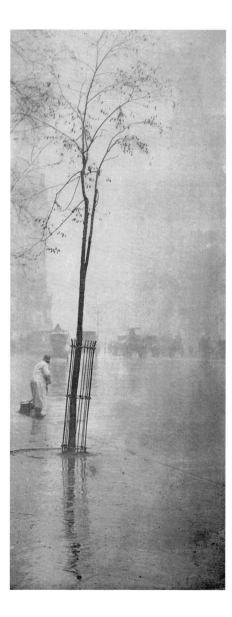

fig. 13 ALFRED STIEGLITZ
Spring Showers—The Street Sweeper, *1901*
photogravure on Japanese tissue
National Gallery of Art, Washington,
Alfred Stieglitz Collection
EXHIBITED AT 291, 1913; ANDERSON GALLERIES,
1921, 1924

fig. 14 PABLO PICASSO
Standing Female Nude, *1910*
charcoal
The Metropolitan Museum of Art, Alfred Stieglitz
Collection, 1949
EXHIBITED AT 291, 1911; AN AMERICAN PLACE,
1937, 1941

as they tried to explain and defend this new work.[49] Like other proponents else-where, they advanced the concept of correspondence between the arts, reflecting their strong symbolist heritage, and insisted, as de Zayas and Paul Haviland wrote, that "modern art does not aim at either representation or decoration and should be looked upon as aiming to give us an abstract emotion such as would be given us by music."[50] They also updated the symbolist belief in synesthesia—the possibility of suggesting one thing by means of another—and proposed the idea of equivalence. As de Zayas asserted in his 1911 essay on Picasso, the artist "receives a direct impression from external nature," which he analyzes, develops, and translates, "with the intention that the picture should be the pictorial equivalent of the emotion produced by nature."[51]

As photography was still at the core of all of the activities at 291, it is not sur-prising that Stieglitz, Steichen, and de Zayas, among others, quickly realized that what Stieglitz had come to call "the idea of photography" posed questions that were of central importance to the other arts. Beginning in 1908 they stated and restated the idea that with the invention of photography, art could no longer be representa-tional; it had to be different from photography, therefore it had to be abstract. They recast ideas that had been frequently voiced in the late nineteenth century, that because the camera can so easily, quickly, and accurately record the facts of the external world, artists must recognize, as Steichen explained in 1908, that a paint-ing "must first and foremost be beautiful in form and in color regardless of its phys-ical representation of nature, otherwise it is only a photograph."[52] In 1910 Stieglitz asserted that "the other arts could only prove themselves superior to photography by making their aim dependent on qualities other than accurate reproduction." For this reason, he continued, "the works shown at the Little Galleries in painting, drawing and other graphic arts have all been non-photographic in their attitude, and the Photo-Secession can be said now to stand for those artists who secede from the photographic attitude towards the representation of form."[53] More succinctly, in 1913 when the large exhibition of modern art opened at the New York Armory, Stieglitz proclaimed that the show consisted of "a score or more of painters and sculptors who decline to go on doing what the camera does better"; both their vision and their art, he explained, was "anti-photographic."[54]

If painting and photography were dialectical opposites, and if painting in this new age had to be anti-photographic, then it stood to reason, as de Zayas clearly articulated in a series of articles written in 1913 and expanded in 1915, that photog-raphy had to be non-painterly. Positioning photography firmly at the center of the intellectual and aesthetic discourse he envisioned would occur in the twentieth cen-tury, de Zayas argued that photography was a vehicle not for aesthetic pleasure but

truth because it provides "the plastic verification of fact."[55] Whereas art, and especially abstract art, is subjective and strives to present emotional truths, what de Zayas came to call "pure" photography was, or could, be objective. De Zayas suggested that the "artistic-photographer," like Steichen, "uses nature to express his individuality," whereas the "pure" photographer, like Stieglitz, "puts himself in front of nature, and without preconceptions... [and] with the method of an experimentalist, tries to get out of her a true state of conditions," to arrive at "a comprehension of the object."[56] Proclaiming that "Photography is not Art. It is not even an art," de Zayas suggested that the medium "escapes through the *tangent of* the circle," circumventing traditional artistic methods, and thus it reveals "a new way to progress in the comprehension of form."[57] Moreover, he predicted that because all art expresses the spirit of its time and because the religion of the modern age was science, photography would "surpass art," for it would provide this scientific age with the "material truth of form" that it so clearly demanded.[58]

By 1913 Stieglitz had spent more than twenty years struggling to have photography accepted as an art, and only a few years earlier he had strenuously defended the photographer's creative individuality, applauding those photographers and critics like Charles Caffin who recognized that a pictorial photograph aims "to be beautiful. It will record facts, but not as facts."[59] Nevertheless, he enthusiastically embraced de Zayas' ideas, telling one correspondent that with the publication of his articles "the meaning of photography as a medium of expression is finally getting its place"; he even took credit for their formulation, noting that they were "one of the blossoms of the seed sown by me."[60] While he never extracted himself from his photographs, as de Zayas suggested, the idea that photography could not only surpass art but reveal fundamental, perhaps even objective truths, that it could impart not pleasure, but knowledge, proved to be far more appealing to Stieglitz than the symbolist evocations of many of the pictorial photographers he had previously supported. Moreover, Stieglitz would come to discover and exploit the way in which photography could reveal what he firmly believed were objective truths and yet strip them of their specificity and render them not as literal descriptions but symbols.[61]

Recent scholarship has shown that almost every one of the major European artists exhibited at 291 actively explored how photography could be used in the construction or dissemination of their art.[62] Rodin, for example, recognizing photography's ability to control information, carefully supervised photographs made of his sculpture, while Constantin Brancusi, who was exhibited at 291 in 1914, became so concerned with the ways in which photographs informed interpretations and revealed or concealed the works' essence that he learned to make his own photographs. Exploiting photography's commercial applications, Rodin and Matisse frequently

allowed photographs of their art to be exhibited alongside the originals, as they often were at 291, thus allowing visitors and potential purchasers to view many more works than could otherwise be accommodated in a single venue.[63] Seizing on photography's ability to provide an easily accessible visual encyclopedia, almost all of these artists collected photographs of works of art by present and past masters and thus entered into a dialogue with art from all time and all continents. Several, Rodin and Picasso in particular, used the photographs they or others took of their own work in progress as a way to gain critical distance from their art and rethink its progress; to reevaluate formal, tonal, and compositional relationships within their canvases or sculpture by examining them in the limited black-and-white tonal range; to explore alternative paths by drawing, cutting, or pasting photographs together; and at times to merge what had previously been two or more separate pieces into one new work in a photographic collage.

These artists, however, also explored photography conceptually. In his photographs made in Horta and elsewhere, Picasso saw the ways in which the camera compressed space and stacked planes one on top of another; and he noted how a wide-angle lens seemed to splay forms out at their edges, revealing their separate structural, almost skeletal elements. Picasso also understood that the medium could be a liberating tonic in the creation of abstract art, for he recognized that when he worked from photographs he could more easily get away from his own empirical tendencies because he started with something that was already one step removed from reality. Brancusi, fascinated with the ways in which photography could reveal more than the human eye could see or choose to comprehend, explored how his photographs, which have been referred to as one of the earliest examples of installation as art, could expose new relationships between his works; how they could emphasize the almost lifelike presence of his sculpture as each piece seemed to converse with its neighbors; and how the numerous reflections in his highly polished bronzes could reveal both the external world around the sculpture and its internal life.[64] Not coincidentally, it was precisely these artists, who were thinking about their work in relationship to photography, who welcomed first Steichen and later Stieglitz, de Zayas, and Haviland into their studios and readily accepted their invitation to exhibit in a small photography gallery thousands of miles away. These artists also benefited enormously from their contact with 291 and from seeing their works reproduced alongside photography; "to them," as Stieglitz explained, "photography suddenly assumed a new meaning."[65]

Thus, by 1913 Stieglitz and his associates at 291 were fully up-to-date with the latest advances in modern European art. Through their exhibitions and publications, as well as the discussions that Stieglitz initiated at the gallery, this group of

artists, photographers, and critics had not only introduced modern art to the American audience, but they had also formulated a cogent argument for its legitimacy and defense. With the fervor and idealism of young converts, they had established 291 as a revolutionary outpost that was known and admired by artists in both Europe and America for its commitment to a wide-ranging and unfettered examination of new or unconventional ideas about art. As one critic noted in 1912, they had brought "New York almost abreast of Paris, to say nothing of London, Berlin, or Munich" in its level of activity and understanding of new art.[66] And Stieglitz had succeeded in placing photography at the very center of the evolving discourse on modernism. 291 was, as Herbert Seligmann wrote a few years later, "a vision" conceived and constructed "through photography."[67]

"The Nursery of Genius"

When the large International Exhibition of Modern Art opened in February 1913 at the 69th Infantry Regiment's Armory in New York, among the more than 300 artists represented were many whom Stieglitz had previously shown, thus confirming, as Stieglitz and critics of the time recognized, the prescient nature of many of the exhibitions that had been presented at 291 from 1908 through 1912. In response to this sprawling extravaganza, in the months immediately before, during, and after, Stieglitz organized a series of small, concise exhibitions at 291: the month before the Armory Show opened he presented an exhibition of John Marin's watercolors; concurrent with the larger show he displayed his own photographs; and immediately thereafter he mounted Francis Picabia's latest watercolors and gouaches (pls. 24–33). Each exhibition included recent depictions of New York and thus visitors over the course of three months were able to consider the ways in which one European and two Americans artists, and two painters and one photographer, responded to and depicted the city. Stieglitz also, somewhat equivocally, supported the larger venture. While privately he despaired that the notoriety of the Armory Show was overwhelming the art, publicly he supported it: he lent work to it, bought several pieces from it, and gave interviews to the press defending the exhibition.[68] Gleefully proclaiming that "the dry bones of a dead art are rattling as they never rattled before," he announced in the *New York American* that the Armory Show consisted of work that demonstrated that "art begins where imitation ends," and he predicted that "when the smoke has cleared away you'll go back to your habitual worship of eternal repetitions of mere externals of people and things ... —but you won't feel satisfied."[69]

Ironically, Stieglitz himself was no longer satisfied after the Armory Show. In the wake of the sensationalism of that show and the removal of the 15 percent tariff

that had previously been charged on importing works of art less than twenty years old, several other galleries in New York began to exhibit modern European art, including the Daniel Gallery, the Carroll Galleries, and the Washington Square Gallery. (Even the conservative Montross Gallery exhibited Matisse in 1915, prompting one of Gertrude Stein's correspondents to note that the French artist had thus become "old-fashioned."[70]) These new businesses also made arrangements with their European counterparts to act as the sole American agent for some of the more popular modern artists, thus preventing 291 from having easy access to both the diversity and quality of work they had previously exhibited.[71] In addition, other periodicals, such as *The Soil*, *Seven Arts*, and *The Little Review* began to address some of the iconoclastic ideas that had first been championed in *Camera Work* and drew younger and often more radical writers and readers away from the older periodical. Other photography journals like *Platinum Print* began to pick up the photographers Stieglitz and *Camera Work* had left behind, while other forums such as The Little Book-shop Around the Corner became the meeting place for former members of the Photo-Secession.[72] Other patrons, such as Mabel Dodge, Walter and Louise Arensberg, and Gertrude Whitney began to court and support modern artists and theoreticians. The lines between these groups were not clearly defined—Dodge and Arensberg and the artists and writers they championed, such as Andrew Dasburg, Hutchins Hapgood, Marcel Duchamp, or Man Ray, frequented Stieglitz's gallery and he occasionally attended their soirées—but they diverted attention away from both 291 and, more specifically, Stieglitz. Moreover, in the years immediately after the Armory Show, some of the revolutionary ideas Stieglitz had explored at 291 became almost mainstream, perhaps even trivialized, and certainly commercialized.

Unable to be one among many, Stieglitz tried to respond. With de Zayas acting as his agent in Paris in the summer of 1914, he aggressively sought to make the 1914–1915 season at 291 "a very live one…a hummer," as he wrote. Promising to have no exhibition run longer than sixteen days, he pledged to "force issues," and told de Zayas that he was "more eager than ever" to have an exhibition of Picasso's most recent work. When that failed because of an exclusive arrangement that Picasso's new dealer Daniel Henry Kahnweiler had made with the Washington Square Gallery, he applauded de Zayas' efforts to borrow work by Picasso from the Picabias' collection. And he enthusiastically sought contacts with Guillaume Apollinaire to learn more about his publication *Les Soirées de Paris*, and worked to secure an exhibition of African art from Paul Guillaume.[73]

But the outbreak of World War I in the late summer of 1914, coupled with his growing economic and personal difficulties, and the threatened destruction of the building housing 291, constrained Stieglitz's activities and sapped some of his ener-

gies. *Camera Work* also faltered as he spent a considerable amount of time focusing on the number devoted to the question "What Is 291?" that was finally released in January 1915. In late 1914 and early 1915 Stieglitz recognized, as he had often in the past, that he needed to separate himself from the growing crowd of art enthusiasts in New York. Radical, unexpected actions were necessary to confound his critics, reclaim his position as New York's preeminent iconoclast, and reassert 291's intellectual integrity. He explored two experiments ardently championed by his trusted young colleague de Zayas: a new publication, which would be titled *291*, and a new gallery, the Modern Gallery. Although unforeseen at the moment of their inception, these activities would force Stieglitz to begin to confront the roles of commerce in the artistic enterprise and the machine in modern life and art, and the character of modern American art.

De Zayas later remarked that he hoped that the Modern Gallery, which opened in October 1915, would bring "the artist in contact with the public, the producer with the consumer without intermediaries."[74] Responding to the dire economic position of many artists in both Europe and America, de Zayas and Stieglitz conceived of the Modern Gallery as an offshoot of 291, but entirely different from it. The Modern Gallery would present work "'291' considers worthy of exhibition," yet its goal was

"to do *business* not only to fight against dishonest commercialism but in order to support ourselves and make others able to support themselves."[75] Although 291 was a commercial gallery and charged commissions, Stieglitz's quixotic business habits, coupled with the radical and consequently often baffling nature of much of the work that was shown, had resulted in limited sales.[76] The Armory Show's successful reception made de Zayas confident that modern art would now be able to "pay its own way," and he intended that 291 should be involved with "purely intellectual" matters, while its younger affiliate, the Modern Gallery, would be "purely commercial."[77] At first, Stieglitz was, as he wrote de Zayas in August 1915, "heart & soul for the Gallery, for the Idea," but after it opened, his enthusiasm diminished and several months later he announced that 291 and the Modern Gallery had separated.[78] De Zayas continued to run the gallery for three years but later admitted that he never made any money and had only two buyers, Arthur B. Davies and John Quinn, neither of whom "needed to be lured into buying."[79]

The primary reason for the break was the profound difference in de Zayas' and Stieglitz's ideas about the nature of art

itself and society's responsibilities to both the artist and his or her work.[80] With his strong romantic tendencies and his elitist, symbolist heritage, Stieglitz had a deep belief in the artist as a creative genius, capable both of begetting works of great originality and of divining profound, even transcendent truths. With such an understanding, he could not conceive of art as a commodity that could be bought and sold like groceries. Art was a spiritual expression, not a product, and Stieglitz maintained that the public needed to share this faith—or learn how to share this faith—and support artists in the same way they supported religious leaders. Capable of divine revelation, art for Stieglitz was to be understood as a selfless act, not something made for personal gain. De Zayas, far more democratic and pragmatic, also tried to be far less idealistic. He saw art as a direct expression of contemporary life, not removed or isolated from it. Because he had confidence in the public's ability to "further modern thought by weeding out the true from the false," he was content to rely on the consumer society's basic law of supply and demand. "I thought that if the pictures do not sell themselves," he wrote several years later, "they could at least speak for themselves; and I thought the best policy I could adopt was to leave people alone to think for themselves."[81]

The periodical *291* also displayed signs of the divergence between Stieglitz and his younger colleagues, and his enthusiasm for it too waned with time. In the spring of 1915, de Zayas, Haviland, and Agnes Ernest Meyer (a supporter of *291* and wife of the financier Eugene Meyer) proposed a monthly "devoted to the most modern art and satire." Hoping that "such a publication might bring some new life into *291*," Stieglitz later recalled that it "met with my fullest approval" and agreed to allow it to carry the name of *291*.[82] Along with de Zayas, Haviland, and Meyer, he was also one of its editors and with Haviland and Meyer, one of its financial backers. De Zayas' caricature on the cover of the first issue of *291* confirms Stieglitz's enthusiastic participation (pl. 34). Depicting him as a camera with bright, intent eyes, de Zayas titled the work *291 Throws Back Its Forelock*, as if to suggest that the photographer had once again unfurled himself from the body of his camera, proudly lifted his head up, and shaken off the lethargy that had previously diminished him.

Yet subsequent issues began to reveal differing ideas and even to criticize Stieglitz. Forcefully tackling the issue of the machine and its role in modern American art and life, the July—August 1915 number of *291* consisted of five abstract portraits by Picabia of the major supporters of *291* and himself, depicted as mechanical contraptions (pls. 59, 62, 63, and 64; fig. 16).[83] As Picabia recounted to a reporter, when he arrived back in the United States only a few weeks before, he instantly recognized that "the genius of the modern world is machinery, and that through machinery[,] art ought to find its most vivid expression." Further, Picabia saw that

in America "the machine has become more than a mere adjunct of human life. It is really a part of human life—perhaps the very soul."[84] By depicting his collaborators as machines—Stieglitz as a camera, Haviland as a lamp, de Zayas as some sort of viewing device, Meyer as a spark plug, and himself as a horn—Picabia, according to de Zayas, "has married America like a man who is not afraid of consequences." Drawing on American consumer culture with its emphasis on mass production and advertising, Picabia, as he himself remarked at the time, "introduced into the studio" mundane and inanimate machines from everyday American life and turned these anti-art objects into art. He "obtained results," de Zayas concluded, and thus he demonstrated to American artists how they too could merge a modernist expression with distinctly American subject matter.[85]

But as Picabia made evident in his portrait of Stieglitz, titled *Ici, C'est ici Stieglitz,* and de Zayas in his postscript to the July–August issue of *291,* both men felt that the photographer had also attempted and failed to consummate this union. De Zayas believed that Stieglitz had succeeded in his own photographs: he had carried "photography … to the highest degree of perfection" for he had "searched for the pure expression of the object" in order to determine "the objectivity of form," and in so doing he too "had married Man to Machinery and obtained issue."[86] But, they both asserted, Stieglitz had failed to reach a similar synthesis with the other arts. He had been unable to attain the "Ideal" depicted in Picabia's portrait because, as de Zayas wrote, "he imported works" from Europe with the intention that they would be used "as supports for finding an expression of the conception of American life." Instead, the result was only "servile imitation" from American artists who simply "copied a method" instead of understanding its ideas. Despite the fact that "in politics, in industry, in science, in commerce, in finance, in the popular theater, in architecture, in sport, in dress," Americans had been unafraid to abandon "European prejudices" and create their "own laws in accordance with [their] own customs," in art America still looked to Europe. As Pepe Karmel notes, Picabia's portrait of Stieglitz echoes this conclusion (see pages 216–217). The bellows of the camera—that is, the supporting structure that Stieglitz had erected—was not strong enough to sustain his ideal and therefore he had failed to bring forth genuine expression of "the real American life." "America," de Zayas concluded, "remains to be discovered."[87]

Stieglitz was aware of this. Yet, while he shared de Zayas and Picabia's conviction that modernism could develop out of the American culture and that American art could truly be avant-garde, he had much more confidence than they did in the potential of the younger American artists whose work he had championed; so much so, in fact, that he announced in *Camera Work* in 1915 that 291 would no longer

exhibit work by Europeans.[88] More emotional than conceptual in his approach, Stieglitz was also still too much a product of the late nineteenth century and he could not share de Zayas' and Picabia's unabashed celebration of the machine: in his mind, the machine was too spiritually bereft to be an object of veneration. Nor did he believe that an art based on the depiction of machines and their products would enable Americans to discover who and what they were. Instead, he tried to humanize the machine, telling O'Keeffe only a year later, "machines have great souls—I know it."[89] As if challenged to demonstrate his ability to inject a soul into the inanimate machine of the camera, in late 1914 Stieglitz once again brought out his camera and intermittently, over the next three years, made a series of photographs that address these issues. In several works from 1915 or shortly thereafter he responded to the abstract portraits in *291* by de Zayas, Picabia, and others. Once again commenting on the profound differences between this new art and the new photography, he depicted artists such as de Zayas, Picabia, or Charles Demuth in front of their own art or works of significance to them, and he positioned friends and family, such as Marie Rapp or his own daughter Kitty, in front of drawings whose shapes echo their own forms (figs. 15, 17; pl. 133; fig. 153). Through his careful attention to details of pose, dress, and gesture; through the close proximity of camera and subjects whom he engaged fully in the creation of his art; and through their quiet, thoughtful expressions, Stieglitz was able not only to establish an almost palpable physical link with these friends, family, and colleagues, but a psychological bond as well.

In April 1917 he commented further on the issue of the machine in American art when he photographed Marcel Duchamp's ready-made, *Fountain*, a urinal rejected from the exhibition of the Society of Independent Artists (pl. 65). Carefully lighting it and positioning it on a pedestal in front of *The Warriors* by Hartley, Stieglitz tamed this machine-made, anti-art object, much as he tamed the machine of the camera, and transformed it into a work of art, making it, as he wrote, as beautiful as "a Buddha.... The 'art of China' brought up to date."[90] In addition, Stieglitz was also undoubtedly relating this work to O'Keeffe's *Abstraction*, a plaster cast of a hooded *memento mori* figure on view in her 3 April to 14 May 1917 exhibition at 291 (fig. 87n).[91] Approximately the same size, both are white forms that, when seen from the front, arch away from the viewer, and both are wider at the bottom and curve in to a bulbous shape at the top. History has come to view *Fountain* and all the controversy surrounding it as one of modernism's seminal moments, while O'Keeffe's *Abstraction* is all but forgotten.[92] That Stieglitz transformed *Fountain* into something as beautiful as a Buddha undercut Duchamp's intention; that he saw Duchamp's and O'Keeffe's works as comparable demonstrates his less than complete understanding of the importance of Duchamp's statement.

VOILÀ HAVILAND

LA POÉSIE EST COMME LUI

F. Picabia
1915
New York

At the same time that Stieglitz at least initially supported de Zayas and Picabia's investigation of America's new mechanistic and commodity culture, he also looked to "discover America" through alternative paths. In the years around the Armory Show, he came to realize that just as his perspective as a photographer had allowed him to approach modern art from an unconventional vantage point, so too might other non-traditional and non-hierarchical ways of making art help him and other American artists to understand all forms of expression more fully and American art more specifically. He looked for these alternative routes in so-called primitive or naive art.

The first exhibition to explore these ideas was in 1912 when he and the American painter Abraham Walkowitz organized a selection of drawings, watercolors, and pastels by children aged two to thirteen.[93] While he knew that children's art was a subject that fascinated Matisse, Picasso, and Kandinsky, among many other modern artists, he did not present this show to suggest that this art was a source for their work or to refute the prevailing belief that any child could paint as well as some of the modern artists he had exhibited. Instead, he wanted to prove the impossibility of an observation made to him by a young painter who remarked that he saw the world "with the eyes of a child."[94] While it may have been the first exhibition of its

fig. 18 Alfred Stieglitz at 291 (Children's Art Exhibition),
c. 1914
*Yale Collection of American Literature, Beinecke Rare Book
and Manuscript Library*

kind in America, numerous shows of children's art had been presented in almost every important art center in the first few decades of the twentieth century.[95] As has often been noted, fin-de-siècle intellectuals cultivated the naive and searched for aspects of life and experience that had been lost in overdeveloped Western cultures. Not only children's art, but also other forms of primitive, tribal, or exotic art, were perceived to be less civilized and therefore less corrupted by Western society, with its materialism, rigid hierarchies, and preconceived ideas.[96] More immediate and inventive, more expressive of the joy of discovery, and, most especially, more genuine, children's art was thought to depict archetypal forms and express, as one of Stieglitz's contemporaries wrote, "a universal humanity."[97]

In his review in *Camera Work*, the critic Sadakichi Hartmann asserted that while the 1912 exhibition of children's art at 291 drew attention to the "elemental qualities" that contemporary art seemed to have lost, it also pointed to ways in which artists could imbue their work with "fresh and exquisite virility." He noted that the children drew freely, vividly, "without a special purpose," without hesitation, and without conforming to preestablished conventions. They saw the world fresh, without intellectualization or rationalization, but with "curiosity and wonder."[98] Echoing conventional thinking of the time, both Hartmann and Stieglitz felt that education killed this creativity: "Give a child a brush and a paint box and leave him alone. Don't bother him with theories, don't attempt to confine his genius within established limits. The great geniuses," Stieglitz insisted, "are those who have kept their childlike spirit and have added to it breadth of vision and experience."[99] With his romantic conviction that art was a gift of revelation, Stieglitz believed that untutored children were closer to their unconscious sources of inspiration and therefore far more likely to perceive fundamental truths or meaning in nature. "So it is only from the little children [that] we can learn the point of view of the true child of nature," Stieglitz told the *New York Tribune*, and that, he concluded, "is art."[100]

For Stieglitz, as well as some of his associates, children's art was their first extensive exposure to a form of so-called primitive art that was thought to be closer to the unconscious, a subject extensively explored in *Camera Work* at this time. Arguing against the nineteenth-century positivist idea that intelligence was the source of

both man's supremacy over other species and his creativity, Henri Bergson in an excerpt from *Creative Evolution* published in *Camera Work* in 1911 suggested that it was intuition that leads us "to the very inwardness of life ... by intuition I mean instinct that has become disinterested, self-conscious, capable of reflecting upon its object," while in a subsequent article he argued that artists "make us see something of what they have seen ... things that speech was not calculated to express."[101] "Modern psychology," de Zayas explained in *Camera Work* in 1912, "admits the principle that the less filled the brains are with knowledge, the more deeply the impression penetrates.... That is why the work of children is always impressive." Working in "an unconscious way," de Zayas continued, the child "does not use his reflective facilities ... hence its extraordinary spontaneity." However, while he extolled the unconscious as "the sign of creation" and consciousness "at best that of manufacture," de Zayas, like Stieglitz, insisted that "those who consciously imitate the work of children produce childish art, but not the work of children."[102] Instead, the modern artist "has had to abandon the complex study of realistic form ... and turn to the imaginative and fantastic expressions of Form in order to have a complete understanding of its expression."[103] They must be "seekers of the inner spirit in outer things," as the 1912 excerpt published in *Camera Work* from Wassily Kandinsky's *On the Spiritual in Art* had preached.[104] Only then, as de Zayas continued, does art become a vehicle for "psychology and metaphysics," and reach "its highest manifestations" by expressing "not the objective, but the subjective."[105]

Stieglitz saw the ideas provoked by children's art as central to the mission of 291 after the Armory Show; so much so that one critic dubbed 291 "the nursery of genius" (fig. 18).[106] He published children's poetry in *Camera Work* and he organized three more shows of children's art in 1914, 1915, and 1916.[107] The second, selected from more than one thousand examples, demonstrated to Caffin a marked difference between the technical renditions by older boys and the comparatively imaginative and sensitively colored studies by girls.[108] As if to test this observation, the third exhibition, held in 1915, presented work only by boys aged eight to fourteen and made under the guidance of their teachers. The fourth show, in 1916, described as teeming "with suggestive significance in many directions," only displayed work by a ten-year-old "Unguided and Untaught" girl, Stieglitz's niece Georgia Engelhard.[109]

Max Weber had first introduced Stieglitz to African sculpture in 1909 and by 1911 Stieglitz began planning an exhibition, which finally came to fruition through de Zayas' efforts and was shown in November and December 1914. Claiming to be the first exhibition anywhere of African sculpture as art, it included eighteen works

and was prefaced by a statement by de Zayas.[110] While de Zayas expressed many racist ideas about African art in his introduction and later publication, *African Negro Art: Its Influence on Modern Art,* his assessment of its impact on contemporary Western artists was more astute. He noted the liberating impact of African art on Picasso and others who discovered in it new paths to expression without recourse to direct imitation. Breaking down the entrenched sensibilities of educated Westerners to connect what is seen with what is known, African art, de Zayas asserted, taught the fundamentally different idea of connecting what is seen with what is felt. As one critic later noted, African art led to "the expression of emotion rather than the expression of vision and this, the modernists say, is the truth, therefore the beautiful in art."[111]

Stieglitz understood African art to be untutored, deeply spiritual and profoundly authentic; like children's art it was a product of "the true child of nature." Pronouncing the African exhibition to be "possibly the most important show we have ever had," he kept nine examples for his personal collection, placed them in his galleries in the 1920s and 1930s, and photographed people holding them on at least four occasions.[112] (Imbibing Stieglitz's appreciation, Georgia O'Keeffe later used these pieces as touchstones for her own art.[113]) Stieglitz also extended this dialogue in a series of installation photographs made in 1914 and 1915. Previously he had made surprisingly few photographs of the exhibitions at 291, yet he felt compelled to record 291's "most important show," the African art exhibition (pl. 42).[114] Shortly thereafter he made two studies of what was probably a temporary installation of two works by Picasso, paired with an African reliquary mask, a wasps' nest, and 291's signature brass bowl (pl. 51).[115] Comparing art and nature, Western and African art, intellectual, supposedly naive, and natural art, Stieglitz not only concisely summarized the dominant issues under discussion at 291, but he also made a work that eloquently spoke of the nexus of the 291 space with European and American modernist art and photography. Even the shapes of the disparate objects depicted—the lines of the violin in Picasso's drawing and the shapes of the mask, bowl, and wasps' nest—echo one another, compounding and enriching the dialogue. Moreover, Stieglitz trumped Picasso, much as he would do later in 1917 with Duchamp, by appropriating their art, exposing some of their sources, and transforming their work into a personal statement of his own.[116] Once again, he asserted the central position both he and the medium of photography occupied in this evolving twentieth-century discourse.

Stieglitz was also intrigued with what he understood as another facet of primitivism: women's art. Like so many others of his time, he saw in it many of the same qualities he thought he perceived in children's art and African art.[117] A devoted

fig. 19 GEORGIA O'KEEFFE
No. 4 Special, *1915*
charcoal on paper
National Gallery of Art, Washington, Alfred Stieglitz
Collection, Gift of the Georgia O'Keeffe Foundation
EXHIBITED AT 291, 1916

reader of Havelock Ellis, Edward Carpenter, Herbert Spencer, and Sigmund Freud, among others, Stieglitz believed, as Carpenter wrote, that "woman is the more primitive, the more intuitive, the more emotional. If not so large and cosmic in her scope, the great unconscious processes of Nature lie somehow nearer to her."[118] Stieglitz took this a step further to posit that if women, like children and other so-called primitive peoples, were fundamentally different from Western men—that is, less rational, analytical, and objective; more emotional, reactive, and subjective; less cerebral; more intuitive, sensual, and sexual; and less well educated—their art should also be fundamentally different from art by men. In the years immediately after the Armory Show, Stieglitz became convinced that if a woman expressed herself without recourse to servile imitation, if she gave voice to her genuine feminine spirit, her art would not only necessarily be different from art by men, but, more important, it could also come closer both to divining archetypal truths and to revealing a universal woman's spirit.

Earlier in his career Stieglitz had encouraged women artists—almost one-quarter of the members of the Photo-Secession were women—but it was only after 1913 that he began to emphasize their work. In addition to the 1916 exhibition of watercolors and drawings by his ten-year-old niece, he also exhibited paintings by Marion Beckett and Katharine N. Rhoades in 1915, and included Georgia O'Keeffe's work in three exhibitions at 291 in 1916 and 1917. His motives for mounting these shows were not entirely dispassionate: he was personally involved with Rhoades and Steichen was romantically linked to Beckett. Nevertheless, he did herald O'Keeffe's work and decide to exhibit it several months before he laid eyes on her. And, while his oft-repeated comment "Finally, a Woman on paper," probably was not uttered when he first saw her drawings in January 1916, the remark does encapsulate his understanding of her accomplishment.[119] Describing O'Keeffe as a "Great Child," "a child of nature," he declared in 1918 that she merged what she saw with what she felt, for her "brain and heart are one."[120] In his mind—but not in fact—O'Keeffe was a largely uneducated genius whose work did not derive from European influences, but was, as a critic later wrote, "entirely and locally American."[121]

In 1916 and 1917, the last year of 291's existence, Stieglitz presented a series of exhibitions that succinctly assessed his accomplishments and also predicted the

course he would direct for American painting and photography in the next decade. In March 1916, after a three-year hiatus in photography exhibitions at 291, he presented work by the young American Paul Strand. Coupled with the selection of Strand's photographs that he reproduced in the last two issues of *Camera Work* in October 1916 and June 1917, Strand's art cogently integrated Stieglitz and de Zayas' theory of pure, objective photography with a radically new and dynamic pictorial vocabulary derived from his study of Cézanne, Picasso, Braque, and Marin. Immediately following the Strand exhibition, in April 1916 Stieglitz presented forty of Marsden Hartley's military portraits painted in Berlin in 1914 and 1915. Merging his knowledge of Picasso, Braque, Kandinsky, Franz Marc, and Robert Delaunay with imagery derived both from his fascination with Native American culture and the pageantry of the German military, Hartley had also constructed a vibrant, convincing new vocabulary of form and color that spoke powerfully, if elusively, of his experiences in Berlin during World War I. And finally, in two group exhibitions in May 1916 and November–December 1916, and a one-person show in April 1917, Stieglitz introduced Georgia O'Keeffe to the artistic community at 291. The draw-

ings, watercolors, and oil paintings that he presented were the direct result of her attempt to purge her art of all inherited ideas; to render herself almost childlike in order to make her work pure, direct, and immediate, expressive of what she felt, not what she knew. Although Stieglitz refused to acknowledge it, she too had blended her symbolist heritage and her study of Arthur W. Dow with the knowledge she had derived from the European and American artists and photographers presented at 291 and in *Camera Work*, including Rodin, Matisse, Picasso, Kandinsky, Dove, Hartley, Strand, and even Stieglitz himself. Out of this amalgamation, she developed what were described as challenging and highly "personal abstractions" of "amazing psychological frankness."[122] Each of these three artists synthesized newfound knowledge in a distinctive modernist vision. And, of even greater importance for Stieglitz, Strand and O'Keeffe had derived not just their imagery, but also their inspiration from their American experience. Along with Marin, these artists, Stieglitz believed, had the potential to "discover America."

In truth, however, much remained to be done. While Hartley, O'Keeffe, and Strand had made dazzlingly inventive works between 1915 and 1917, in the years immediately there-

fig. 21 ALFRED STIEGLITZ
The Last Days of 291, *1917*
palladium print
National Gallery of Art, Washington, Alfred Stieglitz Collection

after all struggled to find a style, subject matter, and a vision that matched the intensity and originality of their early accomplishments. Stieglitz, perhaps more so than these artists, realized they were just beginning. In June 1917, only two months after the United States declared war on Germany, he closed 291. The melodramatic photograph *The Last Days of 291*, which so clearly alludes to the heraldic imagery in Hartley's painting *The Warriors*, makes apparent Stieglitz's appreciation that one period had come to an end and a new one was about to begin (fig. 21 and pl. 68). With its depiction of a young soldier, armed with a sword and a broom and valiantly protecting the works of art scattered around it, the photograph speaks of the battles that had been fought at 291, the art and ideas that had been exposed and defended, and the conventions that had been challenged and swept aside. But, with the older, bandaged warrior looking on from the left—a bust possibly of Stieglitz's father—it also suggests that the fifty-three-year-old Stieglitz had been wounded in the process and that it was time for younger rebels to assume a more central position. Stieglitz recognized the truth that Picabia and de Zayas had articulated: much servile imitation and little true understanding of modernism existed in America, and the country still did not possess a supporting structure to nurture artists like Hartley, Marin, O'Keeffe, or Strand, and allow them to mature. As he asked in 1916: "Is the American really interested in painting as a life expression? Is he really interested in any form of art?"[123] That would be both his question and his challenge in the 1920s.

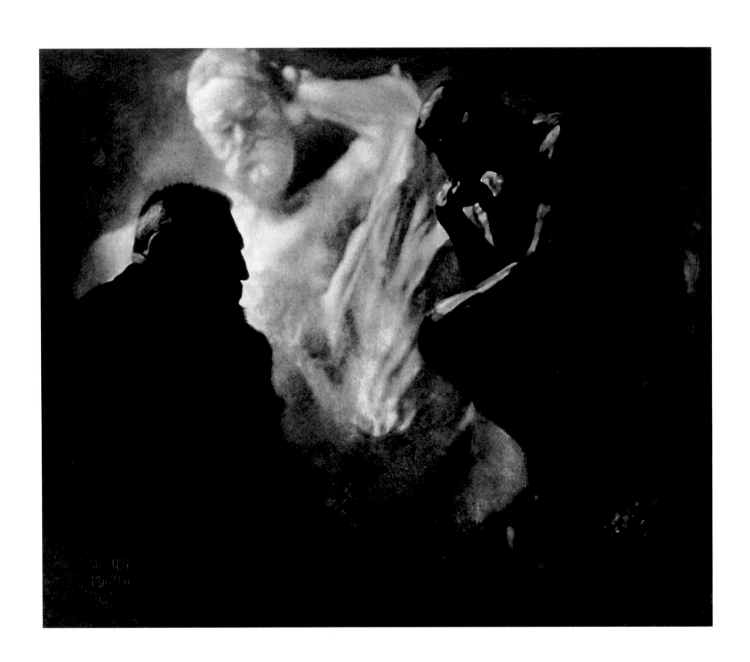

Anne McCauley

EDWARD STEICHEN

ARTIST, IMPRESARIO, FRIEND

B etween 1906, when he returned with wife and baby to Paris, and 1914, when he fled before the advancing German troops, Edward Steichen (or "Eduard," as he was then known) served as the right-hand man for Alfred Stieglitz in his "fight" for modern art at the 291 gallery. Whereas Stieglitz, fifteen years his senior, had risen to international celebrity within photographic circles during the 1890s, Steichen, only twenty-seven when he settled back on the boulevard du Montparnasse, had two things that Stieglitz lacked: he was trained as a painter (as well as a photographer) and he had spent 1900 to 1902 meeting key people in the Paris art world and improving his French. More comfortable in German-speaking countries and unfamiliar with studio jargon, Stieglitz played Dante to Steichen's Virgil as his ambitions for 291 extended beyond photography to include already established "fine arts." But the play of power between Stieglitz and Steichen ran in both directions, with Stieglitz holding the purse strings and making the final decisions on whether what Steichen proffered would be shown. He also found his own artists, and listened to rival voices offering alternative talents.[1]

After meeting Stieglitz briefly in New York en route to Paris from Milwaukee in 1900, Steichen became a vocal overseas advocate for American art photography and channeled European gossip and tales of his developing career to his supportive friend. He grew closer to Stieglitz only after his return to New York in 1902, however. Marrying in 1903 and with the birth of a daughter in 1904, Steichen set up a commercial studio at 291 Fifth Avenue to support his family. He gave more and more of his time to Stieglitz's new journal, *Camera Work*, and the meetings and exhibitions of the Photo-Secession, of

2 EDWARD STEICHEN
Rodin, "The Thinker," and
"Victor Hugo," *1902*
EXHIBITED AT 291, 1906

which he was a founding member. When Stieglitz considered opening a gallery in 1905, Steichen volunteered his former studio as a possible location, designed its installations and publications, and helped hang a series of ambitious international pictorialist photographic exhibitions during its first season. When his photographic production declined and his income became unsteady,[2] Steichen made a farewell visit to his parents in Wisconsin, packed up his studio/home, and set off for Paris in October 1906.

The city that Steichen confronted was quite different from the one that he had left as a promising artist in 1902: it was much more expensive and a new group of radical painters, the fauves, had caused a stir the previous year with their acid colors and crude modeling. The hottest exhibition venue was no longer the Salon Nationale des Beaux-Arts, where he had exhibited in 1901 and 1902, but the juried Salon d'Automne, founded in 1903 by the Republican architect and Dreyfusard Frantz Jourdain along with other defectors from the Salon Nationale, including Steichen's good friend Rodin.[3] Immediately visiting the fall 1906 show, which featured Gauguin and Carrière retrospectives, a Russian section organized by Diaghilev, and five oils by the fauves' leader Henri Matisse, Steichen complained to Stieglitz, "Holy giminie—it gave me a stomach ache."

1907 was a difficult year for Steichen because he had to assimilate much challenging art and figure out how to support a growing family in the wake of the stock-market crash of 1907. Installing his studio at 103 boulevard du Montparnasse in a style reminiscent of the decor he had designed for 291, he waited for clients who never came. He exhibited one painting in the spring Salon Nationale before abandoning that group for the Salon d'Automne, where he showed from 1907 to 1912. But, more important, he began organizing a wide range of exhibitions for the 291 gallery back in New York.

Like many other artists who became paid or unpaid advisors in Paris for wealthy American collectors and dealers (such as Mary Cassatt, who played this role for Louisine Havemeyer, or Walter Pach, who did it for John Quinn), Steichen became a scout for Stieglitz and a private guide through studios and galleries for a select but loyal group of American visitors. They ranged from wealthy friends, to young American artists new to the city, to critics such as Charles Caffin. While he did not apparently receive a commission for his work, he benefited in that many of his wealthy friends bought his paintings and photographs and, in the case of Agnes and Eugene Meyer, sent him annual checks in times of need.

Steichen's first thought after he arrived back in Paris was to continue the promotion of Rodin in the United States, which he had begun with his photographic portraits in 1901 and perpetuated with the help of well-placed friends such as

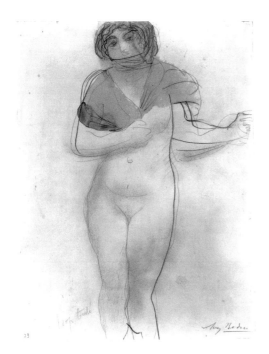

fig. 22 **AUGUSTE RODIN**
Drawing No. 4 (Nude with Shawl)
graphite and wash
The Art Institute of Chicago, Alfred Stieglitz Collection
EXHIBITED AT 291, 1908 AND/OR 1910

dancer Loïe Fuller and Kate Simpson (Mrs. John Woodruff) during his years in New York. Rodin was an international celebrity, and his recent drawings of nude models caught in often explicitly erotic poses were unknown to most Americans and would certainly rattle the staunch New York art world. After a year of negotiating with the busy sculptor, he managed to put together a group of recent drawings that were shipped off in November 1907 and exhibited to widespread acclaim the following February. Another more comprehensive Rodin drawings show, from which many works were sold, was mounted in 1910.

From a European artist's standpoint, exhibiting at a small American gallery with no track record and few sales could be a waste of time. Rodin needed neither money nor publicity in 1908, but knew he had admirers in America and was quite fond of the young Steichen. What made the Rodin shows possible was that Steichen had established a collegial, long-term relationship with the great master and, of course, that Rodin was a generous man open to many foreign admirers. No other famous living European artists were similarly featured at 291, but almost all those selected by Steichen were persons whom he appreciated as both original, challenging creators and dynamic human beings.

The second show that Steichen personally brought to New York in March 1908 was of a much younger artist whose career had just taken off in Europe. Henri Matisse had become the new *enfant terrible* of the Paris scene in 1905, the year that he showed *Luxe, Calme et Volupté* (among other works) at the Salon des Indépendants and five bold paintings at the Salon d'Automne. While neo-impressionist painter Paul Signac snapped up *Luxe, Calme et Volupté*, the former Académie Julian student and novice American collector Leo Stein bought *Woman in a Hat* for 500 francs. Leo's brother Michael and his wife, Sarah, who had only moved to Paris in January 1904, also bought a Matisse drawing after the 1905 fall show and had acquired six works by 1906. During 1906–1907, Matisse's paintings began to sell in large numbers, albeit at very low prices, and he was embraced by Parisian dealers ranging from Vollard (who paid Matisse 2200 francs for twenty paintings in April 1906) to Druet (Rodin's dealer and photographer who gave Matisse a one-man show in spring 1906) to Félix Fénéon, the former anarchist who acted as manager for the Bernheim Jeune gallery.[4] Gertrude Stein's friend Etta Cone, the German collector Karl Osthaus, and the socialist deputy Marcel Sembat began to purchase, as did two Russians, Sergei Shchukin and the textile magnate Ivan Morozov (who had 200–300,000 francs per year to spend on art).[5]

Steichen visited the celebrated salons of the outspoken Leo Stein and his silent sister Gertrude, but was uncomfortable with their mannered eccentricities. He felt more at home around Michael and Sarah Stein, who probably introduced him to Matisse in early 1907. Immediately liking the proper painter whose family life and businesslike management of his career were compatible with his own, Steichen also admired Matisse's radical experiments with color at a time when he had begun to experiment with Autochrome plates and to move away from the muted blues and greens of his nocturnal landscape paintings.

Steichen apparently took Stieglitz to see Matisse's paintings at Bernheim Jeune in the summer of 1907[6] and plugged them in a January 1908 letter in which he noted that they "were just shown in Berlin at Cassirers."[7] Stieglitz would have known the gallery and publications of Paul Cassirer, who with his brother Bruno had opened a gallery in 1898, backed the Berlin Secession, and promoted French impressionists and post-impressionists such as Cézanne and Van Gogh.[8]

The Matisses that Steichen was able to bring to New York in late February 1908 (along with Steichen's own photographs, hung just after his arrival) were not revolutionary paintings, however, but rather a sampling of small, inexpensive works on paper that Steichen must have selected with the artist.[9] Even though the watercolors gave some sense of Matisse's experiments with non-referential color, they resembled those of neo-impressionists such as Signac. The vigorously sketched drawings of nudes were cruder versions of traditional French académies, and the recent lithographs and etchings recalled the sparse contours of Rodin's watercolors shown the previous month. The one oil, borrowed in New York from painter George Of, Stieglitz's framer, oddly seems to have provoked little comment.

In the wake of this exhibition Steichen and Matisse became very good friends. He was a regular guest at Matisse's comfortable new house in the western suburb of Issy that his improving financial situation allowed him to rent in 1909 and buy for 68,000 francs in 1912. When Steichen moved in the spring of 1908 to the village of Voulangis east of Paris, he invited Matisse for lunch and horseback riding. After Steichen put up a pre-fabricated metal studio across the street from his house, he suggested that Matisse do the same.[10] It was there that Matisse painted his large decorative panels, and there that Steichen photographed him in 1909 not as a painter, as commercial photographer Henri Manuel had done, but as a sculptor arrested in the act of modeling the looming clay figure of *The Serpentine* (pl. 3).

Steichen's pattern of sticking with an artist he liked continued with Matisse: he sent over more Matisse drawings in spring 1910 along with photographic reproductions of his paintings. In spring 1912, he introduced New Yorkers to twelve of Matisse's small works of sculpture, most of which had appeared in the 1908 Salon

3 EDWARD STEICHEN
Matisse—The Serpentine, *c. 1910*
REPRODUCED IN CAMERA WORK,
APRIL–JULY 1913

d'Automne and the 1910 Grafton Galleries post-impressionism show in London, as well as twelve of the more familiar drawings. Steichen's interest in promoting Matisse, like Leo Stein's collecting of him, waned by 1912, however, for the simple reason that the artist no longer needed his help. In contrast to 1908, when Steichen could write after the show that "Matisse got hard up and asked several times about the money so I advanced it,"[11] he reported in December 1912 that "He had a very swell thing at the autumn salon this year—but just a little 'stunty' [probably *Capucines à la danse*].... I understand he is getting rich—selling everything—most of his sculpture editions sold and orders for 3 or 4 years."[12]

Steichen continually encountered problems getting European works through customs. In late 1908 he complained that the line-up for the spring season at 291 was rather weak "but that is due to our customs. I could easily send over some corking stuff otherwise.... I will send ... in a week or two some watercolors by John Marin—a young American ask Caffin [who had been in Paris in 1908] about them— *They are the real* article, and being an American there is no duty trouble."[13] Steichen was referring to the fact that since 1897 works of art imported to the United States had been subject to a 15% duty, but works by Americans living abroad were duty-free. Paul Haviland in November 1908 looked up the details of the customs regulations and found that the security bonds paid for foreign works had to be twice the estimated duty; if the works were not for sale, then they could enter duty-free.[14] The passage of the Payne-Aldrich tariff bill in 1909 made works of art more than twenty years old duty-free, but imposed a 15% duty for recent works. Haviland responded by drafting articles of association making the gallery a non-profit organization "for Customs Hall purposes."[15]

Steichen did not turn to his fellow American artists in Paris merely because it was easier to ship their works: he remained firmly nationalistic and, despite his friendships with French artists, believed that his compatriots needed his support. He first had to take on the older generation of expatriate painters still enraptured by Monet's Giverny canvases or Dagnan-Bouveret's Breton peasant scenes. The Society of American Artists in Paris, founded in the late 1870s, had come under attack as early as 1901, when Steichen's friend and photographic sitter John Alexander and others accused it of trying to monopolize American submissions to international exhibitions.

By 1908, the situation had changed little, with the Society characterized by younger artists as the "Decorative Trust," composed of men who all had the Légion d'Honneur, were doing almost nothing for American art, and in some cases had even stopped painting.[16] Remembering Alexander's defense of an earlier generation of American artists in Paris in 1901, Steichen helped organize a two-week, invita-

tional exhibition at the American Art Association that opened on 25 January 1908 with paintings by Daniel Brinley, Robert Coady, Leon Dabo, Maximilian Fisher, Frederick Frieseke, Maurice Sterne, John Marin, Max Weber, and George Oberteuffer, as well as his own oils and recent Autochromes (shown in reproduction). The process of putting this exhibition together inspired these artists to form a new secessionist group, the "New Society of American Artists in Paris." Meeting at Steichen's studio on 25 February 1908, they declared they were open to all American artists in Paris and selected an advisory board that included Steichen, Alfred Maurer, Max Weber, Daniel P. Brinley, and Donald Shaw MacLaughlan (whose etchings Stieglitz was currently showing at 291).[17] Their goal was not only to attract attention to new American work, but also to gain official recognition at the upcoming Vienna international exhibition.

Although Steichen was friendly with all the members of the new society, he did not admire their work equally. The artist to whom he first drew Stieglitz's attention was John Marin, who attended the first meeting. Marin, eight years older than Steichen, had been in Paris since September 1905. In 1907 he had exhibited his street scenes in the Salon des Indépendants, and gouaches of Venice, beach scenes, and three etchings of Parisian landmarks in the Salon d'Automne.[18] As a former student of William Merritt Chase at the Pennsylvania Academy of the Fine Arts and classmate of Arthur B. Carles, who had arrived in Paris on a scholarship in 1907, Marin could easily have been introduced to Steichen in 1907.

The works that Steichen selected for the 291 show in spring 1909 were not the more conservative, topographical etchings of Notre Dame, Rouen Cathedral, and medieval Paris that Marin had produced since his arrival, but his fluid, Whistlerian watercolors of the same subjects. Even though they featured muted grays, roses, and blues and conventional midground compositions, Marin's 1908–1909 watercolors showed an awareness of the techniques of the neo-impressionists and Matisse, in which white areas of paper appeared behind unblended wedges of color. As critic Charles Caffin, who had seen Marin's work in the summer of 1908, noted in the catalogue introduction, the watercolors could be categorized as "stirred by Matisse" while also evoking Whistler and Japanese simplification.

The decision to supplement the Marin show with fifteen oil sketches by an even more radical expatriate artist, Alfred Maurer, seems to have been made early in 1909. Since his return to Paris in 1902, Maurer, who like Marin was much older than Steichen, had garnered many medals with his large, full-length studies of fashionably dressed women painted in an impressionistic style reminiscent of William Merritt Chase and Jacques Émile Blanche. He had seen the celebrated 1905 Salon d'Automne show and was leading visitors to Leo and Gertrude Stein's collection before Steichen

fig. 23 ALFRED MAURER
Fauve Landscape, *c. 1907–1910*
oil on gessoed panel
Collection of Tom and Gil LiPuma
POSSIBLY EXHIBITED AT 291, 1909

had even arrived in Paris. Within the New Society of American Artists, Maurer was the first to assimilate the saturated oranges, yellows, and lime greens of fauvism and exhibited six fauve-influenced landscapes in the 1907 Salon d'Automne. As Katherine Brinley, wife of Daniel Putnam Brinley, wrote in 1905, Maurer was "a man who has 'arrived,' perhaps the best known American painter here."[19]

The small oil sketches on board that Steichen selected for 291 and asked to be hung in a tight grid were the most radically abstract color works seen in the gallery to date (fig. 23). As Steichen wrote to Stieglitz, Maurer's gold-framed oils "are certainly howlers as color and ought to make the people that kicked at Matisse feel ashamed of themselves—Everybody is jumping on the poor devil for 'going to the bad' and he is having quite a time of it." Countering the charge that Maurer was merely an unoriginal follower of Matisse, Steichen added that he used a skilled technique that gave his works greater luminosity.[20]

Steichen continued to promote his fellow American painters in Paris in late 1909, when he envisioned a sampling of works by four artists: three members of

the New Society of American Artists who were still in France (Maurer; Laurence Fellows, who lived in Villiers-sur-Morin not far from the Steichen's house at Voulangis; and Steichen himself) plus Arthur B. Carles, who had become Steichen's good friend and had spent the summer of 1908 in a hotel in Voulangis (fig. 24). After Steichen's arrival in New York in December 1909, the show expanded to become "Younger American Painters," opening on 9 March 1910. It included two additional founding members of the Society, Daniel Putnam Brinley and Max Weber, who had returned to New York in late 1908. A third, Marin, was back in the city in late 1909 and had met Stieglitz, starting a collaboration that would last for the rest of their lives. A few months earlier Stieglitz had mounted an exhibition that included some of the watercolors Marin had done with Steichen at Voulangis in 1909 along with his etchings and pastels. Stieglitz seems to have added works by Arthur Dove, who had been in Paris in 1908–1909 but by 1910 was living in Connecticut, and Marsden Hartley, who had not yet been to Europe but had exhibited at 291 in 1909. The "Younger American Painters" exhibition represented a hodge-podge of styles, ranging from the Monet-influenced impressionism of Brinley to the glaring color of Maurer, but all the works were marked by a rejection of the

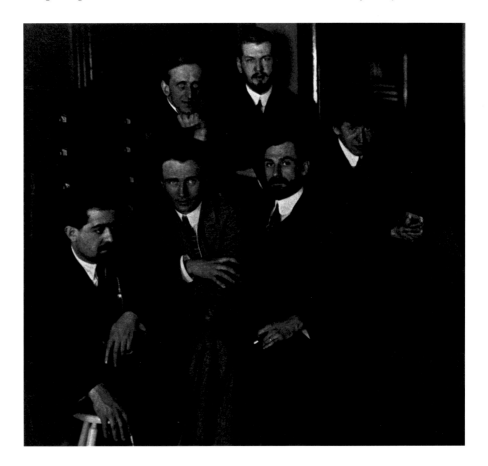

fig. 24 UNKNOWN ARTIST
A Group of Young American
Artists of the Modern School
(from left, front: Jo Davidson,
Edward Steichen, Arthur
B. Carles, John Marin; back:
Marsden Hartley, Laurence
Fellows), c. 1911
Bates College Museum of Art,
Lewiston, Marsden Hartley
Memorial Collection

social realism of The Eight and a primary interest in saturated color and divided brushwork.[21]

The only other Americans in (or passing through) Paris whom Steichen pushed for subsequent 291 shows were his close friends Arthur B. Carles, Katharine Rhoades, and Marion Beckett. Carles' paintings, featured 17 January–3 February 1912, parallelled Steichen's in their shift between 1907 and 1912 from cool, moody nocturnal landscapes to much brighter and vigorously brushed figure studies and rural sketches influenced by Matisse. Of all the American painters in France, Carles was closest to Steichen, even returning in 1921 to live in the house he continued to rent at Voulangis. Carles also became a good friend of Stieglitz, who kept up with him in the early 1920s but never showed his work again.[22]

Katharine Rhoades and Marion Beckett, two well-born young women who were studying painting in New York, went to Paris at some point between 1908 and 1910 and began frequenting 291 upon their return.[23] They probably met Steichen during his winter 1910 visit to New York, and by the summer of 1912 were painting with him at Voulangis.[24] Steichen wrote to Stieglitz in December 1912: "Have you seen Miss Beckett's paintings?—I think she made the cleanest clearest step in advance of anyone whose work I've been watching.... I think she and Miss Rhoades are entitled to a show at 291."[25] It was only in January 1915, after all the parties involved were resettled in New York, that the show materialized. It featured Beckett's fauve-influenced portraits of Steichen, Steichen's wife, Stieglitz's wife, and Rhoades, and Rhoades' portrait of Steichen's daughter and a landscape of Voulangis (among other works).[26]

Steichen's tendency to encourage Stieglitz to show the works of people who were his personal friends continued in the case of Edward Gordon Craig, the British set designer. Steichen appar ently met and photographed Craig in late October 1906, when en route to London he stopped in Holland to photograph the American dancer Isadora Duncan, who had just had Craig's child.[27] Craig's formation of a new, abstract theater, in which faceless actors moved before overscale, flat scrims modulated with changing, colored lighting, was set forth in a 1906 manifesto, "The Actor and the Uber Marionette," which appealed to Steichen's taste for art that expressed eternal truths allegorically. As early as 1908 Steichen told Stieglitz that he was corresponding with Craig in order to put together a show of his designs,[28] and in 1909 introduced him in Paris to the flamboyant former actor. As Steichen wrote

fig. 25 GORDON CRAIG
Study for Movement, *from* A Portfolio of 14 Etchings, *1907*
etching
The Metropolitan Museum of Art, Alfred Stieglitz Collection, 1949
EXHIBITED AT 291, 1910–1911

Craig: "He [Stieglitz] likes the drawings you have here [in Paris]—but naturally thinks the etchings finer—so don't fail to send along a set—and some other top-notch drawings—as your show will be looked forward to by many people, who really will be able to appreciate them, and I am sure will buy—don't make the price list any higher than you can help—the Secession charges a commission of 20% on sales...."[29]

Eighteen older drawings, eight sketches inspired by musical scores, and nineteen etchings of movement were shown in December 1910–January 1911, but found few buyers. The drawings of British locales recalled Arts and Crafts illustrations of the 1890s, and the etchings of movement (fig. 25) superficially resembled the latest cubist abstractions while in fact demonstrating Craig's rejection of "realist" theater in favor of timeless, Greek-inspired stagecraft. The check for $80 that Stieglitz forwarded to Craig represented the cost of the fourteen etchings that he himself had bought.[30]

The state of the Parisian art scene in late 1910, and Steichen's mode of organizing exhibitions, is best conveyed in a letter to Stieglitz: "There has been a general settling down among the 'wild ones' [fauves] and the result is that shorn of their extreme excentricities there is *nothing* left—for instance Van Dongen has gotten mondaine—exhibits two portraits that could almost be done by Henri [Robert Henri]. Matisse always remains a big man but he bit himself this year even as Coburn & Käsebier have done when they made enlargements [a reference to the two large decorative panels, *La Danse* and *La Musique*, shown in the 1910 Salon d'Automne].... the Munich section [a special show of Munich decorative arts in the Salon d'Automne] ... is good but very inferior to what the Vienna Hoffmann, Klimt crowd do.... I wonder what your plans are this winter. I have any amount of material available ... a Cezanne water color show and a collection of 14 & 15th century Persian paintings all XXX material—I can get anything else you want—Steinlen—or whatever you wish.... I am pestered to death over here by all sorts that want to get into the Secession shows...."[31]

This letter reveals that the two men were conversant with Munich and Vienna secession artists whom they never exhibited as well as other fauves, such as Van Dongen, who similarly were not shown. It also points out how Steichen offered Stieglitz a shopping cart of options based on what dealers had available. Many of these were never exhibited for reasons that have more to do with chance than adherence to a coherent aesthetic program. Steinlen's prints and Persian miniatures never made it to New York. Other aborted shows that Steichen offered were Frank Brangwyn etchings that photographer Alvin Langdon Coburn was pushing from London in late 1906; Maurice Denis small oil sketches (July 1908); lithographs by the English aesthete Charles Shannon (1908); color woodcuts by Finnish artist and student of

Gordon Craig's Ellen Thesleff (1910–1911); and Maillol bronzes to be shown with Agnes Meyer's and Kate Simpson's Rodin bronzes (1912). It is difficult to reconcile Brangwyn's Rembrandtesque etchings of heroic workers with the Catholic allegories of Denis (who admittedly was going through a fauvist phase in 1908) and Shannon's strongly scratched and modeled crayon lithographs of nude bathers.

It is also important to consider the living artists, younger or established, avant-garde or traditional, who were exhibiting in Paris and whom Steichen never approached. Apart from the mention of the Denis sketches, Steichen ignored the Nabis (Vuillard, Bonnard, Roussel), who were considered radical painters and represented by Bernheim Jeune, from whom he borrowed other things. While concentrating on Matisse, he excluded the other fauves—Georges Braque, André Derain, Maurice Vlaminck, and Otto Friesz. In fact, Steichen promoted only two living artists who were French by birth, and both had already been "discovered" and purchased by Americans (Matisse by the Steins and Cones, Rodin by the Simpsons and many others).

On those rare occasions when Steichen turned to established artists from an earlier generation, he relied on dealers to help put the shows together. The November 1910 exhibition of lithographs by Manet, Cézanne, Renoir, and Toulouse-Lautrec (of whom only Renoir was still alive) came from Ambroise Vollard, the man who in the 1880s had inspired impressionist lithography and whose shop all modernist collectors regularly visited.[32] Steichen himself visited Vollard with Arthur B. Carles and Charles Caffin on 4–5 July 1910, and he purchased a Picasso bronze head for Stieglitz for 600 francs on 15 January 1912. Later that year, he arranged for his friends Agnes and Eugene Meyer to buy Cézanne's *Still-life with Apples and Peaches* from Vollard for the sizeable sum of 50,000 francs.[33]

Steichen's interest in Cézanne was just a small part of a widespread exaltation of the artist as the precursor of "modernism" that took off after his death in 1906.[34] Cézanne had been given a one-person exhibition at the 1904 Salon d'Automne and a more comprehensive posthumous homage at the 1907 Salon d'Automne. In June 1907, Steichen and Stieglitz visited the Cézanne show of seventy-nine watercolors at Bernheim Jeune, and despite Stieglitz's initial bafflement over Cézanne's disjointed touches of wash, Steichen in July 1908 volunteered, "I think we might get those Cézanne drawings you saw."

It was only when Bernheim Jeune was ready to release its cache of Cézanne watercolors in 1910 that a New York show became possible. On 11 July 1910, Fénéon, Bernheim's manager, wrote Matisse that the gallery wanted to do a New York Cézanne show: "This New Yorker (the photographer) who organized the exhibition of your drawings, couldn't he take care of it? Please give us your opinion and, if possible,

fig. 26 PAUL CÉZANNE
Trees and Rocks, c. 1890
graphite and watercolor
Philadelphia Museum of Art, The Samuel S. White 3rd
and Vera White Collection
EXHIBITED AT 291, 1911

the name and the address of this impresario. We'll get in touch with him."[35] When the works were shipped in February 1911, Steichen wrote that they were the "cream of what the Bernheims have—And I managed to get the collection as *varied* as possible.... I should liked to have had some Cézanne water colors that Vollard has but it was impossible to make the show up from two houses. The Bernheims are very much interested in our work and as a matter of fact offered to put us up in a big gallery in N.Y.... Their interest of course is purely commercial and they showed it by even making us pay for the *packing* of the Cézanne pictures."[36] Although Steichen knew that Bernheim stood to profit from exposure to the lucrative American market, he felt that the educational value of exposing New Yorkers to Cézanne justified collaboration with dealers. The history of the Cézanne watercolor exhibition makes clear that the application of the term "avant-garde," in the sense of revolutionary and combative, to some of the shows presented at 291 ignores the extent to which the artists had penetrated the European market.

Steichen's comfort with Cézanne as the great fountainhead of twentieth-century art is in contrast to his distinct discomfort with the more radical fragmenting of form introduced by Picasso. Steichen had seen Picasso's works as they were acquired by Leo and Gertrude Stein after 1905 and he had met the artist, but never struck up a friendship. He recognized the originality of Picasso's move into cubism after the 1907 *Demoiselles d'Avignon*. At the same time that he was proposing Gordon Craig drawings and Charles Shannon lithographs in the summer of 1908, he mentioned to Stieglitz: "As for the red rag, I am sure Picasso would fit the bill if I can get them—but he is a crazy galloot hates exhibiting etc."[37] It took the persuasiveness of two men personally closer to Picasso than Steichen—painter Frank Burty Haviland (Paul's brother who had known Picasso since at least 1909) and Mexican caricaturist Marius de Zayas—to sell Picasso on the show. As Steichen admitted when he shipped the Picasso drawings to New York in February 1911, "Haviland and Picasso selected the Picasso pictures themselves. I came in for a little advice in the end to make the collection a little more clear by its evolution.... Picasso was a man I never could see— but he is himself an extraordinary chap and has a live mind so he deserves a chance like the rest of em—I admire him but he is worse than Greek to me—I am afraid I am too human and too sensitive to flesh to follow a man's abstractions into such fields."[38]

When Steichen visited 291 in February–March 1913, he was disturbed by the cubist influences visible in Arthur Dove's, Marsden Hartley's, and Max Weber's recent abstractions and Francis Picabia's paintings, just going up in the gallery. After reading Paul Haviland and de Zayas' *A Study of the Modern Evolution of Plastic Expression,* published by 291 in February to help explain abstract art, he wrote to Stieglitz on his way back to France that art without any clear reference to the visible world became too involuted, a "test tube experiment." One cannot help but hear the voice of Steichen the socialist sympathizer and bearer of the doctrine of *Art social* that had been espoused by Roger Marx, Camille Mauclair, Rodin, and his sister Lilian (who had written an essay, "On art in relation to life," for the April 1903 *Camera Work*) when he writes, "Everywhere is unrest and seeking—to many it is a social and economic problem—But this is only another one of the elements of it.... Something is being born or going to be.... But neither art nor economic problems can find a solution until we grasp the significance of the whole problem."[39] Whereas Stieglitz embraced the new art that was concerned with the artist's introspective analysis of "the reaction of the world on his personality,"[40] Steichen was unwilling to reduce everything to individual psychology.

Steichen's last discovery for 291 (and the last show that he organized while living in France) was Constantin Brancusi. Steichen had informally met Brancusi in spring 1907 while the young sculptor was working for Rodin, but the first real contact between the two was only after Steichen had visited the 1913 New York Armory Show, in which Brancusi had made a splash with five works.[41] After his return to Paris in March, Steichen was smitten by Brancusi's "big bronze bird" (*Maiastra*) in the Salon des Indépendants and discovered that its creator was the man he'd seen at Rodin's but had lost track of. He immediately proposed that Stieglitz buy the bronze version of the plaster *Sleeping Muse* exhibited in the Armory Show for 1000 francs or the far superior marble version for $1000.

Steichen's own purchase of the marble *Maiastra* from Brancusi occurred between spring 1913 and August 1914, the period in which Brancusi became a familiar guest at Voulangis and Steichen pushed for a 291 show.[42] Rather than likening Brancusi's works to the cubist abstractions that he felt lacked spiritual meaning, Steichen saw them as expressions of the artist's desire to evoke the archetypal simplification of primitive art. Steichen had a long-standing interest in fragmentary and rough-hewn sculpture, starting with Rodin and continuing with Matisse; in 1912 he purchased a cast of an archaic Greek statue to place in his garden. Brancusi, like Steichen a consummate craftsman sensitive to the importance of materials in determining the effects of his forms, was just the latest to find inspiration in the classical disembodied marble heads and armless torsos that Rodin and Steichen had admired in the Louvre.

Steichen's stay in New York from January to March 1914, when he installed the Brancusi show, was his last as an artistic impresario. The German invasion of France in August 1914 forced him and his family to abandon their home hastily and sail for New York. However, Steichen's contributions to 291 did not immediately cease: in November he devised an original installation of orange, yellow, and black paper against which were set the African sculpture that Marius de Zayas had assembled in Paris. But he no longer had access to the vital Paris art scene from which he drew material and he confronted severe family and financial problems.

America's entry into the war on 6 April 1917 marked the end of 291 and of Steichen's commitment to Stieglitz. Rejecting Stieglitz's pacifism, Steichen enlisted and was posted to France in October. Floating between France and New York until 1923, Steichen confronted his own limits as a painter and a transformed post-war international art scene. Apart from his purchase of Brancusi's *Bird* in 1926, he seems to have ceased buying traditional art and frequenting galleries after he quit painting and started working for Condé Nast in 1923. His talents as a curator also lay dormant until he organized "Road to Victory" at the Museum of Modern Art in 1942 and took over its department of photography in 1947.

Steichen's exuberant labor for 291 was not merely about promoting advanced art or supporting his starving friends in Paris. It was about making America a better place in which creative people could play a role and be free to express themselves. Like the British socialist H. G. Wells who in 1906 found himself doubting the wisdom and sustainability of unfettered material progress,[43] Steichen turned to Europe to find a culture that valued the spiritual and the beautiful. In 1918, greeted as the saviors of France, Steichen and his countrymen could in contrast feel proud of Yankee courage and technology. The 291 gallery had provided a "cause" for rebel Steichen when he needed it. The moment passed, the gallery closed, he turned forty, and the roar of the twenties could be heard in the distance.

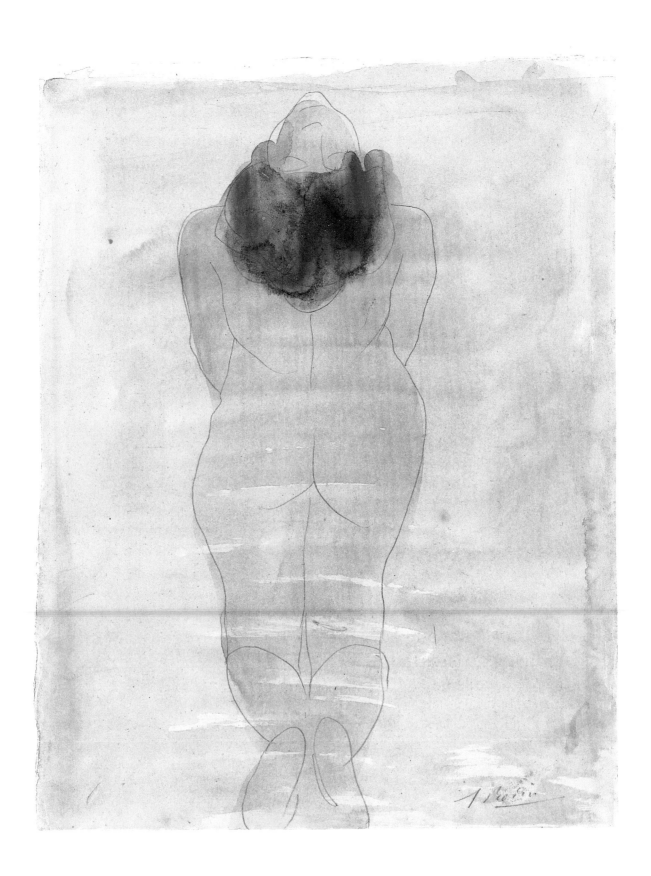

Anne McCauley

AUGUSTE RODIN, 1908 AND 1910

THE ETERNAL FEMININE

I f anyone embodied the aesthetic goals of Alfred Stieglitz and Edward Steichen during the pre-war period, it was the internationally celebrated French master Auguste Rodin.[1] Exalted for his powerful portrayals of fundamental human emotions, Rodin was also cast as a fighter against the establishment, the prudes and right-wing politicians who cloaked their nudes in allegory and drapery. By the time that his drawings appeared on the walls of 291 in January 1908, he could be characterized as both a scorned outsider and a phenomenal commercial success who had sold more than 240,000 francs worth of works from his one-man exhibition at the 1900 Paris World's Fair.

In the United States, Rodin's reputation had been firmly established by press reports, sporadic exhibitions, and testimonies from the many wealthy art lovers who had visited his studio. Americans could have seen Rodin's sculpture in the 1876 Centennial Exhibition in Philadelphia; the 1893 World's Columbian Exposition in Chicago and The Art Institute of Chicago after the close of the show; temporary exhibitions in 1895, 1905, and 1907 in Philadelphia and in The Pennsylvania Academy of the Fine Arts after 1898; the Saint Louis Exposition in 1904; and Copley Hall in Boston in 1905.[2] Major Henry Higginson had loaned five examples of Rodin's sculpture to the Boston Museum of Fine Arts by 1903, and the museum was to acquire one of them, *Ceres*, in 1906. In New York, the American Art Association had exhibited four Rodins for sale in 1895, and Samuel P. Avery had given The Metropolitan Museum of Art its first Rodin in 1893.

Stieglitz certainly would have known about Rodin's reputation as the great *refusé* whose Balzac had been rejected in 1898 and whose other public projects had been criticized or never realized. He also

4 AUGUSTE RODIN
Kneeling Woman, *c. 1900–1908*
POSSIBLY EXHIBITED AT 291, 1908

could have seen his works in Europe prior to 1908.[3] His immediate interest in the artist, though, was fueled by Edward Steichen. Steichen had met Rodin in 1901 during his first stay in Paris, and Rodin became one of his closest friends, favorite sitters (see pl. 2), and mentors. After Steichen returned to New York in 1902, he took it upon himself to try to promote Rodin among American collectors.

His greatest ally was Kate Simpson, daughter of New York banker George Seney and wife of a prominent lawyer who met Rodin in 1901 and whose portrait bust Rodin began in 1902. Steichen met Simpson in Paris in 1901 and also had known the American dancer Loïe Fuller, another of Rodin's American admirers.[4] In 1903, when Fuller decided to organize an exhibition in New York of Rodin's sculpture as well as prints, drawings, and sculpture inspired by her dancing, she consulted both Steichen and Simpson. The exhibition, held at the National Arts Club from 6 to 16 May, included one of Steichen's celebrated and frequently exhibited photographic portraits of Rodin as well as his painting of Beethoven.

One of Fuller and Simpson's goals, shared by Steichen and ultimately Stieglitz, was to get Rodin's work better represented in the Metropolitan Museum of Art.[5] At the conclusion of Fuller's show, Kate Simpson wrote the Board of Trustees to encourage them to buy Rodin's sculpture. Fuller then placed the sculpture from her show on loan to the Met and borrowed money to purchase five of them.[6] However, she was unable to pay off her notes and the works were ultimately returned to Rodin.[7] The Simpsons continued to promote Rodin by purchasing versions of *The Thinker, Saint John, Head of Balzac,* and a *Centauress* in 1903; *The Age of Bronze* in 1905; and three marbles and a bronze in 1906. Simpson loaned some of these works to the Copley Society show in Boston in 1905 and in 1906 to the Metropolitan, where assistant director Edward Robinson (hired in 1905 from Boston) and curator Roger Fry (hired in 1906) were sympathetic to Rodin.[8] She also arranged for a second cast of *Saint John* to be made as a gift to the museum. Her efforts found a willing audience, since Daniel Chester French, head of the sculpture committee, in 1906 urged the museum to buy Rodin, and Robinson in 1907 charged his European agent to visit the master's studio and determine which works might be of interest.

When Steichen returned to Paris in 1906, he naturally renewed his friendship with Rodin and began contemplating a show at 291. In November, he commented that he hadn't seen Rodin yet, "but heard he is doing great things—it is phenomenal the way he is knocked here—many people still laugh."[9] After a difficult year, he managed to return to the Rodin project in fall 1907, when he noted that the Salon d'Automne was advertising a Rodin drawing section.[10] On 15 October he cabled that he had "a corking Rodin exhibit," which he sent via a friend in November.

The fifty-eight unframed drawings mounted behind glass in the small rooms at 291 represented a part of Rodin's oeuvre that both creator and public were beginning to appreciate as valuable works in their own right. Rodin had always been an avid draftsman, but until the 1890s had considered his drawings studio aids, neither for sale nor exhibition. At about the same time that he began making hundreds of fluid pencil contour drawings from an often moving nude model,[11] he allowed 142 drawings from throughout his career to be published in heliogravure by Goupil in a limited edition portfolio, *Les Dessins d'Auguste Rodin* (1897). Substantial numbers of drawings were first shown outside Rodin's studio in 1899 in Brussels, The Hague, Amsterdam, and Rotterdam (c. 100 works);[12] at the Carfax Gallery in London in 1900 (26); at his 1900 Paris Exposition show (128); and almost annually thereafter in exhibitions from Prague (fig. 27) to Rome. Two early drawings appeared in a group exhibition that traveled to the Carnegie Institute in Pittsburgh in 1903 and the Cincinnati Museum Association and The Chicago Art Institute in 1904.[13] The following year three Rodin drawings of nudes were added to the Pennsylvania Academy of the Fine Arts Sixth Annual Exhibition, a show directed to art students rather than the general public.[14] While Steichen was organizing his show, more than three hundred Rodin drawings arrived too late for the Salon d'Automne and were then featured at the Bernheim Jeune gallery between 10 and 30 October 1907 and seventy-three drawings were tied up in Budapest in December.[15]

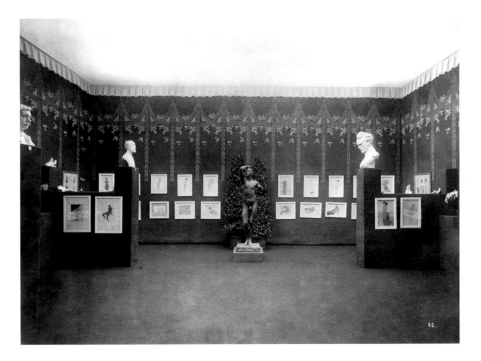

fig. 27 **RUDA BRUNER-DVORAK**
Rodin Exposition in Prague,
1902
gelatin silver print
Musée Rodin, Paris

The drawings had already found ready buyers in Europe, both private collectors and institutions.[16] They had also begun entering the portfolios of a few American collectors and museums. Dr. Denman Ross, lecturer on the theory of design at Harvard, Boston Museum trustee, and a major collector of Asian art, had visited the 1907 Bernheim Jeune show and purchased three drawings, which he gave to the Boston Museum in December 1907 and April 1908.[17] In his lectures and writings, Ross popularized the idea that artists should follow the oriental practice of closely observing nature and then drawing from memory to capture the essential features. His appreciation of Rodin's recent contour and wash drawings, like that of many collectors, was filtered through his love of the abstract flat colors and flowing contour lines of Japanese art, which had been adapted by countless art nouveau designers in the 1890s.[18]

Rodin let visitors thumb through his portfolios and frequently rewarded them with gifts.[19] John Singer Sargent received a drawing in the late 1890s,[20] and Steichen himself was given *Egypte*, showing a frontal, standing nude pressing her breasts together.[21] Photographer Gertrude Käsebier received three or four Rodin drawings in December 1906 after she had met and photographed Rodin in fall 1905 and sent him prints in early 1906.[22] She acquired other Rodins, because her friend Arthur Davies borrowed seven Rodin watercolors and a small bronze from her for the 1913 Armory Show.[23]

The first critical responses to the drawings coincided with the appearance of the Goupil facsimiles and public exhibitions. Camille Mauclair in 1898 stated that they were not finished works of art but rough drafts that had "a special and terrible beauty."[24] Léon Maillard, in his 1899 monograph on Rodin, dubbed them "rare psychological documents" and "instantanés," thrown on the paper in a few seconds like the new snapshots (an analogy that became a cliché in subsequent appraisals).[25] Gustave Coquiot, responding to Rodin's 1900 Paris show, likened them to Hindu, Egyptian, Greek, or Japanese art.[26]

The sexuality of the recent drawings was immediately noted. Mauclair, admitting that the drawings "shocked some," argued that they were no more questionable than "anatomical plates, or the sad immodesty of a post-mortem examination."[27] Critics of a 1902 Rodin show in Catholic Rome, however, attacked them for their "lewd, embracing human bodies making disgusting gestures." The exhibition in 1905 of color lithographs made in 1902 from Rodin's illustrations for a sado-masochistic novel by Octave Mirbeau, *Les Jardins des supplices* (published in 1899), prompted an outcry even in Paris, where conservative critic Louis Vauxcelles gasped over their "lesbianism, frenzy, and paroxysm of sadism."[28]

Perhaps the most celebrated scandal over the drawings occurred in 1906. Harry Graf Kessler, an outspoken patron of modern art and theater and since 1903

director of the Weimar Museum für Kunst und Gewerbe, had organized a Rodin
show at the museum in 1904 and in 1905 brought back a series of nude drawings
from Rodin's studio for a planned Rodin room. One contained a dedication from
Rodin to Grandduke Wilhelm von Sachsen-Weimar, whom Rodin thought had been
responsible for an honorary degree that the University of Jena had presented him in
1905. When the new acquisitions were exhibited, a professor from the local painting
academy attacked them as immoral French imports and insults to the German state.
Kessler was forced to resign his museum position, and the event received interna-
tional publicity.[29]

Far from denying that Rodin's drawings were often sexually explicit, Steichen
and Stieglitz seem to have chosen to emphasize that fact. Although Steichen selected
drawings that he considered appropriate for a New York audience (Rodin kept the
explicit images in his studio), someone decided to reprint an excerpt from Arthur
Symons' recent book, *Studies in Seven Arts*, for the catalogue preface. Symons, an
English aesthete who had met Rodin in 1892, had written openly of the drawings'
portrayal of female sexuality, first in 1900 ("the principle of the work of Rodin was
sex")[30] and more extensively in an essay in *Fortnightly Review* in 1902 (reprinted in
Studies in Seven Arts). Using exalted prose to describe the contorted poses of Rodin's
Eternal Feminine, who "turns upon herself in a hundred attitudes, turning always
upon the central pivot of the sex, which emphasizes itself with a fantastic and fright-
ful monotony,"[31] Symons wanted to confront the bourgeoisie with taboo sexuality
just as he had defended French decadent poetry.

Steichen may have met Symons during his many trips to London, or even at
Rodin's when Symons visited the artist in 1902. Stieglitz's friend James Huneker,
who favorably reviewed the show, had known him since the late 1890s. Regardless of
who selected the Symons text, many members of the Stieglitz circle believed that a
revolution in art entailed a frank acceptance of all varieties of sexuality. In 1907
Steichen sent Stieglitz a book on the Belgian etcher of erotica, Félicien Rops, and
the writings of Havelock Ellis (which Stieglitz purchased in 1911),[32] Krafft-Ebing,
Otto Weininger, and Sigmund Freud were beginning to circulate among New York
intellectuals.[33] Rodin's drawings (as well as much of his sculpture) in their break
with academic poses appealed to many people as honest renderings of the arche-
typal female body.

The drawings in the 1908 show ranged from pencil sketches with stumped
shading to nudes, enhanced with bright red, blue, or gold washes, and dubbed
"Phryné," "Calomnie" or "Le Printemps."[34] Although some reviewers such as the
infamous conservative critic Royal Cortissoz dismissed them as caricatural "studio
driftwood" inappropriate for the general public, most raved about their beauty and

fig. 28 AUGUSTE RODIN
Standing Nude with Draperies, c. 1900–1905
watercolor and graphite
The Art Institute of Chicago, Alfred Stieglitz Collection
EXHIBITED AT 291, 1910

force, calling the show "the most important that is to be seen in this city at present." Stieglitz himself was moved to write the artist: "I can only say to have been given the opportunity to live with them constantly for four weeks is the greatest spiritual treat I have ever had. . . . The American women especially seeming intuitively to grasp the elemental beauty you feel to express in all your things."[35] American women were certainly the most visible purchasers from the 1908 exhibition. Kate Simpson acquired an unknown number,[36] and her sister, Mrs. Nelson Robinson, bought *L'Homme qui marche* (she later acquired the sculpture of the same name) and *The Serpentine.* Artist and collector Arthur Davies may have also purchased out of the show, because John Sloan reported seeing three Rodin drawings in Davies' studio on 27 January 1908.[37]

After the drawings came down, Rodin's presence continued to be felt at 291. Steichen, back in Paris, had Rodin's secretary send forty-seven drawings to his friend John Trask for the 6th Annual Watercolor Exhibition at the Pennsylvania Academy (23 November– 20 December),[38] and in October began shooting his celebrated nocturnal studies of Rodin's *Balzac* (fig. 12). The Balzac photos (accompanied by Mrs. Simpson's bronze head of Balzac) were exhibited at 291 to rave reviews from 21 April to 7 May 1909. Meanwhile, Steichen helped his young New York friend and journalist, Agnes Ernst, avoid Rodin's amorous advances while picking out a group of early drawings for her attentive beau, financier Eugene Meyer. She reported to Eugene triumphantly on 31 May 1909: "Steichen and I chose fifteen of the drawings and asked him to give us all he could for the 5000 francs."[39] This was the beginning of Steichen's entrepreneurial efforts for the Meyers, who married the following year and became staunch supporters of 291.

In spring 1910 Steichen organized a second show of at least forty-one Rodin drawings, including for the first time earlier works, with Mrs. Simpson's *Thinker* displayed in the center of the gallery.[40] This time, the Metropolitan Museum was interested. Roger Fry, acting as the museum's European agent in consultation with painting curator Bryson Burroughs, in 1909 had selected a Rodin drawing from the artist's studio.[41] Businessman Thomas Fortune Ryan also committed $25,000 in 1910 for the purchase of Rodin sculpture.[42] Robinson, the museum's director, decided to acquire seven recent drawings from the show, with Steichen urging him

also to take eleven early ones. Since he was planning to visit Rodin in July to select sculpture for purchase from the Ryan bequest, Robinson decided to negotiate directly with the artist rather than buy through 291.[43]

In fact, most purchasers of Rodin drawings in 1908 and 1910 were supporters of 291 who had already visited the artist in Paris and bought in New York out of courtesy or convenience. Mrs. Robinson, a "Mrs. Norton," Stieglitz himself, his young amateur photographer friend and 291 supporter Paul Haviland, and Haviland's cousin William acquired a total of twelve drawings in 1910 for $1350, with Stieglitz buying two additional drawings.[44] Haviland's connections with the Metropolitan must have resulted in his publishing a laudatory article on their new Rodin drawings in the May 1910 *Bulletin*.[45]

During the years that he showed Rodin, Stieglitz personally amassed eleven drawings in a variety of styles. The earliest Rodin he owned, *Horseman* (1880–1889), was shipped to him as a Christmas present from Steichen in December 1910.[46] He bought two pencil contour drawings of a seated and dancing nude model as well as a carefully shaded study of a seated woman with her genitalia revealed.[47] From the 1910 show in which they were given the center of the main wall, he also bought two impressively large, rather *japoniste* drawings from the *Sun* triptych, in which silhouetted and abstracted female bodies represented times of day.[48] Three additional nude sketches with watercolor are in the Art Institute of Chicago collection.[49]

Two drawings that entered the Metropolitan Museum's collection only in 1965, as a gift of Georgia O'Keeffe, reveal the private side of Stieglitz's collection:

fig. 29 AUGUSTE RODIN,
Study of a Nude Female Figure, *1905–1908*
graphite
The Metropolitan Museum of Art,
Gift of Georgia O'Keeffe, 1965

Woman Supreme, a splayed-legged female presenting her genitalia directly to the viewer (fig. 29) and another in a similar posture with a broom handle directed to her vagina (entitled *Sabbat*). These works were not exhibited (even though there was a *Sabbat* in the 1910 show), but were obtained directly from the artist. According to an inscription on the cardboard backing for the frame for fig. 29, Stieglitz visited Rodin with Steichen and his wife in 1911 and "saw hundreds of amazing drawings, amongst other things, and this one I fell in love with—never thinking it could become 'mine.' "[50]

For Stieglitz, the fight to gain acceptance for Rodin's works in America was over in May 1912 when the Metropolitan Museum inaugurated its Rodin sculpture galleries to much fanfare (fig. 30). The

fig. 30 Rodin Gallery, The
Metropolitan Museum of
Art, New York, *May 1912*
Archives, The Metropolitan
Museum of Art

drawings, and particularly the more sexually explicit ones, however, held a personal meaning for him, though, as frank portrayals of female sexuality.[51] He was to find in Georgia O'Keeffe's works a further, and more symbolic, interpretation of this theme expressed in an authentically female voice.

For Steichen, Rodin continued to be a force and inspiration. In February 1914 he advised the Met on how to install *La Martyre*, which Mrs. Simpson had gotten her friend Watson Dickerman to donate[52]; he kept in touch with Rodin after he returned to New York in August 1914; and he rushed to Rodin's funeral on 24 November 1917, weeks after arriving in France with the American Expeditionary Force. Kind to younger artists, humble, committed to the power of art to transform life, Rodin the man remained a role model for the rest of Steichen's long and varied professional career.

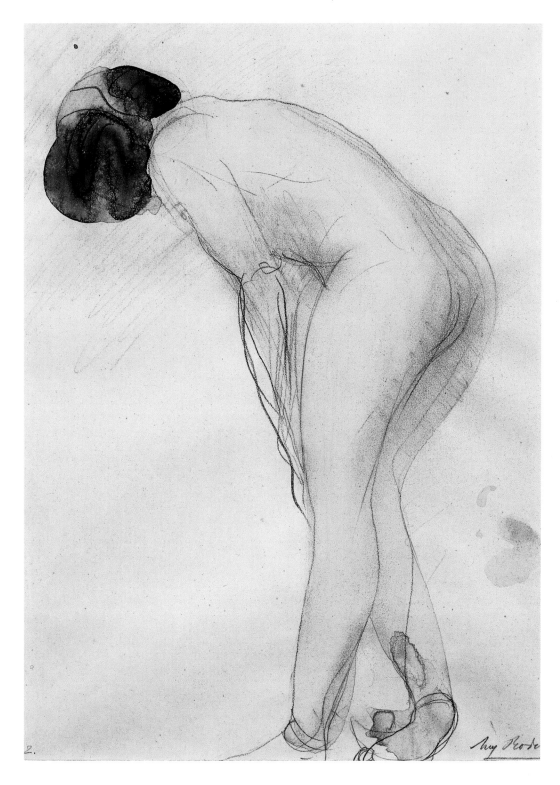

5 AUGUSTE RODIN
Nude, *c. 1900—1908*
EXHIBITED AT 291, 1910

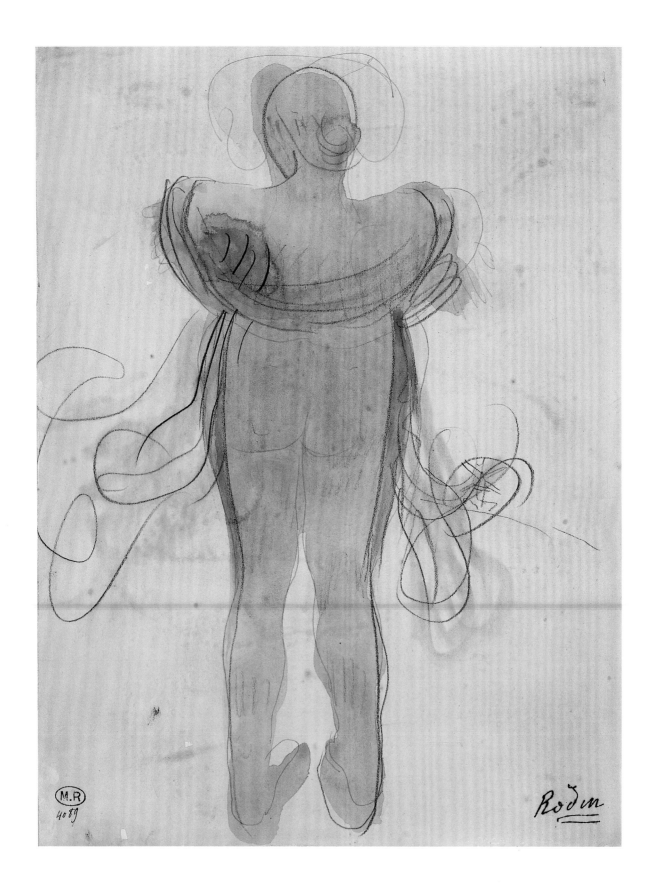

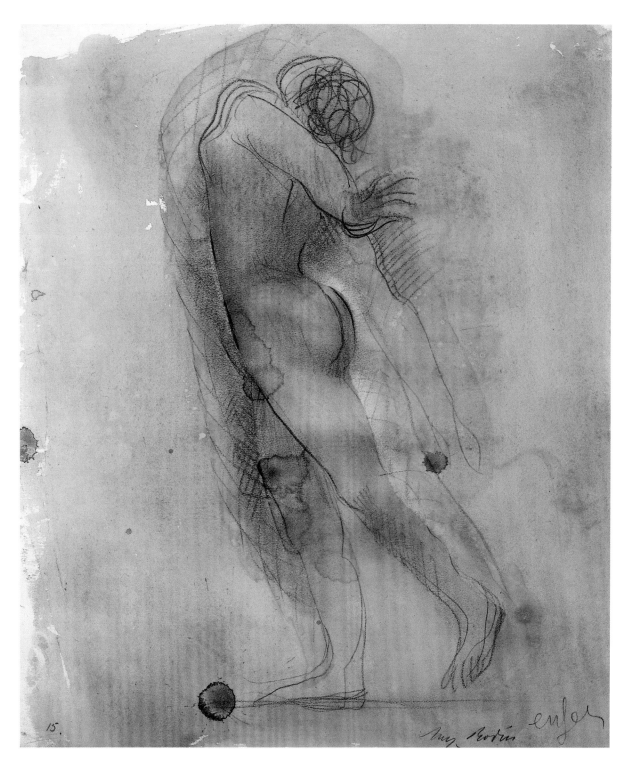

15.

6 AUGUSTE RODIN
Female Nude from Behind, a Scarf
around Her Shoulders, *after 1901*
POSSIBLY EXHIBITED AT 291, 1908

7 AUGUSTE RODIN
Hell, *c. 1900–1908*
EXHIBITED AT 291, 1910

John Cauman

HENRI MATISSE, 1908, 1910, AND 1912

NEW EVIDENCE OF LIFE

I n April 1908 Alfred Stieglitz presented Henri Matisse at 291—an exhibition of drawings, watercolors, lithographs, etchings, and one painting—and ushered in the first wave of modernism in America. This event was a direct consequence of Edward Steichen's scouting expedition to Paris in the autumn of 1906.

In Paris, Steichen had become a regular at the open-house gatherings of the Stein family.[1] He later recalled that at Leo and Gertrude Stein's he saw "all types of modern paintings, from Cézanne and Renoir to Matisse and Picasso," and that "Mrs. Michael Stein, a painter herself, bought nothing but Matisses, and her whole apartment was filled with them."[2] Sarah Stein, with her husband Michael, had recently returned to Paris after seven months in America. Seeking to spread the word of Matisse in the New World, she had brought along three small paintings and a drawing.[3] In New York she had shown them to the painter George F. Of, who framed pictures for 291. (Of asked her to acquire a Matisse for him, and in June 1907 she would buy on his behalf *Nude in the Forest* [pl. 8] from the Galerie Druet in Paris.)

In early 1907, with Sarah Stein as intermediary, Steichen met Matisse, who readily agreed to help him assemble a selection of works on paper for exhibition at 291. In January 1908, while the Rodin show was in progress in New York, Steichen wrote excitedly to Stieglitz from Paris: "I have another crackerjack exhibition for you that is going to be as fine in its way as the Rodins are. Drawings by Henri Matisse the most modern of the moderns—his drawings are the same to him & his painting as Rodin's are to his sculpture. Ask

8 HENRI MATISSE
Nude in the Forest, *1906*
EXHIBITED AT 291, 1908

young Of about him. ... They are to the figure what the Cézannes are to the landscape.—Simply great.—Some are more finished than Rodin's, more of a *study* of form than movement—abstract to the limit.—I'll bring them with me, and we can show them right after mine, if you can so arrange it."[4]

In New York and Paris, rebellion was brewing in the ranks of American artists. In New York, in February 1908, the exhibition The Eight opened at the Macbeth Galleries. Led by Robert Henri, the group had broken with the National Academy of Design over its restrictive selection and hanging policies.[5] In contrast to the preponderant tenebrous realism of the group, one of its members, Maurice Prendergast, painted in a loose, coloristic style.[6] His entries were singled out for derision by critics.[7]

On 26 February, the *New York Times*' Paris correspondent reported: "American art circles in Paris have now given birth to a full fledged secessionist movement.... [A] group of prominent young painters assembled in the studio of Edouardo [sic] Steichen of New York and organized 'The New Society of American Artists in Paris.' The new organization has frankly declared war on the old society of the same name.... The first battle of the new movement will be fought to obtain official representation at the international exhibition which will shortly open in Vienna...."[8]

After this promising debut, the New Society of American Artists in Paris seems to have fizzled. No sooner had the secessionists declared war on the established organization than their general, Edward Steichen, departed for New York to hang Matisse's 291 exhibition. The battle of Vienna would not be fought; the war would be waged on American soil.

On 1 April Stieglitz sent out the following invitation: "An Exhibition of Drawings, Lithographs, Watercolors, and Etchings by M. Henri Matisse, of Paris, will be held at the Little Galleries of the Photo-Secession opening on April sixth and closing April twenty-fifth.... Matisse is the leading spirit of a modern group of French artists dubbed 'Les Fauves.' The work of this group has been the center of discussion in the art-world of Paris during the past two to three years. It is the good fortune of the Photo-Secession to have the honor of thus introducing Matisse to the American public and to the American art-critics."[9]

Stieglitz must have heeded Steichen's directive to "ask young Of" about Matisse, for the painter-framer lent *Nude in the Forest* to the exhibition. As the picture was added while the show was in progress, it was mentioned neither in Stieglitz's announcement nor in any of the reviews.[10] Until the 1913 Armory Show (pages 127–143), it would be one of only two oil paintings by Matisse to be publicly exhibited in America.[11]

Apart from *Nude in the Forest*, the exhibited works were all on paper, in both black-and-white and color.[12] Most depicted female nudes. The selection included

fig. 31 HENRI MATISSE
Nude (Bather), c. 1907
watercolor
The Metropolitan Museum of Art, Alfred Stieglitz
Collection, 1949
EXHIBITED AT 291, 1908

drawings and etchings from 1900 to 1907, lithographs of 1906, and watercolors of 1905–1907. Monochrome works ranged from the volumetric hatchings of the pen-and-brush ink drawing *Standing Nude* (pl. 9) to the spare contours of the lithograph *Half Nude* (pl. 10). In watercolors such as *Nude (Bather)* (fig. 31), the figure and setting are suggested by a few rhyming brushstrokes of broken color, while in a "strand scene" one reviewer noted "seven or eight layers of water-color on a virgin leaf."[13]

To many observers, the lack of finish and the nontraditional poses of the works seemed like an affront. Reviewers, having seen few precedents, had difficulty putting Matisse in critical context; New York had yet to have an exhibition of Cézanne, Van Gogh, or Gauguin. Among the precedents cited were Prendergast, Rodin, neo-impressionism, children's drawings, and Japanese prints.[14] Prompted by Stieglitz, one critic mentioned photography and the fauves.[15]

The critic for *American Art News* declared his inability "to form or pass even fair judgment upon the remarkable productions of this bizarre artist or artisan." Attempting to decipher the watercolors, the reviewer cited the precedent of Prendergast for the "spots of paint daubed on here and there . . . not at first recognizable."[16] Joseph E. Chamberlin of the *Evening Mail* predicted that they would "go over the head of the ordinary observer" and likened them to "religious fanaticism."[17] To

the critic of the *Craftsman*, Matisse was a poseur, "the leading spirit of a group of ultra-modern Frenchmen, many of whom have great gift with tragically decadent souls."[18]

The most frequent observation of critics was that the works were "ugly," often with the connotation "indecent." Chamberlin disdained "female figures that are of an ugliness that is most appalling and haunting."[19] James Huneker of the *Sun* (with perhaps mock indignation)[20] gasped that the artist's depiction "with three furious scratches" of a "female animal in all her shame and horror" caused him to "flee into another room."[21] Elisabeth Luther Cary of the *Times*, the only woman who reviewed the show, had a more measured response, finding in the drawings "a trained insight into the problems of form and movement with a Gothic fancy for the ugly and distorted."[22]

Despite their reservations about Matisse, critics conceded that he was a skilled technician, even a gifted artist. The reviewer for *American Art News* found the drawings to have "strength and purpose."[23] Chamberlin considered some of them to be "strangely beautiful."[24] Huneker praised Matisse's "agility of line" and singled out one drawing for its "virile and masterly strokes."[25] Cary found "one or two" of the watercolors to "have a charm like that of broken snatches of song in the open air."[26] The critic for the *Craftsman* declared that Matisse was "a great master of technique—and a great artist, if estimated from the brilliant stroke, the subtle elimination and the interesting composition revealed."[27]

Despite this smattering of praise, Matisse found no champion in the New York press. For artists, however, the show was a revelation. One young artist attended out of curiosity and left profoundly changed. William Zorach described his visit to 291: "I rode up in the tiny elevator and entered the little gallery. The quiet light was full of a soothing mystic feeling and around the room, and on the square under glass in the middle of the room, I looked at what I now know were Matisse drawings. I was all alone and I stood and absorbed the atmosphere of the place and of the drawings. They had no meaning to me as Art as I then knew Art, but the feeling I got from them still clings to me and always will. It was the feeling of a bigger, deeper, more simple and archaic world.... I left feeling I had seen something living, something that would live with me, and that has lived with me."[28]

Stieglitz helped keep alive the controversy of the exhibition by reprinting five of the press reviews in the July issue of *Camera Work*. But he did not let the reviewers have the last word. In autumn 1908 *Camera Work*'s correspondent Charles H. Caffin interviewed the artist.[29] The resulting article was a pioneering effort to explain Matisse to the American public. Caffin's description of Matisse belied the caricature proffered by the New York press: "When I entered the big building—a disused

9 HENRI MATISSE
Standing Nude, *1901–1903*
EXHIBITED AT 291, 1908

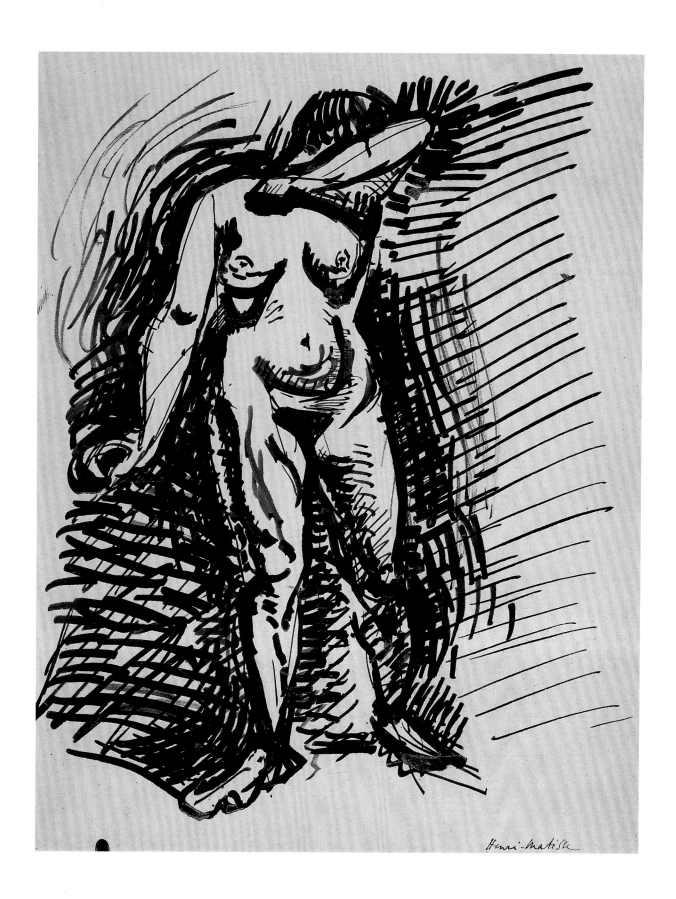

HENRI MATISSE

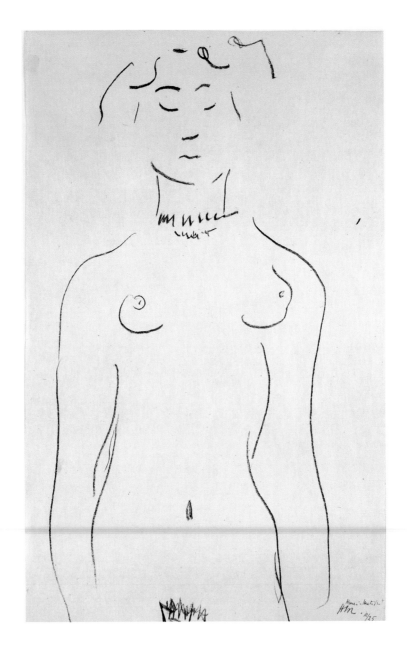

10 HENRI MATISSE
Half Nude, 1906
EXHIBITED AT 291, 1908

convent—in which he works,[30] the first sight I encountered was that symbol of domestic conformity, a baby carriage, and the next the father himself, a stocky simple person, in appearance a sane and healthy bourgeois. No suggestion of the decadent esthete; still less of the poseur or charlatan."

In what could be seen as a coda to the exhibition at 291, Matisse demonstrated to Caffin the process of "organization" by means of his drawings: "He shows me a series of drawings from the nude. In the first, he explains that he has drawn 'what exists'; and the drawing shows the knowledge and skill, characteristic of French academic art. Then others follow in which he has sought for further and further 'simplification,' until finally the figure, as he expressed it, was *organisé.*"[31]

By the end of 1908 Matisse would find a champion among American critics. Bernard Berenson, the widely respected art historian and connoisseur of Renaissance painting, was greatly impressed by Matisse's entries at the Paris autumn Salon.[32] Once he had met the artist, through Sarah Stein, he became convinced that Matisse was continuing the legacy of the great traditions of art. Berenson wrote to his wife Mary: "He talked as if he had never done anything but look and reflect.... One felt in contact with a brain of astonishing vigour, entirely—alas, as I am not—absorbed by art."[33]

When Berenson returned to America, he was distressed to read an attack on Matisse in the pages of the *Nation.* Reviewing Matisse's entries in the autumn Salon (which had so impressed Berenson), the journal's Paris correspondent declared them to be "direct insults to eyes and understanding."[34] Berenson leapt to Matisse's defense in a letter to the *Nation,* declaring that the artist, "after twenty years of very honest searching, at last found the great highroad traveled by all the best masters of the visual arts for the last sixty centuries at least. He is a magnificent draughtsman and a great designer."[35] Berenson's imprimatur would make Matisse a more formidable figure, especially in the United States.

In autumn 1909 Steichen visited Matisse at his studio in Issy-les-Moulineaux outside of Paris, where he photographed the artist modeling the sculpture *The Serpentine* (pl. 3).[36] It was probably at this time that he arranged for Matisse's second exhibition at 291. He was also planning an exhibition of American modernist painters, to appear immediately afterward.

Matisse's second exhibition at 291, held from 23 February to 8 March 1910, included more than twenty-four drawings, accompanied by black-and-white photographs of such key paintings as *The Joy of Life* of 1905—1906 and the *Blue Nude* of 1907.[37] Although the reproductions gave no indication of Matisse's innovative color, they gave visitors to 291 a sense of Matisse's drawing in relation to the larger body of his work. As in the first exhibition, most of the drawings were of female nudes,

among them a *Nude* of 1908 (pl. 11),[38] and three figure studies c. 1908–1909: a standing *Nude Study* (fig. 32), a seated *Nude Study* (rear view), and a seated *Nude Study* (profile).

Critical reaction was more favorable than it had been two years earlier. Arthur Hoeber of the *Globe* was the exception, finding Matisse's work to be "without reference to sanity, to taste, to any essentials of beauty."[39] B. P. Stephenson of the *Evening Post* and James Townsend of *American Art News* credited Stieglitz's gallery lectures for steering them to a more positive appraisal of Matisse.[40] James Huneker (in the *Sun*), Frank Jewett Mather (in the *Post* and the *Nation*), and Elisabeth Luther Cary (in the *Times*), all apparently influenced by Berenson, praised Matisse. The Berensonian ring of Huneker's praise is unmistakable: "Its power of evoking tactile sensations is as vigorous, rhythmic and subtle as the orchestration of Richard Strauss."[41] Mather wrote: "A Matisse drawing belongs in the great tradition of all art that has envisaged the human form in terms of energy and counterpoise."[42] Cary found Matisse to be "a lover of that geometry on which classic art is founded."[43]

New York critics notwithstanding, the exhibition, comprising works from Matisse's innovative, post-fauve years, was, if anything, more challenging than the previous one. As Matisse himself was often at pains to explain, both modernity and tradition were ever present in his work.[44]

One visitor to the exhibition was Florence Blumenthal, whose husband George, head of Lazard Frères in New York, was a trustee (and future president) of the Metropolitan Museum and a distinguished collector of medieval and Renaissance art. The couple had recently returned from Europe, where they had retreated after the death of their only child. Blumenthal had encouraged his grieving wife to take an interest in art history. In Italy they had met Bernard Berenson, who in all likelihood had conveyed to Mrs. Blumenthal his enthusiasm for Matisse.[45]

At 291, Mrs. Blumenthal bought three Matisse drawings (among them fig. 32). As far as it is known, these drawings were the only twentieth-century artworks the couple ever purchased. Mrs. Blumenthal promptly donated them to the Metropolitan Museum. They were the first Matisses to enter an American museum's collection.[46]

From 9 to 21 March 1910, immediately following the second Matisse exhibition, 291 presented "Younger American Painters." Organized by Steichen, the exhibition included nine artists: D. Putnam Brinley, Arthur B. Carles, Arthur Dove, Laurence Fellows, Marsden Hartley, John Marin, Alfred Maurer, Edward Steichen, and Max Weber.[47] The question of whether or not they were followers of Matisse immediately became an issue. Stieglitz encouraged the controversy. He objected to the indiscriminate characterization of the Younger Americans as Matisse followers;

11 HENRI MATISSE
Nude, c. 1908
EXHIBITED AT 291, 1910

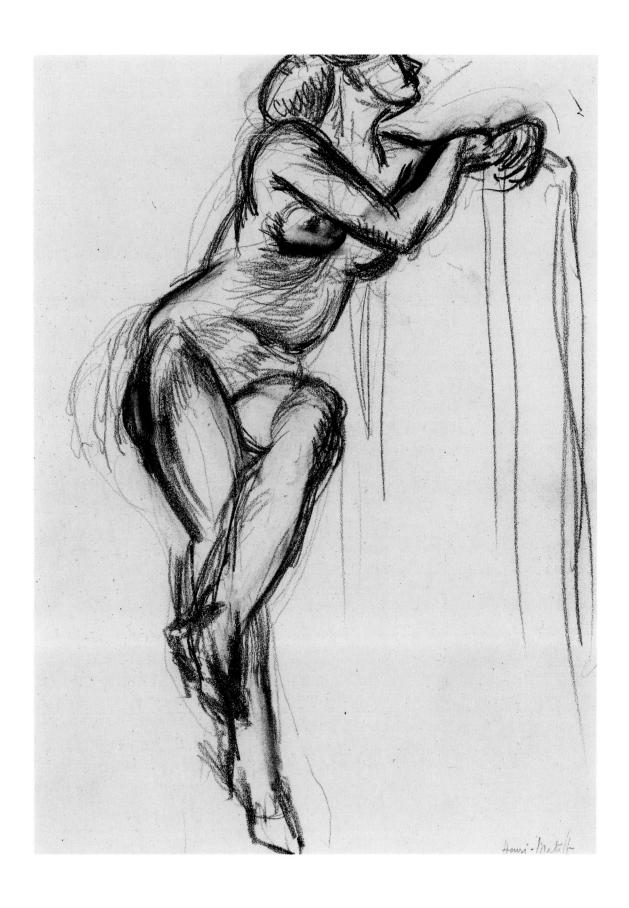

fig. 32 HENRI MATISSE
Nude Study, c. 1908–1909
graphite
The Metropolitan Museum of Art,
Gift of Mrs. Florence Blumenthal, 1910
EXHIBITED AT 291, 1910

yet by raising the issue he was linking them with Matisse in the minds of gallery visitors.[48]

Critics played up the Matisse connection. Guy Pène du Bois reviewed the exhibition for the *New York American* under the banner headline: "Followers of Matisse Exhibit at the Photo-Secession Gallery."[49] James Huneker of the *Sun* wrote: "The chief thing that interested us was to note the influence of Matisse."[50] Harrington of the *Herald* observed that "the echoes of the cry of the last generation, 'Art for art's sake,' are heard in this new school of color for color's sake, of which Mons. Matisse is probably the best known."[51]

Matisse's third and final show at 291, his first anywhere primarily devoted to sculpture, was held from 14 March to 6 April 1912. It included six bronzes, five

plaster casts, and one terra-cotta, as well as twelve drawings. The sculpture, selected by Matisse and Steichen to present "the principal steps of Matisse's evolution as a sculptor,"[52] included *The Serf* and *Female Torso* (figs. 34, 33) in bronze, and *The Serpentine* (pl. 14) and three versions of the *Head of Jeannette* (figs. 35, 36; pl. 15) in plaster. Among the drawings were three recent works in pen-and-ink: *Nude with Bracelets* (pl. 13); and a pair of drawings done in tandem, *Female Nude Lying Face Down on a Table* (pl. 12) and *Female Nude*.

The 1912 exhibition was the most difficult and challenging of the three Matisse exhibitions presented at 291. If the New York critical community was gradually warming to the notion of Matisse as draftsman, the same could not be said for

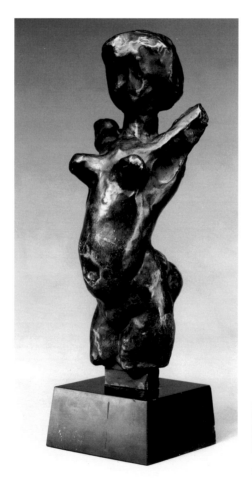

fig. 33 HENRI MATISSE
Female Torso, *1906*
bronze
The Metropolitan Museum of Art, Alfred Stieglitz
Collection, 1949
EXHIBITED AT 291, 1912

fig. 34 HENRI MATISSE
The Serf, *1900–1903 (cast 1931)*
bronze
Hirshhorn Museum and Sculpture Garden,
Smithsonian Institution, Gift of Joseph H.
Hirshhorn, 1966
EXHIBITED AT 291, 1912

fig. 35 HENRI MATISSE
Head of Jeannette II, *1910*
(cast 1952)
bronze
Hirshhorn Museum and
Sculpture Garden, Smithsonian
Institution, Gift of Joseph H.
Hirshhorn, 1966
PLASTER CAST EXHIBITED AT 291,
1912

Matisse as sculptor. Critics whose taste was formed by the Greco-Roman ideal saw the sculpture, with its pronounced anti-classicism and primitivism, as an affront to their aesthetic and social values. The most unrestrained indignation came from Arthur Hoeber of the *Globe,* who denounced the sculpture as "decadent, unhealthy, certainly unreal, like some dreadful nightmare."[53] James Huneker of the *Sun* also delivered a harsh appraisal: "After Rodin—what? Surely not Henri Matisse. We can see the power and individuality of Matisse ... as a draughtsman, but in modeling he produces gooseflesh."[54]

Charles de Kay, writing in *American Art News,* saw violence in the distortions of *The Serpentine:* "[Matisse] cuts away the flesh and some of the ribs from the torso, slaps enormous calves on the legs, draws out the neck, slams down the forehead, [and] pulls out the ears."[55] Joseph E. Chamberlin of the *Evening Mail* rendered a split verdict: *The Serf* was "tremendously strong and graphic, and a work of genius," but *Jeannette III* and *The Serpentine* were "ugly" and "grotesque," respectively.[56] Another mixed verdict was delivered by Elisabeth Luther Cary of the *Times,* who found "vital energy" in *The Serpentine* and "weight and power" in *The Serf,* but concluded that Matisse, if judged by his sculpture alone, would not be considered "an important figure in art."[57]

The most favorable critique was written by Felix Grendon of the radical monthly *The International,* who credited Matisse with delivering the *"coup de grace"* [sic] to "ladylike academicism." Invoking Robert Henri's criterion that a work of art should present "new evidence of life," Grendon declared: "Matisse's work is the most valuable contemporary contribution to sculpture after the masterpieces of Rodin."[58]

According to Stieglitz's associate Paul Haviland, more than 4,000 people visited the exhibition in the course of three weeks.[59] Even if Haviland's figure is exaggerated (it entails an average turnout of nearly 200 a day), it appears that the show generated a great deal of interest. One interested spectator was Gertrude Vanderbilt Whitney, who, on the point of buying *The Serf,* was dissuaded from doing so by her friend and mentor, the portrait painter Howard Cushing.[60] Another was Henry McBride, future critic for the *Sun* and *The Dial.* Viewing *The Serpentine,* he experienced a revelation: "I chanced to see it through two doorways which produced a refracted light that must have been exactly like the one Matisse had worked in, for I saw the intention of the artist clearly. Matisse had merely 'painted' in sculpture, putting in the streak of high-light on the thigh of his Venus and lengthening out the shadows on the lower legs just as they had occurred on his model; ... [the] figure, which at first had seemed an ineffective joke, did actually resolve itself into an excellent interpretation of form."[61]

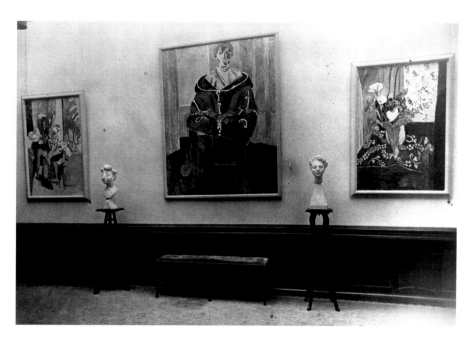

fig. 36 *Matisse exhibition at the Bernheim Jeune Gallery,
1913, with plaster cast (no longer extant) of* Head of
Jeanette III *(1911) and* Head of Jeannette I *(1910)*

Despite the public's interest, not one sculpture was sold. Stieglitz himself
would buy a cast of *Female Torso* (fig. 33), but the purchase seems to have been made
later.[62] Stieglitz did, however, sell three drawings. *Female Nude* was purchased by
Belle da Costa Greene, J. P. Morgan's personal librarian,[63] and the New York lawyer
John Quinn—who within a decade would own the most advanced collection of mod-
ern art in the world—bought two drawings.[64] With these modest purchases, Quinn
and Greene joined the tiny cadre of Americans who collected Matisse before the
Armory Show.

Among the European artists introduced by Stieglitz, Matisse stands apart.
Only Matisse was given three one-man shows at 291; only Matisse was considered a
leading spirit of younger American painters. Matisse affected not only how Ameri-
can artists viewed Europe, but how they viewed themselves.

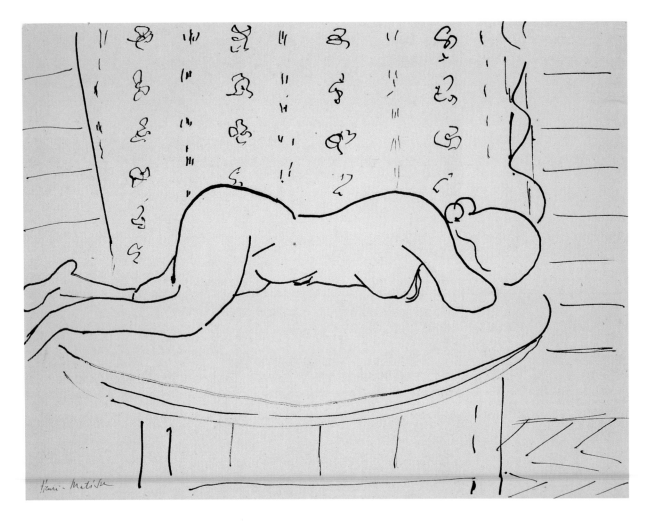

12 HENRI MATISSE
Female Nude Lying Face Down
on a Table, *1912*
EXHIBITED AT 291, 1912

13 HENRI MATISSE
Nude with Bracelets, *c. 1909*
EXHIBITED AT 291, 1912

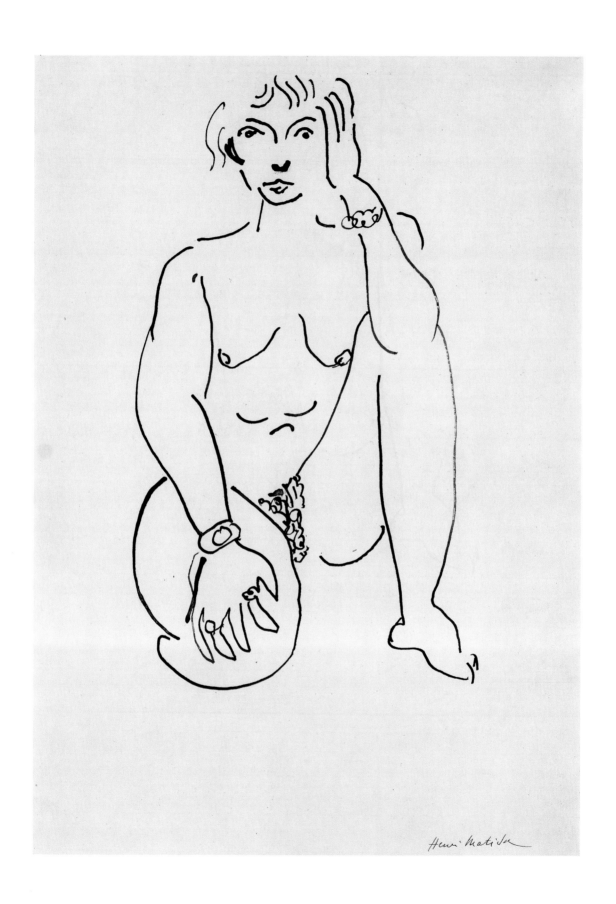

HENRI MATISSE

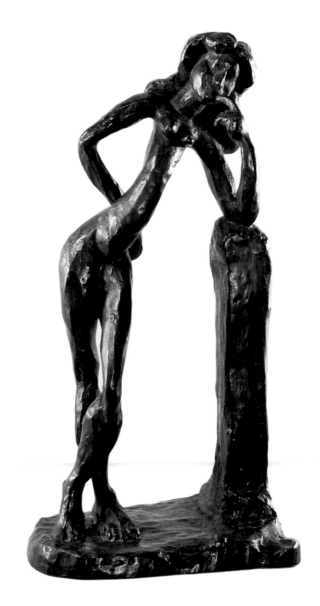

14 HENRI MATISSE
The Serpentine, *1909*
PLASTER CAST EXHIBITED AT
291, 1912

Head of Jeannette III, *1911/cast 1966*
PLASTER CAST EXHIBITED AT 291, 1912

PAUL CÉZANNE, 1911

NATURE RECONSTRUCTED

I n the inaugural show of the 1910–1911 season at 291,[1] Alfred Stieglitz introduced Cézanne's art to the American public with three lithographs: *Portrait of Cézanne* (1896–1897, black and white), *Small Bathers* (1896–1897, color), and *The Bathers (Large Plate)* (color; fig. 37).[2] Although Stieglitz's offering of works by Cézanne, the proclaimed progenitor and exemplar of modern art, was modest in scope and wedged into a diverse group show, it provided a new frame of reference for artists, critics, laymen, and collectors in the United States.[3] These lithographs—the only prints from Cézanne's later years—are also the only works within the artist's entire oeuvre that were intended for a large audience.[4] By displaying these three original graphics, two of which clearly exhibited Cézanne's treatment of form in figure compositions, Stieglitz enhanced the viability of 291 as an oasis of modern art "within," as Sadakichi Hartmann put it, "an uninspirational and artistically behind the time community."[5]

The Bathers (Large Plate) was a replica of Cézanne's oil painting *Bathers at Rest* (1876–1877),[6] possibly his most famous work at the time the lithographs were made. The painting had attracted favorable critical attention in the third impressionist exhibition of 1877 and again in the 1890s. In 1894, *Bathers at Rest* was given to the Museé du Luxembourg as part of the Caillebotte Bequest, but the French government rejected it as being unworthy of a place in the national collection.[7] In spite of this action, Cézanne's dealer Ambroise Vollard commissioned the artist to copy his rejected oil painting as a color lithograph, which Vollard then intended to publish in one of his albums of original prints by contemporary Paris artists. Cézanne, therefore, aware that Vollard was

16 PAUL CÉZANNE
Foliage, *1895–1900*
EXHIBITED AT 291, 1911

fig. 37 PAUL CÉZANNE
The Bathers (Large Plate)
colored lithograph
National Gallery of Art,
Washington, Gift of Karl Leubsdorf
EXHIBITED AT 291, 1910

responding to the popularity of color lithography in Paris in the 1890s, and to the publicity that had surrounded *Bathers at Rest*, executed the color print in the belief that it was destined for accessibility to many viewers.[8] By 1905, when a number of American artists were in Paris, *Bathers at Rest* was shown at the Salon d'Automne. Furthermore, the lithograph *The Bathers (Large Plate)*, along with numerous oils and watercolors by Cézanne, was part of the Gertrude and Leo Stein collection. The Steins' rue de Fleurus apartment was, from 1904 until 1910, a mecca where American artists gathered to look at art and hear Leo expound on his aesthetic perceptions of Cézanne's achievements.

By the time Stieglitz exhibited *The Bathers (Large Plate)* in the United States, the print already had been widely circulated as a black-and-white illustration in Julius Meier-Graefe's 1910 German edition of *Paul Cézanne* and had appeared in part one of the English critic Roger Fry's translation of Maurice Denis' essay on Cézanne.[9] Also

by the time of the exhibition, many major 291 artists had been to Europe on at least one occasion, had had opportunities to study Cézanne's paintings, and had encountered various interpretations of his artistic advances. Once they returned home, they were eager to implement the new concepts and to probe more deeply into the elements of design and color introduced in Cézanne's art. Stieglitz's gallery provided the best opportunity to do so.

Among the offerings that Stieglitz displayed in the 1910 group exhibit were approximately a dozen black-and-white photographs of paintings by Cézanne that the American artist Max Weber had purchased, for thirty francs each, from the Paris gallery owner and photographer Antoine Druet.[10] At Vollard's request, Druet had begun to photograph art in order to verify original paintings, document the completed state of Cézanne's paintings, and prevent other artists to whom his paintings seemed "unfinished" from attempting to complete them.[11] Indeed, as early as 1904, European advocates of modern art and Cézanne enthusiasts had recognized the importance of including photographic reproductions in exhibitions of original paintings. In that year, for the first time, the Salon d'Automne featured a separate photography section that included photographs of paintings by Cézanne. Possibly inspired by the educational value of Weber's Druet photographs of original art, Stieglitz began including photogravures of modern European art in *Camera Work* in 1910; however, no prints of Cézanne's paintings appeared until the special June issue of 1913.

When Stieglitz first began to exhibit modern European art in 1908, he intended for the paintings and drawings to serve as a counterpoint for the photography he displayed. By providing direct comparisons, he meant to raise questions about how each medium depicted the world and to show that similar approaches underlay their execution. Noticing that European non-photographic art was receiving more attention than photography, though, Stieglitz increased his commitment to modern art.[12] He saw in works by Cézanne, for example, an approach to the concrete, objective world, one centered on freedom of expression of form and the material object that was not unlike his own. In contrast to the soft-focused pictorial imagery of his early works, Stieglitz's straight, sharp-focused photographs such as *The Steerage* (pl. 30) emphasized design and direct presentation of geometric forms from the external world. This focus on the objective world encouraged Stieglitz to ally modern art with photography, his own included.[13]

The adoption of a more modern aesthetic in photographic images was not immediate for Stieglitz, just as his ability to appreciate the new trends in European art, including the finer points in works by Cézanne, did not happen instantly. Especially instrumental in his education in modern aesthetics was a trip to Paris in 1909,

during which he and Edward Steichen heard Leo Stein discuss the virtues of modern art in a broad context, new with old, modern with ultra-modern, Western with Eastern. The entire design of a painting functioned for Stein like an intellectual exercise, the "plastic beauty" in Cézanne arising from premeditation and organization of colored planes.[14] Stein saw in the artist "a great mind, a perfect concentration, and great control," believing that "Cézanne's essential problem is mass and he has succeeded in rendering mass with a vital intensity that is unparalleled in the whole history of painting."[15] Stieglitz's decision to show Cézanne's lithographs in 1910 must have been fueled by Stein's discourse in 1909, in which he heralded Cézanne's color and treatment of form, while relegating several European artists that Stieglitz had shown to "second class."[16]

Stieglitz, like many other Americans, was fascinated with the momentum of modernism in art but uncomfortable with certain complexities in its most avant-garde manifestations, namely Cézanne's. The modern European art exhibited at 291 attracted a broad-based audience hoping to see the latest styles from abroad, and many visitors, wishing to extend their education in modern art, looked to Stieglitz to talk about the art he displayed. To do so with the ease of Stein, who consistently made decisive announcements about modern art to his audience of newcomers and avant-garde personalities, Stieglitz needed to know more about Cézanne. He could learn from Stein, an insightful, impromptu speaker and proselyte for modern art, who kept abreast of the latest books and articles, as well as the premier dealers in modern art. In Stieglitz's words: "Leo began to talk. I quickly realized I had never heard more beautiful English or anything clearer. He held forth on art . . . for at least an hour and a half. . . . While Stein ran through the gamut of art, old and new, I listened, spellbound."[17]

Leo had learned about Cézanne through Bernard Berenson, a scholar of Renaissance art, who had advised Stein on the purchase of his first oil painting by Cézanne, *The Conduit*, from Vollard in 1904.[18] Berenson not only had drawn Stein's attention to Cézanne, but had also set an example in aesthetic formulation by converting postulates and linguistic idioms from William James' *Principles of Psychology* to serve another purpose, in this case the formal analysis of Renaissance painting. Particularly important to Berenson were James' principles concerning the perception of three-dimensional form in a three-dimensional space. James determined that form was a psychological factor vital for cognition and that tactile perception and "touch images" were essential to mental processes, stating, "The felt object has a *plastic* reality and outwardness which the imagined object wholly lacks."[19] Berenson admitted, "I owe everything to William James, for I was already applying his theories to the visual world. 'Tactile values' was really James's phrase . . . although he never knew he had invented it."[20]

17 PAUL CÉZANNE
Well and Winding Path in the
Park of Château Noir, *c. 1900*
EXHIBITED AT 291, 1911

18 PAUL CÉZANNE
Landscape with Trees, *1880–1885*
EXHIBITED AT 291, 1911

Stein, following suit, incorporated elements from James' psychology, most specifically the link among tangible, plastic, and real, into his discussions of modern art, especially those about Cézanne. By doing so, he rendered Cézanne's art more accessible to Americans, including Stieglitz and the early modernist artists whose work he showed at 291. Although European artists and writers already had assigned the term "plastic" to certain qualities in Cézanne's painting and understood its connotations of tactility, Stein spoke directly to American artists and used art from his collection to clarify his insights on Cézanne. The still life *Five Apples* (1877–1878) exemplified the psychological phenomenon in which sight and touch fuse to heighten the experience of mass and matter seen as pliable form.[21] Writing from Rome to an American protégé, Stein explained that "nowhere on the ceiling has Michelangelo attained to the sheer expression of form that is often achieved in his drawings. I believe that nowhere is it as complete as in those apples of Cézanne."[22] Especially impressed by the use of such language was Stieglitz, who had once said of his own work that "the quality of touch in its deepest living sense is inherent in my photographs. When that sense of touch is lost, the heartbeat of the photograph is extinct."[23]

James' term "plastic" was ideally suited as a term for describing Cézanne's works. Of the 291 circle in 1910, arguably the most perceptive and articulate writer was Max Weber, who had been in Paris from 1905 until 1908 and had relentlessly mined the resources on art. He had studied with Matisse, made acquaintances with vanguard artists, and regularly visited the Palais du Trocadéro, the Musée Guimet, the Stein salon, and the Salon d'Automne exhibitions. His response upon first viewing paintings by Cézanne at the 1905 Salon d'Automne was, "I had heard of Cézanne before, but when I saw the first ten pictures by this master, the man who actually ... brought an end to academism, I said to myself ... 'this is the way to paint. This is art and nature reconstructed by what I should call today an engineer of the geometry of aesthetics.' "[24] By the time he returned to New York, Weber, who had assimilated Stein's Jamesian psychological and empirical method, was able to approach Cézanne's work with both practical and theoretical insights. Many times he had witnessed Stein seeking diversities of style in the study of art, comparing Cézanne's calculated color structure in the interests of mass and volume with Japanese prints or with Matisse's flat color and linear, decorative flair.[25] Such exposure had enabled Weber to recognize that Cézanne's compositions represented the perceived mass and volume of nature, as well as the tension between the solidity of the pictorial image and the flat plane of the pigmented support. When writing about Cézanne's watercolors, Weber applied his philosophy of art to an interpretation. Describing

the works as "the reorganization of the natural into a purely plastic domain," Weber implied that plastic and tactile features coexist in a "concrete and poetic" reality that causes "the static to vibrate.... In these watercolors can be seen and felt [Cézanne's] power of synthesis in transforming the chaotic into the purely architectural plastic."[26]

Weber's unremitting praise of Cézanne and placement of his art as a cornerstone in the modern movement had a significant impact on Stieglitz and stirred his enthusiasm to stage the first one-man show of Cézanne's art in this country,[27] *An Exhibition of Water-Colors by Paul Cézanne*, from 1 to 25 March 1911 at 291.[28] It followed by only three months the American debut of Cézanne's lithographs. Stieglitz was eager to meet the growing interest in Cézanne that he discerned within the American vanguard milieu. Indeed, prior to 1911 several critics directed requests to the Metropolitan Museum of Art to hold a comprehensive exhibition of Cézanne's art. Much of this interest arose from the attention to Cézanne that Roger Fry's 1910 landmark show in London, *Manet and the Post-Impressionists*, had generated.[29] The exhibition, which placed Cézanne at the forefront of a new movement in art, one that encompassed a diversity of modern styles, was accompanied by a flurry of art discourse by Fry and other English writers that emphasized the importance of formal order and design over mimetic treatment of a subject. In the exhibition catalogue, Fry and Desmond MacCarthy described Cézanne's art as having advanced beyond impressionism because he "aimed first at a design which should produce the coherent, architectural effect of the masterpieces of primitive art.... Cézanne thus showed how it was possible to pass from the complexity of the appearance of things to the geometrical simplicity that design demands...."[30]

Being in agreement with Fry, Stieglitz extended his intention to emphasize the non-photographic aspects of modern art in Cézanne's lithographs with plans to exhibit Cézanne's watercolors. When in January 1911 Stieglitz received a call from Steichen, who was in Paris, to say that Cézanne watercolors were available on loan from the Bernheim Jeune Gallery, Stieglitz answered, "send the Cézannes.... Naturally I was curious to see how the Cézanne watercolors which I had laughed at in 1907 would look to me when unpacked at 291."[31] Upon opening a box of twenty-eight watercolors by Cézanne, selected by Steichen and Paris art critic Félix Fénéon, Stieglitz recalled, "they appeared to me as realistic as a photograph. What had happened to me?... They were as beautiful as I had ever known. In fact, they were something I truly had not seen before."[32] Reasonably priced at $200, only one of Cézanne's watercolors from the 291 exhibition sold: *The Well in the Park of Château Noir* (1895–1898) to Arthur B. Davies.

In October 1911, a short essay on the watercolors appeared in *Camera Work*. Unsigned, but likely written by Stieglitz, it offers an incisive, formalist summation of certain aesthetics in the works, including a reference to the artist's tactile sensibilities: "On first glancing at the few touches of color which made up the watercolors by Cézanne ... the beholder was tempted to exclaim, 'is that all?' Yet if one gave oneself a chance, one succumbed to the fascination of his art. The white paper no longer seemed empty space, but became vibrant with sunlight. The artist's touch was so sure, each stroke was so willed, each value so true...."[33]

There were, of course, scathing dismissals of Cézanne's watercolors by ingrained conservatives and some members of the press, who never budged from an unrelenting, strident negativism in all matters concerning Cézanne. Several of these writers considered Cézanne's works to be "fragmentary drawings washed in here and there with spots and patches of flat tint"; "landscapes ... on the point of disappearing from the paper"; and "hints rather than actual performances."[34] In one case, a critic stated that the watercolors were "artistic embryos, unborn, unshaped, almost unconceived things...."[35]

Other critics, however, though lacking sustained exposure to his art and the intellectual outreach it afforded, attempted to assess the works thoughtfully. By being attentive to alternative forces in different artistic traditions, they noted artistic precedents from Japanese art. Faced with a difficult critical situation, one writer familiar with Eastern cultures gave a sensitive appraisal of a landscape in the 291 exhibition, *Mont Sainte-Victoire* (pl. 19), noting that "one fine little landscape, a mountain that might be Fujiyama ... rising very solid, very dignified, and serene, is modeled with a few forcible strokes of pale greenish grayish neutral color.... The Chinese and Japanese as a people love nature more consistently than any other of the Eastern races, and many of their greatest works in essence resemble this by Cézanne."[36] Using a similar approach, a reviewer saw in Cézanne's works a "beautiful insight into outdoor life, a Japanese feeling ... with a very distinctly Japanese sympathy and power of elimination."[37]

Another writer attempted to connect Cézanne's watercolors with Japanese art, stating, "these drawings resemble the work of those early Kano painters of Japan, who deliberately enlivened their subtle ink washes with a little tint.... The watercolors are among the most abstract forms of expression conceivable. Like Far Eastern drawings, they are merely symbols for swing and spatiality."[38] *Camera Work* critic Charles Caffin linked Western and Eastern traditions by noting that Cézanne's art has "the elements of gravity and greatness that the classic masters ... share with those of Egypt and the Orient."[39] Most critics at the time, barely familiar with Cézanne's watercolors, resorted to Japanese aesthetics as a base for comparisons.

19 PAUL CÉZANNE
Mont Sainte-Victoire, *c. 1890*
EXHIBITED AT 291, 1911

Their background in Eastern art served as a resource for validating a critic's credentials quite aside from the means it provided for recognizing and analyzing certain qualities in Cézanne's painting.

The impact of the show on several of 291's American artists such as John Marin and Charles Demuth manifested itself in watercolors that they painted after 1911. Although Marin steadfastly denied throughout his life that Cézanne had affected his art, even maintaining that while in Paris (1905–1909, 1910) he was unaware of Cézanne's art, and only saw it for the first time at 291,[40] several influential critics connected him directly with Cézanne. One of the first to do so was Caffin, who stated, "Marin is part of that fermentation which, started by Cézanne and stirred by Matisse, has given new impulse to the artist's old recipe of seeing the world for himself. The watercolors are harmonies of indescribably delicate tonalities, wrought on the Japanese principle of Notan."[41] Later, noted critic Willard H. Wright linked Marin, Cézanne, and Chinese painting, writing that Marin's subject matter "has become almost abstract," thereby revealing "a certain inevitable Chinese aspect. Some of his pictures betray a great desire to see and feel, through intense concentration, the inherent ... rhythm of his subject. ... Herein he attunes himself to Cézanne's mental attitude."[42]

In contrast to Marin, Demuth overtly sought ideas from modern European art, particularly Cézanne's, as he experimented with sophisticated formal concerns in a variety of genres. In a landscape dominated by a centrally placed, single mountain motif, *Mt. Gilboa #5* (fig. 38), Demuth's broad, sloping, geometric forms

fig. 38 **CHARLES DEMUTH**
Mt. Gilboa #5, *1912–1915*
watercolor
Hirshhorn Museum and
Sculpture Garden, Smithsonian
Institution, Gift of Joseph H.
Hirshhorn, 1966

fig. 39 CHARLES DEMUTH
Rooftops and Trees, *1918*
watercolor and graphite
The Corcoran Gallery of Art,
Washington, Bequest of George Biddle

fig. 40 PAUL CÉZANNE
Rooftops and Tree, *1888–1890*
watercolor
Museum Boymans-van Beunin-
gen, Rotterdam
EXHIBITED AT 291, 1911

resemble the ordering of natural forms in Cézanne's *Mont Sainte-Victoire* (pl. 19) from Stieglitz's 291 exhibition of 1911. Related to the architectural landscape in Cézanne's *Rooftops and Tree* (fig. 40), also shown at 291 in 1911, is a sequence of watercolors in the same genre but painted by Demuth between 1916 and 1918. In these paintings he experimented with pictorial configurations, relationships of geometric forms in a shallow space, and textural washes that derive from Cézanne, as in *Rooftops and Trees* (fig. 39). In this work, Demuth has adopted a cubist idiom but the formal vocabulary of curvilinear organic shapes in contest with rectilinear elements in the architecture bears a legacy to the watercolors by Cézanne mentioned above.

Although the March 1911 exhibition of Cézanne's work was the last to be held at 291, which closed in 1917, the same year that publication of *Camera Work* was suspended, Stieglitz was a premier force in the development of American early modernism. He not only kept alive an experimental approach to Cézanne, one that bridged Western and Eastern traditions in art, but at 291 he encouraged change and artistic investigation, the reevaluation of aesthetic canons, and a determination to face the challenge posed by Cézanne's art.

20 PAUL CÉZANNE
Madame Cézanne with Hydrangeas,
1882–1886
EXHIBITED AT 291, 1911

21 PAUL CÉZANNE
Tree Study, *c. 1890*
EXHIBITED AT 291, 1911

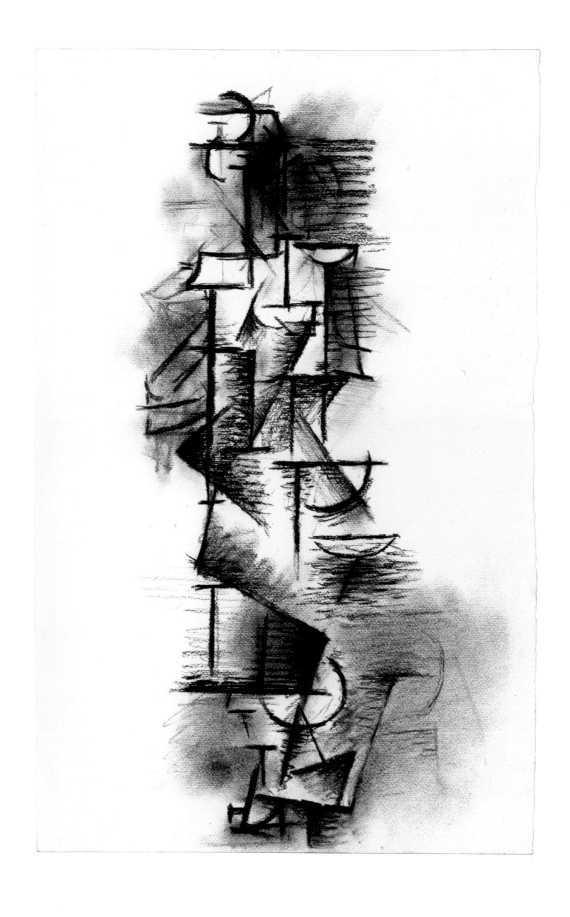

Charles Brock

PABLO PICASSO, 1911

AN INTELLECTUAL COCKTAIL

As early as 1908 Edward Steichen mentioned to Stieglitz the possibility of a Picasso show for 291, but then immediately contravened the proposal by suggesting that the practice of exhibiting fine art at the Photo-Secession be suspended. With the furor of the Rodin and Matisse exhibitions still fresh in his mind Steichen wrote from Paris: "I think we should if we have two shows have one!!! and the other an 'understandable' one.... As for the red rag I am sure Picasso would fill the bill if I can get them but he is a crazy galloot hates exhibiting etc. However we will try him. Of course I do not see the necessity of so much outside photography unless we decide on a new policy of work and I think now as I said in New York let's take a year off and think about it...."[1] This ambivalence and his use of the humorous term "crazy galloot" were early indications of his general lack of enthusiasm for Picasso and undermined any hope for the project that year. The first Picasso exhibition in America would instead have to wait until 1911 when a different set of players and more favorable circumstances conspired to make it possible.

Between 1908 and 1911 Stieglitz gradually achieved a more profound appreciation of the young Spaniard's genius. Max Weber, who had been introduced to Picasso at the Steins' famous salon on the rue de Fleurus in Paris, returned to New York in 1909 and became a critical source of information. Weber brought with him a small still life, the first work by Picasso that Stieglitz had ever seen. Moreover, Weber's exhibitions at 291 in 1910 and 1911 were the first important displays of proto-cubist style in America.[2] In the summer of 1909 Stieglitz himself traveled to

fig. 41 PABLO PICASSO
Standing Female Nude, *1910*
charcoal
The Metropolitan Museum of Art,
Alfred Stieglitz Collection. 1949
EXHIBITED AT 291, 1911; AN
AMERICAN PLACE, 1937, 1941

fig. 42 PABLO PICASSO
Peasant Woman with a Shawl, 1906
charcoal
The Art Institute of Chicago, through prior bequest of Janice H. Palmer

Paris where, through the offices of Steichen, he was able to study at firsthand the Steins' collection. On that occasion, Leo Stein launched into a passionate lecture on the significance of Picasso. Stieglitz was so impressed that he immediately offered to publish the remarks in *Camera Work*.[3]

By the spring and summer of 1910 the Stieglitz circle's keen interest in Picasso was manifesting itself in a number of different ways, as the Younger Americans Show at 291 in March confirmed. In May Gelett Burgess, whose caricatures of cubism would be exhibited at 291 in 1912, published a photograph of Picasso's studio and the first reproduction anywhere of the epochal *Les Demoiselles d'Avignon* in the *Architectural Record*.[4] And on 12 July 1910 Hamilton Easter Field, a frequent visitor to 291 and cousin of Stieglitz's close associate Paul Haviland, wrote to Picasso by way of Haviland's younger brother Frank Burty to confirm a commission for an ambitious suite of works for the decoration of his library.[5]

Amid a growing network of relationships, Marius de Zayas emerged to catalyze events. Journeying to Paris to investigate the innovations of French modern art on behalf of 291, he wrote to Stieglitz on 28 October 1910: "I have gone four times to the Salon d'Automne...the real article is a Spaniard, whose name I don't recall, but Haviland knows it, because he is a friend of his brother."[6] With Frank Burty Haviland's support, de Zayas, whose fluency in Spanish made him a much more effective emissary than the skeptical Steichen, convinced Picasso to exhibit at 291.

The works for the Picasso exhibition were selected by a jury composed of Picasso, de Zayas, Frank Burty Haviland, and Steichen.[7] Despite his misgivings, Steichen, who by this time was adept at the complex logistics of organizing shows in Paris for 291, made the necessary arrangements: "I am sending the Picassos on the next boat.... Haviland and Picasso selected the Picasso pictures themselves. I came in for a little advice in the end to make the collection a little more clear by its evolution. It shows his early work and his 'latest'—certainly 'abstract'—nothing but angles and lines that has got [to be] the wildest thing you ever saw laid out for fair. Picasso was a man I never could see.... I admire him but he is worse than greek to me.... Picasso may be a great man but it would be rank snobbery for me to say I see it now."[8]

The Picasso exhibition opened on 28 March 1911 and consisted of forty-nine watercolors and drawings displayed under sheets of glass mounted directly on the wall. In some cases works were grouped by subject matter and, given the large number of drawings involved and the small confines of the 291 gallery, it can be assumed that they were often double- or even triple-hung. Thirty-four additional drawings were also available for viewing on request.[9] Prior to the show, on 7 March 1911, de Zayas sent Stieglitz an abstract of his article for *América: Revista mensual illustrada*, based on interviews with Picasso.[10] Along with a catalogue announcement that proclaimed the display "the first opportunity given to the American Public to see some of Picasso's work in this country," Stieglitz distributed de Zayas' article as an advance proof of *Camera Work*, no. 34, "to satisfy those who sought enlightenment as to the aims and purposes of an artist who is breaking virgin ground."[11]

Barring photographic evidence, the question of precisely which works were shown in 1911 must remain one of the great mysteries in the early history of modernism in America. Nevertheless, two drawings can be definitively linked with the Picasso show, and specific descriptions from thirteen newspaper reviews suggest a host of other possibilities.[12] Together with more general discussions of the installation a fairly complete idea of the display can be formed.

fig. 43 PABLO PICASSO
Study for "Les Demoiselles d'Avignon" (Nude with Arms Raised), *June 1907*
gouache
private collection

The published descriptions cannot be correlated with absolute certainty, but in many cases, the level of detail is often sufficient to discuss with confidence the range and types of drawings on view. For instance, the "full-length drawing of a peasant woman hanging at the entrance to the gallery" denotes a work in the series of peasant women Picasso sketched in Gosol, Spain, during the summer of 1906 (fig. 42).[13] Two separate descriptions, "figures which have hexagonal legs"[14] and "the human form looks not unlike the mannikin that an artist keeps in his studio, save that its wooden joints are fearfully and wonderfully colored...,"[15] refer to drawings such as *Study for "Les Demoiselles d'Avignon"* (fig. 43) that are in turn related to a complex series of deformations of the human figure from 1907–1908 (fig. 44). The linked phrases "childish wooden images, Alaskan totempoles" evoke *Standing Nude in Profile* from the spring of 1908 (fig. 45).[16] "A girl with a nose clumsily cut from a block of wood standing at an angle of about thirty degrees across an almost full face, one side of which has been twisted out of joint" and "A man's or a woman's face ... looks almost exactly like that of

a football player with a headguard and a noseguard on…"[17] seem to be generic descriptions of Picasso's female and male head studies from 1908 and 1909 (figs. 46, 47).[18] Picasso also executed at least two studies of a woman's back in 1908 with lines radiating from the spine that closely match a reviewer's inspired analogy: "back of a giantess corseted…. The lines are pyramidal."[19] A "plate containing a crystal, a fruit which resembles the crystal and the head of a woman which undeniably resembles the fruit" correlates with *Head of a Woman, Casket and Apple* datable to early 1909.[20] That year Picasso also executed a number of cubist studies of cups that may be related to "watercolor of a tin cup."[21] Finally, the reference to " 'The Village,' the sepia-colored picture of solitude and desertion…the cubes representing the houses could be made impersonal by omission of the roof-effects" describes works like *The Mill at Horta* from spring–summer 1909 (fig. 48).[22] To these can be added the two drawings that were sold from the show: the Gosol period *Study of a Nude Woman* (fig. 49), purchased by Hamilton Easter Field, and the famous 1910 cubist study, *Standing Female Nude*, bought by Stieglitz himself.[23]

Because of accounts that stress the selection committee's desire to show the evolution of Picasso's work, it has often been falsely assumed that the whole course of Picasso's career from childhood to 1910 was represented in the show.[24] The evidence suggests, however, that Picasso's Gosol works from 1906, such as Field's study and

fig. 44 PABLO PICASSO
Study for Nude with Drapery,
1907
watercolor
The Baltimore Museum of Art:
The Cone Collection, formed by
Dr. Claribel Cone and Miss Etta
Cone of Baltimore, Maryland

fig. 45 PABLO PICASSO
Standing Nude in Profile, *1908*
gouache and pastel
Musée Picasso, Paris

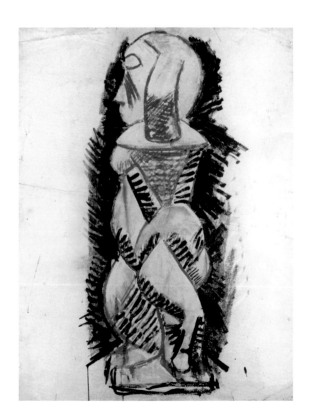

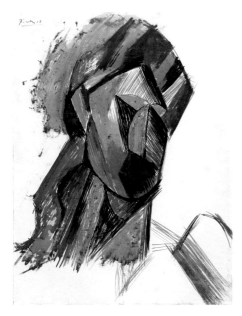

fig. 46 PABLO PICASSO
Head, 1909
gouache
The Museum of Modern Art, New York, Gift of Mrs.
Saidie A. May

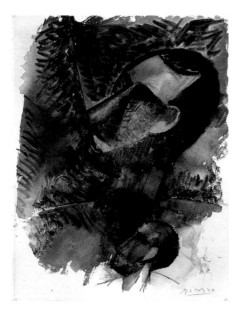

fig. 47 PABLO PICASSO
Studies for the Head of a Man, 1908
gouache, pen, and blue ink with graphite
Davis Museum and Cultural Center, Wellesley
College, Massachusetts

the peasant woman that greeted visitors at the entrance to the show, were the earliest drawings displayed, with the balance of the installation featuring rich thematic groupings of works before 1911 that conveyed Picasso's genius for inventively reworking a common theme.[25] The "evolution" demonstrated by the exhibition then took two forms: a general development from the Gosol figure sketches to the highly abstracted cubistic studies as well as more complex interrelationships between clusters of closely related cubist drawings. While the former would have been understood, the latter groupings confounded viewers: "The worshippers of Picasso say they feel sensations over what has been cleverly described as his 'emotional geometry....' But they do not seem to understand whether Picasso begins with a geometrical sketch and ends with an unexplainable painting, or begins with the painting and ends with a turbulent mixture of cones and cubes ... which was the beginning and which was the finished product of four studies, the unexplainable figures or the geometrical confusion...."[26] Given the large number of works involved, the exhibition, in sum, must have been a remarkably thorough account of Picasso's work as a draftsman during the 1906 to 1910 period.

The critical reaction to the show, while at times hostile, was more often simply bewildered and skeptical. Arthur Hoeber was the most vehement in his expressions of outrage: "Any sane criticism is out of the question.... The results suggest the most violent wards of an asylum for maniacs, the craziest emanations of a disordered mind, the gibberings of a lunatic!... It is almost worth a visit to these galleries to see how far foolishness and imbecility will go ... the limit has been reached."[27] More typical, however, were the reviewers who found the work incomprehensible but refrained from completely condemning the exhibition. The *New York Evening World* told readers to prepare to "receive the artistic jolt of your young life" while stopping short of "advising any earnest truthseeker to stay away."[28] Others called it the "new thrill in town,"[29] and "a disquieting array."[30]

At a loss as to how to address the work itself, many reviewers directed their ire toward the de Zayas handout circulated by Stieglitz. Hoeber complained: "... when it becomes necessary to explain pictures by vague words and protests it is a certainty that the work needs all the assistance literature can give it."[31] Mr. Tyrell noted that de Zayas explained "what the Picasso kind of art is not" and in exasperation

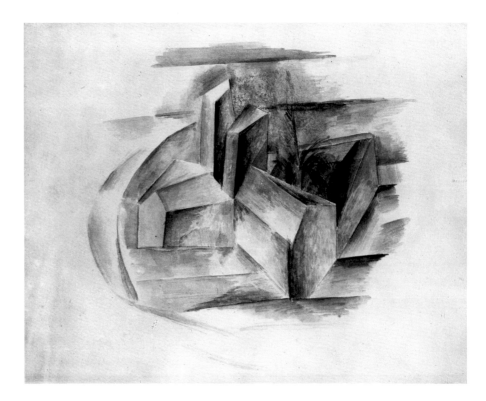

added "Now will you be good!"[32] J. Edgar Chamberlin feigned support for de Zayas' views: "We stand absolutely with Mr. de Zayas, and say that form produces in our spirit impressions resulting in a totally different coefficient from that produced in Picasso's case, and that his pictures displease us radically and violently."[33] Mr. Harrington protested that the pamphlet was "an injunction...forbidding them to criticize anything which Señor Picasso has to offer."[34] And Mr. Fitzgerald devoted a whole article to the issue entitled "The New Art Criticism" in which he scathingly concluded: "The old-fashioned critic was bad enough.... The new-fashioned critic is no better, for he makes it a matter of conscience to approach all things with the innocence of the imbecile."[35]

American critics, for the most part baffled by Picasso, were also often insightful and sensitive in their analyses. Some mentioned the primitivist roots of Picasso's art. The *New York World* noted, "Some of his figures suggest the early Egyptian type,"[36] a comment echoed by James Huneker who described the artist as "Obsessed by the Egytians."[37] Elizabeth Luther Carey wrote that the drawings "hark back to primitive symbols for the expression of their exceedingly sophisticated feelings and ideas."[38] In the same vein, Chamberlin more specifically observed: "...it would be an error to apply to Señor Picasso's method any term that implied progress, or advance, or development.... these things of Picasso's are neo-African. They remind one of nothing so much as of the carvings in ebony or blackened wood, rudely representing the human figure, made by the natives of the west coast of Africa."[39]

Carey, Huneker, and Israel White proved to be the most informed and sophisticated commentators. Carey and White even avoided the common error of classifying Picasso as a post-impressionist, with the former declaring the term a "crass misnomer"[40] and the latter correctly observing that Picasso "attempts to carry the idea of the Post-Impressionists a step forward and to build up a new artistic process."[41] Carey presciently noted that the controversy surrounding the show was "a sound that is quite apt to precede revolution of one kind or another" and sensed that Picasso had "the genuine pioneer quality from which we may expect discoveries that stir the imagination."[42] White in turn made a clever analogy with contemporary scientific theories concerning the creation and collapse of the universe, hypothesizing, "a collapse ... has occurred and that the process of aesthetic development has begun over again" before concluding, "I find Picasso using cubes and crystals, the very elements of pictorial design, and so arranging and expanding his crystals as to suggest natural forms and faces and figures. No effort is made to present the actuality of appearances, yet the most striking impression of this exhibit of experiments is the character and expression Picasso succeeds in imparting as he gropes after a new and impersonal use of form."[43] Huneker, a critic closely aligned with Stieglitz, ended his discussion with the most simple and incisive of questions: "Will Pablo Picasso restore form to its sovereignty in modern art?"[44]

If Stieglitz was perturbed by the dismissive tone of the many reviews, he was also tremendously gratified by the widespread interest in Picasso that such thorough coverage generated.[45] Writing to the painter Arthur B. Carles, he exulted: "The Picasso show has created a stir for fair and we are IT once more."[46] And a week after the show opened he declared to de Zayas: "Exhibition a very great success. We've again made a hit at the psychological moment. In a way this is the most important show we have had.... The future looks brighter than it has in a long while."[47]

One of the most important consequences of the show's success was to establish de Zayas as another Stieglitz envoy in Paris alongside Steichen. Buoyed by the encouraging reports, de Zayas worked to cement 291's relationship with Picasso during and after the close of the show. He relayed copies of exhibition announcements and reviews as well as personal notes from Stieglitz. When Picasso voiced displeasure at delays in the return of his drawings, de Zayas deflected blame from Stieglitz himself.[48] These efforts were crucial to the future of 291 for they assured the Photo-Secession the same kind of access to Picasso that Steichen had made possible with Matisse and Rodin. De Zayas' new status in Paris made it credible for *Camera Work* to claim in October 1911 that the show had helped "greatly to strengthen the position of the Photo-Secession in the art world."[49]

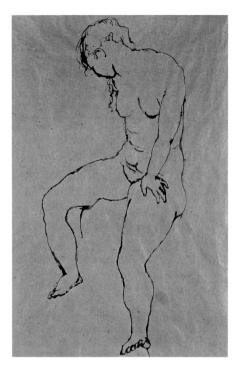

fig. 49 PABLO PICASSO
Study of a Nude Woman, *1906*
gray brown ink on brown paper
John H. and Ernestine A. Payne Fund, Courtesy
Museum of Fine Arts, Boston
EXHIBITED AT 291, 1911

Stieglitz postponed the scheduled exhibition of David Octavius Hill's photographs in order to extend the Picasso show at 291 to the end of the spring season. Anxious to keep the body of works on view at 291 intact, he made a daring if ultimately unsuccessful bid to have the Metropolitan Museum purchase the entire collection.[50] Moreover, following the close of the exhibition, he wrote a letter to the editor of the *Evening Sun* chiding the Metropolitan about the need for an exhibition of post-impressionism whose scope might be extended "to include the work of Matisse and Picasso, two of the big minds of the day expressing themselves in paint."[51]

In the wake of the exhibition, Stieglitz's admiration and support for Picasso grew and deepened. During the summer of 1911 he visited Paris, where de Zayas introduced him to the artist. Comparing his meetings with Picasso and Matisse, Stieglitz later remarked to Sadakichi Hartmann: "Picasso appears to me the bigger man. I think his viewpoint is bigger; he may not as yet have fully realized in his work the thing he is after, but I am sure he is the man that will count."[52] In 1912 Stieglitz purchased the bronze *Head of Fernande Olivier* (pl. 22) from Vollard. He also published Gertrude Stein's prose portrait of Picasso as well as excerpts from Kandinsky's *On the Spiritual in Art* related to the artist.[53] By that fall Stieglitz's personal understanding of the relationship between photography and Picasso's work had crystallized. He conveyed his revelations to Heinrich Kuhn: "You don't understand what Picasso & Co. have to do with photography! Too bad that you can't read the [Stein] text in Camera Work.... Now I find that contemporary art consists of the abstract (without subject) like Picasso etc., and the photographic.... Just as we stand before the door of a new social era, so we stand in art too before a new medium of expression—the true medium (abstraction)."[54]

Although the lack of any photographic evidence will continue to be a barrier to a full understanding of the 1911 Picasso installation, the remarkable drawing that Stieglitz purchased was certainly the exhibition's "storm center" or "clou."[55] Pejoratively referred to by critics as "The Fire Escape,"[56] to Stieglitz it was as "perfect as a Bach fugue"[57] and eventually became a sort of talisman for his experimentations concerning the relationship of art and photography. During the Armory Show in 1913, to which the drawing had been lent, a reporter, while gently mocking Stieglitz's claims for the work's restorative powers, also confirmed its central role in Stieglitz's creative life: "Mr. Stieglitz declares in all sincerity that when he has had a tiring day in his gallery or elsewhere he ... stands before this drawing in black and white ... and gains from it a genuine stimulus. It is to Mr. Stieglitz a sort of intellectual cocktail."[58]

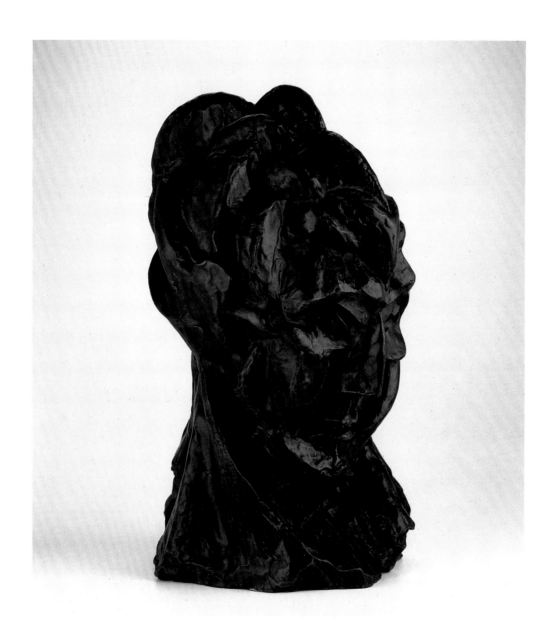

22 PABLO PICASSO
Head of Fernande Olivier, 1909
PURCHASED BY STIEGLITZ, C. 1912;
REPRODUCED IN CAMERA WORK,
SPECIAL NUMBER, AUGUST 1912

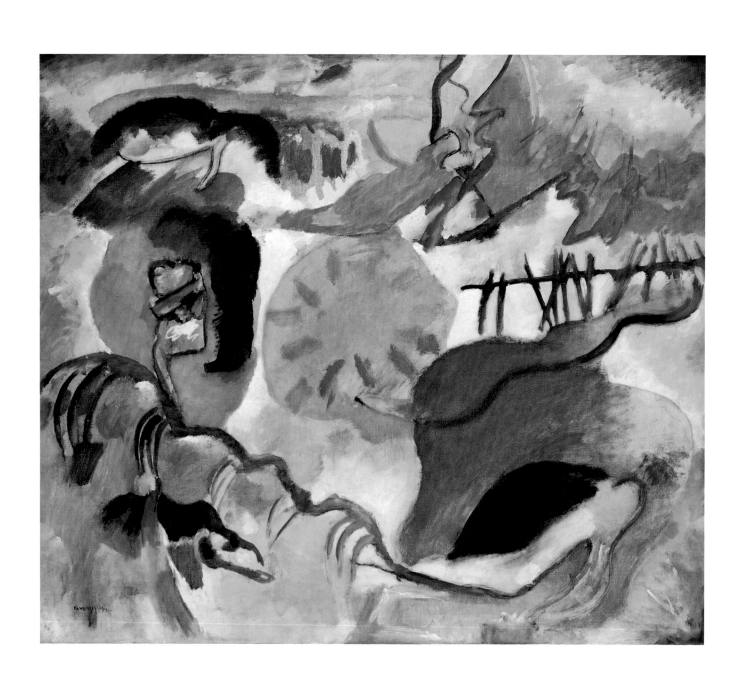

Charles Brock

THE ARMORY SHOW, 1913

A DIABOLICAL TEST

R oger Fry's groundbreaking exhibition *Manet and the Post-Impressionists* was held at the Grafton Galleries in London from 8 November 1910 to 15 January 1911 (see page 108).[1] The extensive press coverage that the show received in the United States generated enormous curiosity among American artists, museums, and the general public about European modernist movements. As a consequence, by the end of 1911 an American version of the Grafton show seemed inevitable.

Several institutions approached Stieglitz about organizing an exhibition of post-impressionist painting for American audiences, but he declined.[2] In a letter to the editor of the *Evening Sun* published on 18 December, he quixotically proposed that Fry's former employer, the conservative Metropolitan Museum of Art, undertake the project instead: "The Metropolitan owes it to the Americans to give them a chance to study the work of Cézanne and Van Gogh ... there can be no question of the Metropolitan securing the loan of the best pictures of these masters. I happen to know they can be had."[3] The following day, however, the American Painters and Sculptors (later incorporated as the Association of American Painters and Sculptors) held their first official meeting. Led by Walt Kuhn, Arthur B. Davies, and Walter Pach, the association would organize the famous International Exhibition of Modern Art of 1913. Known as the Armory Show, it included more than one thousand European and American paintings, sculpture, and works on paper.[4]

23 WASSILY KANDINSKY
The Garden of Love (Impro-
visation Number 27), *1912*
PURCHASED BY STIEGLITZ, 1913

It is not surprising that Stieglitz chose neither to direct a comprehensive exhibition of European art in 1911 nor to become closely involved in the plans for the Armory display. A heavily publicized,

mammoth show of large-scale works for sale to the general public, if indebted to Stieglitz's efforts at 291, was nonetheless antithetical to his ideals. 291 was after all an "experiment station," a private, intimate setting where serious artists could view small drawings and works-in-progress. Moreover, Stieglitz had rehearsed the introduction of European modernism to America many times at the Little Galleries of the Photo-Secession. He was not interested in consolidating past achievements but rather in keeping 291 on the cutting edge. By 1912, as one writer observed, 291 was more than a passive recipient of European ideas, and had become "the nursery of contemporary art... Stieglitz's courage, disinterestedness, and intelligence have placed New York almost abreast of Paris...."[5]

As the opening of the Armory Show approached Edward Steichen wrote to Stieglitz in December 1912: "What is all this talk in the papers about the international exhibition that Davies is heading. Is it going to be good or do you need an antidote?"[6] Stieglitz had, in fact, already begun formulating a twofold response: he would support the exhibition's broad promotion of avant-garde art in the United States while using the publicity and enthusiasm generated by the event to demonstrate that America—largely as the result of 291's exhibitions—was not just an outpost of modernism, but a preeminent center.

Stieglitz's support for the Armory Show took many forms. He agreed to be interviewed about the event by the *New York American* and in the article "The First Great 'Clinic to Revitalize Art' " he exhorted readers to "Go to the coming exhibition at the Sixty-ninth Regiment Armory and see some of the orchestration in colors that will help put life into the dead corpse of painting."[7] He also lent his Picasso charcoal (fig. 41) and sculpture (pl. 22) and six Matisse drawings (pls. 9, 11–13). In addition, he encouraged many of his associates, among them Arthur Carles, Marsden Hartley, John Marin, and Alfred Maurer, to participate. Finally, he purchased Kandinsky's *The Garden of Love (Improvisation Number 27)* (pl. 23), one of the exhibition's most radically abstract, and hence most controversial, paintings.[8]

Meanwhile, Stieglitz sought to balance the disproportionate attention that he correctly assumed would be given to European modernist painting and sculpture at the Armory by organizing three exhibitions on the central role of American artists and the medium of photography in the creation of a modernist aesthetic. Held before, during, and after the Armory display, the shows featured, respectively, the works of John Marin, Stieglitz himself, and Francis Picabia.

The Marin show ran from 20 January to 15 February, two days before the Armory Show opened. It featured one oil painting, one watercolor of the Great Falls on the Potomac River near Washington, eleven watercolors of the Berkshires and Adirondacks, and fourteen watercolors of New York City. In the catalogue Marin, recognizing

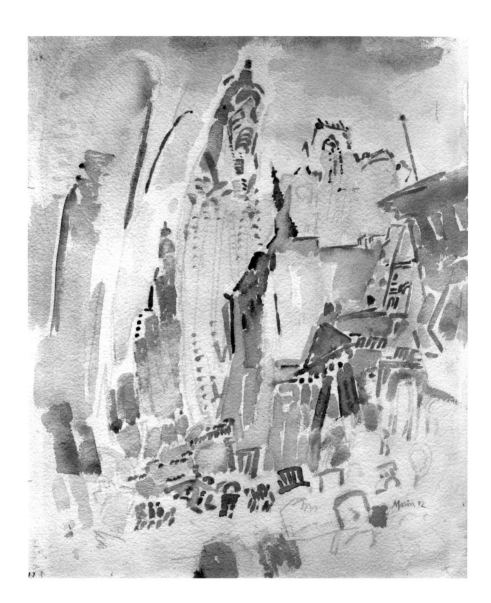

fig. 50 JOHN MARIN
Woolworth Building, No. 29,
1912
watercolor
National Gallery of Art,
Washington, Gift of Eugene
and Agnes E. Meyer
EXHIBITED AT 291, 1913

that the "later pictures of New York shown in this exhibition may need the help of an
explanation," articulated his vision of the city: "Shall we consider the life of a great city
as confined simply to the people and animals on its streets and in its buildings? Are the
buildings themselves dead?... I see great forces at work; great movements ... pushing,
pulling, sideways, downwards, upwards, I can hear the sound of their strife and there is
great music being played. And so I try to express graphically what a great city is doing."[9]

Discussions of Marin's Woolworth Building series (pl. 28, fig. 50, pls. 24, 29)
dominated reviews. Hung together, the group illustrated a progression from figura-
tion to abstraction that caught the attention of numerous critics. One writer empha-
sized how Marin, like Monet in his cathedral series, recorded the changing effects
of the building as seen at different times of the day: "In one picture the Woolworth

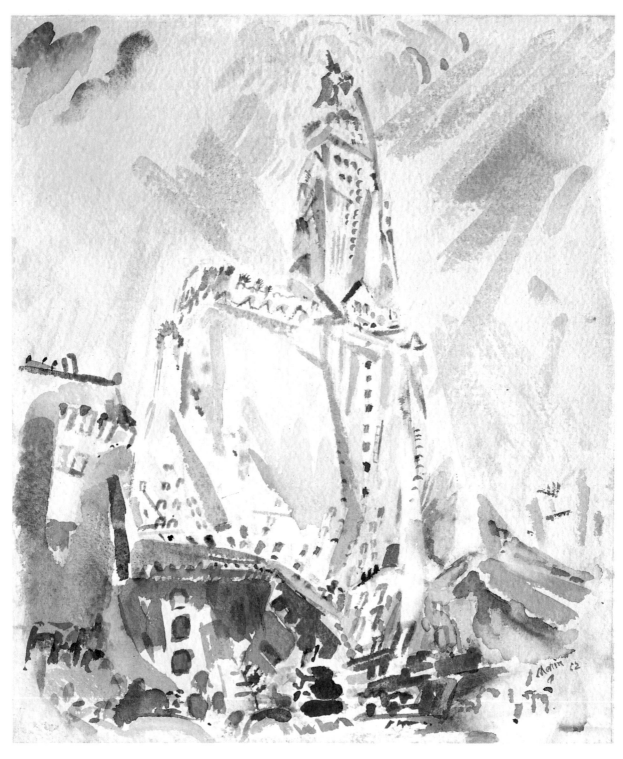

24 JOHN MARIN
Woolworth Building, No. 31,
1912
EXHIBITED AT 291, 1913

Building may be seen standing fairly erect, in another all awry, with the buildings at its base badly shaken; in still another aslant, with the foreground in the condition of scrambled eggs, and in the last as only a mass of curved lines and flourishes. They are not a series depicting an earthquake, but views of the building as seen by the artist at different times and from different angles."[10] Another critic related how the solidity of the building was dissolved in the general tumult of the city: "He shows us, first, the Woolworth building in all its solid glory, but treated with fancy and tinted with lovely lights. Then, in another sketch, the great building seems to begin to join the dance in which all New York is swinging away. There is another and another sketch, each further on, until at last the great building whirls up aloft in a cyclone of color."[11] W. B. McCormick in the *New York Press* provided a number of fantastical interpretations: "In the series are five 'views' of the Woolworth building, the first of which looks like a pianola on end. The second is a sketch in blue and white, in which the tall structure looks as if it were falling apart, and, for the sake of making the spectator feel he is somewhere on solid earth, a two-funneled steamer is introduced in the background.... The fifth looks like a big oyster shell opened over a battleship...."[12]

Paul Haviland lauded the Woolworth series in *Camera Work* as one of the most precocious achievements by an American modernist to date: "These latter, manifesting the newest and most advanced element of Marin's vision, were most worthy of closest study. Such a radical departure from any previous interpretation of New York, so far attempted in any medium, required adjustment of the point of view on the part of the public."[13] Samuel Swift added that "Like Picasso in his noted or notorious patterns ... he has traveled far from the world of conventional actuality."[14] Royal Cortissoz, in the *New York Tribune*, made a perceptive if problematic comparison to "the Italian Futurists who seek to disintegrate things into their emotional constituents."[15] Finally, a Mr. Boswell, in the *New York Herald*, thought the cityscapes suggested "cubism, futurism, and post-impressionism ... yet different."[16]

In his Armory Show interview for the *New York American* Stieglitz had interjected a long discussion about Marin's New York scenes among brief commentaries on Brancusi and Picabia. He aimed to place an American artist, and even more ambitiously, New York itself, at the forefront of the international avant-garde movement.[17] By acting before the firestorm of the Armory, Stieglitz ensured that his message was delivered. Reproductions of Marin's Woolworth watercolors appeared in no fewer than three major articles in the New York dailies, surpassing even the attention paid to the controversial Frenchman Francis Picabia upon his arrival in America[18] (fig. 51). In the wake of this fanfare, six of Marin's controversial cityscapes entered the Armory Show immediately after his exhibition closed.[19]

Marin's Emotional Painting of Skyscrapers

fig. 51 "The Futurist's New York: Marin's Emotional Painting of Skyscrapers," *from* The World, *16 February 1913*

25 ALFRED STIEGLITZ
Old and New New York, *1910*
EXHIBITED AT 291, 1913

Stieglitz opened an exhibition of his own photographs on 24 February, a week after the Armory Show's premiere. Thirty works dating from 1892 to 1912 depicted the Seine, a Parisian boulevard, a horse race, farmlands in the Tyrol, oceanliners, a ferryboat, an airplane, a dirigible, a swimming lesson at Lake George, a swimming pool in Deal Beach, New Jersey, and a young woman. The most prevalent theme, however, was New York City, in thirteen photographs.

Stieglitz conceived of his display of photographs, a medium totally excluded from the Armory Show, as a "diabolical test" of photography's strength.[20] His aim, enunciated by Haviland in *Camera Work*, was not only to judge the merits of his own work, but to illustrate the role that photography had played in the development of modern art: "The period during ... the International Exhibition at the Armory, was deemed a proper one to show the relative place and value of photography. No better work for this purpose could have been chosen than that of Alfred Stieglitz. His prints represent the straightest kind of straight photography; giving us at its best, the results of the honest photographer ... who loves it too much to attempt any suggestions of another medium."[21]

Reviewers parroted Stieglitz's current thinking on photography's relationship to modernism. Swift in the *New York Sun* wrote: "It is not the subjects of these photographs that alone make this little exhibition one of the significant events of the art season. It is the lesson clearly enforced that photography, even without the aid of any manipulation of plates or special arrangement of composition, can represent actualities with something positive and undeniable in the way of expression."[22] J. Edgar Chamberlin observed in the *New York Mail*, "Its purpose is to convince the instructed observer that everything rendered at all by photography is already better rendered by photography than it possibly could be by painting, and that the painters had therefore better devote themselves to subjects and methods which photography cannot touch—to futuristic pictures, in short."[23]

By following Marin's views of the city with a display of his own cityscapes, Stieglitz validated New York as a crucial laboratory for avant-garde experimentation.[24] Three photographs in particular afforded dramatic comparisons with Marin's Woolworth series: *The Flatiron, The City of Ambition,* and *Old and New New York* (pls. 26, 31, 25). As in Marin's works, skyscrapers loom above the viewer, their pinnacles barely contained by the top borders of their respective frames. The snow-covered ground, water, and pavement of Stieglitz's images lead back to labyrinthine middle spaces similar to small structures and other shapes in the foregrounds of

Marin's watercolors. Both artists presented the skycraper not as an impenetrable solid mass but as a transparent, amorphous object interpenetrated and dissolved by natural elements. Whereas Stieglitz, working within the limits of straight photography, achieved his effects by juxtaposing and overlapping the skyscraper with water, trees, smoke, clouds, and sky, Marin was free to transform subjectively the Woolworth tower into a bending, unstable form. Stieglitz's *The Steerage* (pl. 3o) pushes this dialogue even further by demonstrating how the composition of a photograph can be divided, fragmented, and flattened into an abstract, nearly cubistic design. This image of an oceanliner bound for Europe was indicative of Stieglitz's belief that modernism was not an immigrant to America, but rather an immigrant to Europe.[25]

Stieglitz exhibited works with an even greater degree of abstraction at 291 immediately after the close of the Armory exhibition in his installation of Francis Picabia's work, "An Exhibition of Studies Made in New York," 17 March—5 April. Accompanied by a catalogue with a brief explanatory statement by the artist, it comprised sixteen works: two unidentified subjects, two images of the Polish-born Parisian dancer Stacia Napierkowska whom Picabia had encountered on his voyage to America, two renderings inspired by African-American songs he had recently heard in New York, and ten depictions related more directly to Picabia's experience of the city itself.[26]

Picabia publicized his New York series in advance of his 291 opening. He first declared his intention to "impressionize" New York in an interview with Henry Tyrell on 9 February: "...I shall not be here two or three months for nothing. However, I don't make portraits, nor views, nor drawings—I simply equilibrize in color or shadow tones the sensations which those things give me. They are like motifs of symphonic music. Creative art has no business imitating objects. It is meant to give original emotions."[27] By 16 February he was discussing his first New York work in terms that referred to Stieglitz and Marin's cityscapes: "Did I paint the Flatiron Building, or the Woolworth Building, when I painted my impressions of the fabulous skyscrapers of your great city? No. I gave you the rush of upward movement, the feeling of those who attempted to build the Tower of Babel—man's desire to reach the heavens, attain infinity."[28] On 9 March, a week before the premiere of his 291 show and just before the Armory Show closed, three of Picabia's new watercolors were reproduced in the *New York Tribune* mockingly flanked by two small cartoons of children playing with alphabet blocks and jigsaw puzzles (fig. 52).[29]

Introducing works in progress by an artist working at the forefront of modernist experimentation, the Picabia exhibition was characterized as the "very abstract and quintessence of what was new in the bigger show."[30] Picabia's New York work was often dubbed "neo-cubist" or "post-cubist" and represented an attempt

26 ALFRED STIEGLITZ
The Flatiron, *1902*
EXHIBITED AT 291, 1913

to trump cubism's radical advances.[31] As Charles Caffin commented: "The International has closed its doors, but the monster of revolution again rears its head.... And the monster is more aggressive than ever, for these sixteen examples by Francois Picabia ... represent a further departure from the idea of objective representation. Objectivity, though you had to search for it was embedded in the apparently complete abstractions of Picabia's 'Danse a la Source' and 'The Procession; Seville'... but in only one or two of the watercolors now exhibited at No. 291 Fifth avenue, is there any suggestion of objective design.... Picabia renders the impressions he has received of our city in terms that are solely abstract."[32]

Picabia worked on his watercolor series while Stieglitz's photographs were on view at 291. He commented that photography "has helped art to realize consciously its own nature.... The camera cannot reproduce a mental fact. Logically, pure art cannot reproduce a material fact. It can only make real the immaterial or emotional fact. So that art and photograph are opposites."[33] More than Marin's Woolworth series with their specific references to a famous New York landmark, Picabia's abstractions clarified the antithetical relationship between the two mediums.[34] Picabia's New York subjects, especially given the artist's status as a leading European modernist, also lent further weight to the earlier claims implicit in 291's Marin and Stieglitz exhibitions that the city was the logical home of avant-garde art.

fig. 52 "A Post-Cubist's Impression of New York," *from* New York Tribune, *9 March 1913*

They reflected Picabia's view of New York as "the cubist, the futurist city. It expresses in its architecture, its life, its spirit, the modern thought. You have passed through all the old schools and are futurists in word and deed and thought."[35]

Yet the unintentioned outcome of the Armory Show was that European modernism received such intense publicity that Americans were blinded to the merits of their own artists. While applauding the organizers' efforts to promote modernism in general, Stieglitz early on had anticipated their failure to demonstrate that modernism's destiny was in the hands of American painters and photographers. Ironically, it was the Frenchman, Picabia, who expressed most succinctly the buoyant message demonstrated by the three exhibitions discussed here: "the best informed man on this whole revolution in the art of painting ... is an American and a New Yorker, Mr. Alfred Stieglitz."[36] 291's influence as a modernist center was evident upon Picabia's return to Paris where his wife, Gabrielle Buffet-Picabia, opened a gallery in emulation of Stieglitz, and later in 1917 when Picabia himself published the periodical *391*.[37]

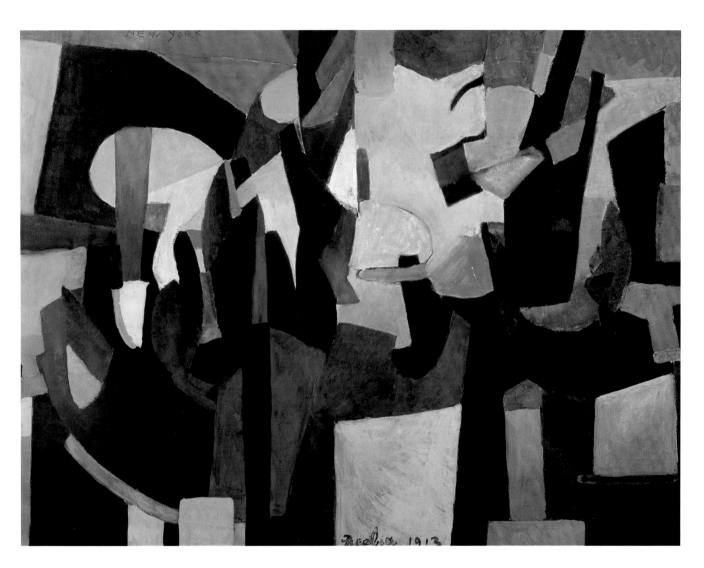

27 FRANCIS PICABIA
New York, *1913*
EXHIBITED AT 291, 1913

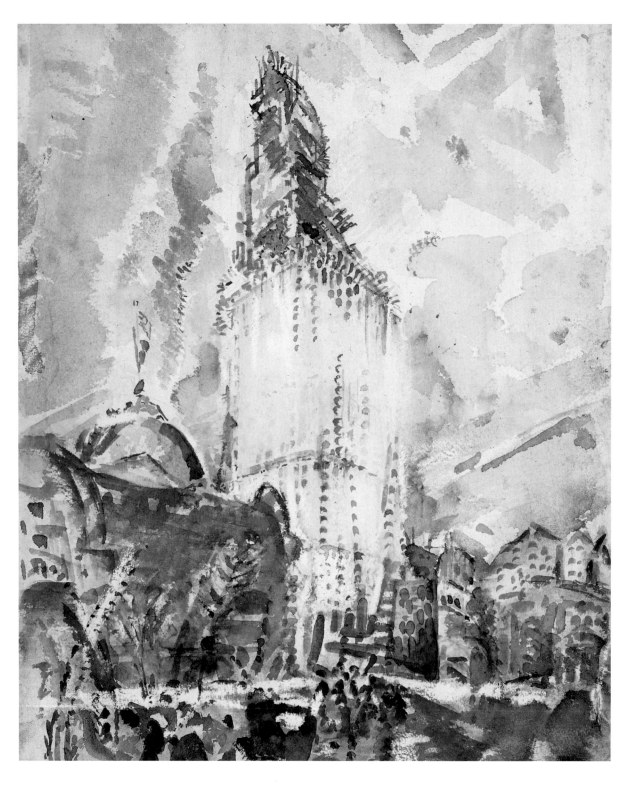

28 JOHN MARIN
Woolworth Building, No. 28, *1912*
EXHIBITED AT 291, 1913

29 JOHN MARIN
Woolworth Building, No. 32, 1913
EXHIBITED AT 291, 1913

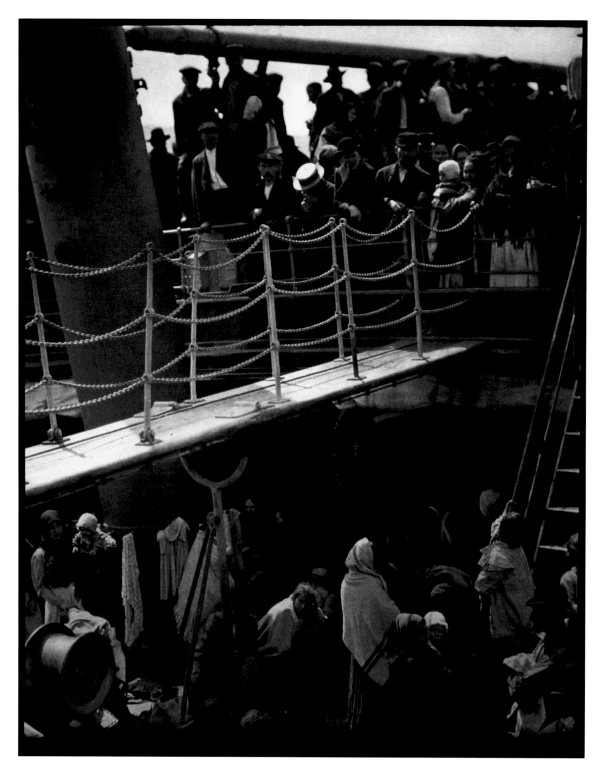

3o **ALFRED STIEGLITZ**
The Steerage, *1907*
EXHIBITED AT 291, 1913

31 **ALFRED STIEGLITZ**
The City of Ambition, *1910*
EXHIBITED AT 291, 1913

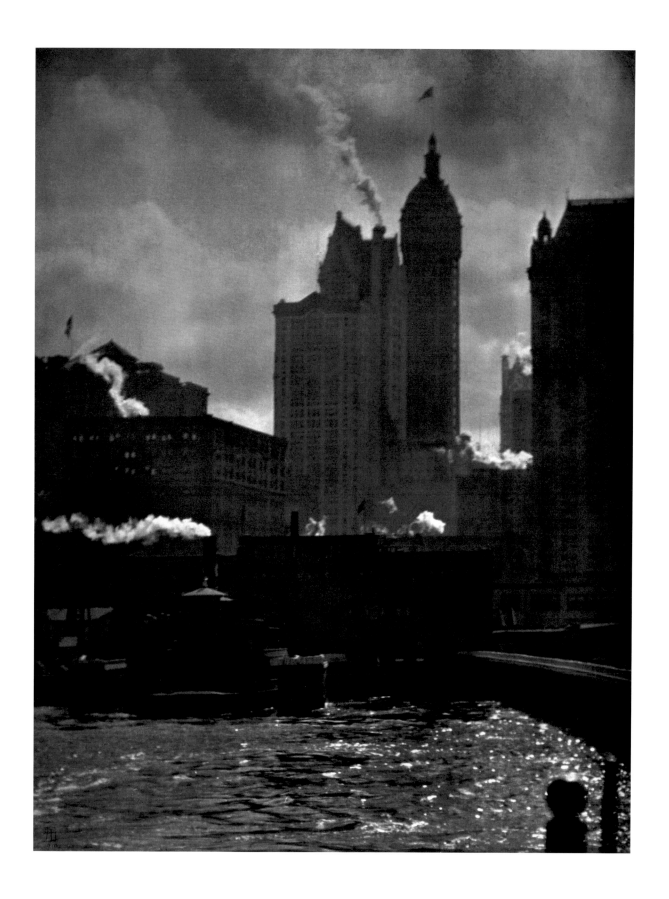

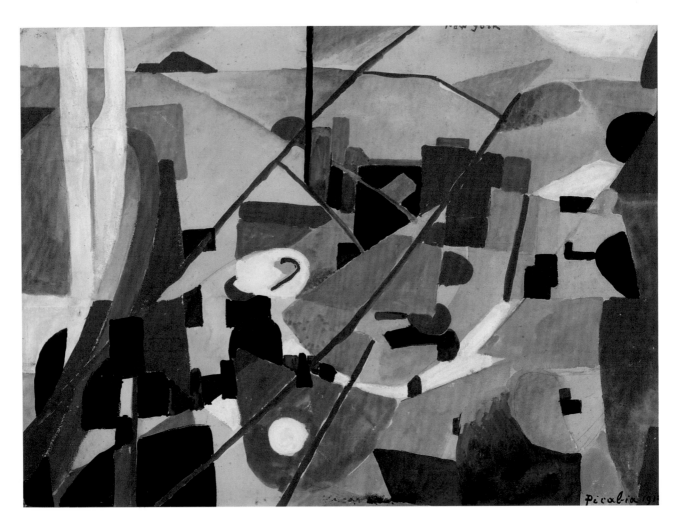

32 FRANCIS PICABIA
New York, *1913*
EXHIBITED AT 291, 1913

33 FRANCIS PICABIA
Star Dancer on a Transatlantic
Liner, *1913*
EXHIBITED AT 291, 1913

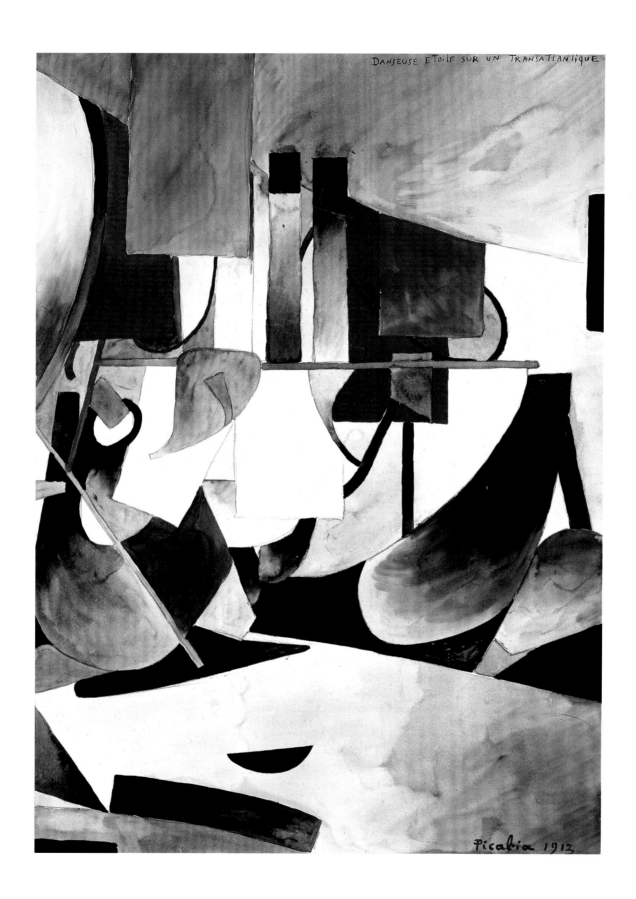

DANSEUSE ETOILE SUR UN TRANSATLANTIQUE

Picabia 1913

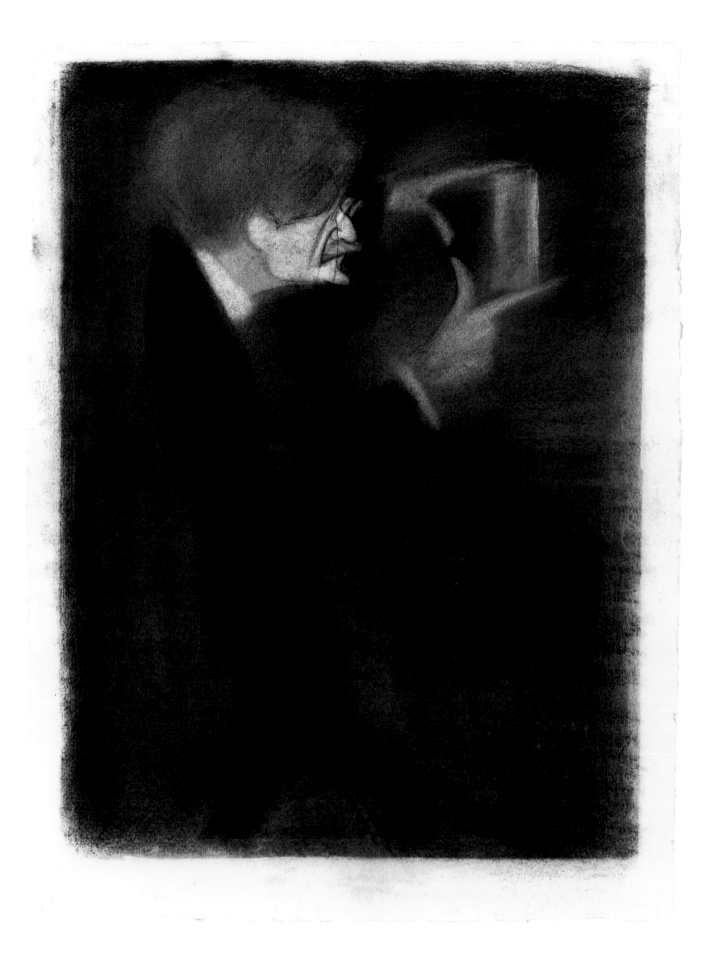

MARIUS DE ZAYAS, 1909–1915

A COMMERCE OF IDEAS

F orced to flee his birthplace in Veracruz, Mexico, because of political unrest, the newspaper caricaturist Marius de Zayas arrived in New York City in 1907.[1] When Stieglitz visited de Zayas' studio that year he immediately insisted that the reluctant young artist exhibit at 291.[2] In January 1909, twenty-five of his charcoal portraits of socialites, performers, and members of the Photo-Secession were installed alongside thirty Autochromes by the photographer and critic J. Nilsen Lauvrik. Enrico Caruso, Diamond Jim Brady, and Stieglitz himself were among those de Zayas portrayed (fig. 53).

The 1909 de Zayas exhibition, the only two-artist exhibition of drawings and photographs ever held at 291, is usually characterized as less important than his 1913 show of more radically abstract caricatures, but was in fact a seminal event. By juxtaposing de Zayas' physiognomic distortions to the versimilitude of Lauvrik's work it significantly advanced the dialogue between abstraction and photography that Stieglitz had initiated at the gallery in 1908. De Zayas' caricatures of his fellow artists also constituted an important early chapter in the history of experimental portraiture in the Stieglitz circle that culminated in the late teens and 1920s with Picabia's mechanomorphic images, Stieglitz's O'Keeffe series, Dove's collages, and Demuth's portrait posters.

The second de Zayas exhibition at the Photo-Secession Gallery was a panorama of New York's social elite promenading up and down Fifth Avenue composed of six- to twelve-inch-high cardboard cutouts arranged on a small, makeshift stage. One of the most popular exhibitions ever mounted at 291, it drew thousands of visitors and

fig. 53 **MARIUS DE ZAYAS**
Alfred Stieglitz, *c. 1909*
charcoal
Katharine Graham
EXHIBITED AT 291, 1909

became the talk of the town during its extended run from from 26 April to November 1910. Stieglitz, identified primarily by his signature shock of hair, was placed near the center of the composition with his back turned to the viewer, carrying a portfolio and briefcase while the other participants strolled past in profile.[3]

In October 1910 de Zayas traveled to Paris where he began exploring the most radical tendencies of European modern art. His year-long stay in the French capital confirmed the importance of Stieglitz's work at 291. He credited the Photo-Secession for preparing him "to see with open eyes"[4] the Salon d'Automne of 1910 and wrote that "the 'Little Galleries'... appear bigger than many of the colossal rooms of the Louvre.... there is not such an institution here or anywhere else that would approach it."[5] Any doubts de Zayas may have harbored about Stieglitz's battle to establish a modernist vision in America were dispelled; he became a convert to the cause: "I am convinced that if the Secession has changed route you certainly are the man, the only man I know of, who can take it to a safe port. As we are not working for today, nor for tommorrow, nor for ourselves, but for all times, and for everybody, I hope that in order that your work would be complete, you would be able, now that you have realized a big idea, to find men who will construct it doing what you have done, so it will exist for 'secula seculurom.'[6]

In Paris de Zayas helped organize the ambitious display of Picasso's drawings that was sent to 291 in early 1911 and sowed the seeds of the 1914 African art show and his later experiments in abstract portraiture.[7] He also emerged as the Photo-Secession's most important interpreter and critic of modern art movements when his first two articles were published in *Camera Work*.[8] Now keenly aware of the significance of developments in Europe, de Zayas advised Stieglitz that Paris is "where you have to get all your ammunition for your future fights."[9]

In part because of ill health, de Zayas spent the next two and a half years in New York. From the fall of 1911 until spring 1914, he achieved a new level of maturity as a theorist. In 1912 he provocatively claimed "Art is Dead," because the culture of religious faith necessary for its survival no longer existed; vanquished by science and doomed to rummage through history for what cannot be found in the present, the contemporary artist was fated to be "an eclectic in spirit and an iconoclast in action."[10] De Zayas perceived the modern artist as a casualty on an evolutionary path that moved away from the abstract and the imaginative toward the factual representation of form epitomized by photography: "I believe that the influence of Art has developed the imagination of man, carrying it to its highest degree of intensity and sensibility, leading him to conceive the incomprehensible and the irrepresentable. No sooner had the imagination carried man to chaos, than he groped for a new path which would take him to that 'whither,' impossible to conceive, and he found pho-

tography. He found in it a powerful element of orientation for the realization of that perfect consciousness for which science has done and is doing so much, to enable man to understand reason, the cause of facts—Truth."[11]

In de Zayas' scheme, the photographer who expressed "pure objectivity"[12] was closely aligned with the true scientific spirit of the age, an ideal he believed Stieglitz embodied: "Stieglitz has begun with the elimination of the subject in represented Form to search for the pure expression of the object. He is trying to do synthetically, with the means of a mechanical process, what some of the most advanced artists of the modern movement are trying to do analytically with the means of art."[13] De Zayas thought that the role of the artist as a skilled translator of subjective emotion was an anachronism that would be ultimately displaced in the modern era by theorists and experimenters like Stieglitz in search of objective truths; the most advanced artists of his day were scientists in training.[14]

Entitled *An Exhibition of Caricatures, Absolute and Relative*, de Zayas' third and last show at 291 in the spring of 1913 reflected his scientism. In the catalogue text he outlined the distinction, derived from "experimental analysis," between absolute and relative works: "I call absolute caricatures those in which the individual influences time by the whole of his actions; and relative, those in which time influences the individual—that is to say when the individual has to make abstraction of his real self to adapt it to the character of a given moment of circumstance."[15] He believed that spirit could be represented mathematically by "algebraic formulas" and that matter could be represented by "geometrical equivalents." Moreover, de Zayas found that "man in relation to his own life and to mankind, forms a third psychological entity, which is not an arithmetical addition, but a chemical combination."[16]

De Zayas' efforts to arrive at a new scientific approach to portraiture were most evident in the caricatures with strong geometric features inscribed with mathematical equations such as those of Stieglitz, Agnes Ernst Meyer, Paul B. Haviland, and Picabia (figs. 54–57). All four translated the distinct physical features of their subjects into geometric arcs and lines. For example, Stieglitz's mustache is encoded in the triangular form composed of parallel diagonal lines in the lower left corner of his portrait, and his intense glare and glasses are represented by the two dark circles at the center of the composition. Douglas Hyland has also suggested that the complexity of the algebraic formulas in the portraits corresponds to the complexity of the subject's intellect,

fig. 54 MARIUS DE ZAYAS
Alfred Stieglitz, c. 1913
charcoal
The Metropolitan Museum of Art, Alfred Stieglitz Collection, 1949
EXHIBITED AT 291, 1913

fig. 55 MARIUS DE ZAYAS
Agnes Meyer, *c. 1912*
charcoal
The National Portrait Gallery, Smithsonian
Institution, Collection of Anne Meyer
EXHIBITED AT 291, 1913

fig. 56 MARIUS DE ZAYAS
Paul B. Haviland, *c. 1913*
charcoal
Albright-Knox Art Gallery, Buffalo, New York,
James G. Forsyth and Charlotte B. Watson Funds
EXHIBITED AT 291, 1913

with Stieglitz and Meyer possessing more inquisitive and theoretical natures than Haviland and Picabia.[17] De Zayas further related that the inspiration for the Stieglitz portrait was a soul-catcher from Pukapuka, or Danger Island, he had seen at the British Museum in 1911, indicating that very specific sources, just as they have been for Picabia's machine images, may yet be found to explain the motifs in his other caricatures.[18]

The most radical works from the 1913 show have traditionally been identified as "absolute" caricatures, but the opaque nature of de Zayas' terminology makes it difficult to categorize with complete certainty any of the eighteen items displayed as either "absolute" or "relative." Yet by interjecting, however obtusely, the concerns of science and mathematics, de Zayas succeeded in substantially broadening and complicating the notion of what a modern portrait could be.

Traveling on commission from *Puck* magazine to portray contemporary European artists and writers, de Zayas reengaged the French modernists when he returned to Paris in May 1914. Through Picabia, de Zayas soon met Apollinaire and a series of projects was initiated.[19] In July de Zayas' caricatures of the French poet (fig. 58), Stieglitz, Picabia, and the dealer Ambroise Vollard appeared in Apollinaire's avant-garde magazine, *Les Soirées de Paris*.[20] De Zayas, Apollinaire, Picabia, and the

composer Alberto Savinio also began collaborating at this time on *À quelle heure un train partira-t-il pour Paris?*, a pantomime.[21] In addition, tentative plans were made to exhibit Apollinaire's *calligrammes*, poems shaped like their subjects, at 291. These various activities were indicative of the close relationship between de Zayas' work and the principles of simultanism then being promulgated by Apollinaire; just as the *calligrammes* conflated image and text, de Zayas' caricatures conflated the mathematical equation with the portrait, stimulating a variety of simultaneous physical and intellectual sensations.[22]

De Zayas' intention in entering Apollinaire's circle was not to defer to the Frenchman's leadership, but rather to bolster the Stieglitz circle's claim for the primacy of New York and 291 as the epicenter of the avant-garde. He was careful to include Stieglitz's caricature along with his depiction of Apollinaire in the July 1914 issue of *Les Soirées de Paris*, and the pantomime and the 291 *calligrammes* show were slated to be New York events.[23] De Zayas wrote that "in all our excursions we make propaganda for '291' and 'Camera Work' "[24] and assured Stieglitz that he was working hard to make the French understand "the convenience of a commerce of ideas with America."[25]

The outbreak of World War I in Europe in August 1914 helped to shift the center of the art market and the avant-garde from Paris to New York. On 12 September

fig. 57 **MARIUS DE ZAYAS**
Francis Picabia, as published in "Les Soirées
de Paris" *(July 1914)*, *398*
EXHIBITED IN CHARCOAL AT 291, 1913

fig. 58 **MARIUS DE ZAYAS**
Guillaume Apollinaire, as published in "Les
Soirées de Paris" *(July 1914)*, *378*

de Zayas returned to the United States "with all the honors of the war" in tow including nearly forty works from the collections of the Picabias and the African art dealer Paul Guillaume. These would figure prominently in the 1914–1915 season at 291.[26] He wrote to Stieglitz: "I left France and specially Paris in a very bad condition. Since the war started it seemed that all intellectuality had been wiped out. I believe that this war will kill many modern artists and unquestionably modern art. It was time otherwise modern art would have killed humanity. But what satisfies me is that at least we will be able to say the last word."[27]

With the field now open for New York to assume the leadership of the modernist movement (if only in a valedictory role), de Zayas felt that the Photo-Secession needed urgently to define its agenda more clearly. To that end he helped to conceive two new projects: the periodical *291* and the exhibition space known as the Modern Gallery.[28] Stieglitz, Agnes Meyer, and Paul Haviland backed the periodical, issuing twelve numbers between March 1915 and March 1916. In sharp contrast to the restrained typography and layout of *Camera Work*, the official Photo-Secession periodical *291* was large and bold, deriving from Apollinaire's typographical experiments and drawing upon the Italian futurists' mimicry of commercial advertising. De Zayas thus clarified the identity of the Photo-Secession, transforming it from something that he perceived as nebulous into something more clearly and aggressively modern. While a broad catholic range of opinions could be found in the pages of *Camera Work*, *291* firmly established an insistently contemporary style. Proclaiming a diagrammatic, modern machine aesthetic, de Zayas' cover design for the first issue of *291* showed Stieglitz's body transformed into a camera with a black rectangle representing the box and a black triangle its bellows. Inscribed "291 throws back its forelock," it conveyed a positive, virile image of Stieglitz as a photographer who had "married Man to Machinery" and "obtained issue" (pl. 34).[29]

In the July issue of *291* de Zayas observed: "America has not the slightest conception of the value of the work accomplished by Stieglitz. Success, and success on a large scale, is the only thing that can make an impression on American mentality. Any effort, any tendency, which does not possess the radiation of advertising remains practically ignored."[30] Designed to remedy this neglect and mirroring the relationship between the *291* magazine and *Camera Work*, the Modern Gallery, supported primarily by Eugene and Agnes Meyer, was conceived as a bigger and more blatantly commercial undertaking than the Photo-Secession Gallery: "We have already demonstrated that it is possible to avoid commercialism by eliminating it. But this demonstration will be unfertile unless it be followed by another: namely, that the legitimate function of commercial intervention—that of paying its own way

fig. 59 ALFRED STIEGLITZ
Marius de Zayas, *1915*
platinum print
National Gallery of Art,
Washington, Alfred Stieglitz
Collection

while bringing producers and consumers of art into a relation of mutual service—
can be freed of the chicanery of self-seeking."[31]

The Modern Gallery opened in October 1915 as "an additional expression of
'291,'[32] but the cooperative arrangement between the two galleries, as reported in
Camera Work, was soon terminated: "Mr. de Zayas, after experimenting for three
months on the lines contemplated, found that practical business in New York and
'291' were incompatible. In consequence he suggested that '291' and the Modern
Gallery be separated. The suggestion automatically constituted a separation."[33] The
new gallery's exhibitions featured an impressive array of African art and major
works by Braque, Picabia, Picasso, and Brancusi that, as had been envisioned, often
constituted larger, more comprehensive versions of shows held earlier at 291. How-
ever, de Zayas (fig. 59), who had hoped to offer financial assistance to many of the
artists in France impoverished by the war, proved to be no more effective at selling
modern art than Stieglitz. After the demise of 291 in July 1917, the Modern Gallery
closed in April 1918.

While *291* and the Modern Gallery have been seen as a radical response by
Stieglitz's younger admirers to his supposed inertia and conservatism around 1915,
they can more precisely be understood as experiments that took Stieglitz as their
willing subject. Orchestrated primarily by de Zayas, their purpose was not necessarily

to usurp Stieglitz's role but to explain more clearly the nature of 291 and modernism in America. Like de Zayas' many portraits of Stieglitz, the magazine and the gallery sought to lay bare the true shape and measure of his character and vision.

Because 291 and the Modern Gallery represented the type of experimentation and criticism that Stieglitz had long advocated, he encouraged and participated in de Zayas' ventures. The strategy of opposing the status quo with blunt, dialectical counterattacks was Stieglitz's own. He had tried previously to make his role the subject of closer scrutiny in the issue of *Camera Work* devoted to the question "What is 291?,"[34] and in the protracted negotiations with de Zayas that preceded the founding of the Modern Gallery he had always invited "Absolute, brutal, frankness."[35]

By articulating in the strongest terms modernist and commercial agendas, 291 and the Modern Gallery often threw Stieglitz's belief in art's spiritual value, rooted in his symbolist beginnings, into especially stark relief. Stieglitz's nature was, however, ultimately too multivalent, eclectic, and elusive to be understood solely in relation to the objective standards of science or business with which de Zayas had tried to assess him. As a result, de Zayas' relationship with Stieglitz remained ambivalent and substantially unchanged by the new enterprises. Stieglitz helped to edit and finance the full run of 291 and de Zayas, as director of the Modern Gallery, continued to facilitate exhibitions at gallery 291 like the 1917 Gino Severini show even after the termination of the cooperative arrangement between the two galleries.[36]

In the 1915 "What is 291?" issue de Zayas characterized himself as one of the "cause-and-effect speculators … with whom no wonder remains wonderful, but all things in Heaven and Earth must be computed and 'accounted for.' "[37] Given his affinity for formulas and equations, Stieglitz's complex nature must have caused him some consternation. In attempting a summation he later wrote: "It would be a mistake to think that Stieglitz's purpose and objective was to make people understand modern art…. In Stieglitz's hands modern art had transcendental value. He showed it not only for what it was but for what it could be for the individual to find his own real self…. both the practical and the impractical attitude of Stieglitz helped to land modern art in New York and stay and develop there."[38]

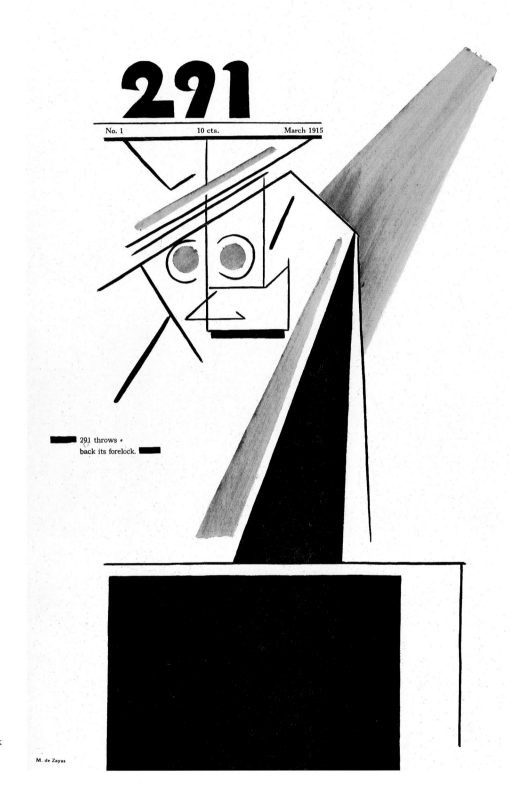

291

No. 1 10 cts. March 1915

291 throws
back its forelock.

M. de Zayas

34 MARIUS DE ZAYAS
291 Throws Back Its Forelock
REPRODUCED IN *291*, NO. 1,
MARCH 1915

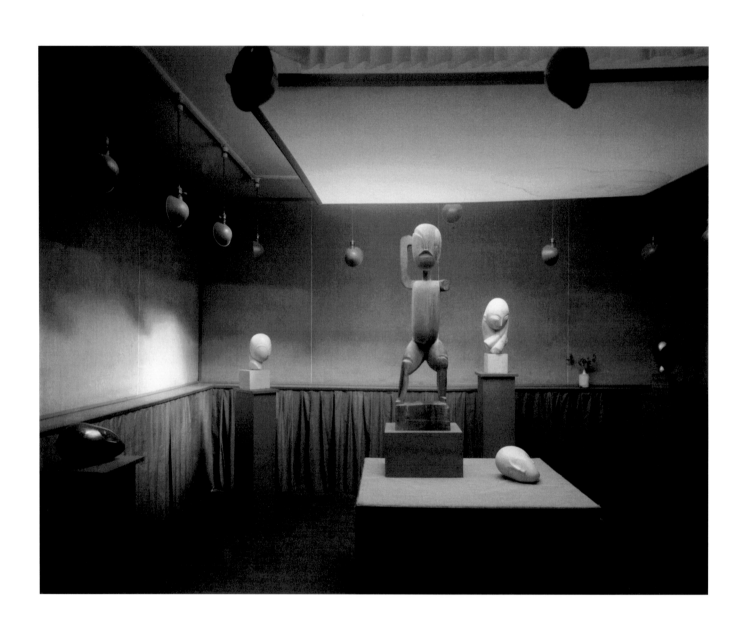

Ann Temkin

CONSTANTIN BRANCUSI, 1914

STARTLING LUCIDITY

C onstantin Brancusi's 1914 exhibition at the Little Galleries of the Photo-Secession was a turning point in the sculptor's career. Today Brancusi is known as the artist who defined the path of modern sculpture, the creator of such twentieth-century icons as *The Kiss*, *Bird in Space*, and *Endless Column*. But in 1914 he had yet to be granted a one-person show, and at home in Paris he had attracted notice only from a few sharp-eyed critics and fellow artists. Brancusi had arrived in Paris just ten years earlier, a Romanian pilgrim to the capital of modern art, equipped with a degree from the National School of Fine Arts in Bucharest. In Paris he had attended the Ecole Nationale des Beaux-Arts and worked briefly for Auguste Rodin. By the end of 1907, however, he had separated himself from the reigning sculptural conventions of verisimilitude and emotional expressiveness. Over the next few years Brancusi would elaborate his distinct sculptural idiom, characterizing figures through gracefully generalized forms and a few signal details.

It was in New York City that Brancusi had achieved the only renown he could claim for this new form of sculpture. At the 1913 Armory Show, where American audiences had received a startling introduction to European modernism, his work had been a sensation. Along with the art of Marcel Duchamp and Henri Matisse, the sculpture of Brancusi was derisively singled out as emblematic of all that was incomprehensible in contemporary art. Although four of his five pieces were plaster—insurance was prohibitive for works in marble or bronze—they were enough to convince the press and the public of his obsession with "eggheads" and "bug-eyes."[1]

35 ALFRED STIEGLITZ
Brancusi Exhibition at 291,
1914

Concurrently with the Armory Show, Brancusi showed three sculptures at the annual Salon des Indépendants in Paris. There his work was noticed by Edward Steichen, the American painter and photographer then living in France and serving as Stieglitz's scout in Europe.[2] The two had met in 1907, when Brancusi was working in Rodin's studio, making sculpture that echoed the master's in its emotionality and naturalistic detail. Steichen was delighted to discover how Brancusi's work had developed, and he purchased the bronze *Maiastra* that Brancusi showed at the Salon. An early version of his signature motif, the bird, the *Maiastra* was installed atop a tall column that Brancusi built for it in Steichen's garden in Voulangis.

How and when Steichen proposed a Brancusi exhibition is not known. It is unlikely that Stieglitz had met the sculptor, although his wife and niece had visited Brancusi while in Paris during the summer of 1913.[3] In the months following the Armory Show, Stieglitz found himself in a vulnerable position. He now stood on the sidelines in an area that he had considered his sole province for almost a decade: bringing European modernism to New York. Stieglitz had tried to promote the new works with care and discrimination, but the Armory Show, he believed, had turned modern art into a circus. Suddenly 291 seemed to have lost its cachet; both sales and reviews for recent shows had been lackluster. A bold move was very much in order.

Correspondence between Brancusi and Walter Pach, an organizer of the Armory Show, suggests that finalization of the 291 exhibition had been relatively sudden. Pach and Brancusi had become friendly in the months before the Armory Show, and Brancusi must have asked his advice about exhibiting with Stieglitz. In a letter written as late as February 1914, Pach discourages Brancusi, criticizing Stieglitz as a weak businessman,[4] but the sculptor had already accepted the invitation.

The sculptures in the exhibition represented a tightly knit cross-section of Brancusi's work of the past three years. They demonstrated the four types of female figures that had been the focus of his recent efforts: *Sleeping Muse* and *Muse*, both initially suggested by a portrait head of the Baroness Renée Frachon, and *Danaïde* and *Mademoiselle Pogany*, both inspired by the young Hungarian artist Margit Pogany (pls. 36, 39, 37, 40, 41). All demonstrated the female face as a highly schematized form that suggested certain characteristics without any aspiration to strict realism. *Muse* and *Mademoiselle Pogany* were presented in marble, and *Sleeping Muse* and *Danaïde* were each shown in marble and closely related bronze versions. By exhibiting the same subjects in both marble and bronze, Brancusi demonstrated his conviction that working in a different material utterly redefined a given sculptural form.

Brancusi also sent a bronze *Maiastra*, a close cousin of the work that Steichen owned (pl. 38). Named for the magical bird of Romanian legend, known for its beautiful song and radiant feathers, *Maiastra* was an early example of the more than

fig. 60 **CONSTANTIN BRANCUSI**
Head of a Child, *1914/1915, originally part of*
Prodigal Son (The First Step)
oak
Musée Nationale d'Art Moderne, Centre Georges
Pompidou, Paris, Brancusi Bequest, 1957

thirty birds he would carve and cast during his career. The corre-spondence indicates that Brancusi and Steichen had agreed that a marble *Maiastra* would be exhibited as well, but in the end the sculp-tor sent only the bronze.[5]

Brancusi's first sculpture in wood, *Prodigal Son,* also debuted in the exhibition. It is sometimes referred to as *The First Step,* the title Brancusi provided in an initial list of works, but in a letter of 13 Febru-ary he asked Steichen to change the name to *Prodigal Son;* in either case, the title applies a traditional Western subject to a form indebted to African art.[6] Like much of Brancusi's wood sculpture of the 1910s, it depicts a full figure, whereas his marbles and bronzes are of the head alone. Photographs and drawings of the sculpture are the only record of its existence, as Brancusi destroyed it after it had returned to Paris. (He also rejected a second version of the same work, suggesting that his dissatisfaction was based on principle rather than mishap.) Brancusi preserved the head, however, and made it an independent sculpture; although made of wood, it is closely in keeping with his other heads of children in marble or bronze (fig. 60).

Brancusi deputized Steichen to take charge of the installation, the first at 291 to consist entirely of sculpture. In the Armory Show, Brancusi's work had been clus-tered atop a rectangular pedestal (fig. 61). At 291, Steichen carefully choreographed

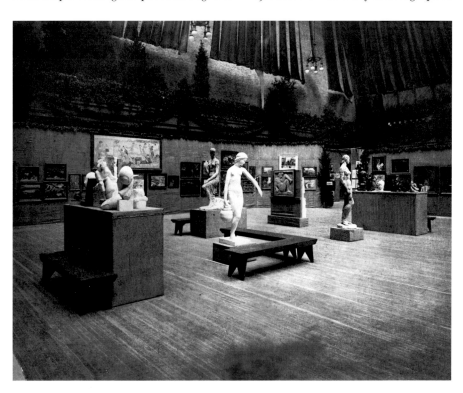

fig. 61 Interior of the 69th
Regiment Armory showing
installation of works by
Brancusi
Archives of American Art, Smith-
sonian Institution, Washington

the placement of sculpture in a presentation known through a photograph by Alfred Stieglitz (pl. 35). This view was one of five "arrangements" at the Little Galleries of the Photo-Secession published in *Camera Work* in 1916,[7] which suggests the importance that Stieglitz attached to Steichen's installation.

The six female heads were distributed in the first room. The objects were placed atop the gallery's narrow columnar pedestals, as Brancusi had not yet devised his practice of pairing a hand-carved oak base with marble or bronze sculpture. The focal point of the exhibition was *Prodigal Son*, which stood on the central table, with the marble *Sleeping Muse* resting nearby. *Prodigal Son* was a perfect foil for the sensuous female heads. The gallery was thus animated by the contrast between elegant, polished surfaces and rough-hewn wood, an effect that would later make Brancusi's wood bases such striking counterpoints to the sculpture above them.

In Steichen's insightful installation, two rooms of 291 presented Brancusi's work in the two ways in which it was equally but differently impressive: in a sensitive ensemble that pointed up the variations and connections between the pieces, and in majestic isolation. The first gallery, as seen in the photograph, explored the former approach, while the second followed the latter. No photographs survive to document the installation in the smaller room, but newspaper reviews indicate that it simply contained *Maiastra*. According to one critic, the bird was "perched atop of a packing box," Steichen's provisional answer to the supporting column Brancusi had built for his *Maiastra* in Voulangis.[8]

Critical response was largely positive, a dramatic reversal from the Armory Show reviews just one year earlier. The June 1914 issue of *Camera Work* reprinted six newspaper articles. An introductory comment by Paul Haviland led the praise: "Never before has an exhibition in the little gallery seemed to be so complete, or the gallery itself so choicely fitted to its contents."[9] Virtually every writer referred to the jokes that had greeted Brancusi's Armory Show debut but noted that there had been admirers all along. Many remarked that the plasters there had not done his work justice. Several critics compared the work to ancient Chinese or Egyptian art to evoke the quality of Brancusi's abstraction or the subtlety of his carving, and even those perplexed by his stylization approved of his technique. As W. B. McCormick wrote in *The New York Press:* "That there is an artist living today who can rival the ancient Chinese craftsmen in sheer perfection of technique is a joyous thing to contemplate, even if that artist does insist on giving us egg-headed, pop-eyed Mlle. Poganys."[10]

The lengthiest and most exuberant review came from a young critic named Henry McBride, newly arrived at *The Sun*. His text initiated what would be an eloquent, lifelong defense of the sculptor's work. In Stieglitz's gallery, McBride wrote,

36 CONSTANTIN BRANCUSI
Sleeping Muse, 1909–1911
EXHIBITED AT 291, 1914

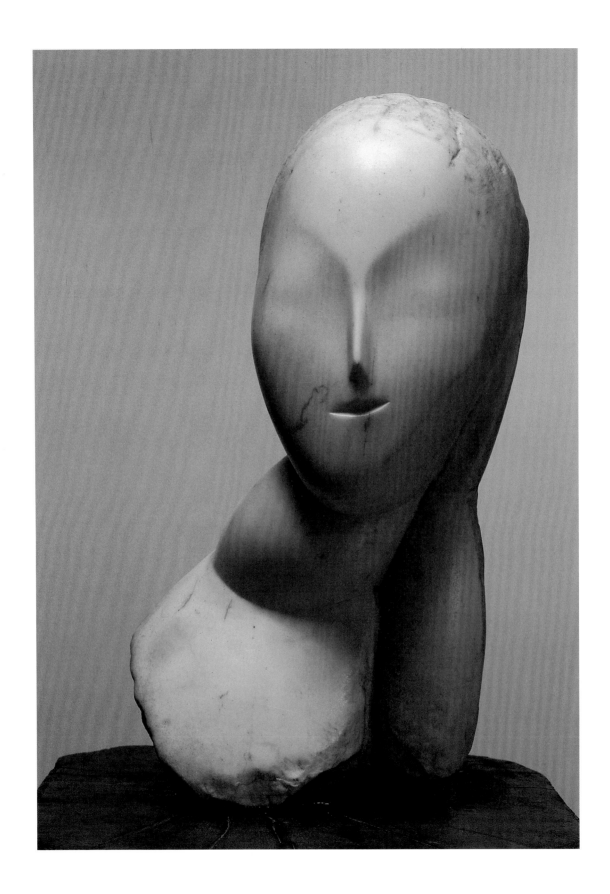

MODERN ART AND AMERICA

"the Brancusi art seems to expand, unfold and to take on a startling lucidity." A fervent advocate of the avant-garde, McBride used the occasion to champion the art of "progress and liberty" and the ambition to explore new problems instead of "the completely solved, tabulated, indexed problems of the long dead past."[11]

The atmosphere behind the scenes is vividly evoked in the surviving correspondence between Brancusi, Steichen, and Stieglitz.[12] Brancusi's letters from Paris reveal him to be understandably anxious on this important occasion. At first he writes only to Steichen, who had left Paris for New York before the sculpture was shipped. A letter dated 13 February, from Brancusi to Steichen, testifies to the warmth of their friendship: the salutation is "Cher vieux," which translates roughly as "Dear old buddy."[13] He ends it with a warm handshake—"recevez un bon poigne de maine tres cordial cher vieux." (As always, the artist's sometimes improvised French includes a few misspelled words.) A few weeks later, Brancusi worries that he is annoying Steichen with his frequent inquiries as to progress, but teases him that, if so, it is Steichen's own fault, as "it's you who asked me to do the exhibition."[14]

Correspondence becomes three-way once the show has opened, and Stieglitz writes the artist to assure him that all is well. Brancusi is much more formal with Stieglitz than with Steichen, carefully reviewing points the dealer made in a prior letter and always adding a typically elaborate French closing. In his letters Stieglitz dealt mainly with matters of business, but he took care always to compliment the artist and to thank him for having allowed them "to live surrounded by your work" for a while.[15]

The correspondence during and after the exhibition introduces several issues that will recur throughout Brancusi's career. The first is the problem of international customs, and the predicament caused when officials confronted objects they did not know how to characterize. On this occasion a customs problem in New York delayed the delivery of the sculpture to the gallery, and the exhibition opening had to be postponed. Brancusi had asked for news of the show in a letter of 20 February, but it did not in fact open until 12 March. The troubles were resolved only after Stieglitz paid twelve hundred francs and promised that Brancusi would sign a form before the U.S. consul in Paris asserting that the sculpture was "personal work and that not more than one original and two duplicates exist."[16] Though temporarily solved, the drama of international art customs would become forever associated with Brancusi when, in 1926, a U.S. customs officer refused to admit that a *Bird in Space* belonging to Steichen was anything more than "a household good." A notorious court trial ensued, and the victory for Brancusi was one of the century's landmark moments in the public reception of modern art.

The confusion of the customs officers centered not only on the unfamiliarity of the objects, but also on the distinction between handicraft and mass production,

37 CONSTANTIN BRANCUSI
Muse, *1912*
EXHIBITED AT 291, 1914

an issue that was important to Brancusi. Because the customs officers did not recognize the objects as what they knew to be sculpture, they ultimately accepted them as art on the basis of their exclusivity. But in cast sculpture, the possibility of creating multiple renditions of a single work leads into a gray area, even for experts. Although Stieglitz had persuaded Brancusi to sign the form stating that no more than "one original and two duplicates" existed of each piece, he subsequently asked Brancusi to make another "duplicate" of *Danaïde* and *Sleeping Muse*.[17] Stieglitz qualified his request with the admission that the present owners would be asked to consent to the "duplicates," but Brancusi recoiled at such terminology. Even when he did make bronze versions of a marble, he wanted to distinguish it from the large editions he had seen produced in Rodin's studio, identical bronzes that the artist's hand may have never touched. Brancusi went to great lengths to explain to Stieglitz that each bronze was a unique work of art, subject to modifications unique to it, perfected in a unique way. But he hesitated to decline Stieglitz's request, and stalled for several weeks before sending a telegram with regrets.[18]

The correspondence also reveals the importance that Brancusi would attach to photography, a point that would not be lost on the two distinguished photographers with whom he was dealing. Later in the 1910s Brancusi would view sculpture and photography as so closely interrelated that he learned to take and develop his own pictures. His photographs would become invaluable in communicating his vision of his art, as well as exquisite works in and of themselves. But even while still employing professionals, as he was in early 1914, Brancusi was aware of the power of the photograph in promoting his work. In February he promised to send Steichen some photographs, saying that they could be used for posters.[19] He also mailed two photographs of the marble *Maiastra* he had withheld, and purely on the basis of these photos Stieglitz later sold the sculpture. On 26 March, Stieglitz, happy with the show's success, asked Brancusi for photographs of his entire oeuvre, presumably to invite further sales. When Brancusi finally sent four photographs a month later, he bemoaned their quality in a comment that prophesied his decision to give up on professional photographers altogether.[20]

The exhibition was a strong financial and critical success. Brancusi set the prices, to which Stieglitz agreed without question (fig. 62). One piece was sold even before the exhibition opened: Arthur Davies, owner of the marble *Torso* that had been in the Armory Show, bought the marble *Sleeping Muse*.

fig. 62 *List of titles and prices for 291 Brancusi exhibition, from a letter of 13 February 1914, Brancusi to Stieglitz*

Brancusi had to explain to Steichen, in a letter of 20 February, that the arrangement had been made through Walter Pach and the money sent directly to Brancusi, and therefore Stieglitz could take no commission on the sale.[21] Davies also bought the marble *Muse* or "Naide." This sale has been a source of confusion, for on Stieglitz's summary statement at the end of the exhibition, he inverted the terms "Naide" and "Danaïde." Whereas he noted that Davies bought the marble *Danaïde*, that work in fact was returned to Brancusi with *Prodigal Son*, the only two pieces in the exhibition that were not sold. The bronze *Danaïde* and *Maiastra* were acquired by Agnes and Eugene Meyer, prominent patrons of 291. The Meyers, in fact, had paid for the shipping and insurance for the Brancusi exhibition. They would become lifelong friends of the artist and owners of five of his works, including a grand, black marble portrait of Agnes (*Portrait of Mrs. Eugene Meyer, Jr.*, 1930–1933, National Gallery of Art, Washington). Stieglitz himself bought the third bronze, *Sleeping Muse.*

Perhaps the biggest breakthrough for Brancusi's career was the interest shown by the lawyer John Quinn, who was to become his greatest patron. In 1914 Quinn was fast becoming the largest collector of modern art in New York, and one of its most powerful advocates. In 1913 he had been the legal counsel to the Armory Show and had successfully effected the bill that permitted tax-free importation of contemporary art. Quinn was both the largest lender to and the largest buyer from the Armory Show, but it wasn't until the 291 exhibition that he bought any work by Brancusi. There, however, Quinn swiftly committed to *Mademoiselle Pogany*, which at six thousand francs was the most expensive object, and also purchased the marble *Maiastra* that Stieglitz offered on the basis of Brancusi's photographs. This latter transaction was the source of the only misunderstanding during the exhibition. In an early letter Brancusi had written that *Maiastra* and its elaborate carved stone base cost two thousand francs together, but he later revised the figure to two thousand francs each. Stieglitz insisted that the original quotation hold firm, and Quinn became the owner of a magisterial ensemble that remains a masterpiece of Brancusi's oeuvre.

The exhibition at 291 was to be Brancusi's only collaboration with Stieglitz. Several of Stieglitz's close associates shared the same doubts about his business acumen that Walter Pach had expressed to Brancusi prior to his exhibition. In a move toward independence, Agnes Meyer, Marius de Zayas, Paul Haviland, and Francis Picabia established the Modern Gallery in 1915. Among Meyer's first initiatives was to persuade her friend Brancusi to exhibit his sculpture at this fledgling venture. From that point on, Brancusi's reputation as one of the masters of modern art was firmly established. Stieglitz's historic exhibition had launched the sculptor on a path that assured him an ever-growing and devoted following of American collectors.

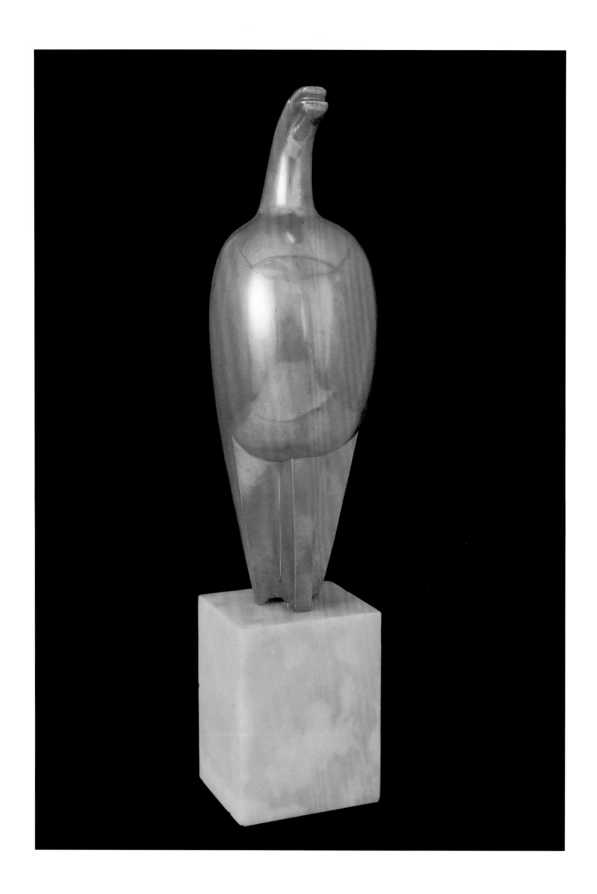

MODERN ART AND AMERICA

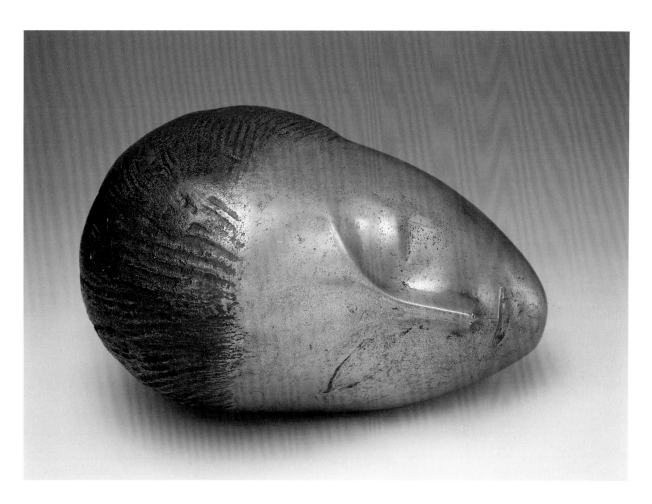

38 CONSTANTIN BRANCUSI
Maiastra (Bird Before It Flew),
c. 1911
EXHIBITED AT 291, 1914

39 CONSTANTIN BRANCUSI
Sleeping Muse, *1910*
EXHIBITED AT 291, 1914

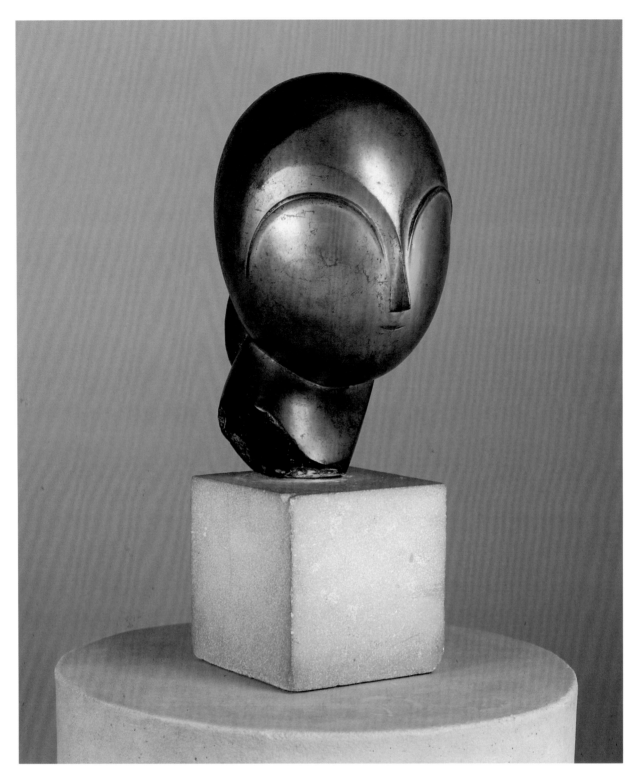

40 CONSTANTIN BRANCUSI
Danaïde, *c. 1913*
EXHIBITED AT 291, 1914

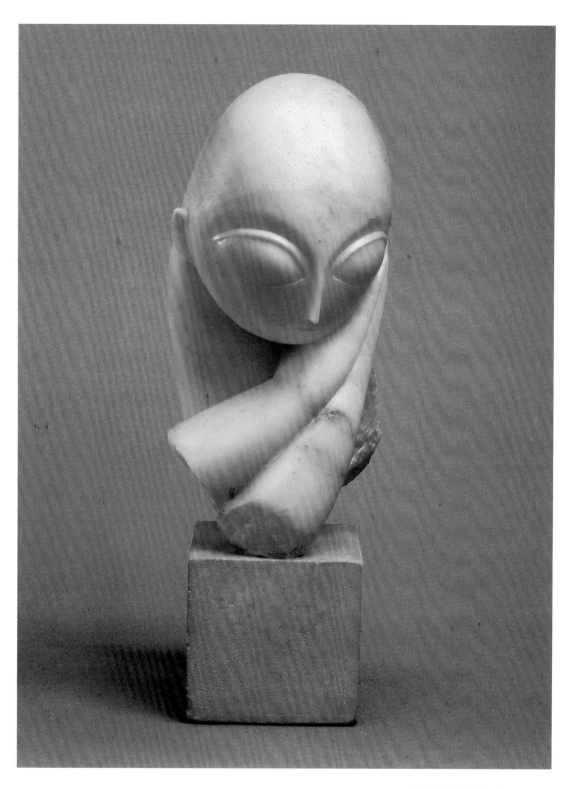

41 CONSTANTIN BRANCUSI
Mademoiselle Pogany, 1912
EXHIBITED AT 291, 1914

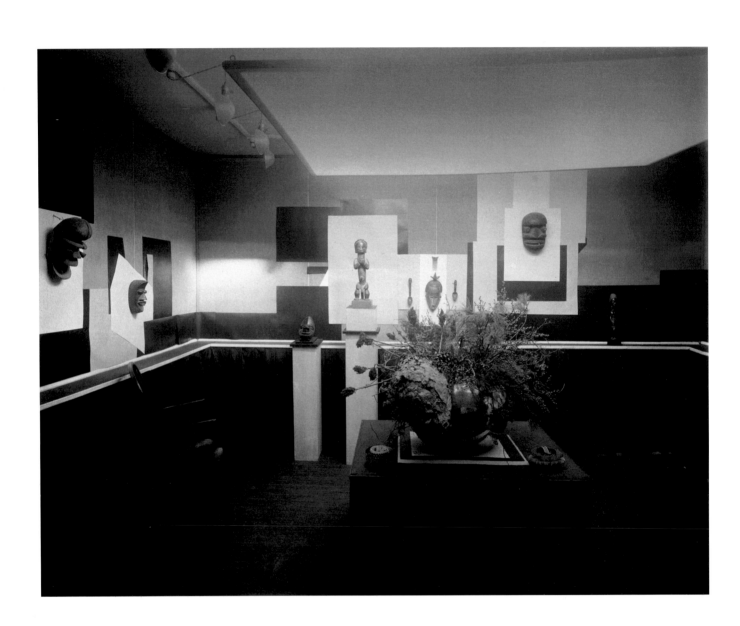

Helen M. Shannon

AFRICAN ART, 1914

THE ROOT OF MODERN ART

I n the June 1914 issue of *Camera Work*, Alfred Stieglitz announced that four photography exhibitions would open the fall schedule at his gallery 291.[1] The show that began the season, however, on 3 November, was something quite different: "Statuary in Wood by African Savages—The Root of Modern Art." This dramatic change of plans indicates Stieglitz's receptivity to the various streams feeding European, especially French, modernism, in this case the interest in so-called primitive arts.

On the announcement card, Stieglitz described the presentation as "the first time in the history of exhibitions that Negro statuary will be shown from the point of view of art,"[2] and this claim is provisionally true. The expression "the point of view of art" distinguishes the exhibition in his avant-garde gallery from those in natural history and ethnographic museums in Europe and the United States. In New York, the only previous showing of African work was at The American Museum of Natural History, which had opened a gallery in 1910 for its Congo collection gathered during a scientific expedition (fig. 63). The densely packed, heterogeneous compendium of swords, shields, baskets, and textiles was typical of the period in its attempt to present the life of "primitive" peoples. The spacious installation at 291, on the other hand, allowed the aesthetic qualities of the sculpture to be studied from various viewpoints.

What Stieglitz terms "Negro statuary" refers to the figurative sculpture that had been of interest to European modernists of the previous decade—artists such as Maurice Vlaminck, André Derain, Henri Matisse, and Pablo Picasso—as they formulated innovative ways of depicting the human face and body.

42 ALFRED STIEGLITZ
Installation of African Art
Exhibition, *1914*
REPRODUCED IN CAMERA
WORK, OCTOBER 1916

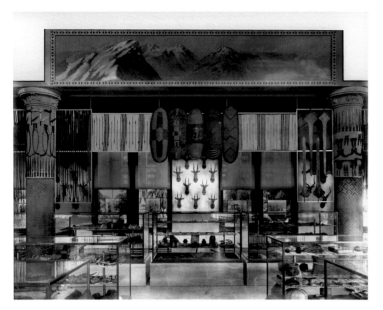

fig. 63 *African Hall, American Museum of Natural History, New York, September 1910*

The claim that this was the first time that African objects were shown in an art setting must also be qualified. Stieglitz may not have been aware of—or chose to ignore—the few African pieces that had been presented the previous spring, along with other examples of art from around the world, in the gallery on Washington Square run by Robert Coady and Michael Brenner.[3] But his installation was indeed the first in the world devoted to African sculpture in an avant-garde gallery. No similar event was organized in Paris until November 1916, when a group of artists showed African and Oceanic sculpture at the Lyre and Palette Club. For many reasons, both planned and fortuitous, 291 became a primary site for the modernist framing of those works now referred to as African art.

"Statuary in Wood by African Savages" was the first of three exhibitions planned to celebrate the gallery's tenth anniversary. The second show, of recent work by Picasso and Georges Braque, opened on 9 December, followed on 12 January 1915 by the paintings of Francis Picabia. When Stieglitz later recalled these exhibitions, he stated that they "brought to a close the definite series of experiments begun at '291' some years ago."[4] Those "experiments" had begun in 1905 when he attempted to position photography as fine art, rather than documentation. In 1908, Stieglitz began to present works in other media by artists who "secede from the photographic attitude toward representation of form,"[5] that is, those who chose abstraction over naturalism. The African sculpture that had been "discovered" by artists in France and Germany in the first decade of the century exemplified these anti-naturalist criteria.

For Stieglitz, the African sculpture was the most significant of the three exhibitions. He mentioned it throughout the fall in correspondence to 291 supporters. To John Marin he related that "De Zayas brought with him some things he had collected abroad for us to show. Above all a very remarkable collection of Negro art. How old these things are no one knows, but they are very very remarkable."[6] To Arthur Dove he reported that "There is a wonderful show on now by Negro savages. It will be open until November 27th. It is possibly the most important show we have ever had."[7]

43 Mask, *We or Bete
people, Ivory Coast, 19th/early
20th century*
EXHIBITED AT 291, 1914

44 Standing Figure with Bowl on
Head, *Bete people, Ivory Coast,
19th/early 20th century*
EXHIBITED AT 291, 1914

Stieglitz himself did not organize these exhibitions. This was done in Paris by Marius de Zayas, the Mexican-born caricaturist who might have been called the gallery's chief curator. Stieglitz's support of the African work, however, was undergirded by his own exposure to modernist primitivism, that tendency on the part of Western avant-garde artists to study non-mimetic styles, represented here by the art of Africa.[8] During a 1909 visit to Paris, on the suggestion of the artist Max Weber, Stieglitz visited the African galleries at the Musée du Trocadéro, the ethnographic museum where Picasso had been shocked by the alien works.[9] The earliest notice of de Zayas' interest in an African show was in 1911, during his year-long stay in Paris. On 11 April, he wrote to Stieglitz, "I remarked more than ever the influence of the african negro art among the revolutionists.... I am convinced once more of the necessity of having a show in the S [States or Secession?] of the negro art."[10] That summer, Stieglitz returned to Paris and was escorted by de Zayas to Picasso's studio, where he undoubtedly was introduced to the painter's study of "primitive art."

By 1911, European modernist primitivism was already well known in New York art circles. Weber and other artists had learned of its impact from classes they took with Matisse in Paris, starting in 1908. In the May 1910 edition of *Architectural Record*, Gelett Burgess published "The Wild Men of Paris," a report of his visit to artists' studios. In his ground-breaking article, Burgess remarked on how "Matisse praises the direct appeal to instinct of the African wood images" and noted Picasso's "sub-African caricatures."[11] Even critics in the mainstream press discussed African influences. In reviewing Picasso's 1911 show at 291, J. Edgar Chamberlin in the *New York Evening Mail* wrote: "These things ... are neo-African. They remind one of nothing so much as of the carvings in ebony or blackened wood, rudely representing the human figure, made by the natives of the west coast of Africa."[12]

Despite de Zayas' early enthusiasm in 1911, no initiative was taken to organize an exhibition until late May of 1914, when he traveled to Paris to arrange for the anniversary season at 291. One explanation for this lapse may have been the difficulty in finding work to exhibit. In the nineteenth century, European museums had imported much African material culture from their colonies, but the United States had no such ties to Africa. Thus, any prospective American dealer had to acquire sculpture from a European source. De Zayas found such a person in Paul Guillaume, who in February 1914 had opened a Paris gallery where he sold contemporary art and *sculptures nègres*. In late May, de Zayas wrote Stieglitz of his discussions with the gallery director: "I believe I can ... arrange an exhibition of remarkable negro statuettes. Guillaume, the art dealer has a very important collection and is willing to let you have them. I have always believed that a show of the art of the negroes would be a great thing for 291. Tell me if you want them."[13]

The French dealer wrote to Stieglitz on 25 May, "I have recently opened a gallery where I propose to show the most interesting of the young contemporary painters.... Moreover, I have a collection of negro sculpture (statuettes and masks).... If you would like to have an exhibition of them in New York, I am at your disposal to discuss that."[14]

On 3 June, Stieglitz related his reaction to this correspondence to de Zayas: "This morning I had a letter from Paul Guillaume.... He says that he would be glad to let us have a show of negro art. Has he really very good things, and what do you think about it? Of course I would like to have a show of Negro art as you know, I want to make the next season at '291' a very live one."[15]

After receiving Stieglitz's approval, de Zayas began research in July, including photographing African art at the Trocadéro. The outbreak of war in early August interrupted his plans, however, and by early September he was forced to return to New York with the works for the three anniversary exhibitions. Guillaume, de Zayas wrote, "was only too glad to let me have all the African sculpture I could put in a trunk and bring to New York."[16] In a letter of 13 September, after he had returned safely to the United States, he wrote, "My dear Stieglitz, We arrived here yesterday at night, not flying but retreating and with all the honors of the war, for I brought with myself the pictures of Picasso, Braque and Picabia that I had promised you for the exhibitions at 291. Also fifteen of the best negro things that have ever been brought to the civilized races (?)."[17]

The exhibition photograph, however, does not show the installation as it appeared when it opened, but rather the reconfiguration by Edward Steichen, who often designed 291 installations on visits from his home in France (pl. 42). In 1963 Steichen related how he came to reinstall the works on view: "When I returned to New York... an exhibition of African sculpture collected by de Zayas was on display.... I asked Stieglitz to let me brighten up that fine exhibition, and he agreed. I bought several reams of yellow, orange, and black sheets of paper. I took all the sculptures down and made an abstract geometric pattern on the walls with the gay-colored papers, then put the sculptures back in place. The whole room came alive, the colored papers serving like a background of jungle drums."[18]

The transformation occurred sometime between Henry McBride's *New York Sun* review of Sunday, 8 November, when he referred to the gallery's signature gray walls, and Forbes Watson's Saturday, 14 November, column in the *New York Evening Post*, in which he noted the "setting of crude and violent color."[19] The colored papers remind us that this was not yet the modernist white-box gallery. In a 1990 article, Ralph Harley Jr. produced a colorized version of the photograph, adding orange, yellow, and black to the walls.[20] My reading of the tonal gradations in the black-and-white

45 Spoon, *Guro or Bete people,*
Ivory Coast, 19th/early 20th century
EXHIBITED AT 291, 1914

46 Spoon, *Ivory Coast,*
19th/early 20th century
EXHIBITED AT 291, 1914

fig. 64 ALFRED STIEGLITZ
A Fang Male Reliquary
Figure, *1914*
De Zayas Archives, Seville

photograph suggests that there were several shades of orange and yellow. It is possible that these colored papers alluded to Picasso's palette during his Negro period of 1907–1908, which Steichen would have known from his years in Paris. The Spanish artist's *Bathers in a Forest* (1908; pl. 52) illustrates his use of varying shades of oranges, yellows, blacks, and grays. The "abstract geometric pattern" of the papers in overlapping horizontal, vertical, diagonal, and trapezoidal forms suggests Picasso's later analytical cubist phase, represented by the fractured figure and background of his *Standing Female Nude* (1910; fig. 41). Stieglitz had bought this drawing for his own collection out of the 1911 Picasso show and published it three times in *Camera Work* between 1911 and 1913.

While the backdrop of colored papers reprised Picasso's styles, Steichen's innovative placement of some works, either consciously or unconsciously, approximated their original expressive function in Africa. The We and Bete masks on the far left (pl. 43) and far right (Côte d'Ivoire) were made to intimidate malevolent forces. By raising them to eye level, a direct physical and emotional impact between the object and the viewer is provoked. The non-threatening Baule sculpture (Côte d'Ivoire), on the shelf at the extreme right, was placed below the viewer's line of sight. This figure is a spirit spouse, a flattering representation of the mate that the Baule believe each person had before birth.

The placement of other works may also have been influenced by Steichen's response to them. It is this interaction with figurative sculpture that marks the Western avant-garde reception of African art. The statue on the pedestal in the center of the wall from the Fang people (Gabon) (fig. 64) served as a guardian for spiritually potent ancestral remains. Although the high placement makes its hands appear to be raised in offering, the figure is actually holding a container of powerful ritual substances that helped protect ancestors and their descendants. The mask on the left pedestal and the second mask on the left wall of the We people (Côte d'Ivoire), not as exaggerated as the previous two, have been placed in less confrontational positions. Similarly, the Baule portrait mask in the middle of the facing wall, with its delicate features, is also on a lowered sight line. It is flanked by two spoons and surmounted by a comb. This arrangement retains vestiges of the decorative, symmetrical design schemes of the colonial museum. This mix of the vocabulary of Victorian ethnographic museums and the new modernist aesthetic of 291 reveals the transitional nature of this art world moment.

Research has uncovered more photographs of works connected to "Statuary in Wood," presumably also shot by Stieglitz. In one (fig. 65), three works stand in front of what appears to be another wall papered by Edward Steichen. On the left is a Guro (Côte d'Ivoire) mask (pl. 49); on the right is an Akye (Côte d'Ivoire) figure, used in

funerary rituals. Between them is a rare Bete or Guro sculpture, perhaps a pestle for ceremonial use. In another image (fig. 66), the same work replaces the Baule mask between the two spoons, suggesting an experimental rearrangement of the objects.[21]

Critics had strong reactions, both positive and negative, to the exhibition. Everyone understood that Stieglitz was offering textbook examples of the dramatic influence that African art had on the European avant-garde. Elizabeth Luther Carey, in *The New York Times*, declared that "the Post-Impressionist and the Congo savage have much in common, as the exhibition of African carvings at the Photo-Secession Galleries clearly demonstrates," and the writer in *The New York World* wrote that "Extremes meet when the advanced art radicals of today hark back to the weird wood carvings of Congo and Ivory Coast negroes."[22]

The most denigrating review was by Watson, of the *New York Evening Post*, who wrote that "In the case of these exhibits it was not necessary to explain that they are savage. Savage indeed! The rank savor of savagery attacks the visitor the instant he enters the diminutive room. This rude carving belongs to the black recesses of the jungle. Some examples are hardly human, and are so powerfully expressive of gross brutality that the flesh quails."[23]

Others saw more redeeming qualities. Chamberlin, in the *New York Mail*, wrote: "We do not think of the wild African tribes as great sculptors, but this exhibition ... proves that they are real artists, expressing a definite idea with great skill—inherited, traditional skill. Their use of the rich dark wood of Africa, the exquisite,

almost unbelievable beauty of the patina they put on these wood sculptures, are [sic] remarkable. Forms are rude and conventional, but the expression is quite as successful as that of the archaic Greek sculptures."[24]

Some writers, leery of the current art trends, placed the African works on a higher aesthetic level than that of the European avant-garde. The writer in *The New York World* argued that "the French apostles have a long road to travel before they can get within hailing distance of their African precursors."[25] Chamberlin stated that "enamored by their success, Picasso has adopted their limitations—and produced a merely curious, not an admirable, result, like the negroes."[26]

Pablo Picasso was more favorably matched with African sculpture during the next exhibition at 291. Two photographs exist that are usually identified as documents of the Picasso-Braque installation that opened on 9 December. In one (pl. 51), two works by Picasso are shown with a reliquary figure of the Kota people (Gabon), as well as a wasps' nest and an empty brass bowl.[27] Of six reviews and notices in newspapers, an art magazine, and *Camera Work*, no critic or writer, not even Stieglitz himself, mentions the presence of the African sculpture or the nest.[28] It is difficult to believe that less than two years after the widespread uproar over the radical art at the Armory Show, no one would have acknowledged the presentation of these atypical objects in a gallery as if they were "art." The reason, perhaps, is that this is not an installation photograph, but a posed composition never seen by the critics or the general public.

Visual elements within the photographs also point to this conclusion. The Picassos, for example, are not attached to the wall but rather lean on the ledge. The stand for the wasps' nest, an unpainted pedestal topped by a box with a piece of paper or cloth attached to its front, has the same temporary quality. Furthermore, the brass bowl is empty; in every other 291 photo it is filled with dried vegetation.

Finally, this image by Stieglitz seems too studied to be a documentary shot. Unlike typical installation photographs that often have a compressed sense of space to accommodate the maximum number of works in the image, these five objects are methodically placed to give the best view of each. The ceiling scrim echoes the overlapping rectangular shapes under the brass bowl, which were probably the colored papers that Steichen had used in the African show. Even the hanging lamp shades that clutter earlier gallery views have been eliminated, creating a less distracting image. This photograph has the plenitude and closure of a designed composition. How did it come to be made?

These objects appear to have been deliberately brought together to illustrate the defense of modernism propagated by the Stieglitz circle. The person who wrote the most about these ideas was de Zayas. In "Modern Art—Theories and Represen-

tations," published in *Camera Work* in March 1914, he declared that "Modern art is analytical.... It proceeds toward the unknown, and that unknown is objectivity. It wants to know the *essence* of things; and it analyses them in their phenomena of form, following the method of experimentalism set by science." Objectivity "culminates, so far as related to plastic representation by man, in Photography."[29]

This image, then, arranged by Stieglitz, de Zayas, perhaps Steichen, and others to test avant-garde theory, documents not an exhibition, but the idea that form is the subject of modern art, exemplified by photography. Every piece in the image interacts synergistically. The crescents and angular shapes of the Kota figure (pl. 50) find echoes within the two drawings. The half-moon at the bottom of *Violin* (pl. 58) inverts the same form at the top of the sculpture; the sharp angle that peaks at the upper right of the drawing has resonances with the diamond shape of the wooden figure. The calligraphic quality of the branches that hold the nest has parallels with the linear marks drawn by Picasso. The shape of the nest itself is oval like the face of the African sculpture.

The presence of the wasps' nest also suggests that the basis for comparison was not just form, but also material. The nest's fabric of masticated wood fiber— the constituent parts of paper—would have been similar in color and texture to the newsprint used in the collage *Still Life: Bottle and Glass on Table* to the left of the photo. The brass bowl may have been emptied to emphasize its material, the same as the copper and brass sheets covering the Kota figure.

The act of bringing these disparate objects together as equals became an exercise in canon reformation. Modernism challenged traditional modes of artistic production, including subjects, styles, materials, and sources. In Stieglitz's photograph, the aesthetic hierarchy that had ranked the "high" art of Western painting and drawing, the "low" art of Western crafts and design, the even lower level of "savage" works, and a natural object made by insects, has collapsed to the same democratic level.

The search for modernist primitivism in American art has focused primarily, as in European art, on its manifestations in painting, sculpture, and other traditional media. However, in the United States the encounter with African art produced a different result. By 1914, the same types of works that had disquieted modernists in France and Germany entered 291 already validated as aesthetic objects, framed within a more distanced, "objective," formal view. While a source for artists of all media, the sculpture at Stieglitz's gallery may have had its most immediate innovative impact on the development of American modernist photography. Stieglitz's clouds and Paul Strand's bowls and fences could count their genesis in the Negro statuary at 291.

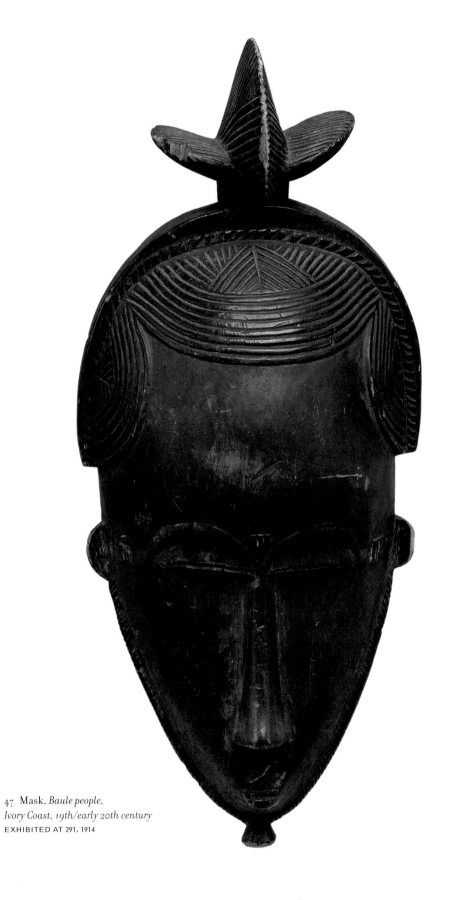

47 Mask, *Baule people,*
Ivory Coast, 19th/early 20th century
EXHIBITED AT 291, 1914

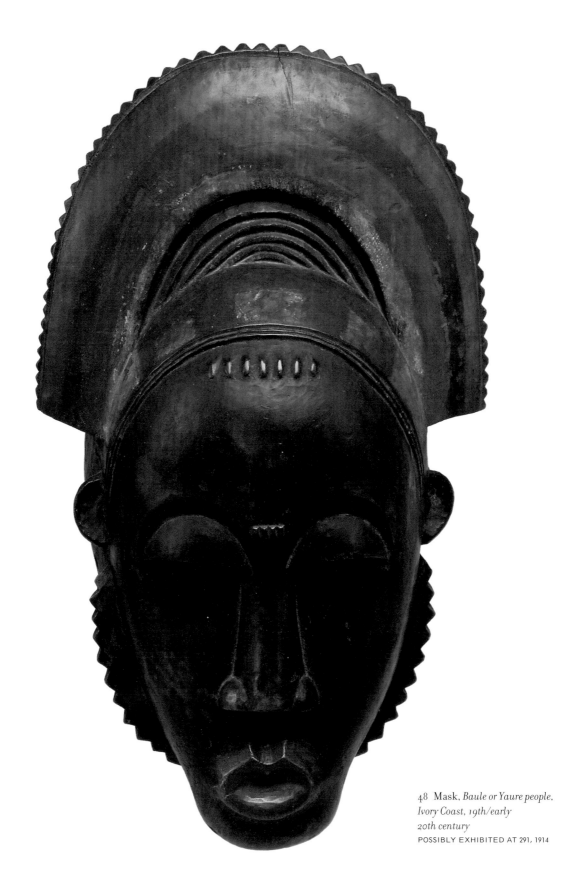

48 Mask, *Baule or Yaure people,*
Ivory Coast, 19th/early
20th century
POSSIBLY EXHIBITED AT 291, 1914

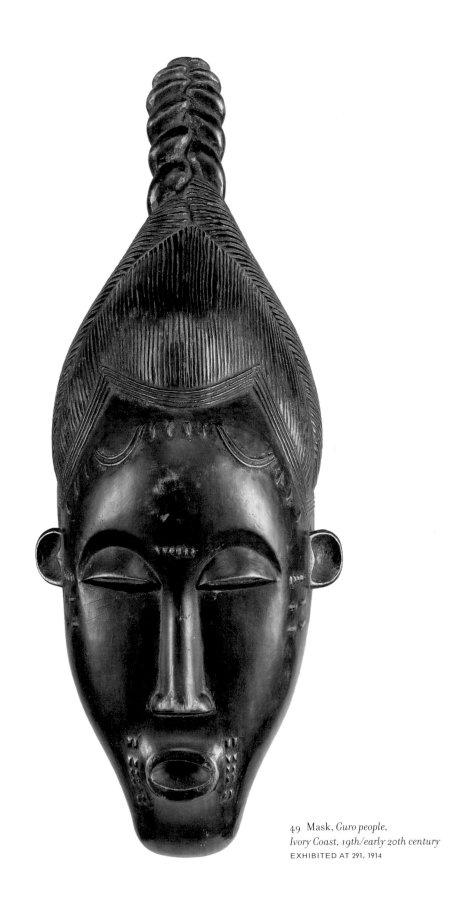

49 Mask, *Guro people,*
Ivory Coast, 19th/early 20th century
EXHIBITED AT 291, 1914

MODERN ART AND AMERICA

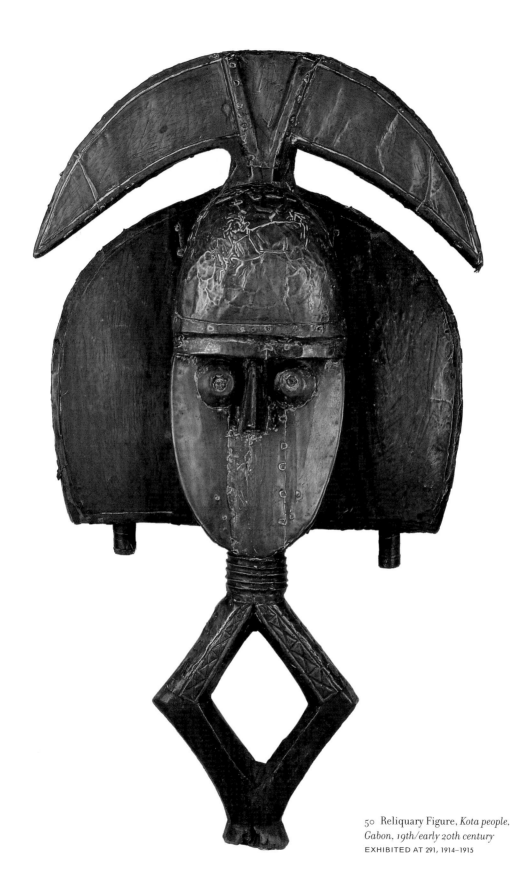

50 Reliquary Figure, *Kota people,*
Gabon, 19th/early 20th century
EXHIBITED AT 291, 1914–1915

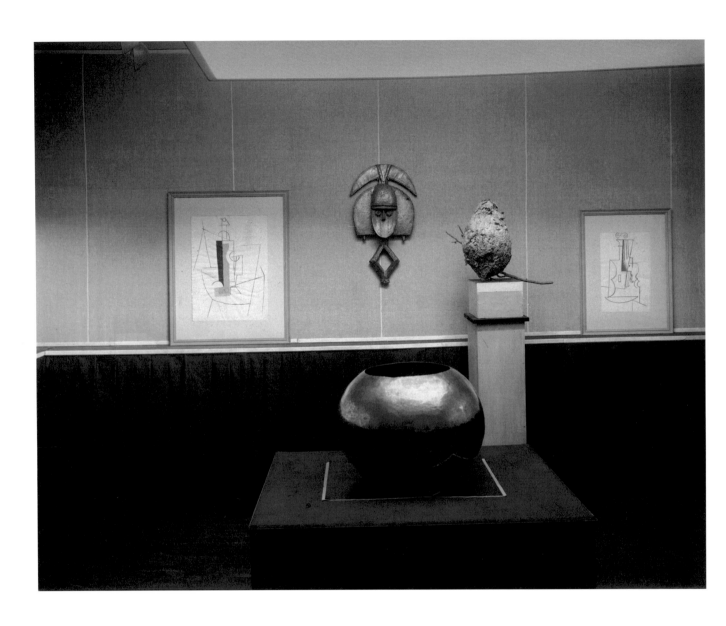

Pepe Karmel

PABLO PICASSO AND GEORGES BRAQUE, 1914 – 1915

SKELETONS OF THOUGHT

he Picasso-Braque exhibition that took place at 291 from December 1914 through January 1915 was the first to provide American audiences with an overview of 1912–1913 cubism. The earlier exhibitions of Picasso's work at the Photo-Secession Gallery and at the Armory Show had given a clear idea of his evolution only through the end of 1910.[1] The 1914–1915 exhibition at 291 revealed a radical new chapter in the evolution of cubism—one that would lead in opposite directions: toward both geometric abstraction and dada.

If works by Picasso and Braque were little seen in New York, it was largely in consequence of contractual arrangements in Europe. From 1907 onward, both artists sold the bulk of their production to Daniel-Henry Kahnweiler, but retained their freedom to sell and exhibit elsewhere. Picasso's relationship with Kahnweiler offered no impediment when Marius de Zayas persuaded him to send his drawings to New York for exhibition at 291 in 1911. The situation changed in fall 1912, however, when Kahnweiler convinced Braque and Picasso to sign contracts giving him the exclusive rights to market their work. Kahnweiler had relatively little interest in the American market. His marketing efforts, as John Richardson has shown, were directed primarily toward Germany, where he worked actively with dealers such as Alfred Flechtheim and Justin Thannhauser.[2] When he did turn his attention to the United States, Kahnweiler declined to use 291 as his representative, choosing instead the Washington Square Gallery run by Michael Brenner and Robert Coady.[3]

Returning to Paris in spring 1914, de Zayas approached Picasso about lending work to another show at 291. The artist directed him to Kahnweiler, who said that his exclusive contract with Brenner made

51 ALFRED STIEGLITZ
291—Picasso-Braque
Exhibition, *1915*

fig. 67 **PABLO PICASSO**
The Frugal Repast, *1904*
etching in zinc, printed in black
The Art Institute of Chicago, Alfred Stieglitz
Collection
PROBABLY EXHIBITED AT 291, 1915

it impossible for him to lend work to another New York gallery. De Zayas wrote Stieglitz grumpily that Kahnweiler was "taking a decided attitude of commercialism and pure commercialism."[4] Access to Picasso's work became even more difficult in summer 1914, with the outbreak of war in Europe. Vacationing in Switzerland, Kahnweiler found himself barred from returning to France because of his German nationality. Indeed, the French government seized his entire gallery stock as the property of an enemy alien. (It was auctioned after the war, over the artists' protests.)

Meanwhile, de Zayas and Stieglitz found another source of works by Picasso: the collection of the artist Francis Picabia and his wife, Gabrielle Buffet. The Picabias had visited New York in 1913, on the occasion of the Armory Show. 291 had celebrated their visit with an exhibition of Picabia's watercolors, and the couple had become friendly with Stieglitz and de Zayas. On their return to Paris, the Picabias had resolved to open a non-commercial gallery on the model of 291, dedicated to advanced art.[5] Though the gallery opened only briefly, the Picabias were left in possession of a significant group of art works that they had amassed for its stock. This group apparently included eighteen Picassos, eight of them quite recent.

There is something mysterious about the Picabias' collection, which appears nowhere in the provenances of Picasso's or Braque's cubist works. It is not clear why Picasso would have been willing, in 1913–1914, to bend the terms of his exclusivity agreement with Kahnweiler so that the Picabias could exhibit his work, or why Kahnweiler himself would have been willing to let the Picabias act as his agents, when he was not willing to lend directly to Stieglitz. Whatever the explanation, the fact was that the Picabias had the pictures Stieglitz and de Zayas wanted, and were willing to lend them to 291—indeed, to sell them, if there were interested buyers.[6] Reading between the lines of the subsequent correspondence, it appears as if Gabrielle Picabia, negotiating on the couple's behalf, used the leverage of Picasso's work to arrange for 291 to show additional work from their collection—specifically works by her husband and by Braque. Stieglitz retained fond memories of Picabia from his 1913 visit, and there was little question that he would be glad to exhibit his more recent work, but de Zayas had to labor to convince him to show Braque.[7]

"An Exhibition of Recent Drawings and Paintings by Picasso and by Braque, of Paris" finally took place from 9 December 1914 through 11 January 1915.[8] Henry McBride, in the New York *Sun,* described the installation as "a gala affair," noting that the gallery's walls were "newly done in pale canary hangings of cheesecloth."[9] The Picasso-Braque show was followed in January by the Picabia exhibition. This

PABLO PICASSO
Bathers in a Forest, *1908*
EXHIBITED AT 291, 1914–1915

was accompanied by a *second* Picasso exhibition, in the back room of the gallery. This smaller show of drawings and prints was drawn from the collection of the collector and critic Adolphe Basler. He had placed the work on deposit with Stieglitz as security for a loan. Much to Basler's dismay, Stieglitz later foreclosed on the loan, selling some of the pictures and incorporating others into his own collection.[10]

Since no checklists survive, the contents of these exhibitions can only be partially reconstructed. From what information is available, it appears that the shows were strong in the "crystalline" cubism of 1908–1909 and in the "hieroglyphic" cubism of 1912–1914, but offered fewer examples of the denser, more "abstract" work of 1910–1911.[11]

The earliest work in either exhibition seems to have been a rare early proof of *The Frugal Repast* (fig. 67), printed with blue ink before the plate was purchased and steel-faced by the dealer Ambroise Vollard.[12] Also known as *Les Deux Amis*, the work was mentioned under that title in a review of the Picasso-Braque exhibition. It may also have been included in the subsequent exhibition of works by Picasso alone, as one review of that show mentions an "impression" of "Apaches" (the slang term for the denizens of the Montmartre underworld).[13]

The print seems to have been accompanied, in the second exhibition, by a small study of a seated harlequin (The Metropolitan Museum of Art, New York). The figure's long nose and chin, and his distinctive hat, recall the head of the standing harlequin in Picasso's 1905 etching and watercolor of a *Circus Family*—a precursor to the great canvas of *The Saltimbanques* in the National Gallery.[14] (Indeed, the head and torso, in the drawing shown at 291, are inscribed over two studies for the left leg of the standing harlequin.) However, the figure in the drawing is linked by its pose and accessories (especially the small kerchief tied around its neck) to the harlequin in the canvas *Au Lapin Agile* (The Metropolitan Museum of Art, New York). In the finished painting, the seated harlequin bears Picasso's own features, but it is possible that he originally resembled the model of the *Circus Family*.

The Picasso-Braque exhibition may have included a striking Kota figurine (pl. 50) of the type that had inspired two "dancers" painted by Picasso in 1907, while he was working on the *Demoiselles d'Avignon*.[15] The figurine had possibly been in the November 1914 exhibition of African sculpture at 291, and it is visible in a gallery photograph (pl. 51) by Stieglitz, taken either during the Picasso-Braque exhibition or at a later date. It is unlikely that either of the paintings inspired by the figurine was exhibited at 291. However, the Picasso-Braque exhibition does seem to have included a powerful gouache of *Bathers in a Forest* (pl. 52), documenting Picasso's transition from the flattened silhouettes of the *Demoiselles* to the faceted, three-dimensional figures of the 1908 *Three Women*.[16]

The exhibitions seem to have been particularly rich in works from 1909. Three large drawings of heads documented Picasso's transition from an "African" style of uneven bulges and hollows to a "crystalline" style of regular facets. The earliest of this group is a spring 1909 drawing of a head of a woman with raised arms (pl. 53). This drawing, which Stieglitz acquired from Basler, enlarges a detail from another drawing of a full-length figure showing several different poses on the same sheet, so that the figure seems to have three arms and three legs.[17] The large drawing of the head is visible in the background of a photograph of Stieglitz's daughter Kitty, but no evidence exists to establish the full-length figure's presence at 291.

A forceful drawing of a head with large facets (pl. 56) dates from late spring or summer 1909.[18] Stieglitz acquired both this sheet and another head from summer 1909 (pl. 55), distinguished by more consistent, curvilinear faceting. The last drawing of the series served as a study for a sculpted *Head of Fernande Olivier* (pl. 22), executed the following fall. Stieglitz had purchased a cast of this *Head* in 1912, and had loaned it to the Armory Show, but we do not know whether it was exhibited in 1914–1915. The most obvious point of resemblance between drawing and sculpture is the hair, with its protruding braids, defined by lines running along

fig. 68 PABLO PICASSO
Still Life, *1909*
charcoal
*The Metropolitan Museum of Art, Alfred Stieglitz
Collection, 1949*
EXHIBITED AT 291, 1915

their crests. Many years later Picasso told Roland Penrose: "I thought that the curves you see on the surface [of my sculpture] should continue into the interior. I had the idea of doing them in wire." If this is true, the hair in the drawing should perhaps be understood as a series of interlacing strands, later converted into solid facets.

These cubist drawings of 1909 were accompanied by a large, realistic still life from the same year, showing a hyacinth spreading its leaves as if to embrace a nearby bottle of wine (fig. 68). The volumetric shading of the hyacinth and flower pot seem to link this drawing to a handful of other works done in fall 1909, when Picasso alternated between cubist faceting and a kind of simplified realism, anticipating the "metaphysical" style of Giorgio de Chirico.

From spring 1910 through summer 1912, Picasso explored a very different style of densely shaded, overlapping planes, obviating the difference between figure and ground. Of the works shown at 291 in 1914–1915, only two seem to have been done in this dense, "difficult" style. One was a small ink sketch of an oil and vinegar caster (The Metropolitan Museum of Art, New York), which was also reproduced in *291*. The other was a small drawing of a seated man holding a cane (fig. 69). The pose of the figure seems to have been inspired by a

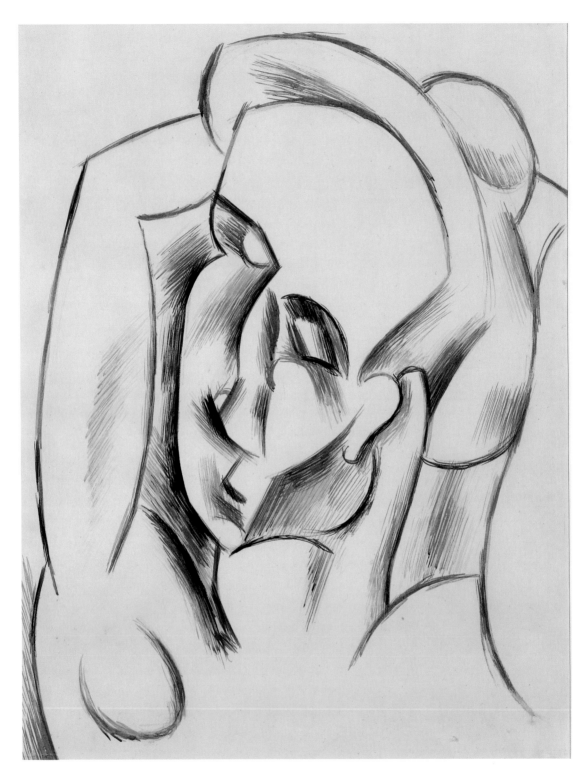

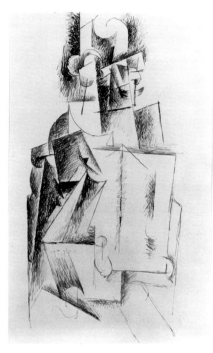

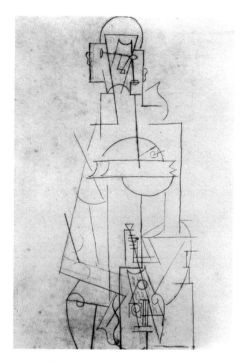

fig. 69 PABLO PICASSO
Seated Man Reading a Newspaper, *1912*
ink
The Metropolitan Museum of Art, Alfred
Stieglitz Collection, 1949
EXHIBITED AT 291, 1915

fig. 70 PABLO PICASSO
Seated Woman with Guitar, *1912*
graphite and ink
Yves Saint Laurent and Pierre Bergé Collection

photograph of the collector Frank Haviland, taken early in 1912 in Picasso's Paris stu-
dio. (Frank Haviland was the brother of Paul Haviland, an important patron of 291.)
The drawing itself, however, belongs to a group of studies for the canvas *The Aficionado*
(Daix/Rosselet 500), painted in summer 1912 in the south of France. In a letter of 10
July 1912 to Braque, Picasso wrote, "I have transformed an already begun painting of
a man into an aficionado; I think he would look good with his *banderilla* in hand, and I
am trying to give him a real southern face."[19] Indeed, in the finished painting, the cane
has become a *banderilla*, and the figure no longer recalls the photograph of Haviland.

Although the exhibitions were relatively poor in works from the period
1910–1911, they were exceptionally rich in pictures manifesting the simpler, more
open style of later 1912 and 1913. The earliest of this group was a drawing of a *Head*
(pl. 54), apparently done in late summer 1912. Shown in the "Basler" exhibition, it
was acquired by Stieglitz and is visible in the background of his photograph of
Charles Demuth, taken in 1915. This *Head* is closely related to a series of drawings of
a *Seated Woman with Guitar* (fig. 70), but, once again, we have no way of knowing
whether the exhibition included the full-length figure.

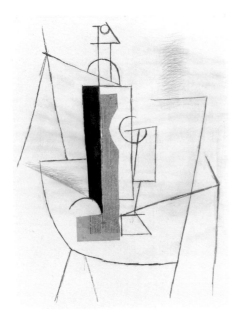

fig. 71 PABLO PICASSO
Still Life: Bottle and Glass on Table, *1912*
charcoal, ink, and pasted newspaper
The Metropolitan Museum of Art, Alfred Stieglitz
Collection, 1949
EXHIBITED AT 291, 1914–1915

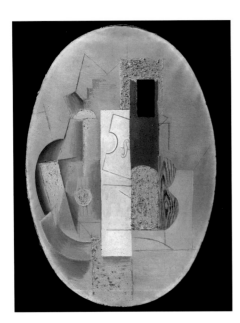

fig. 72 PABLO PICASSO
Violin and Guitar, *1913*
oil, cloth, charcoal, and gesso on canvas
Philadelphia Museum of Art: The Louise and
Walter Arensberg Collection
EXHIBITED AT 291, 1914–1915

A reference in a review to Picasso's use of "wall paper" suggests that the Picasso-Braque exhibition included at least one *papier collé* incorporating this material, possibly the fall 1912 *Guitar and Wine Glass* (Marion Koogler McNay Art Museum, San Antonio).[20] It definitely included the late 1912 *papier collé Still Life: Bottle and Glass on Table* (fig. 71). Stieglitz bought this for his own collection, noting, "I consider it the most important Picasso drawing I have ever seen ... The most complete 'abstraction' of the modern movement."[21] Picasso's superb drawing of a *Violin* (pl. 58), done around the same time, was reproduced on the back cover of the November 1915 issue of the magazine *291*, and then acquired by the Arensbergs, important patrons of both cubism and New York dada. Both *Violin* and *Still Life: Bottle and Glass on Table* appear in the gallery photograph with the Kota reliquary figure (pl. 51). The photograph also includes a large glazed bowl, in the foreground, that was a perennial fixture of the gallery, and a wasps' nest, discovered by Stieglitz's friend and assistant Emil Zoler, that the 291 artists seem to have regarded as a sylvan "ready-made."[22]

These remarkable works on paper were supplemented by the early 1913 canvas *Violin and Guitar* (fig. 72), acquired by the Arensbergs in 1918. This was definitely in the first of the two 291 exhibitions, since reviews refer to its distinctive facture: rough bands of plaster alternating with smooth bands of white paint and blue paint.[23]

Difficult though it is to identify the Picassos exhibited at 291, it is even harder to identify the Braques. The evidence suggests that these were all fairly recent works. *Untitled (Still Life)*, a 1912–1913 *papier collé* by Braque (pl. 57), was reproduced on the front cover of the November 1915 issue of *291*. Like Picasso's violin drawing (pl. 58), reproduced on the back cover of the same issue, it was acquired by the Arensbergs.[24] Other cubist Braques in North American collections may have arrived by the same channel. One candidate would be the 1913 *Glass, Bottle and Guitar* from Katherine S. Dreier's collection (fig. 73), which, like the Arensberg *Violin*, includes an area of white lines drawn on black paper, in contrast to the black-on-white of the surrounding composition.[25] Another would be a painting of *Cards and Dice*, which belonged to the painter Arthur B. Davies. One of the organizers of the Armory Show, Davies bought regularly from Stieglitz.[26] The small oval canvas displays the colorful stippling technique that Braque and Picasso began to use in spring 1914.

If the hidden agenda of the 291 exhibition was for the Picabias to profit from sales, the show was clearly a failure. Business was bad enough for Stieglitz to complain about it to McBride, who humorously attributed the drop off in sales to the fact that "all the millionaires have moved uptown."[27] Stieglitz gave a more serious explanation in a letter to Gabrielle Picabia. "De Zayas has told me ... that you are desirous of turning some of the Picassos and other things you have here into cash," he wrote on 30 December 1914. The war had rendered this almost impossible, he explained. "Many of the 'rich' are really poor.... The values of stocks have been cut nearly into two. Many have stopped dividends. Value of bonds has decreased tremendously.... Nobody in the whole world, either here or in Europe will dream of paying ante-war prices today."[28] Nonetheless, the Picabias left their collection in New York, where it provided material for several shows at the Modern Gallery opened by de Zayas, Agnes Meyer, Paul Haviland, and the Picabias at the end of 1915.[29]

The critical reception of the Picasso-Braque exhibition should be seen in the context of the reactions to other New York exhibitions of cubism. At the Armory Show, the artist Kenyon Cox had denounced the new movement as "revolting and defiling."[30] The critic Frank Jewett Mather saw it as an unwholesome art, "spawned from the morbid intimations of symbolist poetry and distorted Bergsonian philosophy."[31] A large exhibition of other "cubist" artists also opened at the Carroll Gallery in December 1914, again provoking mostly negative reactions. Frederick James Gregg, the organizer of the Carroll show, did his best to provoke conservative critics by writing that his exhibition would give the New York public "the opportunity to catch up, to realize how far art in America is behind the times." The reviewer for the *New York Tribune* responded that "the public has caught up with his wondrous masters—and left them far behind." Most of the works in the Carroll Gallery exhibition seemed to this reviewer to be mere "eccentricities," on which he declined to waste his time. He concluded: "We may say as much of the drawings by Picasso and Braque at the Photo-Secession gallery, adding merely, for the benefit of people who are interested in that sort of thing, that it is just the sort of thing in which they will be interested."[32]

The critic for the *Evening Post* also rejected Gregg's allegation that art in America was behind the times. Attentive viewers were "perfectly familiar" with the development of cubism, whose "short life" was, in any case, already "on the wane," as demonstrated by the exhibition at 291, where a "noticeable decline" was evident in the work on display: "Picasso is clever and variable, but not at all

important, and what he shows this year compares unfavorably with what he has shown here before."[33]

For the reviewer of the *New York Herald*, the exhibition at 291 was merely a display of the "latest extreme absurdities." In fact, the exhibition provided the first examples seen in America of the cubist techniques of *collage* and *papier collé*, revolutionary innovations that would decisively change the course of modern art. Unimpressed, the *Herald*'s reviewer wrote: "At last an art extremist has found a use for a newspaper. In two of his works, now being shown in the gallery of the Photo Secession, No. 291 Fifth Avenue, Picasso has used slices of newspapers with pieces of wall paper and daubs of plaster to get 'effects.'"[34] The reviewer immediately warned "those not initiated into the psychological intricacies of the new art" against "puzzl[ing] their brains as to the 'meaning' of Picasso's work." Indeed, he cited Stieglitz himself as saying that "the moment one begins to think he becomes hopelessly out of accord" with the work. One's response should be "a matter of sensation solely."[35]

Charles Caffin, the critic for the *New York American*, saw no contradiction between thinking and feeling. On the contrary, he described Picasso and Braque as "intellectualizing their sensations in pictorial terms." Proposing a synesthetic analogy between music, architecture, and the new art, Caffin asked his readers to imagine themselves attending a service in Saint Patrick's cathedral. Studying the columns, vaults, and buttresses of the cathedral, they might come to see the building "as a bodiless structure of innumerable forces, some in correspondence, some in conflict ... [a] skeleton of intellectualized sensations." Similarly, after the organ music of the service had died away, they would be left with "an intellectualized impression of the music ... the varieties and qualities of sound, its crescendos and diminuendos, and, above all, its rhythms." If they were then asked to explain the sensations produced by the architecture and the music, they might do so with a combination of words, inflections, and "pantomimic" gestures. And if these words and gestures were recorded simultaneously in print and in moving pictures, the result would be something like a cubist painting. The ultimate expression would have been arrived at via multiple translations, so that it would have only an indirect relationship to the original synesthetic experience of music and architecture.[36] The problem, as usual with the symbolist theory of expression, was that the same analysis might have served to explain completely different pictures.

Other reviewers had more to say about what Picasso's and Braque's pictures actually looked like. Henry McBride, in the *Sun*, commented that Picasso had visibly "progressed" since the pictures exhibited in the Armory Show. He noted in passing Picasso's use of *papier collé* and *collage*: "Bits of real newspapers are pasted carefully into certain sections of some of [his pictures], and in others there is a coating of

pulverized stone applied heavily where it does the most good." What struck McBride, above all, was the distinctive sparseness of Picasso's drawing and composition: "He has fewer lines and less work in his pictures." The "straggling lazy charcoal lines" were mere "skeletons of thought." (McBride here echoes Caffin, who a week earlier had described a cubist picture as a "skeleton of intellectualized sensations.") Such simplification of form was not unusual in advanced French art. However, it was usually made up for by an intensification of color derived from impressionism. The "chaste," pale tones of Picasso's new work offered no such compensation. "Where it gets its power will be a mystery to the disciple of the plein-air school," McBride commented.

McBride's willingness to accept such minimal, elliptical compositions reflected, in part, his awareness that Picasso was capable of drawing superbly in a more traditional style. As he reminded his readers, Picasso's earlier works "had a Dutch intensity of finish to them."[37] Indeed, Stieglitz and de Zayas may have included the 1904 etching of *The Frugal Repast* (fig. 67) precisely in order to remind visitors of Picasso's technical virtuosity.

The reviewer for *American Art News* also made a point of citing this etching, as if to validate his observations about Picasso's newer work: "The drawings by Picasso are distinctly linear in conception, and may be regarded as the most abstract form of visualized emotion. The quality and expressiveness of line is remarkable, although the absence of a feeling for color detracts perhaps from the fulness of the message.... To those who do not understand [Picasso's] abstract lines it will be necessary only to look at the etching entitled 'Les deux Amis' [fig. 67], than which nothing could be more exquisitely drawn...."[38] Less impressed by the quality of Braque's drawing, the reviewer argued that he "has no such knowledge to back his attempts in the Picasso direction, which are felt to be ambitious rather than original."[39]

Like McBride and the reviewer for *American Art News*, Elizabeth Luther Carey, in the *New York Times*, made a point of Picasso's skill as a draftsman, commenting that "there is a tale that Picasso faked Daumiers when he was ... poor," and pointing out that "this is cited, no doubt, to prove to the incredulous that he could 'draw well' in the conventional sense of the word."[40] Carey then went on to say: "Of course he now draws far better, almost incredibly well."[41] This is absolutely true. While the draftsmanship of *The Frugal Repast* is superb, it still displays the nervous, finicky quality of Barcelona *modernisme* and art nouveau in general. In contrast, Picasso's summer 1912 *Head* and his winter 1912–1913 *Violin* (pls. 54, 58) manifest a classical sense of clarity and economy. The paradoxical result of Picasso's experiment with the geometrical language of cubism had been to make him into a great realistic draftsman.

As he remarked to Leo Stein: "Even if this new way is a mistake, it has profited me, for I did a figure the other day and it was better than any I had done before."[42]

Carey returned to the topic of Picasso's skill in her review of the January 1915 Picabia-Picasso exhibition. "At the Photo-Secession Galleries in one of the inner rooms are half-a-dozen drawings, and an impression of the 'Apaches' [apparently, *The Frugal Repast*, fig. 67] illustrating the progress of Picasso, synthetically represented. This inner room is the magnet for students of art." Reviewing Picasso's evolution from the rose period to cubism, Carey concluded: "Since most of us grant that the writing of experience is never wholly erased from a still sound mind, no doubt we should assume that the poignancy and cruelty and tenderness are all in the complicated designs with their beautiful flickering lights and darks and their interesting and tremendously difficult perspectives."[43]

However, Carey's most insightful comments appear in her review of the first Picasso-Braque exhibition. Like other critics, she notes Picasso's use of unconventional materials, such as "a piece of newspaper, a French scrap of paper, torn off and transferred bodily to Picasso's composition."[44] In *Violin and Guitar* (fig. 72), she observes, Picasso "places a band of roughness next to a band of smoothness, to stimulate our tactile sense," making painting—traditionally a visual medium—speak "with the language of texture."[45] This is remarkably acute. Most other critics ignored this aspect of cubism until the 1950s, when Braque pointed out in an influential interview that "in painting the contrast of materials plays as important a role as the contrast of colors."[46]

Carey's reference to "bands" of roughness and smoothness reflects her close attention to the "geometrical construction" of Picasso's new pictures. The rectilinear grid of 1910–1911 cubism had placed relatively equal emphasis on horizontal and vertical axes. One of the distinctive features of Picasso's and Braque's 1912–1913 work is the evolution of the grid into a series of predominantly vertical bands (pls. 54, 57, 58; figs. 71–73), which seem to move backward and forward in space, even though they lie side by side in the picture plane. As Carey writes, Picasso "makes his lines advance and retreat with marvelous skill and sensitiveness. He places one form over another in a way to suggest expansion of space." Here, too, Carey anticipates Braque's comments of the 1950s, where he explains that he and Picasso had adopted the method of overlapping planes as a way of escaping from traditional perspective: "I said farewell to the vanishing point. To avoid a recession towards infinity, I superimposed planes one on top of another, separated by just a small distance. To make it clear that things were arranged one in front of the other, instead of going back into space."[47] For the first time in America (and possibly anywhere), Carey's review heralds the invention of a radically new form of pictorial organization, one which continues to define modern art down to our own day. Its effect on American art is incalculable.

55 PABLO PICASSO
Study, *1909*
EXHIBITED AT 291, 1915

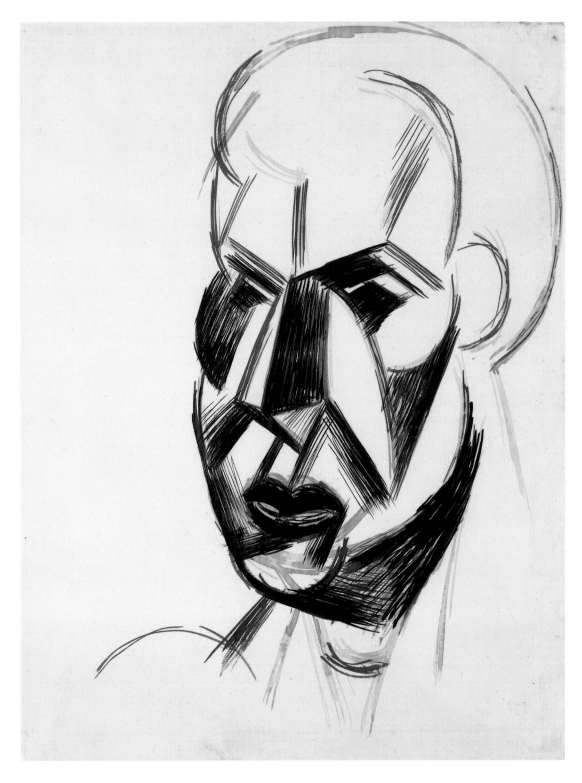

56 PABLO PICASSO
Head, *1909*
EXHIBITED AT 291, 1915

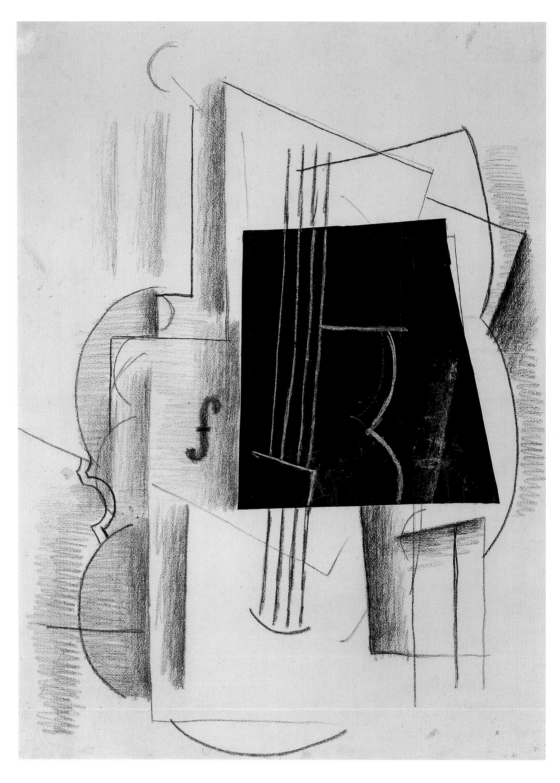

57 GEORGES BRAQUE
Untitled (Still Life), *1912–1913*
EXHIBITED AT 291, 1914–1915

58 PABLO PICASSO
Violin, *c. 1912*
EXHIBITED AT 291, 1914–1915

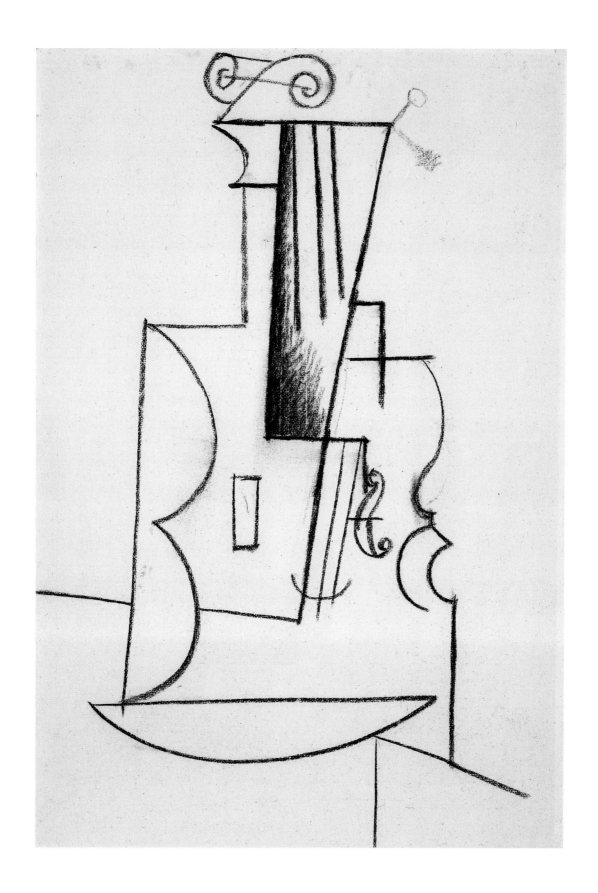

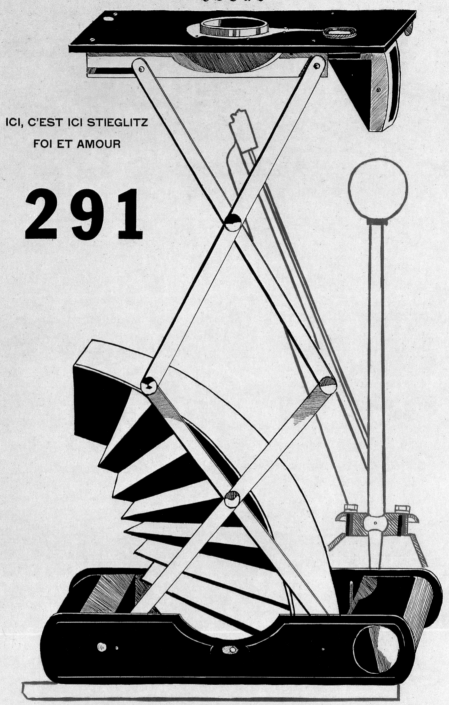

ICI, C'EST ICI STIEGLITZ

FOI ET AMOUR

291

Pepe Karmel

FRANCIS PICABIA, 1915

THE SEX OF A NEW MACHINE

I n October 1915, with his usual flair for publicity, Francis Picabia told the *New York Tribune*: "This visit to America ... has brought about a complete revolution in my methods of work.... Prior to leaving Europe I was engrossed in presenting psychological studies through the mediumship of forms which I created. Almost immediately upon coming to America it flashed upon me that the genius of the modern world is in machinery and that through machinery art ought to find a most vivid expression.... The machine has become more than a mere adjunct of human life. It is really a part of human life—perhaps the very soul. In seeking forms through which to interpret ideas or by which to expose human characteristics I have come at length upon the form which appears most brilliantly plastic and fraught with symbolism. I have enlisted the machinery of the modern world, and introduced it into my studio."[1]

In hindsight, this revelation appears as a key moment in the development of modern art.[2] Although the term "dada" was not coined until the following year (and in Zurich, rather than New York), Picabia's machine drawings of 1915 (pls. 59, 62–64) announce a radically different spirit in art.[3] In comparison, even cubism seemed old-fashioned.

The development of New York dada has been meticulously chronicled by Francis M. Naumann, William Camfield, and other scholars.[4] Nonetheless, the relations between Picabia, Duchamp, and the Stieglitz circle bear reexamination. Picabia had first shown at 291 in 1913, capitalizing on his success at the Armory Show. In January 1915 he had his second exhibition there, immediately after the show of cubist work by Picasso and

59 FRANCIS PICABIA
Here, This is Stieglitz/Faith
and Love
REPRODUCED IN 291, NOS. 5–6,
JULY–AUGUST 1915

203

Braque that Picabia and his wife Gabrielle Buffet had played a key role in arranging. Picabia's exhibition was accompanied, furthermore, by a second Picasso show, comprising drawings from the collection of the critic Adolphe Basler.[5] Picabia once again appeared to the New York public as a practitioner of cubism, broadly understood. However, the drawings published in the July 1915 issue of *291* mark a dramatic break with his earlier style.

Scholars have linked Picabia's new work to a growing rift within the Stieglitz circle. The journal *291* was published by Marius de Zayas, Agnes Ernst Meyer, and Paul Haviland, longtime friends and supporters of Stieglitz who had come to the reluctant conclusion that he was no longer promoting new art with the requisite energy. Though the new journal borrowed the name of Stieglitz's gallery, its editorial policy was meant to mark a departure from it, summed up in Picabia's irreverent, seemingly non-artistic drawings. Picabia also joined with de Zayas, Meyer, and Haviland in the creation of their own exhibition space, the Modern Gallery, which opened in October 1915.[6]

At first glance, the battle lines seem clearly drawn between the proto-dada spirit of the Modern Gallery group and the more conservative aesthetic of the original 291. But on closer examination this antithesis begins to dissolve. For one, the Modern Gallery continued the exhibition policy of 291 virtually without a change (and with an equal lack of economic success). And in 1917, when the scandalous sculpture *Fountain*, a newly purchased urinal, was rejected by the Society of Independent Artists, it was Stieglitz who came to Duchamp's aid.

The allegiances and divisions of these years may have been motivated as much by personalities as by aesthetic or philosophical concerns. In 1913, when Picabia and his wife first visited New York, Stieglitz was tremendously taken with them. After their departure, he wrote a friend that "All at '291' will miss him. He and his wife were about the cleanest propositions I ever met in my whole career. They were one hundred percent purity. This fact added to their wonderful intelligence made both of them a constant source of pleasure."[7] However, it was Marius de Zayas rather than Stieglitz who went on to forge a close friendship with Picabia, during the course of a 1914 visit to Paris. In the spring of 1915, when Picabia returned, unaccompanied, to New York, he fell into an existence that his wife described, diplomatically, as "dissipated." De Zayas, a bachelor, may have found this lifestyle more sympathetic than did Stieglitz.[8]

Duchamp, who arrived for the first time in New York in 1915, had been a friend of Picabia since 1911. In Paris, they both belonged to the ranks of secondary Salon cubists. In the United States, however, the 1913 Armory Show had, more or less by accident, established them as the leading representatives of the Paris avant-

garde. Duchamp later described Picabia as a great "negator," who helped inspire him to break with conventional painting.[9] The roles of leader and follower were soon reversed. Between 1911 and 1913, while Picabia continued to work in a cubist style, Duchamp moved on to what would soon become known as dada; the more objective, "machine" style of his *Chocolate Grinder* displaced the cubist/futurist imagery of earlier pictures like *Nude Descending a Staircase* and *The Bride*.[10] It should be said, however, that the borders between cubism and dada were far more fluid at this time than they would later appear. Americans, in particular, found cubism as bizarre and provocative as dada would strive to be.

In 1915, Picabia remained far more important in the Stieglitz circle than Duchamp. His movement away from the large, brightly colored cubist canvases exhibited at 291 to the smaller "machine" drawings executed in the months that followed echoed the evolution that had occurred in Duchamp's work two years earlier, but Picabia's shift had a greater impact on the Stieglitz circle because it occurred in front of their eyes. The "machine" drawings, which announced the emergence of New York dada, have attracted most of the attention from critics and historians, but Picabia's earlier canvases in many ways hold the key to these later drawings. To clarify the internal logic of Picabia's development is also to clarify the relationships between symbolism and modernism, cubism and dada, body and machine.

Although Picasso and Braque, the inventors of cubism, were represented by several works at the Armory Show, Duchamp and Picabia garnered the most notice. Almost immediately upon arriving in New York, in January 1913, Picabia began a series of large watercolors presenting his impressions of the city and of the transatlantic journey that had brought him there. Exhibited at 291 in March, these works received significant coverage, mostly favorable, in the New York press. Picabia returned to Paris in April, but his U.S. visit continued to exercise an important influence. Inspired by 291, he and his wife planned to launch a Paris gallery, which opened in the following January but quickly folded.[11] New York also seems to have provoked an important shift in Picabia's style, but it is comprehensible only within the terms of his Paris works.

Dancers at the Spring and the other 1912 canvases Picabia exhibited at the Armory Show had evoked figures and landscapes in a visual language of large flat color planes with interlocking contours—a language deriving directly from Picasso's *Three Women* of 1908. Hanging in the Steins' salon from 1908 through 1913, the *Three Women* exercised an almost incalculable influence on avant-garde painting of those years, providing a model for canvases by Paris artists such as Duchamp and Fernand Léger, Russians such as Malevich, and Americans such as Morgan Russell and Max Weber.[12] Many of these artists perceived a resemblance between Picasso's

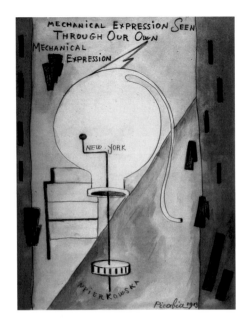

fig. 74 FRANCIS PICABIA
Mechanical Expression Seen Through
Our Own Mechanical Expression, *1913*
watercolor and crayon
private collection

color planes, with their curved contours, and the cylindrical forms of modern machinery. Léger and Malevich accentuated this resemblance by shading their planes so that they looked like segments of cones and cylinders. In 1912, Duchamp began to augment these shaded planes with a network of light-colored strips and lines. The figures in canvases such as *The Bride* and *Nude Descending a Staircase* seem to have been assembled from metal tubes, struts, and wires—a still-novel technology popularized by the sport of cycling. (It is no coincidence that Duchamp's first ready-made, assembled in 1913, incorporates a bicycle wheel.)[13] Duchamp gave *The Bride* to Picabia in 1912, but its influence does not become visible in his work until 1913, when Picabia visits New York.

Picabia's early 1913 watercolors reveal several different styles and sources of inspiration. The linear, diagrammatic style of a small watercolor inscribed *Mechanical Expression Seen Through Our Own Mechanical Expression* (fig. 74) anticipates the "mechanical" drawings of the summer of 1915. At the center of the image is a chemical retort, drawn upside down (or, more likely, drawn right-side up and then inverted). It is flanked by vertical bands that seem to represent the facades of buildings—tall "slabs" like those described by the *American*'s reviewer—punctuated by dark lozenges suggesting windows. A long diagonal indicates a street receding between the buildings. The interior of the flask is labeled "New York," and "Napierkowska" is written below it. This was the name of an exotic dancer, Stacia Napierkowska, whom Picabia had encountered during his Atlantic crossing.

The same motifs appear in Picabia's larger, more elaborate watercolors, but segregated into distinct groups. Some develop the image of the city (pls. 27, 32), depicted in a style similar to that of Picabia's 1912 canvases. Others celebrate Picabia's memory of Stacia Napierkowska (pl. 33) and his impressions of African-American entertainers.[14]

Just as Picabia's 1912 visit to Spain had provided the source material for the large canvases shown at the Armory, so too his "impressions" of New York were enlarged and developed in the canvases executed after his return to Paris. The three canvases exhibited at 291 in January 1915—*I See Again in Memory My Dear Udnie, This Has to Do With Me* (pl. 61), and *Comic Wedlock* (pl. 60)—were thus, in effect, returning to their point of origin.[15] All three of these display a marked change in style from his earlier Paris canvases. The broad color planes with interlocking contours, derived from Picasso, are increasingly supplemented with undulating tubes, strips, and bands derived from Duchamp. Camfield notes that the "membranelike forms

and the pendulant biomorphic shape" in the upper part of *I See Again in Memory My Dear Udnie* seem to be modeled directly on *The Bride*. But if *The Bride* provided the model for Picabia's "half-visceral, half-animated" forms, Picabia goes beyond Duchamp in discarding the brownish fug of 1910–1911 cubism in favor of "icy colors" suggesting the shimmer of "finely rolled steel." In this respect, as Camfield observes, the coloring of Picabia's new paintings anticipates the deliberately impersonal finish of his later "machinist paintings."[16]

This impersonal finish, however, is combined with forms of alarming sensuality. What is expressed in mechanical terms, here, is the spectacle of the female body in motion, and the male paroxysm induced by that spectacle. Picabia's representation of sexuality as a mechanical phenomenon seems to have been shaped not only by Duchamp but also by writers such as Alfred Jarry and Remy de Gourmont. Linda Dalrymple Henderson has noted the widespread influence of Gourmont's *Physique de l'amour: Essai sur l'instinct sexuel*, which was published in 1903 and had gone through ten editions by 1912.[17] Combining Darwinian determinism with the imagery of the industrial revolution, Gourmont strips away romance and sentiment to present sexuality as nothing more than a mechanical process, driven by the inexorable laws of reproduction. Discussing certain primitive species, he writes that "the female ... is the machine and has to be wound up to go; the male is merely the key."[18] Elsewhere he insists that "coupling is not fecundation; it is merely the mechanism," and that the accord between male and female sex organs is "mechanical and mathematical."[19] Such views were parodied by Alfred Jarry, whose "supermale," capable of incessant, machinelike intercourse, could find a suitable partner only in a machine.[20]

Individual elements in Picabia's paintings, such as the projecting coil at the lower left of *I See Again in Memory My Dear Udnie*, suggest the masculine role as a key or trigger for sexual activity. But the proliferation of curvilinear and labial elements in Picabia's elaborate mechanisms clearly marks them as feminine. The machine style of these years is neither neuter nor inanimate; on the contrary, it is strongly gendered and very much alive. The three large canvases, with their feverish colors and wanton curves, must have made an overwhelming impression in the claustrophobic setting of 291, but the reviews were curiously indifferent.

The reviewer for the *New York Tribune* described Picabia's pictures as "mere riddles of fantasticality," which might "safely be left to the people who care to give their time to that sort of thing." (A month earlier, the same reviewer had dismissed the Picasso-Braque show at 291 by noting, "for the benefit of people who are interested in that sort of thing, that it is just the sort of thing in which they will be interested.")[21] The *New York Herald*, which had praised Picabia's 1913 watercolors, focused on *This*

60 FRANCIS PICABIA
Comic Wedlock, 1914
EXHIBITED AT 291, 1915

61　FRANCIS PICABIA
This Has to Do with Me, *1914*
EXHIBITED AT 291, 1915

Has to Do With Me: "Here Mr. Picabia, a leader of the new art, describes himself by a lot of curves, angles and streaks that look as if they might be the result of a collision between an aeroplane, an automobile and a submarine."[22]

The reviewer for *American Art News* professed to be mystified by Picabia's "combination of colored flat, curved and round surfaces, with a few odd bands and bars thrown in," but was evidently discomfited by the "souvenir of his dear ——, who produced apparently a most extraordinary effect upon him."[23] (Whatever *Udnie* meant, the word was evidently not fit to print in a family publication.) In the *New York Times*, Elizabeth Carey, who had responded favorably to the preceding exhibition of Picasso and Braque, denounced *Comic Wedlock* and *I See Again in Memory My Dear Udnie* as "unpleasant arrangements of strangely sinister abstract forms that convey the sense of evil without direct statement."[24] Though slightly Victorian, this seems like an accurate description of what the artist was trying to achieve in his pictures. (Later in his career, Picabia abandoned the veil of abstraction and based much of his work directly on images borrowed from pornographic magazines.)

Despite these negative reviews, when Picabia returned to New York, in May 1915, his first impulse seems to have been to continue working with sexual-mechanical imagery of the same feminine character. Soon after his arrival, he executed the drawing *Girl Born Without a Mother* (fig. 75), which was promptly reproduced in the fourth issue of *291*. As Camfield observes, the drawing reproduces the key elements of *I See Again in Memory My Dear Udnie*, but strips the composition down to its mechanomorphic essentials.[25] The masculine elements of the projecting springs are more prominent than in the painting, but they are still set within a context of rounded, feminine forms. The drawing clearly functioned as a kind of talisman for the *291* circle. Three months later, in the September–October issue of *291*, Paul Haviland used its title to set the keynote for a text on the "age of the machine," writing that man loved the machine because it was his "daughter born without a mother."[26]

Picabia deployed a similar arrangement of forms in *Voilà Elle*, published in the November issue of *291*. Picabia's drawing appeared in tandem with *Elle*, a drawing-poem by de Zayas modeled on Apollinaire's *calligrammes*, and the two works were exhibited together at the Modern Gallery in the same month (fig. 76). The two works are closely linked in both form and content.[27] Both are organized around a strong vertical axis, set against curvilinear forms inclining to the right. Naumann notes that de Zayas' poem envisions woman as "a mindless being," propelled by the quest for "extremes of pleasure,"

fig. 75 **FRANCIS PICABIA**
Girl Born without a Mother, 1915
pen and ink
The Metropolitan Museum of Art, Alfred Stieglitz Collection, 1949
REPRODUCED IN 291, NO. 4, JUNE 1915

fig. 76 MARIUS DE ZAYAS
Elle, *and*
FRANCIS PICABIA
Voilà Elle
REPRODUCED IN 291, NO. 9, NOVEMBER 1915

while Camfield identifies the apparatus of Picabia's drawing as "an automatic love machine." The masculine pistol at left (in the same position as the springs of *Girl Born Without a Mother*) is clearly designed to activate the feminine pipes and cylinders around it.[28]

The drawings by Picabia and de Zayas appeared on the two inside pages of the November *291*, while the front and back covers were devoted to cubist violins by Braque and Picasso, which had been exhibited at 291 in January 1915 (pls. 57, 58).[29] The juxtaposition of the two pairs of images is no less significant than the pairing between Picabia and de Zayas. The metaphorical comparison between the curves of a violin, guitar, or mandolin and the curves of the female body is constantly repeated in 1910–1914 cubism. In this sense, Braque and Picasso's images provide an important antecedent for the image of the body as a sexual apparatus. As Braque himself noted, he had been drawn to musical instruments as subject matter because "one brings them alive by touching them."[30] Furthermore, the wires descending from the nails at the upper right of Picabia's drawing are clearly borrowed from the string and nail at the upper right of Picasso's violin.[31]

fig. 77 FRANCIS PICABIA
Fantasy
REPRODUCED IN 291, NOS. 10–11,
DECEMBER 1915–JANUARY 1916

In fact, the relationship between Picabia and de Zayas, on one hand, and Picasso and Braque, on the other, extended well beyond the pages of the November 291. Picasso's summer 1912 drawing of a head (pl. 54), exhibited at 291 in January 1915, seems to have provided the model for de Zayas' caricature of Stieglitz (pl. 34), which appeared on the cover of the first issue of 291 in March 1915. In both images, a strict vertical axis sets off a trapezoidal facial plane, tilting to the right; however, de Zayas revises Picasso's composition by placing the narrow end of the trapezoid at upper right instead of lower left. Similarly, Picabia's drawing *Fantasy*, published in the December 1915 issue of 291 (fig. 77), echoes the structure of several fall 1912 still lifes by Picasso, with a conspicuous circle at top center set against a scaffolding of short verticals and long horizontals, traversed by a prominent diagonal accent (fig. 78). These Picassos were not exhibited in New York, but Picabia might well have seen them in Paris before his departure.[32]

The critical question is not whether Picasso and Braque's work of 1912–1913 provided a model for this or that particular drawing by Picabia, but whether it contributed in a more fundamental way to the new machine style of 1915. Conventional histories often set up a simple antithesis between cubism as an "artistic" style and dada as an "anti-art" style. But this antithesis obscures the extent to which cubism itself was regarded as an anti-art style. The first examples of dada "machine" drawing, it might be argued, are to be found in 1912–1913 cubism. As Camfield has noted, when Braque's *Violin: "Mozart/Kubelick"* was exhibited at the Armory Show, it provoked a cartoon parody depicting it as "a fanciful machine two years in advance of Picabia's droll contraptions." Similarly, the humorist Gelett Burgess contributed a "Nonsense Machine" of spools, wires, and cogs to a March 1913 exhibition satirizing the Armory Show.[33] The hard-edged, inorganic geometry of cubism clearly seemed "mechanical" to contemporary viewers.[34] And the rectilinear forms of 1912–1913 cubism seemed even more "mechanical" than the curved forms of 1908–1909.

To this extent, it seems significant that a critical mass of 1912–1913 pictures by Picasso and Braque remained on hand at 291 when Picabia arrived there in May 1915. It may have been the encounter with these pictures that provoked his shift from the organic, curvilinear style of his early paintings to the inorganic, rectilinear style that suddenly emerges in his work of 1915.

The first examples of this new style are the machine drawings published in the July–August issue of *291*: metaphorical portraits of Stieglitz (pl. 59), de Zayas (pl. 64), Haviland, an unnamed "young American girl in a state of nudity" (pl. 62), and Picabia himself (pl. 63). These were the first individualized "portraits" that Picabia had created in several years.[35] Picabia was probably familiar with the abstract caricatures that de Zayas had published in 1914 in *Camera Work* and *Les Soirées de Paris*, but these do not seem to have provoked him to experiment with caricature before his arrival in New York.[36] Rather, the immediate stimulus for his experiment in this new genre was the appearance of *291* itself, which seems to have been intended (by Stieglitz, at least) as a vehicle for both satire and artistic experimentation.[37] De Zayas' caricature of Stieglitz on the cover of the first issue (pl. 34) struck a definite satirical note, as did many of the other drawings in the first four issues.[38]

fig. 78 PABLO PICASSO
Guitar on a Table, 1912
oil, sand, and charcoal on canvas
Hood Museum of Art, Dartmouth College, Hanover,
New Hampshire; gift of Nelson A. Rockefeller, Class of 1930

Humor was a new artistic goal for Picabia, and the challenge of achieving it may well have sent him back to Henri Bergson's well-known essay on laughter, which, in the pages on caricature, stated that "The attitudes, gestures, and movements of the human body are laughable in exact proportion as that body reminds us of a mere machine."[39] The mechanical does not represent the hidden truth of human existence for Bergson, as it does for Gourmont. Rather, the mechanical is the enemy of the truly human. The "living personality" is free, but it easily falls victim to habit. The essence of humor is to expose these mechanical habits that have imprisoned the self—"to bring out the element of automatism" that someone "has allowed to creep into his person."[40] An ironic, intentionally literal reading of Bergson might thus have led Picabia to the idea of satirizing his subjects by representing them as machines.

He may also have been influenced by the technical demands of producing work for black-and-white reproduction rather than exhibition. Looking at the illustrations in books and catalogues, and the diagrams then common in magazine articles, Picabia would rapidly have realized that the technology of print reproduction required a style of hard lines and sharp contrasts rather than the delicate tints and washes of his 1913 watercolors. The heroic isolation of specific objects, such as the spark plug representing a "young American girl in a state of nudity" (pl. 62), may have been suggested by sophisticated advertisements such as Lucian Bernhard's 1914 poster of a Bosch spark plug (fig. 79).[41]

Duchamp had already demonstrated, in his *Chocolate Grinder* of 1914, that mechanical subject matter and a style of crisp mechanical precision could provide a

substitute for traditional forms of pictorial symbolism. Yet it was Picabia's "object portraits" that had the greatest historical impact as a model for artists such as Max Ernst. What made them such a potent example was Picabia's combination of machine imagery with the new pictorial syntax that had emerged in the 1912–1913 cubism of Picasso and Braque.

In this respect, it is the de Zayas portrait (pl. 64) that offers the clearest guide to Picabia's methods and intentions. As Camfield notes, the composition is based on a wiring diagram from a 1915 volume on *The Gasoline Automobile*, showing the connections among instrument panel, steering wheel, battery, headlights, spark plugs, and horn.[42] Picabia rotates the diagram to create a more symmetrical composition, and diminishes the size of the realistic elements in relation to the wires. The found image of the wiring diagram provides a "ready-made" version of the cubist grid. It is an abstract scaffolding that can support a series of representational signs, some drawn and others written.

Thus the "realistic" images of headlights, engine manifold, steering wheel, spark plug, and corset (added by Picabia) correspond to the legible elements of Picasso and Braque's violins: f-shaped soundholes, scrolled necks, indented sides, etc. Similarly, the inscription, "De Zayas! De Zayas! Je suis venu sur les rivages du Pont-Euxin," paraphrasing Xenophon, occupies the position of the newspaper headlines frequently found in cubist *papiers collés*.[43] The juxtaposition of spark plug, corset, and so forth evokes the theme of mechanical sex found in Picabia's earlier work. However, the formal language of the image as a whole is dramatically different. Compared to Picabia's 1913–1914 pictures, with their curvilinear, "feminine" forms, the de Zayas drawing seems stiffly "masculine."

This masculine character is even more pronounced in the other "portraits" of this series. For his self-portrait, inscribed "Le Saint des Saints: c'est de moi qu'il s'agit dans ce portrait" (pl. 63), Picabia selects the motif of an automobile horn, superimposed on what appears to be a piston or combustion chamber. The black and white shading of the horn reduces it to a silhouette, aligned on a vertical axis with the cutaway section of the piston. As in Picasso's 1912–1913 *Violin* (pl. 58), the cubist grid contracts to a self-enclosed arrangement

fig. 79 LUCIAN BERNHARD
Bosch, 1914
lithograph
The Museum of Modern Art, New York,
Gift of the Lauder Foundation

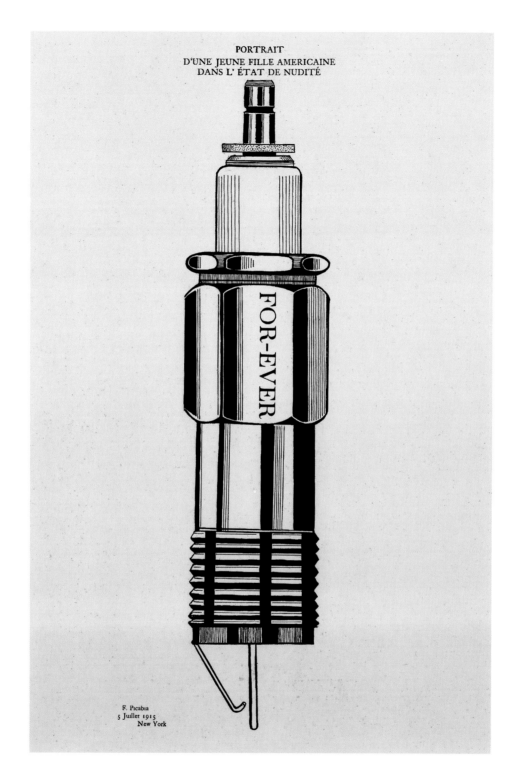

PORTRAIT
D'UNE JEUNE FILLE AMERICAINE
DANS L' ÉTAT DE NUDITÉ

FOR-EVER

F. Picabia
5 Juillet 1915
New York

62 FRANCIS PICABIA
Portrait of a Young American Girl in
a State of Nudity
REPRODUCED IN 291, NOS. 5–6, JULY–AUGUST 1915

of vertical and horizontal lines, accented by occasional curves. The symmetrical, rectilinear character of the composition contrasts strongly with the asymmetrical, curvilinear character of the earlier *This Has to Do With Me* (pl. 61).

Picabia's *Portrait d'une jeune fille américaine dans l'état de nudité* (pl. 62) strips away even the remnants of the grid to focus obsessively on the outline of a spark plug. Gabrielle Buffet interpreted this as a generalized portrait of the "American Girl," a "kindler" of erotic "flames." William Innes Homer argued that it was, instead, the portrait of a specific individual: Agnes Meyer, whose intelligence, initiative, and wealth provided the spark that set *291* in motion. Willard Bohn combined these interpretations, arguing that the spark plug was meant to mock Meyer as a flirt or *allumeuse*.[44] It cannot be said, however, that the spark plug is a conventionally feminine or seductive object. On the contrary, it resembles a kind of mechanical phallus, something that might have been invented by Jarry. Picabia seems to be suggesting that the American girl, beneath her feminine exterior, is essentially masculine or sexless.

This, at least, was the meaning that a contemporary critic garnered from the image. In October 1915, when the Modern Gallery opened, its organizers sent out copies of *291* as a kind of aesthetic manifesto. Reviewing the publication for the *Evening Sun*, Robert J. Cole responded irritably to Picabia's "Patent Office diagram or design of a straight cylinder with bolts and washers firmly placed.... This may be intended to show that the young American girl is a hard, unchangeable creature without possibilities. If that is the meaning a good portrait of one would show the same thing clearly and with a thousand times the force." Stiffness and endurance might have been admirable characteristics in a man, but a girl was clearly supposed to be more pliable.[45]

Phallic symbolism plays an even more important role in Picabia's *Ici, c'est ici Stieglitz* (pl. 59), which depicts a camera, supplemented with an automobile's gearshift and brake lever. Noting that the camera's bellows is broken, the gearshift is set to neutral, and the brake lever to park, critics have interpreted the image as a symbol of exhaustion. Wanda Corn, for instance, writes: "Representing Stieglitz as a driving and seeing machine, a visionary, Picabia also represented him as aging and exhausted, the phallic bellows of the Kodak camera having lost its erection."[46]

The symbolism of the drawing is more complex than critics have recognized. Comparison between Picabia's drawing and its source (an advertisement for a "Vest Pocket Kodak") reveals that the scissor hinges supporting the lens plate have stretched out to twice their usual height, presumably in pursuit of the "Ideal" inscribed at the top of the drawing.[47] The phallic symbolism of these hinges is underscored in Picabia's 1918 drawing *Cantharides* (i.e., "Spanish Fly"), where they

reappear, labeled "Ardor" and "Organ" (fig. 80). Evidently, the fabric bellows in *Ici, c'est ici Stieglitz* has collapsed because it has torn loose from the unnaturally extended lens plate. This contrast between the virile lens plate and the impotent bellows may correspond to the divided assessment of Stieglitz's achievement in an editorial by de Zayas, published in the same issue of *291*. Here, de Zayas credits Stieglitz with bringing still photography "to the highest degree of perfection," but laments that he has failed in his parallel effort to improve American taste by importing "works capable of serving as examples of modern thought plastically expressed."[48]

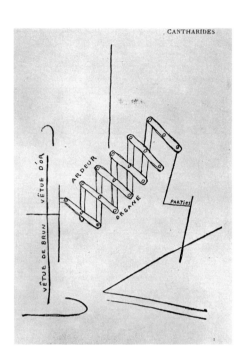

fig. 80 FRANCIS PICABIA
Cantharides, 1918
published in Francis Picabia, Poèmes et dessins de la fille née sans mère, *Lausanne, 1918*

Looking back over Picabia's development, it becomes apparent that there is something distinctly misleading about his October 1915 statement that "this visit to America" had brought about a "revolution" in his art, inspiring the idea of a new machine style.[49] The experience of New York had indeed influenced his art, but in 1913 rather than 1915. The roots of his machine style lay as much—if not more—in the French art of Duchamp, Picasso, and Braque as in the direct experience of American industry and technology. The artistic breakthrough of 1915 did not have to do with machines, per se, but with the recognition that they could be reproduced in a "masculine" language of hard-edged realism and rectilinear abstraction, instead of a "feminine" language of biomorphic metaphor and curvilinear decoration.

The machine drawings published in *291* inaugurate the most original and productive phase of Picabia's career, extending from 1915 until roughly 1920. The first exhibition of his work in this new style took place in January 1916, not at 291, but at the Modern Gallery, founded by de Zayas, Meyer, and Haviland in collaboration with Picabia and his wife. The New York critics agreed, for the most part, that the work was amusing and even beautiful—but not art. Only Henry McBride, in the *Sun*, spoke out in favor of it, after some hesitation, arguing that it represented an honest expression of the industrial reality of life in New York City.[50] By this time, Picabia had left New York. Although he returned for several months in 1917, his close bond with Stieglitz was never reestablished.[51]

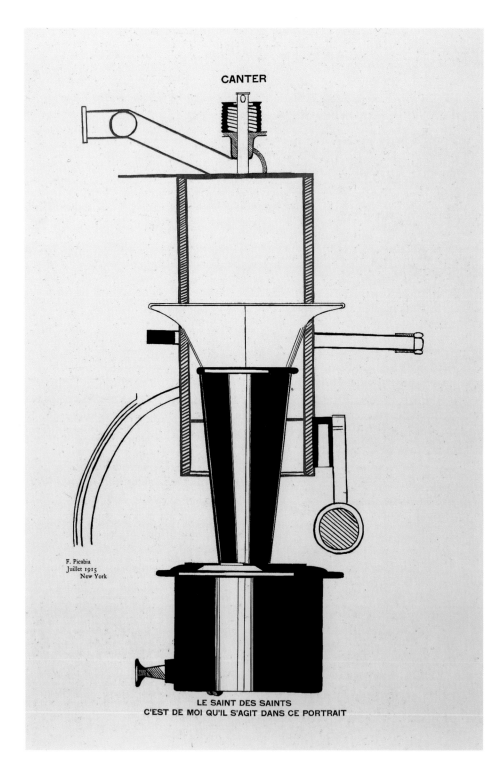

CANTER

F. Picabia
Juillet 1915
New York

LE SAINT DES SAINTS
C'EST DE MOI QU'IL S'AGIT DANS CE PORTRAIT

63 FRANCIS PICABIA
The Saint of Saints/ This is a Portrait
About Me
REPRODUCED IN 291, NOS. 5–6, JULY–AUGUST 1915

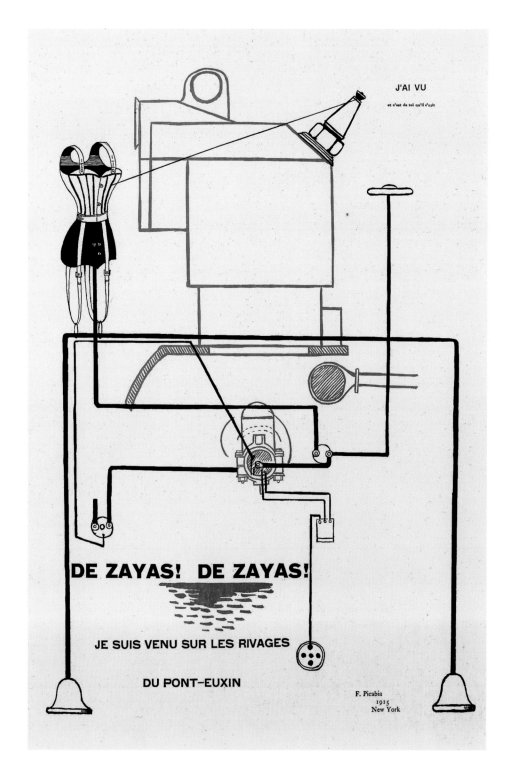

64 FRANCIS PICABIA
De Zayas! De Zayas!
REPRODUCED IN 291, NOS. 5–6,
JULY–AUGUST 1915

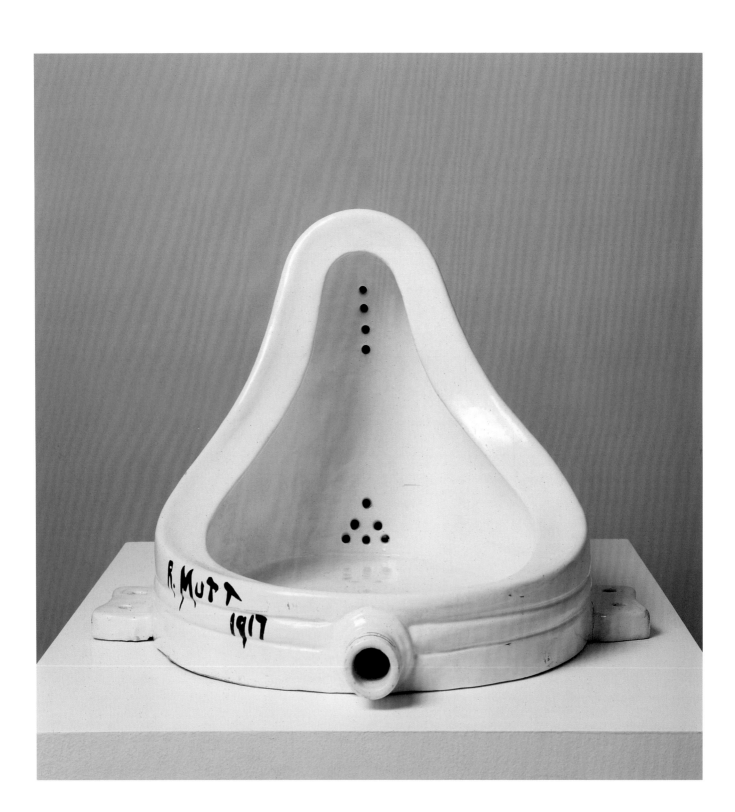

Pepe Karmel

MARCEL DUCHAMP, 1917

THE NOT SO INNOCENT EYE

L ike Marcel Duchamp himself, the history of *Fountain* (pl. 65) is both simple and baffling. Resident in New York since 1915, Duchamp had been enlisted in fall 1916 as the only European on the board of directors of the newly organized Society of Independent Artists. The chief purpose of the Society was to mount an annual exhibition, open to any artist willing to pay the modest dues. The exhibition would thus escape the old-fashioned prejudices of the jury at the National Academy of Design. Applications flooded in. By the time the first exhibition opened, on 10 April 1917, the Society had twelve hundred members and more than two thousand works on display.[1]

Despite the rules of the Society, one submission had not been included in the exhibition. A sculpture entitled *Fountain*, supposedly submitted by a Philadelphia artist named R. Mutt, proved upon inspection to be nothing more than a white porcelain urinal. The painter George Bellows, on the organizing committee of the Society, proclaimed that it was "indecent" and could not be shown. Another committee member, the collector and patron Walter Arensberg, responded: "A lovely form has been revealed, freed from its functional purpose, therefore a man clearly has made an aesthetic contribution.... This Mr. Mutt has taken an ordinary object, placed it so that its useful significance disappears, and thus has created a new approach to the subject." Bellows was outraged. "You mean to say, if a man sent in horse manure glued to a canvas that we would have to accept it?" (Bellows' question seemed equally relevant three-quarters of a century later, when the exhibition of a canvas with elephant manure glued to it aroused a major controversy in New York City.) "I'm afraid we would," Arensberg

65 MARCEL DUCHAMP
Fountain, *1917 (1964 edition)*
original ready-made
FIRST EDITION EXHIBITED AT
291, 1917

responded, but the committee as a whole disagreed. *Fountain* was taken off display, and Duchamp and Arensberg resigned in protest from the board of the Society.[2]

Fountain was quickly removed to 291, where it seems to have been on display for a week, in the course of which Stieglitz took the eloquent photograph (pl. 67) that became the point of reference for all future discussion of the work (especially after the original object was lost).[3] Exactly why Stieglitz came so readily to Duchamp's assistance is not clear. In fact when Duchamp first arrived in New York, Stieglitz pronounced him a "charlatan," while Duchamp, for his part, recalled that Stieglitz "didn't amuse me much." Stieglitz was too much the philosopher—"a sort of Socrates." If Stieglitz and Duchamp had become friendly by 1917, it was because they were both mandarins: connoisseurs who held back from the hurly-burly around them.[4]

Stieglitz's photograph was published in the May 1917 issue of *The Blind Man* (pl. 66), a small journal created by Duchamp, Beatrice Wood, and Henri-Pierre Roché as a vehicle for discussion of the Indepedents' exhibition. *Fountain* was defended in an unsigned editorial on "The Richard Mutt Case"; in an essay by Louise Norton on "The Buddha of the Bathroom"; and in a poem, "For Richard Mutt," by the painter Charles Demuth. Yet the identity of the artist remained mysterious. Duchamp was ready to defend the object, but curiously reluctant to take credit for it.[5] Purchased by Walter Arensberg, the original *Fountain* was subsequently lost, and it might be said that Duchamp did not really acknowledge his paternity until 1950, when he authorized Sidney Janis to "remake" the work by selecting a new urinal for an exhibition. New urinals stood in for the "original" on several occasions in the 1950s and 1960s, and in 1964 Duchamp authorized an edition of "replicas" based on Stieglitz's 1917 photograph.[6]

In 1966 Duchamp finally explained some of the circumstances of the work's creation, saying that the pseudonym "R. Mutt" had been inspired by J. L. Mott Iron Works, a large manufacturer of "sanitary equipment." Finding this too obvious, however, he had modified Mott to Mutt. (The latter name was familiar from the popular comic strip, "Mutt and Jeff.")[7] In 1970, Duchamp further explained that the idea for *Fountain* had come to him while talking with two friends, Walter Arensberg and Joseph Stella, and that the three of them had immediately gone in search of a urinal.[8]

It is clear that the *Fountain* was selected and submitted as a test of the Society's commitment to its founding principles—a test the Society flunked.[9] What is less clear is the artistic or philosophical significance of the object in itself. As William Camfield points out, Duchamp's later accounts are not completely in accord with his statements and actions in 1916. In the 1960s, he stressed the non-aesthetic nature of the *Fountain* and his other ready-mades. "I threw the bottle-rack and the urinal into their faces as a challenge and now they admire them for their beauty," he remarked scornfully.[10] In 1917, however, the *Fountain*'s beauty was Duchamp's point. The

Fountain by R. Mutt Photograph by Alfred Stieglitz

THE EXHIBIT REFUSED BY THE INDEPENDENTS

THE BLIND MAN

The Richard Mutt Case

They say any artist paying six dollars may exhibit.

Mr. Richard Mutt sent in a fountain. Without discussion this article disappeared and never was exhibited.

What were the grounds for refusing Mr. Mutt's fountain:—

1. Some contended it was immoral, vulgar.

2. Others, it was plagiarism, a plain piece of plumbing.

Now Mr. Mutt's fountain is not immoral, that is absurd, no more than a bath tub is immoral. It is a fixture that you see every day in plumbers' show windows.

Whether Mr. Mutt with his own hands made the fountain or not has no importance. He CHOSE it. He took an ordinary article of life, placed it so that its useful significance disappeared under the new title and point of view—created a new thought for that object.

As for plumbing, that is absurd. The only works of art America has given are her plumbing and her bridges.

"Buddha of the Bathroom"

I suppose monkeys hated to lose their tail. Necessary, useful and an ornament, monkey imagination could not stretch to a tailless existence (and frankly, do you see the biological beauty of our loss of them?), yet now that we are used to it, we get on pretty well without them. But evolution is not pleasing to the monkey race; "there is a death in every change" and we monkeys do not love death as we should. We are like those philosophers whom Dante placed in his Inferno with their heads set the wrong way on their shoulders. We walk forward looking backward, each with more of his predecessors' personality than his own. Our eyes are not ours.

The ideas that our ancestors have joined together let no man put asunder! In *La Dissociation des Idées*, Remy de Gourmont, quietly analytic, shows how sacred is the marriage of ideas. At least one charm-

ing thing about our human institution is that although a man marry he can never be *only* a husband. Besides being a money-making device and the *one* man that *one* woman can sleep with in legal purity without sin he may even be as well some other woman's very personification of her abstract idea. Sin, while to his employees he is nothing but their "Boss," to his children only their "Father," and to himself certainly something more complex.

But with objects and ideas it is different. Recently we have had a chance to observe their meticulous monogamy.

When the jurors of *The Society of Independent Artists* fairly rushed to remove the bit of sculpture called the *Fountain* sent in by Richard Mutt, because the object was irrevocably associated in their atavistic minds with a certain natural function of a secretive sort. Yet to any "innocent" eye

fig. 81 EDWARD WESTON
Excusado, 1925
gelatin silver print
Collection Center for Creative
Photography, The University of
Arizona, Tucson

unsigned editorial in *The Blind Man*, endorsed if not written by Duchamp, rejected the argument that the work was not art because it was plumbing, insisting grandly that "The only works of art America has given are her plumbing and her bridges."[11] In the same issue of *The Blind Man*, Louise Norton wrote that despite the *Fountain*'s associations with bodily functions, "to any 'innocent' eye how pleasant is its chaste simplicity of line and color!" For Norton, it recalls a "lovely Buddha" or a nude by Cézanne. Similarly, Walter Arensberg, at the Independents, had defended the object by saying that "a lovely form has been revealed, freed from its functional purpose."

The photographic response to *Fountain* also underscored its figurative character. As Camfield notes, Stieglitz seems to have chosen Marsden Hartley's 1913 canvas, *The Warriors* (pl. 68), as a backdrop for his photograph (pl. 67) precisely because the nichelike configuration of the painting would echo and emphasize the Buddha-like contours of the object on its pedestal.[12]

Richard Whelan points out that Edward Weston photographed a toilet bowl in 1925, and cites his comment: "Here was every sensuous curve of the 'human form divine' but minus imperfections" (fig. 81). Weston may or may not have been familiar with Stieglitz's photograph of the *Fountain*, but his commentary would apply equally well to it.[13] Wanda Corn goes even further, arguing that Stieglitz "photographed the urinal as Duchamp himself might have most enjoyed it, as a sexualized body."[14]

Indeed, the association between urinal and body may not be completely serendipitous, but may, rather, reflect the misogynist viewpoint reflected in a note in Duchamp's diaries for 1914: "—one only has: for *female* the public urinal and one *lives* by it." As Camfield observes, this "transforms an object for use by males into a female, uterine-like shape which receives injections of a male fluid."[15] Conversely, it transforms the sexual relationship between man and woman into a bodily function akin to the discharge of waste products into a convenient receptacle—a receptacle, furthermore, available indifferently to the first passer-by. Duchamp's comments recall his frequent representations of sex as a dehumanized, mechanical activity in works such as his 1912 *Bride* and his 1913 *Chocolate Grinder*.[16]

Fortunately, the historic significance of the *Fountain* resides not in its iconography, but in the actions that transform it from utilitarian object to artistic statement. The first of these is the selection—the act of choosing one particular object from the infinite universe of potential ready-mades. The second is the decision as to a particular mode of display. Stieglitz's photograph shows the urinal lying on a pedestal. It is, in effect, seen lying on its back, rotated 90° from its normal position when bolted to a wall. On other occasions, Duchamp displayed it suspended in space, hung on strings or wires. At the Independents, however, it was supposed to be displayed on a pedestal,

as in Stieglitz's photograph.[17] As Camfield notes, the unsigned editorial in *The Blind Man* stresses the fact that the artist "took an ordinary article of life [and] placed it so that its useful significance disappeared under the new title and point of view."[18]

Duchamp's aesthetic strategy here is both completely novel and surprisingly familiar. The idea of defamiliarizing and hence aestheticizing an object by looking at it from an unusual point of view had a long history. Nineteenth-century scientists such as Heinrich Helmholtz and Ogden Rood had suggested that a purely visual impression of the landscape could be obtained by looking at it upside down, so that its three-dimensional aspects became unrecognizable.[19] The impressionists adopted this as an explicit goal. Claude Monet, for instance, told an American painter to "try to forget what objects you have before you, a tree, a house, a field or whatever. Merely think here is a little square of blue, here an oblong of pink, here a streak of yellow, and paint it just as it looks to you, the exact color and shape."[20] A generation later, Wassily Kandinsky recalled returning to his studio one day at dusk and discovering a mysterious abstraction: "Suddenly I saw an indescribably beautiful picture drenched with an inner glowing.... I rushed toward this mysterious picture, of which I saw nothing but form and colors, and whose content was incomprehensible.... It was a picture I had painted, leaning against the wall, standing on its side."[21]

Similarly, Louise Norton's comment that the *Fountain* will reveal its "chaste simplicity of line and color" to any "innocent" eye conceals an implicit reference to a famous passage from John Ruskin: "The whole technical power of painting depends on our recovery of what may be called the *innocence of the eye;* that is to say, of a sort of childish perception of these flat stains of colour, merely as such, without consciousness of what they signify."[22] The innocence required of the viewer of the *Fountain* is not simply moral, but phenomenological, and it is a new "point of view" that allows the observer to attain it. Like Kandinsky before him, Duchamp achieved this innocence by turning his work—albeit intentionally, not accidentally, and in three dimensions, not two.[23]

Duchamp's disdain for merely "retinal" art is well known, so it may come as a surprise to find him relying on a strategy developed to serve the ideal of pure opticality. However, the recognition of Duchamp's intellectual indebtedness serves to clarify his central insight that the impressionist ideal of defamiliarization could be detached from the medium of painting and applied directly to objects in the real world. By displacing an object from its usual setting and orientation, the artist could focus the viewer's attention on its symbolic potential rather than its quotidian function. Without ceasing to be an object, it would also become a sign. This was an insight so brilliant that modern art required nearly fifty years to absorb it. But it is scarcely an exaggeration to say that contemporary art, from Robert Rauschenberg and Jasper Johns onward, depends on Duchamp's invention of the ready-made.

67 ALFRED STIEGLITZ
Marcel Duchamp, Fountain, *1917*

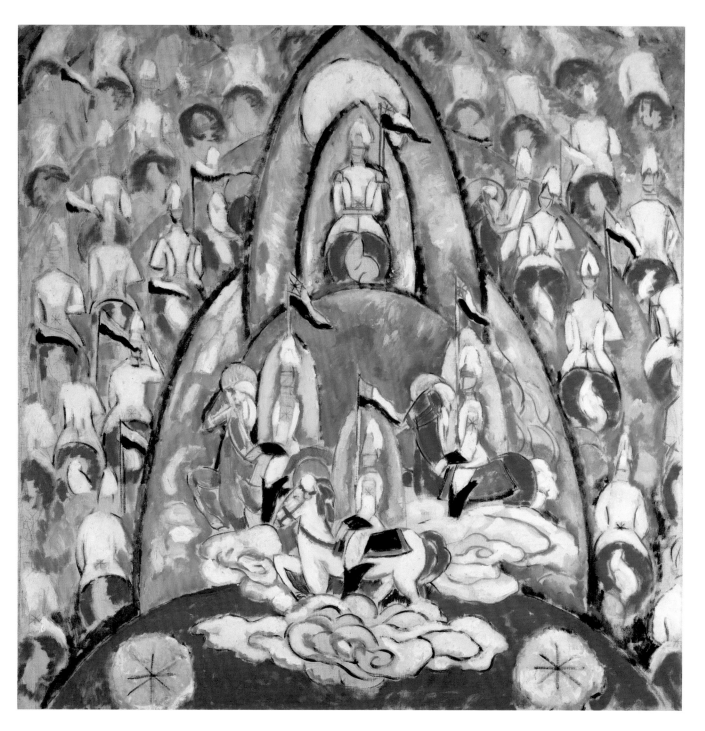

68 MARSDEN HARTLEY
The Warriors, *1913*
EXHIBITED AT 291, 1916

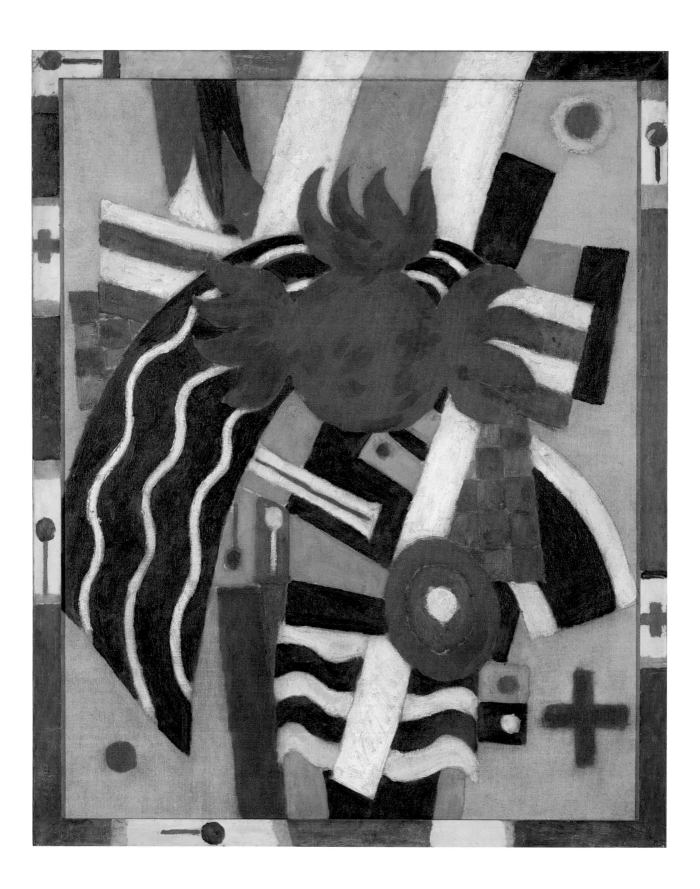

Bruce Robertson

MARSDEN HARTLEY, 1916

LETTERS TO THE DEAD

I n 1916, Marsden Hartley exhibited his Berlin paintings at 291, marking the culmination of the first phase of his career. Some forty paintings were on view, the record of an astonishing period of invention and inspiration from his first long sojourn in Europe. Hartley's exhibition, it may be argued, represented the most complex and confident American response to the new art in Europe, the one that was most a meeting of equals. Georgia O'Keeffe recalled that the effect of the paintings was overwhelming, "like a brass band in a small closet."[1] But the exhibition was also a record of the relationship between Hartley and Stieglitz, which had begun in 1909, when, just days after first seeing his paintings, Stieglitz had offered him an exhibition at 291. This demonstrable faith in his art, in the cultural capital of the country, by the most magnetic art figure in the city, created for Hartley a bond of trust and a faith in Stieglitz that was never to dissipate.

In 1912, using Stieglitz's contacts as well as a few from his student days, Hartley went to Paris. There his painting quickly developed from imitations of Matisse, to assimilations of Picasso's newest cubism and the work of Kandinsky. But for Hartley, an ambitious artist, Paris was too crowded, and from the very first he wanted to stand out. Understanding that he would cut a more interesting figure in Germany, where he would be one of the few Americans, he moved to Berlin.

While in Paris, Hartley had begun to explore "subliminal or cosmic cubism," a free-floating mysticism intended to translate music (or other non-material inspiration) into visual images. The "spiritual illuminations" that prompted the new work made them distinctly like what Kandinsky and Franz Marc were doing in Germany; indeed, as he wrote to

69 MARSDEN HARTLEY
The Aero, *1914*
EXHIBITED AT 291, 1916

Stieglitz, "My first impulses came from the mere suggestion of Kandinsky's book the spiritual in art."[2]

After meeting Kandinsky and Marc, however, Hartley immediately changed tack. In Berlin, he promoted himself as someone bringing the latest styles to the city. At the same time, his art became increasingly orderly and concrete. This initial development was brought to a halt when he returned to New York at Stieglitz's insistence: Stieglitz, like any good dealer, wanted Hartley to promote himself back home. In mid-November of 1913, complaining, Hartley sailed for America, but returned to Berlin at the end of April 1914. He remained in Berlin until the end of 1915—a full year and a half—and it is this second period of European work that formed the basis of his exhibition at 291.

Hartley had done no painting in America, and was relieved to pick up his brushes: "I am at work now on a large scale again and it seems good and quite novel to be actually wielding pigment—I want so strongly now a long season of creative effort and hope that much can be accomplished."[3] Though constantly complaining of isolation, he networked assiduously: "Now I am prepared for any connections that may be made ... but for now I want to keep free of all ideas of exhibitions as much as possible."[4] Stieglitz supported the decision: "I do hope you will finally connect in Germany. America supporting abstraction in the near future seems impossible."[5] Hartley's initial works were variations on those of the previous year, but simplified and more solid. "I know you will all be interested in what I have to show— a direct continuance of what I had on a bigger and simpler scale."[6] But even as he refined his work, he embarked on a different series, one inspired by Native American art. These "Amerika" paintings, as he called them, set out symmetrically and hieratically signs of Indian culture: eagles, tepees, chiefs in war bonnets. Mixed in with these stereotypical figures are more subtle signs, culled from his study of Native American artifacts in the Trocadéro and the Museum für Völkerkunde. Symmetry and legibility were desirable as the subject was unfamiliar to German audiences, and because Hartley had nothing to hide. The paintings were an overt statement of his mental affiliation with Indian spirituality, something willed rather than spontaneous, and relatively external to his private life.

As war fever developed, the Amerika paintings were put aside and Hartley began making images that were clearly pro-German, also designed to be legible to his audience. His initial reaction to the war, as he wrote Stieglitz at the end of July, was of "a stillness which is too appalling ... many people in a stifling still expectancy— a psychic tension which is superb and awesome."[7] *Portrait Arrangement* (fig. 82), for example, spells out both the tension and the expectancy in its regimented arrangement of explicitly German motifs.

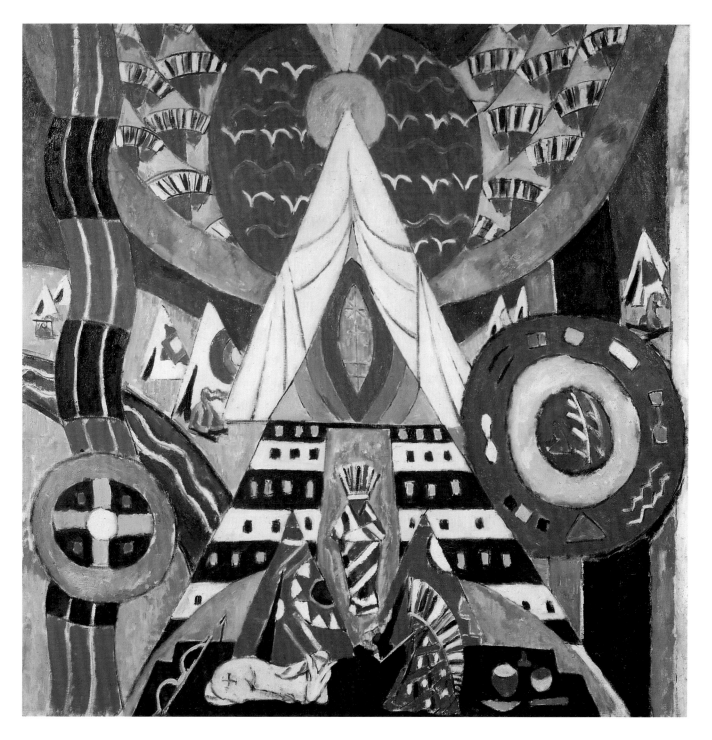

Indian Composition, *c. 1914—1915*
EXHIBITED AT 291, 1916

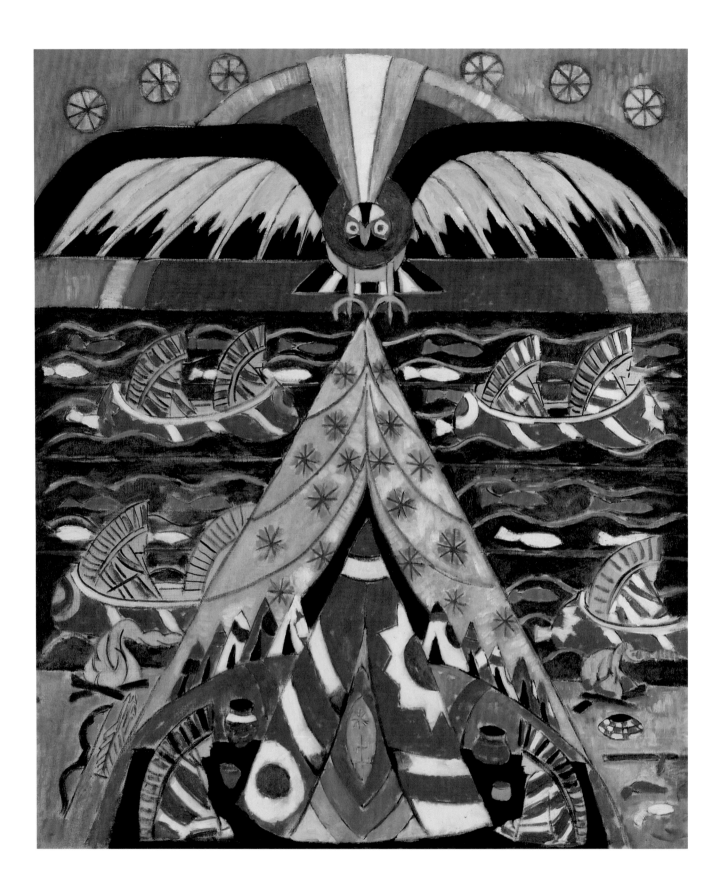

fig. 82 MARSDEN HARTLEY
Portrait Arrangement, *1914*
oil on canvas
Collection of the McNay Art Museum, San Antonio, Texas;
Museum Purchase
POSSIBLY EXHIBITED AT 291, 1916

71 MARSDEN HARTLEY
Indian Fantasy, *1914*
EXHIBITED AT 291, 1916

Throughout this period Hartley continued to be concerned with visionary art. During the summer of 1914, he began a set of essays "On the Decline of Vision." He distinguished between artists who were visionaries of the material (Picasso) and the spiritual (himself), while maintaining that the true visionary "is beyond any help that nature can offer him—what he sees is superior to what is seen above and beyond what nature presents. It is he who actually shapes the 'soul' of nature for us and for the universe."[8] Just as the war was about to begin, Hartley saw the artist's vision as constructive, able to shape the world we experience.

Two months later the casualties began arriving, and by the fall his friend Karl von Freyburg was among the dead: "It is difficult to go on from day to day under this pressure—in general gloom of continuous dark weather and the war.... Lieut. Von Freyburg...went to a sudden death Oct 7th and lies in a war grave in the region of Arras, near Amiens."[9] Freyburg, declared Hartley, was irreplaceable: "There never was anywhere a man more beloved and more necessary to the social well-being of the world—in every way a perfect being—physically—spiritually and mentally beautifully balanced.... This is for me the most heart-rending phase of the war."[10]

Hartley's immediate reaction to the news was a dream vision, one he recorded much later in one of his "Letters to the Dead," addressed to Freyburg. In the dream, he was crossing a landscape during a thunderstorm. A lightning bolt hit a white snake (the two forms are similar) and a surge of white light illuminated Hartley's right side. In this light "there appeared a full-length image of yourself clad in full uniform but the uniform purged of all military significance was white."[11]

For Hartley, all the horror of the war was symbolized in one body, that of Frey-burg, and his task as an artist was to create concrete paintings out of the vision. The first of these works, a memorial to his friend, embodies the dream: Freyburg is presented full-length in Hartley's largest painting, *Portrait of a German Officer* (pl. 75). Of all the military paintings, it is the one in which Hartley is most reluctant to fragment the figure. Despite the dematerialized form of the vision, the painting is an homage to Freyburg's body, the hips and pelvis marked by the tassels and helmet, the chest framed by the flag, and, hugely oversized, Freyburg's Iron Cross centered

at the top, a testament to his bravery and purity. Two other paintings mark what is deliberately excised from this vision: Freyburg's head and face. If in the memorial painting Hartley is reluctant to really "see" him face to face, *Painting No. 47, Berlin* (pl. 73) and *Painting No. 49, Berlin* (pl. 72) place the helmet at the center of the painting: if not the face, then at least its sign. But after these paintings, the rest of the series quickly becomes more generalized. Not Freyburg's body, but all the signs of war are captured in Hartley's vision. The elements remain the same but the placement on the canvas is no longer centered on a body but on a scene, one that is both celebratory and tragic.

Five months later, Hartley was still mourning. "For many weeks I could not do anything or write anything," he wrote to Stieglitz in March.[12] His depression, however, was not just from the war and Freyburg's death so much as his money troubles: the onset of the war had disrupted all financial transactions and Stieglitz's drafts were not getting through. His letters are full of anxiety and at the end of October, just weeks after Freyburg's death, he had written: "I am living under conditions that destroy all attention to work—and lack of money prevents me from even buying paint."[13]

The paintings he produced in reaction to the war thus reflect several things. One, obviously, is the horror of war itself, but another is the daily reality of the situation. The scale of *Portrait of a German Officer* is all the more remarkable and even more a testimony to the significance of Freyburg as the generative core of these paintings, given what we know about Hartley's material circumstances: investing in a canvas of this size involved begging and borrowing money from his friends. Hartley's dominating ambition was also reflected in these paintings. Only a month after he heard of Freyburg's death, he was able to boast to Stieglitz: "I have perfected what I believe to be pure vision and that is sufficient. Then too I am on the verge of real insight into the imaginative life which is I am certain to produce important things. I am no longer that terror stricken thing with a surfeit of imaginative experience undigested.... Just now the themes are teutonic. I hope later to get other experiences. Then I shall also return to my ideas and sensations upon the word Amerika."[14] As this last word suggests, the military paintings are built on the work that preceded them.

By March 1915, Hartley was satisfied with his progress. As he wrote to Stieglitz: "I work and live and live and work and what I haven't on canvas I have inside of me which only I can value most. I have loved the long siege of freedom. I am having the real chance to create myself and swing rightly into the true sway of the universe. I have achieved a nearness to the primal intention of things never before accomplished by me."[15] By this point, however, Stieglitz was urging him to return to

72 MARSDEN HARTLEY
Painting No. 49, Berlin
(Portrait of a German Officer
or Berlin Abstraction),
1914–1915
EXHIBITED AT 291, 1916

the United States. Hartley insisted on staying, hoping that the war would end and that he would have a big break. It seemed he would: he sold four paintings to a young German couple, and then landed a large show at Munchener Graphik-Verlag, which he called the 291 of Germany.

The reaction to the show was largely negative, but gratifyingly so. It aroused opposition and condemnation, and confirmed Hartley's status as one of the most radical artists in Germany. Discussing the reaction to his exhibition, he declared: "They are really only getting Cubism into their system and now here is someone revolting and swing[ing] back to caveman expression."[16] This is the clue to his vision: it is primal, "caveman expression." Hartley's reaction to the war was to look for the roots beneath it and to evoke basic, unconscious responses. The "brass band" metaphors used by so many critics are not inappropriate. Musical analogies in Hartley's work in this period need be considered. In his first abstract paintings done in Paris, he had made references to Bach preludes and fugues, and oriental symphonies: music that was serious, clear, and even otherworldly. The music of the military paintings, however, is loud, chaotic, crude. It is music designed to keep men marching in order, and through its repetitive, propulsive rhythms and deafening sounds makes individual men into soldiers—and allies the civilian audiences with that ideal. These are paintings aimed at the Berlin public, but this effort to shake up the German art scene was doomed because of the war. Hartley finally had no more excuses for staying and left for New York shortly after his show closed in Berlin. He brought with him only *Portrait of a German Officer*; the rest of his German work followed later.

Hartley's first show in the States was supposed to have been at 291, in February, but it had to be postponed because the paintings had not arrived. Instead, his first New York appearance, at Anderson Galleries in the Forum Exhibition, was of work he had completed since his return.

The real event, however, was the exhibition in April at 291. Hartley set out his goals in a statement that allowed him to simultaneously advance his pictures as European works while distancing himself from their content. The paintings had been done in the last two years, he wrote, "the entire series forming my first one-man show in Europe." He then excused their subject: "The Germanic group is but part of a series which I had contemplated of movements in various areas of war activity." As the only areas of war activity he had had a chance to see were in Germany, and as right from the start he was aware of how Germany was portrayed in the American press, it is not surprising that even while making the statement he was retracting it. "The forms are only those which I have observed casually from day to day. There is no hidden symbolism whatsoever in them.... Things under observation. Just pictures of any day, any hour." In other words, by calling things "observed

casually" he claimed the objectivity of a journalist, and the interest due anyone reporting on wartime conditions in what was almost enemy territory. He stressed the point further: "They are merely consultations of the eye—in no sense problem[s]; my notion of the purely pictural [sic]." By this point his protestations suggest that he was well aware of the problem on his hands.

Despite this, the press treated him gently. Reviewing the show in Berlin, a *New York Times* reporter had gotten straight to the point: were the paintings pro- or anti-German? In New York, to a surprising degree, the war associations were downplayed. Robert J. Cole, writing for *The Evening Sun*, quoted Hartley's claim to objectivity but concluded that the work did present a problem. Fortunately they were pictorial ones for the viewer to solve, who was advised to "enjoy the good color combinations of flags and checker boards."[17] Oddly, the not-very-obvious fish in the Amerika paintings caught the reviewer's eyes—in order to make a joke about Hartley loving "fish and waves undisturbed by submarines." Cole pondered why the "soldier pieces" produce no effect of "the strife and destruction of battle," and then realizes that it is because the "very modern artist has gone back to the glory of chivalry" and produced "Heraldic Devices," as the review is entitled. Tongue in cheek, he concludes that he is doing just what Hartley forbade him to do, "going back of the facts he 'observed casually.' " In this way Cole understands the fundamentally celebratory nature of the military imagery but defuses it.

The *American Art News* is equally clear about the content: "The Martial Spirit of Hartley," the review is entitled. The reviewer seems to have been guided through the exhibition by Hartley and explicitly understands the progression of the paintings, from the views of military pageantry preceding the war to the "works which by inanimate objects … recall events such as the death of an officer friend and the death of a charger, who is apotheosized in a horse's heaven."[18] The reviewer sympathetically skirts the potential impact of the content on a pro-Allies American public: "Full of gay color and the splendor of war in its brightest aspects are the recent decorative arrangements in paint by Marsden Hartley." Instead the reviewer tries to suggest Hartley's broad-mindedness. Despite the fact that Hartley's Berlin exhibition had upset some German critics, "Hartley most evidently was much impressed with the German army." (The reviewer has also read the *New York Times* review.) Henry McBride for the *Sun* also recommends them for their color: "Any one who takes delight in color should get the same pleasure from these canvases that one obtains from fine stained glass."[19] McBride heightens the medieval reference by comparing the color to the glass in Sainte Chapelle. At the same time, McBride understands that the content is largely military; even, in his eyes, entirely military: he takes the tepees as soldiers' tents.

74 MARSDEN HARTLEY
The Iron Cross, *1914–1915*
EXHIBITED AT 291, 1916

The review by Charles Caffin in the *New York American* is the most substantive. Remembering Hartley's work over the last eight years, he recalls both the first mountain landscapes and then the first abstract work. Now, he says, "Hartley has found his bearings, mental and emotional; and proves it in the superior organization of these later subjects, and in their purer and finer color."[20] On the other hand, while comparing the color combinations to the "clarity and resonance" of "bells and the music of brass and silver instruments," he finds them "threading the sunny air with glad and often jubilant rhythms." While thus eliding the hectic and nervous clamorousness of the paintings, Caffin nonetheless picks up the meaning of Hartley's description of them as movements. "It is shortsighted to speak of them as patterns. They are compositions ... that have grown out of and on to the rhythms of accented movement." But he ominously notes that the objects—the very military elements that "stirred the artist's consciousness"—"seem to minimize the conception; introducing a local and comparatively insignificant note." Caffin concludes: "I wish him an enhanced range of vision."

The response of artists and collectors was also mostly positive. It must have been gratifying that Arthur Davies bought one, as did the collector John Quinn, the critic Paul Rosenfeld, and the patron Mabel Dodge. Indeed, it is clear that Hartley saw himself now ready to move in a larger circle than that of Stieglitz, that he could now be somewhat independent of him. In his autobiography he wrote about his return to New York: "The next aspect of life was Mabel Dodge's salon."[21] He had been scheduled to visit her in her fabled Florentine villa, but because of the war she had left before he could do so. He spent that February, however, living at her house outside New York, working in Maurice Sterne's studio there. Hartley spent the first few months on his return moodily depressed and fussed around with draping fabric, Dodge later recalled. Eventually she threw him out because he was so depressing, but that did little to stop him from fiercely trying to attach himself to her. Indeed, he followed her to Provincetown that summer, and later stayed with her in Taos. Returning to New York, he ingratiated himself with other avant-garde circles, around the Arensbergs and Katherine Dreier, making an appearance as a dadaist.

As these shifts of locale suggest, it took some time for Hartley to find his bearings in America. Indeed, he never did throughout the war years. He expected to be able to return to Europe immediately after his show closed at 291, oblivious to everything but the need to return to Germany and his reputation in Berlin. This instability shows up in the shifts in his art, from the densely painted but simple compositions of paintings done in Provincetown in 1916, to the more fluid still lifes of Bermuda that winter, to experiments in glass painting in Ogunquit the following

summer. All of these are accomplished but none of them builds on the artistic success of the military paintings. At the same time, Hartley's efforts to broaden his European reputation also faltered. The war had come too soon; a few more years and he might have had something solid. As it was, he was just one more modernist artist trying to establish himself in an overcrowded field. Despite the prominence of patrons like Dodge and a few collectors, Stieglitz's forecast that the idea of "America supporting abstraction in the near future seems impossible" proved gloomily true. While Hartley would continue to rely on Stieglitz, his relationship was never the same. He had tasted independence and equality and would always seek it. Nonetheless, despite this straining at Stieglitz's mentorship, Hartley always returned to him. Hartley claimed that the one thing he did understand was friendship, and his nearly thirty-four-year relationship with Stieglitz is the strongest proof that he was right.

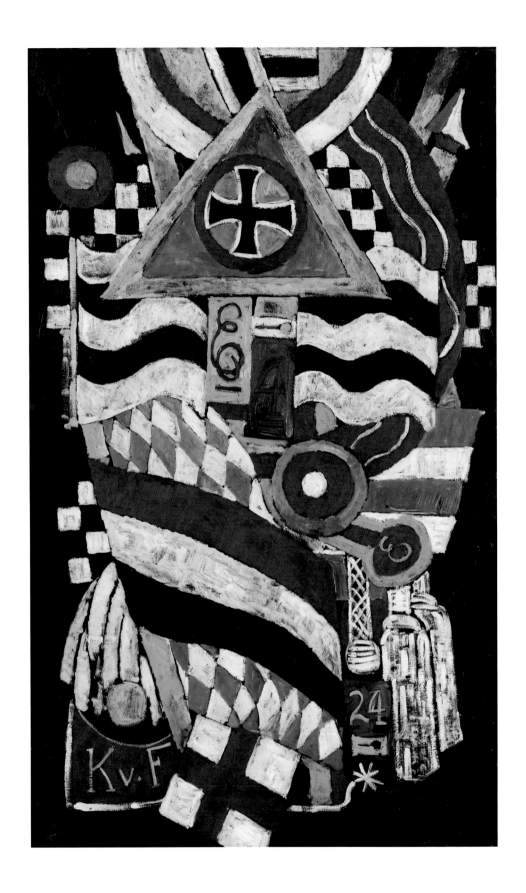

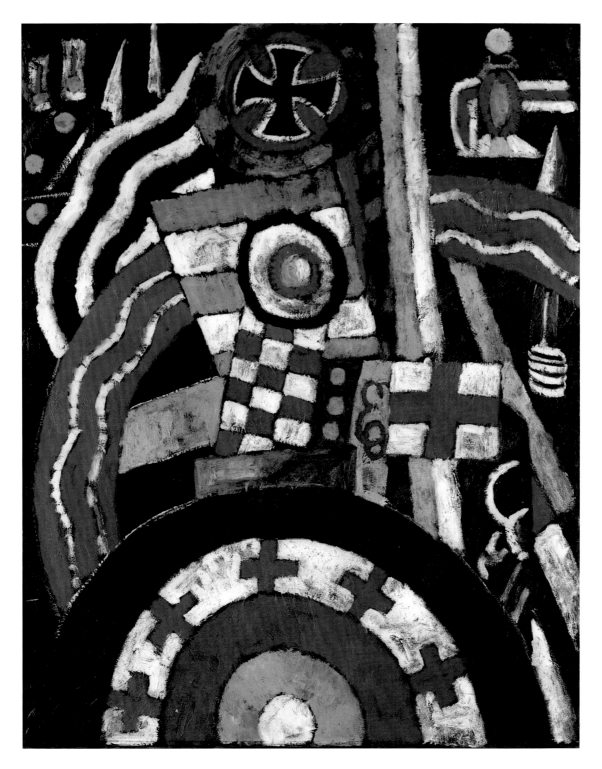

75 MARSDEN HARTLEY
Portrait of a German Officer, *1914*
EXHIBITED AT 291, 1916

76 MARSDEN HARTLEY
Abstraction (Military Symbols),
1914–1915
EXHIBITED AT 291, 1916

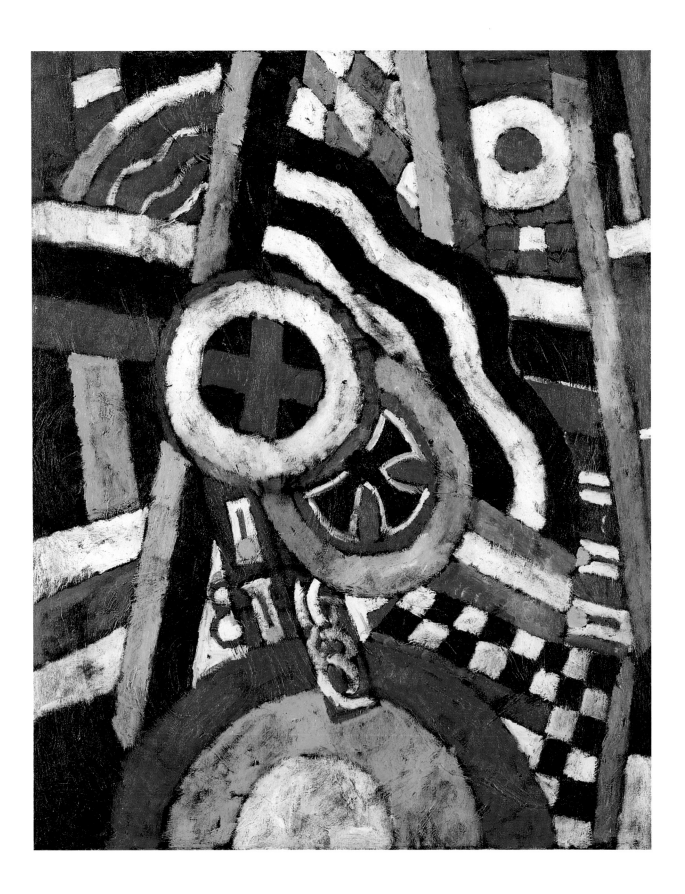

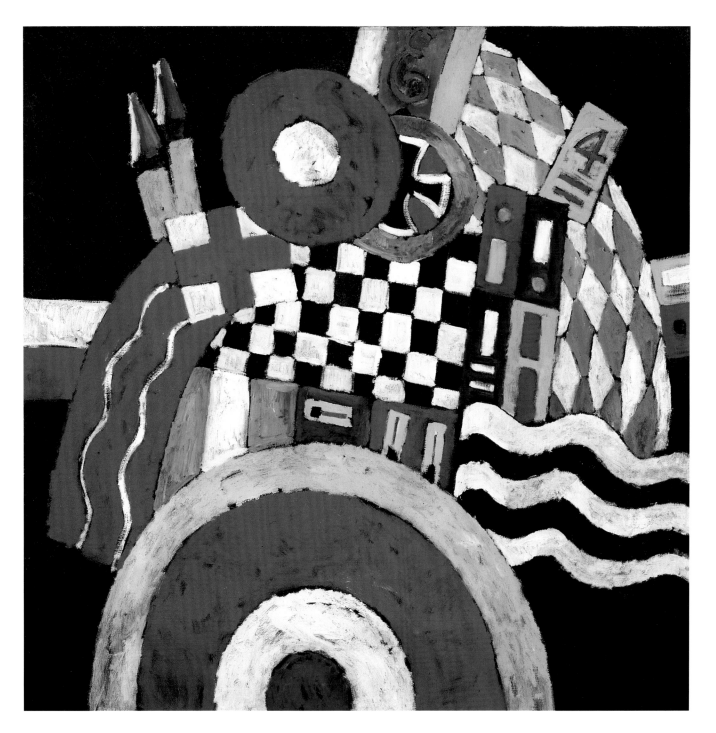

77 MARSDEN HARTLEY
Painting No. 5, *1914–1915*
EXHIBITED AT 291, 1916

78 MARSDEN HARTLEY
E. (German Officer Abstraction),
1914–1915
EXHIBITED AT 291, 1916

PAUL STRAND, 1916

APPLIED INTELLIGENCE

P aul Strand's 1916 exhibition at 291 was a curious affair. Although Stieglitz heralded it as a seminal event in American modernist photography, in fact, the exhibition, which ran from 13 March to 3 April 1916, seems to have contained a motley assortment of photographs.[1] As with so many of the 291 exhibitions, no checklist, catalogue, or installation photographs have survived.[2] Only five photographs can be said conclusively to have been shown, and only one, *City Hall Park*, is among Strand's celebrated canon from this period. The others, including *The River Neckar*, 1911 (fig. 83), *Railroad Sidings*, 1914, *Maid of the Mist, Niagara Falls*, 1915, and *Winter, Central Park New York*, 1915, have been understood as early, student work, expressive of the prevailing tenets of pictorialist photography and lacking in the sophistication and strength of his more mature art.[3] Even one of Strand's most acclaimed photographs from this period, *Wall Street*, a 1915 study of pedestrians scurrying in front of the J. P. Morgan and Company building, may not have been shown (pl. 82).[4]

Exhibition reviews also confirm that the 1916 exhibition included mostly pictorial work. Effusing over his "silvery picture of surpassing loveliness," the conservative critic Royal Cortissoz, who frequently decried the "stupidly ugly pictures" of the modernist artists, praised Strand's "noteworthy" photographs, commending his ability to find "beauty in the most commonplace objects and places."[5] Applauding his "artistic individuality," *American Photography* asserted that the exhibition demonstrated that Strand had achieved "a position of distinction among American pictorial photographers."[6] Only Charles Caffin, a member of the 291 circle, saw these works as slightly different from

79 PAUL STRAND
Bowls, *1916*
REPRODUCED IN CAMERA
WORK, JUNE 1917

fig. 83 PAUL STRAND
River Neckar, Germany, *1911*
Courtesy Galerie Zur Stockeregg, Zurich
EXHIBITED AT 291, 1916

other pictorial photographs of the time. Echoing Stieglitz's praise of Strand's "pure" or "straight" photographs, Caffin noted that he did not "tamper" with the negative or "any part of the process between the snapping of the shutter and the mounting of the picture." Praising the photographs as "wonderfully alive," he extolled their "kaleidoscopic variety" and concluded that they demonstrated "the pleasure and interest that the objective holds for us."[7] These 1916 reviews are in marked contrast to some of the sharp criticisms Strand received when his more modernist photographs *Wheel Organization* and *White Fence* were awarded second and fifth prizes in the 1918 Wanamaker exhibitions (pl. 81). Describing *White Fence*, one critic complained: "We hardly can see how more contrast, emphasis, eccentricity, and ugliness could be combined within the four sides of a print."[8]

Why, then, did Stieglitz choose to exhibit this group of Strand's photographs in 1916? For more than three years he had not exhibited photographs at 291 because he knew of "no work ... which was worthy of '291.' "[9] During this time he had presented some of the most innovative and experimental exhibitions in 291's history, including Brancusi's sculpture and African art in 1914; Picasso's, Braque's, and Picabia's paintings, drawings, and *papier collés* in 1915; and children's art in 1914 and 1915. While these exhibitions included work of great originality, Stieglitz may have needed Strand's work for other reasons. In March 1916 he wanted an exhibition of an American photographer to function, as he wrote a few months later, "as a natural foil" to the Forum Exhibition of Modern American Painters that was on view from 13 to 25 March at the Anderson Galleries in New York.[10] For more than ten years, 291 had been dedicated to fostering a dialogue between photography and the other arts, and Stieglitz had carefully orchestrated the exhibitions, alternating between presentations of paintings, photographs, sculpture, drawings, or prints so that the ideas and issues sparked by one show would be continued and enriched over time. He had also organized presentations at 291 to respond to other exhibitions in New York as well as in the larger art community. Just as he had exhibited his own work at the time of the 1913 Armory Show to demonstrate the differences between the new painting and the new photography, so too did he need to show work by a modern American photographer at the time of the 1916 Forum exhibition.[11]

Other factors may also have led to the 1916 Strand exhibition at 291. In 1915, Stieglitz's close friends Marius de Zayas and Francis Picabia had challenged his preeminent position in the American art world, calling into doubt the nature of 291's accomplishments. While de Zayas and Picabia admitted that Stieglitz was a pioneer

in the introduction of modern European art to America, he had failed, in their assessment, "to discover" American artists who truly understood the deeper significance of this work and used their knowledge to depict contemporary American life: all were, de Zayas' wrote, merely "servile imitators."[12] Moreover, urged on by Duchamp who had arrived in New York in June 1915, de Zayas and Picabia implored American artists to recognize the importance of the machine in modern life. The machine was the god of the twentieth century, they declared, and it was only through the marriage of man and machine that twentieth-century art would achieve its fullest expression.[13]

Stung by the criticism yet confident in the ability of his countrymen, Stieglitz sought modern American artists in 1915 and 1916 to refute these claims. He "discovered" two younger artists, Paul Strand and Georgia O'Keeffe, within months of each other. In the summer of 1915 Strand showed his photographs to Stieglitz and, as the younger photographer recalled many years later, Stieglitz said, "'I'd like to show these.'"[14] Strand later told an interviewer that "Stieglitz was almost embarrassingly cordial. The young man was a find, a real 'discovery'; everything must be done to make him welcome."[15] Stieglitz was equally receptive in January 1916 when Anita Pollitzer brought him drawings by Georgia O'Keeffe, who was at that time living in Canyon, Texas. Describing them as "the purest, finest, sincerest things that have entered 291 in a long while," Stieglitz excitedly proclaimed, as Pollitzer recounted in a letter to O'Keeffe, "I wouldn't mind showing them in one of these rooms one bit—perhaps I shall."[16]

Perhaps not coincidentally, Stieglitz gave Strand and O'Keeffe their debut exhibitions at 291 within a month of each other in the spring of 1916. In truth, both exhibitions were a bit premature, for many of O'Keeffe's works shown that spring were as heavily indebted to art nouveau and symbolism as Strand's were to the outmoded style of pictorialism (see fig. 86, pls. 86–87). What Stieglitz saw in both Strand's and O'Keeffe's work were possibilities, the scattered germs of thoughts that he believed, with proper direction and support, held the potential to merge a modernist vision with an expression of the American experience. He said as much about Strand when he first reproduced his photographs in *Camera Work* in October 1916. Clearly responding to de Zayas and Picabia's criticisms, Stieglitz asserted that Strand was not just a "new picture-maker," for they are "notoriously nothing but imitators of the accepted." Instead, he was an "original worker," Stieglitz declared, a "new worker.... His vision is potential."[17] Moreover, in 1916 as both Strand and O'Keeffe matured under his tutelage, Stieglitz began to promote their work as representative of what he perceived to be the fundamental differences between art by men and art by women. He extolled O'Keeffe as a naive, almost childlike, untutored

genius whose work was expressive not simply of her femininity, but more generally the physical, emotional, and even spiritual components of what it meant to be a woman. If O'Keeffe, in Stieglitz's view, was the consummate woman artist who emerged from the heartland of America, then Strand embodied all of the attributes of the male artist: he was an intelligent artist, the product of New York City—and, of course, more specifically 291—whose work was learned, tough, strong, and rational. Using clipped prose, in contrast to the more flowing and effusive phrases he used to describe O'Keeffe, Stieglitz called Strand's work "pure. It is direct. It does not rely upon trick of process." And he continued, "For ten years Strand quietly had been studying, constantly experimenting, keeping in close touch with all that is related to life in its fullest aspect.... In whatever he does there is applied intelligence."[18] As if to emphasize Strand's careful examination of 291's exhibition history, when Stieglitz reproduced his work in the October 1916 issue of *Camera Work* he included six installation photographs of shows held at 291 in the last ten years, from the 1906 presentation of German and Viennese photographs, to the 1914 shows of Brancusi and African art, and the 1915 exhibitions of Picasso, Braque, and Nadelman.

Strand was perfectly suited to the role that Stieglitz cast for him. Fiercely intent, ambitious, keenly focused, and studious, Strand at age twenty-five was eager to explore his own potential and gratified to become Stieglitz's protégé; he later described it as "like having the world handed to you on a platter."[19] First taken to 291 in 1907 by Lewis Hine, his teacher from the Ethical Culture School in New York, Strand did not become a frequent visitor to the gallery until after the 1913 Armory Show. Before then, he was much more closely associated with former members of the Photo-Secession, especially Gertrude Käsebier, Clarence H. White, and other pictorial photographers who had started meeting at the Little Book-shop Around the Corner, after 291 began to exhibit modern art.[20] Admiring their softly focused, impressionistic images, Strand embarked on what he later referred to as his "Japanese" period, making evocative, atmospheric landscapes.[21] Although he soon rejected this style, Strand nevertheless benefited enormously from the community of ideas that were shared in White's circle. From White himself, from the painter Max Weber who taught at White's photography school, and indirectly through them from Arthur Wesley Dow, Strand learned how to design, compose, and structure his photographs: he learned about the use of a tilted picture plane and layering of objects to suggest depth; about the importance of harmoniously spaced linear design; about abstract arrangements of light and dark; and about the use of strong, geometric forms.

In late 1914 or early 1915 Strand went to 291 and showed Stieglitz some of his photographs, including a landscape study, *Bay Shore, Long Island, New York,* from

fig. 84 **PAUL STRAND**
Bay Shore, Long Island, New York, *1914*
platinum print with gouache
J. Paul Getty Museum, Los Angeles
EXHIBITED AT 291, 1916

1914 (fig. 84). Because of its whip-lash line, its simplified massing of light and dark, its reliance on atmosphere, and its decidedly fin-de-siècle quality, this was an odd image to show Stieglitz and demonstrates how little Strand understood at that time about either modern art or even Stieglitz's own photographs.[22] Nevertheless, the meeting was a defining one for the young Strand. Commenting on this photograph, Stieglitz told him, as Strand recalled, that when making soft-focus photographs with "the lens wide open . . . you had a kind of unity because of the softness of the image, but you lost the individual character of all the materials in the things that you photographed. Water looked like grass, and grass looked like the bark on the tree." And he continued, "Stieglitz was so clear and so convincing that I immediately realized that he was correct."[23]

Liberated by the meeting, in late 1914 or early 1915 Strand began to close his lens down, as Stieglitz had recommended, to achieve a sharper focus. In addition, perhaps influenced by Stieglitz's photographs of New York or John Marin's or Abraham Walkowitz's watercolors of the same subject, Strand also began to turn his camera to the life immediately around him, especially the urban environment. On a trip across the United States in the spring of 1915 and later back in New York that summer and fall, he made several photographs that began to explore the relationships between people and the buildings, streets, and parks around them. Depicting spaces that were often highly energized by bold patterns of light and dark, infused with a

tension between interior and exterior spaces, and composed of a disparate array of people and things, Strand described what Marin called the "warring, pushing, pulling forces" of the modern city.[24] He revealed the dynamism of this new environment in which the physical parts—the streets, parks, waterways, and walkways—were as vibrant and alive as the inhabitants. He showed movement that was both abstract yet controlled, unified by a strong formal design yet expressive of the chaos of the modern city. And he conveyed a sense of energy, complexity, transience, and impermanence that contrasted sharply with the physical solidity of the city's buildings. In addition, Strand frequently put a black edge around his prints, a framing device that Dow had often employed in the illustrations in his book *Composition* and that Stieglitz had also used to great effect in his 1915 reproduction of *The Steerage*, 1907, in *291* (pl. 30). In Strand's photographs such as *City Hall Park* it served to emphasize formal structure, to contain the often wildly scattered movement of people and things, and to emphasize both the act of selection and the point of view of the photographer.

It may have been some of these photographs that so impressed Stieglitz in the summer of 1915, for Strand had taken a subject explored by Marin, Picabia, and Stieglitz himself and done something original with it. As Stieglitz wrote to an English colleague at the time of Strand's March 1916 show at 291, Strand was "without doubt the only important photographer [to have developed] in this country since [Alvin Langdon] Coburn." And he continued, "he has actually added some original vision to photography. There is no guming [sic]—no trickery—Straight all the way through in vision, in work and in feeling."[25] Buoyed by Stieglitz's praise and his plans to publish several of Strand's photographs in the October 1916 issue of *Camera Work*, by his ability to transcend established artists' treatment of the same subject, and by the positive response to his first exhibition, in the summer and fall of 1916 Strand conducted a methodical, systematic, and rigorous analysis of other issues that had been examined at 291 over the last eight years: abstraction, portraiture, and the role of the machine in modern art.

He later recalled that in the summer of 1916 while he was in Twin Lakes, Connecticut, he made photographs such as *Bowls* (pl. 79) to clarify what he referred to as the "abstract method" and to understand "the underlying principles behind Picasso and the others in their organization of the picture's space, of their unity . . . and the problem of making a two-dimensional area have a three-dimensional character."[26] He wanted to see "how you build a picture, what a picture consists of, how shapes are related to each other, how spheres are filled, how the whole thing must have a kind of unity."[27] Like his mentors Cézanne, Picasso, and Braque, Strand used simple, everyday objects—cups, bowls, tables, fruit, and porch railings—for his experiment. Like the cubists, he both deconstructed these objects, turning them on their sides

80 **PAUL STRAND**
New York (From the Viaduct), 1916
REPRODUCED IN CAMERA WORK,
JUNE 1917

and emphasizing their formal structure, and he synthesized new compositions in which all elements before the camera, voids and shadows as well as the objects themselves, functioned as energized positive elements within a dynamic composition. Although the resulting photographs were highly innovative, they were for Strand no more than experiments, and once he had extracted their lessons, he abandoned them and began to apply the knowledge he had gained to studies of the world around him.[28] As in *The White Fence* (pl. 81), a photograph that was not constructed like the Twin Lakes abstractions but extracted from the real world, Strand proved that he could tackle the same issues that the cubists had addressed—space, dimensionality, and structure—and create a work of striking graphic strength and bold geometric rigor.

When Strand returned to New York in the fall of 1916 he embarked on another experiment. As he recalled, he had "a very clear desire to solve a problem. How do you photograph people on the streets without their being aware of it?"[29] Although his initial efforts were somewhat clumsy, he discovered he could use a prism lens that took pictures at a right angle from the direction the camera seemed to be pointing. In photographs, such as *Blind* and *Portrait, Washington Square Park*, Strand drew on many sources (pls. 83, 84). From his progressive education at the Ethical Culture School, he had gained a sympathetic interest in the plight of the common man and the need for moral responsibility and social action. From Hine, he had an example of how another photographer had used his camera to document immigrants at Ellis Island and children at work in the mills and mines. From the popular photographic press, he had received encouragement to record the picturesque qualities of New York's immigrant population.[30] And from intellectuals, writers, and poets associated with *The Seven Arts, The Soil*, and other periodicals, Strand, as well as other artists, had been urged to embrace the ethnic diversity of the new city.[31] While all of these factors undoubtedly influenced him, it was the style of these photographs, and their radical manner of depicting their subjects that both distinguishes them from their predecessors and gives them their strength, directness, monumentality, and sense of honesty. The issue of portraiture in modern art and photography had been extensively analyzed at 291 through exhibitions, discussions, and publications and these precedents proved to be a wellspring of ideas for Strand to draw on in these photographs. With their closely cropped, almost stark presentation that concentrates exclusively on the heads and torsos of his subjects, eliminates all references to the environment, and minimizes all but the most essential details, these photographs clearly demonstrate Strand's "applied intelligence" and reveal his careful study of portraits by not only Cézanne, Stieglitz, and David Octavius Hill and Robert Adamson, but also Matisse, Picasso, and Brancusi, as well as his examination of African

81 PAUL STRAND
The White Fence, *1916*
REPRODUCED IN CAMERA WORK,
JUNE 1917

fig. 85 PAUL STRAND
Wire Wheel, *1917*
platinum print
The Metropolitan Museum
of Art, Alfred Stieglitz Collection, 1949

masks. Made only months after both Picasso and Braque's collages and Marsden Hartley's abstract German military portraits were shown at 291, these photographs, with their frequent inclusion of partial words and numbers, also demonstrate Strand's fluency with these ideas as well.[32]

The final issue that Strand explored in 1917 was the role of the machine in modern art. Again, he was well aware of the precedents for this work: he knew of Picabia's mechanical portraits that had been published in *291*, as well as his mechanically inspired paintings that had been exhibited at the Modern Gallery in the fall of 1915; he knew of Duchamp's art and rhetoric; and he knew of the paintings and photographs of machines by his colleague Morton Schamberg. But Strand's few photographs of automobiles and a motor were loving descriptions, not cool, anti-art objects.[33] *Wire Wheel* (fig. 85) and *Wheel Organization*, for example, owe a greater debt to Stieglitz's photograph of Duchamp's *Fountain*, also made in 1917, than to work by Picabia, Duchamp, or even Schamberg (pls. 67, 59).[34] Like Stieglitz, Strand transformed these mechanical objects into glistening, undulating, almost sensual forms to be admired and visually caressed.

In June 1917 Stieglitz published eleven of Strand's photographs in the last issue of *Camera Work*. Stating that *The White Fence*, the six portraits including *Blind* and *Portrait*, *Washington Square Park*, two abstractions including *Bowls*, and two studies of New York City including *New York (from the Viaduct)* represented "the real Strand," Stieglitz declared that the young photographer "has actually done something from within. The photographer...has added something to what has gone before." Noting that Strand did not "attempt to mystify an ignorant public," Stieglitz wrote that the photographs "represent the essence of Strand" and "are the direct expression of today."[35]

82 PAUL STRAND
New York (Wall Street), *1915*
REPRODUCED IN CAMERA WORK,
OCTOBER 1916

83 PAUL STRAND
Blind, *1916*
REPRODUCED IN CAMERA WORK, JUNE 1917

MODERN ART AND AMERICA

84 PAUL STRAND
Portrait, Washington Square Park, 1916
REPRODUCED IN CAMERA WORK, JUNE 1917

Barbara Buhler Lynes

GEORGIA O'KEEFFE, 1916 AND 1917

MY OWN TUNE

A lfred Stieglitz's support of Georgia O'Keeffe's art began with two exhibitions in 1916 and 1917 at his New York gallery, 291, and continued until his death in 1946. It is well known that his interpretations of the largely abstract work in these exhibitions served as the foundation for critical and public perceptions of O'Keeffe's art through the 1920s: Stieglitz defined the works as symbols of her (and therefore a woman's) sexuality.[1] Yet, until recently, it was not possible to assess Stieglitz's ideas precisely in terms of the works that first inspired them because the content of the 1916 and 1917 exhibitions was not known. The discovery of photographs by Stieglitz, documenting the 1917 exhibition, has clarified those ideas considerably.[2] Stieglitz's understanding of O'Keeffe's work, the degree and nature of O'Keeffe's commitment to abstraction as a language of personal expression, and the critical reception of the abstract works that Stieglitz exhibited in 1916 and 1917 are discussed here. Her early work speaks to her fascination with modern art, and in particular, with the works Stieglitz showed at 291.

The first O'Keeffes Stieglitz saw were relatively rough, highly abstract charcoal drawings. He saw them in January 1916, when he was fifty-two, an internationally known photographer, and one of America's few advocates of modern art.[3] O'Keeffe was a twenty-nine-year-old, completely unknown art teacher living in South Carolina. Several months later, he decided, without consulting O'Keeffe, to include some of her drawings in a group show in May at 291: *No. 2— Special* (fig. 86), *No. 3—Special, No. 4 Special, No. 5 Special* (pl. 87), *No. 7 Special, No. 9 Special* (pl. 86), *No. 12—Special,* and *Untitled*.[4]

85 GEORGIA O'KEEFFE
Blue Lines, *1916*
EXHIBITED AT 291, 1917

fig. 86 GEORGIA O'KEEFFE
No. 2—Special, *1915*
charcoal
National Gallery of Art,
Washington, Alfred Stieglitz
Collection, Gift of the Georgia
O'Keeffe Foundation
EXHIBITED AT 291, 1916

Stieglitz had long contended that women could attain stature as artists equal to that enjoyed by men, and he responded to O'Keeffe's powerful, enigmatic abstractions enthusiastically, saying: "Why they're genuinely fine things—you say a woman did these—She's an unusual woman—She's broad minded—She's bigger than most women, but she's got the sensitive emotion—I'd know she was a woman—Look at that line. They're the purest, finest, sincerest things that have entered 291 in a long while. I wouldn't mind showing them in one of these rooms one bit."[5]

The drawings were equally new and exciting to O'Keeffe, who had started making them the previous fall in South Carolina in an attempt to come to terms with

ideas she had first discovered in the summer of 1912 at the University of Virginia. There she attended a course for art teachers taught by Alon Bement of Teachers College, Columbia University, who introduced her to the theories of Bement's colleague and mentor, the artist-photographer-art educator Arthur Wesley Dow. Dow made a study of world cultures and discovered design principles, particularly in the work of Chinese and Japanese artists, that led him to reject imitative realism, the foundation of art education in the West for centuries and also O'Keeffe's early training. Dow believed artists did not need to copy nature, but could instead express their feelings and ideas. For Dow, such subjective expression was best achieved through a harmonious arrangement of line, color, and *notan* (tonal contrasts).

Bement also introduced O'Keeffe to recent trends in American and European art and suggested that she read Wassily Kandinsky's influential treatise, *The Art of Spiritual Harmony* (1912), which defined art as self-expression. He encouraged her to enroll at Teachers College in the fall of 1914, where Dow headed the art department. There, Dow's premise that music was "the key to the other fine arts, since its essence is pure beauty" was demonstrated in a class of Bement's that O'Keeffe happened to attend.[6] Students were listening to music and, as an exercise, drawing their responses to it. As O'Keeffe recalled, "This gave me an idea that I was very interested to follow later—the idea that music could be translated into something for the eye."[7]

O'Keeffe pursued this idea actively that summer, when teaching as Bement's assistant in Virginia. In June, she sent examples of her recent work to Anita Pollitzer, asking: "Do you like my music—didn't make it to music—it is just my own tune—it is something I wanted very much to tell someone and what I wanted to express was a feeling like wonderful music gives me."[8] In October, Pollitzer wrote: "We are trying to live … by saying or feeling—things or people—on canvas or paper—in lines, spaces & Color. … To live on paper what we're living in our hearts & heads; & all of the exquisite lines & good spaces & rippingly good colors are only a way of getting rid of the feelings & making them tangible."[9]

O'Keeffe clearly believed that such catharsis related to gender. As she wrote to Pollitzer: "… the thing seems to express in a way what I want it to—it also seems rather effeminate—it is essentially a womans [sic] feeling—satisfies me in a way—I don't know whether the fault is with the execution or with what I tried to say."[10]

The dancing curls, ovals, and verticals of *No. 2—Special* (fig. 86) may be read as O'Keeffe's enjoyment of and response to the movements of water, a subject that had inspired several works in pastel from 1915.[11] Four of the abstractions in this group, such as *No. 5 Special* (pl. 87) with its active and repeating swirls, further develop this theme.[12]

Other forms in these charcoal abstractions such as the circles and ovals of *No. 2—Special* (fig. 86) have been described as "feminine." But at the center of this image is a thrusting, phallic form. Because similarly "feminine" *and* "masculine" forms are frequently present in O'Keeffe's abstractions, her imagery transcends the issue of gender-specificity in its expression of the "music" of experience. Pollitzer had described this "music" as something that can "sing out or hollar [sic],"[13] conveying the dynamics of universal oppositions, which is one of the key principles of Dow's theories.

Stieglitz, who firmly believed that women and men could be equally capable artists, also equated creative energy with sexual energy. Referring to the May 1916 exhibition, he wrote: "... mainly owing to Miss O'Keeffe's drawings [it] aroused unusual interest and discussion.... Miss O'Keeffe's drawings besides their other value were of intense interest from a psycho-analytical point of view. '291' had never before seen woman express herself so frankly on paper."[14]

An exchange between Stieglitz and O'Keeffe that reputedly took place at 291 during the 1916 exhibition underscores his belief in the "hidden" meanings of her work, of which he believed O'Keeffe was unaware. O'Keeffe demanded that he remove her drawings from the exhibition, and Stieglitz countered by stating that she had no more right to withhold them from the world than she did a child. "Do you know what they mean?" he is said to have asked. "Do you think I'm an idiot?" she replied, and she described the image of one drawing as the expression of a headache, *No. 9 Special* (pl. 86).[15]

O'Keeffe probably read Stieglitz's assessment soon after it was published. Although later, in the 1920s, she would strongly object to Freudian interpretations of her work—at this time, considering her great admiration for Stieglitz, it is unlikely she objected.[16] She had been instinctively drawn to the aesthetic of his work when she first saw it in 1915 (she responded immediately to the medium of photography) and clearly understood his position of importance in the New York art community. Moreover, Stieglitz's keen, unexpected interest must have encouraged O'Keeffe.

By February of 1917, O'Keeffe had completed most of the work that Stieglitz would include in a one-person show at 291 that April 1917 (fig. 87a—w). The twenty-three exhibited works demonstrate, above all, O'Keeffe's continuing commitment to abstraction. Even the handful of works with recognizable subject matter, such as *Train at Night in the Desert* (fig. 87f) and *Sunrise and Little Clouds II* (fig. 87h) read equally well as abstractions. In addition, these and other watercolors and oils in the exhibition reveal an important aspect of O'Keeffe's thinking that Stieglitz had not known when he responded to her charcoal abstractions in January 1916: her keen

interest in using color as an expressive device. They also demonstrate the important place Stieglitz's work occupied in her mind, as well as that of other artists he supported, which she had come to know through reproductions in the avant-garde periodicals he edited and published, *Camera Work* and *291*, and through exhibitions she had attended at 291 while at Teachers College, Columbia University, beginning in the fall of 1914 and also in March 1916.

Two works included in the 1917 exhibition, moreover, were completed before the May 1916 exhibition.[17] The watercolor drawing *Blue Lines* (pl. 85; fig. 87b), a superbly balanced study of elegantly reductive vertical and horizontal lines, is based on O'Keeffe's observation of the contours of buildings from the window of her New York room. It thus demonstrates O'Keeffe's early interest in the subject matter of the city, which was important to Stieglitz and to several artists he supported, including John Marin (pls. 125, 128).[18]

O'Keeffe made the sculpture *Abstraction* (fig. 87n) in spring 1916 for a sculpture class at Teachers College, in memory of her mother, who had died that May. The hooded figure seems to derive from earlier examples of American funerary sculpture, such as *Adams Memorial* (1886) by Augustus Saint-Gaudens. At the same time, its simple, dramatic shape bears similarities to August Rodin's sculpture of Honoré de Balzac, which had been photographed by Edward Steichen (*Balzac—The Silhouette, 4 a.m.*) and reproduced in the April–July 1911 issue of *Camera Work*.[19]

O'Keeffe completed other works in the 1917 exhibition either while teaching in Virginia during the summer of 1916 or after she moved to Texas in the fall to teach at West Texas State Normal College, Canyon. Two abstract watercolors painted in the summer of 1916, *Blue No. I* and *Blue No. IV* (pls. 89, 88; fig. 87d, e), derive from an undetermined source.[20] Two charcoal abstractions whose contours describe female heads were inspired, as O'Keeffe later explained to Pollitzer, from something she saw while camping with a friend in Virginia in August 1916: "One morning before day light, as I was combing my hair, I turned and saw her lying there—one arm thrown back, hair a dark mass against the white, the face half turned, the red mouth. It all looked warm with sleep"[21] (fig. 87a, p). The tilt of these heads and their simple contours call to mind Brancusi's work, such as *Sleeping Muse* (pls. 36, 39), exhibited at 291 in 1914.[22] Other abstractions, such as the watercolor and oil paintings titled *Tent Door at Night*, depict the contours and shapes of the open tent (fig. 87c, t, w).

Shortly after her arrival in Canyon, O'Keeffe completed a charcoal drawing and watercolor of a train rounding a curve into the town, viewed from the window of the second-story classroom where she taught (fig. 87f, m). O'Keeffe obviously

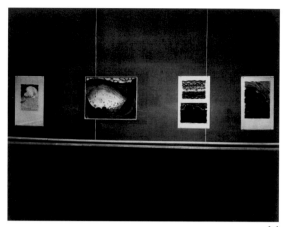

a-e f-i

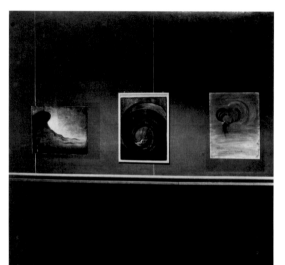

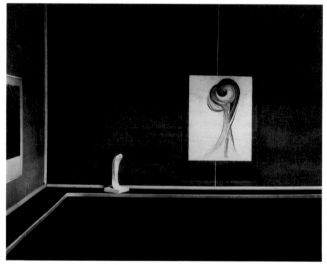

i-l m-o

fig. 87 ALFRED STIEGLITZ
Eight Views of the Georgia O'Keeffe Exhibition
at 291, *1917*
gelatin silver prints
The J. Paul Getty Museum, Los Angeles

responded to the sounds and action of this event, but she
was also well aware of Stieglitz's interest in the train as a
subject through photographs published in *Camera Work*,
such as *The Hand of Man* (no. 1, January 1903, and no. 36, October 1911), *Snapshot—
In the New York Central Yards* (no. 20, October 1907), and *In the New York Central Yards*
(no. 36, October 1911).

One charcoal drawing, *No. 15 Special* (fig. 87g), and four oil paintings in the
1917 exhibition reveal O'Keeffe's fascination with the Palo Duro Canyon, *No. 22—
Special* (fig. 87q), *No. 24—Special / No. 24* (fig. 87r), *No. 21—Special* (fig. 87s), and *Red
Landscape* (fig. 87u), several miles south of Canyon. Three display strident combi-
nations of red, blue, green, green-yellow, and orange applied with short, choppy
strokes, an expressive technique not at all related to the smooth and precise ways in
which O'Keeffe typically worked with oil after 1918 (fig. 87q, s, u).

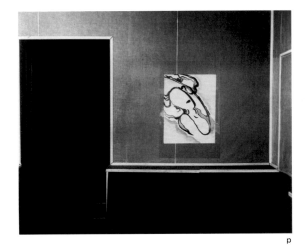

p

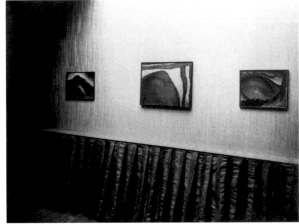

q-s

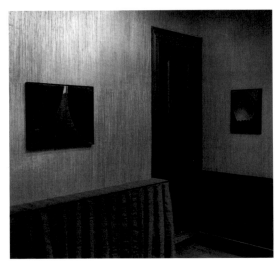

t-u

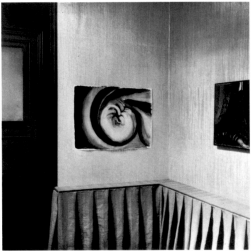

v-w

Such experiments in color are explorations of Dow's and Kandinsky's equation of color with music at the same time that the boldness of the reds in O'Keeffe's works calls to mind the heightened intensities in Marsden Hartley's paintings of the teens, such as *Portrait of a German Officer*, 1914, *The Aero*, 1914, and *Painting No. 5*, 1914–1915 (pls. 75, 69, 77). Hartley's work had been shown at 291 in spring 1916, but precisely which works O'Keeffe saw is not clear. The gray-greens and funnel shape in O'Keeffe's *No. 24—Special / No. 24* (fig. 87r), can be related to the tonalities and forms used by Arthur Dove, another artist whose work Stieglitz supported.

In his review of the exhibition, Henry Tyrrell discussed two of the Palo Duro landscapes and suggested titles for them: "More directly appealing to the material beauty-sense are two oil paintings of lovely but singularly disquieting color tonality, which may be interpretively called 'The Embrace,' and 'Loneliness.' " He described her abstractions of a woman's head as a "sort of allegory in sensitized line" (fig. 87a, p)

and *Train at Night in the Desert* (fig. 87f) as a "vision-bearing cloud in the skies of heaven." He calls *Blue Lines* (pl. 85; fig. 87b) "Two Lives" and describes its parallel lines as "a man's and a woman's, distinct yet invisibly joined together by mutual attraction."[23]

These comments have little to do with O'Keeffe's own ideas about the nature of her "music" and her specific visual sources. Tyrrell borrowed his main thesis from Stieglitz: "Miss O'Keefe [sic] ... has found expression in delicately veiled symbolism for 'what every woman knows,' but what women heretofore have kept to themselves." Had this idea come from Tyrrell's own assessment of the exhibition, it seems likely that he would have referred directly to the works in it that seem to display coiling, womblike shapes—such as *No. 8 Special* and *Blue No. II* (fig. 87l, v). But in fact, these two works relate to another work in the exhibition, *No. 12 Special*, 1916 (fig. 87o), which comes from O'Keeffe's experience and fascination with the forms of the scroll of the violin, the instrument she played frequently in the 1910s and, thus, what these works meant to O'Keeffe differed markedly from how they were first and have been subsequently interpreted.[24]

If Tyrrell's review annoyed O'Keeffe, she must have been pleased by what William Murrell Fisher wrote. He clearly understood her imagery as she had intended it, as the music of self-expression: "Of all things earthly, it is only in music that one finds any analogy to the emotional content of these drawings—to the gigantic, swirling rhythms, and the exquisite tendernesses [sic] so powerfully and sensitively rendered—and music is the condition towards which ... all art constantly aspires."[25]

O'Keeffe's continuing commitment to abstraction was greatly strengthened by her visit to New York that May (1917) to see Stieglitz and her exhibition. On this trip O'Keeffe met photographer Paul Strand and others in the Stieglitz circle. During the several days that O'Keeffe and Stieglitz spent together, their friendship intensified, and he began making photographs of her.

After O'Keeffe's return to Texas in 1917, she created abstractions in watercolor that are among the most remarkable works in her career. In the Evening Star series, combinations of saturated colors create elegant, interlocking, rhythmic shapes that express O'Keeffe's joy in her direct experience of the early night sky in Texas. In addition, she completed a series of abstract "portraits," including three of Paul Strand. She had been interested in the idea of abstract portraiture as early as 1915 and was probably inspired to continue such experiments through her awareness of similar works by Francis Picabia and Marius de Zayas, photographs of which she might have seen in New York. Stieglitz had published works by de Zayas earlier in *Camera Work* (April 1914).

In Texas O'Keeffe also painted a series of nude self-portraits in watercolor that indicate an openness about her body. The strong resemblance between these works and the pencil and wash drawings by Rodin that she had seen earlier, both at 291 and in the April—July 1911 issue of *Camera Work*, is another link between her work of these years and that of others in the Stieglitz circle (pl. 4). The nudes seem to foreshadow the photographs of O'Keeffe that Stieglitz began in June 1918, shortly after her move to New York, at Stieglitz's invitation, which freed her from teaching and allowed her to devote all her attention to her work.[26] From that moment forward and for the next eleven years, O'Keeffe and Stieglitz were almost inseparable and, as a result, the work of each flourished through the inspiration and influence of the other.[27]

In the early years of the twentieth century, Stieglitz's willingness to celebrate and promote the work of a woman distinguished him among his peers. His interpretation of O'Keeffe's art was shaped more by his ideas about the nature of woman, though, than by what he saw or by O'Keeffe's ideas. In 1974, she said: "Eroticism! That's something people themselves put into the paintings. They've found things that never entered my mind. That doesn't mean they weren't there, but the things they said astonished me. It wouldn't occur to me. But Alfred talked that way and people took it from him."[28]

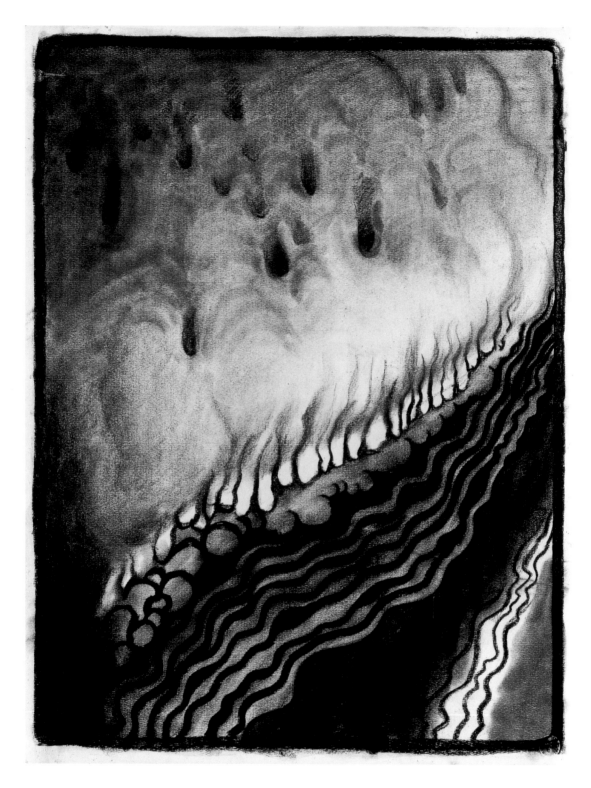

86 GEORGIA O'KEEFFE
No. 9 Special, *1915*
EXHIBITED AT 291, 1916

87 GEORGIA O'KEEFFE
No. 5 Special, *1915*
EXHIBITED IN 291, 1916

88 GEORGIA O'KEEFFE
Blue No. IV, *1916*
EXHIBITED AT 291, 1917

89 GEORGIA O'KEEFFE
Blue No. I, *1916*
EXHIBITED AT 291, 1917

THE ANDERSON GALLERIES,
THE INTIMATE GALLERY, AND
AN AMERICAN PLACE, 1921–1946

Sarah Greenough

ALFRED STIEGLITZ, FACILITATOR, FINANCIER, AND FATHER, PRESENTS SEVEN AMERICANS

To
Catch this song and sing it would do much—make much
Clear

SHERWOOD ANDERSON, 1918[1]

T hroughout his long career, Alfred Stieglitz could be characterized in a number of ways: as an engineer, an amateur photographer, a pictorial photographer, and simply a photographer; as a proponent of the art of photography, an advocate for modernism, and a champion of modern American art. As he affected these transformations, he also reformulated his ideas and reoriented his mission. In his later years when he told the story of his life, he usually presented it as a seamless narrative in which his ideas and activities evolved naturally; he even had a tendency to suggest that his varied activities were inevitable, pre-determined, almost pre-ordained, and that his life and work formed a unified whole, rather than the disjointed and at times uncertain series of events that, in reality, they were.[2]

Especially in 1917 and 1918, immediately after America's entry into World War I, Stieglitz's path was not at all clear. "The worst of it all," he lamented to Arthur Dove in May 1917, "is that I see no future."[3] Isolated by his ambivalent loyalties and his strong feelings for Germany, Stieglitz was further secluded by the closing of 291 in June 1917.[4] For several months in 1917 and 1918 he retreated to a small room one floor below the vacated Little Galleries, which he deprecatingly called "The Vault" or "The Tomb." There he continued to "hold forth," as he said, expounding upon his ideas to those artists, photographers, and writers who continued to visit. Yet, without an exhibition space or new works of art to use as the starting points for discussions, the discourse dissipated and became abstract. Moreover, with the enforced regimentation and curtailed liberties dictated by a country at war, many of the ideas on which 291 had been

90 ALFRED STIEGLITZ
Dancing Trees, *1922*
EXHIBITED AT THE ANDERSON
GALLERIES, 1923; AN AMERICAN
PLACE, 1932

predicated, especially its freewheeling experimentation and the notion of complete artistic freedom, no longer seemed possible: for many, including Stieglitz, it was clear that modernism would have to be rethought.

Just as important, many of Stieglitz's friends and colleagues, as well as others who had animated the collective art scene, left New York City or drifted away from his orbit. Called home by his family, Stieglitz's close collaborator Paul Haviland went back to France in 1915, while Marius de Zayas, who had organized some of 291's most innovative exhibitions, grew increasingly preoccupied directing the Modern Gallery in 1916 and 1917. In July 1917 Edward Steichen, who volunteered for the United States Army Signal Corps, departed for France, and in October, Francis Picabia and his wife Gabrielle left for Europe, never to return to the United States. In 1918 Marcel Duchamp went to South America, Mabel Dodge left for Taos, the eccentric English poet and boxer Arthur Craven and the American poet Mina Loy traveled to Mexico, while closer to Stieglitz, Paul Strand, a conscientious objector, left to work in a medical unit in Minnesota, Marsden Hartley went to New Mexico, and the artist and photographer Morton Schamberg died in the influenza epidemic. An oasis for the world's artists and intellectuals during the early years of the war, New York's artistic community was by 1918 in a period of transition.[5]

Stieglitz's personal life also became more precarious. Immediately after the United States' entry into the war in 1917, the government banned the use of food products to make alcoholic beverages, and production was greatly reduced at the Brooklyn brewery that supplied his wife, Emmeline, with much of her income.[6] His growing estrangement and subsequent separation from Emmeline in 1918 further exacerbated his financial situation and curtailed his activities as both a promoter and impresario for the arts for several years. Not surprisingly, even though he had far more free time than in recent years, Stieglitz made very few photographs after the dismantling of 291 in June 1917 to the summer of 1918.[7]

When the war ended in 1918, Stieglitz, like so many others, had to start his life anew. In the next few years he slowly gathered about him a new group of friends and colleagues, including a few stalwart artists from 291, most notably John Marin and Marsden Hartley, and others who had only been briefly or tangentially associated with the gallery, including Charles Demuth, Arthur Dove, Georgia O'Keeffe, and Paul Strand.[8] While these artists were to become his focus, all benefited from associating with a new generation of American authors, poets, and cultural critics who came to maturity in the years during and immediately after the war. In the late 1910s and early 1920s, the ideas and work of authors and critics such as Sherwood Anderson, Waldo Frank, or Paul Rosenfeld animated and even dominated the discussions of this group.

The structure that Stieglitz established for this new group was also different from the one he had constructed earlier, as was the tone of his enterprise. Before the war his model was scientific: 291 was a catholic laboratory that, in its efforts to challenge conventions, tested the validity of new ideas, experimented with different kinds of art from countries around the world, and allowed the results of one experiment to direct the course of future investigations. After the war, Stieglitz's model was more communal, even familial and intimate, with growing spiritual overtones: he endeavored to nurture, protect, and promote a community of American artists, photographers, writers, poets, and critics whose collective voice, he believed, would enrich a spiritually deprived nation. Less rebellious, more constructive, Stieglitz no longer sought to challenge the status quo, but rather to build up a foundation for a new American art, and he no longer conceived of each new exhibition in response to the one before it, but as an addition on top of it. With no grants or government aid, no history of sustained support of American modernist artists, and little institutional interest, his immediate objectives in the 1920s and 1930s were more practical than they had been at 291 and also more personal: he sought to construct a financial structure that would enable these American artists—Demuth, Dove, Hartley, Marin, O'Keeffe, and Strand—to mature and consolidate the influence of modernism on their work and, on a more personal level, he gave them the advice and encouragement they needed to continue their work.

Stieglitz's new scope and agenda were narrower and more distinctly national than they had been at 291. As these artists and writers wrestled to transform European modernism into a voice that was distinctly their own, they also grappled with the idea of what it meant to create a modern American art. What was the relationship of America to Europe in the wake of World War I, they asked. Was modern American art necessarily different from modern European art? If so, did these differences lie in subject matter alone? Did modern American artists, for example, have to depict elevated trains or skyscrapers to signal their involvement with modern life? Was there a place within this new environment for the depiction of the American landscape? If these differences existed, were they connected to a style or approach? Did American art, because of the supposedly more pragmatic nature of the American character, have to be more representational, less abstract, more concerned with the rendition of facts than experiences? Were there certain attributes that characterized modern American art and distinguished it from its European counterparts? Did it have to be more inventive, less classically ordered than European art, in order to express the American experience? As the artists searched for answers to these questions they not only bonded to form a cohesive community, but also experimented widely, exploring new subjects and

new materials. They did not aim to categorize American art and certainly not to parochialize it, although their assertions and rhetoric may have contributed to a sometime over-simplistic critical reception. And, while they gradually became a small, even exclusive group, that too was not intentional.[9] But rather, as first generation American modernists working immediately after the devastation of World War I they sought to come to terms with both their European heritage and their American experience and to construct an art that was intimately a part of their time and place.

Stieglitz was involved in every aspect of this discussion, helping to formulate, introduce, and defend the ideas born of the discourse he was nurturing. Whereas earlier he had tried to retain an impartial air for the sake of scientific objectivity, in the 1920s and 1930s his stance was far from disinterested or impersonal. And, whereas earlier he was less concerned with himself or others profiting financially from his experiments, now he assumed direct responsibility for the financial well-being of his artists. Once the rebellious midwife to a thousand ideas, Stieglitz now assumed the role of facilitator, financier, and, as Sherwood Anderson described him, "father to so many puzzled, wistful children of the arts in this big, noisy, growing and groping America."[10]

> *Yes, you have struck it—why it's so important:*
> *America without that damned French flavor!—*
> *It has made me sick all these years. No one respects*
> *France [more] than I do. But when the world is to be*
> *France I strenuously hate the idea quite as much*
> *as if the world were to be made "American" or*
> *"Prussian."… That's why I'm really fighting for*
> *Georgia. She is American. So is Marin. So am I.*
> STIEGLITZ TO PAUL ROSENFELD, 1923[11]

Stieglitz's life changed completely and irrevocably on 9 June 1918, when Georgia O'Keeffe returned to New York from Texas. In the past two years she and Stieglitz had corresponded with growing frequency, and Stieglitz, at least, had fallen in love with the young, gifted, and beautiful schoolteacher. In May 1918, distraught that O'Keeffe was ill and possibly suffering from tuberculosis, Stieglitz had asked Strand to go to Texas to ascertain the state of her health and, if possible, convince her to move to New York. Shortly after she was settled in the city, Stieglitz and O'Keeffe began living together, and each soon became enmeshed in the other's art.

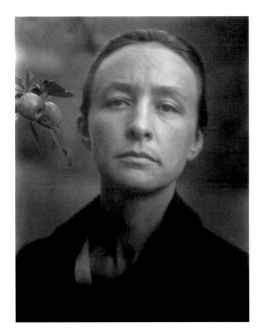

fig. 88 ALFRED STIEGLITZ
Georgia O'Keeffe: A Portrait—Head, *1920*
gelatin silver print
National Gallery of Art, Washington, Alfred Stieglitz
Collection
EXHIBITED AT THE ANDERSON GALLERIES, 1921

Whereas earlier in his career Stieglitz had orchestrated an intense and far-ranging dialogue between photographers, painters, sculptors, critics, and others, now in the late 1910s and early 1920s he focused on a more quiet and highly personal interchange with O'Keeffe. The dialogue that ensued between these two artists, unlike any either had ever experienced, initially gave both of them the emotional support, aesthetic and intellectual stimulation, and moral authority that enabled them to forge new chapters in their art.[12] Stieglitz's portraits of O'Keeffe were the most obvious and immediate manifestation of their union. While the idea of photography was always paramount to Stieglitz, from 1905 through 1917, when he directed 291, he had allowed his own photography to come second to his work at the gallery and his publication of *Camera Work*. During these dozen years he made only approximately 225 finished photographs.[13] Yet in the next four years he made more than 300 works, more than 190 of which were portraits of O'Keeffe.[14] Entranced by O'Keeffe, Stieglitz, in 1918 and 1919, concentrated almost exclusively on photographing her, making very few studies of anyone or anything else. In these portraits he drew on earlier sources of inspiration, particularly Rubens and Franz von Stuck, but the artists exhibited at 291 provided him with the most direct and immediate stimuli. He looked first to the rebellious, heroic, and romantic Rodin, whose quick pencil sketches of nude models dancing in his studio had shocked early visitors to 291. Although many of Stieglitz's photographs of O'Keeffe were posed because of long exposure times, he strove to capture gestures that suggested that she too was dancing before his camera in the studio they shared (compare pl. 7 to pls. 91 and 117). A few of his studies of O'Keeffe are almost exact restatements of some of the drawings by Rodin that he owned, while others engage in the dialogue that had so fascinated Stieglitz during his years at 291 and depict O'Keeffe in clothes, pose, and attitude that echo Steichen's photographs of Rodin's sculpture.[15] Still more merely follow Rodin's lead: much as the sculptor had made studies of hands and feet to understand how fragments could be indicative of character, so too did Stieglitz photograph O'Keeffe's hands and feet, demonstrating that parts of the body were expressive of its whole (pl. 118). But Stieglitz also looked to other artists who had exhibited at 291. From Henri de Toulouse-Lautrec's album *Elles*, a study of cabaret dancers and their admirers that Stieglitz exhibited at 291 in 1909, he may have received encouragement to explore a comparable voyeuristic point of view, recording O'Keeffe as she awoke and dressed (figs. 89 and 90). From

91 ALFRED STIEGLITZ
Georgia O'Keeffe: A Portrait—Torso,
probably 1918
EXHIBITED AT THE ANDERSON
GALLERIES, 1921

Matisse, he learned the ability of a single line or a minimal form to convey a pulsating sensuality, while from Cézanne, he gleaned how a simple pose could suggest not only the deep love, but also the comfortable relationship that existed between two people (compare pl. 10 to pl. 91; or pl. 20 to fig. 90). From Picasso and Brancusi he discovered the power of isolation and how to render a sensuous physicality, intimacy, and also monumentality by focusing exclusively on O'Keeffe's head (compare pls. 22, 37, and 40 to pls. 116 and figs. 88 and 91). And from African art, he explored how frontal, close-up, and almost masklike presentations of the face alone could transform O'Keeffe into an iconic presence (compare pls. 47, 48 to fig. 91).[16]

This dialogue between photographer and painter, however, produced other significant if more subtle changes in their art and their methodology. Although Stieglitz and O'Keeffe shared a common heritage of symbolism, secessionist art, and art nouveau, as well as the new work that had been shown at 291, they were fundamentally very different artists in 1918, with different approaches, objectives, and methods of working. Highly articulate, rational, analytical, and intellectual, Stieglitz read voraciously and widely, but he had worked only episodically in the last twenty years. During this time, his primary subject matter had been the city and other artists and intellectuals. Wary of words, O'Keeffe was a much more intuitive,

subjective, and non-verbal artist, who worked constantly and used her art for self-realization and to clarify her ideas. Before O'Keeffe moved to New York her most significant work was abstract and its subject matter was related to her visual, emotional, and physiological experiences, or was inspired by her intense communion with nature.

Soon after Stieglitz and O'Keeffe started living together both Stieglitz's art and his working method began to change. Inspired at first by his ardent desire to photograph O'Keeffe and later by her steadfast commitment to her work, he began to photograph much more than he had in the past; from 1918 through 1929, the period of their most intense exchange, he made more photographs than in any other period in his life.[17] Because O'Keeffe disliked New York City, they began spending several months out of every year at the Stieglitz family's summer house in Lake George, New York, where, for the first time in his career, Stieglitz consistently made landscape photographs, recording the hills, trees, barns, and clouds around the lake (pls. 92, 93, 109, 121, and 122).[18]

But, of far greater importance, Stieglitz was also moving toward an art that was more intuitive and experiential, less rational, analytical, metaphorical, and studied. His earlier photographs, such as those made in Europe in the 1890s, were often thoughtfully considered and carefully composed prior to exposure. Even those photographs that recorded rapidly changing situations were always refined or altered in the darkroom through cropping and other printing strategies. Using people and things to represent ideas, these photographs were often conceptually or metaphorically based; for example, many of his photographs made in Europe in the 1880s or 1890s were reflections on the picturesque, while many of his views of New York City from the turn of the century, such as *The Flatiron*, 1902, or *Old and New New York*, 1910, were statements about the rapidly changing urban environment (pls. 26 and 25). Even his titles suggest the more symbolic or occasionally didactic nature of his intention: *The Hand of Man*, 1902, *The City of Ambition*, for example (pl. 31). These photographs aimed to be complete definitive statements and there was little about them that was fleeting, fragmentary, partial, or equivocal. After 1918, though, his work, to a great extent, was far less programmed, far more about feelings or visual or emotional spectacles. Whereas earlier in his career Stieglitz conceived of photography and painting as very different things—the former more adept at exploring an external, objective reality and the latter more concerned with a subjective reality—now he saw their similarities, as means mattered less to him than intent. With an ever growing appreciation he understood how he could, as he wrote, "put his feelings into form."[19] In the same way that O'Keeffe put "her experience into paint," as Stieglitz wrote in 1921, and therefore clarified experience for herself, so too did

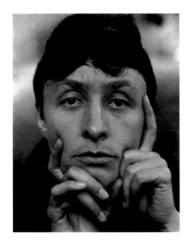

fig. 91 ALFRED STIEGLITZ
Georgia O'Keeffe: A Portrait—Head,
1918
gelatin silver print
National Gallery of Art, Washington,
Alfred Stieglitz Collection
EXHIBITED AT THE ANDERSON
GALLERIES, 1921

MODERN ART AND AMERICA

92 ALFRED STIEGLITZ
First Snow and the Little House,
1923
EXHIBITED AT THE ANDERSON
GALLERIES, 1924

93 ALFRED STIEGLITZ
Music—A Sequence of Ten Cloud
Photographs, No. I, *1922*
EXHIBITED AT THE ANDERSON
GALLERIES, 1923

Stieglitz try to discover himself through his art.[20] Too much a preacher, he could never entirely abandon his didactic nature, as can be seen, for example, in *The Way Art Moves* or *Spiritual America*, but he strove to make more free, open, immediate, and intuitive photographs and to cease constructing metaphors for something else. Instead he created photographs that simply were (pls. 98, 97). His studies of clouds, which he first called *Music—A Sequence of Ten Cloud Photographs* and later *Equivalents*, were the direct result of this new aspiration, but so too were *Dancing Trees*, 1922, *Apples and Gable*, 1922, or *The First Snow and the Little House*, 1923 (pls. 93, 109, 121, 122, 90, and 92). In all of these works he sought to "make an image of what I have seen, not of what it means to me"; "I do not 'think,'" he wrote to the author Sherwood Anderson, "I just *feel.*"[21] "Art begins where thinking ends," he told the writer Herbert Seligmann, while he related to others that he wanted to express "my most profound life experiences."[22] As he sought to "capture the essence of the moment," these photographs, "born of an inner need," were about that which is fleeting and elusive.[23] O'Keeffe was not the only source of these ideas—his symbolist heritage, coupled with his study of Kandinsky, also affected this transformation, as did his growing appreciation of both Arthur Dove's and John Marin's work—but her personality and her work were the most immediate and the strongest influences.[24]

During the early years of their relationship, O'Keeffe was also profoundly influenced by Stieglitz. Yet, whereas O'Keeffe liberated Stieglitz, he and his art grounded her. O'Keeffe herself saw this duality; she told Anderson that whereas Stieglitz's work was "way off the earth," hers was "very much on the ground."[25] Moreover, if O'Keeffe propelled Stieglitz, quite literally, into the clouds, and if her art inspired his hungry, nimble mind with the potential of radical change, he gave her more specific and concrete things. First, he gave her time and opportunity. Although his income was modest, forcing them to live in his niece's studio and later with his brother, O'Keeffe no longer needed to teach to support herself and she could concentrate instead entirely on her art. Second, while she had been working for the last three years primarily in charcoal and watercolor, he may have encouraged her to return to oil painting, for after her move to New York in 1918 she made many more oils than she had in all her previous years.[26] Through his photographs, Stieglitz helped to keep O'Keeffe focused on the external world: as her letters show, she was entranced by the visual world, but especially in 1915 and 1916 her work had become increasingly abstract, personal, even hermetic, and as she herself admitted on occasion, she felt as if she was "floundering" and in a "muddle."[27] She had been fascinated with photography from almost her first meeting with Stieglitz in 1916 and, inspired by his photograph *The Hand of Man*, 1902, had created *The Train at*

fig. 93 ALFRED STIEGLITZ
Georgia O'Keeffe: A Portrait—
Breasts, *1919*
palladium print
National Gallery of Art, Wash-
ington, Alfred Stieglitz Collection
EXHIBITED AT THE ANDERSON
GALLERIES, 1921

fig. 92 GEORGIA O'KEEFFE
Untitled (Self-Portrait—
Torso), *c. 1919*
oil on canvas
Collection Joanne Kuhn Titolo,
Indiana

Night, 1916. When she and Stieglitz began living together in 1918, his photographs not only encouraged her to record the world around her, but also to look at it more closely. His studies of the glistening surface of an apple or the raised grain of wood focused her attention on texture and surface; his photographs of swaying trees or the pendulous shape of her own breasts intensified her appreciation of natural forms; and his painstakingly created palladium prints showed her the wide range of tones that could be extracted from a single color or hue (see pls. 90, 119). In order to understand more fully the textural, formal, graphic, and coloristic implications of Stieglitz's photographs, O'Keeffe even, on at least one occasion, copied one of his nude portraits of her (figs. 92, 93).

As Sarah Peters has demonstrated, the syntax of camera vision and Stieglitz's photographs, as well as those of some of his associates, inspired O'Keeffe to look at the world in new ways.[28] She quickly discovered she could do more than just make "Strand photographs for myself in my head," as she wrote in 1917; she could also incorporate elements of camera vision into her art.[29] For example, from Stieglitz's *Dancing Trees,* O'Keeffe saw how the photographer, by using lenses of different focal lengths, could greatly compress space, pulling background to foreground and thus charging each plane of the picture with equal weight and energy (compare pls. 90, 94, and 170). In works such as Stieglitz's *Apples and Gable* or Strand's *Bowls* she

learned how the photographer, by bringing the camera in extremely close to a subject, could impart a sense of monumentality to a small object and how a soft focus and shallow depth of field could emphasize some elements while minimizing extraneous details (compare pl. 79 to pl. 106). Other photographs showed her specific photographic peculiarities like halation and convergence, while still more, perhaps seen in newspapers, may have encouraged her to try to look down on her subjects as in *From the Lake, No. 1* or *Lake George with Crows* (pl. 171).[30] She also acquired simple strategies from Stieglitz. For example, his habit of mounting and hanging his cloud photographs on their sides or upside down showed O'Keeffe that she too could rotate her paintings of the hills and lake in order to construct a more abstract vision (pl. 176). Intrigued by the sharp lines and flat, clean, translucent surface of a photograph, she rejected the short, textured brushstrokes she had used earlier and her work became less painterly. She even approximated the size of Stieglitz's photographs: many of her still lifes measure approximately eight by ten inches.

Slowly in the late 1910s and early 1920s, O'Keeffe discovered that she could appropriate bits and pieces of photographic vision and thus fold into her art some of the medium's factual presence, its mimetic veracity and authority. But she also realized that she could play with the literalness of the medium, subvert it, and thereby give her art a curious edgy quality. Her paintings from this time clearly derived from a vision related to photography, but they were strangely and often elusively different from it. Stieglitz and photography showed her the importance of selection, elimination, and emphasis. "Nothing," as she succinctly noted in 1922, "is less real than realism—details are confusing."[31] From Dow and art nouveau O'Keeffe had learned about composition and design, from Picasso and Braque she had received instruction about form and structure, and from Kandinsky and Matisse she had garnered invaluable insights into color. From Stieglitz and other photographers she learned how to read photographs, how to appropriate some of their strategies, and how she could both utilize and undercut the mimetic properties of the medium in order to present "the real meaning of things."[32]

In 1918, 1919, and 1920 Stieglitz's and O'Keeffe's relationship and the dialogue they constructed between their art was intense, all-consuming, and exclusive, and much of their time was spent together, not visiting with friends or colleagues. But, while O'Keeffe was a solitary artist, Stieglitz was a social one, and whereas she most likely would have been content with a more quiet existence, Stieglitz needed people around him both for stimulation and confirmation. Beginning in the early 1920s their studio became a meeting place for friends, but the group that congregated there was mostly a new one. A few 291 painters, in particular Hartley and Marin,

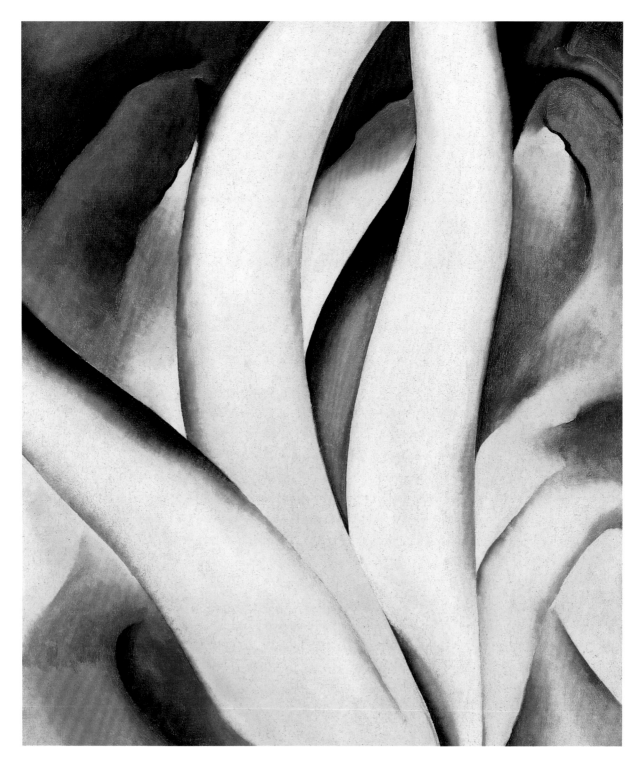

94 GEORGIA O'KEEFFE
Birch Trees, *1925*
PROBABLY EXHIBITED AT THE
INTIMATE GALLERY, 1926 OR 1927

remained on close terms with Stieglitz. Others who had played a more minor role at 291, like Dove who had only one solo exhibition there or Demuth who had never been shown, established much stronger friendships with Stieglitz and O'Keeffe at this time, and Strand rejoined them after his discharge from the army in August 1919. But the greatest change in the Stieglitz group after the war was the infusion of several young, articulate, and passionate writers and critics. Waldo Frank and Paul Rosenfeld became frequent visitors, as did, somewhat later, Herbert Seligmann, Sherwood Anderson, Hart Crane, Jean Toomer, William Carlos Williams: all solicited Stieglitz's advice, sent him their manuscripts for review, and wrote articles about him as well as his associates. The young and enthusiastic group associated with the short-lived periodical *The Seven Arts* provided Stieglitz with many new colleagues. Edited by Frank and Rosenfeld with James Oppenheim and Van Wyck Brooks, *The Seven Arts*, which was published from November 1916 to October 1917, articulated many ideas that would be central to the Stieglitz group in the 1920s. Along with the influential essayist Randolph Bourne, these men viewed themselves as intellectual and social rebels and advocated a position of cultural renewal. Seeing the war as a harbinger of the country's liberation, they believed that its destruction and senseless loss of life for the benefit of capitalism would force Americans to recognize that they could "no longer be *of* Europe."[33] "We are living in the first days of a renascent period," Frank proclaimed in the opening issue, "a time which means for America the coming of that national self-consciousness which is the beginning of greatness."[34] Their mission, as Frank wrote a few years later, was the "understanding, interpreting and expressing [of] that *latent America*, that *potential America* which we believe lay hidden under our commercial-industrial national organization; that America of youth and aspiration; that America which deserves a richer life, a finer fellowship, a flowering of mature and seasoned personalities."[35]

Their nationalism was youthful, optimistic, and in retrospect naive, but unlike later manifestations in the 1930s, it was not political or xenophobic. Beneath their mesmerizing and messianic prose, these critics did not simply want to encourage American art, they also wanted to explore new connections between the individual, culture, and the increasingly industrialized and bureaucratic society.[36] They believed that modern America had failed to give meaning to individuals because it had enshrined a materialistic society at the center of life, relegating self-expression, the imagination, and creativity to the private sphere.[37] With an almost blind faith, they insisted that a close community of artists, which Bourne endearingly called "the Beloved Community," had the power to regenerate both society and culture.[38] In an increasingly secular age, they posited that art was the new religion, a sign of the

95 ALFRED STIEGLITZ
Waldo Frank, 1920
EXHIBITED AT THE ANDERSON
GALLERIES, 1921

fig. 94 ALFRED STIEGLITZ
Paul Rosenfeld, *1920*
gelatin silver print
National Gallery of Art, Washington,
Alfred Stieglitz Collection
EXHIBITED AT THE ANDERSON
GALLERIES, 1921

moral strength of a people or country. Thus the new American art that they sought to create would represent not just the country's culture, but also its spiritual strength.[39] In this way, art became for them not a private matter, but a communal activity; it was, as Frank wrote, an expression of the "national life" and, at the same time, "a means to its enhancement."[40]

As they developed their ideas, Frank, Rosenfeld, Brooks, and later Anderson, Crane, Seligmann, and Williams stressed the importance of both self-expression and experience. Personal expression was imperative, they believed, because it represented the triumph of the individual over the bureaucratic forces of society. Celebrating America's independence, the French writer Romain Rolland urged readers of *The Seven Arts* to "profit by this. Be Free. Do not become slaves to foreign models.... Your true model is within yourselves. Your approach to it must be the understanding of yourselves."[41] The artist, they maintained, was a gifted individual who made visible, and thus understandable, feelings and ideas that others only vaguely perceived. Endowing the artist with enormous power and responsibility, they believed, as Frank wrote in *Our America*, that in "seeking America, we create her. In the quality of our search shall be the nature of the America that we create."[42] Thus, the artist's act of spiritual discovery became the nation's. "Give voice to your own soul," Rolland concluded in *The Seven Arts*, "and you will find you have given birth to the soul of your people."[43] Urging the creation of an intuitive, non-theoretical art based on experience and derived from direct observation, these writers also placed primary importance not on knowledge but experience. Frank explained, "we make our own not what we think, but what we feel."[44] What Brooks called "imagination" and Frank called "vision" could, both insisted, reach "out into an unknown whither the intelligence is able to follow only by a long second" and discover "new and more vital ... ideals." No new society would emerge, no social revolution would be possible, Brooks continued, until a community of artists, "the pathfinders of society," bring Americans "face to face with our own experience."[45] "We have to sing, you see, here in the darkness," Sherwood Anderson explained, "we have to find/each other. Have you courage to-night for a song?"[46]

As they sought to express their new America, this generation of writers developed a new vocabulary. Signaling their allegiance to the cause, Brooks, Frank, Rosenfeld, Williams, and Hartley in *Adventure in the Arts* used words that were invested with new meanings. Brooks himself later remembered that "roots" was a particular favorite: "no other word was more constantly on their lips unless it was the native 'soil' or 'earth'."[47] (Before the war, Robert Coady had even published an

influential little magazine titled *The Soil* that celebrated modern American culture.) The terms "the American earth" or "the native soil" became symbolic of the American past, free from European influence. These writers also frequently spoke of their desire to "cultivate" their roots: "I think there is soil for the raising of a crop if the stones can be taken away," Anderson wrote to Brooks in 1918.[48] While some recent scholars have seen their repeated use of certain words as "code," designed to be understood primarily by only a select few, at the time these writers insisted, as one critic wrote, that they wanted simply to "take those old words," the common vocabulary that all Americans understood, "and breathe the breath of life into them."[49] They wanted to "liberate words," Williams wrote, break them off from the "European mass" and make them "clean" and "new" for America.[50] Describing their cause as a "war of a new consciousness against the forms and language of a dying culture," Frank wrote that "when new cultural foundations are erected the process is by the creating of new conceptions: *Words* whereby these foundations enter the experience of man. Such new words are forms of art."[51]

Stieglitz appreciated the youthful rebels' missionary zeal as much as he did their deep adulation of him. Keenly aware of his own rebellious nature, his aversion to commercialism, and his distrust of American materialism, they celebrated him as a spiritual pioneer. In his 1924 book *Port of New York: Essays on Fourteen American Moderns* Rosenfeld devoted one chapter to Stieglitz, proclaiming him as one of the "great affirmers of life"; while Frank insisted in *Our America*, 1919, that he was "the prophet ... the true Apostle of self-liberation in a destructive land."[52] Stieglitz fully embraced their ideas, goals, methodology, and vocabulary: in 1923 he explained to Crane, "this country is uppermost in my mind—What it really signifies—what it is— I am not trying much analysis—I do not arrive at my results that way"; and in 1925, in response to a request to exhibit Dove and O'Keeffe's work in Europe, he recounted to Anderson, "I told him the Soil was right here—the planting was here— the growing where the planting—in the Soil right here."[53]

The infusion of these young, admiring writers into the Stieglitz group in the late 1910s, however, significantly changed both its character and dynamics; the fact that they became its spokespersons also altered the tenor and content of the discourse around Stieglitz. Deferential and reverential, they were, like Demuth, Dove, O'Keeffe, and Strand, a generation or more younger than Stieglitz, and most approached him more as a father figure or revered mentor than as a colleague. They were also a step removed from him by profession, for by training and expertise they were historians, music or cultural critics, authors or poets, not visual artists or art critics. Prone to hyperbole and lacking the intimate knowledge of what it meant to be a painter or photographer, it was easier for them to misconstrue the nature of

96 ALFRED STIEGLITZ
Sherwood Anderson, 1923
EXHIBITED AT THE ANDERSON
GALLERIES, 1923

97 ALFRED STIEGLITZ
Spiritual America, 1923
EXHIBITED AT THE ANDERSON
GALLERIES, 1924

98 ALFRED STIEGLITZ
The Way Art Moves, 1920
EXHIBITED AT THE ANDERSON
GALLERIES, 1921

fig. 95 ALFRED STIEGLITZ
Dorothy True, as published in "New York Dada," 1921
National Gallery of Art, Washington

Stieglitz's accomplishments and easier for him to overstate them. (Tellingly, Stieglitz's letters to his friends who were artists were, on the whole, more humble, often detailing his struggles to make his art, while those to Frank, Rosenfeld, and other writers more frequently contained loftier pronouncements.) But of greater importance, as this generation of American writers sought to find what Brooks had called a "usable past," they looked for American heros whose work, ideas, and lives they could put forth as models for others to emulate; Stieglitz perfectly and willingly conformed to this objective. As Rosenfeld himself confided to Stieglitz after a conversation with Anderson, "I was again struck by the curious manner in which you become for people not only a person but a symbol."[54]

Invigorated by this community of writers, by their mission to reveal a latent and more spiritual America, and by their scrutiny of language and form, as well as by his own dialogue with O'Keeffe, Stieglitz embarked in the early 1920s on a period of playful but wide-ranging experimentation in both his art and activities. Working with several different cameras and printing techniques, including solarization, he investigated many new subjects in his art, including abstract portraits and sequential and serial imagery. Many of his photographs from this time are also infused with a dada spirit. With their scatological wit, punning titles, sharp social criticisms, and investigation of happenstance and accident, photographs such as *The Way Art Moves,* 1921, a study of sculpture in a wooden cart, *Spiritual America,* 1923, a depiction of a harnessed and gelded horse, and *Dorothy True,* 1919, an unintentional double exposure of True's leg and face, indicate his close connections to New York dada (pls. 97–99). Still friendly with Duchamp and Man Ray, Stieglitz in 1920 asked Tristan Tzara about opening a branch of the dada movement in New York, and in 1921 he allowed *New York Dada* to publish his portrait of *Dorothy True* (fig. 95).[55] When it was reproduced, Man Ray added the caption, "Watch Your Step!" further emphasizing the dada nature of the photograph, for True was stepping on pieces of mount board—that is, stepping on Stieglitz's art. In addition, in 1922 Stieglitz, Rosenfeld, and others published their own journal, *MSS,* with a cover by O'Keeffe that they clearly acknowledged owed "apologies" to *New York Dada* (fig. 158).[56] While Stieglitz shared none of the nihilism of the European dada artists of this time, neither did any of the other American artists who also embraced dada, such as Hartley or Joseph Stella. Instead, the American manifestation of dada, with its enthusiastic embrace of the present, its celebration of America, its exploration of alternative sources for art in both the stuff of life and the work of non-Western peoples, and its belief that photography was an important tool to

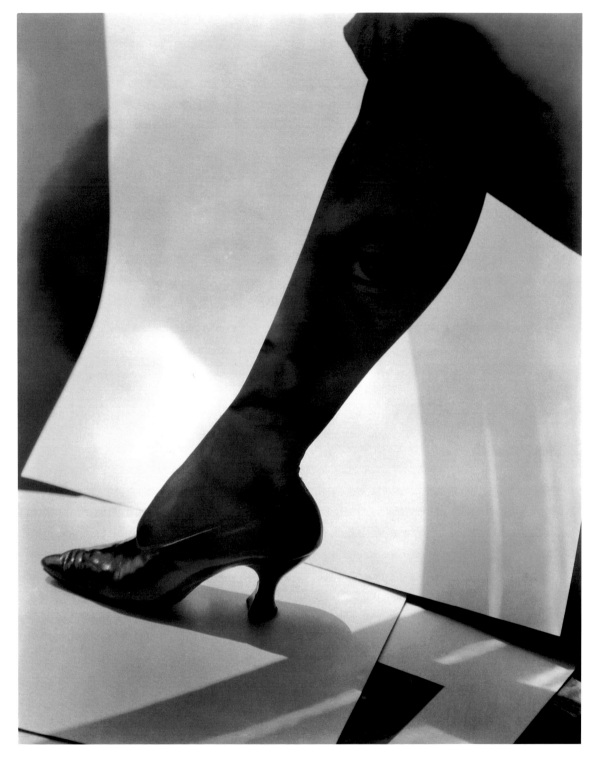

99 ALFRED STIEGLITZ
Dorothy True, *1919*
EXHIBITED AT THE ANDERSON
GALLERIES, 1921

circumvent aesthetic conventions, resonated strongly with Stieglitz.[57] Proudly declaring his own irreverence, Stieglitz noted in 1921 that he had rejected "every ism" as well as all the other "fast becoming 'obsolete' terms" that had once filled the pages of *Camera Work*, and in 1923 he voiced the art/anti-art ideas of dada, writing "Art or not Art, that is immaterial. There is photography."[58]

By the early 1920s, the New York art world had not only regained the momentum it had lost during the war, but far surpassed it. During 1921 alone more than twenty significant exhibitions of modern art were presented in New York at a variety of commercial galleries such as Bourgeois, Belmaison, Daniel, or Montross, and at such venerable institutions as the Metropolitan Museum of Art and the Brooklyn Museum of Art. In addition, the Société Anomyme, founded by Katherine Dreier in 1920, held a series of influential exhibitions, including the first presentations in this country of Archipenko, while the Modern Artists of America, founded by Henry Fitch Taylor in 1920, also exhibited the work of its members, as did the Whitney Studio Club.[59] Stieglitz took advantage of this thriving art scene to garner attention and support for those artists of importance to him. Without a gallery of his own, he invented new and creative ways to secure funding. The "Marin Fund," to which contributors donated money to support Marin for three years, was one solution that he devised in 1923; another was the art auction. A master at generating publicity, he billed a 1921 auction of 117 works by Hartley, which grossed more than $4,000, as an "In Memoriam Sale," even though the painter was, of course, alive and, for at least a while after the auction, thriving; while in 1922 he dubbed a much less successful auction of more than 200 works by forty American artists as an "Artists'" or "Painter's Derby," predicting that it would be "a great sporting event."[60] Drawing on his friendships with art dealers, he organized exhibitions at commercial galleries, including six shows of Hartley's and Marin's work between 1919 and 1924, as well as group shows at non-profit organizations in New York, New Jersey, and Philadelphia.[61] The most celebrated events that he orchestrated during the early 1920s, however, were the exhibitions of his and O'Keeffe's work. This pas de deux began in 1921 with a showing of his photographs that included many portraits of O'Keeffe, both clothed and nude, followed by two exhibitions in 1923 of her paintings and his photographs, and concluded with a joint exhibition in 1924 of fifty-one O'Keeffe paintings and sixty-one Stieglitz photographs, the first time since 1909 that he had exhibited paintings and photographs together. These exhibitions not only established Stieglitz and O'Keeffe as one of the most intriguing and controversial artist couples of the twentieth century, but also confirmed Stieglitz's preeminence in American photography and launched O'Keeffe's career. The critical response to the exhibitions also set the tone for the discourse on O'Keeffe's art

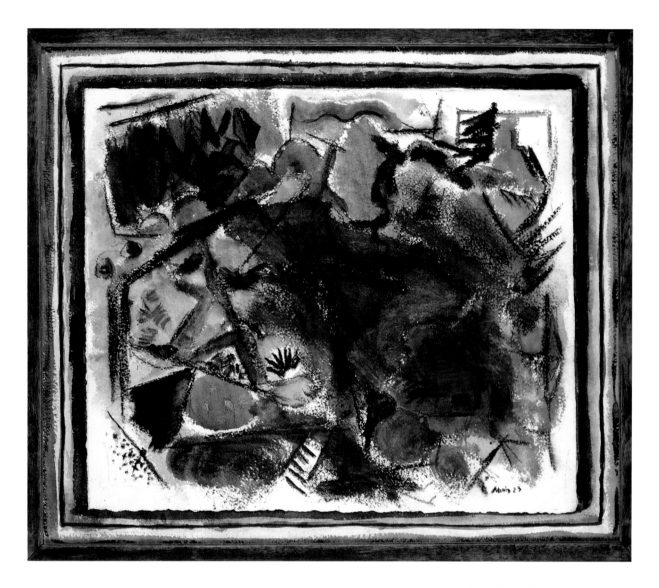

100 JOHN MARIN
Movement, Autumn, *1923*

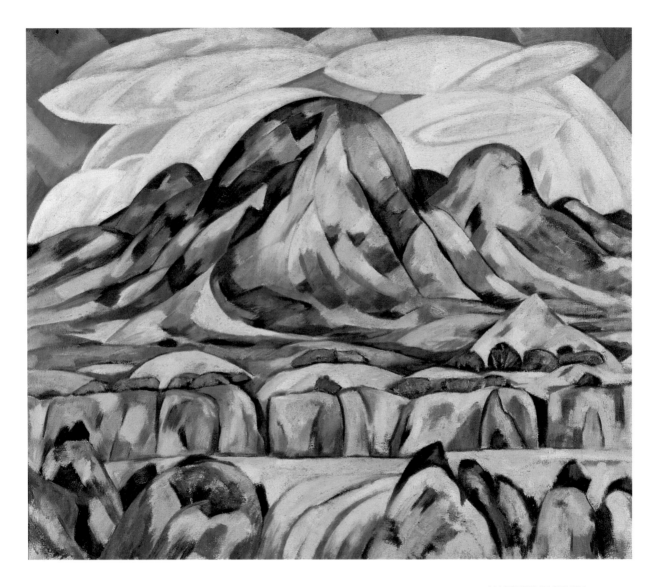

101 MARSDEN HARTLEY
New Mexico Landscape, *1919*

that would be followed for many years and which had a significant impact on the nature of her art.

In 1925 the exhibition *Alfred Stieglitz Presents Seven Americans: 159 Paintings, Photographs, and Things, Recent and Never Before Publicly Shown by Arthur G. Dove, Marsden Hartley, John Marin, Charles Demuth, Paul Strand, Georgia O'Keeffe, Alfred Stieglitz* opened at the Anderson Galleries in New York. Ostensibly a celebration of the twentieth anniversary of the founding of 291, the exhibition, in fact, had very little to do with the past and everything to do with the present.[62] One of the largest exhibitions Stieglitz had ever organized, its catalogue, which he produced because he had come to believe that "the newspapers must have 'something' to start them," was also ambitious, including statements by Anderson, Dove, the German sculptor Arnold Rönnebeck, and Stieglitz himself.[63] Although the seven artists had been coalescing since the early 1920s, it was also the first time that Stieglitz united them in a group. Stieglitz's commitment to Hartley, Marin, and O'Keeffe was patently clear, and, despite some reservations, he continued to support Strand whose loyalty to the older photographer had been amply demonstrated in a series of ten articles published between 1921 and 1924, defending Stieglitz and those associated with him.[64] Although Dove was not active as an artist in the years immediately after his 1912 exhibition at 291 and had only intermittent contact with Stieglitz, by the early 1920s, as his first marriage ended and he recommitted himself to his art, he and Stieglitz had formed a close friendship. In addition, Demuth, who had played a more minor role at 291, also grew closer to both Stieglitz and O'Keeffe in the early 1920s, as he separated himself from his dealer, Charles Daniel, and began to entrust Stieglitz with representing his art.[65]

By 1925 the idea of a close-knit group, with the reciprocal support that members offered one another, was almost as important to Stieglitz as the individuals. During the years when he had been without a gallery, he had become increasingly convinced of the necessity and efficacy of group action. The "Beloved Community" that Bourne, Anderson, Frank, Rosenfeld, and others had celebrated in their writings deeply appealed to him, as did their belief that through the expression of individual but "kindred" men and women, as Rosenfeld wrote, "a single identity" could be created.[66] "We're all after Light—ever more Light," Stieglitz grandiosely told Crane in 1923, "So why not seek it together—as individuals in sympathy in a strong unsentimental spirit—as men—not politicians."[67] Or, as O'Keeffe more tersely recalled many years later, "Stieglitz liked the idea of a group. He wanted something to come out of America—something really important—and he felt you couldn't do that alone."[68]

Through the title for the show, the essays in the catalogue, and the careful installation, Stieglitz sought to orchestrate the perception that these seven individuals

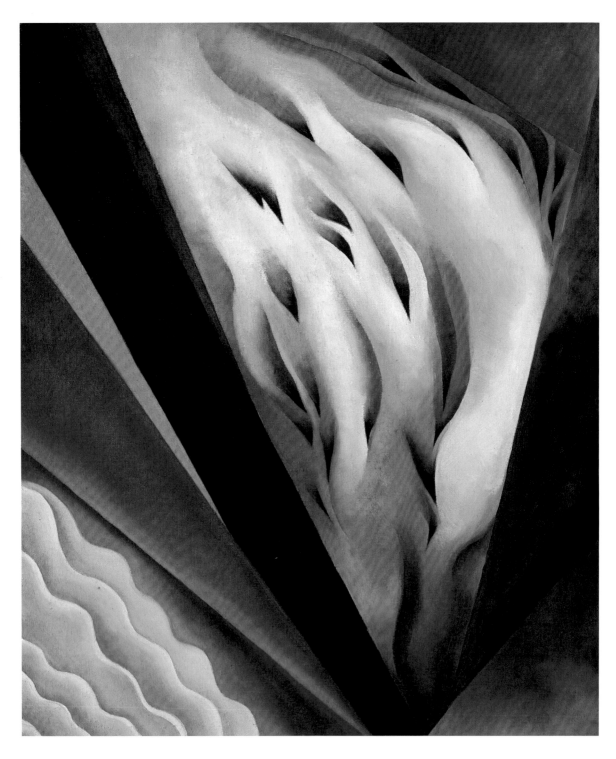

102 GEORGIA O'KEEFFE
Blue and Green Music, *1921*
EXHIBITED AT THE ANDERSON
GALLERIES, 1923

103 ARTHUR DOVE
After the Storm, Silver and Green
(Vault Sky), *c. 1923*
EXHIBITED AT THE ANDERSON
GALLERIES, 1925

fig. 96 CHARLES DEMUTH
Poster Portrait: O'Keeffe, *1923–1924*
poster paint on pressed-paper board
Yale Collection of American Literature, Beinecke Rare Book
and Manuscript Library
EXHIBITED AT THE ANDERSON GALLERIES, 1925; THE
INTIMATE GALLERY, 1926; AN AMERICAN PLACE, 1931

were bound together in a collective voice and expressed a shared vision. To emphasize this idea, visitors entering the gallery first encountered three of Demuth's portrait posters of *Arthur G. Dove, Charles Duncan,* and *Georgia O'Keeffe* (pl. 134; fig. 96).[69] In addition, Stieglitz presented one work by each of the artists (except Strand and himself) in the entrance hall, thus immediately defining the group both in and through their art.[70] In the main room, each artist's work hung on a separate wall for a monographic presentation.[71] Just as Rosenfeld in *Port of New York* had examined fourteen American moderns with the hope that "their various actions had a single tendency," so too did Stieglitz celebrate the accomplishments of the individuals with the belief that their collective voice addressed, as he wrote in the catalogue, "an integral part of America to-day."[72]

But what was this "integral part of America"? In his catalogue essay, Rönnebeck asked precisely this same question. While he noted that the "European conception" of America was "skyscrapers, Jack Dempsey, the Five-and-Ten-Cent Stores, Buffalo Bill, baseball, Henry Ford, and perhaps even Wall Street," he proposed that these were the obvious, superficial, and "Americanized" subjects. He continued that while the seven artists used some of these subjects, they also tried to create a modern "universal reality" or "language" out of the materialistic American culture that "gave full expression to the spirit of *their period*," but was also "profoundly human."[73] With what Rönnebeck called a "daring self-consciousness" and a willingness to express themselves, they were, as the critic Egmont Arens had noted the year before, attempting to forge "the hieroglyphics of a new speech."[74] In much the same way that Anderson, Crane, or Williams wanted to create a new, more spiritually expressive language that spoke more directly of the modern American experience, so too did Stieglitz and others associated with him believe that the "Seven Americans" were developing "a new language [of] paint" to create an art that was more intuitive and experiential.[75] Their work did not seek to illustrate ideas or subjects, but, as Dove succinctly stated in the *Seven Americans* catalogue, this was an art that, like nature, constructed its own reality: "Works of nature are abstract," he wrote, "They do not lean on other things for meanings."[76]

As these artists sought to fabricate this new, more real and immediate art, subject matter became far less important than what Stieglitz called "a feeling of life."[77] "I don't paint rocks, trees, houses, and all things seen," Marin told Stieglitz in 1923, "I paint an inner vision."[78] Differentiating between subject matter and

104 JOHN MARIN
Lower Manhattan (Composition
Derived from Top of Woolworth
Building), *1922*
EXHIBITED AT AN AMERICAN
PLACE, 1932

105 PAUL STRAND
The Court, New York, *1924*
PROBABLY EXHIBITED AT THE
ANDERSON GALLERIES, 1925

style, approach, intention, attitude, and experience, Dove explained a few years later, "When a man paints the El, a 1740 house or miner's shack, he is likely to be called by his critics American. These things may be in America, but it's what is in the artists that counts... What do we call 'America' outside of painting? Inventiveness, restlessness, speed, change. Well, then a painter may put all these qualities in a still life or an abstraction, and be going more native than another who sits quietly copying a skyscraper."[79] If "inventiveness, restlessness, speed, change" were the attributes of America as Dove assumed, or "ingenuity, action, business, adventure, exploiting discovery," as Rönnebeck asserted, then this 1925 exhibition was, as the German sculptor concluded, "essentially American."[80] The predominant feature of the show—and indeed of all the work executed by artists in the 1920s—was a wide-ranging experimentation and an inventive approach to materials and subject matter. Demonstrating an exuberant investigation, this exhibition included oil and metallic paint on canvas, wood panel, and glass; watercolors; collages of watch springs, steel wool, camera lenses, photographic plates, wooden rulers, shells, sticks, foliage, gloves, shoes, and signs from Woolworth's; hand-painted frames; and platinum and gelatin silver photographic prints. Throughout the decade, this group extensively explored the materials of their art: Marin, for example, carefully fabricated collages, that, as in *Lower Manhattan*, folded into his compositions additional pieces of paper, even thread, to further fracture and layer his already dense compositions (pl. 104). Strand, like Stieglitz, investigated different kinds of photographic papers and developing and toning baths to alter both the texture and tonal range of his prints, and, with Charles Sheeler, he made a film, *Manhatta*. Dove, who clearly enjoyed working with his hands and possessed both a thriftiness and ingenuity, as well as a respect for materials, made some of the most inventive collages of the twentieth century (pls. 108, 160, 163).

Although the "Seven Americans" understood subject matter as a vehicle for expression and not as an end in itself, they were just as experimental and innovative in their approach to it as they were in their investigation of materials. While more than half of the works in the exhibition were landscapes, still lifes, or abstractions derived from nature, the diverse approaches range from O'Keeffe's and Strand's close-up studies of plants and flowers; Demuth's radiant, jewel-like presentations of fruits; Hartley's dense, monumental studies of the New Mexico landscape; Dove's highly simplified studies of the sky; and Stieglitz's abstractions of clouds (pls. 106, 107, 137, 138, 101, and 103). The exhibition also included cityscapes by Marin and Strand, photographs of machines also by Strand, and a number of abstract portraits: five collage portraits by Dove of Stieglitz, Paul and Rebecca Strand (titled *Painter Forms, Friends*), a neighbor, Ralph Dusenberrie, and more generic studies, *Miss Woolworth* and *Mary*

Goes to Italy, while O'Keeffe exhibited three works titled *Portrait of a Day—First Day*, *Second Day*, and *Third Day* (fig. 121).[81] Although all of these artists were inspired by the earlier abstract portraits of de Zayas and Picabia published in *291*, these abstract portraits were not simply echoes of an earlier time, but were, instead, one more way of defining and describing their community and of acknowledging respect.

Beyond their fascination with experimentation, the "Seven Americans" were also united by their quest to create a more spiritually expressive art. During the early 1920s, each had pursued a highly simplified style that, at times, especially in the work of Dove and O'Keeffe, verged on the primitive. This approach allowed them to strip away distracting and extraneous elements and concentrate on finding those forms and colors that resonated most deeply with their feelings. All believed that their art involved an intuitive, almost unconscious quest; they worked, as Strand wrote, "from the unconscious to the conscious, from within out." The process, O'Keeffe explained to Anderson, was one of "making the unknown—known."[82] Like their fellow writers, the "Seven Americans" also believed that their art clarified experience not only for themselves but for society; "other Americas will be known through Marin," Seligmann insisted.[83]

The "Seven Americans" exhibition met with an extensive but mixed critical reaction. Each artist received both praise and scorn. While some critics hailed it as pioneering, "the 10 a.m. March 24 interpretation of Modern," and highly experimental, others were less impressed, calling the "pictorial adventures" of these artists "comparatively tame after all the modernism that has flowed under the bridge."[84] Most of the criticism was reserved not for the art, but for the "talky" catalogue.[85] Complaining that "the exhibits are not allowed to speak for themselves," but are surrounded "by a halo of words," Helen Appleton Read concluded that "Americanism and emotionalism are self-consciously and unduly emphasized."[86] While few were as harsh as Read, many of those who were impressed with the exhibition seemed uncertain whether they were responding to the art or to Stieglitz's persuasive oratory powers. As Edmund Wilson, who reviewed the "Seven Americans" exhibition, recalled many years later, Stieglitz was "a spiritual teacher," but he was also a "mesmerist": "I talked about my visit later with an acquaintance.... 'Yes,' he agreed, 'when I came away, I couldn't help wondering a little whether it hadn't been a case of the innocent young serpent being swallowed by the wily old dove.'" And he concluded, "My admiration for these artists was genuine, but if I had not been subjected to Stieglitz's spell, I might perhaps have discussed them in different terms."[87]

Wilson identified a fundamental change in Stieglitz's attitude that occurred in the 1920s. At 291 he had encouraged a free-flowing discussion of ideas and made little attempt to control either the content or the course of the dialogue; in fact, he

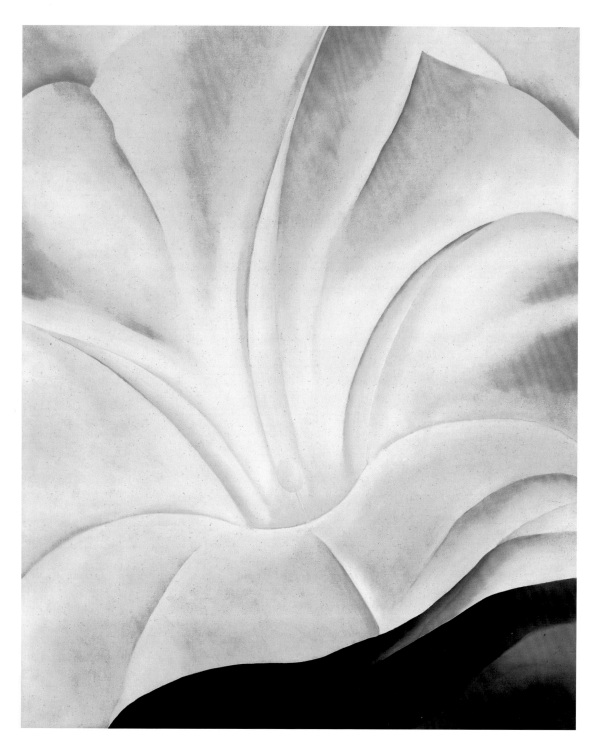

106 GEORGIA O'KEEFFE
White Flower, 1926
EXHIBITED AT THE INTIMATE
GALLERY, 1927

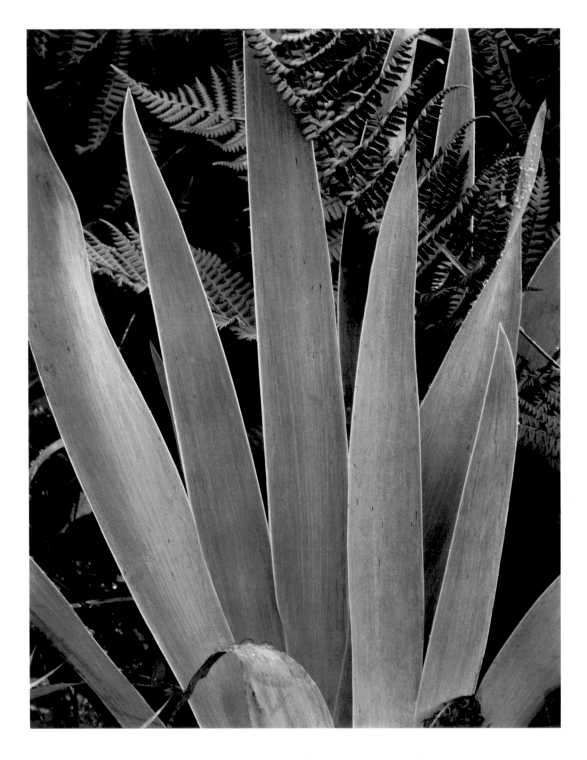

107 PAUL STRAND
Wild Iris, Maine, *1927*
EXHIBITED AT THE INTIMATE
GALLERY, 1929

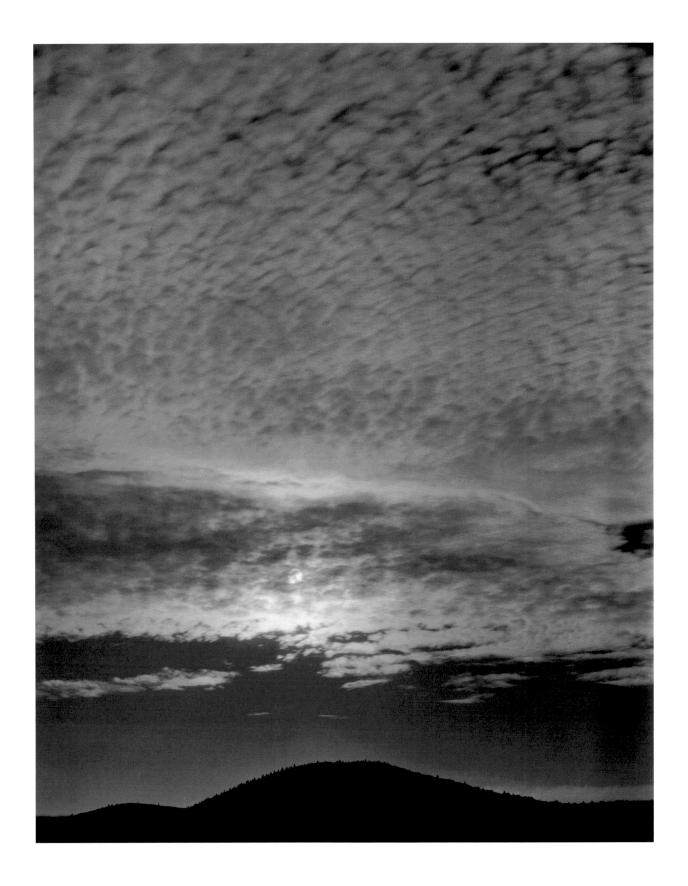

MODERN ART AND AMERICA

had often printed opposing points of view in *Camera Work* precisely to stimulate further debate. However, by the mid-1920s the stakes were higher and the competition more intense. With a brisk art market, a number of galleries were exhibiting modern art. American museums including the Metropolitan Museum of Art, the Pennsylvania Academy of the Fine Arts, and the Brooklyn Museum all held exhibitions of modern art in the 1920s, and other organizations, such as Katherine Dreier's Société Anonyme and Jane Heap's *Little Review* magazine and gallery, were actively promoting the most recent and often very radical art. While much of this attention was focused on modern European art, which still commanded the highest prices, several collectors, including A. E. Gallatin, Earl Horter, Ferdinand Howald, Duncan Phillips, and Gertrude Vanderbilt Whitney were actively acquiring modern American art.[88] Within this more highly charged environment, Stieglitz increasingly became not only more passionate in his promotion of the "Seven Americans," but also more paternalistic toward them. And, in order that they had the opportunity to reach their full potential, he also assumed responsibility for their financial security.[89] In addition, with so many modern artists, both European and American, and so many dealers, all competing for attention, he felt compelled to define and control the discourse around him, transforming what was once an open and highly inventive dialogue into something more polemical and circumscribed. As Wilson noted, in the 1920s Stieglitz was not only an inspirational force, a spiritual leader, but also a partisan spokesman, and increasingly he sought not only to inspire and enlighten his audience, but also to convince and convert them.

Wounded by the harsh criticism, Stieglitz was also amazed that the exhibition was not more financially successful.[90] The year before when he had substituted for a sick Newman Montross during Marin's exhibition at his gallery, he had sold a watercolor for $1,500, substantially more than the usual price.[91] Yet, although more than 2,500 people saw the *Seven Americans* exhibition in the first two of its three weeks, only one work sold, and that to an insider: O'Keeffe purchased Dove's collage *Rain* for $200 (pl. 108).[92] For all of the "Seven Americans" the lack of sales came as a bitter contrast to the success of another exhibition in New York in the spring of 1925 of the contemporary Spanish painter Ignacio Zuloaga. Held around the corner from the Anderson Galleries, it drew 75,000 people, and it was widely reported in the press that at the opening the artist sold four pictures for a total of $100,000; several more sold in the days immediately thereafter.[93] Dove wisely advised Stieglitz that "we cannot show any resentment," and counseled, "the crest of the wave is where the power is. Use it." But Stieglitz, who so often in the past had taken bold steps in response to the actions of others, felt compelled to react. With his restless, competitive nature, his need for a public forum, and his continuing desire to

109 ALFRED STIEGLITZ
Music—A Sequence of Ten Cloud Photographs, No. X, *1922*
EXHIBITED AT THE ANDERSON GALLERIES, 1923

possible reasons why Stieglitz declined to name the seventh artist include his fascination with numerology (he believed that the number seven was auspicious) and his desire to retain some flexibility in the exhibition program. The "Number Seven" or "X" slot was used for shows of Gaston Lachaise, Oscar Bluemner, Peggy Bacon, and Picabia, as well as Demuth.

Perhaps its greatest difference from 291 was that the Intimate Gallery was a cooperative space, one that "belongs to [the] artists."[102] Motivated by his desire to encourage a sense of community among artists, to diminish the idea of art as a commodity or investment, and to establish a more personal relationship between artist and patron, Stieglitz conceived of the Intimate Gallery as an "Artist's Room...a Direct Point of Contact between Public and Artist." Adamantly insisting that this was not a commercial art gallery, club, or "social function" and that he was not a dealer or middleman for art, Stieglitz announced that he had volunteered "his services.... Every picture is clearly marked with its price. No effort will be made to sell anything to any one. Rent is the only overhead charge."[103] "I receive no remuneration in any shape directly or indirectly for the role I play," he told the New York State Tax Commission in 1928.[104] Although no written records survive, Stieglitz's correspondence and descriptions by his contemporaries indicate that he applied a portion of proceeds from most, but not all, sales, to the "rent fund."[105] However, if an artist was in need, Stieglitz often waived this deduction and sent the full purchase price; conversely, if an artist was enjoying comparative success, he (or increasingly she, as the popularity of O'Keeffe's work grew) "contributed" slightly more.[106] Complicating matters still further, Stieglitz occasionally bought works himself and, if someone subsequently wished to purchase the piece for a higher price than he had paid, he reimbursed himself and divided the profits between the artist and the "rent fund."[107] Moreover, he had no qualms about selling a work for far less than its market value if the prospective buyer showed a deep spiritual attachment.[108]

The difference between a commercial art gallery and a cooperative space was lost on most of Stieglitz's public, and his subjective and erratic financial arrangements with artists, buyers, and patrons were at a very minimum difficult to understand and easy to misinterpret. Even so, despite its lofty concerns, monetary matters were at the very core of the Intimate Gallery's concerns, for among its most important, if unstated, objectives was to secure a means of support for the "Seven Americans" and to establish financial parity between their work and that of their European counterparts. The "fight," to use Stieglitz's term, was not only for economic survival, but for the respect he believed these artists should have: "If you know your work—your contributions—to be something positive—I know it must hurt one constituted like yourself," he wrote in 1925, "to feel that true understanding of that

work is lacking."[109] However, in his efforts to achieve financial security for his artists, Stieglitz muddled the public perception of his gallery and himself, for while he adamantly opposed American materialism and passionately advocated a more spiritual art, he seemed to many people by the late 1920s to measure success by the prices realized by the "Seven Americans."

The first incident in this regard occurred in 1926 when the Washington collector Duncan Phillips wanted to acquire *Back of Bear Mountain* from Marin's show at the Intimate Gallery. The critic Henry McBride had praised it as one of the best works in the exhibition, and Stieglitz, fully cognizant that Phillips had spent thousands of dollars on works by European artists, asked $6,000, more than three times the usual amount. According to Stieglitz, when Phillips agreed to buy it, he offered Mrs. Phillips *Sunset Rockland County* as a gift and sold Duncan Phillips *Hudson Opposite Bear Mountain* for half of its asking price of $2,000.[110] Proclaiming that "there was too much hocus pocus going on in the name of French art," Stieglitz anointed the transaction a "miracle…an American has become a sportsman before an American picture."[111] The miracle was sullied, however, when someone, and probably Stieglitz, leaked news of the sale to the press, despite a confidentiality agreement. Not only were angry letters subsequently exchanged between Stieglitz and Phillips, but the photographer was also chastised in the press for "a fake inflation of the values" and "propaganda that is even faintly dubious."[112]

In the wake of this controversy, Stieglitz complicated matters still further. To counter claims that he was charging exorbitant fees, he stopped putting prices on works, but instead asked prospective buyers to make their own offers. Announcing this new procedure in the *Art Digest* in 1927, he gleefully reported that one woman, "in order to become guardian of *The Shelton—Sunspots*," had offered O'Keeffe "an annuity of $1,200 a year for five years," while another had pledged $1,000 a year for three years for one of her paintings of a red canna, but he added that "some pictures found homes at as low as $75."[113] And, in 1928 he made the startling announcement that six relatively small paintings of lilies by O'Keeffe had sold to a French collector for $25,000. Proclaiming her "the Lindbergh of art" for bringing American culture to Europe, Stieglitz expressed delight not only that this sale had set a record "for so small a group of modern paintings by a present day American," but also that the paintings were bought by someone from France, thus indicating that the world at large had recognized the importance of modern American art.[114] Yet, he subsequently amended the story, saying that the buyer was not French, but an American businessman, who planned to move to France and intended to hang the calla lilies in his new home. The businessman, Mitchell Kennerley, the owner of the Anderson Galleries, never realized these plans, though, and returned the paintings to Stieglitz in 1931.[115]

successful and refrained from doing so when they were hard-pressed.[123] But at An American Place he finally had an exhibition space that matched his aesthetic principles. Consisting of five rooms, with a main gallery approximately thirty by eighteen feet and doorless openings to the other rooms, it was as clean and simplified as the paintings and photographs that hung in it (fig. 98). The walls were painted white or a pearl gray, the cement floor was left uncarpeted and painted gray, and the windows were covered with simple shades that rolled up from the bottom to allow for the greatest amount of light.

The exhibition schedule remained much as it had been at the Intimate Gallery: each year until his death in 1946 Stieglitz presented monographic shows, almost always of his three "core" artists—Dove, Marin, and O'Keeffe—interspersed with exhibitions of work by Demuth, Hartley, and Strand, as well as occasional group shows. In addition, as he had done at the Intimate Gallery, he varied the exhibition schedule with occasional shows of work by other artists, including Rebecca Strand, Stanton Macdonald-Wright, Helen Torr, George Grosz, and the photographers Ansel Adams and Eliot Porter. Although he continued to photograph through 1937, when poor health forced him to stop, he showed his own work at An American Place only a few times: in two one-person exhibitions in 1932 and 1934 and two group shows in 1937 and 1941.[124]

While An American Place was in many ways a direct continuation of the Intimate Gallery, Stieglitz himself had changed. In failing health, with a weak heart, he was both less active and less involved in the pressing issues of the day, and he was more focused on his memories. A rebel in his youth and concerned with community in his middle age, he, like any older person, now spent more time reflecting on his past. Beginning in the 1920s and increasingly in the 1930s, he frequently sought to set the record straight, reminding both visitors to his gallery as well as his correspondents of 291's many accomplishments.[125] These stories began to be codified by his followers, first by Herbert Seligmann who recorded and later published some of Stieglitz's conversations from the 1920s and early 1930s and later by Dorothy Norman, who published her own transcriptions in her periodical *Twice A Year*.[126]

As the country sank further into the Depression in the early 1930s and the art community grew increasingly politicized, Stieglitz found himself attacked on all sides. His conviction that art and culture could remake American society, replacing its materialistic values with more spiritual ones, seemed hollow and out-of-touch with the dire economic realities of daily life. Artists and writers on the left, including former colleagues like Waldo Frank and the critic Elizabeth McCausland, reproached him in general for not taking a more active stand in support of the needs and rights of the poor and more specifically for not supporting the Communist

111 ALFRED STIEGLITZ
From My Window at An American Place, North, *1931*
EXHIBITED AT AN AMERICAN PLACE, 1932

112 PAUL STRAND
Ranchos de Taos Church, New Mexico,
1931
EXHIBITED AT AN AMERICAN PLACE, 1932

camera at a young woman's backside it is as if he had *discovered* for the first time in history that a young woman's backside *is* attractive." He linked Stieglitz to such cult leaders as Father Devine and Aimee McPherson, and concluded that "in the conception of himself as 'seer' and 'prophet' lies Stieglitz's real tie to the ways of our country. America produces more of these than any land in the world. The place is full of cults led by individuals who have found the measure of all things within themselves."[139]

While such biased and bigoted remarks would not normally warrant attention, within the highly charged economic, social, political, and cultural turmoil of the time they contributed to the perception that Stieglitz was, at best, elitest and out of touch, and at worst foreign, un-American, and even potentially subversive. Ironically, the new group that Benton came to lead, the regionalists, appropriated many of the ideas that Stieglitz, Frank, Bourne, Rosenfeld, and others had championed for

fig. 99 GEORGIA O'KEEFFE
Black Cross, *1929*
oil on canvas
The Art Institute of Chicago, Art Institute Purchase Fund
EXHIBITED AT AN AMERICAN PLACE, 1930, 1935

more than twenty years, but did so in a way that was not only conservative and politically reactionary, but anti-intellectual, anti-modern, and often xenophobic and jingoistic.[140] They boasted of creating a representational art that was understood by average people and therefore was both more democratic and more American. Artists such as Demuth, Dove, Hartley, and Marin, the regionalist critic Peyton Boswell asserted, "*adopted* European technique without *adapting* it to the national spirit.... These we hail as fine artists, but not as 'American' artists."[141]

For the first time in his life, Stieglitz in 1935 mounted only a weak rejoinder: he exchanged letters with Benton but did not seek to publish a rebuttal.[142] Instead, he, like the other "Seven Americans," retreated and turned inward. Each of these artists had been severely wounded during the Depression: Demuth struggled with poor health and eventually died from diabetes in 1935; Dove was crippled by poverty and subsisted primarily on a $50 per month stipend from Duncan Phillips; the peripatetic Hartley returned to America in 1934, only to destroy 100 paintings and drawings in 1935 because he had no money for

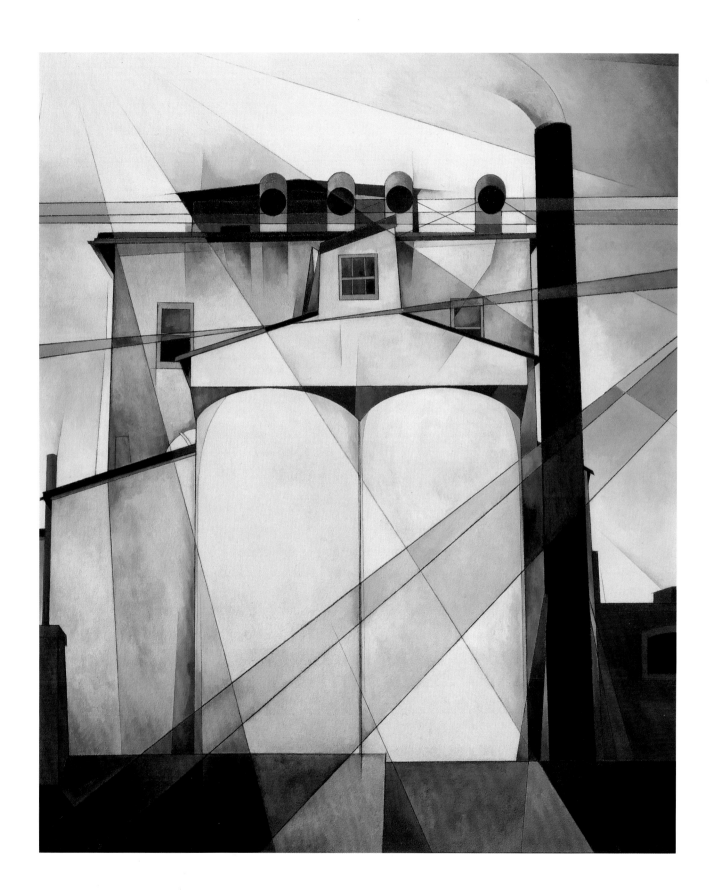

Their very titles reinforced their point of view: Demuth presented *My Egypt*, Marin painted *My Hell Raising Sea*, and Stieglitz recorded the vista *From My Window at An American Place, North* (pls. 113, 127, 111). Hartley's windows, which frame his view, or some of O'Keeffe's titles such as *From the Faraway Nearby*, which emphasize spatial relationships between objects and the artist, also reinforce the vantage point of the artist. Their purpose was not to claim their vista, but to involve their viewers, make them participants in the very act of seeing and therefore knowing the world. In addition, these artists were also demonstrating their complete acceptance of their time, their place, their country, and ultimately, of course, themselves. Each acknowledged that the sublime existed at their doorstep: Demuth's Egypt was Lancaster, Stieglitz's Valhalla was the skyscraper of New York, while for Marin, Hartley, O'Keeffe, and Dove the universal life force—the thing that was always present but constantly changing, that was limitless and perhaps ultimately elusive—could be gleamed in the simple, rugged coast of Maine, the desert of the Southwest, or the modest dwellings on Long Island Sound. Finally, although time ceased to be an issue in their art as they searched for more eternal structures, much of their work from this period has an undeniable elegiac quality. O'Keeffe's paintings of cow skulls hovering above the barren desert, Hartley's studies of dead birds, and Stieglitz's photographs of empty buildings all seem to express the passing of both an era and a dream; or as Demuth most eloquently and evocatively expressed it in a painting of industrial smokestacks against a blue-gray sky, this is where American art and culture had come to *After All*.

To a very great extent, Stieglitz was fundamentally responsible for this transformation in American art. For more than thirty years he had orchestrated one of the most complex, sustained, and influential dialogues ever created in American art and culture. All of the "Seven Americans" drew profound support from the community that he had fostered and deep inspiration from his own art. And, if there was one factor that prevented their work from attaining the triumphs that post–World War II American painting would achieve, it was the relatively small scale of their paintings.[146] Deeply entranced by the possibilities of photography and by the world that could be seen within Stieglitz's own eight-by-ten-inch photographs, they saw little reason to aspire to a significantly greater scale in their own art. The vision of a photographer had liberated, enlightened, nurtured, and perhaps ultimately defined their world.

One more indication of the symbiotic nature of the group of artists and intellectuals whom Stieglitz had sustained for almost four decades came after his death on 13 July 1946: Rosenfeld died the following month, and Dove died only four months later in November. Only the detached Strand, the self-reliant Marin, and the resilient O'Keeffe survived to construct independent lives in the years thereafter.

114 ALFRED STIEGLITZ
From My Window at The Shelton, North, *1931*
EXHIBITED AT AN AMERICAN PLACE, 1932

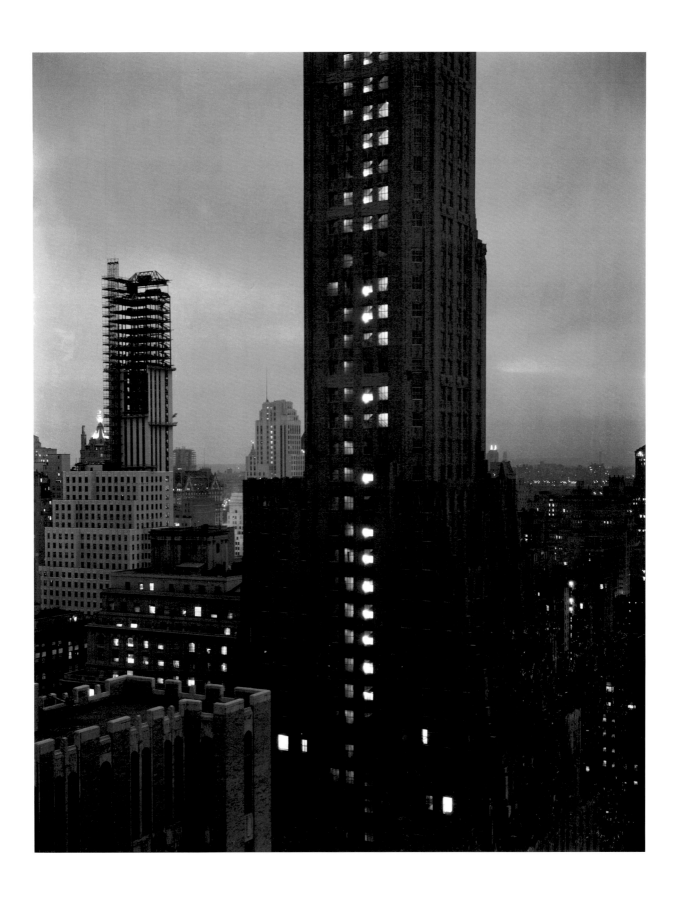

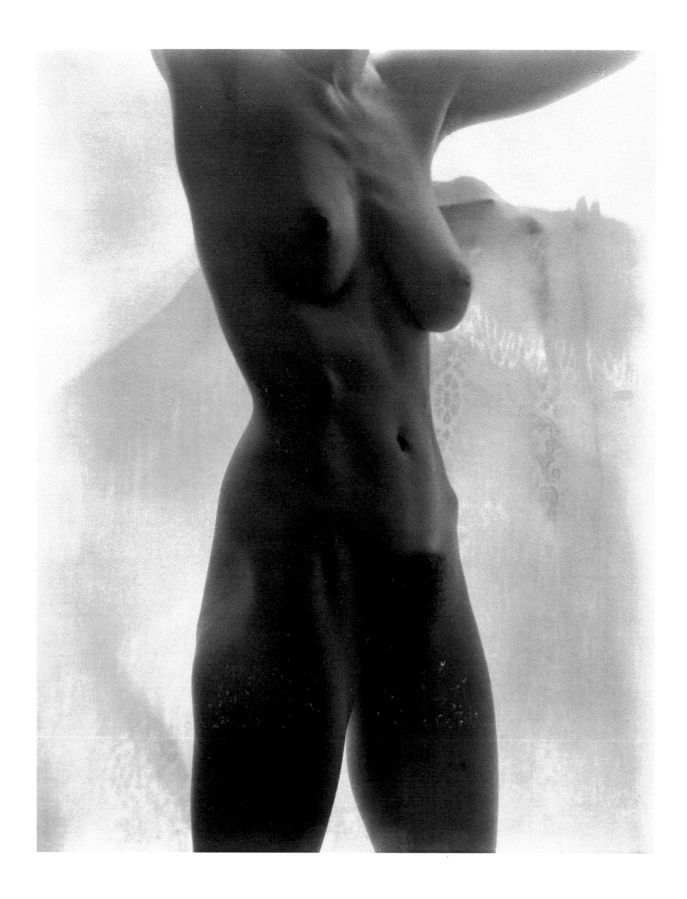

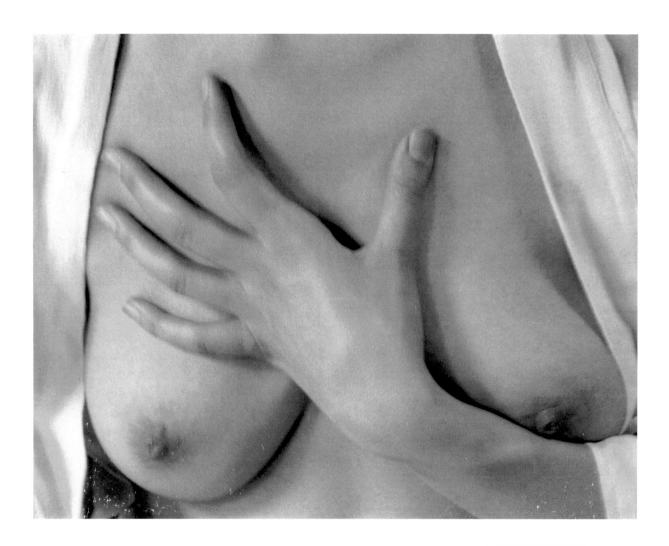

118 ALFRED STIEGLITZ
Georgia O'Keeffe: A Portrait—
Hand and Breasts, *1919*
EXHIBITED AT THE ANDERSON
GALLERIES, 1921; AN AMERICAN
PLACE, 1932

117 ALFRED STIEGLITZ
Georgia O'Keeffe: A Portrait—
Torso, *probably 1918*
EXHIBITED AT THE ANDERSON
GALLERIES, 1921

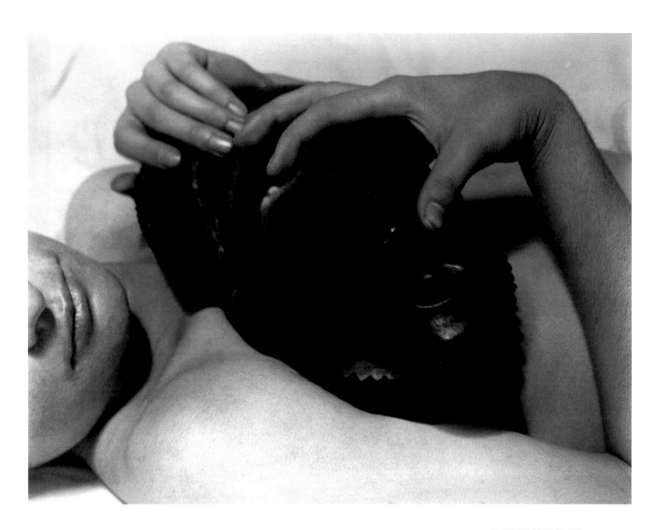

120 ALFRED STIEGLITZ
Claudia O'Keeffe, *1922*
EXHIBITED AT THE ANDERSON
GALLERIES, 1923

121 ALFRED STIEGLITZ
Music—A Sequence of Ten Cloud
Photographs, No. VIII, *1922*
EXHIBITED AT THE ANDERSON
GALLERIES, 1923

122 ALFRED STIEGLITZ
Music—A Sequence of Ten Cloud
Photographs, No. V, *1922*
EXHIBITED AT THE ANDERSON
GALLERIES, 1923

Ruth E. Fine

JOHN MARIN

AN ART FULLY RESOLVED

O ne of the most highly regarded American artists of the first half of the twentieth century, John Marin was admired by painters and collectors alike. In 1926, one journalist described the Marin-Stieglitz relationship as one of "mutual admiration which, expressed by silent loyalty on the part of the non-communicative Marin, is heralded widely by Mr. Stieglitz, who seems never to feel happier than when praising the genius of Marin."[1] The sympathetic warmth of this duo was central to Marin's artistic success; and from the time the two men met, their friendship functioned as an active force in the exhibition program at Stieglitz's Little Galleries of the Photo-Secession (291), Intimate Galleries, and An American Place, where an exhibition of Marin's work marked the start of almost every new season.

Stieglitz met the "waggish, unassuming, boylike and curiously dignified"[2] Marin in June 1909 at his Paris studio. The two were brought together by Edward Steichen whom Marin had come to know in Paris through Arthur B. Carles, a class-mate at the Pennsylvania Academy of the Fine Arts.[3] Prior to that June meeting, from 30 March through 19 April, a group of Marin's watercolors chosen by Steichen was exhibited at 291 in a two-man show that also included oil sketches by Alfred Maurer. Marin temporarily returned to the United States late in 1909, and in February 1910 his first one-man exhibition at 291 took place, including pastels and etchings as well as watercolors.[4] That May Marin sailed to Europe for a stay of several months, which was his second and last trans-Atlantic journey. The belief among many members of the Stieglitz circle that America was swiftly becoming an important artistic center would have validated Marin's ties to his home shores for the rest of his life; and Stieglitz's

123 ALFRED STIEGLITZ
John Marin, *1922*
EXHIBITED AT THE ANDERSON
GALLERIES, 1923

extraordinary financial and psychological support surely provided both a safety net and an anchor for the artist. A testament to the reciprocal intimacy of their friendship is the fact that in 1924 Marin stood as a witness at the wedding of Stieglitz and Georgia O'Keeffe.

The letters Marin wrote to Stieglitz over the years are filled with indications of the painter's great reliance on his friend. For example, in a letter begun on 19 September 1915 and finished on the 26th of that month, from Small Point, Maine, Marin wrote that he "Received checks all right—Many thanks...." On 6 September 1916, writing from Echo Lake, Pennsylvania, he ended with: "Take care of yourself, have a good time. Thanks for the check. Write." And almost thirty years later, in a post-script from Addison, Maine, on 8 September 1942, Marin acknowledged: "Received check—200...."[5] A letter to Stieglitz from Casterland, Lewis County, New York, on 22 July 1913, reports that Marin had "about 50 sheets of paper daubed up [and will] be beginning on their *back sides* pretty soon. So order about 150 new frames...."[6] Financial support was not the only bond and, indeed, Stieglitz was a tireless advocate for Marin, sponsoring or otherwise securing exhibitions, and placing his works in important collections, as well as assuring the painter's freedom from financial concerns throughout his life, thereby permitting him to concentrate on his art.

In 1937 Paul Rosenfeld summarized this support over the years, explaining such interactions as the time when "Marin, who recently had married, announced that the sum of $1,200 would suffice him and his adult bride for a year. The sum was found, and the couple departed for Maine. Six weeks later, Marin returned to New York, and slightly sheepishly announced, 'Mr. Stieglitz, there is something I've got to tell you. I've bought an island in Maine with the money you gave me. It's a very beautiful island: the only drawback is, there isn't any water on it. And, there's another bit of news. My wife—is expecting.' But it was impossible to be annoyed at a painter whose water colors—like Schubert's songs—were fresh and lyrical and saturated with the beauty of the world for attempting to start a new continent. Marin once more returned to Maine, and resumed dining off clams and huckleberries, and painting the landscape."[7] Stieglitz must once again have "found" the necessary sum for the support of Marin and his growing family.

Several years later, according to Rosenfeld, "Marin acquired a Ford car. He had purchased a home in Cliffside, New Jersey, and had taken his family every summer to Maine; but automobiles and peregrination were not in the austere Stieglitzian picture. However, it shortly transpired that travel in the Ford was presenting Marin with new exciting visual experience, and that since the spring nearest the Maine cottage occupied by the painter was not more than a quarter of a mile distant,

124 JOHN MARIN
Sunset, *1922*

the car also had a domestic usefulness."[8] Although it remains unclear whether Stieglitz gave Marin a specific annual stipend, or purchased paintings throughout the year, or sometimes one, sometimes the other, it is clear that Marin and his family depended on Stieglitz for their comfort if not their survival. Stieglitz's role similarly was essential to maintaining public awareness and critical acclaim for Marin's art, even laying the groundwork for its posthumous perpetuation.

Acclaimed for his etchings by 1908, Marin was praised for his watercolors by 1911; and by 1917 he was referred to as "perhaps the most brilliant of our younger water-colourists."[9] The artist also painted in oils as early as 1900, and he continued to do so periodically for the following two decades.[10] Not until late in his career, however, did Marin consistently embrace what was referred to by art critics as the "heavier" or "denser" medium. His unusual commitment to "washes" or "papers," the journalistic terms for watercolor, was frequently criticized. Murdoch Pemberton, one of the artist's strongest enthusiasts, responded in 1928, "We find Marin as strong as the worker in oils. We have no patience with those who try to segregate him or to minimize his genius by pointing to his chosen medium."[11] This high opinion of Marin's work was extended even further by Julius Meier-Graefe, who wrote, "Marin can pass to-day as the representative of art in America."[12] Lewis Mumford put it this way: "Were I writing a history of American civilization and did I want a symbol of the utmost economy and organization we had achieved, I should select not a Ford factory but a Marin water color."[13]

After a break of several years, Marin explored oil painting again in 1928; but none of the new oils was included in his December 1929 exhibition inaugurating An American Place.[14] Instead, a group of watercolors was "hung perfectly ... in a gallery designed for him and O'Keeffe.... You open the door, and there before you are the forty-seven new Marins blazing in your eyes. We doubt if the season will furnish anything quite like it in its combination of sensory and aesthetic emotions.... he catches Nature on the run with those quick, fierce jabs of truth.... [Cézanne] would have caught America in these vivid strokes more quickly than he could have on a tour of our teeming cities and uncouth countryside."[15] Paul Rosenfeld found the show less blazing: "This year's display is the product of a man no longer in his youth [Marin had just turned fifty]. The familiar lightenings have been succeeded by less diffuse a glow. The violent juxtaposition of color has given way to more tranquility interplaying wide areas. Still, no group of them ever shone like this."[16] Rosenfeld proposed that watercolor was central not only to Marin's work, but to American art more broadly: "Marin's use of watercolor has the very mettle of the relations to the abiding characteristic of his age and nation....[watercolor] has long been recognized as a medium curiously sympathetic to the American temperament.... [Ameri-

cans] have developed a mode of life arduous in its extreme changeability and momentum, incertitude and freedom from precedent; its increasing requisitions of powers of abrupt adjustment, rapidity of mental process, intuitive leaps. Precisely these nervous and accelerated conditions have made Americans 'a nation of sprinters,' and decreed to all the quicker media, photography, the short story, imagist verse and the rest, their means of plastic expression."[17]

Contemporary Marin criticism fell into three categories. The first and most prevalent, unfettered enthusiasm, was characterized by the writings of Mumford and Pemberton in *The New Yorker*, Henry McBride in *The New York Sun*, and Ralph Flint in *The Christian Science Monitor*.[18] The second was admiring of Marin's art but moderated by the concern expressed by Guy Eglington as early as 1924 that "surely everything in the way of genuine appreciation has been said. Too much perhaps."[19] Lloyd Goodrich echoed this opinion some years later, in response to Marin's November 1930 exhibition at An American Place: "Marin remains one of our most genuine, most truly original artists—even if not the combination of Michelangelo, Shakespeare, and Beethoven that his admirers seem to believe him."[20]

In a review of an exhibition at the Museum of Modern Art featuring Marin and eighteen other American artists, Forbes Watson tempered his praise by disparaging Marin's use of watercolor, with an edge of sarcasm about Stieglitz's entrepreneurial style: "The watercolors of that excitable expressionist, John Marin, have been exhibited so often outside of the sacrosanct premises of his chief promotor, Mr. Alfred Stieglitz, that the cold atmosphere of a large general and uneven exhibition cannot very permanently affect Mr. Marin's unique position among American watercolor specialists. His is a small, a special gift lacking the strength of a robust art. But even the exaggerated overrating of his friends cannot destroy his rare quality."[21]

Last, a few critics did not grasp Marin's modernism at all. Marya Mannes wrote that she could not "understand the beauty or power in tangential pencil strokes, flying loose and out, and jagged blocks of uncertain color, set at angles and cross-hatched; ... They are, to me, ugly—... And inspire me with a deep longing to cry out vulgarly, 'For God's sake, sharpen your pencil and change your water.'"[22] Royal Cortissoz's consistently negative voice offered such scathing opinions as "In the main [Marin] leaves the impression of an artist moving about in worlds unrealized and expressing himself in terms that are not only inchoate, but repellent."[23]

Marin's favorite themes during the years of The Intimate Gallery and An American Place included bustling New York scenes such as *Region of Brooklyn Bridge Fantasy*, 1932 (pl. 128); Cliffside, the surrounding New Jersey environs, and the route

fig. 100 JOHN MARIN
From the Bridge, *1931*
watercolor, graphite, black crayon, and charcoal on paper
private collection

between New Jersey and New York that he frequented, such as *West Forty-Second Street from Ferry Boat*, 1929; and the mountains and sea he encountered each summer in Maine, such as *Rocks and Sea, Small Point, Maine*, 1931 (pl. 126).[24] It became Marin's practice to consider his subjects in various media and to rethink them over time. The sorts of subtle variations at which he arrived may be seen when viewing *From the Bridge*, 1931 (fig. 100), with *From the Bridge, New York City*, 1933 (pl. 125). Regardless of medium or motif, however, Marin's primary subject was flux, form in motion, reflecting both physical and metaphysical transition as part of the creative process.

Marin's oils—thirteen of them, depicting Maine subjects—were first shown at An American Place from 11 October to 27 November 1931. The exhibition—"a feast of uncommon beauty"[25]—also included four New York etchings and thirty watercolors painted in New Mexico. *Storm over Taos*, 1930 (pl. 131), is among the most dramatic of approximately one hundred watercolors from Marin's 1929 and 1930 trips to that region, but it was not included in the 1931 show. Subsequently, it became

125 JOHN MARIN
From the Bridge, New York City, *1933*

standard practice for most of Marin's annual American Place exhibitions to include an array of subjects in both oil and watercolor, as well as the occasional etching or drawing in graphite or colored pencil.

Mumford wrote about Marin's 1932 show that the artist "not merely demonstrates a mastery of the [oil] medium, but ... he extends the range of his art by a couple of octaves...."[26] The following year this same critic contrasted Marin's twenty-five-year retrospective of watercolors (immediately preceding a November show that featured his new watercolors and oils) with Edward Hopper's retrospective at the Museum of Modern Art, shifting from the musical metaphor to one rooted in transportation methods: "one may follow Hopper on the pedestrian level; following Marin, one must risk one's neck in an airplane, and abandon comfort for speed and danger and unexpected bumps and sudden splendors through a hole in the clouds."[27]

During the first decade in which Marin seriously explored oils, though, most critical response was measured at best. McBride wrote of the November 1932 display that while "the artist does not fly so high [with oils] as he did in water color ... he flies nevertheless, and that is all that a citizen of the earth asks of an artist."[28] Six years later, Edward Alden Jewell echoed McBride: "the oils ... lag a good bit behind the water-colors.... at their superb best Marin's water-colors are full of magic. He is then a winged Pegasus."[29] The brochure for this show included Marin's Valentine's Day ode "To My Paint Children," in which he addresses himself with equal affection to his works in both media: "I would say you are neither the one/or the other to be jealous of one another/to you my Oil Kids—your Poppa—got a/somewhat repuation a making your *water* sisters/but you Seem to be a Coming along—/tolerably well...."[30]

Great oils followed, such as *Grey Sea*, 1938 (pl. 132), which was first seen in the 7 November–27 December 1938 exhibition that finally elicited an aptly enthusiastic description of the work in this medium: "With a vitality, a tumultuousness and pantheistic ardor never surpassed in his watercolors, the latest series of oil paintings by John Marin, genius of American watercolorists, dominates his show at An American Place. All the powers of the sea, its terrible beauty, titanic movement and treacherous calm, is projected in these paintings of Cape Split, Maine.... The swift, magnificently coördinated calligraphy seems to spring from a source in nature common to the scene itself, as if the artist's hand were a seismograph automatically recording the vibration, the unseen life and internal rhythm of the sea.... The wide brush, loaded with pigment and drawn impetuously over the picture surface ... carries the impress of the sweeping movement of the painter's arm and of the sea."[31]

126 JOHN MARIN
Rocks and Sea, Small Point,
Maine, *1931*

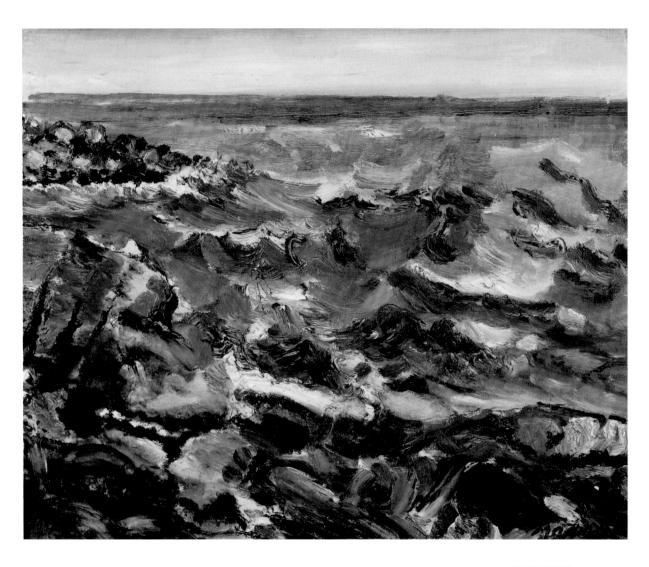

127 JOHN MARIN
My Hell Raising Sea, *1941*
EXHIBITED AT AN
AMERICAN PLACE, 1941–1942

From the late 1930s on, Marin began to produce the oils in which his responses to the sea were most fully resolved. Over the next fifteen years these works evolved and changed. Among the high points is *My Hell Raising Sea*, 1941 (pl. 127), with its dappled, densely layered paint. It was on view at An American Place from 9 December 1941–27 January 1942, after America's entry into World War II. This event was one of several that touched Marin profoundly during the 1940s. Jerome Mellquist suggested that the artist's finest oils dated to mid-decade, paralleling in their density and complexity a time of great difficulty for Marin: his only son, John Jr., had been called up for service. Marie, his beloved wife of more than forty years, died in 1945, and the death of Stieglitz the following year doubled his loss. Marin was bereft of both personal and artistic support.[32]

Marin's embrace of a symbolist figuration during the 1930s and 1940s supports the notion of a powerful emotional shift in his responses to the world. Although figures had long played a symbolic role in his New York street scenes, such content was expanded in the circus pieces, which, like many of Marin's watercolors and oils, were initiated by sketchbook studies (see fig. 101). The symbolic content of Marin's late art has yet to be fully explored, but was apparent in the 21 March –12 April 1942 American Place exhibition subtitled "Pertaining to New York, Circus, and Pink Ladies—Works from 1936–1941." Many reveal a shift toward the linear, calligraphic movement that culminated a decade later in the vividly active, open composition of *The Written Sea*, 1952 (fig. 102).

Long after Marin began to work steadily in oils, his watercolors continued to be featured in special exhibitions at An American Place, for example, a 1939 retrospective titled *Beyond All "Isms": 20 Selected Marins (1908–1938)*.[33] By contrast, Stieglitz never sponsored an exhibition solely devoted to the "heavier" of the artist's paint children. It remains unclear whether this contributed to or resulted from the fact that the critical response to the oils rarely equaled the effusiveness accorded to the watercolors. Not until 20 March–6 May 1950, though, four years after Stieglitz's death, was an exhibition solely of Marin's oils, a retrospective of twenty-seven works, on view at An American Place.[34] It was Marin's final show there.

Stieglitz brought attention to Marin's writings as well as his art, enhancing the almost mythic place he held in the Stieglitz circle of intellectuals. Explaining that "[Marin's] letters—there are not many—are

fig. 101 JOHN MARIN
Sketchbook sheet of a circus scene, *1930s or 1940s*
graphite and crayon
National Gallery of Art, Washington, Gift of John Marin Jr.

fig. 102 JOHN MARIN
The Written Sea, *1952*
oil on canvas
private collection, Courtesy of Richard York Gallery

as living and beautiful as his watercolors," Stieglitz first published one in The Intimate Gallery's brochure for his 9 November – 11 December 1927 show. In it Marin explained how "…this/seemingly crazy stroke is put down/with deliberate-mulish-wilfulness/I find myself constantly juggling/with things playing one thing against/another—and then when I get through/they look so much like—Marin/they act like Marin—cannot/I ever get away from this fellow/Marin…."

The down-to-earth character of Marin's syncopated writing was more fully introduced to his admirers four years later. Contradicting Stieglitz's suggestion that Marin's letters were rare, Herbert J. Seligmann edited and An American Place sponsored a volume entitled *Letters of John Marin.*[35] It was appreciatively received. *The New Yorker,* for example, reported that there were "no high falutin words about 'organization of form.' " This modesty also was evident in published interviews, for example, so delightful a comment as "When I'm up against a mountain … I don't say I can paint it, but ask 'Mountain, will you allow me to look at you?' "[36]

Dorothy Dannenberg's review of *John Marin: The Man and His Work,* by E. M. Benson, published in 1935, points to Marin's reputation at the time: "Awarded

accolades by the critics annually, [Marin] is yet little known or appreciated by the art public. Most of the writing about him hitherto has been by devotees who have preserved the cult-like aura which surrounds him...."[37] The mastermind behind the cultlike aura was Stieglitz, whose steadfast support of Marin's career was widely reported. The director of the Museum of Modern Art, New York, Alfred M. Barr Jr., for one, in the catalogue for Marin's 1936 retrospective, credited the exhibition as "in no small part a tribute to [Stieglitz's] devoted championship of Marin's work." In the end, Barr continued, "Marin must fight his own battle," which the director believed he would win.[38] And win he did.

The show inspired such enthusiastic headlines as "Marin Triumphs in Retrospective Exhibit of Work" (*New York Post*, 24 October 1936), and glowing articles like one by Mellquist, dubbing the exhibition "the most important event in American art since the memorable Armory Show of 1913."[39] Mellquist's bow to Marin, like Barr's, was accompanied by a bow to Stieglitz: "[Marin] has proved to be majestic and soaring and deep and inexhaustible. His work stands on another plane from where it was before and, by virtue of that fact, so does American Art.... And let us not forget the man who first saw what was in the crazy, shy little Yankee Marin—Alfred Stieglitz, his friend and champion, who has presented in this show a masterpiece in hanging which will be remembered for many years. He has given Marin to America and the world."[40]

A week before the show closed, Stieglitz wrote Marin an extraordinary letter that conveys both a sense of the toll the retrospective had taken on the artist and the level and many kinds of support both the photographer and his wife, painter Georgia O'Keeffe, offered their friend: "My dear Marin: You had better get busy on your show which is to go up here Jan. 1st. Forget about the $1500.00. That will work out all right You 'owe' me nothing And as for your new framing O'Keeffe is ready to go $500.00 on that and don't worry about that either. Just get busy & get things ready & done properly. We must win out. And will. And to hell whether painting will be dead or alive in days to come. You have *your* job to do. And I'm with you all the way through it. As is Georgia—We each have our job to do.—And so also together—Is tough going perhaps but there is still a going.—That's important—A fellow gets a bit 'tired' occasionally & that's a mistake. No, it isn't for him to get tired.—That's the sum of it.—So get busy.—Have Of[41]—or whoever—bill to John Marin, c/o Alfred Stieglitz (or rather An American Place)—.... Your old friend *Stieglitz*—. N.B. Well, Godwin has been here. 4 of your things are to go to his house for him to choose from. So may be something will happen I think so. They are A 1 things —Taos.—I'll make the prices as that they'll be not too high. And a lady from Chicago just bought a small thing of yours for $325. Georgia was at the museum & sent her here!! So I hope this is a beginning."[42]

O'Keeffe's behind-the-scenes role continued for many years. Emily Genauer, who happened by An American Place during the time of the installation, credited her for hanging by subject the works in "Pertaining to New York, Circus, and Pink Ladies."[43] And for a few years after Stieglitz's death O'Keeffe quietly carried on An American Place, which frequently sponsored exhibitions of Marin's work.[44]

A press release of 15 August 1950 announced an extraordinary change in Marin's life—his appointment of Edith Gregor Halpert's Downtown Gallery as his exclusive agent. As part of the arrangement, Halpert committed to maintaining a John Marin Room at all times, echoing the educational, non-commercial stance that Stieglitz had embraced in respect to the artists he championed. "As [the Marin Room] was not intended as an exhibition gallery, but rather an informal and intimate place where a retrospective selection of oils and watercolors by America's leading contemporary artist may always be seen, most of the paintings are not hung, but stand on aluminum channels especially designed and constructed for the purpose.... The color of the walls was mixed by John Marin himself, and the floor and ceiling colors selected by him. An additional feature of the room is the permanent

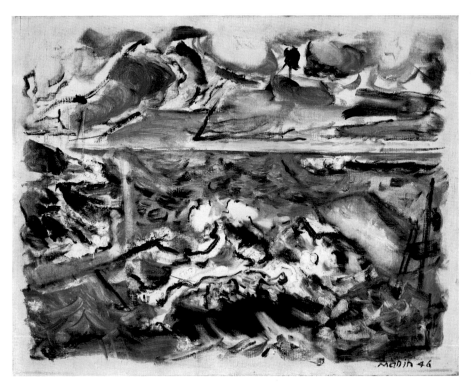

fig. 103 JOHN MARIN
Movement—Sea and Sky, *1946*
oil on canvas
The William H. Lane Collection, 1985, Courtesy Museum of Fine Arts, Boston
EXHIBITED AT AN AMERICAN PLACE, 1947

display of publications relating to the artist. And in the anteroom, to further empha-
size his versatility, there is a group of Marin's etchings."[45]

With Stieglitz's necessary blessings, Halpert had been showing Marin's work
at her gallery since 1928. In addition, over the years the photographer's cooperation
had made it possible for her to place occasional exhibitions elsewhere, for example,
a show of Marin's watercolors and O'Keeffe's oils at the Society of Arts and Crafts in
Detroit in January–February 1934. But the very first exhibition of new paintings by
Marin ever held at a gallery other than those sponsored by Stieglitz opened at The
Downtown Gallery on 27 December 1950.[46] Earlier that year Marin's one-man exhi-
bition—more oils (twenty-nine) than watercolors (twenty-five)—filled half of the
American pavilion at the Venice Biennale. This exhibition, too, was a first: the first
retrospective in Europe of work by a living American artist outside of a private
gallery.

The coherent interaction of Marin's work regardless of medium was remark-
ably consistent, and especially so during the final decades of his career: each image
and method contributed visual data and richness of facture to every other one. The
watercolors became increasingly dense, like the oils, as apparent in *Sea, Green and
Brown, Maine*, 1937 (pl. 130); the oils, which started out to be richly impastoed, in
later years incorporated thinly painted areas related to the watercolors, as apparent
in *Movement—Sea and Sky*, 1946 (fig. 103). In both media a calligraphic line took on
a prominence that reflected Marin's ever-present commitment to drawing, always
apparent from the hundreds, perhaps thousands, of small, swiftly made sketches he
produced over the years. Many became sources for more finished works, although
not in any slavish sense. These drawings were on public view more frequently late in
Marin's life than early, and they provided insight into his artistic process. While
Marin always maintained a sense of speed and spontaneity in his finished works,
"These copious and vital notes, these workings and reworkings prove that a Marin
watercolor is not thrown together at the moment but is very carefully considered
and constructed."[47]

Stieglitz's importance to Marin's career was not curtailed by death. From 7
January through 15 February 1947, the Institute of Modern Art, Boston, hosted a ret-
rospective exhibition of oils, watercolors, drawings, and etchings selected from the
works Stieglitz had held back from sale so Marin himself would have a stellar retro-
spective representation of his work. The exhibition, which was seen in Los Angeles,
Cleveland, Washington, and San Francisco, was listed in the January 1948 *Art News*
as one of the best exhibitions of the previous year. Spectators in Boston "flock[ed]
in at the rate of 200 a day—which is big for Boston ... not yet conditioned to modern
art ... [but Marin's] name is in grave danger of becoming locally popular. The

artist's wizardry with color, now delicate, now blatant; his often dynamic and some-times lyrical presentation of form; his almost playful insistence upon symbolism, and the powerful intellect which seems to couple with frenzied inspiration in his work have weened many to whom the phrase 'modern art' is anathema."[48]

In a February 1948 poll conducted by *Look* magazine, Marin was elected by two different groups—one of museum directors, the other of painters—as "America's Artist No. 1." The artists' poll reinforced the longstanding notion of Marin as an "artists' artist" that had been apparent for years. It was expressed in 1932, for exam-ple, by McBride who wrote that Marin's art was "a joy and comfort to artists."[49] In the catalogue for the 1936 Museum of Modern Art retrospective, Marsden Hartley, comparing the painter to T. S. Eliot in "pacing his strokes to a new beat though it is the same language,..." praised his work for "lift[ing] water colour painting out of the embroidery class, out of the class of minor accomplishments of the idle ladies and fussy bachelors—... and has made of it a major medium."[50]

By the last years of Marin's life, a new and younger generation of painters and critics, less prone to the arch language of Marin's contemporaries, but equally enthusiastic, was writing about his art. For example, painter Louis Finkelstein's 1950 discussion of "Marin and DeKooning" suggests a fascinating kinship: "...it is the lack of formulation, or rather the refusal to rely on formulation lest that reality for which the form exists escape them, that distinguishes their work.... an insis-tence upon art as organic synthesis.... the rejection of all discipline save that of the experience itself."[51]

Admiration from painters continued beyond Marin's lifetime, and came from artists whose work was not rooted in the visible world as his was. Fairfield Porter's review of Marin's 1955 memorial exhibition at the Museum of Fine Arts, Boston, uses language very different than McBride's, but also suggests that Marin brought joy to artists, that even abstract and younger generation painters "who never looked at his work in his lifetime were busy rediscovering for themselves the vision of a functional world Marin was the first to find—one that does not contain objects."[52]

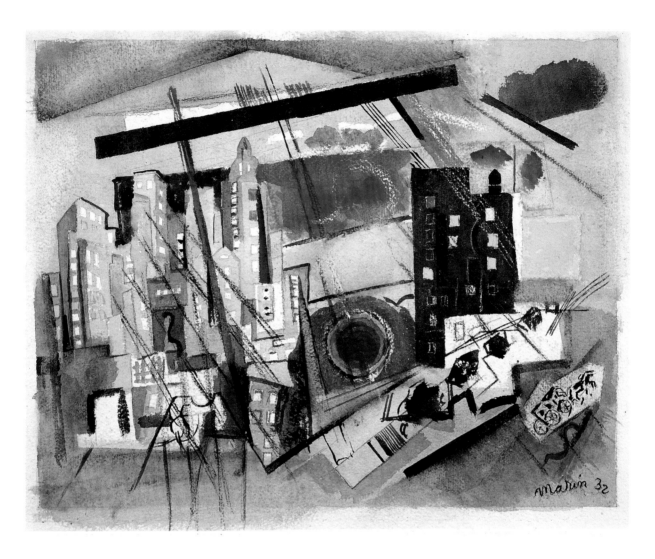

128 JOHN MARIN
Region of Brooklyn Bridge Fantasy,
1932

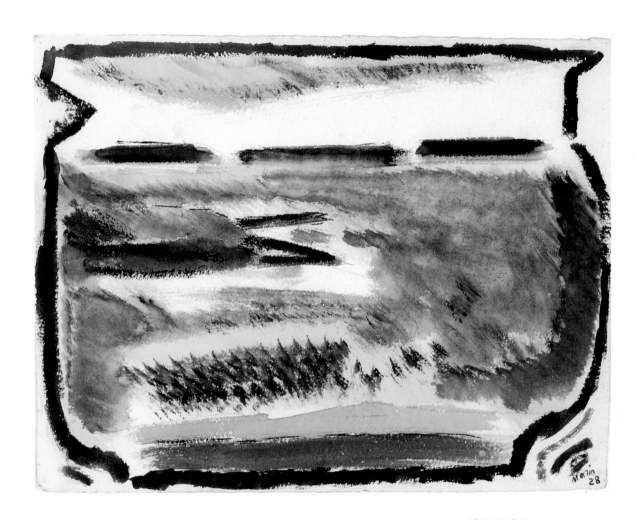

129 JOHN MARIN
A Southwester, *1928*
PROBABLY EXHIBITED AT AN
AMERICAN PLACE, 1928

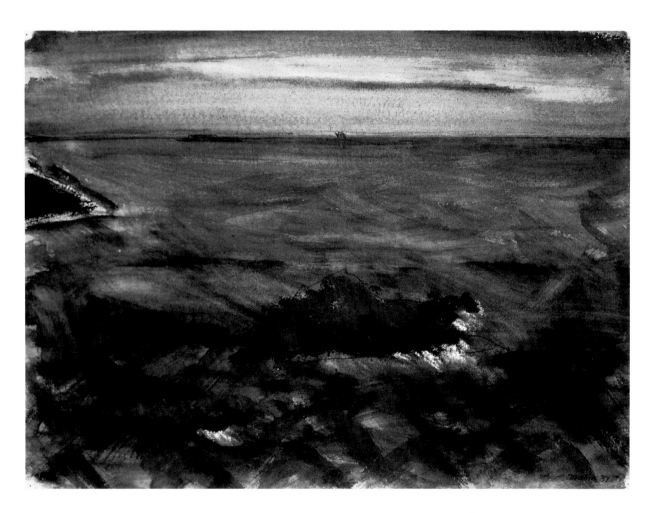

130 **JOHN MARIN**
Sea, Green and Brown, Maine, *1937*

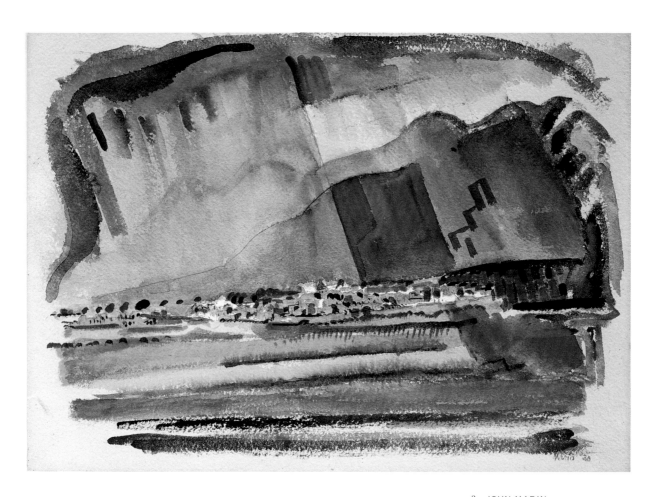

131 JOHN MARIN
Storm over Taos, *1930*

MODERN ART AND AMERICA

132 JOHN MARIN
Grey Sea, *1938*

CHARLES DEMUTH

A SYMPATHETIC ORDER

When the exhibition *Alfred Stieglitz Presents Seven Americans* opened in March 1925, Charles Demuth was among the featured artists. That December Stieglitz inaugurated the Intimate Gallery and described it as dedicated to the "intimate study of Seven Americans: John Marin, Georgia O'Keeffe, Arthur G. Dove, Marsden Hartley, Paul Strand, Alfred Stieglitz, and Number Seven (six + X)."[1] Scholars have recently speculated that by apparently classifying Demuth as "Number Seven" and "X," Stieglitz obscured his achievement, perhaps because of his homosexuality.[2] Yet the history of Stieglitz and Demuth's relationship, and in particular their correspondence, suggests otherwise.

Demuth began frequenting 291 as early as 1909. Having developed an avid appreciation for European modernism while visiting Paris in 1907, he probably attended the gallery's exhibitions of Matisse (1910, 1912), Rodin (1910), Picasso (1911), and Cézanne (1911). Demuth later became personally acquainted with Stieglitz through Marsden Hartley whom he met in France in 1912. Hartley wrote to Stieglitz from Paris about "a chap named Demuth" and encouraged his new friend to seek out the legendary photographer.[3]

When Demuth returned to the United States in 1914 Stieglitz immediately welcomed him into the 291 circle. Along with a host of luminaries long associated with the gallery, he was invited to contribute to the July issue of *Camera Work* devoted to the question "What is 291?" Demuth's response, written in an idiom reminiscent of Gertrude Stein, was adulatory: " 'Let us go in here,'—and we went in again to the place which is more that than gallery,—just a place in movement; just—rather, one of the few. The walls this time were

133 ALFRED STIEGLITZ
Charles Demuth, *1915*

363

emotionally hung with African carvings,—there was also yellow and orange and black; yellow, orange, black. There were photographs of African carvings. There was a photograph of two hands. That was a moment."[4] Stieglitz also asked Demuth to pose as part of the series of portraits of artists at 291 that he was working on at the time. The most famous of these presents the young artist as a handsome, powerful figure with arms crossed and head slightly lowered glaring aggressively at the viewer (pl. 133). He stands in front of one of the large, imposing Picasso drawings of a head that the dealer and writer Adolphe Basler had left on deposit at the gallery.[5]

Demuth's first one-man exhibition took place in October 1914 at the Daniel Gallery, which had recently opened on 2 West 47th Street in response to the enthusiasm for modern art generated by the Armory Show. Charles Daniel later claimed that Stieglitz would not handle Demuth because he did not want to distract attention away from John Marin's work as a watercolorist.[6] This became a concern for Stieglitz in the 1920s when Demuth was better known, but in 1914 Marin's reputation was so well established that it is unlikely that Demuth, thirteen years his junior, would have been perceived as much of a threat. A more plausible reason for Stieglitz's doubts about Demuth at this time was that he had not reached maturity as an artist. Just as he had hesitated to show Max Weber's work because he found it too dependent on European modernism, Stieglitz was probably troubled by the strong resemblance between the watercolors Demuth painted in Provincetown during the summer of 1914 and the Collioure watercolors by Matisse that had been exhibited at 291 in 1908. Spurred on in part because of the works by Picasso that he had seen at 291 in 1914 and 1915, Demuth established a signature style—a sophisticated variation of cubism defined by a subtle wedding of organic and linear forms—while working with Hartley in Provincetown and Bermuda in 1916 and 1917. With the demise of 291 in 1917, Demuth and Stieglitz's only collaboration from the period was confined to the pages of *The Blind Man* where Stieglitz's photograph of Duchamp's *Fountain* appeared with Demuth's article defending the work.[7]

Demuth turned to Stieglitz for support in the early 1920s when his health deteriorated due to the effects of diabetes. In January 1921 he confided that "most of the time, well,—I'm not up to doing very much about anything. Will see you I hope some time soon when things are more or less—more or less—God knows what."[8] That August he wrote Stieglitz that he had decided "to do something to stop the wheels going around backwards," and left on what would prove to be his last visit to Paris.[9] Before sailing he removed most of his work from the Daniel Gallery and gave primary responsibility for his oils to Stieglitz.[10]

In Paris Demuth became reconciled to the limitations of his physical condition. He realized that he could no longer live an independent life abroad, and would

have to learn to think of himself as an American artist. He wrote to Stieglitz on 10 October from a French hospital: "It is all very amazing...the great French men telling us that we are very good... It is like Baudelaire and Poe. I wish that you could be here to get the thrill of it, after the work and love you have given the painters French and American. It seems almost as though the dream were 'coming true,' that after all, Art is not only in pictures, books, etc. but also the nearest we can get to—you can call it what you like—I'll write Sympathetic Order!... Sometimes it seems almost impossible to come back, we are so out of it. Then one sees Marcel [Duchamp] or [Albert] Gleizes and they will say: 'Oh Paris. New York is the place—there are the modern ideas—Europe is finished.'"[11] Shortly after his return to the United States, in a letter to Stieglitz dated 28 November, Demuth made clear his commitment to America: "It was all very wonderful, but I must work, here.... New York is something which Europe is not—and I feel of that something, awful as most of it is. Marcel and all the others, those who count, say that all the 'modern' is to us, and of course they are right.... What work I do will be done here; terrible as it is to work in this 'our land of the free.' We will talk it out together, soon. I could write a book about it, of course, but all that is left of my energy, I suspect, had better go into painting! Together we will add to the American scene...."[12]

Demuth, living and working at his family home in Lancaster, Pennsylvania, was now fully enlisted in Stieglitz's fight for the creation of an indigenous American modernism, but his health continued to hinder his ability to paint. In June 1922 he entered the Physiatric Institute in Morristown, New Jersey, and began a treatment that radically curtailed his diet and led eventually to a severe loss of weight. When Stieglitz asked him to contribute to the issue of his periodical *MSS* devoted to the question "Can a Photograph have the Significance of Art?" Demuth had to decline: "Just a line, in the heat and, in other things as trying.... I'm working a bit. My old age has started—at least, middle period!... Sorry couldn't do something for 'M.S.S.' about camera. Couldn't. Very little left after I do my daily (sometimes, now, weekly) painting."[13]

Early in 1923, with his body ravaged by the effects of his strict diet, Demuth pressed Stieglitz to photograph his hands: "Perhaps you can do my hands then.... It, if you wish to do them, would ... be well to do them soon, for in the language of the moment: Every day they grow thinner and thinner."[14] After being photographed in

fig. 105 ALFRED STIEGLITZ
Charles Demuth, *March 1923*
palladium print
National Gallery of Art, Washington, Alfred Stieglitz Collection
PROBABLY EXHIBITED AT THE ANDERSON GALLERIES, 1923

March, he wrote to Stieglitz from Morristown on 16 April asking him to send the pictures along and reporting that in the wake of insulin injections his health had miraculously improved: "From varied sources comes great enthusiasm [concerning] what you did of me.... Could you send me some of the old proofs, or, any scraps, of mine so that I might see. I don't know when I will get to town. The serum seems to be—well, it seems like a trick. I feel I will waken. It is not possible. If it be true what it is doing, then ... there must be a few who 'know.' " After receiving the prints (figs. 104, 105), Demuth replied with poignant wit and emotion: "You have me in a fix. Shall I remain ill retaining that look, die, considering 'that moment,' the climax of my 'looks,' or live and change. I think the head is one of the most beautiful things that I have ever known in the world of art. A strange way,—to write of one's own portrait,—but, well, I'm a, perhaps, frank person. I send it this morning to my mother. The hands, too, Stieglitz— how do you do it? The texture in this one is, simply is! I hope that I see you soon. Thank you—it seems so little to write just that. But, as I say, I hope that I see you soon.... Yes, I grow fat 12 or 13 pounds. It is beyond belief the power and subtility of the serum."[15]

With his health improving Demuth embarked in 1924 on a series of paintings called portrait posters.[16] Wedding the bold graphic style of advertising with an often hermetic and elusive symbolism, they constituted his most challenging and radical work to date. The first three subjects in the series were Charles Duncan, Georgia O'Keeffe, and Arthur Dove (pl. 134), all artists long associated with Stieglitz.[17] While the Duncan portrait's meaning remains largely inaccessible, scholars generally agree that the Dove and O'Keeffe images are filled with allusions to the two painters' artistic and personal lives.[18] In the Dove portrait, for instance, the landscape recalls the subject's many nature abstractions and the red ribbon tied around the sickle refers to his wife, Helen (Reds) Torr. The pears and the sansevieria in the O'Keeffe portrait highlight her interest in biomorphic flower and fruit still lifes.

Stieglitz, who always took pride in introducing groundbreaking work, championed the portrait posters, including them in the 1925 "Seven Americans" exhibition, which he declared "an integral part of my life."[19] Stieglitz hung Demuth's portraits at the entrance where they functioned as advertisements for the work of Dove and O'Keeffe, all the while underscoring his main ambition for the show: to identify a cohesive, definitive group of native talents.[20] In addition to furthering the

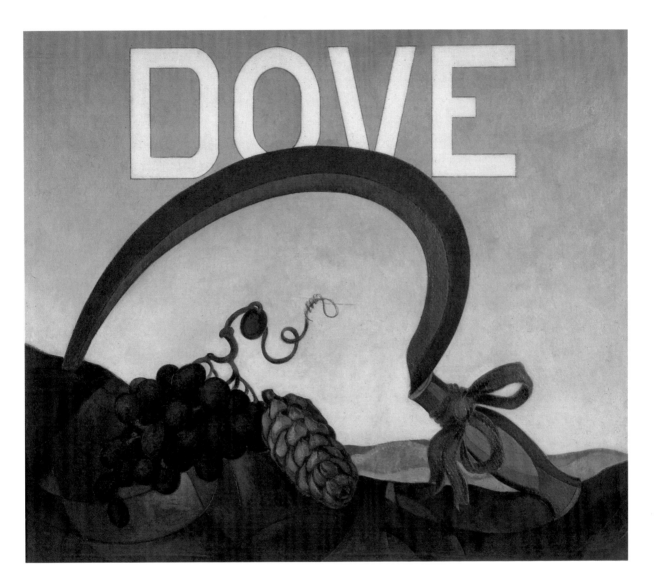

134 CHARLES DEMUTH
Poster Portrait: Dove, *1924*
EXHIBITED AT THE ANDERSON
GALLERIES, 1925; THE INTIMATE
GALLERY, 1926; AN AMERICAN PLACE,
1931

immediate goal of the exhibition, the portrait posters also greatly appealed to Stieglitz because they were closely related to the tradition of symbolic, experimental portraiture that he had sponsored and nurtured since his exhibition of Marius de Zayas' abstract caricatures at 291 in 1913.

Demuth's homages to Duncan, Marin, and O'Keeffe were not well received and that July Demuth wrote to Stieglitz to complain: "Almost everyone has told me what a mistake I made showing them without explaining that they were made for my own amusement." However, rather than abandon the project, Demuth instead vowed to continue the series: "I'll do three, or more, and show them all next winter. I'll make them look at them until they see that they are, so-called, pictures."[21] Stieglitz concurred and all three of the original posters as well as new abstract portraits of John Marin (pl. 135) and Bert Savoy were included in Demuth's first solo exhibition at the Intimate Gallery in 1926.[22] At least one critic was swayed by Demuth and Stieglitz's persistence: "We know that in change is life, but our knowledge does not make it easier for us to accept that change when it arrives.... When last year Alfred Stieglitz showed the so-called poster portraits, we accepted them as a jeu d'esprit, a fire-cracker that had perhaps been exposed too long to the damp air. Now he shows them a second time and we are forced to regard them in a different light. Whether we like them or not, they are the new Demuth...."[23] Demuth's portrait posters were subsequently featured in his solo shows at the Intimate Gallery in 1929 and An American Place in 1931, further reinforcing their central place in his oeuvre.

During the three-year interim between Demuth's two solo shows at the Intimate Gallery from the spring of 1926 to the spring of 1929 he was often discouraged and struggled to paint. Still subject to the debilitating effects of diabetes, on 30 October 1927 he informed Stieglitz that "the summer didn't add much to my work. Tried some watercolours several weeks ago—they were terrible...."[24] And again the following summer of 1928 noted: "My work...has been going, but going very strangely.... you'll see them unless they look too strange some morning and I do away with them...."[25] Despite these difficulties and the deep feelings of loneliness and isolation that he had come to accept as part of being an artist in America, Demuth maintained his commitment to Stieglitz's program of developing an American modernism based on an intimate knowledge of American places: "What could any of us add to Europe? Perhaps I like to suffer.... It may never flower, this our state, but if it does I should like to feel from some star, or whatever, that my living added a bit. For this flower, if it does [flower], I can imagine Rome in its glory looking very mild."[26]

Stieglitz, for his part, continued to reassure Demuth of his belief in his artistic abilities and his important role in the Stieglitz circle. In an undated letter from the Intimate Gallery period he wrote: "I've been thinking an awful lot about the whole

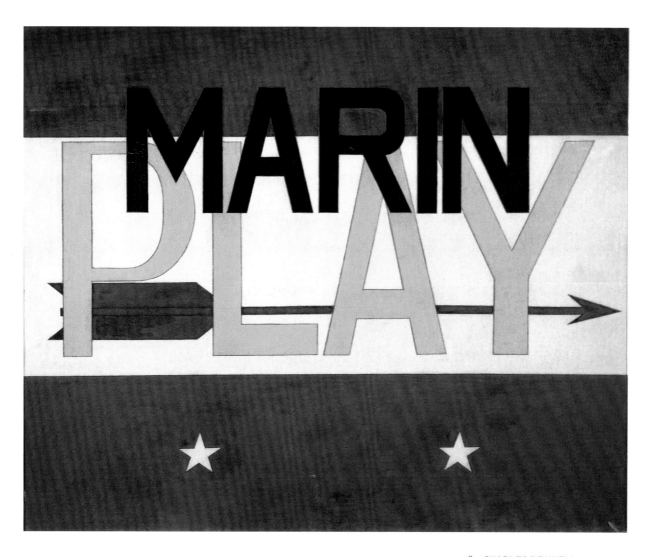

135 CHARLES DEMUTH
Poster Portrait: Marin, *1926*
EXHIBITED AT THE INTIMATE
GALLERY, 1926; AN AMERICAN PLACE,
1931

situation. That is, the situation of the, what I call, A-1 men. And amongst the A-1 men of course is the woman, O'Keeffe.... I think it an outrage that so little has been achieved for you, considering what has been written about you and what you are really doing.... For remember my fight for O'Keeffe and Marin is my fight for you as well. You may not understand but somehow or other I'm sure you must feel what I've said to be absolutely true."[27] Shortly after the opening of An American Place on 28 January 1930, Stieglitz observed: "I seem always to be in the position of money-gouger—most amusing when in all the years of gouging I have yet to receive a penny from the gouging! And none of the artists I have gouged for have become rich like the French artists so lovingly supported by art loving America! Why aren't you, and Marin and O'Keeffe and Dove Frenchmen?—& I at least a Man Ray in Paris? I can't be a Steichen or a Sheeler in America. Am too old to join the game. But it's great to have the clean place & not be overrun by the mob ... So here's 'Well!' and good luck. We're all in one Boat guaranteed Non-Sinkable."[28]

In the late 1920s and early 1930s Demuth created the most accomplished watercolors and paintings of his career, many of which were featured in his five solo

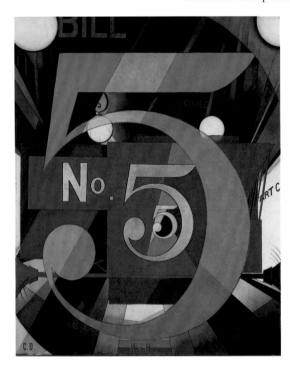

fig. 106 CHARLES DEMUTH
I Saw the Figure 5 in Gold, *1928*
oil on composition board
The Metropolitan Museum of Art, Alfred Stieglitz Collection,
1949
EXHIBITED AT THE INTIMATE GALLERY, 1929;
AN AMERICAN PLACE, 1931 AND 1938–1939

and group exhibitions held at the Intimate Gallery and An American Place from 1929 to 1932. Among the late works exhibited that can be identified from reviews or catalogues were the poster portraits *Longhi on Broadway* (fig. 136), *Love, Love, Love* (pl. 136), and *I Saw the Figure Five in Gold* (fig. 106); the iconic cityscapes *My Egypt* (pl. 113) and *Buildings, Lancaster*; the fruit watercolor *Green Pears* (pl. 138); the vegetable watercolor *Red Cabbages, Rhubarb, and Orange*; and the late figurative work *Distinguished Air* (fig. 107). In addition to a wide selection of late works, Demuth's final shows also included a variety of examples of Demuth's watercolors from the late teens and early to mid-twenties of flowers and fruit, circus performers, and of literary subjects taken from Henry James' novels and short stories.[29]

Demuth's homage to the poet William Carlos Williams, *I Saw the Figure Five in Gold*, represented the crowning achievement of symbolic portraiture as practiced by the Stieglitz circle.[30] While usually classified as a portrait poster, the immediate precedent for the work was O'Keeffe's *Radiator Building* (fig. 97). Uniting the portrait and the cityscape, both works depicted New York at night illuminated by electricity with the names of their respective subjects, "Carlo(s)"

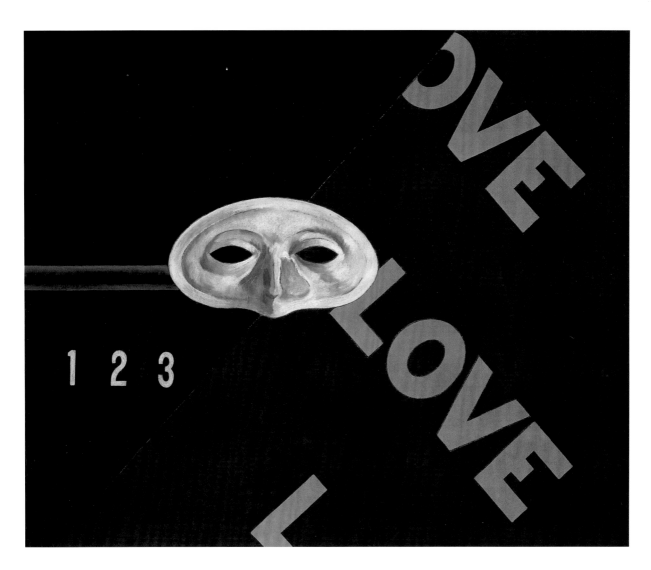

136 CHARLES DEMUTH
Love, Love, Love (Homage to
Gertrude Stein), *1929*
EXHIBITED AT THE INTIMATE
GALLERY, 1929; AN AMERICAN PLACE,
1931

and "Stieglitz," prominently featured in lights on the top floors of skyscrapers. However, while O'Keeffe's painting is a relatively static, realistic image, the projection and recession of the orbs of light and the number fives in Demuth's work managed to vividly convey the synesthesia of sight, sound, and movement achieved by Williams in his poem about a fire truck with the number five emblazoned upon it hurtling through the streets of New York.

Demuth's late flower and fruit watercolors and cityscapes fulfilled his hope that together with Stieglitz he would "add to the American scene." In watercolors such as *Green Pears* (pl. 138), *Corn and Peaches* (pl. 140), and *Red Poppies* (pl. 139), Demuth depicted items found in his garden or at the local farmers' market in Lancaster. He removed the undulating cubist armature that had often surrounded the objects found in his earlier works like *Apples* (pl. 137) and isolated the fruit and flowers against a white background. The result is a more distinctively American idiom of harsh, stark, monumental forms that memorialized the fecundity of the native landscape. Similarly, Demuth's late townscapes such as *My Egypt* (pl. 113), *...And the Home of the Brave* (pl. 141), and *Chimney and Water Tower* (pl. 142) rendered the bare, unadorned

forms of American industry in a cold, exacting, disciplined style that invested these structures with the timelessness associated with the architecture of ancient Greece and Egypt.[31] Like Stieglitz's late photographs of Lake George and New York, Demuth's watercolors and paintings of Lancaster transmuted the loneliness, despair, and anguish of American life into works of enduring beauty.[32]

Perhaps the strongest indication of the extent of Stieglitz's empathy and support for Demuth was the decision to include the small watercolor depicting a homosexual liaison, *Distinguished Air*, in the 1930 group exhibition at An American Place.[33] The title of the watercolor is taken from a collection of three stories about Weimar Berlin by Robert McAlmon and is based loosely on an episode where the narrator suggests to the expatriate painter and overt homosexual Foster Graham that they visit an art exhibition. Characterized as "a kind of 'coming out' "[34] for Demuth, it depicts a sailor arm in arm with a man in a bowler hat, another man in a bowler, sometimes identified as Demuth himself, leaning on a cane leering at the sailor,

and two women.[35] They are all gathered together before Brancusi's *Princess X,* the infamous phallic sculpture that had been criticized when it was shown at the 1917 Society of Independent Artists in New York and removed from the Salon des Indépendants in Paris in 1920. As Jonathan Weinberg has observed, *Distinguished Air* therefore "presents us with a 'scandalous' homosexual couple contemplating a particularly 'scandalous' work of art."[36]

Stieglitz's willingness to accept the risk of exhibiting *Distinguished Air* recalls the long history of his support of displays of sexually provocative works of art including the exhibition of Rodin's drawings at 291 in 1908 and 1910, Duchamp's *Fountain* at the Society of Independent Artists and 291 in 1917, and his own nude studies of O'Keeffe at the Anderson Galleries in 1921. There is no direct evidence concerning Stieglitz's attitude toward homosexuality, but considered together, these episodes do suggest his sympathy for the need of Demuth and other creative artists to explore alternative identities, often through anonymous surrogates, that lay beyond the bounds of social norms.[37] The history of Stieglitz's support of sexually charged works of art also underscores how Stieglitz and Demuth were both profoundly influenced by Rodin's late figure drawings. These quick sketches of models informally moving about Rodin's studio employed lively pencil outlines filled with flowing monochromatic washes (see pls. 4–7). Often described as "snapshots," they inspired Stieglitz's intimate photographs of the female nude (see pls. 91, 117) as well as Demuth's provocative figurative work from his circus and vaudeville performers of 1917 and 1918 to the later more explicit homoerotic watercolors.

Shortly before his death in 1935 Demuth alluded to Stieglitz's steadfast support of his career in an essay he wrote for *America and Alfred Stieglitz* entitled "Lighthouses and Fog": "Lighthouses are fixed. Sometimes they seem to have moved but—they really haven't. Lights in lighthouses sometimes move but they do not move as lights in a political street parade move."[38] In 1968 O'Keeffe provided a coda for the two artists' relationship: "He [Stieglitz] had a remarkable way of giving people faith in themselves.... As I think about the relationship between Demuth and Stieglitz I rather think that Stieglitz was probably a bit of a steadying hand on his shoulder. They had a faith in common that neither found too often elsewhere."[39]

137 CHARLES DEMUTH
Apples (Still Life: Apples, Number 1), c. 1925
PROBABLY EXHIBITED AT THE
ANDERSON GALLERIES, 1925;
PROBABLY EXHIBITED AT AN
AMERICAN PLACE, 1931

138 CHARLES DEMUTH
Green Pears, 1929
EXHIBITED AT AN AMERICAN PLACE,
1931

139 CHARLES DEMUTH
Red Poppies, *1929*

140 CHARLES DEMUTH
Corn and Peaches, *1929*

141 CHARLES DEMUTH
…And the Home of the Brave, *1931*

142 CHARLES DEMUTH
Chimney and Water Tower, 1931
EXHIBITED AT AN AMERICAN PLACE,
1936

PAUL STRAND

UNQUALIFIED OBJECTIVITY

B y the time Paul and Rebecca Strand's only joint exhibition opened at An American Place on 10 April 1932 their relationship with Stieglitz was as tenuous as their marriage; neither survived the year. Paul Strand had known Stieglitz for more than seventeen years, O'Keeffe for fifteen, and Rebecca for thirteen.[1] Once a protégé of the older photographer, over time he and Stieglitz became co-equals, helping and supporting each other to chart a new, more modern vision for both photography and American art. They shared much in common: both were children of middle- or upper-middle class recent European immigrants and both were secular, assimilated Jewish intellectuals, products of New York's rich cultural mélange of the turn of the century.[2] Yet their relationship was also one of father and son, age and youth, and different generational as well as personal perspectives.[3] And it was one of strong, if unspoken, personal and professional rivals.

In late 1914 or early 1915 when Strand first started visiting 291, Stieglitz had spent the last ten years working primarily as a gallery director and publisher. Although he had made a series of exuberant studies of New York City in 1910 as well as portraits of the artists and critics associated with 291, these were comparatively few in number. In 1915, when he saw Strand's studies of New York City, Stieglitz abruptly returned to his own art, as if to reclaim his rights to a subject. Beginning in 1915 and continuing for the next two years, he made a series of views of the city from his window at 291. Devoid of literary or narrative subject matter, these photographs, such as *From the Back Window, 291*, 1915, form a more objective formal record than any of Stieglitz's earlier studies of the city and demonstrate his careful study of both Cézanne and

fig. 108 ALFRED STIEGLITZ
From the Back Window, 291, *1915*
platinum print
National Gallery of Art, Washington, Alfred Stieglitz
Collection

Picasso (fig. 108). With their tilted, stacked planes that build one on top of another like steps on a staircase, and their architectonic, almost skeletal forms, they recall Picasso's *Mill at Horta*, which may have been shown at 291 in 1911, *The Reservoir, Horta*, which was reproduced in *Camera Work* in 1912, and a *Standing Female Nude*, 1910, which Stieglitz had purchased (figs. 48, 41).[4] Taken at night or in subdued lighting conditions, these photographs are concerned with presenting the scaffolding or engineering of the new city, and with their contrasts between open, light forms and closed, dark ones they address issues of substance and transparency, permanence and impermanence.

From the Back Window, 291 is, in addition, markedly different from Strand's 1915 or early 1916 photographs of New York. Although the younger photographer also pointed his camera down to compress space, as in *Wall Street*, 1915, for example, he was more concerned at this time with rendering the flux, chaos, and mood of urban life than he was in presenting a formal arrangement (pl. 82). After the summer of 1916, however, when Strand made his pioneering photographic abstractions of kitchen crockery, chairs, tables, and railings, he too fully understood, as he later said, "the underlying principles behind Picasso and the others in their organization of the picture's space" (pl. 79).[5] When he returned to the city later that fall he began to construct arrangements that showed his new-found interest in the architectonics of form. In photographs such as *New York*, 1916, *Geometric Backyards, New York, Demolition*, or *Backyard, Winter, New York*, all from 1917, he, like the cubists or Stieglitz, dissected the views in front of his camera, breaking down their component parts in order to create pictorial spaces with new relationships between foreground and background, shapes and voids, and between the objects depicted and the physical space they inhabited (fig. 109).[6] Strand's interests in the skeletal structures of the city and the idea of transparency, as can be seen in *Demolition*, were as keen as his fascination with rendering a sense of the physical and emotional weight of the urban environment. Drawing on his summer's work where he had filled the frame with only one or two objects, Strand greatly simplified his photographs, using far fewer elements than Stieglitz, to fabricate bold geometric compositions that convey the physical presence of the city, the delicacy of laundry hanging on a line in a tenement backyard, or the weight of snow on a rooftop. Most significant, just as Picasso and Braque worked as a team

to construct cubism, so too did each of these two photographers use the other's work, not in a way that was imitative or derivative, but as a springboard to create new photographs that built on and expanded the art and ideas of the other.

Strand's and Stieglitz's partnership extended into other areas of their art as well. As they struggled to adapt to the rapidly changing photographic materials of the time, they exchanged technical information about different kinds of developing and toning solutions; newly released brands, grades, and textures of paper; as well as their own, often fortuitous discoveries.[7] At the time, Strand was one of the few photographers with whom Stieglitz conversed and both were equally committed to and fascinated by the process and craft of photography. Augmenting the ideas first expressed by Marius de Zayas in *Camera Work* and expanded by Stieglitz in his conversations and correspondence, Strand also helped to articulate a new modernist aesthetic for photography. Responding to the notion frequently voiced at 291 that modern photography and painting were antithetical, de Zayas in 1913 had posited that whereas painting was the subjective deformation of form, photography revealed "the objective reality of forms," and he concluded that the "pure" photographer must eliminate extraneous subject matter in order "to search for the pure expres-

fig. 109 PAUL STRAND
Backyard, Winter, New York, *1917*
platinum print
Philadelphia Museum of Art, purchased with funds
contributed by Mr. and Mrs. Robert A. Hanslohner

sion of the object."[8] In an article first published in *Seven Arts* and reprinted in the last issue of *Camera Work* in 1917, Strand, like others in the Stieglitz circle, argued the modernist notion that "the full potential of every medium is dependent upon the purity of its use." Condemning any manipulation of the negative or print as expressive of "an impotent desire to paint," he asserted that photography "finds its raison d'être, like all media, in a complete uniqueness of means," and he insisted that the defining characteristic of photography was its "absolute unqualified objectivity." It "is in the organization of this objectivity that the photographer's point of view" is expressed.[9]

But Strand, like Stieglitz and other visionary modernists, positioned his new aesthetic within a broader context and predicted that photography, like the other arts, could become a medium for social change. Responding to charges that de Zayas had made earlier that American artists had yet to express a genuinely American life, Strand asserted, using *Camera Work* as his evidence, that in photography "America has really been expressed in terms of America without the outside influence of Paris art-schools or their dilute offspring

here." Disregarding the pictorial photographs that had been published in *Camera Work* and were clearly imitative of popular painting, Strand argued that Stieglitz and other photographers had no precedents for their art: "everything they wanted to say, had to be worked out by their own experiments: it was born of actual living." Equating this kind of photography with the most obvious symbol of American ingenuity, aspiration, creativity, and skill, he concluded, "In the same way the creators of our skyscrapers had to face the similar circumstance of no precedent ... it was through that very necessity of evolving a new form, both in architecture and photography that the resulting expression was vitalized."[10]

In 1917 Strand's and Stieglitz's relationship also extended into their personal lives when the younger photographer became intimately involved with the next subject of Stieglitz's art, Georgia O'Keeffe. When Stieglitz's two young protégés first met at 291 in May 1917, each was immediately attracted to the other. O'Keeffe recounted to a friend that she "fell for him," and when she returned to Texas in early June, she wrote to Strand, "Yes youve [sic] gotten in me—way down to my finger tips—the consciousness of you."[11] She was, though, perhaps as smitten with his photographs as she was with the photographer: "I knew you would write. I knew the day I saw Walkowitz's work that I meant something to you," she told him, "it was just a look in your eyes that made me turn away quickly... Then the work—Yes I loved it—and I loved you."[12] In another letter from June 1917 she confided to him, "I believe I've even been looking at things and seeing them as though you might photograph them—... making Strand photographs for myself in my head."[13] While Strand's work continued to intrigue O'Keeffe for several years and while his ardor for her increased in the next few months, her interest in him diminished. By December 1917 O'Keeffe felt that something in Strand was, as she bluntly told him, "hardening, making a crust over the thing in you that makes me want to put my arms round you," and at the same time she found herself becoming increasingly fascinated with Stieglitz.[14] When O'Keeffe fell ill in the spring of 1918, Stieglitz, who knew full well of O'Keeffe's and Strand's interest in one another, asked the younger photographer to make the long trip to Texas to ascertain the state of her health and, if possible, to convince her to move to New York. Stieglitz undoubtedly hoped that his own importance to O'Keeffe would be acknowledged, as it was, in a letter Strand wrote shortly after his arrival in Texas: "it's very clear that you mean more to her than anyone else."[15] Strand returned to New York in June, with O'Keeffe, and she and Stieglitz began living together shortly thereafter.

Although O'Keeffe and Strand's romantic exchange ended, at least on her part, in early 1918, their artistic dialogue continued. As both were students of Dow, 291, and Stieglitz, they shared much in common. O'Keeffe's paintings, particularly

her studies of the trees and flowers of Lake George made in the early 1920s, inspired Strand to focus his camera on enlarged details of the rocks and flowers of Nova Scotia and Georgetown, Maine (pls. 106, 107).[16] Moreover, O'Keeffe's habit of rendering natural forms as if they were parts of the human body influenced Strand: where O'Keeffe presented alligator pears as if they were breasts, Strand depicted rocks as if they were torsos or legs.[17] Strand's photographs, especially those from 1916 and 1917 that show identifiable objects reduced to abstract forms, also encouraged O'Keeffe to continue her own investigations into this same pictorial problem.[18] In addition, O'Keeffe made references to several of Strand's photographs in her own art: for example, in her watercolor *Trees and Picket Fence*, perhaps painted when Strand was with her in Texas in 1918, she alluded to Strand's *White Fence*, 1917, both in her choice of subject matter and in the way she constructed the picture with a dark object in the background and brighter forms in the foreground. In her rare figure studies from 1918, of women in the markets of San Antonio, she clearly referred to Strand's 1916 portraits of people on the streets in New York; and in her drawing and watercolor of *Bowls of Fruit*, 1918, she may have been trying to affect a breakthrough similar to the one Strand had achieved in *Bowls* (pls. 81, 83, 84, 79).[19] Moreover, in the early 1920s O'Keeffe continued to go back to Strand's work episodically; for example, in 1920 she made a study of New York that is reminiscent of Strand's studies of the city, such as *The Truckman's House*, 1920, or those presented in his 1920 film *Manhatta*; and in 1923 and 1924 his photographs were especially useful to her as she sought to make her art less abstract and more objective.[20]

Considering the extent of this personal and professional dialogue, it is perhaps not surprising that when Strand married in 1922, he chose someone remarkably like O'Keeffe in physical appearance, character, and even manner of dress. With a handsome face, dark hair that she, like O'Keeffe, often wore pulled back, and an attractive figure, Rebecca (Beck) Salsbury, the daughter of the manager of Buffalo Bill's Wild West Show, was as independent and opinionated as O'Keeffe, but more vivacious.[21] Strand, who had previously made few portraits of family and friends, began photographing Beck in a manner that echoed that of Stieglitz's portraits of O'Keeffe (fig. 110). Although he did not hungrily record every facet of Beck's body as Stieglitz did with O'Keeffe, he too made close-up studies of his wife's face and head with his large eight-by-ten-inch view camera that are devoid of props or background details that might distract the viewer's attention. And he too recorded Beck's hands and torso much as Stieglitz had photographed O'Keeffe's.[22] Moreover, like Stieglitz, he believed that a portrait should consist of many individual photographs that collectively expressed, as he wrote in 1922, "a record of innumerable elusive and constantly changing states of being."[23] Strand's portraits do not range as

fig. 110 PAUL STRAND
Rebecca, 1922
National Gallery of Art, Washington, Southwestern Bell
Corporation Paul Strand Collection

far as Stieglitz's in their exploration of expression and pose, but they are also less numerous.

The similarities were all too obvious for the highly competitive and territorial Stieglitz. In letters to Beck, he mocked Strand's efforts. Stieglitz, who often equated photographing with the act of making love, gleefully noted that in order to keep Beck's head still during long exposures, Strand had to use a head stand. Stieglitz called the stand "the Iron Virgin," clearly suggesting it was some sort of chastity belt, and represented a failure on Strand's part that he, the more virile photographer, had no need to use when photographing O'Keeffe.[24] More pointedly, though, as he had done so often in the past, Stieglitz consciously set out to teach the younger photographer a lesson and made a series of photographs of Beck that were radically different both from his own studies of O'Keeffe and from Strand's portraits of her. His stated intention was to demonstrate to the younger photographer that each subject demanded its own solution, but Stieglitz also, no doubt, wanted to humble him as well. Literally appropriating Strand's model and, of course, metaphorically appropriating his wife, Stieglitz photographed Beck holding a glass ball in 1921, which when she saw it she teasingly told Stieglitz he should send to Paul "to show him how superior we are as a working team."[25] Extending this flirtatious and provocative patter still further, when Beck visited Lake George without her husband in early September 1922, Stieglitz made several photographs of her nude body in the lake. Exploiting the spontaneity afforded by his hand-held four-by-five-inch Graflex camera, Stieglitz wanted to show Strand, as he recalled many years later, that in Beck he had "a much more pliant and vital model than the then rather fragile O'Keeffe" (fig. 111).[26] With their contrasts between submerged and exposed forms, their subtle depiction of light, texture, and tone, and their delicate rendition of the movement of the water and the warmth of the sunlight, these photographs are, as Stieglitz wrote to Beck later that fall "entirely different from [Paul's] things of you." He hoped that "perhaps they will clarify some things."[27]

Although Strand made few portraits of Beck after 1923, he seems to have not yet learned the full extent of Stieglitz's attitude toward his subject matter.[28] When Strand joined Beck at Lake George later in September 1922, Stieglitz was "amazed" to discover that he had the effrontery to record his landscape: his barns, his trees, his hills. "He photographed like one possessed," Stieglitz exclaimed to Paul Rosenfeld, "shooting right and left, forward and backward, upward and downward and in

directions not yet named."[29] More bluntly, he told Strand, "You have no right to make photographs here. It is part of my life."[30] While Strand eventually destroyed all but one of his negatives made at Lake George, his actions ironically may have helped to push Stieglitz to begin one of his most sustained and, in his mind, most important series, the *Equivalents*, for only a few weeks after the Strands left Lake George he embarked on his photographs of the hills and clouds around his summer home (pls. 93, 109, 121, 122).[31]

Despite these incidents, in the early 1920s Strand continued to espouse and staunchly defend the ideas and art of Stieglitz and his circle. He wrote numerous articles at this time, far more than at any other point in his career.[32] As he continued to articulate a new theory for photography, he was one of the few Stieglitz artists to directly confront the role of the machine in modern society and culture. Yet far from embracing the new technology as Picabia, Duchamp, and others had advocated before the war, Strand warned that contemporary society was faced with the "alternatives of being quickly ground to pieces under the heel of the new God or with the tremendous task of controlling the heel." Writing with the urgency, earnestness, and often the stridency of an idealistic young convert, he inveighed against scientists and inventors of machines who allowed "quantity not quality" to reign supreme, and asserted that they had created "a new Trinity: God the Machine, Materialistic Empiricism the Son, and Science the Holy Ghost." This new Trinity had not

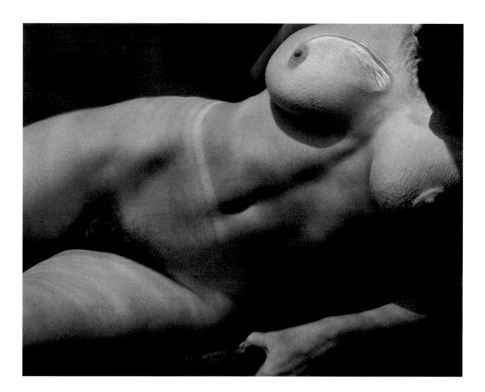

fig. 111 ALFRED STIEGLITZ
Rebecca Salsbury Strand, *1923*
gelatin silver print
National Gallery of Art,
Washington, Alfred Stieglitz
Collection

only deposed the artist, whose creativity was of "no value in a fairly unscrupulous struggle for the possession of natural resources," but also rendered suspect his knowledge, based on "intuitive rather than intellectual" skills: "a menace to a society built upon what has become the religious concept of possessiveness."[33]

Yet, like many other modernists of the period, Strand had an unwavering faith in the redemptive power of art, and he, like Stieglitz, believed that photography, because it utilized the mechanical camera, could demonstrate "the deeper significance of the machine." The camera, he asserted, "can hold in a unique way, a moment," and therefore "the photographer may do with a machine what the human brain and hand, through the act of memory cannot do." In this way photography could "control the heel" and "humanize . . . not only the new God but the whole Trinity."[34] To demonstrate his proposition, Strand made several photographs of machines to accompany his article celebrating not only the brilliant precision of mechanical objects, but also their cold, hard, elegant, and often imposing forms. Emphasizing the craftsmanship of these machines, Strand, as one critic subsequently noted, also suggested the "kind of tactile stimulus Picasso attempted" in his collages by contrasting corrugated and highly polished metal, serrated wheels, and rubber belts.[35]

Strand also actively supported the loose coalition of cultural nationalists like Waldo Frank and Paul Rosenfeld, who gathered around Stieglitz seeking a more meaningful existence for the individual within the increasingly technological, mechanistic, and bureaucratic society. Because all of these critics had first experienced modern art in the years immediately before the war as a profoundly liberating force, they came to view it as an agent not just for cultural change, but also for a complete social, moral, spiritual, and even religious transformation. Art, they believed, would enable Americans to break free from their puritanical past and their middle-class values and, as Strand wrote, to "come to grips with the difficult reality of America, to break through the crust of mere appearance." Like other Stieglitz artists, Strand did not believe that an American art would be created simply by recording American subject matter or by the facile depiction of "mere externals." Instead artists must make images that were "sharply particularized," that "shoved [us] into the core of our own world—made [us] look at it," that make us "experience something which is our own, as nothing which has grown in Europe can be our own," and that present "a vision of the forces which animate that objectivity."[36] Celebrating those who strove for greater clarification and knowledge, Strand also embraced the modernist idea of continual analysis and exploration, insisting that the artist must be "a constant experimenter in means and in expression," for only then would he or she discover the fundamental truths that modern art promised to reveal.[37]

144 PAUL STRAND
Akeley Motion Picture Camera, 1923
PROBABLY EXHIBITED AT THE
ANDERSON GALLERIES, 1925

145 PAUL STRAND
Lathe No. 1, New York, *1923*
PROBABLY EXHIBITED AT THE
ANDERSON GALLERIES, 1925

Strand, though, like Hartley, had a difficult time in the years immediately after World War I. Although he made several distinguished photographs, such as his studies of machines or New York City, his work was scattered and fragmented and did not consistently rise to the level of creativity seen in his 1915 to 1917 images (pls. 105, 144, 145). Indeed, because he had to work to support himself and his wife, throughout the 1920s he was only able to photograph on weekends and vacations. Yet, through ingenuity and persistence, he cobbled together a professional career for himself using his photographic skills. And, even though he viewed his commercial art as suspect, many of his assignments, coupled with his own interest in experimentation, not only led him away from Stieglitz, but also to the rediscovery of his own voice.

In the early 1920s Strand explored a number of ways to support himself. Drawing on his work in the army, he briefly pursued medical photography. In 1920 he also tentatively investigated the rapidly growing profession of freelance advertising photography, making photographs of, among other things, ball bearings, that were subsequently included in the 1925 *Seven Americans* exhibition at the Anderson Galleries.[38] His work in the newly emerging field of filmmaking, though, proved to be the most liberating. In 1920 he and Charles Sheeler made a seven-minute film on New York, subsequently called *Manhatta*. A curious amalgam of styles, it presented, in a series of fairly static shots, a modernist view of the "towering geometry of lower Manhattan and its environs," and sought to capture, as a press release noted, "those elements which are expressive of New York, of its power and beauty and movement."[39] Drawing on photographs that both Sheeler and Strand had previously made of New York, as well as several by Stieglitz, the film was a portrait of the city, often seen from dizzying perspectives looking up or down. Unlike most commercial films, *Manhatta* was "an experimental film," as one reviewer noted, "a daring adventure in a new art," with "no heroine, no villain, no plot."[40] However, although Strand called it a "scenic," suggesting that it was only a series of loosely connected shots with no narrative structure or thematic progression, he and Sheeler undercut its radical, modernist nature in a number of ways. First, they introduced a sense of the passage of time by structuring *Manhatta* around a day in the life of the city. In addition, as Jan-Christopher Horak has noted, they organized the film like a symphonic score, with an introduction, statement of theme, variation on theme, and recapitulation.[41] Finally, and most tellingly, they wrapped around their bold visual imagery intertitles drawn primarily from Whitman's poem "Manahatta," thus softening the film and giving it a decidedly romantic quality.

Strand's other films from the 1920s were more commercially oriented; indeed, his primary means of support throughout the decade was as a professional

cameraman, and he shot films for Pathé, Metro-Goldwyn-Mayer, Paramount, and Fox Films. Occasionally he was the photographer for feature-length films, such as *Crackerjack* in 1925, but more often he took whatever jobs were available, including horse racing, boxing matches, and college football. At the time Strand did not regard this work as significant, however it conditioned him to think about both creating a more sustained form of expression and constructing a larger portrait of a person or place. Other factors inspired him as well. Throughout the 1920s many of the writers associated with Stieglitz, as well as others of the time, were preoccupied with the problem of how to create a broader depiction of a person or place. Rosenfeld's *Port of New York*, 1924, Frank's *City Block*, 1922, or *Time Exposures*, 1926, Sherwood Anderson's *Winesburg, Ohio*, 1919, Jean Toomer's *Cane*, 1923, John Dos Passos' *Manhattan Transfer*, 1925, Carl Sandburg's *Lincoln*, 1926, or Edgar Lee Master's *Spoon River Anthology*, first published in 1916 and reissued in 1924, all attempted to construct descriptions that were not only revealing portraits of specific people or places, but also spoke to the sociological, cultural, and historical components that related individuals to each other and bound them to their communities. All were composed of many separate elements—individual chapters—that, while complete unto themselves, together more forcefully addressed their shared subject. All built "through the array of facts," as Strand wrote of *Lincoln*, "into a portrait in a real sense," revealing "a beautiful single growth—like a tree."[42]

In 1929 on a trip to the Gaspé Peninsula and more forcefully on trips to New Mexico in 1930 and 1931 Strand began to construct broader portraits in keeping with this new objective. Pulling his camera back, he focused not so much on the sharply particularized details of plants or trees as on revealing the larger relationships between people, places, and things. Although none of his photographs made in New Mexico in 1930 and 1931 depicted people, all revealed the human touch or presence: he photographed abandoned mining towns that express the beauty, poignancy, and haunting intimacy of unknown and long-gone lives; he recorded churches that had been fabricated by hands laying mud and plaster onto adobe bricks; and he recorded the larger vistas of landscape that, although uninhabited by people, were nevertheless strangely expressive of emotional turmoil (pls. 147, 148, 112, 149, 146). Without recording the people of New Mexico, Strand succeeded in creating a portrait of the place that spoke of its traditions, values, and spirit. These photographs were his most sustained and important accomplishment in fifteen years, and they were the subject of his last exhibition at Stieglitz's galleries in 1932.[43]

Throughout the 1920s Strand had steadfastly supported Stieglitz. Writing with care but difficulty, he had penned seven articles between 1921 and 1928 defending and promoting Stieglitz's artists.[44] In 1922 he helped Stieglitz edit the issue of *MSS*

devoted to the question "Can a Photograph have the Significance of Art?"[45] As their income increased throughout the decade, the Strands bought art from the exhibitions Stieglitz organized at both the Anderson Galleries and the Intimate Gallery, occasionally providing the only sales for these financially strapped artists.[46] When Stieglitz opened the Intimate Gallery late in 1925, they regularly contributed to the fund he established to cover the room's rent and printing costs. And in 1929 when Stieglitz closed the Intimate Gallery, they, along with Dorothy Norman, spearheaded the effort not only to find him a new space, but also to raise the necessary funding to cover its costs; they even helped to design the new gallery. As late as 1931 Strand also insisted that he would not allow his work to be published in a book that did not include Stieglitz.[47] Stieglitz, however, only half-heartedly acknowledged their commitment. In 1928 when he donated his photographs to the Metropolitan Museum, he listed Beck Strand as one of the contributors.[48] Yet his other thanks to the Strands themselves were few and often so convoluted that they became defenses of his own actions, not genuine acknowledgments of gratitude.[49]

fig. 112 PAUL STRAND
Alfred Stieglitz, *1922*
gelatin silver print
National Gallery of Art, Washington, Southwestern Bell Corporation Paul Strand Collection

Of greater significance for Strand, between the close of 291 in 1917 and his 1932 joint exhibition with Beck, Stieglitz gave the younger photographer very few exhibitions. In 1925 he included Strand in the *Seven Americans* show and later that year cited him as one of the artists to whom the Intimate Gallery was devoted, but other unnamed artists, such as Charles Demuth, were more regularly exhibited.[50] Moreover, although he persuaded Katherine Dreier to include his own photographs as well as work by Demuth, Dove, Hartley, Marin, and O'Keeffe in the celebrated International Exhibition of Modern Art organized by the Société Anonyme at the Brooklyn Museum in 1926–1927, Strand's art was strangely absent.[51] The only exhibition Strand had at the Intimate Gallery and the only one-person show Stieglitz organized for him between 1916 and 1932 was in 1929, and during this exhibition he criticized Strand, both to his face and to others, for being imitative and overly concerned with technical perfection.[52]

Stieglitz later apologized and, oddly, bought a print for O'Keeffe, but he had been complaining about Strand's work for some time: writing to Marin in August 1920, he stated, "What you say about Strand's work tallies to the dot over the i with

what I feel.—Ditto Stella's 'Brooklyn Bridge.'—It's A1 work without the *living* element"; in 1921 he told Sherwood Anderson, "To be a master of the process is no mean achievement. And [Strand] has that. The rest may still come.—In the meantime I still hope he'll be able to find *himself* fairly soon"; while in 1927 he confided to Herbert Seligmann, "I realize more and more how far removed I am from what Strand is doing."[53] What O'Keeffe had once perceived in Strand as a "hardness," Stieglitz came to view as a lack of passion. Writing in 1928 Stieglitz told Seligmann, "I do hope [Strand] has a few really living things—living in the big sense. Whether passion is necessary to produce such a thing or not, all I know is that no half- or three-quarter erection will puncture a real virgin."[54] While he had once celebrated the "absolute unqualified objectivity" that Strand sought, increasingly in the late 1920s Stieglitz saw it as a dogmatic and unfeeling approach.

Moreover, just as Stieglitz emphasized the sexual nature of O'Keeffe's work in his discussions in the late 1910s and early 1920s, so too did he stress the absence of emotion in his remarks on Strand's work not just to friends, but also to critics. In the late 1920s and early 1930s many reviewers commented on this aspect of Strand's work. Some saw it as an asset: Harold Clurman described the "grave and awful completeness" of Strand's photographs that are "too far aloof to lend themselves to our needs or to yield to the pressure of our desires," but concluded that they are "not cold," and possess an "objective sensuousness."[55] Elizabeth McCausland also defended the work, noting that although his photographs were "crystallinely pure," they were not "immune to the storms and passions of feelings."[56] Yet others, like Henry McBride, while praising the work as "astonishing," neverthess continued that "the relentless perfection of the mechanics of vision is almost cruel," and Katherine Grant Sterne also noted their "complete lack of comment."[57]

By the late 1920s Stieglitz and Strand had become very different photographers. While both still embraced the modernist notion that art embodied a certain kind of truth that could not be revealed in any other way, the truths they sought to expose were diametrically opposed. As seen in his photographs made throughout the 1920s and early 1930s, Strand had developed a rigorous vision that paid careful attention to formal relationships but was focused fundamentally on the external world and sought to heighten his viewers' perception of that world. Rational, analytical, highly serious, and somewhat unyielding, he did not strive, as he noted, "to describe an inner state of being," but rather as his friend Clurman wrote, he treated all his photographs "as if they were as removed from him as machines."[58] Far more romantic, expressive, self-absorbed, and self-indulgent, Stieglitz, whether photographing nature, the city, or even other people, was, as O'Keeffe perceptively noted, "always photographing himself."[59] Moreover, in the

early 1930s as the Depression worsened, politics protruded into this already contentious mixture as Strand increasingly felt that Stieglitz's attitude and approach were both elitist and ineffective. And finally, personal politics also clouded the scene. Dorothy Norman, with whom Stieglitz was very close at this time, did not like either Paul or Beck Strand and as she came to assume more responsibilities at An American Place, she increasingly made them feel unwelcome.[60]

Thus in 1932 when Paul and Beck Strand's exhibition opened at An American Place, both men—but especially Stieglitz—were too entrenched in their positions to back down.[61] Although Stieglitz candidly admitted that Paul Strand's work was the best he had made in years, he once again criticized it, later claiming rather pathetically, as Clurman recounted to Strand, that "because you were so superb a photographer—your prints better than his in many respects—he felt it his duty to counteract glib praise from unqualified people by testing your work by the severest standards and thereby stimulating you to deeper efforts."[62] At the close of the show Strand turned in his key to An American Place and embarked on a new phase in his career as a filmmaker, political activist, and photographer.

146 PAUL STRAND
Near Rinconada, New Mexico, *1932*
EXHIBITED AT AN AMERICAN PLACE, 1932

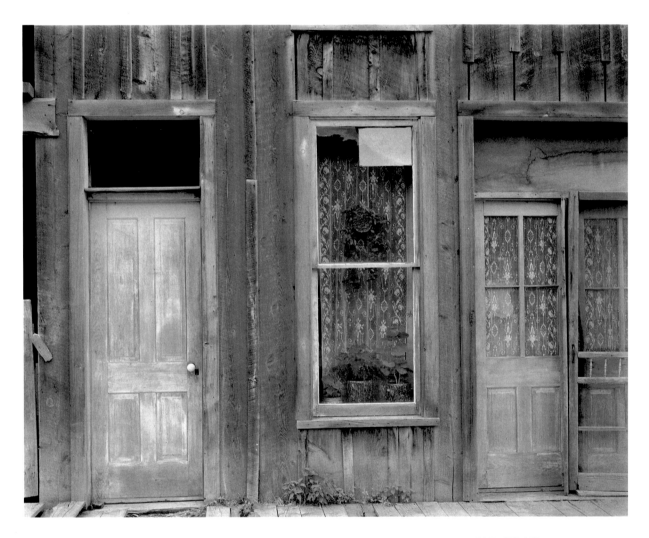

147 PAUL STRAND
Red River, New Mexico, *1931*
EXHIBITED AT AN AMERICAN PLACE, 1932

148 PAUL STRAND
Hacienda, near Taos,
New Mexico, *1930*
PROBABLY EXHIBITED AT
AN AMERICAN PLACE, 1932

149 PAUL STRAND
Ranchos de Taos Church,
New Mexico, *1931*
EXHIBITED AT AN AMERICAN PLACE, 1932

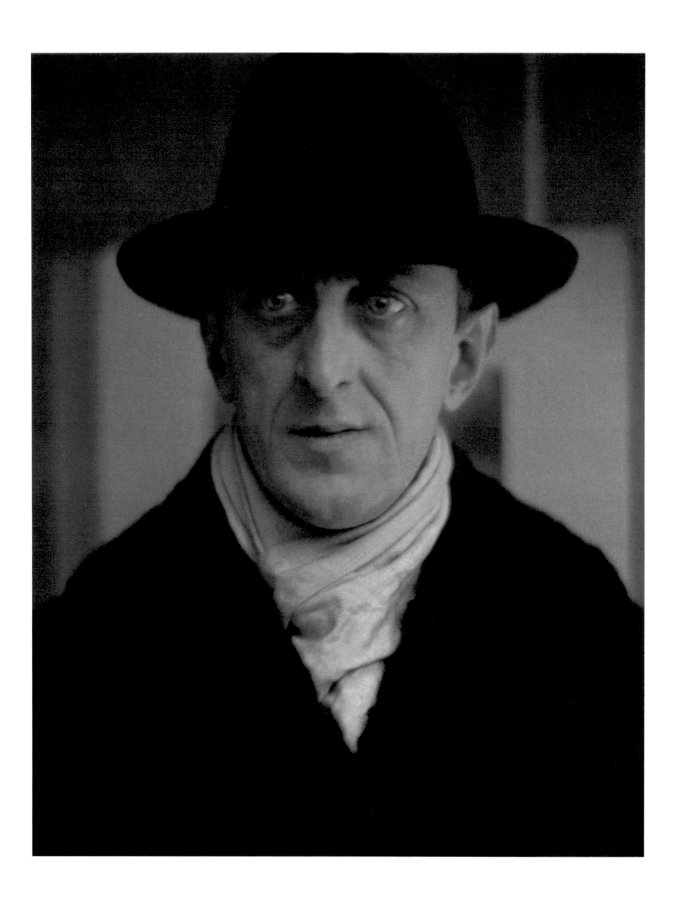

MARSDEN HARTLEY

ON NATIVE GROUND

I n 1930 Marsden Hartley was once more in New York, after having spent most of the 1920s in France. As was often the case, he was unsure of himself and in an emotional turmoil despite a surface bravado that enabled him to declare to his friend Adelaide Kuntz that "New York has received me very graciously—and my return seems to be accepted on all sides with satisfaction."[1] He was forcing himself to accommodate to circumstances; he had no alternatives. A great economic collapse had occurred months earlier, Europe had never provided him a living, and the show that Alfred Stieglitz had given him in January 1929 at the Intimate Gallery had not been a success.

In fact, the exhibition was more or less a bust, despite all of Stieglitz's efforts. It included "one hundred paintings in oil, water-color, silver point, and pencil: still-life, landscape—mountains—trees—etc—by Marsden Hartley, painted in Paris and Aix-en-Provence—France—1924–1927," as well as earlier New Mexican scenes. While an old friend, Lee Simonson, praised him in the gallery brochure for the "direct intensification of his inner sensibility," and deemed him "one of the three or four important painters of our generation," reviewers saw things differently.[2] One, Murdock Pemberton, criticized Hartley for overlooking *American* art and for "intellectualiz[ing] his life to the point where he can go over to Europe and worship Cézanne at the foot of his own shrine [Mont Sainte-Victoire] and not be ashamed of it." But Hartley needed "'imaginative wisdom' or 'emotional richness'" to be distinctive.[3] Stieglitz reported that Henry McBride, the preeminent critic of the day, was unenthusiastic, branding Hartley's landscapes "reminiscent of too many others. "American artists,"

150 ALFRED STIEGLITZ
Marsden Hartley, 1915–1916
EXHIBITED AT THE ANDERSON
GALLERIES, 1921

401

McBride had cautioned, "should not flee their country but should work in America even though the conditions for the artist be impossible here."

Stieglitz wrote Hartley about the show soon after it had closed at the end of January 1929. He said that the Intimate Gallery had "looked rich and full," and when he had been ill, his assistant Emile Zoler, Georgia O'Keeffe, and Paul and Rebecca Strand had watched over things.[4] Stieglitz had hoped the show would overcome McBride's prejudices, but it did not, and he confessed that he agreed more or less with McBride that American artists should remain in America.

This was the heart of the matter and was certainly one cause for the split that widened between the two men during the 1930s. Stieglitz believed he was being realistic and tried to spell out the facts to his friend: "Eventually, unless a miracle happens, and I am not a great believer in miracles, you will have to face a reality which I fear you never tried to understand. You have really made no 'practical' contact in Europe and you are really without contact in your own country. Spiritually you undoubtedly are achieving what you must achieve, but the so-called economic problem, which after all is one that none of us can escape, is quite as difficult, if not more so, than it was when you originally came to 291. Of course one can always hope if one is so inclined but unless that hope is actually rooted in one's spirit and is not self-deception, it is bound to end in disaster."[5]

While he was trying to assuage what he knew would be a severe jolt, he revealed one of the matters that irritated Hartley and others: Stieglitz's distaste for his business. "I cannot possibly become a rich man," he lamented, because he despised "the idea [of richness] or dealing in art more than ever."[6] Equating pictures with money was repugnant to him, so while he wanted to help the artists he represented, he had little success in providing them funds. He was, of course, being a bit dramatic. John Marin, O'Keeffe, and Charles Demuth fared better than Hartley, whose New Mexican landscapes of the early 1920s (see pls. 101, 110, 151), not to mention the newer works in the 1929 show, met with less acclaim than did the work of the other artists. Whatever the actual case, Stieglitz tried to soothe Hartley by asserting that "There are vaults and vaults full of O'Keeffes and Marins and Doves, not to say that practically all of my own work is there." He reminded Hartley that he was not alone and that "as a matter of fact, you are in very good company, a true aristocrat and aristocracy come high in the U.S.A."[7]

Actually, McBride's comments were brief, only a short paragraph in his *New York Sun* column, "Attractions in the Galleries."[8] He scoffed at Simonson's suggestion that Hartley's French mountains were no different than those in Maine. And while Hartley's still lifes were rich in color, "the very newest landscapes are disappointingly academic," an assessment viewers probably found not far off the

151 MARSDEN HARTLEY
New Mexico Recollections, No. 12,
1922–1923
POSSIBLY EXHIBITED AT THE
ANDERSON GALLERIES, 1925

fig. 113 MARSDEN HARTLEY
Landscape No. 29, Vence, *c. 1926*
oil on canvas
Courtesy Babcock Galleries, New York
PROBABLY EXHIBITED AT THE INTIMATE GALLERY, 1929

mark. Hartley had experimented in his landscapes with what he perceived French painters, notably Cézanne, to be doing. How did one correlate an "absence of personal life" with form and color?[9] He used a formal, architectonic style in which shapes, primary colors, and overall forms conveyed little subjectivity or symbolism except as references to Cézanne.

An example of this is *Landscape No. 29, Vence* (fig. 113), a painting executed around 1926 that is actually not of Vence but of Cézanne's Château Noir with Mont Sainte-Victoire in the background. Hartley assimilated Cézanne's techniques to create an image not unlike a tapestry. The colors and clearly defined shapes reflect Cézanne's work. While they have an appealing pattern and some strong color, they do not convey much if anything about Hartley's subjective response to the scene, even though we understand how much Cézanne meant to him.

The day after Hartley received Stieglitz's letter in late February, he wrote back at length, claiming not to be struggling, but merely readjusting. Stieglitz's letter was "an achievement of spiritual beauty"; it enabled him to cope with the bad news,

MODERN ART AND AMERICA

although soon he would be grumbling about McBride's "vicious and vulgar arti-
cle ... as cheap a piece of journalism as has been pulled off in years."[10] His emotions
swirled about. To Stieglitz he had defended his expatriation and "the privilege of
experimentation," but to Kuntz he complained that he had heard from someone
recently returned from the United States that he was spoken of as having slipped in
his painting during the past four years. Worse yet, the comments had come from the
Intimate Gallery, perhaps from Stieglitz himself.[11]

The stage was thus set for the decline in Stieglitz's and Hartley's professional
relationship, which began in 1909 and ended after a final exhibition at An American
Place in 1937. The issue aside of Americans painting America, their differences
grew because Stieglitz seemed to Hartley to favor other artists, because the Great
Depression made the market bad for everyone, and because Hartley's painting *was*
difficult and uneven. The relatively small audience who heeded what was showing at
the Intimate Gallery and then An American Place responded more favorably to the
work of O'Keeffe, Marin, Demuth, and perhaps even Arthur Dove, than to Hartley's
French landscapes in 1929 or later; his 1930 New Hampshire landscapes; those of
Dogtown, behind Gloucester Harbor in Massachusetts, 1931; ones from Mexico and
the German Alps, 1932–1934; or the primitivist land- and seascapes and still lifes
from Nova Scotia, 1935–1936. Works which today are considered among Hartley's
most well rendered and intriguing were frequently questioned by his critics. In
1936, for instance, when An American Place held its first Hartley show in four
years, the reviewer for the *Magazine of Art* said of his landscapes that "richly con-
ceived as several of them are, particularly the New England ones, [they] leave one
slightly chilled by their gray objectified solemnity. They lack intensity of observa-
tion and sharpness of statement." Recalling "the flavorous quality of Hartley's ear-
lier landscape paintings," the reviewer found it "even more difficult to explain the
existence of his banal and uninspired Alpine vistas."[12] The critic for *Art News* had
been even less enthusiastic, deeming Hartley's recent exhibitions "more and more
embroidered with eccentricities which have the wasteful concentration of an escap-
ing valve.... It is lamentable," the writer continued, "to watch a fine mentality go
off the deep end as Hartley's does in the painting and too-too-utter catalogue....
Can nourishment be found in The Is-ness Of The Was," the reviewer closed, on a
note of irony.[13]

One has to admire Stieglitz for continuing to support Hartley, and for
believing in him, at least more or less. The thoroughly conventional reviews for
the *Magazine of Art* and *Art News* missed almost entirely what Hartley was about. As
he was painting the first series of Dogtown works in October 1931 he had written
Kuntz that he was giving all his attention to "this extraordinary stretch of almost

152 MARSDEN HARTLEY
Mountains in Stone, Dogtown, *1931*

metaphysical landscape—it cannot appeal to dull painters because it calls for deep contact and study and I am capable of both, and while my pictures are small—they are more intense than ever before, and I have for once (again) immersed myself in the mysticism of nature." He told her that he was striving for "the emotions *beneath the pattern.*"[14] Hartley was trying to paint "not ideas about the thing but the thing itself," as the poet Wallace Stevens put it in a poem that described what both he and the painter sought to achieve in their work.[15] Hartley was using Dogtown to express larger issues and through the force of form and color to convey his sense of man's place in the world and the need for endurance. In one of the paintings exhibited in 1936, *Mountains in Stone, Dogtown* (pl. 152), autumnal reds and yellows play against the various grays of large boulders, while a cross-shaped tree, stripped of branches and leaves, is silhouetted against a vividly blue sky and in the plane of the painting touches one of the two white clouds stretching across the blue expanse. The scene is one of solitude and tranquillity but also of vitality and emotion because the colors pulsate, the heavy texture of the paint gives the picture a tactile quality, and the design of the forms has movement.

Equally forceful are his paintings of the Alps (fig. 114). Uninterested in conventional foreground, Hartley reduced or even negated the space between the mountain and the viewer in order to merge the object, the canvas, and the observer, a matter akin to what Jackson Pollock achieved with his action paintings or Mark Rothko with his blocks of pure color.

In 1936 Stieglitz understood Hartley—one has only to look at his photographs of tall buildings, for instance, to see this—but the *Art News* reviewer did not, although he spoke more than he knew when he mocked Hartley for attempting to achieve "The Is-ness Of The Was." Particularly after Hartley's return to the United States in 1930, he concentrated on the "Is-ness" of monumental nature, more often than not depicting American scenes because of the goading of Stieglitz and the reviewers, although he believed that the documentary quality that made a painting "American" was of little matter. It was the expression of "the qualities of life as it is and the essential truths of experience— experience unembellished and unadorned," that counted.[16]

After what was essentially a failure with the 1929 show, Hartley licked his wounds. He realized, as he informed Kuntz, that there could be no exhibition in

1930 because he needed to produce new paintings before any "big coming out ... the prima donna kind," that he yearned for and, as usual, expected.[17] Marin, after all, had recently received "$6000 for one water-colour and several others."[18] Hartley thought he was not alone because O'Keeffe, for example—of whom he was always somewhat jealous because of her closeness to Stieglitz—had suffered a "poor year & for obvious reasons because she must have a re-birth in order to live in the world's eye. Her introvert's story is told," he asserted, adding that "when she attempts extraversion she is as feeble as a child of premature birth. All that is good for her," he declared, condescending to her as was his wont in the company of others.[19]

He soon declared to Stieglitz, "I am ill," after Rebecca Strand wounded him with an offhand remark. He claimed not to want to be a burden to anyone, but was precisely that to his long-suffering friend. "I feel so single handed and in reality so feeble minded with what surrounds and confronts me," he moaned, although soon he had recovered enough to tell Stieglitz that he would "live and have being again."[20] His relationship with Stieglitz continued in this fashion: he relied heavily on the older man, but remained distressed by what he perceived to be Stieglitz's lukewarm reception to his painting. He told Isabel and Gaston Lachaise that Stieglitz simply did not care for it, not only because it was "too foreign" for An American Place, but because he was not well and sensed "much antagonism from the outer world."[21]

Hoping to paint enough canvases for Stieglitz to have an impressive exhibition the next winter, Hartley headed for New Hampshire in the summer of 1930. He had at best mixed success with his painting: the mountains lacked distinctive shape, the colors of autumn were dull, and his driver/companion had little interest in art. Nevertheless, from the summer's work and from still lifes done in France Stieglitz mounted an exhibition that opened mid-December 1930. While the works were not among Hartley's major efforts, they were enough to please McBride, who announced "Marsden Hartley's 'Comeback,'" asserting that "Mr. Hartley takes his place naturally amid the seven stars of the American Place and 100 percent Americans can go to see the show without any sense of incongruity.... [T]here are still some European pictures in the collection. But here is the triumph of the whole affair—the American pictures decidedly overtop them. It is distinctly a case of American uber alles."[22] No matter that McBride thought the New Hampshire landscapes were of Maine, the praise was welcome and, along with the news that he had won a Guggenheim Fellowship, buoyed Hartley into the fall of 1931. His experience painting in Dogtown added to his satisfaction, so that by mid-August he told Stieglitz the summer might prove to be "general resurrection-revelation—evolu-

tion out of revolution I am wanting to phrase it." His new art was "emotion contained—'art condensed not diluted' as Degas puts it."[23]

Except for one still life in an informal exhibition at An American Place in 1932, Hartley did not show there for the next four years. The reasons were several: he was away from the United States—first in Mexico and then in Germany in 1932–1934; his art appeared at venues other than An American Place in the meantime—twenty of his Dogtown works were shown at the Downtown Gallery in April and May 1932, for example; the works he painted during his absence were not of American but of Mexican and German subjects; and various friendships took him away from his formerly deep reliance in Stieglitz. Hartley understood that his friend, somewhat isolated himself, would have little interest in his Mexican endeavors, whereas his newer confidante, Kuntz, would. He wrote her about one of his most extraordinary works done in Mexico, *Eight Bells Folly: Memorial for Hart Crane* (pl. 153), a "marine fantasy symbolic of Hart Crane's death by drowning," he explained and described it in detail: "There is a ship foundering—a sun, a moon, two triangles, clouds—a shark pushing up out of the mad waters—and at the right corner—a bell with '8' on it—symbolizing 8 bells—or noon when he jumped off— and around the bell are a lot of men's eyes—that look up from below to see who the new lodger is to be—on one cloud will be the number 33—Hart's age—and according to some occult beliefs [that] is the dangerous age of a man—for if he survives 33 he lives on—Christ was supposed to be 33—on the other cloud will be a 2—the sum of his poetic product."[24]

He added to the painting two six-pointed stars on the left cloud, not the number 2, but the number 6, which was associated with ambivalence, equilibrium, and also hermaphroditism, all matters relevant to Crane himself as well as to his poetry. Hartley shifted numbers around, moving the number 33 to the ship's sail, adding another 8 to a cloud, and placing the number 9—the tripling of the triple and thus a complete image of the body, mind, and spirit—in front of the shark.

What makes *Eight Bells Folly* and others of his Mexican works powerful is their symbolism, something that would remain prominent in Hartley's work until his death. The Dogtown paintings brought this to the fore; now with the Mexican pictures he combined intense interest in mysticism with symbols and color to produce works as forceful as were his German Officer paintings of 1914–1915. *Morgenrot, Mexico (Red Morning, Mexico)*, probably begun during the summer of 1932, is a good example (fig. 115). The large red hand set in whitish light and backed by six gold spheres, with a seventh on a gold wristband, is a striking design. Hartley was representing what he had read among various mystics, especially Paracelsus and his follower Jakob Böhme, for whom the seventh realm of divine corporeality, the

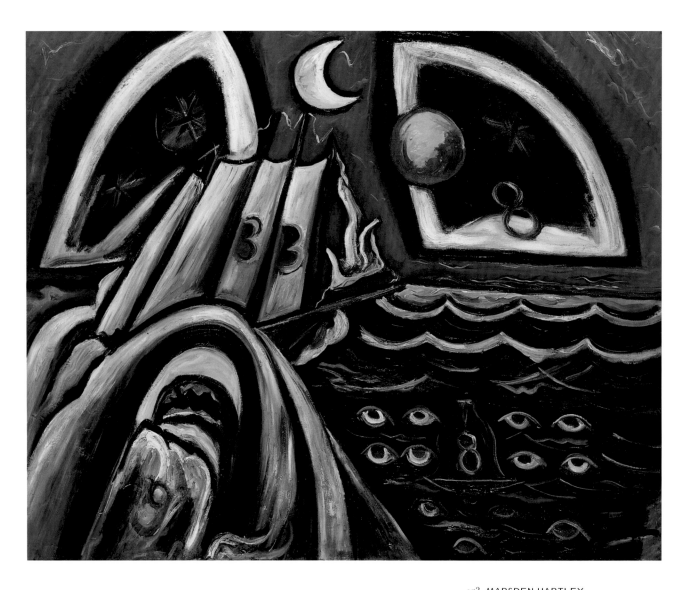

153 MARSDEN HARTLEY
Eight Bells Folly: Memorial for Hart
Crane, *1933*

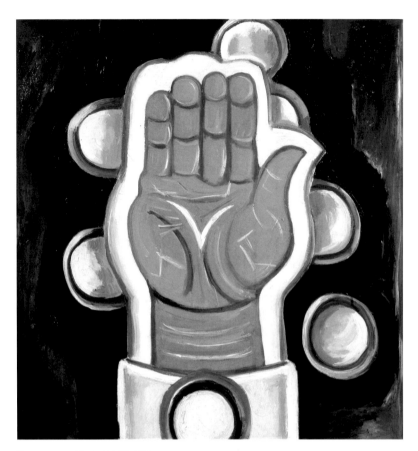

fig. 115 MARSDEN HARTLEY
Morgenrot, Mexico, *1932*
oil on canvas
Courtesy Babcock Galleries, New York

materialized word, was where individual sounds contributed to the divine harmony of the spheres. In *Morgenrot, Mexico* the seventh seal is on the divine hand made corporeal, 7 is the symbol of order and wholeness. The title of the painting is in German and reflects his admiration for that country as well as the fact that he was living among Germans when he painted the work. The red hand evokes Native Americans, the hot land, the brilliant sun, and even the blood of man, which are all parts of God made corporeal on the seventh day when all was harmonious.

In early January 1934 he told Kuntz as he was preparing to return to the United States from Germany that he expected "no great obstacles ahead."[25] He did not understand Depression America, which had little interest in his work. By November he was becoming desperate, especially because Edith Halpert, his dealer at the Downtown Gallery, had forwarded a letter from the Lincoln Storage Company announcing that he owed $184 for the storage of his paintings. Hartley

turned first to Stieglitz for help, but he declined, saying that he had few funds of his own, and suggested that it was a matter for Halpert. She did not have sufficient cash, and the problem was temporarily resolved only after Hartley obtained fifty dollars from a nephew, fifty dollars from Kuntz, and one hundred dollars from Louis Shapiro, a Boston man who admired his work. He knew he could not rely on Stieglitz any longer to sustain him. Hartley remained friendly in his letters to the older man, but he told his niece, Norma Berger, that "Stieglitz in spite of himself goes on with the injured papa attitude whose son went out and married a woman beneath him—woman being the art market[—]and is silently saying—well son— you would have her—knowing what a slut she is." He knew he was "novelizing," but, he asked, "In the name of heaven, why must the Hartley crew make such a mess of things?"[26]

The mess worsened, and on his birthday, 4 January 1935, he had to go to the storage vaults to reduce his inventory of paintings so they could fit into one vault. He destroyed more than one hundred paintings and drawings, coming away devastated by the experience and the depths of his poverty. That spring he had to eat on sixty cents a day, once a week dining at Stieglitz's expense at the Shelton Hotel. Despite his generosity, Hartley found the older man strange—"a funny boy," he called the dealer who, while kind to him socially, was "too queer for words about prices & me— and I don't wish to play cymbals to the 'first violins.' "[27]

He had played cymbals to O'Keeffe's violin early in 1936, writing an introduction to a catalogue for her show at An American Place in January and early February. He was pleased to be a part of the gallery again, and it gave him the confidence to request an exhibition. He told Stieglitz he must have one and assured him that "all the blackness is gone out of my pictures and this is victory enough for it typifies a comforting state of progression."[28] While others found the show disappointing, McBride praised it, which pleased Hartley, even as he grumbled about selling only six paintings at low prices.[29] He saw himself standing alone against the world, and despite the help of Stieglitz and O'Keeffe he criticized them for their lack of enthusiasm toward him. One can imagine them asking what the man wanted. It was, of course, recognition, money, and to be first violin at An American Place, something Stieglitz could not completely orchestrate. Hartley would have one final exhibition at the gallery in 1937.

The show took place from 20 April to 17 May and consisted of twenty-one paintings and drawings from Dogtown and Nova Scotia, where Hartley had spent long summers in 1935 and 1936. He was excited about the exhibition—"my best show in years," he assured Kuntz, "and I am all agog about it myself." Although none of the work was literally of Maine, he wanted "to be known as *the* painter of Maine,"

fig. 116 MARSDEN HARTLEY
The Great Good Man, *1942*
oil on masonite
Gift of the Lane Collection
Courtesy, Museum of Fine Arts,
Boston

he emphasized to her, having made the point in an introduction for the catalogue entitled "On the Subject of Nativeness—a Tribute to Maine."[30]

The exhibition was unsuccessful; he sold nothing. Later, after he urged Lloyd Goodrich, curator of the Whitney Museum, to do so, he arranged for the museum to purchase one work for eight hundred dollars. Hartley told Goodrich that he thought he should break with An American Place because it was widely disliked.[31] The schism between Hartley and Stieglitz was almost complete. The artist held the dealer partly responsible for the failure; the dealer had lost his enthusiasm and patience for the idiosyncratic painter and during the show told one critic, Elizabeth McCausland, that Hartley was not a major artist.[32] When a younger dealer, Hudson Walker, visited the exhibition and was enthusiastic about it, Stieglitz agreed to turn everything over to him. At this point Hartley was pleased, because he knew Stieglitz disapproved of his work. "I once saw a bill of consignment on the table in the office of the American Place," he wrote Walker after the break with Stieglitz was complete. Hartley claimed that the bill was "to the Downtown Gallery and it was for three O'Keeffe's and the prices ran $3000— for the smallest, $4800, for the next size, and—$10,000.00 for the largest which would doubtless have been a petunia or an ox-skull, all that without batting an

eyelash and yet he seems to think that nothing at all is a lot for me, and I never could make out his psychology in the matter, save that he is just hyped about O'Keeffe and Marin and he gets a racetrack quiver when he mentions these names or hears them mentioned."[33]

Given all the circumstances leading up to the final break, it was inevitable. Stieglitz had his own quirks, but with Hartley he was remarkably patient and only drew back during the 1930s when Hartley did not focus on American subjects and when little he painted sold. But Stieglitz did Hartley a considerable favor, because it was his disapproval that brought Hartley back to American subjects, so that during the last six years of his life he created many of his greatest pieces: powerful, direct expressions of his wonder at the beauty and force of nature, particularly that of Maine. Mount Katahdin, crashing waves, small birds, and the vast sea, along with primitivist portraits of heroic beings, constituted his final statements about a world he clung to, even though he had a lover's long-standing quarrel with it (see pls. 154–158; fig. 116).

MODERN ART AND AMERICA

155 MARSDEN HARTLEY
Summer, Sea, Window, Red
Curtain, *1942*

156 MARSDEN HARTLEY
The Wave, *1940*

157 MARSDEN HARTLEY
Mount Katahdin, Maine, *1942*

158 MARSDEN HARTLEY
Mount Katahdin, Maine No. 2,
1939–1940

William C. Agee

ARTHUR DOVE

A PLACE TO FIND THINGS

I n June 1924, Arthur Dove (1880–1946) remarked to his companion and future wife, Helen (Reds) Torr, that he liked "balance and direction."[1] Dove and Torr led a quiet life, away from the city, often on the water they both loved. Balance and direction were essential to this life and to Dove's art, which drew its inspiration from the immediate experience of the natural world around him. In large measure, Alfred Stieglitz, sixteen years his senior, made this possible for Dove. The two shared a lifetime relationship of mutual support, remarkable for its closeness, and kinship of views on art and life. To Dove, Stieglitz was a guiding and stabilizing force. By his own admission—"I couldn't have existed as a painter without that super-encouragement"[2]—it is unlikely that Dove's art would have reached the heights it did without it. In turn, the emergence of Dove and his art helped to confirm for Stieglitz his beliefs in himself as an artist and champion of modern American art.

Stieglitz was nothing less than a surrogate father to the artist, who once said that the three important people were "Christ, Einstein, and Stieglitz."[3] Dove's real father ("my other 'old man,'" Dove had called him),[4] a prosperous manufacturer and landholder in Geneva, New York, actively discouraged his son's calling as an artist and refused him help of any kind to the day he died.

Dove, educated at Hobart College and Cornell University, moved to New York in 1904, where he supported himself as an illustrator while beginning to paint in an impressionist manner. In 1908 Dove and his first wife traveled to France, where they remained for more than a year as Dove absorbed his first lessons in postimpressionist art. There Dove met Alfred Maurer, who introduced him to Stieglitz sometime in late 1909 or

159 ALFRED STIEGLITZ
Arthur G. Dove, 1911–1912
EXHIBITED AT THE ANDERSON
GALLERIES, 1921

421

early 1910. Stieglitz, who was then immersing himself in recent avant-garde art, responded to the modernist impulses of Dove and his painting and included him in his landmark 1910 exhibition "Younger American Painters."[5] The exhibition launched Dove's career, and confirmed his path as an emerging modern artist. Until his death, Dove never had another gallery or dealer.

In early 1912, Stieglitz gave Dove his first major one-man exhibition, a show of some ten pastels, the Ten Commandments,[6] which established Dove as an important member of the American modernist vanguard. But neither balance nor direction, life nor art, came easily for Dove, and this promising start, which had accounted for works still central to early modernism, did not sustain itself. He moved to a farm in Westport, Connecticut, to pursue a financially independent life, away from the city and free from his family. His search to make a life on his own terms exacted a high price. It was impossible to make a living from the farm despite long hours of backbreaking labor. Worst of all, it meant that after 1912, Dove painted only intermittently, if at all. He had lost his early direction, and a highly promising artist had been sidetracked; instead of independence he had become captive to a dead end. It was as if on some level Dove found it difficult to confront his calling as an artist.

Yet Stieglitz never lost faith in Dove and his abilities, partly, perhaps, because his own art was itself in a fallow period. Stieglitz gently prodded and encouraged him: "No painting for you in sight?" he inquired,[7] until Dove finally gave up farming and resumed painting in the summer of 1921. Dove was fairly exultant when he wrote to Stieglitz in August that "It is *great* to be at it again, feel more like a person than I have in years."[8] Dove had a new lease on life: he no longer had to fight his father, who had died earlier in the year, and he had ended his first marriage, to start over with Reds. Stieglitz had seen him through until Dove could begin again on his own. In fact, Stieglitz may well have helped to galvanize Dove by the example of his own newly rekindled efforts, for by 1920 Stieglitz had begun the most productive decade of his life.[9] All was not rosy, however, for Dove always found the hard way, in art and in life. From the farm, Dove and Reds moved to a leaky and cramped boat, moored on the North Shore of Long Island at Halesite, which required countless hours of repair and maintenance. It took another three years, from 1921 until 1924, before he painted on a steady basis.

Dove did not exhibit regularly until 1926, when Stieglitz gave him a one-man show at the Intimate Gallery, his first in fourteen years. If Dove's rhythm was slow in coming, it did at last mature into a rich and productive flow of work, marked by an annual spring exhibition with Stieglitz, a predictable and reassuring routine unbroken for the rest of their lives. Stieglitz handled all the logistics and financial

matters connected with his art, which allowed Dove the freedom to work at his own pace. Stieglitz sometimes advanced him funds, and his unfailing, patient support allowed Dove to grow as an artist. Dove would later tell the dealer, "You know the paintings are as much yours as they are mine."[10]

Over the course of a lifetime, Stieglitz and Dove influenced each other in many other ways. Because his role as a champion of modern art was so prominent, it is easy to forget that Stieglitz himself was, first and foremost, an artist of the highest accomplishment. He set standards of quality and achievement that inspired Dove and others; Dove once said that he thought "Rembrandt, Picasso, and Stieglitz were the greatest artists."[11] By his example, Dove would have learned the importance of constancy, hard and sustained work, bearing down with intensity, reaching for new levels of growth and avenues of expression, even, or most especially, as they grew older. Stieglitz's visual and critical acumen, spoken and unspoken, demanded the best from artists.

We think of Stieglitz as a visionary voice from on high, handing down full-blown, certified truths about modern art. This was not the case, for in the years after 1908, both Stieglitz and Dove had to educate themselves in modernist ideas and practice.[12] They grew side by side, at points more like fellow students, rather than teacher and pupil. Both learned as they went, from experience, and they shared a deep and abiding belief that true and convincing art came from the artist's personal "honesty, sincerity, vitality, intensity of feeling, and freshness of vision," as William Homer has described it.[13] Both, in their own ways, sought an art that was organic and poetic, an art that was modern and expressed personal freedom. To best achieve these ends, art should be abstract, which they believed to be a purer, higher form of expression, well suited to discover the true reality of the world hidden behind outward appearances. They initially learned from the key figures of European modernism but sought an art that spoke of America, free and clear of dependence on European roots. For his part, Dove was not so outspoken on this matter, and even voiced some qualms about an overtly American art. Yet he produced an art that was distinctly American, not by the graphic depiction of American life, but by its inner qualities.

In their continuing give and take, Stieglitz and Dove each took up themes that posed challenges and possibilities for the other. In effect, they created a dialogue between painting and photography that yielded rich results. In 1922, for example, Stieglitz undertook his famous series of sky and clouds, symbolizing states of mind and emotion, which had a tremendous impact on his circle. Yet cosmic images, especially the sunrise, the very symbol of life, growth, and regeneration, had informed Dove's work as early as 1913, in paintings that Stieglitz would have known well. In

turn, Dove quickly responded to the extraordinary power of the cloud photographs in paintings such as *After the Storm, Silver and Green (Vault Sky)*, c. 1923 (pl. 103); *Moon and Sea No. II*, 1925 (private collection); *Golden Storm*, 1925 (Phillips Collection, Washington); *Clouds*, 1927 (fig. 117); and others. Dove sought to capture, in painting, the same magisterial and deep emotional tone he found in the Stieglitz photographs.[14] Even in the wispy pieces of chiffon and the silvery grays of the material and the support used in *Sea II* (pl. 160), a collage of 1925, Dove evoked the mood and look of the sky and clouds as much as of the ocean; its companion piece, *Sea I* (Museum of Fine Arts, Boston, William H. Lane Collection), is literally a scene of sun and sky over the water. The two collages also relate closely to *Silver Storm* (private collection) of the same year in its vertical disposition of thin clouds, which in turn is reminiscent of any number of Stieglitz *Equivalents*, including several of 1925 (NGA 1949.3.924). Indeed, myriad tones and gradations of grays and silvers thereafter became a characteristic of Dove's color, one of the most salient, if still little remarked, aspects of his art.

Dove held Stieglitz's cloud images in the greatest respect and admiration throughout his life, and in 1942 he bought two *Equivalents*.[15] Dove told Stieglitz they

fig. 117 **ARTHUR DOVE**
Clouds, *1927*
oil and sandpaper on sheet metal
Gift of the William H. Lane Foundation, 1990
Courtesy, Museum of Fine Arts, Boston
EXHIBITED AT THE INTIMATE GALLERY, 1927

160 ARTHUR DOVE
Sea II, *1925*
PROBABLY EXHIBITED AT THE
INTIMATE GALLERY, 1926

had inspired new ideas, which became clear in a new series of cloud paintings, and most notably in *Partly Cloudy* (fig. 118), of that same year. The painting, one of the high points in his late work, forecasts the hovering rectangles of Mark Rothko. In *Flight*, of 1943 (Phillips Collection, Washington), the world is seen from above, suggesting the curvature of the earth, similar to the view that may be read in the cloud formation in the 1926 *Equivalent* that he owned (NGA 1949.3.965), as well as to the perspective in others, such as a 1929 *Equivalent* (NGA 1949.3.1025).[16]

fig. 118 **ARTHUR DOVE**
Partly Cloudy, *1942*
oil on masonite
The University of Arizona Museum of Art, Tucson,
Gift of Oliver James
EXHIBITED AT AN AMERICAN PLACE, 1942

So, too, Stieglitz equated his images of clouds and their harmonies with music and its composition, and in 1922 he entitled the first series *Music* and then *Songs of the Sky*. Stieglitz was only one in a long line of nineteenth- and twentieth-century artists who had developed this analogy as they sought to compose an abstract art that would be as pure and nonreferential as music.[17] In this Dove had been a pioneer, for as early as 1913 he had done a series based on musical themes, and surely Stieglitz had learned from such examples the possibilities of working like a composer. In turn, in the later 1920s, Dove extended the analogy to a working methodology by making paintings as he listened to records, as in *George Gershwin—I'll Build a Stairway to Paradise* (fig. 119) and *Orange Grove in California by Irving Berlin* (Fundación colección Thyssen-Bornemisza, Madrid).

Stieglitz insisted on exploring the properties of a given medium, testing new techniques and materials, and seeking to know the full range of its possibilities and limitations.[18] It was a lesson well learned by Dove, who reached beyond painting to invent collages composed of discarded, non-art materials, which were virtually without precedent in American art. Later, he investigated materials and techniques and their history in depth, and by the mid-1930s he had become expert in his knowledge of them. He employed new types of metallic and aluminum paints as well as wax emulsion to achieve a rich surface texture, resulting in heightened expressive effects in his later art.

To explore the possibilities of photography, Stieglitz tested its aesthetic powers against painting.[19] As a result, one of his greatest achievements was to combine the formal advances of modern painting with the unique expressive and technical

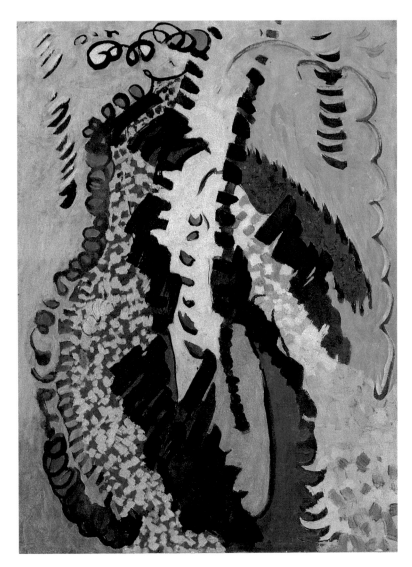

fig. 119 ARTHUR DOVE
George Gershwin—I'll Build a Stairway to Paradise, *1927*
ink, metallic paint, and oil on paperboard in frame
Gift of the William H. Lane Foundation, 1990
Courtesy, Museum of Fine Arts, Boston
EXHIBITED AT THE INTIMATE GALLERY, 1927

means of photography. If Stieglitz purposefully compared his medium to painting, the visual evidence suggests that, in turn, Dove held up painting to the challenge of photography. Could he, he seems to have asked himself, make a painting as small as a photograph yet with the same immediacy and emotional intensity? Although they are little known and seldom seen, Dove did a series of small, memorable gems, measuring eight by ten inches, the usual size of a black-and-white photograph. Works such as *Moon* (fig. 120), of 1928, are not minor studies or variations, but

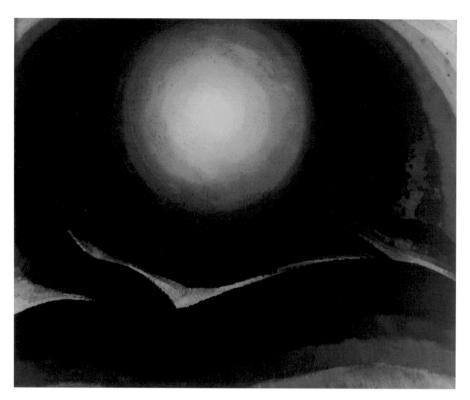

fig. 120 **ARTHUR DOVE**
Moon, 1928
oil on wood
Fisk University Galleries, Nashville, Tennessee,
Alfred Stieglitz Collection
PROBABLY EXHIBITED AT THE INTIMATE GALLERY, 1929

complete and independent works that demand close, intimate inspection. Clearly, *Moon* was deeply felt and lovingly painted, with the rich, dark luminescence that characterizes many of Stieglitz's cloud photographs. They are too much alike in theme, size, composition, and mood, and are too close in date, for these similarities to be coincidental. These works embodied for both men strong personal feelings, and represented a kind of emotional self-portrait. Indeed, Dove, like Stieglitz, believed his art to be, finally, an art of self-portraiture.[20] Dove extended the metaphor by also seeking to portray the mood of the seasons, as in *Summer* (Museum of Fine Arts, Boston, William H. Lane Collection) and *Autumn* (Addison Gallery of American Art, Andover, Massachusetts), both of 1935. At one point, he even set out to capture, in sequence, the mood of the days of the week, as in *Sunday* (location unknown) and *Wednesday* (Museum of Fine Arts, Boston, William H. Lane Foundation), both of 1932. After 1921, Dove often made small watercolors as preparatory studies, which he then sorted out, selecting a few as the basis for large, finished paintings. In the late 1930s and early 1940s, however, he made more than

two hundred works on paper measuring four by three inches, close to the exact size of many of Stieglitz's *Equivalents*.[21] These later works have an immediacy and a density of texture that make them of a different order than the earlier, more open and fluid watercolors. Some relate to known paintings, but they are primarily independent works, indicating that, once more, Dove had aspired to match, in paint, the power and intensity that Stieglitz had achieved with photography.

From 1908 to 1917, Stieglitz educated himself and others, Dove among them, by his pioneering exhibitions of the key figures of modernism, including Cézanne, Rodin, Rousseau, Picasso, Matisse, Brancusi, and Severini, as well as by his publication in *Camera Work* of important modernist writings by Wassily Kandinsky, Henri Bergson, Gertrude Stein, and Marius de Zayas, all influential to Dove. Through Stieglitz's efforts, which were at the heart of early modern art in America, young and old absorbed these first, formative lessons. They learned together in a joint venture, on new ground, with no guarantees of efficacy or success, which makes the saga of early American modernism all the more compelling.

Stieglitz collected important art to learn and to teach. The works he acquired were readily available at the gallery, offering a visual resource that no museum before 1930 could match. The 1912 Kandinsky that Stieglitz purchased from the Armory Show in 1913, *Improvisation Number 27* (pl. 23), was an immediate and continuing inspiration for Dove. This painting abounded in the open and fluid shapes in which we can trace the birth of biomorphism, the form language at the heart of much of his art, as well as that of later artists such as Arshile Gorky. Any portfolio of Dove's work reflects its pervasive impact, but *Calf*, c. 1911–1912 (private collection); *Goat*, 1935 (The Metropolitan Museum of Art); and *U.S. 1940*, 1940 (Fundación colección Thyssen-Bornemisza, Madrid), offer telling evidence, both early and late.

In August 1922, Stieglitz made clear his allegiance to a small group of Americans when he wrote to Dove saying, "You know there are very few artists in this country whose work means anything to me. It is all too still-born—& 'ART.' Yours, and Marin's, and Georgia's are never that."[22] The Seven Americans exhibition, held in March 1925, and the opening of An American Place in 1929, were defining moments for Stieglitz and his circle. In both these years Dove's art took significant turns. They were not radical changes in course, but rather a clarifying of new definitions and interpretations of the guiding principle Dove had long followed. In 1914, Dove had written that the means used at 291 was "a process of elimination of the non-essential. This happens to be one of the important principles of modern art."[23] Indeed, it was the generating principle for Dove and a summation of the working process he had first conveyed to Arthur Jerome Eddy that same year, when he spoke of how he had given up the "disorderly methods" of impressionism with

its "innumerable little facts," seeking instead the "simple motif," in which a "few forms and a few colors sufficed for the creation of an object."[24] The principle was part of a long-standing modernist drive, rooted in the symbolist tradition early fostered by Stieglitz, to clarify and simplify the pictorial structure, to discover, like the scientist, the compact and economical solution. After 1910, Dove subjected his art to an ongoing process of abstraction and distillation, seeking to extract fundamental truths to find a new, personal reality, both tangible and tactile as well as inner and emotive.

Dove often spoke of searching for the real in his work, a search that forms a common thread in his art and that is well documented in his letters and diaries. It appeared as early as 1916, when he noted that the "reality of sensation alone remains";[25] in 1928 he said his new paintings "have what Brancusi would call the shock of reality";[26] and in 1931, he spoke of making paintings "real in themselves,"[27] a statement he repeated almost verbatim in 1943.[28] This parallels a guiding principle for Stieglitz, of seeking an "objective reality of form,"[29] an art without pretense or sham, that could "record a feeling of life."[30] Indeed, in 1909 Stieglitz had said: "I hate anything that isn't real,"[31] and in 1923, he wrote that he was trying to find in photography a reality so subtle that "it becomes more real than reality,"[32] what he referred to in another context as an "exactness of reality."[33]

In October 1924, Dove told Stieglitz that his new work had "certainly broken through something."[34] He didn't know what to call the work except "things," and he reported that one of them had affected Reds so much that she said she was "almost jealous" of it.[35] The "things" were Dove's collages, a series of some twenty-five works done primarily in 1924–1925, which, at their best, include some of Dove's most radical and successful work. Reds had reacted to the three-dimensional presence, the physical *reality* of the doll head in *Miss Woolworth* (no longer extant). We have been a long time in coming to grips with the collages because they have seemed to most as outside the flow of his art, as oddities, bearing little on his work as a whole.[36] When we understand the collages as an integral step in his continuing drive to a heightened reality, however, they make perfect sense and take their proper place in his work. They were presaged as early as 1921 when Dove told Stieglitz that his new paintings seemed to him "more real than anything yet," and included "stronger things" such as a "sluice gate of rusty used iron, warm grey weathered wood, and a strip of blue grey water,"[37] all elements that invoke the feel and texture of the collages. Stieglitz was pleased with them, not least of all the portrait of himself (fig. 121),[38] and included six in the Seven Americans exhibition, where Reds reported that people were "resentful"[39] of *Miss Woolworth*. But the exhibition surely encouraged both Stieglitz and Dove, despite a lukewarm critical reception.

fig. 121 ARTHUR DOVE
Portrait of Alfred Stieglitz, *1925*
assemblage: camera lens, photographic plate, clock
and watch springs, steel wool on cardboard
The Museum of Modern Art, New York, Purchase
EXHIBITED AT THE ANDERSON GALLERIES, 1925

In *Goin' Fishin'* (pl. 163) and other collages, Dove fused what appears to be an ordinary American genre scene with highly sophisticated, contemporary formal means that incorporated elements of cubist displacement, futurist sequential motion, and dada non-art and junk materials. This process of transforming a glimpse of the American scene, by the most modern means, into an effective, personal

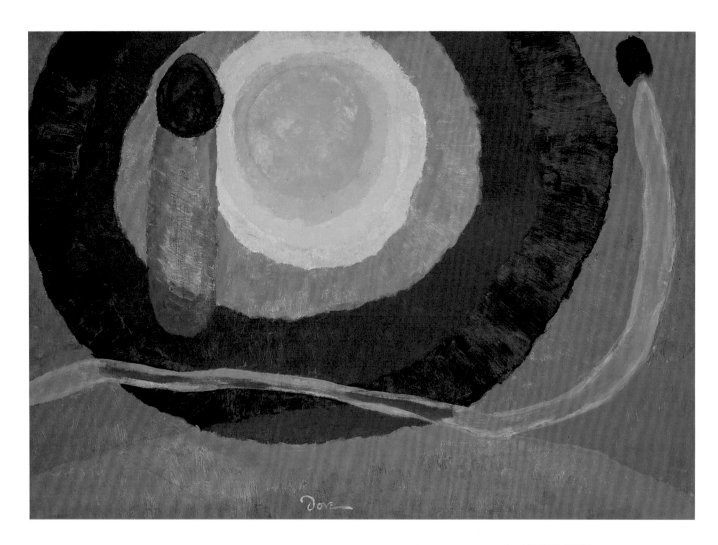

161 ARTHUR DOVE
Sunrise I, *1936*
EXHIBITED AT AN AMERICAN PLACE,
1937

expression defined much of Dove's art throughout his life. He understood that modern art in America was a particular mix of the native with an international language; otherwise it was doomed to be minor and provincial. Indeed, this mix has been the special contribution of American art to the modernist lexicon. Dove summarized his views in about 1930 by noting: "When a man paints the El, a 1740 house or a miner's shack, he is likely to be called by his critics, American. These things may be in America, but it's what is in the artist that counts. What do we call 'American' outside of painting? Inventiveness, restlessness, speed, change. Well, then a painter may put all these qualities in a still life or an abstraction, and be going more native than another who sits quietly copying a skyscraper.... The American painter is supposed to paint as though he had never seen another painting.... The French go and come freely through the history of art, back and forth ... taking what stimulates, adding, discarding, absorbing...."[40]

He understood that it was just as modern and American to paint a landscape as it was to paint the latest urban novelty; he understood that the "place to find things is in yourself and that is where you are...."[41] The landscape tradition, which included Dove, Marin, and O'Keeffe and was extended by Gorky and Jackson Pollock, was just as vital to modernism as that tradition which embraced the urban spectacle. Dove did not confuse the novel with the truly modern. Nor did he mistake an American subject matter for an American style, a common pitfall in our art and writing, as John McCoubrey noted decades ago.[42]

The qualities Dove described as American are found in abundance in his art, as in the inventiveness of his collages and his insistence on change and growth. Speed and restlessness are everywhere found in his whiplash linear tracings, a type of drawing that shapes and forms as it moves over his surface. It is most especially evident in his music works of 1927. The automatist improvisation of these remarkable paintings and collages looks forward to the technique as well as to the intertwined skeins of paint that constitute the surfaces of Pollock's poured paintings of 1947–1950.

Perhaps the most American quality of Dove's art was his search for the real. Realism has come in many forms and definitions, but throughout our history it has been the most persistent strain in American art. Dove's search for the real involved every aspect of his art and his being. For Dove (and Stieglitz) reality was not the imitation of appearances, but rather referred to an essential, inner truth. Dove himself was a man of probity and humility, and he invested his life and his art, "each bit," with thought and feeling to give it "dimension," a favorite term denoting something true, of substance and breadth.[43] Like the man himself, his art was straightforward and without pretense; it could be blunt, even to the point of leaden, but always we

feel we are in the presence of something actual, true, authentic. His sense of the real included the sensory, as in the touch and feel of the specific textures and weighty objects in the collages. By his process of reduction, of finding the simple motif, Dove discovered the "gummy, redolent essence of the thing," as it has been termed.[44]

Dove's art would also include other sensory phenomena: sound, as in his painterly improvisations of music, or weather, as in his pictorial responses to the feel of a day. His sense of the real also included the spiritual, a sense of a higher order to the world, an unseen but no less real spirit, to which man evolves through growth and change, the fundamental laws of life itself. Dove sought the reality of place, his own small corner of the world, the rising sun over a modest pond, not a grandiose Bierstadt landscape, but a humble place made profoundly beautiful once invested with Dove's art. There was also a pictorial reality, fundamentally important to his art as well as to other modernist painters, of the primacy of the painting itself. Paint is real in itself; the pigment has a life of its own and is as real as nature. While the painting took its reference from the natural world, it was finally an independent object, inviolate unto itself; it was not a picture of something, but something invented, a "thing" (as he termed it) in its own right, with its own reality, its own laws, and its own references.

The opening of Stieglitz's gallery An American Place in 1929 coincided with a new surge of confidence in Dove, which was no accident, for both men were now sure of their direction. Dove worked with ever greater seriousness and intensity, without interruption ("the greatest luxury," he wrote to Stieglitz),[45] pushing himself to explore his "inner horizon for new ideas"[46] and making a painting a day.[47] For Dove, his continuing search for the real meant a steady drive to a "pure" art, a more abstract kind of painting. In October 1929, Dove wrote to Stieglitz to say: "Am more interested now than ever in doing things than doing something about things. The pure paintings seem to stand out from those related too closely to what the eye sees there. To choose between here and there—I should say here."[48] This drive parallels the drive to "pure" photography that characterized the work of Stieglitz and others after 1916.[49] From 1929, Dove moved toward ever greater clarity, distillation, broadness of vision and scale, in keeping with his first principles, to eliminate the nonessential and to find the simple motif. This drive, which characterized his later work until his death, can be said to start in the simplicity of the four-part division of the 1929 Sun on the Water (fig. 122); it then progressed through the Sunrise (pl. 161) series of 1936 and culminated with one of his greatest paintings, That Red One of 1944 (pl. 166).

This path was more complex and varied, of course, than this outline suggests. It was also fraught with personal difficulty. Dove's flow of work was once again

fig. 122 ARTHUR DOVE
Sun on the Water, *1929*
oil on canvas
private collection
EXHIBITED AT THE INTIMATE GALLERY, 1929

interrupted when he returned to his birthplace, Geneva, New York, in 1933 after the death of his mother. Trying to salvage something of the family holdings, he spent five financially unrewarding years of hard and fruitless labor there, before finally returning to Long Island in 1938, to a small house in Centerport, on the water he had always loved. No sooner had he returned, however, than he was felled by debilitating illness. For the rest of his life, his activity was severely restricted. He could now do little except paint. By a terrible irony, only through illness had he found, finally, the independence he had long sought, the freedom to devote himself solely to his art.[50]

Yet through all this Dove the artist prevailed and the last ten years of his life, through 1946, were his most productive. He was a better artist at the end than he had been early on, and in his last five years he made his best paintings. His course, however, was not always consistent. His art became increasingly abstract in the 1930s, but he still made overtly figurative paintings that sometimes reverted to the illustrational, a chronic habit that sometimes undermined his work. Nor did he ever entirely relinquish the dynamic drawing and biomorphic shapes that owed so

much to Kandinsky and that had long marked his art, for they had accounted for too much good art to let them go. Yet after 1929, as it was always, finding the simple motif and eliminating the nonessential was his overriding concern. In the course of the 1930s, while his surfaces remained brushed and painterly, his motifs, most often the sun and moon, increasingly became single large shapes, focused at center. He searched for forms ever more "real in themselves" [51] that exist "as something decidedly itself" while he "decided to let go of everything and just try to make oil paint beautiful in itself with no further wish." [52] Thus, as in the 1936 *Sunrise* series (pl. 161), the sun retains it natural reference, but becomes a single, dominant abstract shape, filling the canvas, emblematic of his search for a "more close up thing in the paintings."[53] The sense of the sun bursting forth in these paintings once more recalled certain of Stieglitz's *Equivalents* of 1929 (NGA 1949.3.1017) and the grandeur of a 1923 *Song of the Sky* (NGA 1949.3.849), but Dove's use of the sun as a single shape was entirely his own solution. His art of the early 1930s, done in and around Geneva, in the verdant farmland of upstate New York, has a new sense of being close to the earth and thus often parallels the mood and look of Stieglitz's photographs at Lake George done at this time. In at least one contemporary series, of poplar trees in 1929, Stieglitz seems to have had Dove in mind, for the close-up view of the branches recalls the similar composition found in Dove's collage *Rain* (pl. 108) of 1924, then owned by O'Keeffe.

By the late 1930s, the drive to the abstract had found new inspiration. In June 1939, although still recovering from illness, he was well enough to renew his painting. He reported to Stieglitz that his work was "going fine," and added, tellingly: "Am getting some new directions, so we think."[54] He had seen the abstract art of Piet Mondrian, Jean Hélion, and Naum Gabo, and discovered anew the later geometric work of Wassily Kandinsky and Paul Klee. After 1939, the influence of the new abstraction was evident in Dove's art in two types of paintings. In *Brothers # 1 and #2*, of 1941 and 1942 (pl. 165), and *Structure* (Collection Curtis Galleries, Minneapolis) and *Square on the Pond*, 1942 (pl. 162), the dominant shape is the centered diamond, single or paired, and although distilled from the architecture across the pond where Dove lived in Centerport, clearly derived from Mondrian's diamond paintings. Mondrian's paintings were well known in America since 1926, when Stieglitz himself discovered them in the seminal exhibition held by the Société Anonyme at the Brooklyn Museum, and incorporated the diamond shape in an *Equivalent* from Lake George (NGA 1949.3.978) and another, *From "Room 303"—(Intimate Gallery)—N.Y.*, both of 1927.[55] These works may well have been the first overt use of Mondrian's format and compositions in American art, a vital development in our art, and another instance of how photography and painting intermixed and enriched one

162 ARTHUR DOVE
Square on the Pond, *1942*
EXHIBITED AT AN AMERICAN PLACE,
1942

another in the work of the two men. Or, in paintings such as *Shapes*, 1940–1941 (Phillips Collection, Washington), and *Dancing Willows*, 1943 (Museum of Fine Arts, Boston, Gift of the William H. Lane Foundation), Dove employed intersecting circles and parabolas whose curvatures offer a dramatic pictorial contrast to the stark geometry of the diamond. Both, however, were evidence of Dove's directives to himself to get "a single event rather than to make an arrangement of many,"[56] or to seek "straight scientific painting."[57] His quest, late in life, to continue to explore the possibilities of his chosen medium cannot help but recall Stieglitz's pioneering explorations of his medium, both in technique and expression, almost a half century earlier.

On 20 August 1942, Dove noted in his journal that his work was "at the point where abstraction and reality meet."[58] It was an apt observation, and it well forecasts the essential character of *That Red One* of 1944, the summation of his life and art. It is a transcendent painting, a sunrise seen between two trees, across the millpond from his small house in Centerport where he lived out his days. The sun is seen as the generative force. The theme can be taken as the conclusion of a long tradition rooted in American luminism and in symbolism, which reaches back to the sun paintings of Van Gogh, an artist he deeply admired, and in the twentieth century includes the sun paintings of Marin, Oscar Bluemner, and O'Keeffe, as well as the images of sun, clouds, and skies of Stieglitz. The painting is a summation of the modern tradition, from impressionism to purism, while also forecasting later developments in the work of artists such as Rothko, Motherwell, David Smith, and Kenneth Noland. It is a thoroughly modern, up-to-date painting, filled with rich possibilities and refuting any notion that Stieglitz and his circle were old hat.

It is large, for Dove, as he experimented with a new size in his late work to heighten the impact and identification of the painting. Just as important, it has an expanded internal scale, with the shapes larger and broader, now rendered in clear, flat, separate, linear divisions, as opposed to the multiple, overlapping shapes of his earlier work. This gives the special clarity that Dove and Stieglitz valued, and to which Stieglitz referred in 1940 when he saw Dove's new paintings.[59] The forms are real in themselves; there are no extraneous parts. The painting is frontal, iconic, declarative. There is both the organic, in the circular sun, and the geometric, the powerful red verticals that allude to Mondrian. The means and the ends are identical; the forms and colors coincide exactly, and are simultaneously both the subject and the structure. The colors are few, bold, and intense, only the primaries and their gradated variants, painted with a special luminosity that went far beyond the earthen tones that characterized much of his earlier work. They call to mind the

unmodulated bands of color that Matisse, who had been so important to Dove early in his life, had begun to employ that same year in his late cut-outs. They indicate the color mastery Dove had reached, prompting one critic to describe his painting as "pure poetry," by which "color alone can lift up the heart."[60] It represents the point where early American modernism and the post-1945 generation of Pollock, Rothko, and Motherwell intersect.

That in these later years his art continued to grow and even flowered, despite adverse circumstances, testifies to Dove's sure sense of purpose and direction, even in the face of physical decline. Both he and Stieglitz maintained their unwavering support and commitment to an ideal, the spirit that meant all of life, by dint of sheer resolve. Their old habits of perseverance, commitment, and openness to the new, ingrained by long years of experience, never waned, and served both artists well, to the end.

163 ARTHUR DOVE
Goin' Fishin', 1925
EXHIBITED AT THE INTIMATE
GALLERY, 1926; AN AMERICAN PLACE,
1934

164 ARTHUR DOVE
Fields of Grain as Seen from Train,
1931
EXHIBITED AT AN AMERICAN PLACE,
1932 AND 1939

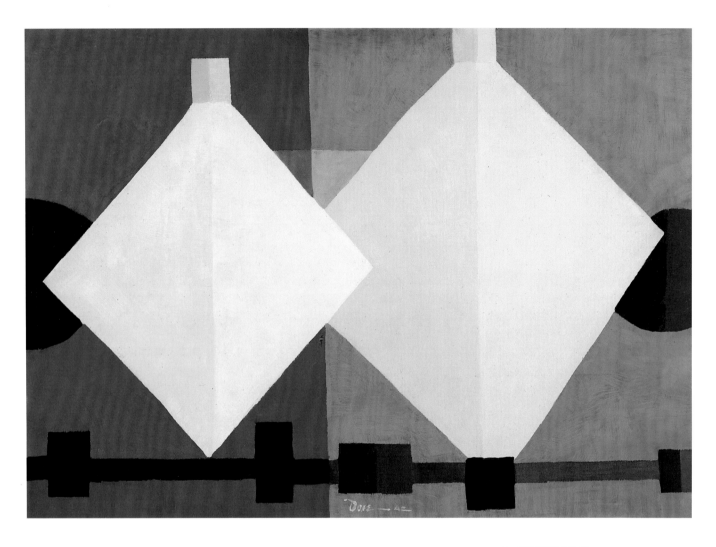

165 ARTHUR DOVE
The Brothers, *1942*
EXHIBITED AT AN AMERICAN PLACE,
1943

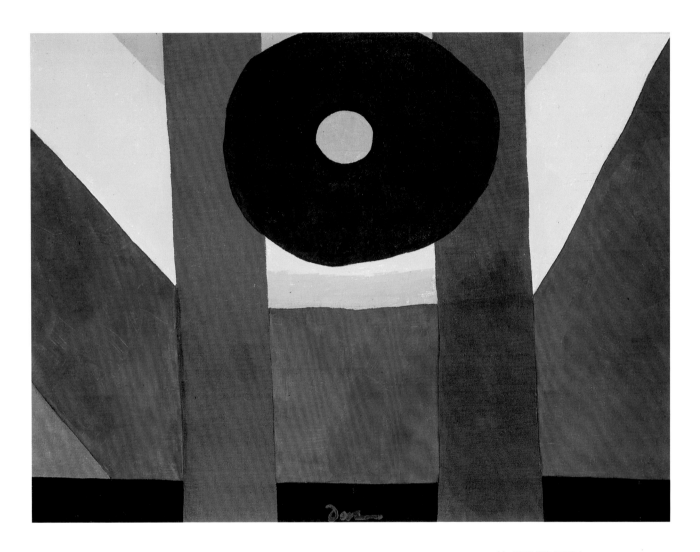

166 ARTHUR DOVE
That Red One, 1944
EXHIBITED AT AN AMERICAN PLACE,
1944

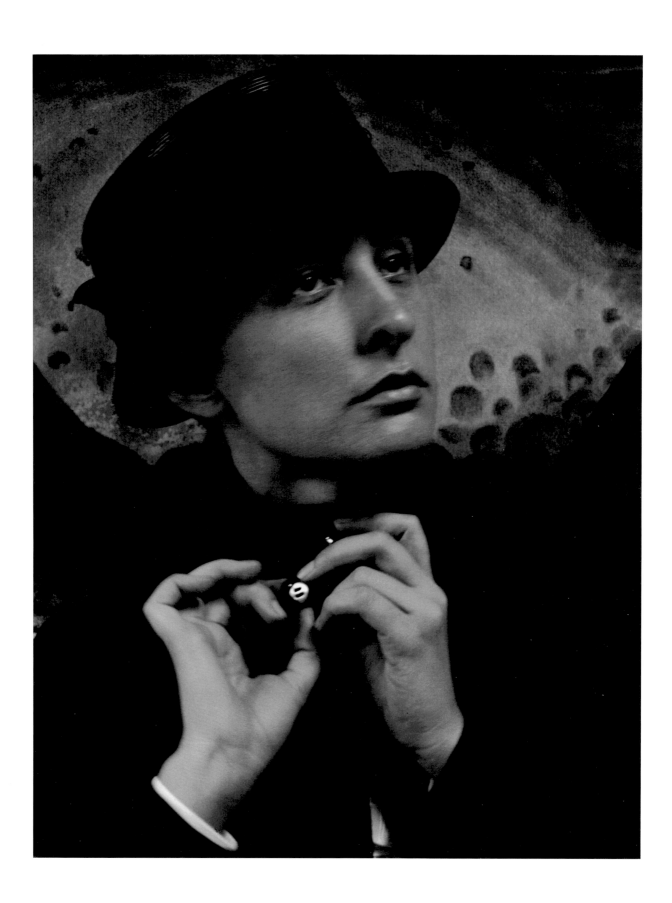

Sarah Greenough

GEORGIA O'KEEFFE

A FLIGHT TO THE SPIRIT

F ew people knew Stieglitz as well as Georgia O'Keeffe; few loved him as long; and few were as candid as she was in her assessment of his strengths and weaknesses. Toward the end of her life she wrote in her direct, plain-spoken manner, "Stieglitz was a very exciting person. His battle was principally for the American artist-photographer, sculptor, or painter. He thought the artist should be appreciated and well paid." And she continued, "he gave a flight to the spirit and a faith in their own way to more people—particularly young people—than anyone I have known." But she added, "He was either loved or hated—there wasn't much in between.... He thought aloud and his opinions about anything in the morning might be quite different by afternoon.... There was such a power when he spoke— people seemed to believe what he said, even when they knew it wasn't the truth. He molded his hearer.... If they crossed him in any way, his power to destroy was as destructive as his power to build—the extremes went together. I have experienced both and survived, but I think I only crossed him when I had to—to survive." And she concluded, "There was a constant grinding like the ocean. It was as if something hot, dark, and destructive was hitched to the highest, brightest star."[1]

During their long relationship, O'Keeffe crossed Stieglitz only a few times, yet those incidents left an indelible mark on her art and the trajectory of her career. In their early years together their work evidenced a rich communion as they fed on each other's art and love, appropriating bits of style, approach, methodology, and subject matter, and each provoked profound and lasting changes in the other's work. But their relationship as artist and impresario was less closely synchronized, occasionally

167 ALFRED STIEGLITZ
Georgia O'Keeffe: A Portrait—
Head, *1918*
PROBABLY EXHIBITED AT THE
ANDERSON GALLERIES, 1921
AND 1923

fraught with conflicting motives, and compromised, at least initially, by their fundamentally different interpretations of the nature, importance, meaning, and place of O'Keeffe's art within both the Stieglitz circle and the larger artistic community. Both were highly ambitious and O'Keeffe was as driven to prove the merits of her art as Stieglitz was to reveal them, but because each assessed those merits differently, they often worked at cross purposes. In time, like many couples, they began to think more alike and thus learned to act more in concert. But, especially when they first met, they were often out of kilter because they were from different worlds with different generational outlooks and intellectual preconceptions. Stieglitz was a product of a late nineteenth-century New York-European intellectual milieu: educated on Goethe and Spencer, steeped in Freud and Bergson, and nurtured on Rubens and Franz von Stuck, Stieglitz conceived of and spoke about O'Keeffe's art in a manner and in terms that the younger, more modern, open, frank, highly astute and well read but less verbal, and seemingly less cosmopolitan O'Keeffe would never use. From their earliest encounters, Stieglitz made his understanding of O'Keeffe's work clear: by describing her as "the Great Child" or "the child of nature," he linked her art with that of the children and Africans whose work he had previously celebrated at 291 for its direct expression of emotions not vision, and for its revelations of the subconscious not conscious mind; by noting in *Camera Work* that " '291' had never before seen a woman express herself so frankly on paper," he located her powers of self-expression, which he saw as her important contribution to modern art, firmly within her expression of her sexuality; and by describing her art, again in *Camera Work*, as "of intense interest from a psycho-analytical point of view" he invited critics and others to discuss it in this light.[2] O'Keeffe's own agenda was more direct: she wanted to clarify her experiences through her art and to express those things for which she had no words; or, as she told her friend Anita Pollitzer in 1915, using the analogy often voiced at the time, she wanted to depict "a feeling like wonderful music gives me."[3]

As Barbara Lynes has demonstrated, these differences were dramatically revealed in the early 1920s when Stieglitz presented O'Keeffe to the New York art world through a series of exhibitions that were, if nothing else, unorthodox.[4] First, in 1921 he mounted an exhibition of 145 of his own photographs. While much of the show was devoted to portraiture, almost a third of the exhibited works depicted O'Keeffe, often in nude studies. Stieglitz did not identify O'Keeffe in the titles but instead grouped all of his photographs of her into a section called *A Demonstration of Portraiture*, with smaller subunits of *Hands*, *Hands and Breasts*, *Torso*, and *A Woman* (pls. 91, 115, 117, and 118). His understanding of O'Keeffe as a woman, as expressed in these photographs, was obvious: part child, part seductress, she was a being of

168 GEORGIA O'KEEFFE
Red & Orange Streak/Streak,
1919
EXHIBITED AT THE ANDERSON
GALLERIES, 1923

MODERN ART AND AMERICA

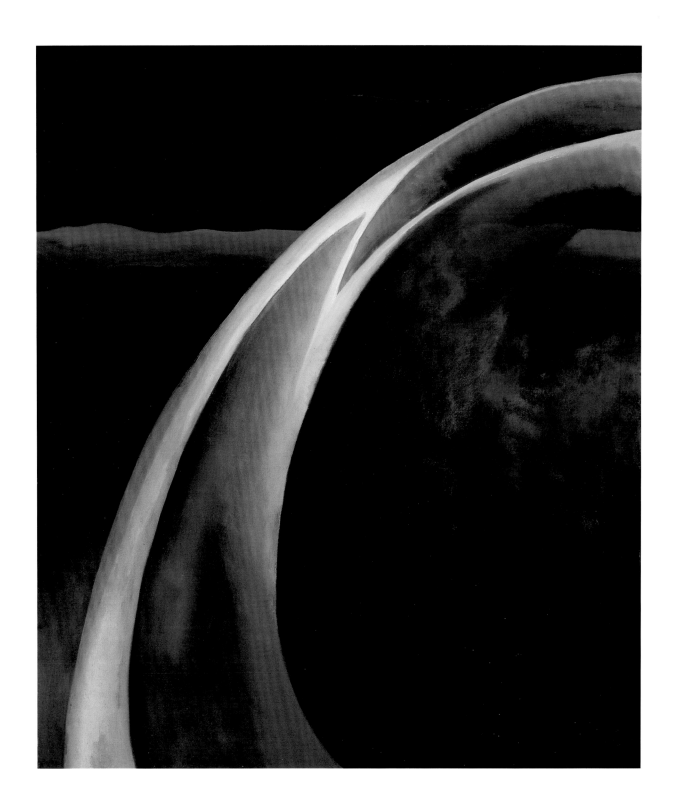

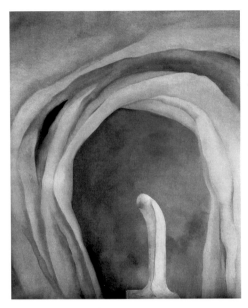

fig. 123 ALFRED STIEGLITZ
Georgia O'Keeffe: A Portrait—Painting and
Sculpture, *1919*
palladium print
National Gallery of Art, Washington, Alfred Stieglitz
Collection

immense beauty, often fiery energy, and intense passion and sexuality: she was, in short, the *Woman Supreme* whom Stieglitz had glimpsed in Rodin's drawings (see page 77).[5] Stieglitz's view of O'Keeffe as an artist was also revealed. Through his depictions of her seated on the ground next to her watercolor box and paper, he presented her as a youthful, almost childlike artist whose inspiration was derived directly from nature. Through his presentations of her hands delicately hovering above her fragile charcoal drawings, he emphasized that hers was a physical, tactile art, deriving far more from her senses than her intellect, and that it was fundamentally about physical and emotional sensations, not intellectual conceits. And, through his photographs where her hands become almost one with her drawings, he revealed that hers was an art that directly expressed her physical self, and therefore, in his mind, her sexual being (pl. 115).

In addition to the studies of O'Keeffe's face and body, Stieglitz included two *Interpretations* within his *Demonstration of Portraiture*, one of which, a photograph that has come to be called *Georgia O'Keeffe: A Portrait—Painting and Sculpture*, further clarifies his interpretation of O'Keeffe's art and reveals how far removed it was from her own intentions (fig. 123). Stieglitz photographed two works by O'Keeffe whose meaning she had clearly articulated. Intrigued by "the idea that music could be translated into something for the eye," O'Keeffe in 1918 and 1919 made a series of paintings, including *Music—Pink and Blue No. 1*, which sought to make music visible (pl. 169).[6] With its gently arching curve covered with undulating and overlapping forms and its large central blue area, *Music—Pink and Blue No. 1* gives the impression of a sound that is slowly rising up to envelop its surroundings.[7] The sculpture *Abstraction*, 1916, made shortly after O'Keeffe's mother's death, is a hooded *memento mori* figure. By placing the sculpture directly beneath the arching void in *Music—Pink and Blue No. 1* Stieglitz dramatically changed the meanings of both works. Just as he had done earlier when he constructed and photographed a temporary installation of a drawing and *papier collé* by Picasso, paired with an African reliquary figure and a wasps' nest, or when he positioned and photographed Duchamp's *Fountain* in front of Hartley's *Warriors*, Stieglitz appropriated O'Keeffe's art and transformed it to express his own idea that the source, nature, and importance of O'Keeffe's art lay in her expression of her sexuality.[8]

Described as a "revelation of the ultimate achievement of photography," Stieglitz's 1921 exhibition elicited a great deal of attention in the press: more than

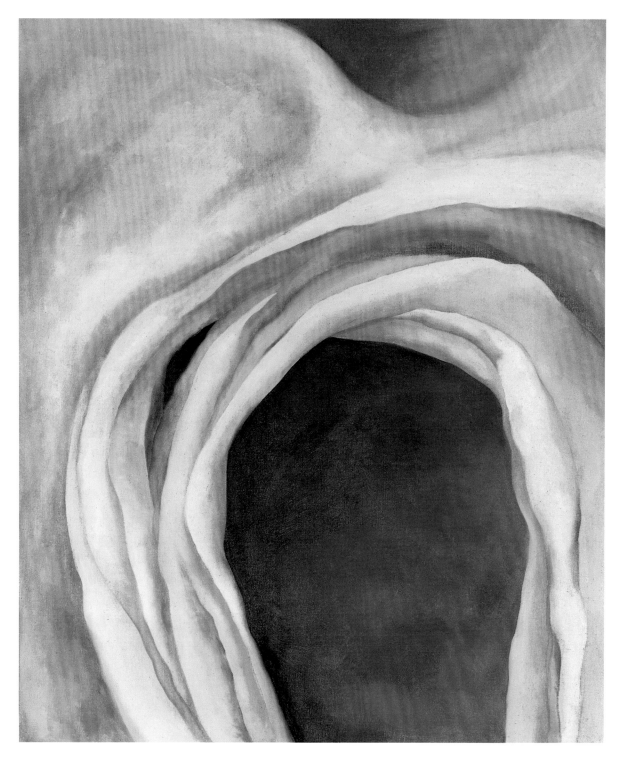

169 GEORGIA O'KEEFFE
Music—Pink and Blue No. 1, *1918*
EXHIBITED AT THE ANDERSON
GALLERIES, 1923

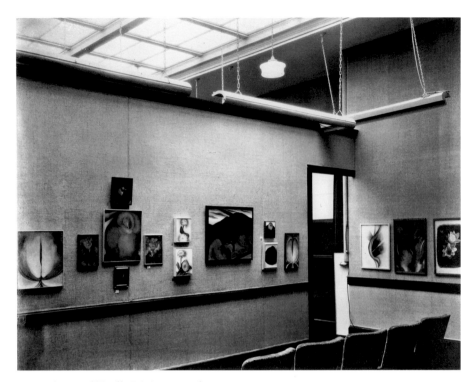

fig. 124 Georgia O'Keeffe Exhibition, *1923*
Manuscripts and Archives Division, The New York Public Library

8,000 people saw it in the seven days it was on view and, as one critic noted, "never was there such a hubbub about a one-man show."[9] Several reported that Stieglitz had turned down offers of $1,500 for one of the portraits of O'Keeffe, and the critic Henry McBride announced the startling news that Stieglitz had priced one photograph of a nude at $5,000.[10] While many reviewers used the opportunity to discuss Stieglitz's life and work as a whole and to remind readers of 291's accomplishments, several commented on the portraits of O'Keeffe and some admitted that viewers were "plainly shocked" by their frank revelations.[11] Suggesting that he had created other, even more audacious works, Stieglitz provocatively claimed in the exhibition brochure that he had omitted some works because "the general public is not quite ready to receive them."[12] Thus, although he had coyly not named O'Keeffe in his titles, as a result of this exhibition she became, as McBride later noted, "a newspaper personality" long before her work as an artist was widely known.[13]

The next exhibition in this series, *Alfred Stieglitz Presents One Hundred Pictures, Oils, Watercolors, Pastels, Drawings By Georgia O'Keeffe, American,* opened at the Anderson Galleries on 29 January 1923 (fig. 124). Including ninety works never before exhibited, the show consisted not only of abstractions derived from her memories of Texas and her experiences with Stieglitz, but also many still lifes and studies of

the landscape around Stieglitz's family's summer house in Lake George, New York (pls. 102, 168, and 169). Accompanying the exhibition was a pamphlet with a statement by O'Keeffe in which she expressed both her great ambition for art but also her ambivalence about exhibitions. Asserting her desired independence from critical opinion, she wrote that she had realized it was "a stupid fool thing not to at least paint as I wanted to and say what I wanted to when I painted," regardless of whether "the wise men" think it is "Art or not Art." But she also wondered why she agreed to this exhibition "when there are so many exhibitions that it seems ridiculous for me to add to the mess." "Alfred Stieglitz," she continued, "is responsible for the present exhibition." Yet, a few lines further she reversed herself, concluding, "I guess I'm lying... if I must be honest... I am also interested in what anybody else has to say about them and also in what they don't say because that means something to me too."[14] Oddly, O'Keeffe did not stop Stieglitz from reprinting in the brochure an effusive statement from Marsden Hartley's 1921 book *Adventures in the Arts*, even though when she first read it in manuscript form she told a friend that she "wanted to lose the one for the... book when I had the only copy." Years later she remembered that she "almost wept" on reading it.[15] Riddled with sexual innuendo and Freudian interpretations of her art, Hartley provocatively described her "shameless private documents" with their "unqualified nakedness of statement."[16]

With such authoritative visual and verbal models to follow, many of the critics echoed both Hartley's and Stieglitz's assessment, as well as those that had been put forth by another Stieglitz associate, Paul Rosenfeld, in a lengthy article published in October 1922.[17] Helen Appleton Read began her review with a quote from Stieglitz proclaiming that " 'Women can only create babies, say the scientists, but I say they can produce art, and Georgia O'Keeffe is the proof of it.' " After printing excerpts from Hartley's statement, Read announced: "To me [O'Keeffe's paintings] seem to be a clear case of Freudian suppressed desires.... she sublimates herself in her art."[18] Alexander Brook noted in his review that in O'Keeffe's paintings "one does not feel the arm's length that is usual between the artist and the picture; these things of hers seem to be painted with her very body."[19] And while Herbert Seligmann, a close Stieglitz associate, partially acknowledged O'Keeffe's stated intention, he concluded his review by writing "She has made music in color issuing from the finest bodily tremor in which sound and vision are united."[20] Significantly, his comment seems to apply more aptly to Stieglitz's photograph *Georgia O'Keeffe: A Portrait—Painting and Sculpture* than it does to O'Keeffe's art.

O'Keeffe responded in several ways. Since 1919 her art had been changing, becoming less abstract and more objective; however, beginning in 1923 she consciously made its roots in the natural world far more obvious than she had in the

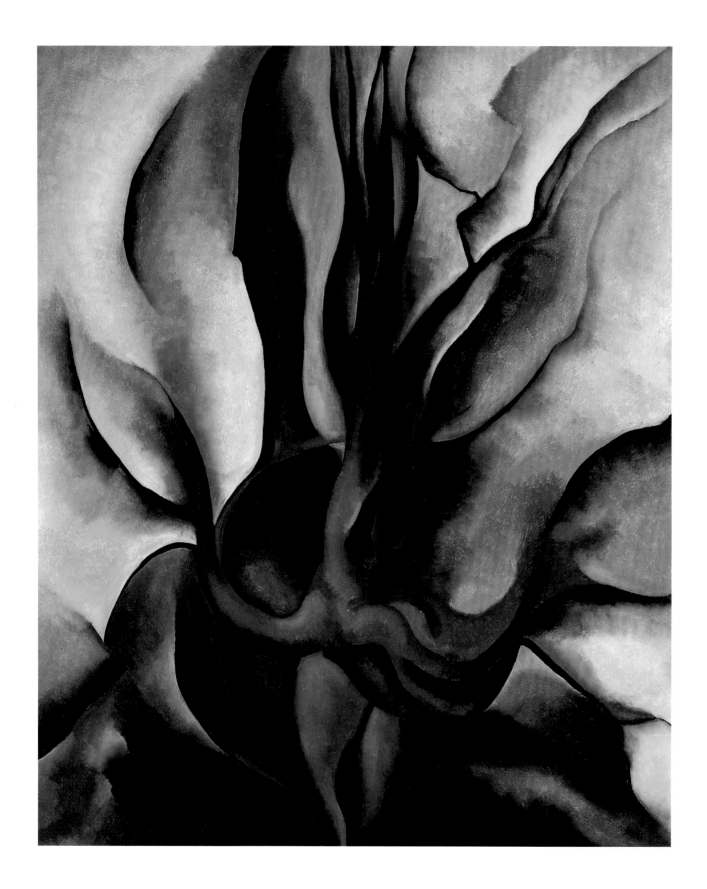

past (see, for example, pls. 170, 172, and 178). As she told the author Sherwood Anderson early in 1924, "my work this year is very much on the ground—There will be only two abstract things—or three at the most—all the rest is objective—as objective as I can make it."[21] Recognizing the power of the printed word, she also gave interviews, as Lynes has noted, shortly after the more egregious reviews were published in an effort to correct the public record.[22] Once again, she put forth the analogy to music—" 'Since I cannot sing I paint' "—but she also stressed the literalness and simpleness of her paintings, noting how many of them derived from the "little, pretty scenery" around Lake George.[23] In addition, she cultivated her friendship with the critic Henry McBride whose witty remarks amused her, and she began to assert more control over the content of her exhibition brochures: her 1924 catalogue included reviews from her 1923 show by McBride and Alan Burroughs, but contrary to the practice Stieglitz had scrupulously followed in *Camera Work*, these had been edited to exclude offending passages.[24]

But what she changed most and first was her active and open participation in Stieglitz's photographic portraits of her. She withdrew from his camera: of the 330 portraits Stieglitz made of her between 1917 and 1937, more than 190 were made from 1917 though 1922. When she did sit for him after the spring of 1923 we see a different person. Gone are the heavy eyes, the languid, seductive expressions, and in their place are depictions of a woman often with an intense gaze, a fierce, determined expression, and occasionally even an androgynous look. Whereas earlier her hair was often loose around her face, falling on her forehead and shoulders, as if she had just woken up or gotten out of bed, now it was almost always pulled back severely. And, whereas earlier she often appeared in her nightgown, a loose robe, or entirely nude, now she was always clothed, wrapped up in a heavy, dark coat, often with a hat, and, except for one time in 1932, Stieglitz never again made nude photographs of her.[25] After 1923 she did smile for Stieglitz's camera—perhaps even more so than she had before—and while it is a smile that directed warmth toward Stieglitz, it is far more an expression of self-confidence and self-satisfaction (fig. 125).

In April 1923 Stieglitz followed O'Keeffe's exhibition with a show of his own work. Including 116 photographs, most made in the last two years, it presented twenty-two portraits of O'Keeffe, a significantly smaller portion than had been shown in 1921. Although widely reviewed and generally praised, the portraits of O'Keeffe did not receive much attention; instead, Stieglitz's photographs of clouds elicited the most favorable comments. Yet, as one critic noted, the exhibition had not "evoked the antagonism of its predecessor," and he cautioned that Stieglitz had better be "careful" that he did not "become accepted as orthodox, even as a classic."[26]

170 GEORGIA O'KEEFFE
Autumn Trees—The Maple,
1924
EXHIBITED AT THE ANDERSON
GALLERIES, 1925; AN AMERICAN
PLACE, 1935

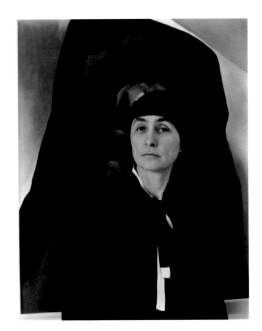

Fearful of doing anything predictable, Stieglitz, perhaps in an effort to recapture public attention, opened a joint exhibition of both his and O'Keeffe's work at the Anderson Galleries on 3 March 1924 that included fifty-nine of O'Keeffe's oils, watercolors, pastels, and drawings hung in a large room and sixty-one of his photographs installed in two smaller adjacent rooms. For her part, O'Keeffe had wanted an exhibition in 1924 not only to "clarify," as she wrote in the brochure, "some of the issues written of by the critics and spoken about by other people," but also, as she told Anderson before the show opened, to "confirm" for herself and others "what had started last year."[27]

But this exhibition was also the first time in twenty-five years that Stieglitz had mounted a show of both paintings and photographs and it was the only joint exhibition he ever shared with another artist.[28] Twice in the past he had organized photography shows to coincide with other art exhibitions elsewhere in the city—in 1913 he mounted an exhibition at 291 of his own photographs at the time of the Armory Show and in 1916 he presented Strand's photographs again at 291 at the time of the Forum Exhibition of Modern American Painting—and in both instances he had wanted to make specific comparisons between modern art and modern photography. The 1924 exhibition presented Stieglitz and O'Keeffe as an artistic couple, but it also did far more than that: Stieglitz's photographs, mainly his studies of clouds titled *Songs of the Sky*, were offered as evidence, as O'Keeffe wrote to Anderson, "proving my case." Noting that in his photographs of clouds, "he has done with the sky something similar to what I had done with color before," O'Keeffe continued, "he has done consciously something that I did mostly unconsciously—and it is amazing to see how he has done it out of the sky with the camera—."[29] To a great extent, Stieglitz wanted these photographs to be understood in the same way that he had perceived O'Keeffe's early abstractions: that is, as the embodiment of pure emotions. As further evidence of his appropriation of O'Keeffe's objective, in 1922 Stieglitz titled his early photographs of clouds *Music: A Sequence of Ten Cloud Photographs*, while those from 1923 he called *Songs of the Sky*, and in the fall of 1923 he wrote that he wanted the composer Ernest Bloch to exclaim on seeing them, "Music, music! Man, why that is Music."[30]

Most of the reviews were positive and, while Helen Appleton Read continued to insist that each of O'Keeffe's paintings was "a portrait of herself," most avoided the turgid discussions of her sexualized imagery that so dominated her reviews in

1923.[31] Voicing ideas similar to those O'Keeffe herself had explained in her letter to Anderson, several critics commented on the conscious or learned nature of Stieglitz's emotive expressions. Describing him as an "artist, scientist, and philosopher," Elizabeth Cary noted that his photographs of clouds expressed "a written philosophy" for which he "gave elaborate explanations and follows them intellectually through one state of struggling to another." Implying that O'Keeffe's compositions were simpler, she noted that they asked fewer questions and were "more satisfying" and "complete themselves in their growth."[32] Later in the year Paul Rosenfeld, in his book *The Port of New York*, contributed an effusive account of O'Keeffe's work, opening his essay by writing, "known in the body of a woman, the largeness of life greets us in color."[33] Yet, because of Stieglitz's fame and reputation, because of the clear similarities between both their art and their intentions, this joint exhibition, whether intended or not on Stieglitz's part, offered some cover to O'Keeffe and enabled her to show her work and attempt to find an audience, without being the sole object of attention. In addition, this exhibition may have suggested to Stieglitz that a group exhibition of like-minded artists pursuing a common goal could be an effective means to clarify their collective ideas and even garner greater attention, for beginning in 1925 he focused less intensely on O'Keeffe and more on the collective activities of the "Seven Americans." Thus, to a very great extent, Stieglitz and O'Keeffe's 1924 joint exhibition marked a turning point both in the critical reception of her art, but also, although less obviously at first, in their relationship as well.

In 1923 and 1924 O'Keeffe also began to gain a measure of financial independence. More than five hundred people a day were reported to have seen her 1923 show, and she sold several paintings.[34] In fact, her work sold so well and so quickly that Stieglitz raised the prices of several paintings at least three times during the course of the exhibition: one work was quadrupled from its original price of $450 to $1,800, an extremely high amount for an artist who had had so few exhibitions, and by 1927, when her reputation was more established, she had sold a painting for $6,000.[35] While Stieglitz was still conflicted about the practice of selling art, seeing it more as a reflection of the public's acceptance of the validity of his ideas than as an economic reality, O'Keeffe was more open, direct, and pragmatic in her attitude. She concluded her statement in her 1924 brochure by writing that she had decided once again to endure the critics' remarks not only because she wanted to prove them wrong, but also because "I hope someone will buy something," and, noting that she had tried to accommodate her audience, she added that she kept her pictures small because "New York space necessitated that."[36] At the same time, she admitted to a friend that the only reason she tolerated publicity, which she found embarrassing,

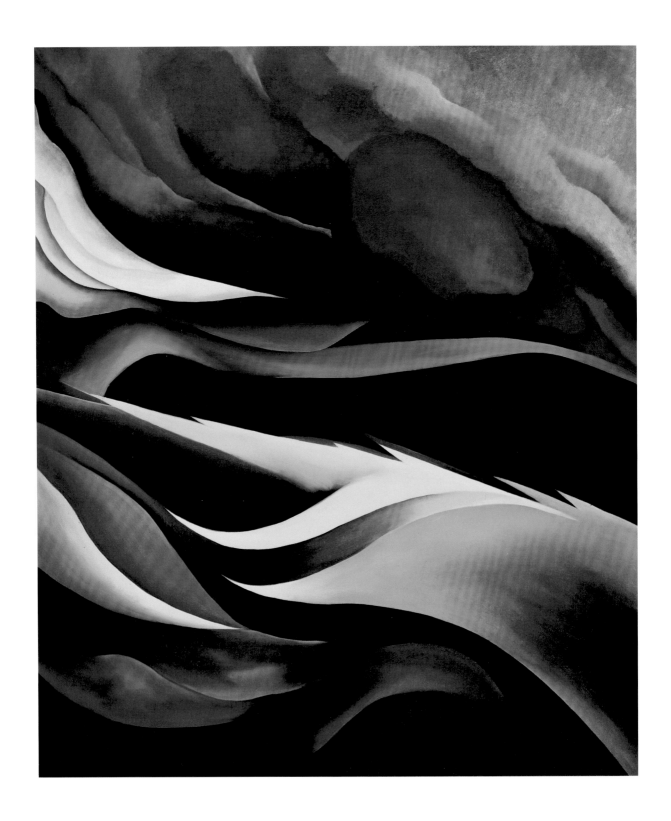

MODERN ART AND AMERICA

was because "most people buy pictures more through their ears than their eyes—one must be written about and talked about or the people who buy though their ears think your work is no good—and won't buy and one must sell to live."[37]

In March 1925 Stieglitz opened the *Seven Americans* exhibition at the Anderson Galleries, presenting work by Demuth, Dove, Hartley, Marin, O'Keeffe, Strand, and himself, and later that fall he opened the Intimate Gallery devoted to the "study of Seven Americans." Although he would remain fiercely committed to O'Keeffe's work until his death in 1946, hosting yearly exhibitions of her art at the Intimate Gallery and after 1929 at An American Place, beginning in 1925 he also actively championed Dove and Marin as archetypes of the new American art he sought to encourage. But, just as important, beginning in 1923 and 1924 he started to discuss her work as a representation not solely of a woman's art or more specifically O'Keeffe's own sexuality, but of modern American art. Her midwestern roots coupled with the fact that she had never been to Europe allowed him to promote her as the exemplar of an indigenous American modernism far more easily than he could any of the other "Seven Americans," all of whom had been to Europe, often working and studying there for several years. Despite his knowledge to the contrary and his earlier prodigious efforts to keep her informed on the latest developments in both European and American art, hers was an art, he now insisted, that had never been sullied by contact with European ideas and therefore escaped the trap of "servile imitation" that de Zayas had asserted plagued all other American modernists. Transforming the "child of nature" into the child of America, Stieglitz described O'Keeffe in the mid to late 1920s as the product of "the American soil." In 1926 Seligmann recorded a conversation at the Intimate Gallery where Stieglitz remarked, "All the world comes to America to ask 'What is American?' " Asserting that O'Keeffe was "as American as the Woolworth Tower," he declared, "Georgia O'Keeffe is American. She has never been to Europe," and emphasizing her simple heritage, he concluded, "She has lived on the plains of Texas where she taught school."[38] While Stieglitz still spoke of her work as more intuitive, less intellectual than the "men's" work, he nevertheless presented her as a coequal: "Georgia ... *is* American. So is Marin. So am I," he told Rosenfeld in 1923.[39]

Not surprisingly, many of the critics of the time echoed Stieglitz's revised assessment of O'Keeffe's art as the embodiment of the American spirit and utilized his new terminology. In his review of the 1925 *Seven Americans* exhibition, Edmund Wilson noted that "In Georgia O'Keeffe America seems definitely to have produced a woman painter comparable to her best women poets and novelists." But he, like Stieglitz, nevertheless continued to assert that "the art of women and the art of men have, as I have suggested, fundamental differences, [that] sometimes seem

171 GEORGIA O'KEEFFE
From the Lake, No. 1, *1924*
EXHIBITED AT THE ANDERSON
GALLERIES, 1925

incommensurable."[40] In the midst of exuberant praise for O'Keeffe's 1927 show at the Intimate Gallery—one critic proclaimed her as "one of the milestones of American art," while another wrote that "she paints...as no other American does"—Frances O'Brien, a friend of O'Keeffe's, put forth this new reading of the story of O'Keeffe's life, sanctioned by both Stieglitz and the artist herself.[41] Describing "a tall, slender woman, dressed in black," who paints "carefully, swiftly, surely," and "has never allowed her life to be one thing and her painting another," O'Brien wrote that "O'Keeffe is America's. Its own exclusive product." Noting that she had been born in Wisconsin and "absorbed an atmosphere untainted by theories, by cultural traditions," and that she studied with William Merritt Chase, O'Brien asserted that O'Keeffe was able to "purge herself of New York's borrowed art theories and the academic technique" so that "in her painting as in herself is the scattered soul of America come into kingdom."[42]

O'Keeffe thrived in this new, exalted position. Both part of the "Seven Americans" and separate from it because of her sex and her special relationship to Stieglitz, O'Keeffe gained a freedom and independence that others in the group never achieved. Not known for her literary skills or her oratory powers, she felt no compulsion, as did Strand for example, to clarify her ideas or to defend the other "Seven Americans" either in print or in the endless conversations that Stieglitz directed at his galleries. In the mid-1920s her art showed this newfound self-confidence, becoming bigger, bolder, and stronger. Especially in her greatly enlarged studies of flowers, she seemed at times almost to pour herself into her subjects, diving into their core to extract forms and colors of significance to her. Many of her compositions from this time are as much about color as they are about form, as she explored new combinations, creating paintings with hot pinks, yellows, and oranges, with subtle variations of blue, black, and purple, as well as ones that were almost entirely white (pls. 106, 177). As she gained confidence, she also addressed new subjects: most notably, in 1925 she started to paint New York. Although Stieglitz warned her, as she later wrote, that "it was an impossible idea—even the men hadn't done too well with it," she was not dissuaded: "From my teens on I had been told that I had crazy notions so I was accustomed to disagreement and went on with my idea of painting New York." And, she added, after one New York painting sold the first afternoon that her 1927 show was open, "no one ever objected to my painting New York after that."[43] She did not deal with the realities of city life—noise, pollution, crowded streets—but instead created a more fanciful portrait of a city mainly through a depiction of its skyscrapers. Her highly simplified, at times almost cartoonish studies of the city, motivated by her belief that "one can't paint New York as it is, but rather as it is felt," revealed a wit and whimsy unknown in her previous art:

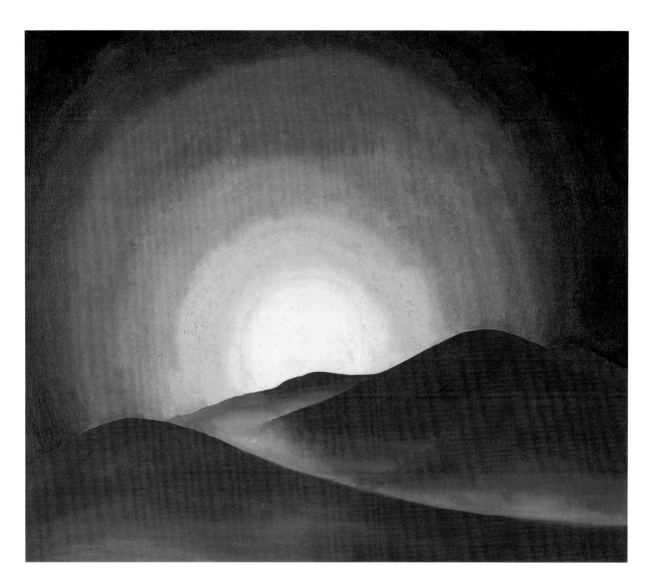

172 GEORGIA O'KEEFFE
The Red Hills with Sun, *1927*
EXHIBITED AT THE INTIMATE
GALLERY, 1928

in *The Shelton with Sunspots* the sun eats a corner out of a building and dapples the rest of her canvas with festive balloonlike sunspots; in *New York Night* a tiny car navigates the city's streets; while in *East River from the 30th Story of the Shelton Hotel* a toylike tugboat plies its harbor; and in her most celebratory painting of this series, *The Radiator Building—Night, New York*, she changed the name in the brilliant red sign in the upper left from "Scientific American" to Alfred Stieglitz (fig. 97).[44] Illuminated either by festival-like searchlights or a radiant sun, O'Keeffe's city was a magical realm, but ultimately it was the view of an outsider—a visitor or tourist—not a native New Yorker.

Yet, as O'Keeffe gained in stature, self-confidence, and independence, Stieglitz became increasingly infatuated with Dorothy Norman, a much younger woman who volunteered her time to help run the Intimate Gallery. Exasperated both with Stieglitz's behavior and his refusal to summer in any place other than Lake George, O'Keeffe went to New Mexico in April 1929. As she shed New York and embraced the brilliant light of New Mexico, her work became cleaner and sharper as she began to employ greatly simplified forms, often with overt religious symbolism. The churches, crosses, and animal skulls of the Southwest became the object of her scrutiny, as well as the underlying structure of the parched land itself (pl. 173, 174, and fig. 126). Encapsulating not only the passion and intensity of the life in the Southwest but also its ultimate mystery and impenetrable sense of otherness, the crosses, O'Keeffe believed, were essential to understanding the New Mexico experience: "Anyone who doesn't feel the crosses," she told McBride, "simply doesn't get that country."[45] Stripped of the fleshiness of her earlier work, the best of her paintings after 1929 began to be infused with a religious, iconic, and even monumental quality. Many are also charged with a curious tension. Using strong, geometric forms that were pushed to the extreme foreground and forcefully demand attention, even the more two-dimensional works, such as *Cow Skull: Red, White, and Blue* and *Black, White, and Blue*, have a suggestion of background space (fig. 126 and pl. 182). This sense of flatness and depth, of near and far, of dislocations of space and scale, of examining and knowing one thing in detail while being uncertain about its relationship to a larger whole, is something O'Keeffe would extensively explore in the 1930s and early 1940s and would yield some of her most distinguished works from this time.

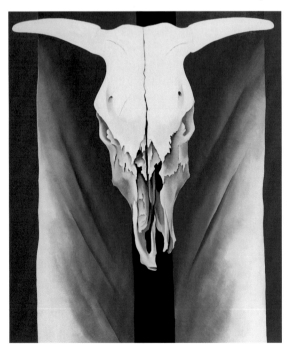

fig. 126 GEORGIA O'KEEFFE
Cow's Skull, Red, White and Blue, *1931*
oil on canvas
The Metropolitan Museum of Art, Alfred Stieglitz Collection, 1952
EXHIBITED AT AN AMERICAN PLACE, 1931–1932

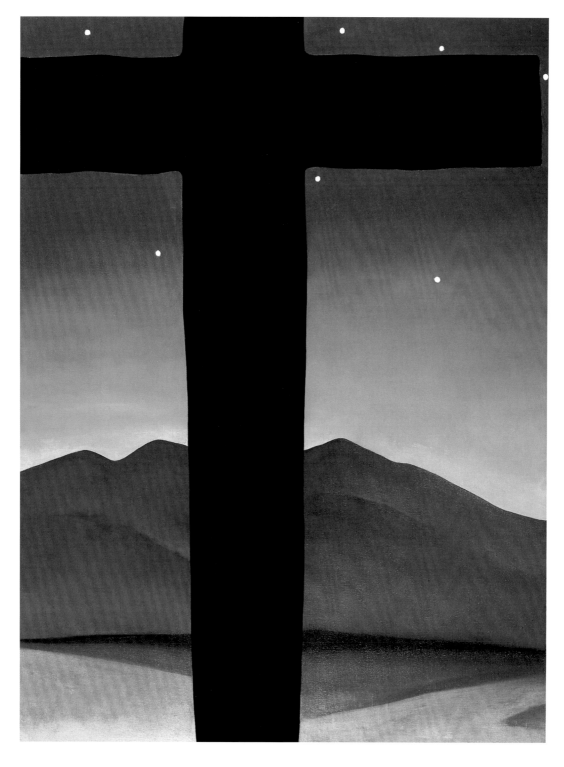

173 GEORGIA O'KEEFFE
Black Cross with Stars and Blue, *1929*
EXHIBITED AT AN AMERICAN PLACE,
1930

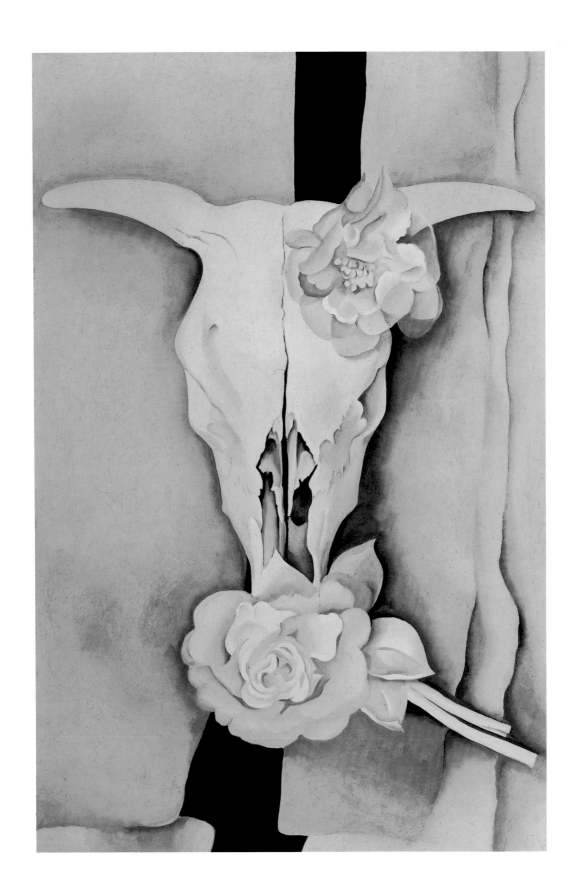

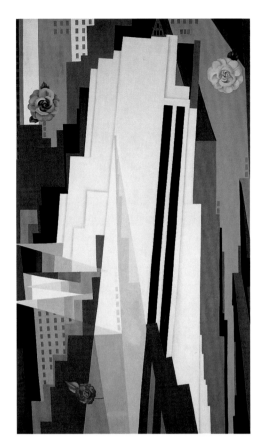

fig. 127 GEORGIA O'KEEFFE
Manhattan, 1932
oil on canvas
Smithsonian American Art Museum, Gift of the Georgia
O'Keeffe Foundation

174 GEORGIA O'KEEFFE
Cow's Skull with Calico Roses,
1931
EXHIBITED AT AN AMERICAN
PLACE, 1931–1932

In the early 1920s when she was still under the sway of Stieglitz's photographs, many of O'Keeffe's paintings were not much more than eight by ten inches, the size of most of the photographer's prints. Yet, perhaps as a result of the scale of the New Mexican landscape itself, the size of her borrowed studio spaces, or even the magnitude of her revived ambition and confidence, among O'Keeffe's paintings from New Mexico in 1929, 1930, and 1931 were some of her largest works to date. Size and scale were clearly issues of importance to O'Keeffe at this time. Although in 1923 she noted that she purposely kept her works small to accommodate New York's cramped living spaces, increasingly throughout the decade she expressed a desire to work on a larger scale, telling one friend in 1929, "I have such a desire to paint something for a particular place—and paint it *big*."[46] The opportunity presented itself in 1932. First, responding to increasing criticism that too many of the nation's public murals were being given to foreign artists such as Diego Rivera, who had recently been commissioned to paint murals for Radio City Music Hall, the Museum of Modern Art in the spring of 1932 exhibited proposals for murals by sixty-five American-born or naturalized American artists. Photographers, such as Berenice Abbott, Charles Sheeler, and Edward Steichen, and painters, such as Stuart Davis, William Gropper, Ben Shahn, and O'Keeffe, were among those who had been invited to submit sketches and a seven-by-four-foot panel. O'Keeffe's submission, *Manhattan,* was significantly different from any of her previous studies of New York: not only did it consist of numerous views of skyscrapers superimposed on each other, as if derived from a composite photograph, but, like several of her New Mexico compositions, three flowers incongruously float around the buildings (fig. 127). O'Keeffe was asked, on the basis of her submission, to paint a mural for the Ladies Room at Radio City Music Hall for $1,500, and, eager to pursue her desire to work on such a large and public scale, she accepted without consulting Stieglitz. By all accounts, he was furious.[47] For more than a dozen years Stieglitz had worked tirelessly to raise the prices of O'Keeffe's paintings to a level that he felt was commensurate with their worth, and only a few months before he had sold two of her paintings, which by the early 1930s routinely brought between $6,000 and $9,000, to the Whitney Museum of American Art.[48] And for him, Rockefeller Center represented American culture at its very worst: its greed, commercialism, materialism, and bureaucracy. Yet underneath his concerns for her

professional reputation, their relationship was also severely strained as a result of Stieglitz's continuing affair with Norman and his inclusion of several photographs of the young acolyte in his exhibition earlier that same year, as well as by O'Keeffe's long trips to the Southwest. The magnitude of Stieglitz's fury, coupled with O'Keeffe's own fears about working and possibly failing in such a public venture, ultimately proved to be too much for her to handle: as she said to a friend, "I must admit that experimenting so publicly is a bit precarious in every way," and she continued, "my kind of work is maybe a bit tender for what it has to stand up to in that kind of world."[49] Later that fall when the canvas did not properly adhere to the wall and O'Keeffe did not feel she had enough time to complete her work before the inflexible opening date, she quit.[50] By February 1933 she was admitted to Doctors Hospital in New York and treated for psychoneurosis.

O'Keeffe did not paint for more than a year and it took her much longer than that to regain the momentum she had lost. When she did, her work was cooler, more distanced, less passionate, and with its frequent inclusion of both flowers, cow skulls, and other animal bones, it alluded not only to contemporary surrealist art, but also issues of life, death, and mortality. It also took her at least a year to reestablish her

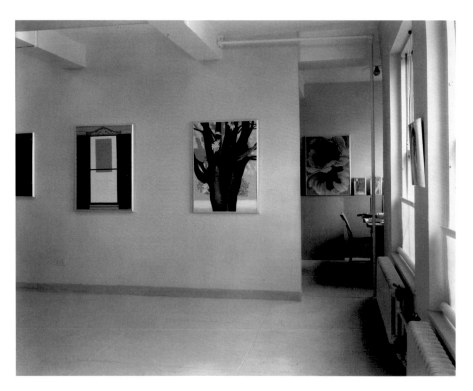

fig. 128 ALFRED STIEGLITZ
Georgia O'Keeffe: A Portrait—Exhibition at An American Place, *1930*
gelatin silver print
National Gallery of Art, Washington, Alfred Stieglitz Collection

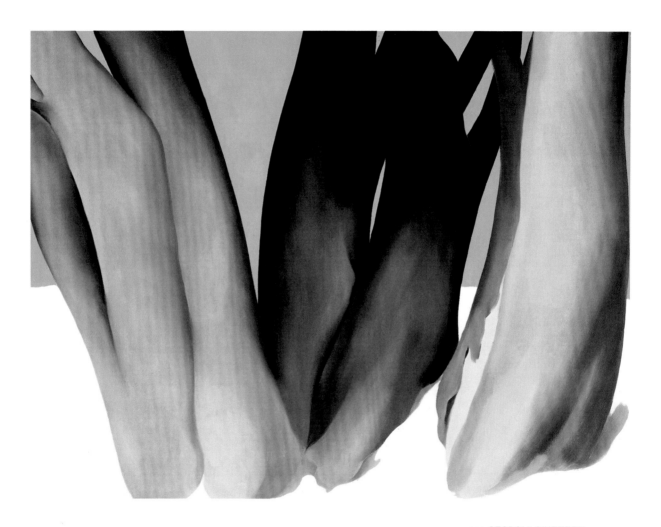

175 GEORGIA O'KEEFFE
Bare Tree Trunks with Snow, *1946*
EXHIBITED AT AN AMERICAN PLACE,
1950

relationship with Stieglitz. Severely shaken by her illness and increasingly debilitated by his own failing health, Stieglitz pulled back on his relationship with Norman who remained involved with An American Place but was careful to visit when O'Keeffe was not present. O'Keeffe, with her highly attuned sense of design and sensitivity to visual relationships, installed many of the exhibitions at An American Place, and in 1934 she resumed her practice of spending several months of each year in New Mexico. As they moved into the last phase in their relationship, both Stieglitz and O'Keeffe seemed not only to have accepted the failings and foibles of the other, but also to have learned how to live with and navigate around them. As O'Keeffe recounted to McBride in the early 1940s, "I see Alfred as an old man that I am very fond of—growing older—so that it sometimes shocks and startles me when he looks particularly pale and tired." And she continued, "Aside from my fondness for him personally I feel that he has been very important to something that has made my world for me—I like it that I can make him feel that I have hold of his hand to steady him as he goes on."[51]

While she originally was the one being helped, by the early 1940s their roles had almost reversed and she continued to lend a steadying hand to Stieglitz until his death in 1946, and in the years immediately thereafter she worked to preserve his accomplishments. Faced with the massive project of dealing with his large, unfocused collection of art and photography, she recognized the importance of making the work visible, noting that "because it is mostly contemporary work, public opinion concerning it is still being made." And in her direct, pragmatic way, she continued, "if the material is not seen, opinion is not being formed."[52] Acknowledging that "the collection does not really represent Stieglitz's taste" and that there were many things that "he did not want," she trimmed some works, most notably several paintings by Hartley, and then divided the remainder with the largest groups given to the Metropolitan Museum of Art, the Art Institute of Chicago, and, at the urging of her friend Carl Van Vechten, Fisk University, while smaller bequests were donated to the Philadelphia Museum of Art and the National Gallery of Art.[53] Stieglitz's own photographs—"to me the most important part of the Collection"—were treated as a separate unit and the "key set," consisting of the best print of every mounted photograph in his possession at the time of his death, was donated to the National Gallery. Smaller collections of his work were given to the Metropolitan Museum of Art, the Art Institute of Chicago, the Museum of Fine Arts, Boston, Fisk University, the Philadelphia Museum of Art, and the Library of Congress, and later to the Museum of Modern Art, the George Eastman house, the San Francisco Museum of Modern Art, the Phillips Collection, and, indicating her great admiration for Japanese and Chinese art, the National Museum of Modern Art, Tokyo.

In 1949 when many of the bequests from the Stieglitz estate were made, O'Keeffe wrote a long article describing the collection and explaining her decisions for its disposition. But she also used the opportunity to reflect on the role Stieglitz had played in American art for more than fifty years. While noting his many accomplishments, she singled out his commitment to "protecting the artist" as among his most important contributions to American art, specifically citing his belief "that the artist and his work is something rare among us that no one can own, that should be given to the people." The American artists whom Stieglitz nurtured and supported— Demuth, Dove, Hartley, Marin, Strand, and herself—had all experienced and benefited from "the flight" he gave to their spirits. She continued, "maybe they were good to start with. Maybe Stieglitz's interest made them better than they would have been without him. We cannot say." Yet twice in this candid article she described the "violence" of Stieglitz's arguments: "Anyone who has not witnessed these scenes cannot imagine their violence. His interests were intense and he enjoyed fighting for them." Recalling that Stieglitz loved to stage horse races when he was a child, she reflected: "I have known three of the men who were his playmates with this toy racing stable. It was obvious that he had been the leader. It was his racing stable and they played his games. This continued on through his life. He was the leader or he didn't play. It was his game and we all played along or left the game. Many left the game, but most of them returned to him occasionally, as if there existed a peculiar bond of affection that could not be broken, something unique that they did not find elsewhere."[54]

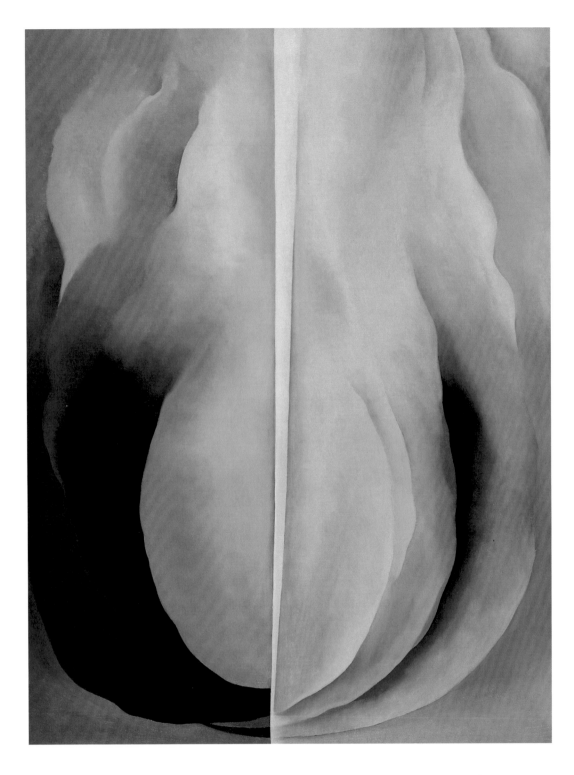

176 GEORGIA O'KEEFFE
Abstraction Blue, *1927*
EXHIBITED AT THE INTIMATE
GALLERY, 1928

177 GEORGIA O'KEEFFE
Jack-in-the-Pulpit No. IV, *1930*
EXHIBITED AT AN AMERICAN PLACE,
1931

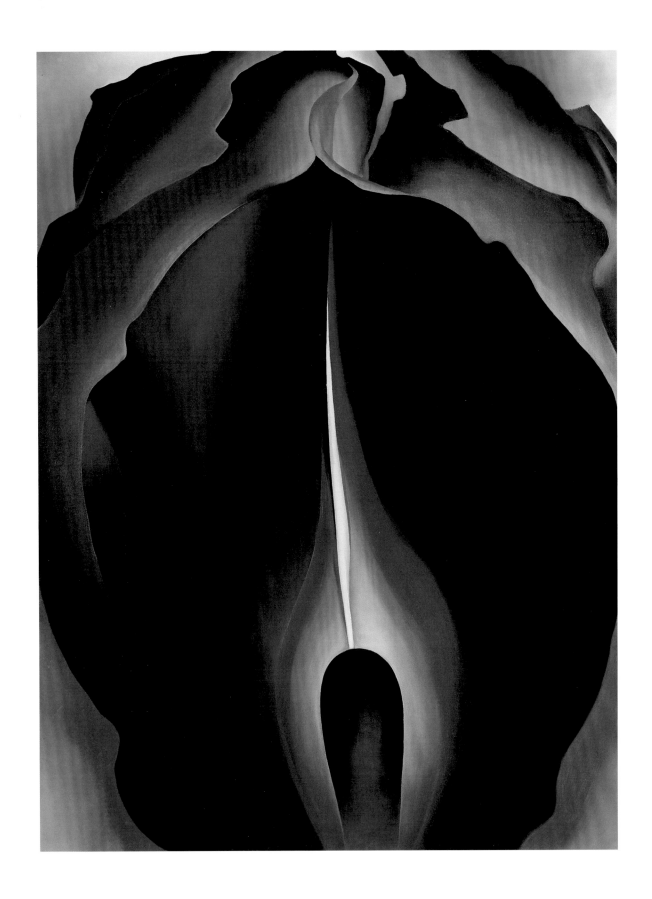

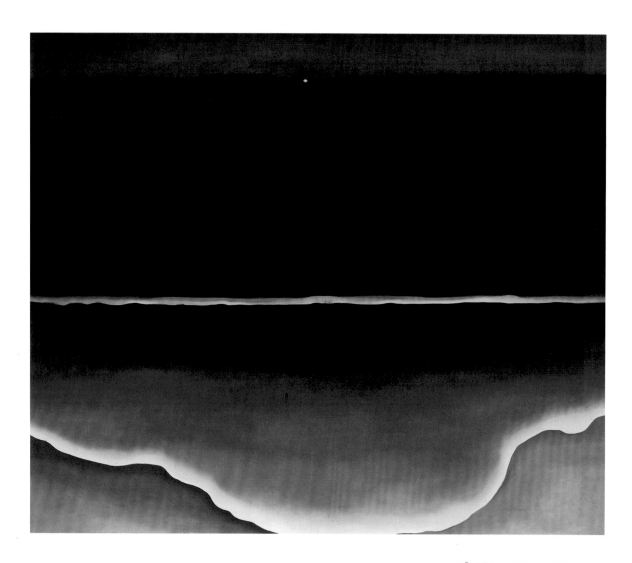

178 GEORGIA O'KEEFFE
Wave, Night, 1928
EXHIBITED AT THE INTIMATE
GALLERY, 1929; AN AMERICAN PLACE,
1935

179 GEORGIA O'KEEFFE
Black Place II, *1944*
EXHIBITED AT AN AMERICAN PLACE,
1945

MODERN ART AND AMERICA

180 GEORGIA O'KEEFFE
Farm House Window and
Door, *1929*
EXHIBITED AT AN AMERICAN
PLACE, 1930

181 ALFRED STIEGLITZ
Door to Kitchen, *1934*
EXHIBITED AT AN AMERICAN PLACE,
1935

MODERN ART AND AMERICA

183 ALFRED STIEGLITZ
Grass, *1933*
EXHIBITED AT AN AMERICAN PLACE,
1935

182 GEORGIA O'KEEFFE
Black White and Blue, *1930*
EXHIBITED AT AN AMERICAN PLACE, 1931

184 ALFRED STIEGLITZ
Hedge and Grasses, *1933*
PROBABLY EXHIBITED AT AN
AMERICAN PLACE, 1935

185 ALFRED STIEGLITZ
Lake George, *probably 1931*

186 ALFRED STIEGLITZ
House and Grape Leaves, *1934*
EXHIBITED AT AN AMERICAN PLACE, 1935

187 ALFRED STIEGLITZ
Little House, Lake George, *probably 1934*
PROBABLY EXHIBITED AT AN
AMERICAN PLACE, 1935

188 ALFRED STIEGLITZ
From My Window at An American
Place, Southwest, *1932*
PROBABLY EXHIBITED AT AN
AMERICAN PLACE, 1935

189 ALFRED STIEGLITZ
From My Window at The
Shelton—West, *1931*
EXHIBITED AT AN AMERICAN PLACE,
1932

190 ALFRED STIEGLITZ
From My Window at An American
Place, Southwest, *1932*
PROBABLY EXHIBITED AT AN
AMERICAN PLACE, 1935

191 ALFRED STIEGLITZ
New York from The Shelton, *1935*
PROBABLY EXHIBITED AT AN
AMERICAN PLACE, 1932

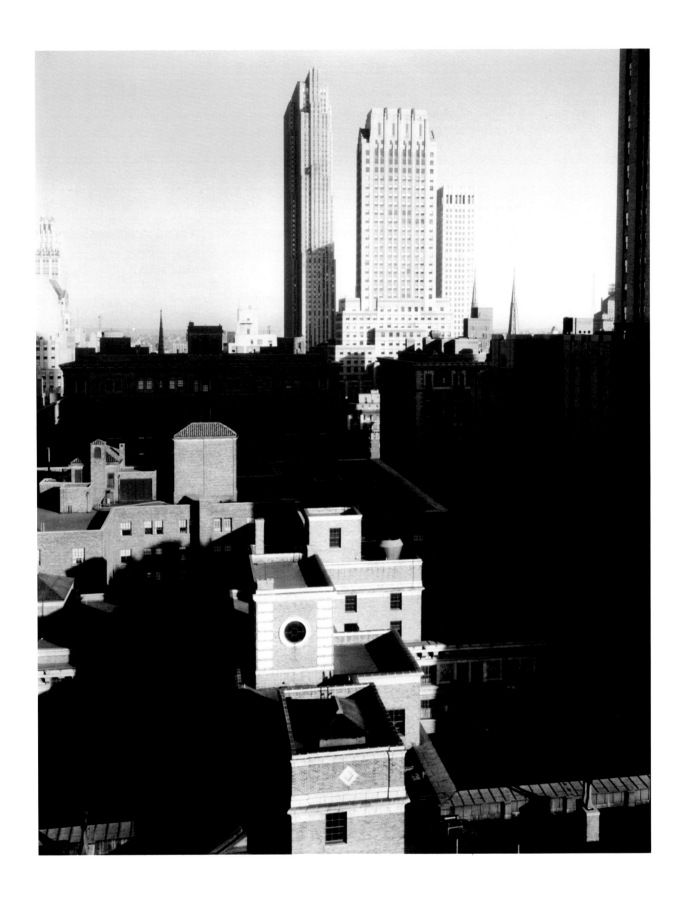

NOTES

PART I

GALLERY 291

1. Stieglitz, as quoted in "Some Remarkable Work by Very Young Artists," *The Evening Sun*, 27 April 1912, unknown page. Clipping in the Dorothy Norman Papers, CCP.

2. Stieglitz, "Conversations," typed manuscript, YCAL, as quoted in Geraldine Wojno Kiefer, "Alfred Stieglitz, *Camera Work*, and Cultural Nationalism," *Art Criticism* 7 (1992), 3.

3. In 1912 de Zayas made a portrait of Stieglitz reproduced in *Camera Work* 38 (April 1912) as *L'Accoucher d'Idées*, or *The Midwife of Ideas*.

4. Stieglitz, "The Photo-Secession," *Bausch and Lomb Lens Souvenir*, Rochester, 1903, 3.

5. In January and February 1902, members of the Camera Club of New York who disapproved of Stieglitz's management of the organization's journal, *Camera Notes*, were elected officers, forcing Stieglitz to resign as editor in July. In addition, the committee for the 1901 Philadelphia Photographic Salon, appointed by the Photographic Society of Philadelphia, was composed almost entirely of photographers who were opposed to the symbolist-inspired artistic work that Stieglitz and his colleagues had championed in earlier salons. Finally, in 1900 Stieglitz had seen his own leadership of American photography questioned with F. Holland Day's successful exhibition of the "New School of American Photography," in London and Paris. For further discussion, see William Inness Homer, *Alfred Stieglitz and the Photo-Secession*, Boston, 1983; and Sarah Greenough, "Alfred Stieglitz and the Opponents of the Photo-Secession," *New Mexico Studies in the Fine Arts* 2 (1977), 13–19.

6. Stieglitz, "Modern Pictorial Photography," *The Century* 44 (October 1902), 825, and Stieglitz, *Souvenir*, 1903, 3.

7. See Stieglitz, "The Photo-Secession at the National Arts Club, New York," *Photograms of the Year 1902*, London, 1902, 20.

8. Stieglitz, "The Photo-Secession," *Camera Work* 3 (July 1903), unpaginated. At least initially, Stieglitz believed that some of the "other interested" individuals might include "patrons" of pictorial photographers. See John Aspinwall to Stieglitz, 16 January 1902, YCAL.

9. Throughout the late 1880s and 1890s, Stieglitz had effectively used his published writings as a way of establishing a position of leadership within the photographic community. See Richard Whelan, ed., *Stieglitz on Photography: His Selected Essays and Writings*, Millerton, N.Y., 2000.

10. Stieglitz, *Prospectus for Camera Work*, New York, 25 August 1902, unpaginated, and Stieglitz, with Joseph T. Keiley, Dallett Fuguet, and John F. Strauss, "An Apology," *Camera Work* 1 (January 1903), 15–16.

11. For further discussion, see Greenough 1977, 13–19, and Gillian Greenhill Hannum, "Photographic Politics: The First American Photographic Salon and the Stieglitz Response," *History of Photography* 14 (July–September 1990), 285–295. Stieglitz frequently described projects that he disapproved of and felt received undue attentions as "noisy." He told Dorothy Norman that Curtis Bell's First American Photographic Salon was a "noisy project for popularizing the 'art' side of photography." "Four Happenings," *Twice A Year* 8–9 (spring–summer and fall–winter, 1942), 119. He would later describe the Armory Show in similar language.

12. Stieglitz, [Letter to the Members of the Photo-Secession], *Photo-Era* 15 (October 1905), 147. As it was defined in 1905, the Council of the Photo-Secession included Eugene, Käsebier, Keiley, Steichen, Stieglitz, and White, as well as the photographers John Bullock of Pennsylvania, William Dyer, Illinois, Dallett Fuguet, New York, Eva Watson-Schutze, Pennsylvania, Edmund Stirling, Pennsylvania, and John Francis Strauss, New York. Most of the decisions regarding the early exhibitions seem to have been made by Stieglitz in consultation with Steichen and Keiley.

13. See n. 12.

14. Stieglitz, [Letter to the Members of the Photo-Secession], *Photo-Era* 15 (October 1905), 147. In 1909 Steichen reported that this commission had risen to 20 percent.

15. Stieglitz, [Letter], *Art Digest* 1 (March 1927), 20.

16. Marie Rapp Boursault, as quoted by William Innes Homer, *Alfred Stieglitz and the American Avant-Garde*, Boston, 1977, 80.

17. Richard Whelan points out that the word "little," while referring to the size of the galleries, also was a term frequently used by Arts and Crafts artists and writers, denoting "simplicity, informality, camaraderie, and exclusiveness." After 1910 there were also numerous "little theaters" and "little reviews." Whelan, *Alfred Stieglitz: A Biography*, Boston, 1995, 213. See also Frank Wertheim, *The New York Little Renaissance: Iconoclasm, Modernism and Nationalism in American Culture, 1908–1917*, New York, 1976.

18. After a little more than a year of running 291, Stieglitz wrote to Heinrich Kühn, "You should really hear how A.S. often

holds forth not only on photography but on art and social conditions in America." Stieglitz to Kühn, 17 Nov 1906, YCAL.

19. Hutchins Hapgood, *A Victorian in the Modern World*, New York, 1939, 337.

20. Caffin to Stieglitz, 1 July 1907, YCAL.

21. E. O. Beck, "Newark (Ohio) Exhibition of Pictorial Photography," *Camera Notes* 4 (April 1901), 263.

22. Stieglitz as quoted by Theodore Dreiser, "A Remarkable Art," *The Great Round World* 19 (3 May 1902), 434.

23. "Our Illustrations," *Camera Work* 32 (October 1910), 47.

24. Editors, "The Editor's Page," *Camera Work* 18 (April 1907), 37.

25. Geiger was a friend of the photographer Frank Eugene and while Steichen may have known him, Stieglitz at the time would also have been impressed by his association with Franz von Stuck. Stieglitz met MacLaughlin, who studied with Gérôme, in Paris in 1907. Stieglitz was also most likely responsible for the exhibition of eighteenth-century Japanese prints from the collection of one of the supporters of 291, F. W. Hunter. Haviland and Higgins were friends and hence his 1909 exhibition.

26. As early as the summer of 1908, Steichen urged Stieglitz not to present too many exhibitions of art other than photography. Steichen to Stieglitz, June 1908, YCAL.

27. Edward Steichen to Stieglitz, June 1908, YCAL. Steichen may also have hoped that more "understandable" art would also prove more saleable, for his letters also mention his concern for prices and his desire to convince artists to ask for lower amounts. He wrote to Stieglitz in November 1907, "I have not got the prices yet" for the Rodin drawings that would be shown at 291 in 1908 "because I want to get him worked into letting down a bit." YCAL. Several of the early shows were commercially successful: "Notes," *The Craftsman* 2 (1907), 769, reported that in the Pamela Colman Smith show "one half [of] the main collection was sold, while nearly all of the most significant magazines purchased the right for reproduction of one or several drawings."

28. Steichen to Stieglitz, December 1912, YCAL.

29. As quoted by Dorothy Norman, "From the Writings and Conversations of Alfred Stieglitz," *Twice A Year* 1 (fall–winter 1938), 81; Stieglitz, [Letter to the Editor], *The Evening Sun*, 18 December 1911, editorial page; and Picabia, "A Post Cubist's Impressions of New York," *New York Tribune*, 9 March 1913, part 2, 8. In *A Life in Photography*, New York, 1963, unpaginated, Edward Steichen wrote that he painted a "fake" Cézanne and included it in the 1911 291 exhibition to "test some of our public." He added that he "burned the fake as soon as I could get my hands on it." Subsequent scholars have debated the accuracy of this story. Penelope Niven, in *Steichen: A Biography*, New York, 1997, 248–251, accepts Steichen's account, however Grace Mayer doubted its veracity, Steichen Archive, Photography Department, Museum of Modern Art, New York.

30. Stieglitz to Sadakichi Hartmann, 22 December 1911, YCAL.

31. Marius de Zayas in *How, When, and Why Modern Art Came to America*, ed. Francis Naumann, Cambridge and London, 1996, 212–213. Naumann notes that this article, "Pablo Picasso," *Camera Work* 34–35 (April–July 1911), 65–67, was originally published in May 1911 in *América: Revista mensual illustrada* and printed as a pamphlet and distributed during the Picasso exhibition at 291.

32. Stieglitz to Hartmann, 22 December 1911, YCAL.

33. Stieglitz as quoted in the *New York Sun*, 3 March 1913, reprinted in *Camera Work* 42–43 (April–July 1913), 47.

34. Stieglitz to George D. Pratt, 7 December 1912; and Stieglitz to John Galsworthy, 8 October 1912, YCAL.

35. Stieglitz to Walter Zimmermann, 1 August 1910, letter published in Stieglitz, *Photo-Secessionism and Its Opponents*, New York, 1910, 10.

36. Critics of the time were often baffled by Stieglitz's manner. See Mr. Tyrrell in the *New York World*, as quoted in *Camera Work* 33 (January 1911), 48, who affectionately described him as "a pleasing all-round paradox," while O'Keeffe in *Georgia O'Keeffe: A Portrait by Alfred Stieglitz*, New York, 1978, and reprinted 1997, unpaginated, remembered that when she was a student in New York in 1908 and visited 291, fellow students purposely baited Stieglitz, "they wanted to 'get him going,'" because they heard he was "a great talker." When they left, she reported they seemed "soundly whipped—but they were very proud of a few things they had been able to say."

37. "Henri Matisse at the Little Galleries," *Camera Work* 23 (July 1908), 10.

38. Haviland, "Photo-Secession Notes," *Camera Work* 38 (April 1912), 36.

39. Stieglitz to John Aspinwall, 9 January 1912; Stieglitz to Arthur Jerome Eddy, 10 November 1913, YCAL.

40. Whelan 1995, 303.

41. Haviland 1912, 36. Haviland also noted that more than 4,000 people saw the Matisse exhibition during its three-week venue at 291.

42. Arthur Hoeber, in the *New York Globe*, as quoted in "Photo-Secession Notes," *Camera Work* 38 (April 1912), 45.

43. Repudiating 291's earlier commercial status, Stieglitz rechartered 291 in 1909 as an educational institution to avoid paying tariff on importing works of art less than twenty years old. The stated objective of the incorporated "Photo-Secession Exhibition Society" was "to encourage art and education [through] exhibition." It also pledged not to "engage in or be connected with business of a private or commercial nature." *The Photo-Secession Exhibition Society: Constitution and By-Laws*, New York, 1911. Paul Haviland Papers, Musée d'Orsay.

44. Jonathan Weinberg, in *Famous Artists: Essays on Ambition and Love in Modern Art*, New Haven, forthcoming, notes how

"*Camera Work* became the ultimate level playing field since, no matter what the medium or size of the work of art, in reproduction it would share the same format as the photograph."

45. Stieglitz, "Photo-Secession Notes," *Camera Work* 30 (April 1910), 54.

46. Whelan 1995, 295.

47. Stieglitz wrote to Hollie Elizabeth Wilson, 2 April 1915, YCAL, that "there is a relationship between all the numbers, running through the whole set of *Camera Work* there is a very positive idea expressed and evolved."

48. A. L. Coburn, "The Relation of Time to Art," *Camera Work* 36 (October 1911), 72, and "Plato's Dialogues: Philebus," *Camera Work* 36 (October 1911), 68. On 8 October 1912 Stieglitz wrote to John Galsworthy that Picasso was "the great force in the plastic arts," who "will bring art to its true expression." In 1911 Stieglitz made two photographs, both of which he titled *A Snapshot: Paris*, reproduced in *Camera Work* 41 (January 1913).

49. For further discussion, see Judith K. Zilczer, "The Aesthetic Struggle in America, 1913–1918: Abstract Art and Theory in the Stieglitz Circle," Ph.D. diss., University of Delaware, 1975.

50. Marius de Zayas and Paul Haviland, *A Study of the Modern Evolution of Plastic Form*, New York, 1913, 20.

51. De Zayas, "Pablo Picasso," *Camera Work* 34–35 (April–July 1911), 66.

52. Steichen, "Painting and Photography," *Camera Work* 23 (July 1908), 5.

53. Stieglitz, "Photo-Secession Notes," 1910, 54.

54. Stieglitz, as paraphrased in "The First Great 'Clinic to Revitalize Art,'" *New York American*, 26 January 1913, 5-CE, and Stieglitz to George D. Pratt, 7 December 1912, YCAL.

55. De Zayas, "Photography," *Camera Work* 41 (January 1913), 17.

56. De Zayas, "Photography and Artistic Photography," *Camera Work* 42–43 (April–July 1913), 13. See also de Zayas in *291* 7–8 (October 1915), 1.

57. De Zayas, "Photography," 1913, 17.

58. De Zayas and Haviland 1913, and de Zayas, "Photography," 1913, 17–20.

59. Charles H. Caffin, *Photography as a Fine Art*, New York, 1901, reprinted 1971, 10.

60. Stieglitz to R. Child Bayley, 15 April 1913, YCAL.

61. For further discussion of the ways in which symbolist painters used photography in a similar manner, see Dorothy Kosinski, *The Artist and the Camera: Degas to Picasso*, New Haven, 1999, 17.

62. The most notable recent publications are Kosinski 1999; Elizabeth A. Brown, "Through the Sculptor's Lens: The Photographs of Constantin Brancusi," Ph.D. diss., Columbia University, 1989; Ann Temkin and Margit Rowell, *Constantin Brancusi, 1876–1957*, Philadelphia, 1995; Marielle Tabart and Isabelle Monod-Fontaine, *Brancusi Photographer* [exh. cat.,

Musée National d'Art Moderne], Paris, 1979; Anne Baldassari, *Picasso and Photography: The Dark Mirror*, Paris and Houston, 1997; Hélène Pinet, *Les photographies de Rodin* [exh. cat., Musée Rodin], Paris, 1988. These build on earlier publications and exhibitions including Van Deren Coke's *The Painter and the Photograph*, Albuquerque, 1972; Erica Billeter, *Malerie und Photographie im Dialogue* [exh. cat., Kunsthaus Zürich], Zurich, 1977.

63. Photographs were exhibited alongside other works of art in the 1910 exhibitions of both Matisse and Cézanne's work.

64. Elizabeth A. Brown, "Brancusi's Photographic Insights," in Kosinski 1999, 272.

65. Stieglitz to W. Orison Underwood, 30 April 1914, YCAL.

66. Felix Grendon, "What Is Post-Impressionism?" *New York Times Book Review*, 12 May 1912, 294. *The New York Evening Sun*, 12 April 1912, estimated that the total attendance at 291 from November 1905 through April 1912 was 167,000 people. As quoted in Jerome Mellquist, *The Emergence of American Art*, New York, 1942, 202.

67. Herbert Seligmann, "291: A Vision Through Photography," in Waldo Frank et al., eds., *American and Alfred Stieglitz: A Collective Portrait*, New York, 1934, 105–125.

68. Stieglitz lent six Matisse drawings, his Picasso *Standing Female Nude* and his Picasso sculpture *Head of Fernande Olivier* (fig. 14 and pl. 22). He bought five Alexander Archipenko drawings; an Arthur B. Davies drawing; a Manuel Manolo sculpture; and Wassily Kandinsky's *The Garden of Love (Improvisation Number 27)* (pl. 23).

69. Stieglitz, "The First Great 'Clinic to Revitalize Art,'" 1913, 5-CE.

70. Carl Van Vechten wrote to Gertrude Stein "Matisse has reached the Montross Galleries—in other words become old-fashioned." As quoted in Donald Gallup, ed., *The Flowers of Friendship: Letters Written to Gertrude Stein*, New York, 1953, 105. Whelan 1995, 331, further notes that in February 1914 Henry McBride suggested that someone should give bus tours of the galleries exhibiting modern art, "At $1 'per' there would be millions in it for some one."

71. In 1914 Michael Brenner and Robert Coady made an arrangement with Picasso's new dealer, Daniel-Henry Kahnweiler, to be his sole American dealer thus making it difficult for Stieglitz to exhibit his work. De Zayas wrote to Stieglitz on 26 May 1914, "That Brener [sic] Galerie [sic] from what I can see is going to be a danger to modern art in America. Kahnweiler also is taking a decided attitude of commercialism and pure commercialism." As quoted in de Zayas 1996, 171.

72. Paul L. Anderson in "Development of Pictorial Photography in the United States during the Past Quarter Century," *American Photography* 8 (1914), 332, wrote that *Platinum Print* was designed "to take the place between *Camera Work* and the periodicals devoted to the less advanced photographer." For further discussion of The Little Book-shop Around the Corner and the

activities of some of the former members of the Photo-Secession, see Bonnie Yochelson, "Clarence H. White, Peaceful Warrior," in *Pictorialism into Modernism: The Clarence H. White School of Photography*, New York, 1996, 42–50.

73. See Stieglitz to de Zayas, 3 June 1914, 9 June 1914, and 7 July 1914 in de Zayas 1996, 172–175, and 182.

74. De Zayas 1996, 94.

75. De Zayas 1996, 93, and de Zayas to Stieglitz, 27 August 1915, in de Zayas 1996, 191.

76. Although in later years Stieglitz would claim that he never sold anything at 291, most exhibitions resulted in at least some sales. As de Zayas noted, "Stieglitz knew how to sell, when, and to whom. But the cases were rare and exceptions to the rule." De Zayas 1996, 82.

77. " '291' and the Modern Gallery," *Camera Work* 48 (October 1916), 64. See also de Zayas 1996, 191.

78. De Zayas 1996, 189, and " '291' and the Modern Gallery," *Camera Work* 48 (October 1916), 64.

79. De Zayas 1996, 94.

80. For further discussion, see Stephen E. Lewis, "The Modern Art Gallery and American Commodity Culture," *Modernism/modernity* 4 (September 1997), 67–91.

81. De Zayas, "Economic Laws and Art," *291* 2 (April 1915), unpaginated, and 1996, 94.

82. Stieglitz, "Four Happenings," 1942, 131.

83. This issue of *291* has been extensively analyzed by scholars. See William Camfield, "The Machinist Style of Francis Picabia," *Art Bulletin* 48 (September–December 1966), 309–322; William Innes Homer, "Picabia's *Jeune fille américaine dans l'etat de nudité* and Her Friends," *The Art Bulletin* 57 (March 1975), 110–115; William Camfield, *Francis Picabia: His Art, Life and Times*, Princeton, 1979; Willard Bohn, "The Abstract Vision of Marius de Zayas," *Art Bulletin* 62 (September 1980), 434–452; William Rozaitis, "The Joke at the Heart of Things: Francis Picabia's Machine Drawings and the Little Magazine *291*," *American Art* 8 (summer–fall 1994), 42–60; Marcia Brennan, "Alfred Stieglitz and New York Dada: Faith, Love, and the Broken Camera," *History of Photography* 21 (summer 1997), 156–161; Wanda M. Corn, *The Great American Thing: Modern Art and National Identity, 1915–1935*, Berkeley, 1999, 23, and 66.

84. Picabia, as quoted in "French Artists Spur on American Art," *New York Tribune*, 24 October 1915, part 4, 2.

85. De Zayas in *291* 5–6 (July–August 1915), unpaginated, and Picabia, "French Arts Spur on American Art." For further discussion, see Rozaitis 1994, 56–59.

86. De Zayas, "Photography and Artistic Photography," 1913, 14, and de Zayas in *291* 1915, unpaginated.

87. De Zayas in *291* 1915, unpaginated.

88. Whelan 1995, 379. In the last two seasons of 291's existence from 1915 to 1917, all the exhibitions, except one, were of work by Americans.

89. Stieglitz to O'Keeffe, 7 October 1916, as quoted in Sarah Greenough and Juan Hamilton, *Alfred Stieglitz: Photographs and Writings*, Washington, 1983 and 1999, 201.

90. Sarah Greenough and Juan Hamilton, *The Correspondence of Alfred Stieglitz and Georgia O'Keeffe, 1916–1918*, forthcoming, Stieglitz to Georgia O'Keeffe, 19 April 1917.

91. For a reproduction of O'Keeffe's plaster cast of *Abstraction*, see Barbara Buhler Lynes, *Georgia O'Keeffe: A Catalogue Raisonné*, New Haven, 1999, no. 66.

92. For the most thorough discussion of *The Fountain* see William A. Camfield, *Marcel Duchamp*, Houston, 1989.

93. Although most accounts indicate that Walkowitz obtained the drawings from "an east side settlement house," Josephine Nivison's diaries state that the drawings came from her students. See Gail Levin, *Edward Hopper: An Intimate Biography*, New York, 1995, 154.

94. Stieglitz, as quoted in "Some Remarkable Work by Very Young Artists," 1912, unknown page.

95. Jonathan Fineberg, *The Innocent Eye: Children's Art and the Modern Artist*, Princeton, 1997, 12.

96. For further discussion, see Robert Goldwater, *Primitivism in Modern Art*, New York, 1966; William Rubin, ed., *"Primitivism" in Twentieth Century Art*, New York, 1984.

97. Barbara Worwag in Jonathan Fineberg, ed., *Discovering Child Art: Essays on Childhood*, Princeton, 1998, 86.

98. Sadakichi Hartmann, "The Exhibition of Children's Drawings," *Camera Work* 39 (July 1912), 45–46. Tellingly, most of the critics were not surprised to see an exhibition of children's art at 291 and most also saw its connections to modern art. See *Camera Work* (July 1912), 45–49.

99. Stieglitz, as quoted in "Some Remarkable Work by Very Young Artists," 1912, reprinted in Dorothy Norman, *Alfred Stieglitz: An American Seer*, New York, 1973, 115.

100. Stieglitz, as quoted in "The Future Futurists," *The New York Tribune*, 31 March 1912, part 5, 4.

101. Henri Bergson, "An Extract from Bergson," *Camera Work* 36 (October 1911), 20–21; Bergson, "What is the Object of Art?" *Camera Work* 37 (January 1912), 22–26. As quoted by de Zayas and Haviland 1913, 17–18, Stieglitz, when asked to explain Marin's watercolors, compared the experience to tasting an oyster and noted that as it was impossible to describe a taste, "Neither can I explain to you in words the pleasure I get from a painting or statue. The plastic artist expresses himself through his own medium and you must study him through his medium to get at what he wished to express."

102. De Zayas, "The Sun Has Set," *Camera Work* 39 (July 1912), 20–21.

103. Marius de Zayas, "The Evolution of Form, Introduction," *Camera Work* 41 (January 1913), 45.

104. Wassily Kandinsky, "Extracts from 'The Spiritual in Art,' " *Camera Work* 39 (July 1912), 34.

105. De Zayas and Haviland 1913, 19.

106. Mr. Harrington in *The New York Herald*, as quoted by Mellquist 1942, 201.

107. See, for example, "The Skylark," by Mary Steichen, "Agee not quite nine," *Camera Work* 42–43 (April–July 1913), 14.

108. Charles Caffin in the *New York American*, as quoted in *Camera Work* 45 (January 1914), 23–24.

109. Caffin in the *New York American*, as quoted in *Camera Work* 49–50 (June 1917), 34.

110. Stieglitz and de Zayas had been discussing this exhibition since 1911, the year when Stieglitz and Weber's friendship ended. See de Zayas to Stieglitz, 21 April 1911, 7 September 1913, 26 May 1914, and Stieglitz to de Zayas, 3 June 1914, YCAL. The claim to be the first exhibition of African sculpture as art is dubious for in the spring of 1914 Robert Coady had exhibited a few African pieces at the Washington Square Gallery, but the exhibition at 291 was certainly larger and more significant.

111. De Zayas in "'291' Exhibitions: 1914–1916," *Camera Work* 48 (October 1916), 7, and *African Negro Art: Its Influence on Modern Art*, New York, 1916, and [Review], *New York Tribune*, 2 February 1918, as quoted in de Zayas 1996, 67.

112. Stieglitz to Dove, 5 November 1914, YCAL. Stieglitz made four portraits that include African art: two include a mask from the Baule or Yaure people and are of Claudia O'Keeffe, plate 120, and National Gallery, 1949.3.519; two are of O'Keeffe holding a spoon from the Guro or Bete people (fig. 156 and private collection). In addition, according to records in Marius de Zayas Archives, Seville, Stieglitz also made eight photographs of individual objects hanging in the African art show. In his manuscript for *How, When, and Why Modern Art Came to America* (de Zayas Archives), de Zayas noted that Stieglitz made ten photographs of the African art. However, one of the photographs he attributed to Stieglitz is actually signed by de Zayas on the verso and another appears to have been taken by someone other than Stieglitz, possibly Sheeler.

113. I am grateful to Juan Hamilton for sharing this information with me about O'Keeffe's assessment of the African sculptures in Stieglitz's collection. O'Keeffe painted one of Stieglitz's masks, *Mask with Golden Apple*; see Lynes 1999, no. 408.

114. Stieglitz made a few installation photographs of early shows at 291, some of which were published in *Camera Work* 14 (April 1906), 42–43. The only other installation photographs that survive were made between 1914 and 1917. Some, such as those for Brancusi or O'Keeffe, were made to send to distant artists to show them what their exhibitions looked like (pl. 35 and fig. 87). The rest, like his photograph of Duchamp's *Fountain*, were made to demonstrate a specific point.

115. Despite the extensive reviews of almost every exhibition at 291, there is no mention in the press of an exhibition that paired Picasso's work with an African reliquary. While the exhi-

bition immediately following the African art show was of work by Picasso and Braque, the pieces were from the Picabia's collection and neither of the drawings depicted in Stieglitz's photograph were in their collection. Instead, they appear to have been works Stieglitz acquired from Adolphe Basler. Stieglitz also made a photograph of a temporary installation of the African art, pairing the two spoons that are shown in pl. 42 with an additional sculpture and a comb (fig. 66). (The only extant print of this is in the Marius de Zayas Archives in Seville, Spain.)

116. It is tempting to speculate that Stieglitz might have made this photograph to send to Picasso. He had visited Picasso in his studio in 1911, knew Picasso was interested in photography, and de Zayas had recently told him of Picasso's great admiration of *The Steerage*. See de Zayas to Stieglitz, 11 June 1914, YCAL. However, no correspondence is known to exist between Stieglitz and Picasso, nor has a copy of Stieglitz's photograph surfaced in the archives at the Musée Picasso.

117. For insights into the understanding of women in art at the turn of the century, see Bram Dijkstra, *Idols of Perversity: Fantasies of Feminine Evil in Fin-de-Siecle Culture*, New York, 1986. For a discussion of Stieglitz's assessment of O'Keeffe in this regard, see Barbara Buhler Lynes, *O'Keeffe, Stieglitz and the Critics, 1916–1929*, Ann Arbor, 1989, 12–16.

118. Lynes 1989, 243.

119. In Anita Pollitzer's letter of 1 January 1916, recounting her visit to Stieglitz to show him O'Keeffe's works for the first time, the words "Finally a woman on paper" have been added in another hand.

120. Stieglitz to O'Keeffe, 19 March 1918, in Greenough and Hamilton, forthcoming, and Stieglitz to O'Keeffe, 31 March 1918, as quoted in Anita Pollitzer, *A Woman on Paper: Georgia O'Keeffe*, New York, 1988, 159.

121. Herbert Seligmann, "Georgia O'Keeffe, American," *Manuscripts* 5 (March 1923), 10.

122. Edward Steichen, *A Life in Photography*, New York, 1963, unpaginated.

123. Stieglitz, "Foreword," *The Forum Exhibition of Modern American Painters* [exh. cat., The Anderson Galleries], New York, 1916, 35.

STEICHEN

1. This essay is part of a larger study of Edward Steichen's activities in France. I would like to thank Wanda de Guébriant, Françoise Heilbrun, Guy-Patrice Dauberville, Mack Lee, and Cécile Giteau for giving me access to archival materials in their collections.

2. Among these were images of his wife and new baby, members of the Stieglitz family, and the Garden of the Gods in Colorado (shot in 1906 during his summer vacation). Steichen did,

however, sell more than half the old photographs from his one-person exhibition at 291 and also sold from his one-person painting show at the Glaezner Gallery (25 February–10 March 1905).

3. For a first-person account of the politics of the founding of this Salon, see Frantz Jourdain, *Le Salon d'Automne*, Paris, 1928, and Patrick F. Barrer, *Quand l'art du XXe siècle était conçu par des inconnus—L'Histoire du Salon d'Automne, de 1903 à nos jours*, Paris, 1992. The Salon hung pictures in single rows, not stacked; believed in mixing media (with sections for fashion, books, music, architecture, photography after 1904, cinema, and even flowers); and featured major retrospectives in addition to works by living artists.

4. Fénéon wrote to Matisse in 1907 asking to be the first to see the works Matisse had just done in Collioure and received shipments of paintings during the summer, for which he paid prices ranging from 200 francs for *A Flower* to 900 francs for *La Toilette*. Henri Matisse Archives, Paris.

5. Shchukin paid 4,000 francs for the *Red Desert* in 1908. His famous commission for *La Danse* and *La Musique*, negotiated in 1909, were for the astonishing sums of 15,000 and 12,000 francs (20,000 was finally paid). See Albert Kosténévich and Natalia Sémenova, *Matisse et la Russie*, Paris, 1993, for an excellent account of Matisse's Russian patrons.

6. Bernheim Jeune did not have a public exhibition of Matisse works during the time that Stieglitz was in Paris in 1907. He had participated in the spring in a group show of flowers and still lifes, so perhaps some works were still in the gallery. See Guy-Patrice and Michel Dauberville, *Henri Matisse chez Bernheim-Jeune*, Paris, 1997.

7. Steichen to Stieglitz [January 1908], YCAL. The show to which Steichen refers is unclear. Cassirer may have helped organize the Berlin Secession in 1907, at which Matisse showed drawings, but he only held a controversial one-person Matisse show December 1908–January 1909.

8. Cassirer was doing in Germany very much what Stieglitz was doing in New York, concentrating in the high-end impressionist market. He promoted contemporary German art such as that of Max Liebermann, while maintaining direct ties to the Paris galleries of Durand-Ruel, Bernheim Jeune, and Vollard. On Cassirer, see Peter Paret, "Bemerkungen zu den Thema: Jüdische Kunstsammler, Stifter und Kunsthändler," in *Sammler, Stifter und Museen—Kunstforderung in Deutschland im 19. und 20. Jahrhundert*, Ekkehard Mai and Peter Paret, eds., Cologne, 1993, and Christian Kennert, *Paul Cassirer und sein Kreis*, Frankfurt-am-Main, 1996.

9. Fénéon recorded that the lithographs sold for 30 francs in 1909. Matisse Archives, Paris, letter from Felix Fénéon to Matisse, 30 October 1909. The drawings, however, were more expensive, with their prices listed as 125 French francs each in the 1910 Grafton Galleries post-impressionism show (letter

from Matisse to M. Dell, 27 October 1910, Matisse Archives, Paris). Before leaving for New York on 29 February 1908, Matisse gave Steichen a drawing, probably the pen-and-ink sketch of a nude in the collection of The Museum of Modern Art. Steichen may have also been given a watercolor, because in his thank you note to Matisse he mentions that he and his wife were very happy to own "our watercolor." Steichen to Matisse, 27 February 1908, Matisse Archives, Paris.

10. Musée Municipal, Issy-les-Moulineau, *Henri Matisse: L'Atelier d'Issy, 1909–1917*, Issy, undated.

11. Steichen to Stieglitz [summer 1908], YCAL.

12. Steichen to Stieglitz [December 1912], YCAL.

13. Steichen to Stieglitz [winter 1908], YCAL.

14. Paul Haviland to Stieglitz, 2 November 1908, YCAL.

15. Paul Haviland to Stieglitz, 2 October 1909, YCAL. The surviving act, dated 18 October 1909, states that the Photo-Secession Exhibition Society "shall not engage in or be connected with business of private or commercial character," which was clearly not the actual practice. For information on art tariffs, see Ida Tarbell, *The Tariff in Our Times*, New York, 1911; John Quinn, *A Plea for Untaxed Contemporary Art*, New York, 1913; and Leonard D. Duboff, *The Deskbook of Art Law*, Washington, 1977.

16. "American Artists in Paris Divided," *New York Times*, 26 February 1908, 4.

17. MacLaughlan (1876–1938) worked in France for many years, with trips to Italy in 1904, 1905, 1908, and 1909. Even though MacLaughlan was in Paris while his show was at 291, Steichen did not organize it; he did forward a check from Stieglitz to him in Italy. William Homer says that the show was Stieglitz's idea. William Homer, *Alfred Stieglitz and the American Avant-Garde*, Boston, 1977, 310. Stieglitz could have gotten MacLaughlan's etchings (close in style to those of Joseph Pennell) from his New York dealer, Fredericks Keppel & Co., which printed an illustrated catalogue in 1908. On the New Society, see "American Artists in Paris Divided," and "American Artists found new Protective Society," *New York Herald*, 29 February 1908, and Queens Museum, *The New Society of American Painters in Paris, 1908–1912*, New York, 1986.

18. Marin's etchings received favorable press attention in 1907 and 1908, with the staid *Gazette des Beaux-Arts* reproducing a view of the *Cathedrale de Meaux* (1907) in its 1 November 1908 issue.

19. Letter dated September 1905, cited in Margaret Burke Clunie, *Daniel Putnam Brinley: The Impressionist Years*, Brunswick, Me., 1978, unpaginated. The best source on Maurer's career and his Paris years is Stacey B. Epstein, *Alfred H. Maurer: Aestheticism to Modernism* [exh. cat., Hollis Taggert Galleries], New York, 1999. I would like to thank Ms. Epstein for sharing her findings with me.

20. Steichen to Stieglitz [winter 1908], YCAL. Panels that fit the size and description of the 291 works surfaced in the 1970s

and were reproduced in Peter Pollack, *Alfred Maurer and the Fauves: The Lost Years Rediscovered* [exh.cat., Bernard Danenberg Galleries], New York, 1973, nos. 1–23. See also Epstein 1999, nos. 24–29. Maurer's larger oils from 1907 to 1914 were often even more radical in color than these thinly painted plein-air sketches of the French countryside.

21. Critics noted this diversity, but Sadikichi Hartmann praised the overall intense color of the exhibition. Paul Haviland apparently bought from the show, because a 1910 balance sheet for his 291 account lists a Marin watercolor for $95 and a Fellows painting for $25. Paul Haviland Archives, Musée d'Orsay, Paris. The Eight, led by Robert Henri, had exhibited together at the Macbeth Galleries, New York, in February 1908.

22. Stieglitz bought two landscapes and encouraged Carles' organization of exhibitions at the Pennsylvania Academy of the Fine Arts and elsewhere in the early 1920s. For a reproduction of the panel that Stieglitz bought and a discussion of Carles, Steichen, and 291, see Barbara Wolanin, *The Orchestration of Color: The Paintings of Arthur B. Carles* [exh. cat., Hollis Taggart Galleries], New York, 2000, 40–44, 49–55, pl. 4.

23. Rhoades and American sculptress Malvina Hoffman were Class of 1904 at the Brearley School in New York, and many writers say that they traveled together to Europe during Malvina's first trip, which Hoffman dates to 1910 (Malvina Hoffman, *Yesterday is Tomorrow—A Personal History*, New York, 1965). On Rhoades see *Avant-Garde Painting and Sculpture in America 1910–1925* [exh. cat., Delaware Art Museum], Wilmington, 1975.

24. Clara Steichen in her suit against Marion Beckett in 1919 for alienating her husband's affections claimed that Steichen met Beckett in 1910. "Artist's wife sues for loss of his love," *New York Times*, 5 July 1919, 11. Penelope Niven, who provides the most detailed discussion of the relationship among Beckett, Rhoades, Carles, and Steichen, puts them together at Voulangis after 1910 but is rather vague on exact dates. Niven, *Steichen—A Biography*, New York, 1997, 354–360, 468–489.

25. Steichen to Stieglitz, [December 1912], YCAL.

26. The fate of these paintings is unknown. Reproductions of Rhoades' works can be found in the Archives of American Art, Rhoades papers. Beckett showed portraits of Steichen and of her father, Charles H. Beckett, in the 1913 Armory Show; Rhoades showed one French landscape. Beckett continued to exhibit at the Modern Gallery in 1917 (portraits), Montross in 1925 (still lifes, 10–12 portraits including one of Georgia O'Keeffe), and at the Delphic Studios in 1935.

27. Craig and Duncan had met in 1904 in Berlin. Duncan rented a seashore villa in Noordwyk in order to have Craig's child, Deirdre, who was born 24 September 1906. Attending Duncan at the time of the birth was Kathleen Bruce, a young British sculptress who had had a brief romance with Steichen in 1902. Duncan must have met Steichen during his first stay in Paris, because she summoned him in 1906 to Noordwyk in an

effort to reintroduce him to Bruce. Craig arrived shortly after the birth. In a letter to Stieglitz that has been dated August 1907 but must be from October 1906, Steichen reported that he "got some fine things of Gordon Craig in Holland," which must be the full-length, boyish portrait that appeared in *Camera Work* in the April–July 1913 issue.

28. Steichen to Stieglitz [July 1908], YCAL.

29. Steichen to Craig [1909], Craig archives.

30. Stieglitz did not reveal that he was the purchaser and thanked Craig for his "great kindness in helping the good work along at '291.'" In the Stieglitz collection at the Metropolitan Museum is a portfolio of fourteen etchings published by Luigi Tassini in Florence in 1907. One of these etchings was reproduced in *Camera Work* (October 1910). I would like to thank Laura Muir for confirming this information for me.

31. Steichen to Stieglitz [late 1910], YCAL.

32. The Americans who made purchases at Vollards' before World War I included the Steins, Steichen's friend the Boston painter and photographer Sarah Sears, the Havemeyers, Frank Macomber in Boston, William Glackens (who was buying for Barnes), Agnes and Eugene Meyer, Walter Pach, the Metropolitan Museum of Art, and John Quinn. Vollard also regularly shipped his works to foreign dealers such as Cassirer and Thannhauser and to exhibitions such as the Armory Show and the Grafton Galleries post-impressionist shows.

33. Roughly equivalent to $157,000, this price was much higher than what Vollard was receiving from Morozof, Shchukin, Cassirer, and others for Cézanne oils. This suggests that Steichen was somewhat naïve in his business dealings with established dealers such as Vollard. Vollard Archives, Bibliothèque du Louvre. Most authors have dated this purchase to 1910, but the Vollard records clearly list the receipt for payment on 29 February 1912 and the shipping instructions on 12 March.

34. For a survey of Cézanne's reputation in America, see John Rewald, *Cézanne in America: Dealers, Collectors, Artists and Critics, 1891–1921*, Princeton, 1989.

35. Letter from Fénéon to Matisse (translation by the author), Matisse Archives, Paris.

36. Steichen to Stieglitz [February 1911], YCAL.

37. Steichen to Stieglitz [summer 1908], YCAL. By the end of 1908, Picasso in fact had exhibited only in group shows at Vollard (1901), Berthe Weill (1902), and the Galerie Serrurier (1905).

38. Steichen to Stieglitz [February 1911], YCAL.

39. Steichen was surrounded by proponents of "Art social" during his 1900–1902 stay in Paris. The philosophy of this movement can best be measured on the pages of *La Revue Socialiste*, in which Marius-Ary Leblond wrote articles on "Rodin social" (1900), "Art et socialisme" (1901), "L'idéal artistique du Socialisme et son état au XIX siècle" (1902), and Camille Mauclair published on "L'oeuvre social de l'art—Les Beaux-Arts"

(1901). Steichen was a friend of Mauclair and took a portrait of his wife in exchange for his writing an article for *Camera Work*.

40. Marius de Zayas and Paul B. Haviland, *A Study of the Modern Evolution of Plastic Expression*, New York, 1913, 36.

41. These works were selected by Walter Pach and Arthur Davies from Brancusi's studio, after Pach saw Brancusi's entries in the 1912 Salon des Indépendants. See the article by Ann Temkin in this catalogue and her earlier "Brancusi and his American Collectors," in *Constantin Brancusi, 1876–1957*, eds. Friedrich Teja Bach, Margit Rowell, and Ann Temkin [exh. cat., Philadelphia Museum of Art], Cambridge, Mass., 1995, 50–73.

42. Many writers on Brancusi have dated Steichen's and the Meyers' acquisitions of versions of the *Maiastra* earlier, based on a letter that Steichen wrote to Brancusi scholar Athena Tacha in 1962 in which he recalled purchasing the work in 1909–1910. His letter to Stieglitz, which can be definitively dated to 1913 after the Armory Show, clearly indicates that this was Steichen's first real social contact with Brancusi, and that Meyer could have only bought the gilded bronze version of the *Maiastra*. Steichen could similarly have purchased the polished bronze version (that he subsequently gave to his daughter Kate, now Tate Gallery, London) later, in 1913.

43. H. G. Wells, *The Future in America*, London, 1906.

RODIN

1. I would like to thank Colta Ives, Laura Muir, Clare Vincent, Ruth Butler, Barbara Hinde, Cheryl Leibold, and Kathleen McDonald for their assistance in the preparation of this essay.

2. On Rodin in America, see Ruth Butler, "Rodin and his American Collectors," in *The Documented Image: Festschrift in Honor of Elizabeth Gilmore Holt*, eds. Gabriel P. Weisberg and Laurinda S. Dixon, New York, 1987, 87-110, and Alain Beausire, *Quand Rodin exposait*, Paris, 1988.

3. Stieglitz was in Europe from 1881 to 1890, on his honeymoon in the summer of 1894 and in the summers of 1904 and 1907. Rodin's works were shown in 1883 in Munich, 1885 in Nuremberg, 1897 in Dresden, and were featured in numerous secessionist exhibitions in which Stieglitz also exhibited photographs. On Rodin's reputation and collectors in Germany, see Ernst-Gerhard Güse, "August Rodin und Deutschland," in *Auguste Rodin Zeichnungen und Aquarelle*, ed. Ernst-Gerhard Güse, Stuttgart, 1984, 13–39.

4. Although no letters between Steichen and Fuller survive and he never made her portrait, they probably met via Rodin during Steichen's 1900–1902 Paris stay. Fuller was championed by Roger Marx, who introduced her to Rodin in c. 1896–1898 and helped organize her private theatre at the 1900 World's Fair. Marx, a Jewish art critic, socialist, and founder of *La Revue blanche*, was part of a Dreyfusard circle that defended Rodin at the time of the controversy over the Balzac statue. Steichen met several members of this circle in 1901–1902.

5. Stieglitz saw the Metropolitan as the primary representative of conservative American taste and repeatedly tried to convert it through gifts and solicitations for purchases. See Malcolm Daniel, "Photography at the Metropolitan—William M. Ivins and A. Hyatt Mayor," *History of Photography* (summer 1997), 110–113.

6. The best account of Loïe Fuller's long friendship with Rodin and this exhibition is Richard Nelson Current and Marcia Ewing Current, *Loïe Fuller: Goddess of Light*, Boston, 1997. On the history of Rodin collections at the Metropolitan Museum, see Clare Vincent, "Rodin at the Metropolitan Museum of Art—A History of the Collection," *Metropolitan Museum of Art Bulletin* (spring 1981), 2–46.

7. While at the Metropolitan, the sculpture was kept in Frank Elwell's office. Elwell (1858–1922) had been a student of Falguière in Paris and served as curator of ancient and modern statuary at the museum from 1901 to 1905. Reference to Elwell's keeping four Rodins in his office (*Fauness and Nymph, A Head and Hand, Mask*, and *From the Sea*) can be found in a 28 October 1903 letter from John Simpson to Rodin. Archives, Musée Rodin, Paris.

8. Roger Fry in a letter dated 17 April 1906 described how he was rehanging Gallery 24 to include authentic works in good condition and had borrowed "two superb Rodin bronzes" from Mrs. Simpson. Denys Sutton, ed., *Letters of Roger Fry*, New York, 1972, 1:263.

9. Steichen to Stieglitz [1 November 1906], YCAL.

10. Stiechen to Stieglitz [fall 1907], YCAL.

11. Kirk Varnedoe identifies three styles of Rodin's "late drawings," which he places in the period from 1900 to 1917. Albert Elsen and Kirk Varnedoe, *The Drawings of Rodin*, New York, 1971. J. A. Schmoll gen. Eisenwerth pushes Rodin's late style back to 1897. "Rodins Späte Zeichnungen und Aquarelle," *Auguste Rodin Zeichnungen und Aquarelle* 1984, 245–248.

12. Claudie Judrin, "Les Dessins," in *Rodin et la Hollande*, Paris, 1996.

13. This exhibition was organized by the International Society of Sculptors, Painters and Gravers of London. Both drawings, *The Shades* (owned by British artists Charles Ricketts and Charles Shannon, purchased from the 1900 Carfax show) and *Rock in the Inferno* (from the collection of the Pennsylvania Academy of the Fine Arts), were 1880s works done in Rodin's "black manner."

14. Sylvia Yount and Elizabeth Johns, *To Be Modern: American Encounters with Cézanne and Company*, Philadelphia, 1996, 10, 23 n. 7. I would like to thank Cheryl Leibold for directing me to this information.

15. See Claudie Judrin, *Inventaire des dessins du Musée Rodin—Exposition, Bibliographie*, Paris, 1984–1992, 6 vols.

16. According to Otto Grautoff, by 1908 drawings were in the Musée de Luxembourg in Paris; the Folkwang Museum in Hagen (bought by Karl Osthaus, the famous modernist collector); the Berlin Museum printroom; the collections of Dr. Hermann Linde in Lübeck and the Grandduke of Sachsen-Weimar; and "English Museums and various private collectors in Berlin, Paris, London and New York." Otto Grautoff, *Auguste Rodin*, Leipzig, 1908, 92. The "English Museums" included the British Museum, which had acquired a Rodin drawing from Claude Philips in 1905. On Rodin's French collectors, see Judrin 1984–1992, 1:xlix–liii.

17. According to notes on the accession cards, *Standing Nude* (07.858) and *Cambodian Dancer* (08.187) were purchased for 375 francs each, with *Anxiété* (07.857) for 1000 francs.

18. Ross wrote "I greatly admire the drawings of Rodin I have seen" in his 1912 artists' manual, *On Drawing and Painting*, Boston, 1912, 135. The Rodin drawings were the most radically abstracted Western works that Ross had given to the museum to date: he lent in 1907 (and gave in 1909) two Degas pastel landscapes and in 1906 gave 1800 Japanese prints that had formerly been on loan. On Ross' significant presence at Boston, see Walter Muir Whitehead, *Museum of Fine Arts Boston: A Centennial History*, Cambridge, Mass., 1970, 1:134–141.

19. Rodin did not have his drawings mounted on the walls of his studio until after the move to the Hôtel Biron. According to Ruth Butler, it was his American-born mistress, the Duchess de Choiseul, who during Rodin's absence in 1911 first hung the drawings. Ruth Butler, *Rodin: The Shape of Genius*, New Haven, 1993, 464. The celebrated photographs showing unmatted drawings slipping around in their white, uniformly sized frames (thus allowing Rodin to remove and change them) thus postdate the 291 exhibitions.

20. A "black period" drawing, *À la Clodion*, formerly in Sargent's collection and bought by Grenville Winthrop in 1926, is in the Fogg Art Museum, Harvard University (1943.914).

21. This drawing is in the collection of Joanna Steichen. Steichen also received another drawing of two figures embracing (given by his daughter Kate to the Museum of Modern Art, New York in 1980) and several works from Rodin, including three bronzes (a reduced *Jean d'Aire*, one of the Burghers of Calais; *Sculptor and Muse*; and a reduction of *The Man Who Walks*). Letter of authentication from Léonce Benedite to Mrs. Clara Steichen dated 18 September 1919, in Archives, Musée Rodin. In 1908 Steichen wrote to Stieglitz that "Rodin gave me a beautiful cast— the first impression of his 'l'homme qui marche' (about three feet high)." In spring 1920 he reported to Stieglitz from Voulangis that Clara had taken his Rodin bronze, leaving only "a Rodin plaster" (identity unknown); YCAL.

22. These drawings may have been sent via Baron de Meyer in London, who had provided a letter of introduction for Käsebier to Rodin in 1905. Käsebier wrote to Rodin in late December

1906: "*You remember me!* The precious drawings are in my keeping. Words cannot express my delight. They will inspire me as long as I live." Archives, Musée Rodin.

23. It is telling that Davies borrowed Rodins from Käsebier and not from Stieglitz. Käsebier definitively ceased relations with Stieglitz in January 1912, when she resigned from the Photo-Secession. The organizers of the Armory Show seem to have wanted to keep Stieglitz largely out of the show, even though he is listed with other collectors as an "honorary vice president" and loaned Picasso and Matisse drawings and his recently acquired Picasso bronze. Exactly what Rodins Käsebier loaned is unclear. As Barbara Michaels noted, Rodin is listed in the catalogue with one bronze and seven drawings and Käsebier's name appears under the drawings. Two of the drawings were apparently sold from the show, which suggests that they weren't Käsebier's. The sculpture was the gift for which Käsebier thanked Rodin on 23 January 1913: "Today the U.S. Customs has released your beautiful, glorious gift to me and I am drunk with delight.... I would love to know what you had in mind when you made it." Archives, Musée Rodin. Barbara L. Michaels, *Gertrude Käsebier: The Photographer and Her Photographs*, New York, 1992, 176, n. 7.

24. Camille Mauclair, *Auguste Rodin: The Man, His Ideas, His Works*, London, 1905; French edition, *Rodin et son oeuvre*, 1900, chap. 4.

25. Léon Maillard, *Auguste Rodin statuaire*, Paris, 1899, 92.

26. Gustave Coquiot, "Rodin-Ses dessins en couleurs," in *La Plume—Rodin et son oeuvre*, Paris, 1900, 8–9.

27. Mauclair 1905, 98.

28. Claudie Judrin, "Rodin's 'Scandalous' Drawings," in *Rodin—Eros and Creativity*, eds. Rainer Crone and Siegfried Salzmann, Munich, 1992, 146–147.

29. Accounts of this scandal that vary in their details appear in Judrin 1992; Güse 1984, 28–31; and Kessler's letters to von Hoffmannsthal, *Hugo von Hofmannsthal Harry Graf Kessler Briefwechsel 1898–1929*, Frankfurt-am-Main, 1968, 114–116. On Kessler, see also Cynthia Saltzman, *Portrait of Dr. Gachet: The Story of a Van Gogh Masterpiece*, New York, 1998, chap. 14.

30. Arthur Symons, "Les dessins de Rodin," in *La Plume* 1900, 47.

31. Arthur Symons, *Studies in Seven Arts*, 2d ed., New York, 1907, 19.

32. Receipt for purchase of six volumes of *Psychology of Sex* and *Evolution of Modesty* from F. A. Davis & Co., 17 October 1911, YCAL.

33. Much could be written about the sexual insecurities of members of the Stieglitz circle which inspired their fascination with the new literature on human sexuality. Richard Whelan, in *Alfred Stieglitz: A Biography*, Boston, 1995, characterized Stieglitz as a devoted reader of Krafft-Ebing and Ellis (page 264). While Ellis' study included extensive, non-judgmental discussions of

homosexuality, masturbation, and fetishism, it also was remarkable for its frank acknowledgment of women's need for sexual fulfillment. See Phyllis Grosskurth, *Havelock Ellis: A Biography*, New York, 1985, 216–235. On Gertrude and Leo Stein's interest in Weininger's *Sex and Character* (English trans., 1906) and Freud, see Brenda Wineapple, *Sister Brother: Gertrude and Leo Stein*, New York, 1996, 262–265, 316. For a general overview of the interest in sexuality that characterized the intelligentsia in the early 1900s, see Sanford Gifford, "The American Reception of Psychoanalysis, 1908–1922," in *1915, The Cultural Moment: The New Politics, the New Woman, the New Psychology, the New Art, and the New Theater in America*, eds. Adele Heller and Lois Rudnick, New Brunswick, N.J., 1991, 128–145.

34. *Phryné* and possibly other drawings from this exhibition appeared as reproductions in the 1908 German monograph by Otto Grautoff, *Auguste Rodin*. Grautoff approached Rodin in July 1907 in search of photographs for his book and stated that he had purchased 90 photos from Druet and had spoken with Steichen about doing some 10 to 20 new photographs (Archives, Musée Rodin, unpublished letter, 8-8-1907). In his book Grautoff includes two Steichen portraits of Rodin and credits him as the photographer for the drawings reproduced as plates 92–101, which he claims Rodin appreciated as successful reproductions. *Phryné* (pl. 103) bears the same title as a drawing in the 1908 show; the drawing of a kneeling nude (pl. 104) entered Stieglitz's collection and is now in The Art Institute of Chicago; the Cambodian dancer (pl. 100) was reproduced in *Camera Work* in 1911; and the earlier drawing of *Shadows Speaking to Dante* (pl. 92) was bought by Grenville Winthrop in New York in 1926 and is currently in the Fogg Art Museum. Four of the negatives Steichen took for Grautoff were subsequently used as the basis for *Camera Work* illustrations in 1911. There are probably Steichen copy prints of drawings that have not yet been identified in the Musée Rodin; his studies of Rodin sculpture have been catalogued.

35. Stieglitz to Rodin, 17 January 1907, *Correspondance de Rodin, vol. II 1900–1907*, Paris, 1986, 29, n. 3.

36. It is difficult to identify which drawings Simpson purchased in 1908. They might include *Two Figures* and *Figure Bending Forward* (part of the Simpson bequest to the National Gallery of Art, Washington). From dedications dated 7 July 1908, 11 October 1908, and 1909, one can tell that certain drawings in the National Gallery were given to Simpson during subsequent trips to Paris. In March 1909 she reminded Rodin that she was waiting for him to send the drawing that he promised as "a souvenir of our beautiful evening at Versailles" of August–September 1908. Archives, Musée Rodin, letter from Kate Simpson to Rodin.

37. John Sloan, *New York Scene*, New York, 1965, 189. Davies had been in Paris in 1895 and 1897 as a buyer for the Macbeth Gallery and was there again in 1912 to find works for the Armory Show; trips between 1897 and 1912 are undocumented. Since he

was a frequent purchaser from Stieglitz's subsequent shows, it is possible that his Rodin drawings were from this show.

38. Maurice Baud, Rodin's secretary, noted on 1 November 1908 that he had sent forty-seven drawings to Steichen for Philadelphia. Archives, Musée Rodin.

39. Agnes Meyer papers, Library of Congress, Washington. Thirty-two-year-old Eugene Meyer had already learned about Rodin from the American sculptor Gutzon Borglum, whose work he had collected and promoted in spring 1908 before Agnes went to France on 4 August. Meyer visited Rodin with her in the fall and met Steichen at that time.

40. How this show was put together is somewhat unclear. In fall 1909 Steichen wrote Stieglitz that he was writing to Trask "to send to you the Rodin drawings and I will bring along a few extra ones—A III kind also the one you wanted for yourself"; YCAL. This suggests that some of the 1910 drawings, particularly the older ones, were those already sent to Philadelphia in December 1908. Forty-one titles were listed in the catalogue, but additional drawings were included.

41. This drawing, *L'Abondonée*, acc.no.10.45.20, was only accessioned in 1910. I would like to thank Betsy Baldwin, associate archivist at the Metropolitan Museum, for providing this information.

42. Ryan, a New York businessman whose portrait bust Rodin had begun in 1909, gave three Rodin sculptures to the Met between 20 December 1909 and 20 April 1910 and donated $25,000 at some point in 1910 for Rodin purchases. See Joseph Brock, *The Metropolitan Museum of Art—The Collection of Sculptures by August Rodin*, New York, 1913.

43. Details on this purchase can be found in the Metropolitan Museum archives and the letters between Robinson and Stieglitz in the Stieglitz archives. Steichen in a letter to Stieglitz in February 1911 regarding payments to Rodin suggested: "Why don't you get Eugene Meyer or someone to buy the old drawings for the museum—$3000 for the set or even $2500." The drawings that the Met selected are a fairly mixed assortment, ranging from the rather crude studies of the face of the Japanese actress Hanoko (10.66.22) to the fairly overworked and mottled "Nero" (10.66.5). The largest and most beautiful drawing of a seated girl with grapes in her hair (10.66.7) is the "uncatalogued one no. 46" that Stieglitz refers to in a 5 April 1910 letter to Robinson. In 1913 the Met acquired additional Rodin drawings that Thomas Ryan personally selected on his November 1912 trip to Rodin's studio.

44. Haviland, who was in charge of the New York branch of his father's porcelain manufactory, paid the gallery $520 for four Rodin drawings. Paul Haviland archives, Musée d'Orsay, Paris. Haviland's father, American-born Charles Edward Haviland (1839–1921), already owned three Rodin bronzes as well as works by Cassatt, Degas, and 6000 Japanese prints. Nathalie Valiere, *Un Américain à Limoges: Charles Edward Haviland*

porcelainier (1830–1921), Tulle, 1992, and Françoise Heilbrun, "Biographie de Paul Burty Haviland (1880–1950)," in *Paul Burty Haviland (1880–1950) photographe* [exh. cat., Musée d'Orsay], Paris, 1996, 11–28.

45. Paul Haviland, "Drawings by Rodin," *Bulletin of the Metropolitan Museum of Art* (May 1910), 126–127. After the close of the 1910 Rodin show, some of the drawings stayed at 291 and were exhibited in November in a group show (with lithographs by Manet, Cézanne, Toulouse-Lautrec, and Renoir from Vollard).

46. Steichen wrote to Stieglitz that Arthur Carles, en route to New York, was "taking along the Rodin drawing the old one of the figure on horseback—It is yours, your Christmas present"; YCAL. This drawing is in The Art Institute of Chicago.

47. The Art Institute of Chicago 1949.898 (dedicated to Clara) and 1949.899; the graphite with stumpwork drawing, A.I.C. 1949.896, was reproduced in *Camera Work* (April–July 1911).

48. *Sun* (The Art Institute of Chicago, 1949.901) and *Leaving Earth* (The Art Institute of Chicago, 1949.902), both reproduced in *Camera Work*. In a letter of February 1911, Steichen tells Stieglitz that Rodin wants all of the *Sun* series back for decorations that he's making for the Luxembourg; YCAL.

49. 1949.897, *Woman with a Shawl*, reproduced in *Camera Work* in 1911; 1949.895, *Frontal Kneeling Figure*, reproduced in Grautoff, 1908; and 1949.900, *Standing Nude with Draperies*, reproduced in *Camera Work*, 1911.

50. The Metropolitan Museum of Art, cardboard backing for 65.261.2. The handwritten inscription is not in Stieglitz's hand but is a transcription. The inscription also describes a book project proposed by Rodin in which reproductions of his drawings were to be combined with Steichen's photographs of his sculpture, with Stieglitz acting as publisher. Stieglitz finally dismissed the idea in 1913.

51. O'Keeffe had visited the 1908 Rodin drawings show. One can posit their liquid, bright watercolor washes, wet-on-wet application, and accidental bleeding of colors as an influence on her 1915–1916 watercolor technique (along with Asian brush painting). Stieglitz's many photographic studies of O'Keeffe's nude body can be compared to Rodin's equally obsessive, repeated drawings of squatting and stretching nudes, with a major difference being that Stieglitz's poses are static unlike the calisthenics of Rodin's athletic figures (real or imagined).

52. Letter dated 6 February 1914, Kate Simpson to Rodin. Archives, Musée Rodin. Dickerman (d. 1923) was a major purchaser of Steichen's paintings.

MATISSE

1. At the two Stein households in Paris—those of Leo and his sister Gertrude and of Michael and his wife Sarah—Americans could meet with artists and writers, engage in spirited discussions, and view their hosts' magnificent holdings of modern art. At the 1905 Autumn Salon Leo Stein had purchased *The Woman with the Hat* (1905, San Francisco Museum of Modern Art), the first painting by Matisse to enter an American collection. Of the four Steins, Matisse was personally closest to Sarah, to whom he often turned for comfort and encouragement.

2. Edward Steichen, *A Life in Photography*, Garden City, 1963, chap. 4, unpaginated.

3. The three paintings, all of 1905, were *The Green Stripe* (Statens Museum for Kunst, Copenhagen), *Madras Rouge: Smaller Version* (Barnes Foundation, Merion, Pennsylvania), and *Nude before a Screen* (formerly Ardrey Collection, Norman, Oklahoma).

4. Undated [January 1908], Steichen to Stieglitz, YCAL. A photostat of the first page and a transcription of the letter appear in Alfred H. Barr Jr., *Matisse: His Art and His Public*, New York, 1951, 112–113.

5. The Eight comprised the artists Robert Henri, Maurice Prendergast, Arthur B. Davies, William Glackens, Ernest Lawson, George Luks, Everett Shinn, and John Sloan.

6. In Paris Prendergast had seen Matisse's entries at the 1907 Autumn Salon, one of which—*Le Luxe I* (Musée Nationale d'Art Moderne, Paris)—so intrigued him that he made a pencil sketch of it ("Sketchbook #38," Museum of Fine Arts, Boston), noting the colors "orange," "green,"and "purple," of the ground, water, and sky.

7. "Artistic tommy-rot" and "an explosion in a color factory" were among the terms of abuse leveled at Prendergast's work (Joseph E. Chamberlin, "Two Significant Exhibitions," *New York Evening Mail*, 4 February 1908, 6; [Arthur Hoeber], "Art and Artists," *New York Globe*, 9 February 1908, 6).

8. "American Artists in Paris Divided," *New York Times*, 26 February 1908, 4. Steichen, Alfred Maurer, Max Weber, D. Putnam Brinley, Jo Davidson, John Marin, and Patrick Henry Bruce, among others, were mentioned.

9. "Henri Matisse at the Little Galleries," *Camera Work* 23 (July 1908), 10.

10. [Stieglitz?], "Photo-Secession Notes," *Camera Work* 30 (April 1910), 47: "[T]wo years ago the Photo-Secession introduced Matisse to the American public. The exhibition included drawings, etchings, water-colors, lithographs, and one painting." See also Stieglitz to Edith Halpert, 20 December 1930, cited in Percy North, "Turmoil at 291," *Archives of American Art Journal* 24 (1984), 16: "... an oil of Matisse loaned by George F. Of was added to the exhibition."

11. In c. 1912 a Matisse painting first entered an American public collection, when *Terrace, Saint Tropez* (1904) was given by Byzantinist Thomas Whittemore to Isabella Stewart Gardner for her museum in Boston (Philip Hendy, *European and American Paintings in the Isabella Stewart Gardner Museum*, Boston, 1974, 162).

12. Such works had been included in Matisse's 1906 one-man show at the Galerie Druet in Paris, where they had made a powerful impression on Picasso; see Pierre Daix, *Picasso: Life and Art*, trans. Olivia Emmet, New York, 1993, 57. According to Daix, Picasso found Matisse's "savage, gestural" and "deliberately anticlassic" style of drawing "a challenge as great as that of the *Bonheur de Vivre*" (1905–1906, Barnes Foundation, Merion, Pennsylvania), concurrently on view at the Independent Salon.

13. Charles de Kay in the *New York Evening Post*. See n. 9 above, 11.

14. James Huneker of the *Sun* wrote that Matisse was "lured by the neo-impressionists" and that his line was "evidently derived from the Japanese." Charles de Kay of the *New York Evening Post* wrote of Matisse's "Rodinesque swirls" and his reversion "to childhood's sunny hour"; see n. 13 above.

15. Joseph E. Chamberlin of the *New York Evening Mail* wrote: "In France they call Henri Matisse 'le roi des fauves'... the 'fauves' are the French equivalent of the out-eighters of our 'eight,' and Matisse is their limit." He added that Matisse's "idea is that you should in painting get as far away from nature as possible. If nature is to be followed, why, let the camera do that"; see n. 9 above, 10.

16. "Exhibitions Now On: Work by Henri Matisse," *American Art News* 6 (11 April 1908), 6.

17. Chamberlin, *New York Evening Mail*; see n. 9 above, 10.

18. "Notes and Reviews," *The Craftsman* 14 (June 1908), 342; see n. 9 above, 12.

19. Chamberlin, *New York Evening Mail*; see n. 9 above, 11.

20. See Marcia Brennan, "Corporeal Disenchantment or Aesthetic Allure? Henri Matisse's Early Critical Reception in New York," *Analecta Husserliana: A Yearbook of Phenomenological Research* 65, Boston and Dordrecht, 2000, 235–250, on Huneker's "deliberately ambivalent account of the exhibition. Readers familiar with Huneker's rhetorical style would have recognized that the critic was parodying conservative American values regarding morality in order to emphasize the piquant aspects of Matisse's artworks."

21. See n. 9 above, 11–12.

22. "Gallery Notes," *New York Times*, 14 April 1908, 8; see n. 9 above, 12.

23. "Exhibitions Now On: Work by Henri Matisse," *American Art News* 6 (11 April 1908), 6.

24. See n. 9 above, 10.

25. See n. 9 above, 11.

26. "Gallery Notes" 1908, 8; see n. 9 above, 12.

27. "Notes and Reviews" 1908, 342; see n. 9 above, 12.

28. William Zorach, "291," *Camera Work* 47 (July 1914; published January 1915), 38.

29. The "Chronology," compiled by John Elderfield with Judith Cousins in *Henri Matisse: A Retrospective* [exh. cat., The Museum of Modern Art], New York, 1992, 181, places the inter-view "around April" 1908. Internal evidence, however, suggests a date later in the year. Caffin reported that Matisse was "modeling a figure in clay" of "a woman, seated cross-legged" (Charles Caffin, "Henri Matisse and Isadora Duncan," *Camera Work* 25 [January 1909], 17). This figure, probably *Small Crouching Nude with Arms*, was after a photograph made in summer 1908 (Albert Elsen, *The Sculpture of Henri Matisse*, New York, 1972, 99–100).

30. Since spring 1908 Matisse had studio, living quarters, and an academy, of which he was master, in the Couvent du Sacré-Coeur, an abandoned convent that had been seized by the French government in 1904 and subsequently leased to artists.

31. Caffin 1909, 18.

32. Matisse exhibited oils, works of sculpture, and drawings in the 1908 Autumn Salon, among them *Harmony in Red* (1908, now in the Hermitage State Museum, Saint Petersburg), perhaps in an earlier, blue version, *Young Sailor I* (1906, private collection), and four major still lifes from 1908.

33. Bernard Berenson to Mary Berenson, 9 October 1908, cited in Ernest Samuels, *Bernard Berenson: The Making of a Legend*, Cambridge, Mass., 1987, 66.

34. "Art," *The Nation* 87 (29 October 1908), 421–422.

35. Bernard Berenson, "De Gustibus," *The Nation* 87 (12 November 1908), 461; reprinted in Barr 1951, 114.

36. The photograph would appear in *Camera Work* 42–43 (April–July 1913), 29, published in November 1913.

37. William Innes Homer in *Alfred Stieglitz and the American Avant-Garde*, Boston, 1977, 61, provides a tentative list of Matisse paintings shown in reproduction at 291, in addition to the two cited above. See also *Camera Work* Special Number (August 1912), which includes Gertrude Stein's word-portraits of Picasso and Matisse, as well as fourteen photographs of the two artists' work.

38. This drawing was reproduced as plate I in *Camera Work* 32 (October 1910), following p. 47. A second drawing, *Reclining Male Nude* (c. 1909, The Metropolitan Museum of Art), also in the exhibition, was illustrated as pl. II.

39. Arthur Hoeber, *New York Globe*, reprinted in "Photo-Secession Notes: Matisse Drawings" 1910, 52.

40. See B. P. Stephenson, *New York Evening Post*, reprinted in "Photo-Secession Notes: Matisse Drawings" 1910, 49–50; and [James Townsend], "Drawings by Matisse," *American Art News* 8 (5 March 1910), 5, reprinted in "Photo-Secession Notes: Matisse Drawings" 1910, 52.

41. Huneker, *The Sun*; see n. 10 above, 48–49.

42. Frank Jewett Mather, *New York Evening Post*; see n. 10 above, 50–51, and *The Nation* 90 (17 March 1910), 272–273.

43. Cary feared, however, that Matisse's influence would be limited by the mediocrity of his American followers, who would turn his "gorgeous hymn to abstract color raised by Cézanne... into a more or less incoherent babbling" (Elisabeth Luther Cary, *New York Times*; see n. 10 above, 53).

44. In 1930 Matisse wrote: "Though I am considered a modernist, I have never abandoned the traditions of painting" ("Matisse Is Coming," *Art Digest* 4 [15 January 1930], 18). In 1910 Matisse was particularly conscious of his links with tradition, as he was in the midst of training students at his Academy; see "Sarah Stein's Notes," in Jack Flam, ed., *Matisse on Art*, Berkeley and Los Angeles, 1995, 46–52.

45. Calvin Tomkins, *Merchants and Masterpieces: The Story of the Metropolitan Museum of Art*, New York, 1970, 218–222.

46. See Barr 1951, 115; and B. B. [Bryson Burroughs], "Drawings by Matisse," *Bulletin of the Metropolitan Museum of Art* 5 (May 1910), 126.

47. Six of the "Younger American Painters"—Brinley, Carles, Marin, Maurer, Weber, and Steichen—were members of Steichen's secessionist group.

48. An informed viewer of the exhibition would have seen that those most strongly influenced by Matisse were Maurer and Weber. Of the nine, however, only Weber and (perhaps) Carles had been students at the Matisse Academy in Paris. Carles claimed to have received criticism from Matisse, presumably at the Matisse Academy (" 'True Art Emotional,' Carles Says," *Philadelphia Press* [21 July 1913], 21, cited in Barbara Ann Boese Wolanin, *The Orchestration of Color: The Paintings of Arthur B. Carles*, New York, 2000, 78–79, n. 20). On Weber's attendance at the Matisse Academy, see Barr 1951, 116, and Percy North, *Max Weber: American Modern* [exh. cat., Jewish Museum], New York, 1982, 16, 25.

49. Guy Pène du Bois, "Followers of Matisse Exhibit at the Photo-Secession Gallery," *New York American*, 21 March 1910, 8; reprinted in " 'The Younger American Painters' and The Press," *Camera Work* 31 (July 1910), 46–47.

50. James Huneker in the *New York Sun*, 19 March 1910, reprinted in " 'The Younger American Painters' and The Press" 1910, 43.

51. A. Harrington, *New York Herald*, reprinted in " ' The Younger American Painters' and The Press" 1910, 45.

52. Paul Haviland, "Photo-Secession Notes," *Camera Work* 38 (April 1912), 36–37.

53. Arthur Hoeber, *New York Globe*, reprinted in *Camera Work* 38 (April 1912), 45.

54. Huneker, *The Sun*, reprinted in *Camera Work* 38 (April 1912), 45.

55. Charles de Kay, "Matisse—Sculptor? 'Mazette'!" *American Art News* 10 (23 March 1912), 8, excerpted in *Camera Work* 38 (April 1912), 46.

56. Joseph E. Chamberlin, *New York Evening Mail*, reprinted in *Camera Work* 38 (April 1912), 45–46.

57. [Elisabeth Luther Cary], "A Few Sculptures by Matisse," *New York Times*, 31 March 1912, magazine section, 15.

58. Felix Grendon, "Matisse," *The International* 6 (July 1912), 34–35. I thank Francis Naumann for bringing this article to my attention.

59. Haviland 1912, 37.

60. Barr 1951, 148–149.

61. Henry McBride, *Matisse*, New York, 1930, 14–15.

62. In late November Steichen wrote to Stieglitz reporting Matisse's disappointment at "not selling any of his sculpture" at 291 (Steichen to Stieglitz, undated [received early December 1912], YCAL).

63. Stieglitz to Belle Greene, 3 May 1912, YCAL.

64. Stieglitz to John Quinn, 3 May 1912; Quinn to Stieglitz, 11 May 1912, John Quinn Memorial Collection, New York Public Library.

CÉZANNE

1. *A Loaned Collection of Some Lithographs by Manet, Cézanne, Renoir, and Toulouse-Lautrec; a Few Drawings by Rodin; and Smaller Paintings by Henri Rousseau*, 18 November 1910 to 8 December 1910. Edward Steichen procured the lithographs for the 291 group show from longtime Cézanne dealer Ambroise Vollard in Paris.

2. Dates for the lithographs are from Douglas Druick, "Cézanne's Lithographs," in *Cézanne, The Late Work* [exh. cat., The Museum of Modern Art], New York, 1977, 137.

3. Cézanne's lithographs attracted little notice from the press, but they were not ignored. These excerpts—"three strong and typical lithographs by Cézanne"; "wonderfully solid and savant...Cézanne drawings"; and mention of Cézanne's "vast primitive talent," and "noble authority," in the "powerful white bathers lifting their big, gleaming bodies against a background suffused with color"—are from reviews by James Townsend in *American Art News*, James Huneker in the *New York Sun*, and E.L. Carey in the *New York Times*, all quoted in *Camera Work* 33 (January 1911), 50, 48, 49. In 1944, when Stieglitz recalled the general reaction to the "bather" compositions, he stated that the "most frequent comment of the visitors at the time was that their 7-year old child could draw better." Alfred Stieglitz, "Impact of Modern European Art on America," in *History of an American. Alfred Stieglitz: "291" and after, Selections from the Stieglitz Collection* [exh. cat., Philadelphia Museum of Art], Philadelphia, 1944, 13.

4. Ambroise Vollard commissioned all three lithographs. These lithographs and five etchings from 1873 constitute Cézanne's entire production of prints.

5. Sadakichi Hartmann, *Camera Work* 31 (July 1910), 48.

6. *Bathers at Rest* (Rewald 26) is now in the Barnes Foundation, Merion, Pennsylvania. John Rewald, in collaboration with Walter Feilchenfelt and Jayne Warman, *The Paintings of Paul Cézanne, A Catalogue Raisonné*, vol. 1, New York, 1996, 179.

7. For information on the Caillebotte Bequest, see Rewald 1996, 257–259.

8. Druick 1977, 130.

9. *Paul Cézanne*, Munich, 1910, with thirty-seven high-quality black-and-white reproductions, was highly sought after by

Americans for its illustrations; *The Burlington Magazine* 16 (January 1910), 207–219.

10. "The Reminiscences of Max Weber" [Interview with C.S. Gruber, Columbia University Oral Research Collection], New York, 1958, 248–249.

11. Jack Flam, ed., "Interview with Jacques Guenne, 1925," in *Matisse on Art*, New York, 1978, 56.

12. Stieglitz issued a public statement in *Camera Work* concerning the "non-photographic" nature of "painting, drawing and other graphic arts" in exhibitions at 291. Specifically mentioning the 1910–1911 season, he wrote that "the Photo-Secession can be said now to stand for those artists who secede from the photographic attitude toward representation of form"; *Camera Work* 30 (April 1910), 54.

13. Bram Dijkstra, *Cubism, Stieglitz and the Early Poetry of William Carlos Williams: The Hieroglyphics of a New Speech*, Princeton, 1969, 97–98.

14. Leo Stein, *The ABC of Aesthetics*, New York, 1927, 176.

15. Leo Stein, *Journey into the Self: Being the Letters, Papers and Journals of Leo Stein*, ed. Edmund Fuller, New York, 1950, 16.

16. Dorothy Norman, *Alfred Stieglitz, An American Seer*, New York, 1990, 87.

17. Norman 1990, 87. Stieglitz was so impressed with Stein's spoken eloquence and erudition in matters of art that he asked him to put his words in print for publication in *Camera Work*, an offer Stein declined.

18. Rewald 406, dated c. 1879. *The Conduit* is now in the Barnes Foundation.

19. William James, "Imagination," vol. 2 of *The Principles of Psychology*, 1890; New York, 1950, 70 (italics mine).

20. Henry Fitch Taylor, "The Summons of Art: Conversations with Bernard Berenson," *The Atlantic Monthly* 200 (November 1957), 124.

21. Rewald 334, *Five Apples*; private collection, Japan.

22. Gail Levin, *Synchromism and American Color Abstraction 1910–1925* [exh. cat., Whitney Museum of American Art], New York, 1978, 12.

23. Dijkstra 1969, 102.

24. "Reminiscences of Max Weber" 1958, 18–19.

25. "Matisse Symposium," 1951, Max Weber Papers, Archives of American Art, Smithsonian Institution, Washington.

26. Max Weber, "Foreword," *Cézanne* [exh. cat., Montross Gallery], New York, 1916.

27. Richard Whelan, *Alfred Stieglitz, A Biography*, Boston, 1995, 293.

28. Stieglitz printed only a checklist for the twenty watercolors on display. John Rewald has identified sixteen of the twenty Cézanne watercolors that Stieglitz exhibited in *Paul Cézanne, The Watercolors, A Catalogue Raisonné*, Boston, 1983, 470. I list these sixteen watercolors below in the order that Stieglitz gave them on the 1911 checklist, but with the dates and French titles that

Rewald assigned: *Coin du Lac d'Annecy* (1896) RWC 472; *La Futaie* (1880–1885) RWC 233 (pl. 18); *Arbres se croissant au bord de l'eau* (1896) RWC 484; *Le Puits dans le parc de Château Noir* (1895–1898) RWC 428; *Groupe d'arbres* (c. 1885) RWC 235; *Étude d'arbre* (c. 1890) RWC 287 (pl. 21); *La Montagne Sainte-Victoire* (1885–1887) RWC 279 (pl. 19); *Étude de feuillage* (1900–1904) RWC 551 (pl. 16); *Paysage de Provence* (1890–1895) RWC 390; *Le Viaduc* (1888–1892) RWC 326; *Puits et route tournante dans le parc de Château Noir* (c. 1900) RWC 513 (pl. 17); *Laveuses* (c. 1880) RWC 103; *Arbres et rochers* (c. 1890) RWC 328; *Toits et arbre* (1888–1890) RWC 360; *Garçon lisant* (c. 1885) RWC 187; and *Madame Cézanne aux hortensias* (c. 1885) RWC 209 (pl. 20).

29. *Manet and the Post-Impressionists*, Grafton Galleries, London, 8 November 1910–15 January 1911.

30. London 1910, 10.

31. Norman 1990, 80. Stieglitz refers to the time when he and Eduard Steichen were in Paris in the summer of 1907 viewing watercolors by Cézanne at the Bernheim Jeune Gallery. At that time, Stieglitz saw nothing in them but "empty paper and a few splashes of color," only valuable to show in New York "to try out the critics."

32. Norman 1990, 81.

33. "Cézanne Exhibition," *Camera Work* 36 (October 1911), 30. A few months later Stieglitz wrote, "Without the understanding of Cézanne, it is impossible to grasp, even faintly, much that is going on in the art world today"; cited in Sarah Whitaker Peters, *Becoming O'Keeffe, The Early Years*, New York, 1991, 24.

34. Excerpts from reviews printed in *Camera Work* 36 (October 1911), 46, 47.

35. Rewald 1989, 154, n. 61.

36. Anonymous review in the *New York Times*, cited in Rewald 1983, 151.

37. Anonymous review in "Art Notes," *The Craftsman* 20 (April–September 1911), 237.

38. Frank Mather, "Paul Cézanne," *The Nation* 102 (13 January 1916), 58.

39. Charles Caffin, "A Note on Paul Cézanne," *Camera Work* 34–35 (April–July 1911).

40. Sheldon Reich, *John Marin: A Stylistic Analysis and Catalogue Raisonné*, vol. 1, Tucson, 1970, 30–31.

41. Charles Caffin, "John Marin," *Camera Work* 27 (July 1909), 42.

42. Willard H. Wright, "John Marin's Water-Colours," *International Studio* 58 (March 1916), xviii.

PICASSO

I am indebted to the Picasso scholars Pepe Karmel, Marilyn McCully, and Jeffrey Weiss for their generous advice and assistance with the research for this essay.

1. Steichen to Stieglitz, undated [summer 1908], YCAL. Penelope Niven, *Steichen: A Biography*, New York, 1997, 289, dates the letter, using the context of other events from the time, to the summer of 1908.

2. Percy North, *Max Weber: Discoveries*, New York, 1999, unpaginated.

3. Richard Whelan, *Alfred Stieglitz: A Biography*, New York, 1995, 255.

4. Gelett Burgess, "The Wild Men of Paris," *Architectural Record* 27 (May 1910), 401–414.

5. This letter is cited in William Rubin, *Picasso and Braque: Pioneering Cubism*, New York, 1989, 366. On Field see Doreen Bolger, "Hamilton Easter Field and the Rise of Modern Art in America," Master's thesis, University of Delaware, 1973, and "Hamilton Easter Field and His Contribution to American Modernism," *American Art Journal* 20, 2 (1988), 78–107.

6. De Zayas to Stieglitz, 28 October 1910, YCAL.

7. Who was involved with the selection is unclear. Steichen wrote to Stieglitz that Frank Burty Haviland and Picasso chose the show with his advice, undated [January or February 1911], YCAL. But in his autobiography, *A Life in Photography*, New York, 1963, Steichen recalled that de Zayas and the sculptor Manolo made the decisions. De Zayas remembered Picasso, Steichen, Haviland, and himself as having made the selections in Marius de Zayas, *How, When, and Why Modern Art Came to New York*, Cambridge and London, 1996, 21.

8. Steichen to Stieglitz, undated [January or February 1911], YCAL.

9. Steichen advised Stieglitz that "Numbers 1–49…are the pictures we intended for the walls. Some as you will see belong in groups and can go under one glass." Steichen to Stieglitz, undated [January or February, 1911], YCAL. Stieglitz recalled the total of eighty-three in "To the Art Editor," *New York Times*, 24 December 1939, section 9, 9, leaving thirty-four available in portfolios.

10. De Zayas to Stieglitz, 7 March 1911, YCAL. The article was "Pablo Picasso," *América: Revista mensual illustrada* 6 (May 1911), 363–365, reprinted in *Camera Work* 34–35 (April–July 1911), 65–67.

11. "Picasso Exhibition," *Camera Work* 36 (October 1911), 30.

12. In addition to the nine reviews published in *Camera Work* 36 (October 1911), 48–65, see R. H. Schumacher, "Picasso's Thought-Pictures," *The Brooklyn Daily Eagle*, 11 April 1911, "Art Exhibitions," *New York Tribune*, 19 April 1911, Arthur Hoeber, "Art and Artists," *The Globe and Commercial Advertiser*, 21 April 1911, and "The Revolutionary Artists," *The Craftsman* 20, 2 (May 1911), 237. The last two were published in Marilyn McCully, *Picasso Anthology: Documents, Criticism, and Reminiscences*, London, 1981, 79–81.

13. Review by a Mr. Tyrell in *New York Evening World* published in *Camera Work* 36 (October 1911), 49. Other works in the series include Christian Zervos, *Pablo Picasso*, Paris, 1942–,

xxii.383, xxii.384, and xxii.385, as well as *Young Girl with Folded Hands*, The Metropolitan Museum of Art, 1972.118.296.

14. Elizabeth Luther Carey, "The Question of Picasso," *New York Times*, 16 April 1911, reprinted in *Camera Work* 36 (October 1911), 51–52.

15. "Art Exhibitions" 1911.

16. Tyrrell 1911.

17. B. P. Stephenson, *New York Evening Post*, 1 April 1911, 50.

18. J. Edgar Chamberlin, *Evening Mail*, as published in *Camera Work* 36 (October 1911), 50–51.

19. James Huneker, "Examples of Pablo Picasso's Work Shown Here," *New York Sun*, 2 April 1911, reprinted in *Camera Work* 36 (October 1911), 54. The two studies are reproduced in *Picasso's Private Drawings: The Artist's Personal Collection of His Finest Drawings*, New York, 1969, 48, as *Standing Woman Seen from the Rear*, and as fig. 213 in Michèle Richet, *The Picasso Museum, Paris*, New York, 1988, 93.

20. Schumacher 1911. The drawing is reproduced in Douglas Cooper and Gary Tinterow, *The Essential Cubism: Braque, Picasso, and Their Friends, 1907–1920*, London, 1983, 327.

21. Hoeber 1911. See for instance Zervos xxvi.401 and xxvi.402. Hoeber also mentions "a charcoal drawing of a dish of bananas."

22. Schumacher 1911.

23. *Study of a Nude Woman* was bequeathed to the sculptor Robert Laurent and then to John Laurent who sold it to the Museum of Fine Arts, Boston, through Parke Bernet in 1970.

24. The notion that there were childhood works on display has arisen in part because Field's drawing, unidentified at the time, was mistakenly thought to be a sketch done by Picasso at the age of twelve. See Dorothy Norman, *Alfred Stieglitz: An American Seer*, New York, 1960, 108, and Bolger 1988, 96. This mix-up may have occurred because Stieglitz once referred to it as having been sold for twelve dollars. Marius de Zayas remembered the show as being chosen from Picasso's "latest drawings." See de Zayas 1996, 21.

25. It would have been in keeping with Stieglitz and Steichen's practice of showing an artist's evolution to have one of the earliest works at the entrance of the show. Stieglitz referred to Field's 1906 Gosol period work as the earliest in the installation. See Herbert J. Seligmann, *Alfred Stieglitz Talking*, New Haven, 1966, 112.

26. Stephenson 1911, reprinted in *Camera Work* 36 (October 1911), 50.

27. Hoeber 1911.

28. See *Camera Work* 36 (October 1911), 49.

29. See *New York World* article in *Camera Work* 36 (October 1911), 49.

30. Mr. Harrington, "Art of Various Kinds in Galleries," *New York Herald*, 6 April 1911, reprinted in *Camera Work* 36 (October 1911), 51.

31. Hoeber 1911.

32. *Camera Work* 36 (October 1911), 49.

33. *Camera Work* 36 (October 1911), 50.

34. Mr. Harrington, "Art of Various Kinds in Galleries," *New York Herald*, 6 April 1911, reprinted in *Camera Work* 36 (October 1911), 51.

35. Mr. Fitzgerald, "The New Art Criticism," *New York Evening Sun*, reprinted in *Camera Work* 36 (October 1911), 68.

36. *Camera Work* 36 (October 1911), 50.

37. James Huneker, "Examples of Pablo Picasso's Work Shown Here," *New York Sun*, 2 April 1911, reprinted in *Camera Work* 36 (October 1911), 54.

38. Carey 1911.

39. *Camera Work* 36 (October 1911), 51.

40. Carey 1911.

41. Israel White, "Radicals to the Fore: Pablo Picasso Leads the Post-Impressionists a Step Further Into the Light," *Newark Evening News*, 1 April 1911, reprinted in *Camera Work* 36 (October 1911), 52.

42. Carey 1911.

43. White 1911. In a similar vein R. H. Schumacher noted that Picasso "is trying to find new forms by shifting and changing facets of crystals." Schumacher 1911.

44. Huneker 1911, 55.

45. The artist Jo Davidson recalled that the show was "the talk of the town," in *Between Sittings: An Informal Autobiography*, New York, 1951, 64. Hoeber 1911 commented on the "enormous crowd of visitors."

46. Stieglitz to Carles, undated (June 1908), YCAL, box 9, folder 215.

47. Stieglitz to de Zayas, 4 April 1911, YCAL, quoted in de Zayas 1996, 162. Stieglitz later recalled that 7,000 people attended the show in "To the Art Editor" 1939.

48. On 10 July 1911 de Zayas wrote to Stieglitz about the problems with the return of the drawings: "I fully explained what your position is in this matter and he understood that you are not to blame for any discourtesy. If I gave him all kind of explanations it is because first I really think he is right and second because this fellow talks a good deal, and I believe the Secession needs them." Also see letters dated 6 April 1911 and 21 April 1911, YCAL.

49. *Camera Work* 36 (October 1911), 29.

50. Stieglitz tried to convince the Metropolitan's director, Bryson Burroughs, to purchase the whole collection, but Burroughs "saw nothing in Picasso and vouched that such mad pictures would never mean anything in America." Stieglitz to Edward Alden Jewell, 19 December 1939, quoted in Norman 1960, 108.

51. Alfred Stieglitz, "Post-Impressionism in America," *The Evening Sun*, 18 December 1911.

52. Stieglitz to Sadakichi Hartmann, 22 December 1911, quoted in Norman 1960, 110.

53. Steichen facilitated the purchase of the Picasso sculpture. See Steichen to Stieglitz, undated (January 1912), YCAL, box 46, folder 1095. Gertrude Stein, "Pablo Picasso," *Camera Work* Special Number (August 1912), 29–30. (Five major paintings by Picasso were also reproduced in the special number.) Wassily Kandinsky, "Extracts from 'The Spiritual in Art,'" *Camera Work* 39 (July 1912), 34.

54. Stieglitz to Heinrich Kuhn, 14 October 1912, YCAL, quoted in Sarah Greenough and Juan Hamilton, *Alfred Stieglitz: Photographs and Writings*, Washington, 1983, 194.

55. Norman used the term "storm center" in Norman 1960, 108. De Zayas described the work as the "clou" of the show in de Zayas 1996, 26. Following a similar strategy, Stieglitz purchased one of the most radical works from the Armory Show, Kandinsky's *Improvisation Number 27*.

56. Schumacher 1911.

57. Stieglitz to Arthur Jerome Eddy, 10 November 1913, YCAL, box 15, folder 367.

58. Samuel Swift, "Art Photographs and Cubist Painting," *New York Sun*, 3 March 1913, reprinted in *Camera Work* 43–44 (April–July 1913), 47.

ARMORY SHOW

1. For the Grafton exhibition see Carol A. Nathanson, "The American Reaction to London's First Grafton Show," *Archives of American Art Journal* 25, 3 (1985), 2–10, and Anna Gruetzner Robins, *Modern Art in Britain 1910–1914* [exh. cat., Barbican Art Gallery], London, 1997, 15–45.

2. In an interview with Baldwin Macy, Stieglitz commented: "…in the last few months I've received over one hundred letters from art institutions all over the country asking about the Matisse and other exhibits and the possibility of arranging others for them of what they with the rest of the world are calling post-Impressionism." Baldwin Macy, "New York Newsletter," *Chicago Evening Post*, 22 December 1911, clipping in YCAL, quoted in Nathanson 1985, 7.

3. Alfred Stieglitz, "Post-Impressionism in America," *The Evening Sun*, 18 December 1911, 14.

4. For the Armory Show see Milton W. Brown, *The Story of the Armory Show*, New York, 1963.

5. Felix Grendon, "What is Post-Impressionsism," *New York Times*, 12 May 1912.

6. Edward Steichen to Alfred Stieglitz, December 1912, YCAL, box 46, folder 1095.

7. Alfred Stieglitz, "The First Great 'Clinic to Revitalize Art,'" *New York American*, 26 January 1913.

8. In April Wassily Kandinsky contacted Stieglitz concerning his purchase of *Improvisation Number 27* and tentative plans were under way for the first Kandinsky exhibition in the United

States. However, the show was never realized. See Gail Levin and Marianne Lorenz, *Theme and Improvisation: Kandinsky and the American Avant-Garde, 1912–1950* [exh. cat., Dayton Art Institute], Boston, 1992, 13.

9. Marin's catalogue essay was reprinted in *Camera Work* 42–43 (April–July 1913), 18.

10. Mr. Boswell, *New York Herald*, reprinted in *Camera Work* 42–43 (April–July 1913), 25.

11. J. Edgar Chamberlin, "New York Skyscrapers Adrift," *New York Evening Mail*, 24 January 1913, reprinted in *Camera Work* 42–43 (April–July 1913), 23.

12. Reprinted in *Camera Work* 42–43 (April–July 1913), 25.

13. Paul Haviland, "Watercolors by John Marin," *Camera Work* 42–43 (April–July 1913), 18.

14. Reprinted in *Camera Work* 42–43 (April–July 1913), 24.

15. Royal Cortissoz, "John Marin, a Painter with a Theory," *New York Tribune*, 2 February 1913, reprinted in *Camera Work* 42–43 (April–July 1913), 26.

16. Mr. Boswell, *New York Herald*, reprinted in *Camera Work* 42–43 (April–July 1913), 25.

17. The Stieglitz critic Charles Caffin, in "Chance to See Paintings by Marin," *New York American*, 27 January 1913, reprinted in *Camera Work* 42–43 (April–July 1913), 42, noted Stieglitz's intentions vis-à-vis the Armory Show: "It [the Armory Show] will be an exhibition almost exclusively—certainly in its main interest—foreign. So it is pleasant in anticipation of this foreign invasion, to note an exhibition fully as independent, quite as conclusively one of artistic liberty, which, moreover, is thoroughly American."

18. "The Futurist's New York: Marin's Emotional Painting of Skyscrapers," *The World*, 16 February 1913; Caffin, "Chance to See Paintings," 1913; and John Marin, "The Living Architecture of the Future," *New York American*, 16 February 1913.

19. *Woolworth Building—Nos. 28, 29, 31, 32, Broadway, Singer Building* (all National Gallery of Art, Washington) and *Broadway, St. Paul's Church* (Delaware Art Museum, Wilmington).

20. Alfred Stieglitz to Ward Muir, 30 January 1913, YCAL: "I am putting my work to a diabolical test. I wonder whether it will stand it. If it does not it contains nothing vital."

21. Paul Haviland, "Photographs by Alfred Stieglitz," *Camera Work* 42–43 (dated April–July 1913, published November 1913), 19.

22. Samuel Swift, "Art Photographs and Cubist Painting," *The Sun*, 3 March 1913, reprinted in *Camera Work* 42–43 (dated April–July 1913, published November 1913), 46.

23. Chamberlin 1913, 47.

24. Haviland, "Photographs," 1913, 19: "A comparison between Marin's rendition of New York and Stieglitz's photographs of the same subject afforded the very best opportunity to the student and public, for a clearer understanding of the place and purpose of the two media."

25. Beaumont Newhall identified the ship as eastbound in *The History of Photography*, New York, 1964, 111.

26. See William Camfield, *Francis Picabia: His Art, Life, and Times*, Princeton, 1979, 41–56, 106–111, and Maria Lluïsa Borràs, *Picabia*, New York, 1985, 96–99.

27. Henry Tyrell, "Oh, You High Art! Advance Guard of the Post-Impressionists Has Reached N.Y. One of Their Leaders, M. Picabia, Explains How He Puts His Soul on Canvas," *World Magazine*, 9 February 1913.

28. "Picabia, Art Rebel, Here to Present New Movement," *New York Times*, 16 February 1913.

29. "A Post-Cubist's Impressions of New York," *New York Tribune*, 9 March 1913.

30. Oscar Bluemner, "Auditor et Altera Pars: Some Plain Sense on the Modern Art Movement," *Camera Work* Special Number (June 1913), 26.

31. The author of "In the Art Galleries," *New York Times*, 18 March 1913, commented: "Those who wish to carry further their education in Post-Cubist art will have an opportunity...."

32. Charles Caffin, "Picabia's Work Represents Further Abstraction in Art," *New York American*, 24 March 1913.

33. Hutchins Hapgood, "A Paris Painter," *Globe and Commercial Advertiser*, 20 February 1913, reprinted in *Camera Work* 42–43 (dated April–July 1913, published November 1913), 50.

34. Stieglitz was quick to point out that Arthur Dove "working independently...utilized similar modes of expression a year ago," in Samuel Swift, "New York by Cubist is Very Confusing," *New York Sun*, 18 March 1913, reprinted in *Camera Work* 42–43 (dated April–July 1913; published November 1913), 48.

35. Francis Picabia, "How New York Looks to Me," *New York American*, 30 March 1913.

36. "A Post-Cubist's Impressions of New York" 1913.

37. Gabrielle Buffet-Picabia wrote to Stieglitz, "I am organizing a gallery in Paris on the order of the idea we discussed so much in New York last year.... Do I need to tell you that the memory of 291 is a great point of support for me in this enterprise?" 17 November 1913, YCAL, quoted in Camfield 1979, 62–63. The gallery called "L'Ourse" or "L'Ours" opened 1 January 1914. Picabia's periodical *391* was published from January 1917 to October 1924.

DE ZAYAS

1. The standard biographical sources for de Zayas are Douglas Hyland, *Marius de Zayas: Conjurer of Souls* [exh. cat., Spencer Museum of Art], Lawrence, Kans., 1981, and Francis Naumann's introduction and afterword in Marius de Zayas, *How, When, and Why Modern Art Came to New York*, ed. Francis Naumann, Cambridge and London, 1996. Also see the chapter devoted to de Zayas in Wendy Wick Reaves, *Celebrity Caricature in America*, New Haven and London, 1998, 72–102.

2. De Zayas recalled his first meeting with Stieglitz in Dorothy Norman, *Alfred Stieglitz: An American Seer*, New York, 1960, 107: "I was not attempting to get into contact with anyone in order to have my work exhibited.... But then, one day in 1907, a man entered my studio and stood looking at my work. He simply walked in.... The man asked me about what I was doing—did I wish to sell or exhibit?...I said, 'No.' It was Stieglitz who had come to see me. In spite of what I had said, he decided to show my work. I told him to keep all of it. I gave him everything of mine on display at 291." On Stieglitz's interest in caricature see Reaves 1998, 72–130.

3. The installation is reproduced in de Zayas 1996, viii–ix.

4. Marius de Zayas to Alfred Stieglitz, 28 October 1910, YCAL, quoted in de Zayas 1996, 157. The Stieglitz–de Zayas correspondence is reproduced in its entirety in de Zayas 1996, 156–211.

5. De Zayas to Stieglitz, 22 December 1910, YCAL, quoted in de Zayas 1996, 158.

6. De Zayas to Stieglitz, 25 January 1911, YCAL, quoted in de Zayas 1996, 160–161.

7. De Zayas wrote to Stieglitz that he was "convinced...of the necessity of having a show in the S. of the negro art," 21 April 1911, YCAL, quoted in de Zayas 1996, 164. He also wrote at this time that he had "started in a new idea and made some caricatures and drawings for the philosophical collection." De Zayas to Stieglitz, 7 March 1911, YCAL, quoted in de Zayas 1996, 162.

8. Marius de Zayas, "The New Art in Paris," *Camera Work* 34–35 (April–July 1911), 29–34, and Marius de Zayas, "Pablo Picasso," *Camera Work* 34–35 (April–July 1911), 65–67.

9. De Zayas to Stieglitz, 22 July 1911, YCAL, quoted in de Zayas 1996, 165–166.

10. Marius de Zayas, "The Sun has Set," *Camera Work* 39 (July 1912), 17, 21.

11. Marius de Zayas, "Photography," *Camera Work* 41 (January 1913), 20.

12. Marius de Zayas, "Photography and Artistic-Photography," *Camera Work* 42–43 (dated April–July 1913, published November 1913), 13.

13. See n. 12, 14.

14. In "The Evolution of Form-Introduction," *Camera Work* 41 (January 1913), 44, de Zayas wrote: "It was not until Art felt the powerful influence of the progress of Science that it awoke and broadened its horizon, calling to its aid the resources which Science had accumulated. Possibly, this only means the absorption of Art by Science." Also see Marius de Zayas and Paul B. Haviland, *A Study in the Modern Evolution of Plastic Expression*, New York, 1913.

15. De Zayas' catalogue essay was reprinted as "Caricature: Absolute and Relative," *Camera Work* 46 (April 1914), 19–21.

16. See n. 15, 20.

17. Hyland 1981, 104, 106, 108, 114.

18. De Zayas 1996, 80. De Zayas photographed African art at the Trocadéro in Paris in 1914 and later published *African Negro Art: Its Influence on Modern Art*, New York, 1916.

19. On Apollinaire and de Zayas see Willard Bohn, "Guillaume Apollinaire and the New York Avant-Garde," *Comparative Literature Studies* 13 (March 1976), 40–50, and *Apollinaire and the Faceless Man: The Creation and Evolution of a Modern Motif*, London and Toronto, 1991.

20. *Les Soirées de Paris* (July 1914), 378, 396, 398, 416.

21. Guillaume Apollinaire, *À quelle heure un train partira-t-il pour Paris?*, afterword by Willard Bohn, Narbonne, 1982. The scenario for the pantomime was published in Bohn 1991, 54–58. The characters were the musician with no eyes, no nose, and no ears, as many women as possible, the Eiffel Tower, the Arc de Triomphe, Notre Dame, a tall factory chimney, the sovereign, two attendants, the soldier, and the poet. De Zayas must have instigated the project. He had previously formed Modern Scenic Art, Inc., for the production of a pantomime in New York in 1912 with Paul Haviland and J. N. Lauvrik entitled *The Star's Necklace*. De Zayas refers to this event as "an artistic success" in a letter to Stieglitz, 14 September 1912, YCAL. De Zayas' designs and an announcement for the *The Star's Necklace* are in the De Zayas Archives, Seville.

22. "Simultanism," *291* 1 (March 1915), unpaginated, assessed the term: "That the idea of simultanism is essentially naturalistic is obvious; that the polyphony of interwoven sounds and meanings has a decided effect upon our senses is unquestionable, and that we can get at the spirit of things through this system is demonstrable."

23. In *291* 1 (March 1915), unpaginated, Stieglitz's description of one of his dreams and Apollinaire's *calligramme* "Voyage" were published one on top of the other with no other items on the page.

24. De Zayas to Stieglitz, 26 May 1914, YCAL, quoted in de Zayas 1996, 170.

25. De Zayas to Stieglitz, 9 July 1914, YCAL, quoted in de Zayas 1996, 184.

26. De Zayas to Stieglitz, 13 September 1914, YCAL, quoted in de Zayas 1996, 185.

27. See n. 26.

28. Two recent interpretations and thorough histories of *291* and the Modern Gallery are Ernst Birss, " 'New York, at First, Did Not See...': Modern Art, the Public, and the Stieglitz Circle," 1913–1916, Master's thesis, University of Alberta, 1995, and Stephen E. Lewis, "The Modern Gallery and American Commodity Culture," *Modernism/modernity* 4, 3 (September 1997), 67–92.

29. Marius de Zayas, "New York, at First, Did Not See....," *291* 5–6 (July–August 1915), unpaginated. De Zayas' image is in stark contrast to Picabia's portrayal of Stieglitz as a dysfunctional camera on the cover of *291* 5–6 (July–August 1915). For

the Picabia portrait see William Rozaitis, "The Joke at the Heart of Things: Francis Picabia's Machine Drawings and the Little Magazine *291*," *American Art* 8 (summer–fall 1994), 43–59.

30. See n. 29 (de Zayas 1915).

31. From a circular announcing the opening of the Modern Gallery reprinted in *Camera Work* 48 (October 1916), 63, and quoted in de Zayas 1996, 93.

32. *291* 9 (November 1915), unpaginated.

33. "'291' and the Modern Gallery," *Camera Work* 48 (October 1916), 64.

34. *Camera Work* 47 (dated July 1914, published January 1915).

35. Stieglitz to de Zayas, 2 September 1915, YCAL, quoted in de Zayas 1996, 197.

36. For the Severini show see de Zayas to Stieglitz, 21 August 1916 and 11 September 1916, YCAL, quoted in de Zayas 1996, 203–204. In contrast to de Zayas and Haviland, Agnes Meyer did sever her relationship with Stieglitz in the wake of the events surrounding the opening of the Modern Gallery. See especially her letter to de Zayas, no date (probably late 1916), De Zayas Archives, Seville, quoted in Birss 1995, 223.

37. Marius de Zayas, "291," *Camera Work* 47 (dated July 1914, published January 1915), 73.

38. De Zayas 1996, 84.

BRANCUSI

1. The one marble was a *Torso* already in New York, as it was owned by Arthur Davies, an organizer of the show. For more on the critical response to Brancusi's show see Ann Temkin, "Brancusi and His American Collectors," in *Constantin Brancusi 1876–1957* [exh. cat., Philadelphia Museum of Art], Cambridge, Mass., 1995, 51–53.

2. Edward Steichen to Alfred Stieglitz, 1913, YCAL.

3. Brancusi's greetings to Stieglitz's wife and niece in his letters (see, for example, letter of 24 April 1914) seem to confirm that meeting, although it is not precisely documented. According to Sue Davidson Lowe, Stieglitz had wanted his wife to select a sculpture "in Steichen's custody" while in Paris, but she was unable to choose. Sue Davidson Lowe, *Stieglitz: A Memoir/Biography*, New York, 1983, 173.

4. Walter Pach to Brancusi, 6 [?] February 1914, quoted in Pontus Hulten, Natalia Dumitresco, and Alexandre Istrati, *Brancusi*, New York, 1987, 94.

5. Brancusi to Steichen, 13 February 1914, YCAL.

6. Brancusi to Steichen, 13 February 1914, YCAL. Judging from reports in the press, in conversation Stieglitz nonetheless referred to the sculpture as "First Step." A different work of wood and stone, dated 1915 and now in the collection of the Philadelphia Museum of Art, is named *Prodigal Son*, and has sometimes been mistaken for the work shown at 291.

7. *Camera Work* 48 (October 1916).

8. W. B. McCormick, "Dominant Egg Note in Brancusi's Sculptures," *New York Press*, 22 March 1914, part 4, 8.

9. Paul B. Haviland, "Exhibition of Sculptures by Brancusi," *Camera Work* 45 (January 1914), 19.

10. McCormick 1914.

11. Henry McBride, "What is Happening in the Galleries," *The Sun*, 22 March 1914, section 7, 2.

12. Brancusi's letters to Stieglitz and Steichen are housed with the Stieglitz papers at the Beinecke Library, Yale University, as are Stieglitz's drafts of his letters to Brancusi. Stieglitz's and Steichen's letters to Brancusi are part of the Brancusi archives at the Musée Nationale d'Art Moderne and not yet available to scholars. They are cited in part in Hulten, Dumitresco, and Istrati 1987.

13. Brancusi to Steichen, 13 February 1914, YCAL.

14. "si je vous derange trop avec mes lettres et tous, ne vous fachez pas car c'est votre fotte [sic]. C'est vous qui m'avez demande de fair l'exposition." Brancusi to Steichen, 16 March 1914, YCAL.

15. Stieglitz to Brancusi, 26 March 1914, YCAL.

16. Stieglitz to Brancusi, 13 March 1914, YCAL. This wording reflects criteria cited in a law passed the previous year that exempted imported works of art made in the last twenty years from a tariff. As Anna Chave points out, it is puzzling that Stieglitz had to pay any amount if the works were in fact accepted as art. Anna C. Chave, *Constantin Brancusi: Shifting the Bases of Art*, New Haven and London, 1993, 314, n. 27.

17. Stieglitz to Brancusi, 26 March 1914, YCAL.

18. Brancusi to Stieglitz, 1 May 1914, YCAL.

19. Brancusi to Steichen, 13 February 1914, YCAL. It is not clear if these were ever sent.

20. Brancusi to Stieglitz, 24 April 1914, YCAL.

21. Brancusi to Steichen, 20 February 1914, YCAL.

AFRICAN ART

My thanks go to David Hart for his research; Steven Nelson, William Siegmann, and Zoë Strother for their suggestions; and Leah Dickerman for her encouragement.

1. [Alfred Stieglitz], "Exhibitions of Photography for '291,'" *Camera Work* 45 (June 1914), 44.

2. Exhibition announcement, YCAL.

3. Henry McBride, reprinted in *Camera Work* 48 (October 1916), 16.

4. Alfred Stieglitz, "Paintings by Francis Picabia," *Camera Work* 48 (October 1916), 8.

5. [Alfred Stieglitz], "Photo-Secession Notes," *Camera Work* 30 (April 1910), 54.

6. Stieglitz to Marin, New York, 29 September 1914, YCAL.

7. Stieglitz to Dove, New York, 5 November 1914, YCAL. The exhibition was originally planned to close on 27 November.

8. I use modernist here as a descriptor for the twentieth-century Western avant-garde, since primitivism as a cultural yearning for a hypothetically simpler time, place, or style can occur in any culture. See Arthur O. Lovejoy and George Boas, *Primitivism and Related Ideas in Antiquity*, Baltimore, 1935, and Frances S. Connelly, *The Sleep of Reason: Primitivism in Modern European Art and Aesthetics, 1725–1907*, University Park, Pa., 1994.

9. For Weber and Stieglitz, see Sue Davidson Lowe, *Stieglitz: A Memoir/Biography*, New York, 1983, 143. For Picasso, see André Malraux, *Picasso's Mask*, trans. June and Jacques Guicharnaud, New York, 1976, 10. The artist commented to Malraux that "When I went to the old Trocadéro, it was disgusting."

10. De Zayas to Stieglitz, Paris, 21 April 1911, YCAL. De Zayas' use of "S" is ambiguous so I have suggested as one possibility a shorthand for the original name of 291, the Little Galleries of the Photo-Secession.

11. Gelett Burgess, "The Wild Men of Paris," *Architectural Record* 27 (May 1910), 403, 408.

12. J. Edgar Chamberlin, reprinted in *Camera Work* 36 (October 1911), 51.

13. De Zayas to Stieglitz, Paris, [26?]/27 May 1914, YCAL.

14. Guillaume to Stieglitz, Paris, 25 May 1914, YCAL, author's translation.

15. Stieglitz to de Zayas, New York, 3 June 1914, YCAL.

16. Marius de Zayas, *How, When, and Why Modern Art Came to New York*, ed. Francis M. Naumann, Cambridge and London, 1996, 55.

17. De Zayas to Stieglitz, New York, 13 September 1914, YCAL.

18. Edward Steichen, *A Life in Photography*, New York, 1963, chap. 5, unpaginated.

19. Henry McBride, reprinted in *Camera Work* 48 (October 1916), 16; [Forbes Watson], reprinted in *Camera Work* 48 (October 1916), 15.

20. Ralph L. Harley Jr., "Edward Steichen's Modernist Art-Space," *History of Photography* 14 (January–March 1990), 1–22.

21. In a review printed in *How, When, and Why Modern Art Came to New York* (see n. 16, 59), Charles Caffin wrote that eighteen works were on view in the exhibition. Fifteen can be identified from photographs. Ten are in the installation view (from left): mask of the We or Bete people (pl. 43); two We masks; reliquary figure of the Fang people, Gabon (fig. 64); Guro or Bete spoon (pl. 45); mask of the Baule people (pl. 47); spoon (pl. 46); unidentified comb; Bete mask; and a male Baule figure.

An article in the *New York World Magazine*, 24 January 1915, 20, illustrates a female Baule figure and a female figure of the Akye people. Fig. 65 shows a mask of the Guro people (pl. 49) and a Bete sculpture, possibly a ceremonial pestle. A Bete standing figure with bowl on head (pl. 44) is reproduced in de Zayas

1966, 60. The other works cannot be accounted for, but an unidentified whip with a carved handle and a mask of the Yaure or Baule people (pl. 48), in the Alfred Stieglitz Collection at Fisk University, are possibilities.

On 4 November 1914, Paul Guillaume wrote Stieglitz that he was shipping two reliquary figures of the Kota people, Gabon (Paul Guillaume to Stieglitz, YCAL). They probably did not arrive until the first week of December at the earliest. One of these two appears in the so-called Picasso-Braque exhibition photograph that will be discussed below.

22. Elizabeth Luther Carey, reprinted in *Camera Work* 48 (October 1916), 14. "Post-impressionist" is used here to refer to anyone working after the impressionists. "News of the Art World," *The New York World*, 8 November 1914, section 2, 2.

23. [Forbes Watson], reprinted in *Camera Work* 48 (October 1916), 15.

24. J. Edgar Chamberlin, reprinted in *Camera Work* 48 (October 1916), 14.

25. "News of the Art World," *The New York World*, 8 November 1914.

26. Chamberlin 1916, 14.

27. The other photograph is reproduced in *Camera Work* 48 (October 1916), 67.

28. "Picasso and Braque," *American Art News* 13 (12 December 1914), 2; Charles Caffin, "Picasso's Latest Pictures of Intellectualized Sensations," *New York American*, 14 December 1914, section 1, 8; Manuel Komroff, "Picasso's at '291 Fifth Avenue,'" *The New York Call*, 13 December 1914, 6; Elizabeth Luther Carey, "Theory and Practice," *New York Times*, 20 December 1914, section 5, 11; Henry McBride, "What's Happening in the World of Art," *The New York Sun*, 20 December 1914, section 3, 2; Alfred Stieglitz, "Recent Drawings and Paintings by Picasso and by Braque," *Camera Work* 48 (October 1916), 7.

29. Marius de Zayas, "Modern Art—Theories and Representations," *Camera Work* 44 (March 1914), 14, 13. My conclusion raises the question of how the two photographs came to be understood as installation views. I believe that their titles, usually some variation of "Picasso-Braque exhibition," are not incorrect if one sees this wording as merely indicating that they were shot during its run, perhaps on the day the gallery was dismantled.

PICASSO AND BRAQUE
I am grateful to Alejandra Munizaga, Kathleen Mrachek, and Charles Brock for their assistance for research for this essay.

1. On Picasso's spring 1911 exhibition at 291, see pages 117–125. The Armory Show contained a small *Head of a Man* from 1912; otherwise the rest of Picasso's work was from 1910 or earlier. See Milton Brown, *The Story of the Armory Show*, New

York, 1963, 145–159 and 276. Braque was represented by minor works of 1906 and 1908, and by his spring 1912 masterpiece, *Violin: "Mozart/Kubelick"*; see Brown 1963, 225–226.

2. John Richardson, with Marilyn McCully, *A Life of Picasso, Volume II: 1907–1912*, New York, 1996, "Collectors, Dealers and the German Connection," especially 313–320.

3. As Richardson suggests (1996, 295–296), Kahnweiler's decision not to use 291 as his American representative may have been influenced by Stieglitz's unimpressive record in selling the Picassos exhibited in 1910.

4. See de Zayas' letters to Stieglitz of 22 and 26 May 1914, reproduced in Marius de Zayas, *How, When, and Why Modern Art Came to America*, Cambridge and London, 1996, 169–171. Ironically, given his condemnation of Kahnweiler's "commercialism," de Zayas himself would open the Modern Gallery in New York a year later, in order, he said, to develop "the interest of the public in modern art from a commercial point of view," in contrast to 291, which was to continue as "a place for experiments" (that is, a non-commercial gallery). De Zayas to Stieglitz, 1 September 1915, reproduced in de Zayas 1996, 196.

5. See the discussion of this project in William A. Camfield, *Francis Picabia: His Art, Life, and Times*, Princeton, 1979, 54, 62–63.

6. In a letter reprinted in de Zayas 1996, 170–171, de Zayas writes that "Picabia and Mme Picabia have about 18 of his [Picasso's] paintings 8 of which are of his latest style and very well selected they are willing to let you have them and sell them if there are any offers." In de Zayas' subsequent letters, it becomes apparent that it is really Mme Picabia alone with whom he is negotiating the terms of the loan.

7. De Zayas wrote on 30 June: "It is all arranged with Mrs. Picabia to send all the Picassos she has.... After long talk with Picabia we have agreed that in order to make the exhibition complete some paintings of Braque ought to be shown at the same time." Anticipating Stieglitz's criticism, de Zayas conceded, "It is true that Braque is a satellite of Picasso," but insisted that "Picasso owes very many things to Braque.... I am sure that you will not hesitate in exhibiting both together, so I have asked Mrs. Picabia to lend us the Braques she has" (de Zayas to Stieglitz, 30 June 1914, reproduced in de Zayas 1996, 180). De Zayas' lukewarm commitment to Braque is also evident in the notice about the exhibition published in *Camera Work* 48 (October 1916): "From December ninth, 1914, to January 11, 1915, there was shown in the little room examples of the most recent work of Picasso, and of Braque, for some time the working companion of Picasso. For the past few years these two men collaborated in new researches. De Zayas says: 'Braque has often been accused of simply being a faithful copyist of Picasso. But while it is true that he has followed Picasso's method of painting it is also true that he has paid his debt by bringing to Picasso contributions of a very personal nature.' The Braques and Picas-

sos shown were from the private collection of Francis Picabia. There were paintings in oil and drawings in charcoal."

8. It was accompanied by "An Exhibition of Archaic Mexican Pottery and Carvings in Stone" from de Zayas' collection, and also by an exhibition of carved insignia or "kalogramas" by the Mexican artist Torres Palomar. The nature of these "kalogramas" is clarified by the review in *American Art News* 13, 10 (12 December 1914), 2, where the writer states that: "The little gallery also hangs a small exhibition of Monograms (Kalogramas), by a Mexican artist, Torres Palomar, who has designed monograms for Nazimova, Pavlova, Pierre Loti, 'La Belle Otero,' and a score of other celebrities."

9. Henry McBride, *New York Sun*, 20 December 1914, 92.

10. Richardson 1996, 349, notes that Basler had visited New York before the outbreak of World War I; needing a loan from Stieglitz, he left a group of nine Picasso drawings, along with a small painting by Rousseau, as collateral. The correspondence between Basler and Stieglitz, preserved at Beinecke Library, Yale University, records their dispute over how many works Stieglitz would retain in return for canceling the debt. Basler's letter of 13 April 1915 proposes that Stieglitz either keep five of the drawings, to cover the value of the loan, or send him "another 400 dollars (2000 frs) to complete the price of these drawings by Picasso & of the picture by Rousseau." In his response of 7 May Stieglitz recalls that Basler had originally proposed that he buy the group of nine Picassos and one Rousseau for $1,000. When Stieglitz said he was unable to do this, Basler had offered him the group for $575; alternatively, he requested that Stieglitz try to sell the pictures individually, for prices totaling this amount. Instead, Stieglitz had offered Basler a loan of $300, with the pictures serving as collateral, to become his if the loan was not repaid, with interest, by 1 June 1915. Stieglitz says that his recollection of this agreement is confirmed by Paul Haviland and Marius de Zayas. He therefore rejects Basler's request that he pay another $400 to complete his purchase of the original group. (This would bring the total price to $700, greater than the $575 price Basler had set on the group while in New York.) For the same reason, Stieglitz rejects Basler's suggestion that the $300 advance should be considered to cover just *some* of the pictures, and that the others should be returned to Paris. Stieglitz offers instead to give Basler a three-week extension on his loan. Basler's response of 29 May acknowledges that Stieglitz is correct about the original terms of the loan, but appeals to him to revise them. On 24 June, Stieglitz writes that he will willingly forgo the interest, will further extend the loan, and will return the Rousseau. On 6 July, Basler asks Stieglitz to return the Rousseau and also two Picassos, "the big still life (*nature morte*) the Hiacynths [sic] & the big head of a woman" (fig. 68 and pl. 5?). The remaining seven Picassos, he estimates, will be worth at least 1,000 francs ($250), a sum roughly equal to the amount of the loan. Stieglitz does not respond to this letter. On 11 October,

Basler writes again to say that he is "astonished" at Stieglitz's silence, and accuses him of "usury." Finally, on 5 November, Stieglitz responds, saying that Basler is a liar, and—worse than that—not a gentleman. The exchange (which also includes heated discussions of the changing values of money and of art) receives a coda in 1926, when Basler writes Stieglitz to request his Rousseau, which Stieglitz had forgotten to return.

11. Most of the works in Stieglitz's collection that derived from his loan agreement (or rather disagreeement) with Basler can be identified thanks to Basler's letters of 13 April and 6 July 1915, which propose that Stieglitz keep "the two big cubistic heads, those two small cubistic drawings, and the head study for the sculpture," and return two other works, "the big still life (*nature morte*), the Hyacinths, and [the] big head of a woman." Of this list, the "two big cubistic heads" (pls. 56, 54) are now in the Stieglitz Collection at The Metropolitan Museum of Art, along with the "two small cubistic drawings" (fig. 69 and The Metropolitan Museum of Art). The two drawings Basler wanted Stieglitz to return—the "big head of a woman" (pl. 53) and the still life of a hyacinth (fig. 68)—are also now in the Metropolitan. The "head study for the sculpture" is in the Art Institute of Chicago (pl. 55). This leaves two out of the nine Basler works unaccounted for. One of these could very well be a pen and ink study of a harlequin at The Metropolitan Museum of Art. The other may be the "impression of the 'Apaches'" mentioned in a review of the Picabia-Picasso show; however, this may have been a print of *The Frugal Repast* held over from the earlier exhibition of works from the Picabia collection (see n. 12 below).

12. The work is mentioned in *American Art News* 13, 10 (12 December 1914), 2. For Stieglitz's purchase, see Alfred Barr Jr., *Picasso: Fifty Years of His Art* [exh. cat., The Museum of Modern Art], New York, 1946, 31. For the printing history, see Bernhard Geiser and Brigitte Baer, *Picasso: Peintre-Graveur*, 2 vols., Bern, 1990–1992, 1:2. The collection files of the Art Institute of Chicago give the title of the work as *Le Repas Frugal (Les Deux Amis)*.

By a process of elimination, this suggests that the Picabia stock of Picasso's was oriented toward works of 1912–1913: the drawing of a *Violin* (pl. 58), *Still Life: Bottle and Glass on Table* (fig. 71), and the canvas of a *Violin and Guitar* (fig. 72), as well as the 1909 *Bathers in a Forest* (pl. 52).

13. For the reviews mentioning *The Frugal Repast*, see notes 38 and 40 below.

14. The watercolor of the *Circus Family* (The Baltimore Museum of Art, The Cone Collection) is reproduced in Daix-Boudaille, XII.18; it seems to have been based on the etching *Les Saltimbanques* (Geiser/Baer, 9), rather than the other way round. The composition is completely rearranged in the large canvas of *The Saltimbanques* (National Gallery of Art, Washington, Daix-Boudaille XII.35).

15. William Rubin, "Picasso," in *Primitivism in Twentieth-Century Art*, New York, 1984, 1:260–271. The Kota figure was presumably part of the group of African sculptures from Paul Guillaume's collection that de Zayas had brought back from Paris along with the Picassos and Braques from the Picabia "collection."

16. Daix-Rosselet 54. The composition of *Bathers in a Forest* (pl. 52) combines the two figures of *Friendship* (Daix-Rosselet 104) with a variant of the *Three Women* composition (see Daix-Rosselet. 124, 131). According to Judith Zilczer, *John Quinn: Patron of the Avant Garde* [exh. cat., Hirshhorn Museum and Sculpture Garden], Washington, 1978, 177, Quinn bought this gouache from 291 in July 1915 for $115. It was not part of the 1911 exhibition: Stieglitz said that only two works from that show were purchased, one by Hamilton Easter Field and the other by himself. Nor does it seem to have been part of the Basler collection; see n. 11 above. It would seem, by a process of elimination, to have been part of the Picabia stock exhibited in December 1914–January 1915.

17. This full-length figure is essentially a variant on the winter 1908–1909 *Bather* from the Louise Reinhardt Smith Collection, now in The Museum of Modern Art, New York (Zervos vi.1072).

18. This should be compared with the realistic drawing, Zervos xxvi.397, and the more abstract variant, Zervos xxvi.398, as well as the gouache version in D.R. 251.

19. 10 July 1912, Picasso to Braque, translated in Judith Cousins, with Pierre Daix, "Documentary Chronology," in William Rubin, *Picasso and Braque: Pioneering Cubism* [exh. cat., The Museum of Modern Art], New York, 1989, 399.

20. For the review, see n. 35, below. *Guitar and Wine Glass* (D.R. 513) is recorded in Kahnweiler's photo files, but seemingly not in his stockbook. It has no recorded provenance before its present collection, the Marion Koogler McNay Art Institute, San Antonio, Texas. It thus seems possible if not likely that it passed through 291. It seems likely that the exhibition at 291 was also the source for other pictures that seem to have arrived in American collections without passing through Kahnweiler's gallery; however, some of these may be works sold by Picasso before entering into his exclusivity agreement with Kahnweiler.

21. Notes on "Alfred Stieglitz Collection" label on back of work, reproduced in the files of the Metropolitan Museum of Art. Stieglitz's notes also indicate that the picture came from the Picabia collection, and was included in the first December–January exhibition.

22. On Zoler, see Richard Whelan, *Alfred Stieglitz: A Biography*, New York, 1995, 307–308, 335, 337, 338, 511–512, and Sue Davidson Lowe, *Stieglitz: A Memoir / Biography*, New York, 1983, 177–178.

23. *New York Times*, 20 December 11; this review is discussed at length below. De Zayas 1996, 246, also mentions the painting's presence in the exhibition. This is quite surprising, since the picture is recorded in Kahnweiler's gallery stock, and Kahn-

weiler refused to lend to 291. (*Violin and Guitar* appears in photo no. 238 of the Kahnweiler archives, under the title *Deux Instruments aux musique*; it appears as no. 1218, *Deux instruments*, in Kahnweiler's stockbook.) Perhaps Picasso found some excuse for reclaiming the picture from Kahnweiler, and then sent it to New York via the Picabias.

24. Braque's *papier collé* does not appear in the records of the Kahnweiler Gallery; it may well have gone directly from the artist to the Picabias and thence to Stieglitz and the Arensbergs.

25. The provenance of this work is somewhat confusing. According to the entry in Isabelle Monod-Fontaine with E. A. Carmean Jr., *Braque, the papiers collés* [exh. cat., Centre Georges Pompidou and National Gallery of Art], Washington, 1982, 25, it entered the Dreier Collection in 1926, possibly acquired from Pierre Loeb in Paris. Loeb might have acquired it either from the Picabias (after its New York exhibition) or from Braque. It does not seem, in any case, to have passed through Kahnweiler's gallery. Other works that first appear in French collections, although they do not appear to have been handled by Kahnweiler, include Romilly 191, 195, 196, 221, 227, 240, and 241; for more information on some of these works, see the entries in Washington 1982, nos. 4, 38, 40, 42, 51. It is conceivable that some of these were shown at 291 and then returned to France.

26. Lowe 1983, 163, writes that "Davies was one of only a handful of regular purchasers from 291, and persuaded others to buy as well."

27. Henry McBride, in the *New York Sun*, 20 December 1914, 92.

28. Stieglitz to Gabrielle Picabia, 30 December 1914, YCAL.

29. See Richardson 1996, 2:360–361. The checklists of the Modern Gallery's exhibitions of Picasso, "Negro Sculpture," and Picabia are given in de Zayas 1996, 135–136.

30. Kenyon Cox, "The 'Modern' Spirit in Art: Some Reflections Inspired by the Recent International Exhibition," *Harper's Weekly* 57, 10 (15 March 1913).

31. Frank Jewett Mather Jr. in the *Independent* of 6 March 1913 (quoted in Brown 1963, 177).

32. Anonymous review, *New York Tribune*, 20 December 1914, part 3, 3. In a separate review, published in the issue of 13 December 1914, part 3, 3, the *Tribune* reviewer noted that Picasso's and Braque's work was being shown in tandem with "some archaic Mexican pottery," adding that: "the relation, of course, is obvious."

33. *Evening Post* of 26 December 1914, 6.

34. *New York Herald*, 14 December 1915. The writer adds: "In the same gallery, however, is a sincere little exhibition of archaic Mexican pottery provided by Mr. M. de Zayas. They at least are a genuine 'expression' of a people whose crudity was not assumed."

35. See n. 34. It may sound as if the critic is parodying Stieglitz's position here, but he isn't. Stieglitz's attitude toward critical explanation is demonstrated in a passage from the 1913

book, *A Study of the Modern Evolution of Plastic Expression*, by his friends and collaborators Marius de Zayas and Paul Haviland. They recount (18) how a visitor to 291 one day asked him to explain the watercolors by John Marin he was then showing. Refusing, Stieglitz asked his visitor whether she liked oysters. "I am very fond of them," she replied. Could she explain *why* she liked oysters, Stieglitz demanded? No, she admitted, she couldn't. "Neither can I explain to you the pleasure I get from a painting or a statue," said Stieglitz.

36. Charles Caffin, "Picasso's Latest Pictures of Intellectualized Sensations," *New York American* of 14 December 1914.

37. Henry McBride, in the *New York Sun*, 20 December 1914, 92.

38. *American Art News* 13, 10 (12 December 1914), 2. The writer goes on to note that the "same fine feeling exists [in *The Frugal Repast*] as in the other [more recent] drawings, only, in the etching, it is obscured by the descriptive quality of the picture"(a reversal of traditional values worthy of Clive Bell or Roger Fry).

39. See n. 38.

40. *New York Times*, 20 December 1914. I have attributed this review to Elizabeth Luther Carey because she is cited in *Camera Work* 48 (October 1916) as the author of the *New York Times* review of the Picabia show that immediately followed the Picasso-Braque show at 291. Carey takes an appropriately skeptical attitude toward the assertion that *The Frugal Repast* looks like a Daumier, writing: "There is an early drawing by Picasso in the exhibition which is said to look like a Daumier and does resemble the work of that great master in the fine gradation of the blacks but certainly in no other particular, and not at all as a whole. There is a tale that Picasso faked Daumiers when he was so poor that even the small sums commanded by the caricaturist meant something to him. Perhaps he did. One could hardly think of his doing specious little Corots or tambourine girls by Diaz. If he faked any one, he probably faked Daumier."

41. This praise of Picasso's draftsmanship is linked, however, to a fundamental criticism of cubism. Carey complains that there is something misguided in Picasso's combination of abstraction and representation. Here, she echoes the reviewers who criticized the cubists at the Armory Show for creating the visual equivalent of program music, and paraphrases Michael T. H. Sadler's introduction to Wassily Kandinsky, *Concerning the Spiritual in Art*, trans. 1914; reprinted New York, 1977, xvii and xx.

42. Leo Stein, *Appreciation: Painting, Poetry & Prose*, New York, 1947; reprinted Lincoln, Nebr., 1996, 188. Similarly, Kahnweiler recalled that, "Already in spring 1914 Picasso had shown me two drawings which were not Cubist but classicist, drawings of a seated man. He had said: 'Still, they're better than before, aren't they?' ... [He meant:] it's better than the classicist, or if you will, the naturalistic drawings that I did before." Daniel-

Henry Kahnweiler, with Francis Crémieux, *My Galleries and Painters*, Paris, 1961, trans. New York, 1971, 54.

43. Elizabeth Luther Carey, "Picabia and Picasso," *New York Times*, 24 January 1915, section 5, 11. Carey's detailed review of Picasso's career suggests that she had studied his work not just in New York but also in Germany. She provides detailed descriptions of two 1905 paintings, *Le Lapin Agile*, acquired by Alfred Flechtheim in 1912, and *Boy with a Pipe*, owned by Paul von Mendelssohn (although she calls the latter a "young girl with her head crowned with flowers").

44. As Carey notes, the inclusion of actual newspaper or wallpaper is an alternative to a painted reproduction of the same material: "In Picasso's paintings we find usually a bit of material representation, or else the material thing itself."

45. Carey's comment about Picasso placing "a band of roughness next to a band of smoothness, to stimulate our tactile sense" is followed by the comment that: "Rodin does this [i.e., he alternates rough and smooth areas], but in a way to which we have become accustomed, so that Rodin's way has passed into a convention, and Picasso's way presently will pass into a convention."

46. Dora Vallier, "Braque, la peinture et nous: propos de l'artiste recueillis," *Cahiers d'Art* 29, 1 (October 1954), 22.

47. Jacques Lassaigne, "Entretien avec Braque," 1961, published in *Les Cubistes* [exh. cat., Galerie des Beaux-Arts, Bordeaux], Paris, 1973, xvi–xvii.

PICABIA

Anyone writing on New York dada is profoundly indebted to the many superb publications on this subject by Francis M. Naumann and William A. Camfield. In addition, I would like to thank Charles Brock, Alejandra Munizaga, and Kathleen Mrachek for their indispensable assistance with research for this essay. The title of my essay is adapted with apologies from Tracy Kidder, *The Soul of a New Machine*, Boston, 1981.

1. "French Artists Spur on American Art," *New York Tribune*, 24 October 1915, part 4, 2; cited in part in William A. Camfield, "The Machinist Style of Francis Picabia," *Art Bulletin* 48 (September–December 1966), 309, and in Camfield, *Francis Picabia: His Art, Life and Times*, Princeton, 1979; a more extensive citation is in William Rozaitis, "The Joke at the Heart of Things: Francis Picabia's Machine Drawings and the Little Magazine 291," *American Art* 8 (summer–fall 1994), 46.

2. As noted in Camfield 1966, 320. Max Ernst, for instance, discovered Picabia's machine drawings in 1919 and adopted them as the point of departure for his own dada drawings.

3. Ileana B. Leavens, *From "291" to Zurich*, Ann Arbor, 1983, 138, exceptionally rejects the use of the term "dada" to describe Picabia's machine drawings of 1915, on the grounds that the

Zurich dadaists would not have endorsed the machine aesthetic before 1918.

4. See especially Francis M. Naumann, *New York Dada: 1915–23*, New York, 1994; Camfield 1979; and William A. Camfield, *Marcel Duchamp: Fountain*, Houston, 1989.

5. For a discussion of the exhibition of works from Basler's collection, see the previous essay in this volume.

6. As William Camfield notes (in Camfield 1979, 67 and 74), Stieglitz had begun to invest less energy in 291 when the building housing it was scheduled for demolition; although this was postponed, Stieglitz increasingly assumed the role of "honored sage and advisor, while initiative was taken by his younger associates, Paul Haviland, Marius de Zayas, and Agnes Meyer," who proposed the "experiments" of the journal 291 and the Modern Gallery. As Camfield says, "Without Stieglitz's approval, they might not have materialized, but he had planned neither of them, and, in a respectful way, they were critical of him." Leavens 1983, 124, suggests that Stieglitz was concerned that de Zayas might request financial support for the Modern Gallery, but this proved not to be an issue because Agnes Meyer backed the project. Leavens 1983, 125, also underscores the fact that Stieglitz's gallery was operated on a non-commercial basis, while the Modern Gallery took a ten percent commission on all sales. On the tensions between Stieglitz and de Zayas, Meyer, and Haviland, see Leavens 1983, 132–133.

7. Letter from Stieglitz to the painter Arthur B. Carles, 13 April 1913 (Alfred Stieglitz Archives, Yale), cited in Camfield 1979, 56.

8. "[An] understanding friend managed to save him from the barracks by entrusting him with an important mission to Cuba. He was to go by way of New York, and set sail in April 1915. Meeting Marcel Duchamp and a group of old-time friends in New York, he forgot his mission and pursued his voyage no further. This total incomprehension of the exigencies of war might have turned out very badly for him if, thanks to his dissipated life in New York, he had not fallen gravely ill. He profited by a temporary discharge which, from medical board to medical board, carried him to the end of the war." (Gabrielle Buffet-Picabia, "Some Memories of Pre-Dada: Picabia and Duchamp," in Robert Motherwell, ed., *The Dada Painters and Poets: An Anthology*, New York, 1951, 258.)

9. Pierre Cabanne, *Dialogues with Marcel Duchamp*, trans. Ron Padgett, New York, 1971, 32–34, 61–62.

10. Machine imagery first appears in Duchamp's work with his *Coffee Grinder* of 1911, but this is executed in a relatively painterly, "artistic" style. The *Chocolate Grinder* of 1914 seems to mark the first occasion in which machine imagery is combined with a clean, mechanical style.

11. Camfield 1979, 54, 62–63.

12. For the history of the painting's reception, see Leo Steinberg, "Resisting Cézanne: Picasso's 'Three Women,'" *Art in America* 66 (November–December 1978), 115–117.

13. As noted in Cabanne 1971, 29 and 34, Duchamp's immediate inspiration for the imposition of white lines on his canvases came from the motion-study photographs of Etienne-Jules Marey, tracing the movements of men walking or fencing while dressed in black suits with white lines painted on them. Translated onto canvas, however, these lines acquire a striking resemblance to tubes, struts, and wires. Marey's best known photographs trace the movements of men walking or fencing, but it is possible that Duchamp was also familiar with Marey's studies of a man riding a bicycle. See Marta Braun, *Picturing Time: The Work of Etienne-Jules Marey (1830–1904)*, Chicago, 1992, figs. 116 and 117B; the second of these shows a bicycle on a test stand in Marey's laboratory in 1895—an object strangely premonitory of Duchamp's first ready-made.

14. "Mr. Picabia Paints 'Coon Songs': Futurist Painter Exhibits Fourteen Works That Are His Impression of New York," *New York Herald*, 18 March 1913, 12.

15. Camfield 1979, 59–60, cites a letter to Stieglitz of 16 June 1913, in which Picabia says that he is working on a large painting "concentrating" the studies shown at 291. Camfield suggests that the canvas in question is either *I See Again in Memory My Dear Udnie* or *Edtaonisl*. But it is possible that it is *This Has to Do with Me* (pl. 61), which includes intersecting sticklike forms similar to those in the spring 1913 drawing *New York* (Camfield 1979, fig. 72).

16. Camfield 1966, 313; and Camfield 1979, 69.

17. Linda Dalrymple Henderson, "Reflections of and/or on Marcel Duchamp's *Large Glass*," in Francis M. Naumann, with Beth Venn, eds., *Making Mischief: Dada Invades New York* [exh. cat., Whitney Museum of American Art], New York, 1996, 232.

18. Remy de Gourmont, *Physique de l'amour*, translated by Ezra Pound as *The Natural Philosophy of Love*, New York, 1922–1932, 28; cited in Henderson 1996, 232.

19. Gourmont 1922–1932, 30–31, 85.

20. See the summary of Jarry's *The Supermale* in Camfield 1979, 26, n. 26. Camfield also discusses the influence on Picabia of machine imagery in the writings of Bergson, Nietzsche, and Roussel.

21. *New York Tribune*, 17 January 1915, and 20 December 1914, part 3, 3.

22. *New York Herald*, 18 January 1915, 13.

23. "Points on Picasso," *American Art News* 13 (16 January 1915), 2.

24. *The New York Times*, 24 January 1915, section 5, 11.

25. Camfield 1979, 80. Although the drawing has occasionally been placed in 1913 or 1914, Camfield argues persuasively for a 1915 dating.

26. Paul Haviland, "We are living in the age of the machine," *291* 7–8 (September–October 1915), 1.

27. De Zayas' drawing is sometimes entitled *Femme!* on the basis of the inscription in its upper left corner. Willard Bohn, "The Abstract Vision of Marius de Zayas," *Art Bulletin* 62 (September 1980), 451, argues that the inscription *Elle*, at lower right, should be regarded as the title, because it functions as the visual mirror image of the word *Elle* in Picabia's drawing. Bohn's insightful analysis of the two works argues for a strong link between them. The November 1915 exhibition of the two works is established by a review in *Arts and Decoration* (November 1915), 35; cited in Naumann 1994, 62.

28. Naumann 1994, 62, and Camfield 1979, 85.

29. Leavens 1983, 136, states that de Zayas' original maquette for this issue placed his own poem on the first page, Picasso and Braque on the inside, and Picabia's drawing on the back cover.

30. Dora Vallier, "Braque, la peinture, et nous," *Cahiers d'art* 29 (October 1954), 16.

31. Braque had introduced the motif of a projecting nail in his winter 1909–1910 canvases, *Violin and Pitcher* and *Violin and Palette*; Picasso took to repeating it as a kind of private joke between himself and Braque. It also reappears, for instance, in his spring 1913 sketch of a guitar or cello on a table (Zervos xxviii.339).

32. Picasso's *Guitar on a Table* (fig. 78) belonged to Gertrude Stein and would have been visible at her rue de Fleurus salon. Camfield 1979, 66, records Picabia's contacts with Stein in spring 1914. Picabia might also have seen other works from this series, such as the drawing *Bottle of Bass and Guitar* (D.R. 511) at Picasso's studio. William Camfield makes a telling comparison between Picabia's *Fantasy* and a nineteenth-century illustration of a beam steam engine (Camfield 1979, fig. 103); this may well have been one of several multiple sources for Picabia's image, but the style of *Fantasy* is closer to cubism than to nineteenth-century illustration.

33. Camfield 1979, 44, and illus. 7. Like Marius de Zayas, Gelett Burgess was both a humorist and a student of cubism. The inventor of the word "blurb" (and numerous other nonsense terms), he was also the author of an article on "The Wild Men of Paris," published in *The Architectural Record* 27 (May 1910), 400–414, describing his visits, in 1908, to the studios of Picasso, Braque, Matisse, Derain, and other avant-garde painters.

34. The analogy between machine parts and the curved forms of 1908–1909 cubism first becomes explicit in the early "tubist" canvases by Fernand Léger, such as his 1909–1910 *Nudes in the Forest*, and in 1912–1913 pictures by Kasimir Malevich, such as *Taking in the Rye*.

35. It is questionable whether the cubist *Jeune Fille* of 1912, reproduced in *Francis Picabia* [exh. cat., Centre National d'Art et de Culture Georges Pompidou, Musée Nationale d'Art Moderne], Paris, 1976, 5, pl. 22, should be regarded as a portrait. Beyond this, it may be necessary to go back to the *Espagnole* of 1902 (Camfield 1979, fig. 8) to find a portrait by Picabia.

36. See Bohn 1980.

37. Leavens 1983, 128.

38. See, for instance, the poem-drawing *Flirt* by de Zayas and Agnes Meyer, in the second issue, and the drawing of a "Coq Gaulois " by Edward Steichen, in the third issue. These stand in marked contrast to the texts accompanying them, which are often sententious or just plain sappy. Bohn 1980, 449, also links Picabia's "humorous" drawings with *Flirt*.

39. Henri Bergson, "Laughter," 1900, translated in Wylie Sypher, ed., *Comedy*, Garden City, 1956, 79. Caricature is discussed on pages 74–79. Bergson's relevance to Picabia's machine imagery was first noted in Camfield 1966, 311. Bergson's essay was clearly familiar to the Stieglitz circle, since an excerpt from it (although one concerned with artistic creation rather than humor) was published in *Camera Work* 37, as noted in Camfield 1979, 53.

40. Bergson in Sypher 1956, 81.

41. Buffet-Picabia 1951, 258, seems to have been the first to note that the items in Picabia's "object portraits" are depicted "with the precision and relief of a mail order catalogue, with no attempt at aesthetic expression. They are distinguished from catalogue representations only by their isolation and by the intentions with which they are charged." Leavens 1983, 35, discusses the increasing use of diagrams in the journalism of the day.

42. Camfield 1966, 315 and fig. 12.

43. In conjunction with the phrase "Je suis venu sur les rivages du Pont-Euxin," the exclamation "De Zayas! De Zayas!" seems like a paraphrase of the Greek exclamation, "Thalassa! Thalassa!" in Xenophon's *Anabasis*. Jean Hubert Martin, "Ses tableaux sont peints pour raconter et non pour prouver," in Paris 1976, 40–49, demonstrates that this and other gnomic phrases in Picabia's machine drawings were taken from a list of Latin and other foreign phrases in the *Petite Larousse*. It is possible that the corset inserted by Picabia at the upper left of his image was inspired by the "realistic" drawing of a woman, from an advertisement, that appears in Picasso's *papier collé Au Bon Marché* (D.R. 557), of early 1913.

44. Buffet-Picabia 1951, 258. Homer 1975, 110–115; Homer buttresses his reading by noting that Meyer was known for driving her own limousine, an unusual act for a rich woman of that era. Bohn 1980, 449, supports his reading by identifying Picabia's *Jeune fille* with the "Flirt" satirized in the poem-drawing by de Zayas and Meyer, published in *291*, no. 2.

45. Robert J. Cole, *Evening Sun*, 12 October 1915, 8; cited in Camfield 1979, 83. In an earlier passage of the review, not cited by Camfield, Cole writes: "From 291 Fifth avenue comes a sheaf of large unbound papers containing many words about art, many marks that evidently meant something to the men that made them and finally a genuine beautiful and moving picture, 'The Steerage,' by Alfred Stieglitz [published in *291*, nos. 7–8]. It is alive, it is true, it speaks to the mind and to the soul."

46. Wanda Corn, *The Great American Thing*, Berkeley, 1999, 23. Similarly, Richard Whelan, in *Alfred Stieglitz: A Biography*, New York, 1995, 349–350, describes Picabia's subject as "a broken camera that lies on its back, its detached bellows drooping like an impotent penis, unable to penetrate the vaginal lens opening." Earlier critics interpret the image in more or less the same fashion, although usually without underscoring the erotic metaphor. See Marcia Brennan, "Alfred Stieglitz and New York Dada: Faith, Love and the Broken Camera," *History of Photography* 21 (summer 1997), 156, n. 6; Rozaitis 1994, 48; Naumann 1994, 60; and Camfield 1979, 83, who credits the identification of the gearshift and parking brake to Paul Schweitzer.

47. The original advertisement for a "Vest Pocket Kodak" is reproduced in Homer 1975, fig. 6, and also in Kirk Varnedoe and Adam Gopnik, *High and Low: Modern Art and Popular Culture* [exh. cat., The Museum of Modern Art], New York, 1990, 269.

48. Marius de Zayas, untitled text in *291* 5–6 (July–August 1915), 6.

49. See n. 1.

50. See "Picabia Again in the Ring," *American Art News* 14 (8 January 1916), 3; "Picabia's Puzzles, " *Christian Science Monitor* (Boston), 29 January 1916, 13; Frederick W. Eddy, untitled review, *The World* (New York), 9 January 1916, section 2, 3. Henry McBride, the critic for *The Sun*, gave the exhibition an ambivalent review in the issue of 16 January 1916, section 3, 7, and then returned to it more enthusiastically in the issue of 23 January 1916, section 5, 8.

51. As Whelan 1995, 383, writes: "Although Stieglitz and Francis still remained friends...the photographer could certainly no longer view his friend as one of the 'cleanest propositions' ever, for he was suffering bouts of delirium tremens, was more addicted than ever to opium and cocaine, and was having a tumultuous affair with Isadora Duncan."

DUCHAMP

I am again indebted to the many superb publications on Duchamp and on New York dada by Francis M. Naumann and William A. Camfield. I would also like to thank Charles Brock for his generous assistance with research for this essay.

1. Francis M. Naumann, *New York Dada: 1915–23*, New York, 1994, 176–177; William A. Camfield, *Marcel Duchamp: Fountain*, Houston, 1989, 14–20. For a recent overview of the still burgeoning literature on Duchamp, see Sheldon Nodleman, "The Once and Future Duchamp," *Art in America* 88 (January 2000), 37–43.

2. Beatrice Wood, *I Shock Myself*, San Francisco, 1988, 29–30; cited in Camfield 1989, 25, and Naumann 1994, 184.

3. Camfield 1989, 34, and Naumann 1994, 184, note that a 19 April 1917 letter from Stieglitz to Henry McBride invites him to

come to "291" to see both his photo of the *Fountain* and the original object.

4. Pierre Cabanne, *Dialogues with Marcel Duchamp*, New York, 1971, 54–55.

5. Camfield 1989, 28–29, citing Francis M. Naumann, in "Affectueusement, Marcel," *Archives of American Art Journal* 22, 4 (Washington, 1982), 8, notes that Duchamp wrote his sister about the brouhaha on 11 April, the day after the opening of the Independents, saying that a "porcelain urinal" had been sent in by "one of my female friends under a masculine pseudonym."

6. Arturo Schwarz, *The Complete Works of Marcel Duchamp*, New York, 1997, cat. 345.

7. Otto Hahn, "Passport No. G255300," *Art and Artists* (London), 1, no. 4 (July 1966), 10; cited in Schwarz 1997, cat. 345, and in Camfield 1989, 23.

8. Schwarz 1997, cat. 345. Camfield 1989, 21–22, suggests that Duchamp and his friends may have purchased the fixture at a Mott outlet store on lower Fifth Avenue. Kirk Varnedoe and Adam Gopnik, in *High and Low: Modern Art and Popular Culture* [exh. cat., The Museum of Modern Art], New York, 1990, 273–278, argue that the Mott company did not make any model corresponding exactly to the urinal visible in Stieglitz's photography. But Camfield 1989, 23, reproduces a very similar fixture, illustrated in a 1902 catalogue of the J. L. Mott Iron Works ("Heavy Vitro-adamant Urinal," model 839-Y).

9. Camfield 1989, 20–21, discusses Duchamp's earlier experience with censorship at the 1912 Paris Salon des Indépendants, and its role in determining his actions in 1917.

10. 1962 letter from Duchamp to Hans Richter, quoted in Richter, *Dada Art and Anti-Art*, New York, 1965, 207–208, cited in Camfield 1989, 42–43. Camfield also cites Duchamp's remarks at a 1961 panel at The Museum of Modern Art: "the choice of these 'readymades' was never dictated by an esthetic delectation. This choice was based on a reaction of visual indifference . . . a complete anesthesia."

11. Camfield 1989, 37, discusses the problematic authorship of this text. See Varnedoe and Gopnik, in New York 1990, 277, suggesting that the author may have been paraphrasing a plumbing catalogue, published in May 1915 by the Trenton Potteries Company, which stated on its cover: "Someone has said that, so far, the great contribution of America to Art is the pure white American bathroom."

12. Camfield 1989, 35, is the first to publish this identification, but credits it to Francis M. Naumann.

13. Richard Whelan, *Alfred Stieglitz: A Biography*, New York, 1995, 382.

14. Wanda Corn, *The Great American Thing*, Berkeley, 1999, 76.

15. Duchamp's note was published in *Salt Seller: The Writings of Marcel Duchamp (Marchand du Sel)*, New York, 1973, 23; it is cited and discussed in Camfield 1989, 50.

16. As Camfield suggests in a long and thoughtful discussion of the sexual valence of *Fountain* (Camfield 1989, 53–59), the work's combination of masculine and feminine associations links it to Brancusi's *Princess X* of 1916, shown at the Modern Gallery the same year, and to other important works by artists such as Picabia, Man Ray, and Morton Schamberg. Earlier, on 43–44, Camfield suggests that a joint visit by Duchamp and Brancusi to the 1912 Salon de Locomotion Aérienne may have played an important role in the development of both artists' work.

17. See the photograph reproduced in Camfield 1989, 21, fig. 5.

18. Camfield 1989, 39, 53.

19. Helmholtz, for instance, noted that, "the instant we take an unusual position, and look at the landscape with the head under one arm, let us say, or between the legs, it all appears like a flat picture." From Heinrich Helmholtz, *Handbuch der physiologischen Optik* (1867), 7–9; cited in Paul Vitz, "Visual Science and Modernist Art," in Calvin F. Nodine and Dennis F. Fisher, eds., *Perception and Pictorial Representation*, New York, 1979, 137–138. Similarly, Rood observed that a landscape seen upside down "appears like a mass of beautiful patches of color heaped upon one another, and situated more or less in a vertical plane." From Ogden N. Rood, "On the Relation between our Perception of Distance and Color," *American Journal of Science* (2d series), vol. 32 (1861), 184; cited in Vitz 1979, 137.

20. Lilla Cabot Perry, "Reminiscences of Claude Monet from 1889 to 1909," *The American Magazine of Art*, March 1927, reprinted in Charles F. Stuckey, ed., *Monet: A Retrospective*, New York, 1985, 183.

21. Kandinsky, *Reminiscences*, 1913, trans. by Hilla Rebay and adapted by Robert L. Herbert, in Robert Herbert, ed., *Modern Artists on Art: Ten Unabridged Essays*, Englewood Cliffs, N.J., 1964, 32.

22. *The Works of John Ruskin*, London, 1903–112, 15:27; cited in Jonathan Crary, *Techniques of the Observer: On Vision and Modernity in the Nineteenth Century*, Cambridge, Mass., 1990, 95.

23. The strategy of "abstracting" one's subject by rotating it was also employed by Picabia in a number of his 1913–1914 works. The flask in *Mechanical Expression Seen Through Our Own Mechanical Expression*, for example, seems to be "upside down," and Camfield 1979, 50, suggests that two other pictures, *New York Seen by the Body* and *Abstract Composition*, were worked in multiple orientations. Similarly the 1916–1918 composition *Fille née sans mère* (Camfield 1979, fig. 133) was made by inverting and overpainting the diagram of a locomotive's piston and driving wheel. This practice also seems to have played a significant role in advanced painting of the period 1920–1955; see the discussion in Pepe Karmel, "A Sum of Destructions," in Kirk Varnedoe and Pepe Karmel, eds., *Jackson Pollock: New Approaches*, New York, 1999, 75–76.

HARTLEY

1. Roxanna Robinson, *Georgia O'Keeffe: A Life*, New York, 1989, 136.

2. *My Dear Stieglitz: Letters from Abroad 1912–1915, Marsden Hartley to Alfred Stieglitz*, Jim Voorhies, ed., forthcoming. Letters cited in this essay may be found in this text.

3. Letter of 15 May 1914, 132.

4. Letter received 12 June 1914, 136.

5. Letter of 12 May 1914, 130.

6. Letter of 6 April 1915, 192.

7. Letter of 29 July 1914, 157.

8. Letter received 12 June 1914, 140.

9. Letter of 23 October 1914, 169.

10. Letter of 29 October 1914, 172.

11. Bruce Robertson, *Marsden Hartley*, New York, 1995, 120.

12. Letter of 15 March 1915, 188.

13. Letter of 29 October 1914, 171.

14. Letter of 9 November 1914, 177. "I find myself wanting to be an Indian—to paint my face with the symbols of that race I adore, to go to the west and face the sun forever—that would seem the true expression of human dignity."

15. Letter of 15 March 1915, 190.

16. Letter of 8 November 1915, 208.

17. Robert J. Cole, "Marsden Hartley's Heraldic Devices," *The Evening Sun*, Tuesday, 25 April 1916, 13.

18. "The Martial Spirit of Hartley," *American Art News*, 8 April 1916, 9. For some reason this has been identified as one of the 1914 portraits of German officers that pre-date the war. Rather, as the critic Charles Caffin makes clear in his review (see below), the painting was the record of "his sensations on hearing of the death of a friend's horse." Presumably, the horse is Freyburg's.

19. Henry McBride, "Current News of Art and the Exhibitions," *The Sun*, 9 April 1916, section 6, 8.

20. Charles Caffin, "Latest Work by Marsden Hartley," *New York American*, 17 April 1916, 8.

21. Marsden Hartley, *Somehow a Past: The Autobiography of Marsden Hartley*, ed. Susan Elizabeth Ryan, Cambridge, Mass., 1997, 92.

STRAND

1. See Alfred Stieglitz, "Photographs by Paul Strand," *Camera Work* 48 (October 1916), 11–12.

2. Strand apparently thought a checklist had been printed; see Maria Morris Hambourg, *Paul Strand: Circa 1916*, New York, 1998, 45, n. 64. However, while an announcement for the show was printed and while a handwritten list may have existed, it appears unlikely that a checklist was ever printed. No copy has ever been found in either Strand's or Stieglitz's extensive papers, and given the importance that both photographers attached to this exhibition, if a printed checklist had existed, one or the other would surely have preserved it.

3. These works, along with *City Hall Park*, match descriptions in exhibition reviews: see Charles Caffin, "Paul Strand in 'Straight' Photographs," *New York American*, 20 March 1916, 7, and Royal Cortissoz, "Random Impressions," *New York Tribune* 19 March 1916, section 3–4, 3. Both were reprinted in *Camera Work* 48 (October 1916), 58. Hambourg in *Paul Strand: Circa 1916* identifies four of these photographs as having been exhibited, but she omits *Winter, Central Park, New York*, even though it matches Cortissoz's description of a "snow-covered hillock, with its indefinite bushes." (For an illustration, see *Paul Strand* [exh. cat., Galerie zur Stockeregg], Zurich, 1987, pl. 1.) In addition, she notes that *Wall Street*, *Fifth Avenue and 42nd Street*, *Overlooking Harbor*, and *Telegraph Poles, Texas* were also shown, however, the sources she cites make no mention of these photographs. Naomi Rosenblum in "Paul Strand: The Early Years, 1910–1932," Ph.D. diss., City University of New York, 1978, 52, notes that *Wall Street* and *Fifth Avenue and 42nd Street* were exhibited. Although she provides no evidence to confirm this, her many conversations with Strand may have led her to this conclusion. *Wall Street*, *Telegraph Poles*, and *Fifth Avenue and 42nd Street* were reproduced in *Camera Work* 48 (October 1916), pls. I–III, along with *City Hall Park*, pl. VI, but nothing in the issue indicates that these were the works from Strand's earlier exhibition. In fact, Stieglitz had often used *Camera Work* to augment the ideas discussed at 291 and reproduced works that he had not or could not exhibit. Weston J. Naef, *The Collection of Alfred Stieglitz: Fifty Pioneers of Modern Photography*, New York, 1978, 473–474, notes that *Blind*, *Conversation*, and *Bowls* were shown but does not provide supporting evidence.

4. Given the bold, graphic strength of *Wall Street*, its symbolic importance, and the fact that Stieglitz awarded it first prize in the 1917 Wanamaker Exhibition, it seems likely that if it had been shown at 291 in 1916, one of the reviewers, especially Caffin who was close to Stieglitz and often parroted his ideas, would have commented on it. (For further discussion of the Wanamaker shows, see Sarah Greenough, *Paul Strand: An American Vision*, Washington, 1990, 166, n. 46.) However, no review of the show mentions it. Moreover, only two vintage prints of *Wall Street* exist; one each at the Philadelphia Museum of Art and the Canadian Centre for Architecture, and neither bears an inscription or label in Stieglitz's or Strand's hand indicating that it was shown. Two letters from Strand to Frederic L. Grayson, son of Strand's friend Harold Greengard, 29 November 1973 and 13 March 1974, in the collection of the Canadian Centre for Architecture, indicate the importance Strand assigned to this photograph, but again do not provide evidence that it was shown in 1916. While *Wall Street* from the Canadian Centre for Architecture, pl. 82, is signed and dated 1915, it is possible that the date

is incorrect for the numeral "5" looks as if it was originally written as a "6." Therefore, it is possible that the work was not made until after Strand's 291 show in March 1916, or that Strand had not yet made a print of it before the opening of the exhibition.

5. Royal Cortissoz, "Random Impressions," *New York Tribune*.

6. "Notes and News," *American Photography* 10 (May 1916), 281.

7. Charles Caffin, "Paul Strand in 'Straight' Photos," *New York American*, 20 March 1916, 7.

8. "The 1918 Wanamaker Spring Exhibition," *American Photography* 12 (April 1918), 231.

9. Stieglitz 1916, 11.

10. Stieglitz 1916, 11.

11. There were few other photographers whose work Stieglitz could have exhibited at this time. He had alienated other pictorial photographers, such as Karl Struss or Alvin Langdon Coburn, who were working with the same content and in the same character as Strand. And Stieglitz himself had not made enough new work since his 1913 show at 291, while other modernists, such as Charles Sheeler or Morton L. Schamberg, were not yet actively pursuing their photography.

12. Marius de Zayas, [Untitled], *291* 5–6 (July–August 1915), unpaginated.

13. For further discussion, see pages 203–219.

14. As quoted by Calvin Tomkins, "Paul Strand: Look to the Things Around You," *New Yorker*, 16 September 1974, 51.

15. Jacob Deschin, "Paul Strand: An Eye for Truth," *Popular Photography* 70 (April 1972), 73.

16. Anita Pollitzer to Georgia O'Keeffe, 1 January 1916, YCAL.

17. Stieglitz 1916, 11.

18. Stieglitz 1916, 11.

19. As quoted by Tomkins 1974, 51.

20. For further discussion, see Bonnie Yochelson, "Clarence H. White, Peaceful Warrior," in *Pictorialism into Modernism: The Clarence H. White School of Photography*, New York, 1996, 42–50.

21. Naomi Rosenblum conversation with Strand, 6 May 1975, as quoted in Hambourg 1998, 18.

22. Strand saw the Armory Show and, although it is not known whether he saw the 1913 exhibition of Stieglitz's photographs at 291, it seems highly likely that he would have seen Stieglitz's photographs reproduced in either the January 1913 issue of *Camera Work* or the October 1913 number, published in March 1914.

23. Deschin 1972, 71.

24. John Marin, [Untitled], *Camera Work*, nos. 42–43 (April–July 1913), 18.

25. Stieglitz to R. Child Bayley, 17 April 1916, YCAL.

26. *Paul Strand: Sixty Years of Photographs*, Millerton, N.Y., 1976, 144, and as quoted by William Inness Homer, *Alfred Stieglitz and the American Avant-Garde*, Boston, 1977, 246.

27. Tomkins 1974, 48.

28. Strand may have returned to this subject after he was released from the army. On 25 October 1919 Stieglitz wrote to Strand, "good to know you [are] at work with eggs & bowls[,] still-lifing to beat the Prussians & with the aid of Portrait Film"; YCAL.

29. Strand, as quoted by Lou Stettner, "A Day to Remember: Paul Strand Interviewed by Lou Stettner," *Camera 35* 16 (October 1972), 73.

30. As early as 1900 Sadakichi Hartmann had urged photographers to study New York City: "A Plea for the Picturesqueness of New York," *Camera Notes* 4 (October 1900), 91–97. See also, Harry A. Brodine, "Street Scenes," *The Photographic Times* 45 (February 1913), 49–53, and William S. Davis, "The Pictorial Possibilities of New York," *The Photographic Times* 47 (October 1914), 395–400.

31. For further discussion of these sources, see Rosenblum 1978, 58–61; Greenough 1990, 37; and Hambourg 1998, 34–37.

32. For further discussion of Strand's use of words and other symbols, see M. Rachael Arauz, "Articulating 'American': Text and Image in American Modernism," Ph.D. diss., University of Pennsylvania, 2000.

33. Strand made four photographs of cars: *Wire Wheel*, 1917 (Metropolitan Museum of Art), *Wheel Organization*, 1917 (private collection), and two photographs now lost, *Automobile* and *Motor*, which were probably made between 1917 and 1919 and were exhibited in the 1920 Wanamaker Exhibition.

34. *Wire Wheel* and *Wheel Organization* are reproduced in Hambourg 1998, pls. 49, 55.

35. Stieglitz, "Our Illustrations," *Camera Work* 49–50 (June 1917), 36.

O'KEEFFE

1. See Barbara Buhler Lynes, *O'Keeffe, Stieglitz and the Critics*, Ann Arbor, 1989; Chicago, 1991.

2. For this discovery I am indebted to Janet Blyberg.

3. Anita Pollitzer, O'Keeffe's friend and former classmate at Teachers College, Columbia University, had received the drawings from O'Keeffe in the mail. Pollitzer brought them to Stieglitz.

4. *Nos. 3, 4, 7, 12*, and *Untitled* are reproduced in Barbara Buhler Lynes, *Georgia O'Keeffe: Catalogue Raisonné*, Washington, New Haven, and London, 1999, 48, 49, 47, 52, and 55. Previous publications have provided a slightly different list of the works Stieglitz saw and exhibited. See Sarah Whitaker Peters, *Becoming O'Keeffe*, New York, 1991, 37, and Jack Cowart, Juan Hamilton, and Sarah Greenough, *Georgia O'Keeffe: Art and Letters* [exh. cat., National Gallery of Art], Washington, 1987, 147.

5. The words "Finally a woman on paper," often quoted as Stieglitz's first response to O'Keeffe's work, are in pencil while the rest of the letter is in ink, and are not in Pollitzer's hand.

6. Arthur Wesley Dow, *Composition: A Series of Exercises in Art Structure for the Use of Students and Teachers*, New York 1899, 5.

7. Bob Groves, "Georgia O'Keeffe and the Color of Music: For More Than a Decade, Santa Fe Chamber Music Festival Performers and the Famous Artist Gave Each Other the Gift of Art," *Impact: Albuquerque Journal Magazine* (28 July 1987), 5.

8. O'Keeffe to Anita Pollitzer, June 1915, in *Lovingly Georgia: The Complete Correspondence of Georgia O'Keeffe & Anita Pollitzer*, ed. Clive Giboire, New York, 1990, 5.

9. October 1915, in Giboire 1990, 64.

10. 4 January 1916, in Giboire 1990, 117.

11. O'Keeffe completed two pastels in 1915 that were intended as abstract portraits. Lynes 1999, 57 and 58. Forms in the charcoal abstractions have also been related to O'Keeffe's awareness of those of the art nouveau and arts and crafts aesthetics; see Peters 1991, 42–61. Jerold Savory has pointed out the resemblance between the forms in *No. 2—Special* and a fountain on the Columbia College campus. Although a fire destroyed this structure before O'Keeffe's arrival in 1915, she could have seen pictures of it. See Jerold Savory, "Georgia O'Keeffe at Columbia College: 1915–16," *Women Artists News Book Review* 20 (1995), 33–34, 38, 61.

12. Lynes 1999, 47, 48, 49.

13. See Giboire 1990, 43.

14. See Alfred Stieglitz, "Georgia O'Keeffe—C. Duncan—Réné [sic] Lafferty," *Camera Work* 48 (October 1916), 12–13, reprinted in Lynes 1991, 166–167.

15. O'Keeffe later described this image as a headache. See Georgia O'Keeffe, *Some Memories of Drawings*, introduction by Doris Bry, New York, 1974, unpaginated.

16. See Lynes 1991, 89–111, and Barbara Buhler Lynes, *Georgia O'Keeffe*, ed. Norma Broude, New York, 1993. O'Keeffe first met Stieglitz in the spring of 1916, when she was in New York pursuing coursework at Teachers College, but had communicated with him by letter since shortly after he first saw her work in January 1916.

17. O'Keeffe returned to Teachers College in March 1916 to pursue additional coursework with Dow and, although she claims to have given up using color from fall 1915 through June 1916, her letters to Pollitzer indicate that she worked with watercolor as early as February 1916. See Giboire 1990, O'Keeffe to Pollitzer, February 1916, 131, 147.

18. O'Keeffe had seen Marin's work at 291 in 1915 and mentions in a letter to Pollitzer two that she had then admired, a "little blue drawing" and the "Woolworth Building"; see Giboire 1990, O'Keeffe to Pollitzer, February 1916, 147. She had seen Marin's and Stieglitz's work in various issues of *Camera Work*, such as (for Marin) 39 (July 1912) and (for Stieglitz) 3 (July 1903), 4 (October 1903), 36 (October 1911), and 44 (October 1913).

19. Pollitzer referred to O'Keeffe's sculpture as "she" and "lady." See Giboire 1990, Pollitzer to O'Keeffe, 18 June 1916, 158, and O'Keeffe to Pollitzer, June 1916, 159.

20. O'Keeffe and Pollitzer make sketches of watercolors in this series in September letters to one another. See Giboire 1990, Pollitzer to O'Keeffe, 195, and O'Keeffe to Pollitzer, 198.

21. See *Some Memories of Drawings*, unpaginated.

22. The figural abstraction pictured in fig. 87 p is no longer extant. The Brancusi exhibition was held at 291 from 12 March–4 April 1914.

23. Henry Tyrrell, "New York Art Exhibition and Gallery Notes: Esoteric Art at '291,'" *The Christian Science Monitor*, 4 May 1917, 10, reprinted in Lynes 1989, 167–168.

24. Jerold Savory was the first to associate *No. 12 Special* with the scroll of the violin, and it is possible that *Blue No. II*, *Blue No. III*, and *Blue No. IV*, 1916 (pl. 88) may be further distillations of this form. See Savory 1995, 34.

25. William Murrell Fisher, "The Georgia O'Keeffe Drawings and Paintings at '291,'" *Camera Work* 49–50 (June 1917), 5, reprinted in Lynes 1989, 169.

26. Whether O'Keeffe collaborated with Stieglitz in the making of this extensive portrait or whether it conveys his ideas about her nature (and the nature of woman) has been the subject of much debate. See Peters 1991, 147–181; Anne Middleton Wagner, *Three Artists (Three Women): Modernism and the Art of Hesse, Krasner, and O'Keeffe*, Berkeley, 1996, 76–103. Sarah Greenough, at the symposium honoring the opening of the Georgia O'Keeffe Museum, July 1997, also discussed this subject.

27. For a discussion of the exchange of ideas between O'Keeffe and Stieglitz, see Peters 1991, especially 63–123, and 147–306.

28. See Dorothy Seiberling, "The Female View of Erotica," *New York Magazine* 7 (11 February 1974), 54.

PART II

SEVEN AMERICANS

1. Sherwood Anderson, "Song of Industrial America," in *Mid American Chants*, New York, 1918, 16.

2. See, for example, Herbert Seligmann, *Alfred Stieglitz Talking*, New Haven, 1966; or Dorothy Norman, *Alfred Stieglitz: An American Seer*, New York, 1973.

3. Stieglitz to Dove, 24 May 1917, as quoted in Ann Lee Morgan, ed., *Dear Stieglitz, Dear Dove*, Newark, Del., 1988, 54.

4. Stieglitz's feelings about the war were complex. His German heritage and his own experiences in Berlin as a student in the 1880s had engendered a strong affection for Germany and predisposed him, at the very least, to regard suspiciously the

frequently voiced tales of German brutality. In addition, as Edward Abrahams has pointed out in *The Lyrical Left: Randolph Bourne, Alfred Stieglitz, and the Origins of Cultural Radicalism in America*, Charlottesville, 1988, 198–199, Stieglitz also admired Germany's "'vision combined with faith.'" While he hoped America would remain neutral, he, like others, felt that the country "needs an earthquake or two. Some terrible calamity to bring the people to a realization of what life really means."

5. In 1916 Leo Stein wrote to Gertrude Stein that "Pascin, Picabia, Nadelman, Duchamp, Gleizes—everybody who isn't in the trenches" was in New York. As quoted by James R. Mellow, *Charmed Circle: Gertrude Stein and Company*, New York, 1974, 295.

6. Abrahams 1988, 197.

7. Only two photographs made by Stieglitz between the close of 291 in June 1917 and the summer of 1918 are known to exist: *Elizabeth Davidson*, 1917, reproduced in Sue Davidson Lowe, "Taken Lightly," *Art and Antiques* 7 (summer 1990), 109, and *Trees and Hills*, 1917, National Gallery of Art, 1949.3.415.

8. Demuth began to visit 291 in 1909, but never had an exhibition there. Dove was first shown in the "Young American Painters" exhibition in 1910, but had only one other exhibition at 291 in 1912. O'Keeffe and Strand were latecomers to 291: O'Keeffe had three exhibitions there in 1916 and 1917, while Strand had only one in 1916. Of the "Seven Americans" that Stieglitz championed throughout the 1920s and 1930s, only Marsden Hartley and John Marin were frequent exhibitors at 291: Hartley had six exhibitions, while Marin had eight. Wanda Corn, in *The Great American Thing: Modern Art and National Identity, 1915–1935*, Berkeley, 1999, 16–18, argues that this group of artists should be called "the second Stieglitz circle," to distinguish them from "the first circle" connected with 291. While this is a useful distinction, the group associated with 291 was very large and fluid, including many who were a part of it intimately but only briefly like Max Weber. The term "first circle" suggests that the group was more clearly defined than it was in reality.

9. For a very different interpretation of the "Seven Americans" and Stieglitz in particular, see Corn 1999.

10. Sherwood Anderson, *A Story Teller's Story*, New York 1924, dedication page.

11. Stieglitz to Paul Rosenfeld, 5 September 1923, YCAL.

12. Stieglitz and O'Keeffe's dialogue has continued long after their death. All the recent biographies on both Stieglitz and O'Keeffe include extensive discussions of their relationship. See Laurie Lisle, *Portrait of an Artist: A Biography of Georgia O'Keeffe*, New York, 1980; Sue Davidson Lowe, *Stieglitz: A Memoir/Biography*, New York, 1983; Roxanna Robinson, *Georgia O'Keeffe: A Life*, New York, 1989; Benita Eisler, *O'Keeffe and Stieglitz: An American Romance*, New York, 1991; and Richard Whelan, *Alfred Stieglitz: A Biography*, Boston, 1995. There have been several more recent

studies that examine their artistic intersection. See Sarah Greenough, "From the Faraway," in Jack Cowart, Juan Hamilton, and Sarah Greenough, *Georgia O'Keeffe: Art and Letters*, Washington, 1987, 135–139, and 169; Anna C. Chave, "O'Keeffe and the Masculine Gaze," *Art in America* 78 (January 1990), 115–124; Barbara Buhler Lynes, *O'Keeffe, Stieglitz, and the Critics*, Chicago, 1991; Belinda Rathbone, Roger Shattuck, and Elizabeth Turner, *Georgia O'Keeffe and Alfred Stieglitz: Two Lives, A Conversation in Paintings and Photographs*, New York, 1992; and Anne Middleton Wagner, *Three Artists (Three Women): Modernism and the Art of Hesse, Krasner, and O'Keeffe*, Berkeley, 1996. The most thorough analysis of O'Keeffe's fascination with photography and especially Stieglitz's photographs is Sarah W. Peters, *Becoming O'Keeffe: The Early Years*, New York, 1991.

13. In the key set of Stieglitz's photographs at the National Gallery are 147 photographs made between 1905 and 1917. To date seventy-eight other works not in this collection have been identified.

14. In the key set of Stieglitz's photographs at the National Gallery of Art are 303 photographs made by Stieglitz between 1918 and 1922, and to date an additional ten more not in the collection have been identified. Of these, 193 are portraits of O'Keeffe.

15. Compare fig. 29 to plate 27 in Georgia O'Keeffe, *Georgia O'Keeffe: A Portrait*, New York, 1978 and 1997. See Peters, 1991, 109–111 for reproductions and a discussion of Stieglitz photographing O'Keeffe mimicking Steichen.

16. O'Keeffe's involvement in the creation of the portrait has been the subject of much speculation. See Lisle 1980, 104–110; Robinson 1989, 206–208; Eisler 1991, 183–190; Whelan 1995, 403–408; Wagner 1996; Chave 1990; Maria Morris Hambourg in O'Keeffe 1997. Contrary to what most scholars believe, O'Keeffe herself repeatedly insisted that the conception and tone of the portrait was Stieglitz's: "it was something *he* wanted to do," she told Mary Lynn Kotz, "Georgia O'Keeffe at 90," *Artnews* 76 (December 1977), 44. See Sarah Greenough and Juan Hamilton, *Alfred Stieglitz: Photographs and Writings*, Washington, 1998, 231.

17. The key set of Stieglitz's photographs at the National Gallery includes 426 works made between 1918 and 1929 and to date an additional fifty more have been identified.

18. Although Stieglitz made some landscape photographs while a student in Germany in the 1880s, as well as some studies of the picturesque views of Katwyck, Holland, and Gutach, Germany, made in 1894, he made very few landscapes between 1894 and 1917.

19. Seligmann 1966, 61.

20. Stieglitz to Herbert Seligmann, 18 September 1921, YCAL.

21. Stieglitz, as quoted by Norman 1973, 161; and Stieglitz to Sherwood Anderson, 11 October 1923, YCAL.

22. Stieglitz, as quoted by Seligmann 1966, 3; Norman 1973, 144 and 161.

23. Stieglitz to Seligmann, 9 August 1923, YCAL, and Stieglitz to J. Dudley Johnston, 3 April 1925, Royal Photographic Society, Bath, England.

24. In his effort to make his work appear more whole and monolithic, Stieglitz, beginning in the 1920s and continuing throughout the rest of his life, reinterpreted his earlier photographs in light of his new ideas. For example, earlier in his career he had said little about the symbolic importance of *The Terminal*, 1893, or *The Steerage*, 1907, yet by the late 1920s both works expressed "a feeling of life as I felt it." See, for example, Dorothy Norman, "Writings and Conversations of Alfred Stieglitz," *Twice A Year* 1 (fall–winter, 1938), 98; Alfred Stieglitz, "Four Happenings," *Twice A Year* 8–9 (1942), 128.

25. O'Keeffe to Sherwood Anderson, 11 February 1924, as quoted in Cowart, Hamilton, and Greenough, 1987, 176.

26. Out of the 227 works made before 1918 that are listed in Barbara Buhler Lynes, *Georgia O'Keeffe: Catalogue Raisonné*, New Haven, 1999, only fourteen are oil paintings. While O'Keeffe undoubtedly destroyed at least some of her early oils and while watercolors, charcoal, pen, or pencil were cheaper and more portable for a young artist, the preponderance of works on paper indicates that she felt these were her most successful subjects before 1918. After 1918 she used oil painting much more than any other medium.

27. See O'Keeffe to Anita Pollitzer, 20 October 1915, as quoted in Cowart, Hamilton, and Greenough 1987, 146.

28. See Peters 1991.

29. Georgia O'Keeffe to Paul Strand, 3 June 1917, as quoted in Cowart, Hamilton, and Greenough 1987, 161.

30. Nos. 342 and 358 in Lynes 1999. Sarah Peters has demonstrated how *Lake George with Crows* was most likely a composite of three different points of view, "the aerial; the high oblique (as if seen from nearby Prospect Mountain, since it includes the far side of the lake); and the low oblique (as from, say, an upper window of the Stieglitz farmhouse on The Hill)." Peters 1991, 238–240.

31. Georgia O'Keeffe, "I Can't Sing, So I Paint," *New York Sun*, 5 December 1922, 22.

32. See n. 31.

33. Waldo Frank, *The Rediscovery of America*, New York, 1929, 66.

34. [Waldo Frank], "The Seven Arts," reprinted in *The Seven Arts*, 1 November 1916, 52. For Frank's authorship of this editorial, see Frank Wertheim, *New York Little Renaissance: Iconoclasm, Modernism, and Nationalism in American Culture, 1908–1917*, New York, 1976, 178.

35. [Editors], "To the Friends of *The Seven Arts*," *The Seven Arts*, 1 October 1917, unpaginated.

36. For a detailed discussion, see Casey Nelson Blake, *Beloved Community: The Cultural Criticism of Randolph Bourne, Van Wyck Brooks, Waldo Frank, and Lewis Mumford*. Chapel Hill, 1990, 122–156. For a different interpretation, see Corn 1999, 11.

37. Blake 1990, 2–6.

38. Blake 1990, 1.

39. [Editorial], *The Seven Arts*, 1 November 1916, 56.

40. Frank 1929, 52.

41. Romain Rolland, "America and the Arts," *The Seven Arts*, 1 November 1916, 48. Louis Untermeyer, *The New Era in American Poetry*, New York, 1919, 14, wrote that the distinguishing characteristic of the age was "its determined self-analysis."

42. Frank, *Our America*, New York, 1919, 10.

43. Rolland 1919, 49.

44. Frank, "Vicarious Fiction," *The Seven Arts*, 1 January 1917, 296.

45. Van Wyck Brooks, *Letters and Leadership*, New York, 1918, 96 and 127.

46. Anderson 1918, 18.

47. Brooks, *Days of the Phoenix: The Nineteen-Twenties I Remember*, New York, 1957, 2. Brooks continued that "it makes all the difference to a people and an age whether its catchwords really do or do not correspond with convictions, and whether these convictions really do or do not reach down among the real problems of personal and social life—whether they really *catch* at the bottom of things.... The rank and file who grasp the idea behind [the catchword] incompletely and in varying degrees and who, if they depended on their understanding of the idea, would be at sixes and sevens, grasp the catchword and unite on a common platform which, if the catchword is a worthy one, educates them through action."

48. Sherwood Anderson to Van Wyck Brooks, 31 May 1918, in Edmund Wilson, ed., *The Shock of Recognition: The Development of Literature in the United States Recorded by the Men Who Made It*, New York, 1955, 1266.

49. J. E. Spingarn, "The Younger Generation—A New Manifesto," *The Freeman* 5 (7 June 1922), 298. While the metaphorical meanings that this group attached to such words as "soil," "earth," and "roots," as well as "American," seems fairly transparent, Wanda Corn notes that they used "these code words...so often, and so boastfully, and so cryptically that it became cant." Corn 1999, 31.

50. William Carlos Williams, *The Great American Novel*, Paris, 1923, 17, 26.

51. Frank, "For a Declaration of War," in *Salvos*, New York, 1924, 14–15.

52. Paul Rosenfeld, *Port of New York: Essays on Fourteen American Moderns*, New York, 1924, 237; and Frank 1919, 186.

53. Stieglitz to Hart Crane, 27 July 1923, YCAL, and Stieglitz to Sherwood Anderson, 10 December 1925, Newberry Library, Chicago.

54. Rosenfeld to Stieglitz, 14 September 1922, YCAL.

55. See Francis M. Naumann, *New York Dada, 1915–1923*, New York, 1994, 196.

56. See also, *MSS* 1 (February 1922), 2. Echoing Man Ray who had written in *The Ridgefield Gazook*, March 1915, that it is "published unnecessarily whenever the spirits move us. Subscriptions free to whomever we please or displease," the editors of *MSS* wrote: "Subscribe One Dollar for Ten Numbers to be issued in Ten Days—Ten Weeks—Ten Months—or Ten Years. The risk is yours. Act at once if you want to be One of the First 100,000,000 Subscribers." *MSS* 1 (February 1922), 2. *The Ridgefield Gazook* as quoted in Naumann 1994, 80.

57. For further discussion see William Agee, "New York Dada, 1910—1930," *Art News Annual* 34 (1968), 105—113; Naumann 1994; Francis M. Naumann with Beth Venn, *Making Mischief: Dada Invades New York*, New York, 1996; Dickran Tashjian, *Skyscraper Primitives: Dada and the American Avant-Garde, 1910—1925*, Middletown, 1975; Judith Zilczer, "Primitivism and New York Dada," *Arts* 51 (May 1977), 140—142.

58. Stieglitz, "A Statement," in *Exhibition of Stieglitz Photographs*, New York, 1921, unpaginated and [*Second Exhibition of Photography by Alfred Stieglitz*], New York, 1923, unpaginated.

59. For further discussion, see Susan Noyes Platt, *Modernism in the 1920s: Interpretations of Modern Art in New York from Expressionism to Constructivism*, Ann Arbor, 1985, 1—34.

60. "A Note by Alfred Stieglitz," in *75 Pictures by James N. Rosenberg and 117 Pictures by Marsden Hartley*, New York, 1921, unpaginated, and Stieglitz, "My Dear Mr. Field," *The Arts* 2 (January 1922), 254. The Hartley auction was very successful and grossed more than $4,000. The "Painter's Derby" was less profitable with many works selling for $10 to $30. An annotated copy of "A Collection of Works by Living American Artists of the Modern School," the catalogue to an exhibition at Anderson Galleries, New York, 22 February 1922, is in the Georgia O'Keeffe Foundation, Abiquiu, New Mexico.

61. In 1919 Stieglitz organized an exhibition of Hartley's pastels at the Charles Daniel Gallery (see Stieglitz to Strand, January 1919); in 1920 he mounted a ten-year retrospective exhibition of Marin watercolors at Daniel's; in 1921 he mounted a exhibition of Marin's etchings at Weyhe's bookstore; and in 1922 he organized another exhibition of Marin's watercolors, oils, and etchings at the Montross Gallery; and in 1923 and 1924 he organized two more shows of Marin's work at Montross. In 1919 he organized an "Exhibition on Modern Art" at the Young Women's Hebrew Association; in 1921 he also helped the painter Arthur Carles mount "An Exhibition of Paintings Showing the Later Tendencies in Art" at the Pennsylvania Academy of the Fine Arts; and in 1922 he organized "A Loan Exhibition of Modern Art" at the Municipal Building in Freehold, New Jersey.

62. The exhibition catalogue listed many of the most important exhibitions at 291 beginning with the 1908 exhibition of Rodin drawings through O'Keeffe's 1917 show. Many of the listings were annotated to indicate that they were the "First American Exhibition" or "First Exhibition Anywhere." See *Alfred Stieglitz Presents Seven Americans*, New York, 1925, unpaginated. For the evolution of Stieglitz's thoughts about this show, see Stieglitz to Dove, 27 January 1925 and 22 February 1925, and Dove to Stieglitz, January 1925, in Morgan 1988, 110—113; Stieglitz to Jennings Tofel, 5 February 1925, YCAL; and Stieglitz to Sherwood, 11 March 1925, Sherwood Anderson Papers, Newberry Library.

63. Stieglitz to Dove, 27 January 1925, as quoted in Morgan 1988, 111.

64. See, for example, Strand, "Aesthetic Criteria," *The Freeman* 2 (12 January 1921), 426—427; "The Independents in Theory and Practice," *The Freeman* 3 (6 April 1921), 90; "American Watercolors at the Brooklyn Museum," *The Arts* 2 (December 1921), 148—152; "John Marin," *Art Review* 1 (January 1922), 22—23; "The Forum," *The Arts* 2 (February 1922), 332—333; "Alfred Stieglitz and a Machine," *MSS* 2 (March 1922), 6—7; "Photography and the New God," *Broom* 3 (November 1922), 252—258; and "Photographers Criticized," *The Sun and the Globe*, 27 June 1923, 20; "The Art Motive in Photography," *British Journal of Photography* 70 (5 October 1923), 612—614; and "Georgia O'Keeffe," *Playboy* 9 (July 1924), 16—20.

65. Barbara Haskell, in *Charles Demuth*, New York, 1987, 178—179, recounts that by 1921 Demuth considered Daniel a "crook." It is interesting to note that Paul Rosenfeld had included some, but not all of these artists in *Port of New York*. He omitted Strand and Demuth and included Kenneth Hayes Miller. Stieglitz also made some notable omissions from the "Seven Americans" group. He did not include Oscar Bluemner and Gaston Lachaise, both of whom he would exhibit at The Intimate Gallery, or Elie Nadelman probably because he did not consider them American. (All were recent immigrants.) Abraham Walkowitz, who had had numerous exhibitions at 291, was also not included nor was Charles Sheeler: both men by 1925 were no longer close to Stieglitz. Stanton Macdonald-Wright, whom Stieglitz exhibited at 291 and would show at An American Place in 1932, was also not included.

66. Rosenfeld 1924, 2.

67. Stieglitz to Crane, 15 August 1923, YCAL.

68. O'Keeffe, in Calvin Tomkins, "The Rose in the Eye Looked Pretty Fine," *New Yorker* 50 (4 March 1974), 44.

69. Although the printed catalogue notes that six portrait posters were shown of *Marcel Duchamp, Charles Duncan, Georgia O'Keeffe, John Marin, Marsden Hartley,* and *Arthur G. Dove,* Stieglitz crossed out *Duchamp, Marin,* and *Hartley* in two copies annotated by him. The *Hartley* portrait was apparently never finished and, although a drawing exists, it seems unlikely that Stieglitz would have exhibited it. However, Helen Appleton Read in "Seven Americans," *The Arts* 7 (April 1925), 231, notes that four portrait posters by Demuth were shown and includes the one of *Marsden Hartley,* as does "H. C." in "Stieglitz Group Anniversary Show," *The Art News* 23 (14 March 1925), 5. Other

reviewers, such as Forbes Watson, "Seven American Artists Sponsored by Stieglitz," *The Art World*, 15 March 1925, 5M, note that only three portrait posters were shown. Although Demuth wrote to Stieglitz on 16 January 1924, YCAL, that he had started a portrait of Duchamp, it does not appear that it was ever completed. *Marin* was completed in 1926. Copies of these are in the catalogue at the Georgia O'Keeffe Foundation, Abiquiu, New Mexico, and the department of photographs, National Gallery of Art, Washington. For further discussion of Demuth's portrait posters see Abraham Davidson, "The Poster Portraits of Charles Demuth," *Auction* 3 (September 1969), 28–31 and "Demuth's Poster Portraits," *Artforum* 17 (November 1978), 54–57; Haskell 1987, 172–191; Robin Jaffee Frank, *Demuth Poster Portraits*, New Haven, 1994; and Corn 1999, 223–233.

70. See Watson 1925, 5M. The literature from the period does not indicate why Stieglitz did not hang photographs by either himself or Strand in the entrance hall. However, the fact that he rarely installed photographs and paintings together in the same exhibition indicates that he realized it was difficult to hang smaller and often more subtly toned black and white photographs on the same wall as larger and more colorful paintings. To date, no installation photographs of this exhibition have been located.

71. Without installation photographs, and to date none have been found, it may be impossible to determine exactly what was included in this exhibition. Two annotated copies of the catalogue indicate that Stieglitz added several works to the show after it was printed. In addition, while the titles listed for Dove's, Marin's, and O'Keeffe's works are fairly precise, those given for Hartley, Stieglitz, and Strand are generic: Hartley exhibited "Landscapes and Still Lifes," Stieglitz, "Equivalents," and Strand, "New York," "Leaves," and "Machines." However, of those works that can be identified from the written lists and exhibition reviews, well over half were landscapes or still lifes. There were also at least fifteen cityscapes, eleven studies of machines, and eight abstract portraits of people.

72. Rosenfeld 1924, 2, and *Alfred Stieglitz Presents Seven Americans* 1925, 2.

73. Arnold Rönnebeck, "Through the Eyes of a European Sculptor," in *Alfred Stieglitz Presents Seven Americans* 1925, 5–6.

74. Rönnebeck 1925, 6, and Egmont Arens, "Alfred Stieglitz: His Cloud Pictures," *Playboy* 9 (July 1924), 15.

75. Lewis Mumford, "O'Keeffe and Matisse," *The New Republic*, 2 March 1927, reprinted in *O'Keeffe Exhibition*, New York, January–February 1928, unpaginated.

76. Dove, "A Way to Look at Things," in *Alfred Stieglitz Presents Seven Americans* 1925, 4.

77. As quoted in Seligmann 1966, 73.

78. Marin to Stieglitz, 14 August 1923, in Dorothy Norman, ed., *The Selected Letters of John Marin*, New York, 1949, 89.

79. Dove, as quoted in Barbara Haskell, *Arthur Dove*, Boston, 1974, 44.

80. Rönnebeck 1925, 5.

81. It is possible that Demuth and Dove made their abstract portraits in response to Stieglitz's cloud portraits. Only the year before, in his joint exhibition with O'Keeffe, he had exhibited several photographs of clouds which he titled *Songs of the Sky— Portrait of K.N.R.* and *Songs of the Sky—Portrait G.O.* K. N. R. was Katharine N. Rhoades and G. O. was Georgia O'Keeffe; National Gallery of Art accession numbers 1949.3.863 through 1949.3.868, and 1949.3.844, 1949.3.889, and 1980.70.191. Dove saw this exhibition before he began making his portraits and Demuth may have; both began making abstract portraits in 1924. In the summer of 1925 O'Keeffe made an abstract portrait of the author Jean Toomer; it is either *Birch and Pine Trees—Pink*, Lynes 1999, no. 506, or *Birch and Pine Tree No. 1*, no. 507. (For further discussion, see Greenough 1987, 285, n. 69.) It is also possible that some of O'Keeffe's other paintings were unidentified abstract portraits. From the beginning of her career, she had made abstract portraits; see *Portrait—W—No. I, II,* and *III* (Lynes 1999, nos. 192, 193, and 194). However, as she herself admitted later in her life, she rarely identified these works as portraits: "There are people who have made me see shapes—and others I thought of a great deal, even people I have loved, who make me see nothing. I have painted portraits that to me are almost photographic. I remember hesitating to show the paintings, they looked so real to me. But they have passed into the world as abstractions—no one seeing what they are." O'Keeffe 1976, unpaginated. In light of this comment, *Autumn Trees—The Chestnut—Red*, no. 120 in the *Seven Americans* exhibition (Lynes 1999, no. 472) may be a portrait of Stieglitz, who also frequently wrote about this tree and also photographed it, titling his work, *The Dying Chestnut—My Teacher*, 1919, National Gallery of Art, accession number 1949.3.439.

82. Strand, "Georgia O'Keeffe," 1924, 20, and O'Keeffe to Anderson, September 1923?, Newberry Library.

83. Seligmann, "Marin," *Manuscripts* 1 (February 1922), 14.

84. "Art," *The New Yorker*, 28 March 1925, 17; Deogh Fulton, "Cabbages and Kings," *International Studio* 81 (May 1925), 145; and R. F. "In New York Galleries," *The Christian Science Monitor*, 20 March 1925, 5. For other reviews, see Edmund Wilson, "The Stieglitz Exhibition," *The New Republic* 42 (18 March 1925), 97–98; Royal Cortissoz, " '291,' " *New York Herald Tribune*, 15 March 1925, 12; Read, "Seven Americans," 1925, 229–230; and Watson 1925, 5M.

85. H. C., "Stieglitz Group in Anniversary Show," *The Art News* 23 (14 March 1925), 5.

86. Read, "Seven Americans," 1925, 229–230, and Helen Appleton Read, "News and Views on Current Art," *Brooklyn Daily Eagle*, 15 March 1925, 28. Ironically, only a month before the show opened Stieglitz wrote to Dove "I had even decided to print: 'Our Foreword is: There is no Foreword.'—I have decided nothing yet except that the Catalogue must be the simplest kind

of affair and that the Public should be given its own chance unguided." 27 January 1925, as quoted in Morgan 1988, 111.

87. Edmund Wilson, *The American Earthquake*, New York, 1958, 1996, 102.

88. For further discussion, see Platt 1985, 1–34; Celeste Connor, "Visions and Revisions of the American Landscape: Paintings and Photographs of the Stieglitz Circle, 1924–1934," Ph.D. diss., University of California at Berkeley, 1989; Elizabeth Hutton Turner, *In the American Grain: Arthur Dove, Marsden Hartley, John Marin, Georgia O'Keeffe, and Alfred Stieglitz: The Stieglitz Circle at the Phillips Collection*, Washington, 1995; and Innes Howe Shoemaker, *Mad For Modernism: Earl Horter and His Collection*, Philadelphia, 1999.

89. For Dove, Marin, and O'Keeffe he became what he referred to as their guarantor. See Katherine Hanna, *History of an American: Alfred Stieglitz, '291' and After*, Cincinnati, 1951, 17.

90. See Stieglitz to Dove, 7 July 1925, as quoted in Morgan 1988, 115. In the same letter, where he contemplates the space that Kennerley had offered him to use as a gallery, he said that in the future "I must see to it that the press gets to see nothing."

91. Stieglitz to Rebecca Strand, 18 February 1924, as quoted in Whelan 1995, 457.

92. See Stieglitz to Sherwood Anderson, 23 March 1925, Newberry Library. A few works may have sold just shortly before the exhibition. In an annotated copy of the exhibition catalogue, Stieglitz noted that O'Keeffe's *Autumn Trees—The Chestnut—Grey*, now called *The Chestnut Grey*, Lynes 1999, no. 473, and *Calla Lilies*, Lynes 1999, no. 460, were "Loaned." This same annotated catalogue also indicates that another work by Dove, *Garden, Rose, Gold, Green*, was also sold. Georgia O'Keeffe Foundation, Abiquiu, New Mexico.

93. See Philip McMahon, "Some Aspects of Ignacio Zuloaga," *The Art Bulletin* 7 (June 1925), 117–130, and "Four Pictures Sold at Zuloaga's Exhibit for a Total of $100,000," *The Art News* 23 (10 January 1925), 1. See also "Zuloaga Painting Sold to Carnegie Institute," *The New York Herald Tribune*, 13 January 1925, 15; "Zuloaga Painting 'Victims of Fiesta' Sold for $14,000," *The New York Herald Tribune*, 18 January 1925, 19; Helen Appleton Read, "Ignacio Zuloaga, Spanish Artist, Paints Bullfighters, Beautiful Women," *Brooklyn Sunday Eagle Magazine*, 25 January 1925, 11.

94. Dove to Stieglitz, January 1925, as quoted in Morgan 1988, 111; Stieglitz, as quoted by Seligmann 1966, 23, and Stieglitz to Dove, 7 July 1925, as quoted in Morgan 1988, 116.

95. Seligmann 1966, vi.

96. As quoted in Susan Noyes Platt, "Responses to Modern Art in New York in the 1920s," Ph.D. diss., University of Texas at Austin, 1981, 41.

97. Dorothy Brett in "The Room," in Waldo Frank et al., eds., *American and Alfred Stieglitz: A Collective Portrait*, New York, 1934, 260, and Seligmann 1966, 55.

98. Seligmann 1966, v.

99. Wilson 1958, 101.

100. Checklist to "The Intimate Gallery...Announces its Third Exhibition," The Anderson Galleries, New York, 1926.

101. Annotated copies of the *Seven Americans* exhibition catalogue indicate that Stieglitz priced all of the portrait posters at $1,000, significantly more than he priced any works by Dove and Strand. While he priced a few of O'Keeffe's paintings over $1,000, most were significantly less. He consistently asked $1,000 or more only for his large cloud studies or Marin's works. Copy of exhibition catalogues at the Georgia O'Keeffe Foundation, Abiquiu, New Mexico.

102. Stieglitz to the New York State Tax Commission, 22 June 1928, YCAL.

103. Checklists to "The Intimate Gallery...Announces its Third Exhibition" 1926, and "The Intimate Gallery...Announces its Eighteenth Exhibition" 1929.

104. See n. 102.

105. For examples of Stieglitz's financial dealings with the "Seven Americans" at this time, see Morgan 1988, 149, 153, 155, 171, 173, and 177; and Seligmann 1966, 9. In addition, if an artist was in desperate need, Stieglitz would often not deduct anything for the rent fund and send the complete purchase price.

106. Stieglitz also had another fund that he used to aid not only the artists he exhibited, but others through difficult periods. Contributors included Rosenfeld, Paul and Rebecca Strand, Aline and Meyer Liebman, Maurice and Alma Wertheim, and his brother Lee Stieglitz. For more information, see Whelan 1995, 482–483.

107. See Stieglitz to Dove, 30 March 1936, YCAL.

108. See Seligmann 1966, 11.

109. Stieglitz to Frank, 19 June 1925, YCAL.

110. Stieglitz, "Here is the Marin Story," New York, 17 April 1927, n.p.

111. Stieglitz to Phillips, 8 December 1926, YCAL, and see n. 110.

112. "Field Marshall Stieglitz," *Art News* 25 (2 April 1927), 8. See also Timothy Robert Rodgers, "Alfred Stieglitz, Duncan Phillips and the '$6000 Marin,'" *Oxford Art Journal* 15 (1992), 54–66; and Hutton Turner 1995, 18–23.

113. Stieglitz, [Letter], *Art Digest* 1 (March 1927), 20.

114. Stieglitz, as quoted by B. Vladimir Berman, "She Painted the Lily and Got $25,000 and Fame for Doing It!" *New York Evening Graphic Magazine Section*, 12 May 1928, 3M, and Lillian Sabine, "Record Price for Living Artist," *Brooklyn Sunday Eagle Magazine*, 27 May 1928, 11.

115. Eisler 1991, 371, concludes that the transaction was a fraud on Stieglitz's part designed to raise O'Keeffe's prices, however Richard Whelan summarizes that "the deal appears to have been made in good faith." Whelan 1995, 498.

116. See Whelan 1995, 511.

117. For accounts of O'Keeffe's sales in the late 1920s, see Lisle 1980, 152–153. For Marin's sales, see Timothy Rogers, "Making the American Artist: John Marin, Alfred Stieglitz and Their Critics, 1909–1936," Ph.D. diss., Brown University, 1994; and Whelan 1995, 525.

118. Dove to Stieglitz, 19 December 1930, as quoted in Morgan 1988, 203.

119. Stieglitz to Charles Demuth, January 1930, YCAL.

120. Demuth, "Lighthouses and Fog," in Frank et al. 1934, 246.

121. The first exhibition at the Museum of Modern Art in November 1929 was a loan show of works by Cézanne, Gauguin, Seurat, and Van Gogh. The second exhibition of *Paintings by Nineteen Living Americans* did nothing to appease Stieglitz for the artists were chosen not by considered curatorial judgment, but by vote cast by the museum's trustees. Alfred Barr wrote in the catalogue that the exhibition included "artists who are so 'conservative' that they are out of fashion and so 'advanced' that they are not generally accepted." As quoted by Whelan 1995, 522.

122. Paul and Rebecca Strand and Dorothy Norman were responsible for securing a group of donors, including Stieglitz's brother, Lee, Jacob Dewald, Aline Meyer Liebman, Strand's father, and Norman herself. They agreed to cover the rent for the first three years. See Whelan 1995, 523.

123. See Norman 1973, 207.

124. Stieglitz included his photographs in the *Seven Americans* exhibition but never exhibited at the Intimate Gallery.

125. See, for example, Stieglitz, "Echoes of '291,'" *Creative Art* 12 (February 1933), 152; Stieglitz, "Not a Dealer," *American Magazine of Art* 27 (1934), 4; or Stieglitz, "To the Art Editor," *New York Times*, 24 December 1939, section 9, 9.

126. Seligmann 1966, and Norman 1938, 77–98; "Alfred Stieglitz: Ten Stories," *Twice A Year* (spring–summer, 1941), 135–163; "Alfred Stieglitz: Four Happenings," *Twice A Year* 8–9 (spring–summer, 1942), 105–136; "Stieglitz Stories," *Twice A Year* 10–11 (spring–summer, 1943), 245–264; and "Alfred Stieglitz: Six Happenings," *Twice A Year* 14–15 (fall–winter, 1946–1947), 188–202.

127. See Stieglitz to Waldo Frank, 6 July 1935, YCAL.

128. As quoted in "Stieglitz Assails W.P.A. Art as 'Wall Smears,'" *New York Herald Tribune*, 3 December 1936, 9.

129. Elizabeth McCausland, note included with her letters to Stieglitz, Elizabeth McCausland Papers, Archives of American Art. McCausland acknowledged that Stieglitz "in complex and devious ways…even saw to it that some artists got at least a partial living wage." *Springfield Sunday Union and Republican*, 7 November 1937, 6E.

130. For further discussion, see Connor 1989, 539–544 and 582–608.

131. Thomas Craven, *Modern Art: The Men, The Movements, The Meaning*, New York, 1934, 311–319.

132. Waldo Frank et al. 1934, 3.

133. See n. 132, v.

134. Fred J. Ringel, "Stieglitz Done by Mirrors," *The New Republic* 81 (6 February 1935), 366.

135. Stephan Bourgeois, "Recent Books: An American Stage," *The Art News* 33 (5 January 1935), 9, 11.

136. John Gould Fletcher, "The Stieglitz Spoof," *American Review* 4 (March 1935), 589.

137. Thomas H. Benton, "America and/or Alfred Stieglitz," *Common Sense* 4 (January 1935), 22. Benton's review may have been, at least in part, a reaction to Rosenfeld's harsh review of Benton's mural *The Arts of Life in America* for the Whitney Museum of American Art. See "Ex-Reading Room," *The New Republic* 74 (12 April 1933), 245–246.

138. Benton 1935, 22.

139. Benton 1935, 24. For further discussion, see also Edward Abrahams, "Alfred Stieglitz and/or Thomas Hart Benton," *Arts* 55 (June 1981), 108–113; and Henry Adams, *Thomas Hart Benton: An American Original*, New York, 1989, 222–225. Benton also threw back at Stieglitz some of the gendered criticism that he and those associated with him had used so frequently in the 1920s, writing: "This man and his confreres are like boys addicted to bad habits whose imaginative constructions have so defined the qualities of 'life' that they are impotent before the fact." Benton 1935, 24.

140. Abrahams 1981, 108.

141. Peyton Boswell, Jr. *Modern American Painting*, New York, 1939, 14.

142. See Stieglitz to Benton, 29 December 1934; Benton to Stieglitz, 1 January 1935; Stieglitz to Benton, 2 January 1925.

143. Rodgers 1994, 321–337.

144. O'Keeffe 1976, unpaginated.

145. Dove to Stieglitz, 1 October 1935, as quoted in Morgan 1988, 237.

146. Only O'Keeffe in *Sky Above Clouds* (The Art Institute of Chicago, 96 × 288 inches) tried (and many would say failed) to rival the scale of post–World War II American art.

MARIN

1. F[orbes] W[atson], "New York Exhibitions," *The Arts* 10 (December 1926), 347.

2. As described retrospectively by Paul Rosenfeld in "John Marin's Career," *The New Republic* 90 (14 April 1937), 290.

3. Marin studied at the Academy from 1899 through 1901. He went to Europe in 1905.

4. Marin's etchings were often on view elsewhere, for example at Kennedy and Co. in New York and Albert Roullier's Art Gallery in Chicago.

5. *The Selected Writings of John Marin*, edited with an introduction by Dorothy Norman, New York, 1949, 27, 30, 205.

6. Norman 1949, 7.

7. Rosenfeld 1937, 291.

8. See n. 7.

9. *International Studio* (March 1917), 33. On the etchings, see Charles Saunier, "John Marin: Peintre-Graveur," *L'Art décoratif* 18 (January 1908), 17–24; on watercolors see E. A. Taylor, "The American Colony of Artists in Paris," *The Studio* 53 (July 1911), 112, in which he wrote that "[Marin] is known chiefly in Paris and his own country by his etchings, but good as they are it is in water-colour he excels."

10. Sheldon Reich, *John Marin: A Stylistic Analysis and Catalogue Raisonné* (2 vols.), Tucson, 1970, vol. 2. Examples include nos. 00.1; 07.3; 12.17; 14.33; 16.48–145. These last comprise the Weehawken paintings about which the dates remain in question, from as early as 1903–1904 to as late as 1916; this author holds to the view stated in *John Marin* [exh. cat., National Gallery of Art], Washington, 1990, 117, 119. See also Klaus Kertess, *Marin in Oil* [exh. cat., The Parrish Art Museum], Southampton, 1987.

11. Murdoch Pemberton, "Marin and Others," *Creative Art* 3 (December 1928), 45.

12. Julius Meier-Graefe, *Vanity Fair* (November 1928).

13. Lewis Mumford, "The Art Galleries: Resurrection—And the Younger Generation," *The New Yorker* (13 May 1933), 42, 44. For a thorough study of the subject of the American in American art, see Wanda M. Corn, *The Great American Thing: Modern Art and National Identity, 1915–1935*, Berkeley and Los Angeles, 1999.

14. Apart from two oils dated to 1921, Reich 1970, vol. 2, lists none between the c. 1916 Weehawken paintings and eight dated to 1928.

15. "The Art Galleries: Housewarming—The Ladies of the Academy," *The New Yorker* 5 (11 January 1930), 73–75.

16. Paul Rosenfeld, "The Marin Show," *The New Republic* 62 (26 February 1930), 48.

17. Rosenfeld 1930, 49.

18. In 1997, Yale University Press reissued Henry McBride, *The Flow of Art: Essays and Criticisms*, edited by Daniel Catton Rich, first published in 1975.

19. Guy Eglington, "John Marin, Colorist and Painter of Sea Moods," *Arts and Decoration* 21 (August 1924), 13.

20. Lloyd Goodrich, "November Exhibitions," *The Arts* 18 (November 1930), 21.

21. Forbes Watson, "The All American Nineteen," *The Arts* 16 (December 1929), 311.

22. Marya Mannes, "Gallery Notes," *Creative Art* 1 (December 1927), 7.

23. Royal Cortissoz's *Herald Tribune* article quoted in "New York Criticism: Marin, the Courageous," *The Art Digest* 7 (1 December 1932), 14.

24. Marin purchased a home in Cliffside, New Jersey, in 1920, prior to which he and his family led a somewhat peripatetic existence, wintering with family, mainly in Brooklyn.

They summered in rented quarters in the Small Point or Stonington/Deer Isle regions of Maine most summers from 1914 until 1933, when they ventured north. The following year they purchased a home in Cape Split, where Marin died in 1953.

25. Ralph Flint, "Recent Work by Marin Seen at An American Place," *The Art News* (17 October 1931).

26. Lewis Mumford, "The Art Galleries: Marin-Miró," *The New Yorker* 8 (19 November 1932), 69–70.

27. Lewis Mumford, "The Art Galleries: Two Americans," *The New Yorker* 9 (11 November 1933), 76–78.

28. Henry McBride, "John Marin Exhibits Oils," *The New York Sun*, 19 November 1932, 7.

29. Edwin Alden Jewell, "Art by John Marin is Displayed Here," *New York Times*, 23 February 1938, 21.

30. "To My Paint Children," dated 14 February, is reprinted in Norman 1949, 177–180; the quotation is on 179.

31. M[artha] D[avidson], "Marin: New Oils and Watercolors," *Art News* 37 (10 December 1938), 17.

32. Jerome Mellquist, "John Marin: Painter of Specimen Days," *American Artist* 13 (September 1949), 69.

33. Concurrently, an exhibition of watercolors was held at The Downtown Gallery. Less wide in scope than the American Place show, it also included works from many phases of Marin's career.

34. No works dated from 1912 through 1928. The 1903/1904 works were the Weehawken paintings about which see n. 4.

35. A few years later, Seligmann's friendship with Marin brought the artist to the Cape Split region of Maine.

36. Ford Baker, "John Marin, Famous Painter Turning to New Field at 75," *Passaic Herald-News*, Bergen-Passaic Edition, 14 June 1947, 5.

37. Dorothy Dannenberg, "Recent Art Books: John Marin," *Art News* 34 (4 January 1936), 12.

38. Alfred H. Barr Jr., "Preface and Acknowledgment," *John Marin: Watercolors, Oil Paintings, Etchings* [exh. cat., Museum of Modern Art], New York, 1936, 9.

39. Jerome Mellquist, "John Marin, Painter of American Nature," *Brooklyn Daily Eagle*, 25 October 1936, 10C.

40. Mellquist 1936, 10C. Even a positive review by Martha Davidson in *The Art News* 35 (24 October 1936), 11, bore the headline, "Marin: Master of a Minor Medium"; and in "John Marin, the Isolated, Honored at the Museum of Modern Art," *Art Digest* 11 (1 November 1936), 14, Royal Cortissoz, as usual, was unimpressed. Acknowledging no quarrel with Marin's "impulse, so familiar in our modern time, toward 'self-expression' in place of representation.... I only feel that self-expression should be reinforced, as it historically has been, by design and craftsmanship."

41. George Of, a painter, also framed works to be exhibited at An American Place.

42. Handwritten letter from Alfred Stieglitz to John Marin, dated Nov. 15/36, on three pages, John Marin Archives, National Gallery of Art Library.

43. Emily Genauer, "Art: Marin at American Place," *New York World-Telegram*, 28 March 1942, 7.

44. After Stieglitz's death, Marin, O'Keeffe, and Dorothy Norman assumed responsibility for the gallery until it closed in 1950.

45. The Downtown Gallery press release, 17 November 1950.

46. The Downtown Gallery press release, 18 December 1950. It would be virtually unthinkable today for a gallery to open an exhibition between the Christmas and New Year's holiday. The press release further notes Marin's accomplishments during the year just past, including his representation in Venice; a retrospective exhibition in his native state, at the New Jersey State Museum, Trenton; and the receipt of honorary degrees from Yale University and the University of Maine.

47. "John Marin," *Art News* 45 (May 1946), 58. Drawings on plastic in the collection of the National Gallery of Art, Washington, which clearly functioned as guides for the various versions of specific subjects, for example, *Prospect Harbor, Maine*, 1952, further indicate that Marin's art was far less spontaneous than both the works and Marin's writings suggest. The drawing and one version of the painting (Reich 52.38) are reproduced in Washington 1990, 281. Another version is in a private collection.

48. Lawrence Dame, "Marin in Boston," *Art Digest* 21 (1 February 1947), 6.

49. Henry McBride, *The New York Sun*, 19 November 1932, 7.

50. Marsden Hartley, "As to John Marin, and His Ideas," in New York 1936, 18, 16.

51. Louis Finkelstein, "Marin and DeKooning," *Magazine of Art* 43 (October 1950), 206.

52. Fairfield Porter, "The Nature of John Marin," *Art News* 54 (March 1955), 63.

DEMUTH

1. This formula was published many times in the announcements for Intimate Gallery exhibitions.

2. Wanda Corn believes Stieglitz did little to advance Demuth's career. She characterizes Stieglitz, Paul Strand, and Paul Rosenfeld as Demuth's "harshest critics" who, for example, in contrast to their strong support of Marin's masculine, American style, downplayed Demuth's work because, tainted by his homosexuality, it was too effeminate. Corn notes: "...Demuth was always X in Stieglitz's mind, the extra member who was more ornament to the second circle than organic to it. X suggests Demuth was unacknowledged, canceled out." See Wanda Corn, *The Great American Thing: Modern Art and National Identity, 1915–1935*, Berkeley, 1999, 196, 203. Jonathan Weinberg does not focus as much attention on Stieglitz's attitude toward Demuth but generally concurs with Corn about "the unwillingness of Stieglitz to accept him fully as one of the 'select.'"

Jonathan Weinberg, *Speaking for Vice: Homosexuality in the Art of Charles Demuth, Marsden Hartley, and the First American Avant-Garde*, New Haven, 1993, 199–200.

While Strand and Rosenfeld may have used words such as "delicate" or "fastidious" to describe Demuth's work, there is little circumstantial and no direct evidence concerning Stieglitz's attitude toward homosexuality. It is also difficult to draw conclusions about how Stieglitz's formula "Number Seven (six + X)" relates to Demuth. The terms "Number Seven" or "X" are theoretically applicable to a number of other artists including Gaston Lachaise (1927), Oscar Bluemner (1928), Peggy Bacon (1928), and Francis Picabia (1928), all of whom were featured in one-person shows at the gallery. Further complicating the notion that these designations marginalized Demuth within the group is the fact that he was exhibited more often than Strand, an artist explicitly named by Stieglitz in his formula. Moreover, the issue is never mentioned by Stieglitz or Demuth in their correspondence.

3. Pamela Edwards Allara, "The Watercolor Illustrations of Charles Demuth," Ph.D. diss., John Hopkins University, Baltimore, 1970, 20–21, as quoted in Barbara Haskell, *Charles Demuth* [exh. cat., Whitney Museum of American Art], New York, 1987, 49. By 1914 Hartley had exhibited at 291 three times.

4. Charles Demuth, "Between Four and Five," *Camera Work* 47 (July 1914, published January 1915), 32. The image Demuth referred to may be a photograph of an African sculpture depicting two hands now in the De Zayas Archives, Seville.

5. Another Stieglitz portrait from this period shows Demuth at Paul Strand's 1916 291 exhibition. It was published in Katherine Dreier, *Modern Art*, New York, 1926, 108.

6. "Alfred Stieglitz didn't want to carry someone who would be in competition with Marin." From an interview with Charles Daniel by Emily Farnham, 27 January 1956, quoted in Emily Farnham, *Charles Demuth: Behind a Laughing Mask*, Norman, Okla., 1971, 110. As has often been noted Stieglitz, in deference to his obligation to Marin, advised Demuth to place his watercolors with the Kraushaar Gallery in the 1920s. See for example Haskell 1987, 178–179, and Corn 1999, 196–197. Nevertheless, he clearly recognized Demuth's talent in the medium and chose to exhibit and promote the watercolors on numerous occasions at The Intimate Gallery and An American Place.

7. Charles Demuth, "For Richard Mutt," *The Blind Man* 2 (May 1917), unpaginated.

8. Demuth to Stieglitz, 2 January 1921, YCAL, quoted in Haskell 1987, 137.

9. Demuth to Stieglitz, summer 1921, YCAL, quoted in Farnham 1971, 125.

10. On 13 August 1921 Demuth described Daniel as a "crook." Demuth to Stieglitz, YCAL, quoted in Haskell 1987, 190.

11. Demuth to Stieglitz, 10 October 1921, YCAL, quoted in Farnham 1971, 130–131.

12. Demuth to Stieglitz, 28 November 1921, YCAL, quoted in Farnham 1971, 136–137.

13. Demuth to Stieglitz, 30 July 1922, published in *MSS* 4 (December 1922), 4, and quoted in Farnham 1971, 139–140.

14. Demuth to Stieglitz, 29 January 1923, YCAL, quoted in Farnham 1971, 141.

15. Demuth to Stieglitz, 2 May 1923, YCAL, quoted in Farnham 1971, 10, 144. Corn believes that Stieglitz's photographs of Demuth's hands played on homosexual stereotypes and were integral to the "feminizing of Demuth" within the Stieglitz circle. Corn 1999, 198. In the National Gallery of Art's Alfred Stieglitz Collection there are two images of Demuth's hands (1949.3.583 and 1949.3.584), one head study (1949.3.542), and one image of Demuth seated (1949.3.541) taken at this time. Farnham reproduces an alternate head study as plate 4-B in Farnham 1971. Farnham mistakenly dates Stieglitz's 1915 image of Demuth (pl. 133) to this period.

16. These works are more commonly known as poster portraits. But as Corn 1999, 383, notes, Stieglitz referred to them as portrait posters when they were first exhibited in the Seven Americans show in 1925.

17. Little is known about Duncan. He exhibited with O'Keeffe at 291 in 1916, was photographed by Stieglitz in 1920, and was included in *A Loan Exhibition of Modern Art* organized by Stieglitz at the Municipal Building in Freehold, New Jersey, in June 1922. This also was the second exhibition organized by Stieglitz that Demuth participated in. He showed a tempera, *Waiting*, and one watercolor, *Tree Forms*.

18. On the portrait posters see Abraham Davidson, "The Poster Portraits of Charles Demuth," *Auction* 3 (September 1969), 28–31, and "Demuth's Poster Portraits," *Artforum* 17 (November 1978), 54–57; Haskell 1987, 172–191; Robin Jaffee Frank, *Demuth Poster Portraits* [exh. cat., Yale University Art Gallery], New Haven, 1994; and Corn 1999, 223–233.

19. *Alfred Stieglitz Presents Seven Americans* [exh. cat., The Anderson Galleries], New York, 1925, 2.

20. For a different interpretation, see Corn 1999, 223.

21. Demuth to Stieglitz, July 1925, YCAL, quoted in Corn 1999, 223.

22. Another almost completely two-dimensional abstraction in the show was an oil painting entitled *Spring* (1922, Art Institute of Chicago) that was described by Royal Cortissoz as "a cluster of 'shirting' samples against a flat background," in "Works by Americans and Old Masters," *New York Herald Tribune*, 18 April 1926. Stieglitz's interest in elaborate symbolism at this time is further underscored by his comments at a lecture on 4 December 1926 at the Société Anonyme's International Exhibition of Modern Art where he lauded Duchamp's *Bride Stripped Bare by Her Bachelors, Even* as "one of the grandest works in the art of all time." Quoted in Richard Whelan, *Alfred Stieglitz: A Biography*, New York, 1995, 487.

23. "Charles Demuth: Intimate Gallery," *Art News* 27 (10 April 1926), 7.

24. Demuth to Stieglitz, 30 October 1927, YCAL, quoted in Farnham 1971, 167.

25. Demuth to Stieglitz, 6 August 1928, YCAL, quoted in Farnham 1971, 167.

26. Demuth to Stieglitz, 6 August 1928, YCAL, quoted in Farnham 1971, 156.

27. Stieglitz to Demuth, undated, YCAL, quoted in Farnham 1971, 151.

28. Stieglitz to Demuth, 28 January 1930, YCAL, quoted in Farnham 1971, 158. Demuth was not exhibited as often as Marin, Dove, or O'Keeffe at The Intimate Gallery or An American Place, but the capricious nature of his illness and its effect on his ability to work offers a plausible reason why he was not shown as consistently as the others.

29. *Longhi on Broadway* (Museum of Fine Arts, Boston, exhibited The Intimate Gallery, 1929, An American Place, 1931), *Love, Love, Love* (exhibited The Intimate Gallery, 1929, An American Place, 1931), *I Saw the Figure Five in Gold* (exhibited The Intimate Gallery, 1929, An American Place, 1931), *My Egypt* (exhibited An American Place, 1930), *Buildings, Lancaster* (Whitney Museum of American Art, exhibited An American Place, 1931), *Green Pears* (exhibited An American Place, 1931), *Red Cabbages, Rhubarb, and Orange* (The Metropolitan Museum of Art, exhibited The Intimate Gallery, 1929), and *Distinguished Air (Your Egypt)* (exhibited An American Place 1930). Demuth's 1931 show at An American Place featured examples of his watercolors of flowers and fruit, circus performers, and Jamesian literary subjects. Demuth works were also exhibited posthumously at An American Place in one solo (1938–1939) and two group exhibitions (1936, 1937).

30. On *I Saw the Figure Five in Gold* see James E. Breslin, "William Carlos Williams and Charles Demuth: Cross Fertilization in the Arts," *Journal of Modern Literature* 6 (April 1977), 248–263; Edward A. Aiken, " 'I Saw the Figure Five in Gold': Charles Demuth's Emblematic Portrait of William Carlos Williams," *Art Journal* 46 (fall 1987), 179–184; Wanda M. Corn, *In the American Grain: The Billboard Poetics of Charles Demuth*, Poughkeepsie, N.Y., 1991; and Corn 1999, 201–213.

31. An American Place published a small printed statement, "It Must Be Said," that praised *My Egypt* in November 1935: "…it is small, obscure, delicate—a study of factory buildings—dextrous, acute, perhaps the finest sense of a modern age that has been expressed."

32. Demuth commented on how the deprivations of life in America could be tranformed into art in a letter to Stieglitz, 15 August 1927, YCAL, quoted in Farnham 1971, 22–23: "America doesn't really care—still, if one is really an artist and at the same time an American, just this not caring, even though it drives one mad, can be artistic material."

33. Regarding *Distinguished Air* see Ray Gerard Koskovich, "A Gay American Modernist: Homosexuality in the Life and Art of Charles Demuth," *Advocate* (25 June 1985), 50–52; Haskell 1987, 204–206; Weinberg 1993, 195–200; and Corn 1999, 233. An alternate title "Your Egypt," was mentioned in a review of the show, "Attractions in the Galleries," *The New York Sun*, 3 May 1930, 8. The work can, therefore, be understood as a complement to Demuth's depiction of Lancaster as his place of exile in the painting *My Egypt*. Here, however, Demuth's homosexual milieu is posited as an alien place for a mainstream audience viewing the picture.

34. Koskovich 1985, 51, quoted in Weinberg 1993, 196.

35. Haskell 1987, 205, identifies the man with the cane as Demuth. Recent scholarship has demonstrated how Demuth's masking of identities in his art and life was related to his homosexuality. Feinberg 1993 places Demuth's career more explicity in the context of the social history of homosexuality in America from 1910 to 1940. Corn 1999, 233, notes how Demuth's homosexuality was related to his creative strategies: "...in Demuth's case, the ability to invent visual forms whose meanings could slip and slide so brilliantly was also tied to behavioral patterns in the homosexual community, where specific words, colors, and elements of dress that convey nothing unusual to the heterosexual person in the street were loaded with significance for those in the gay subculture."

36. Weinberg 1993, 200.

37. Rodin's drawings were often given allegorical and mythical titles. Duchamp, it is generally thought, also used the alias R. Mutt to submit *Fountain* to the Society of Independent Artists. In addition, O'Keeffe was not identified when Stieglitz's nude studies of her were first exhibited at the Anderson Galleries in 1921. Finally, Stieglitz's relationship with O'Keeffe would have been considered scandalous by some in 1921, as he was not officially divorced from his wife until 1924.

38. Waldo Frank, Lewis Mumford, Dorothy Norman, Paul Rosenfeld, and Harold Rugg, eds., *America and Alfred Stieglitz: A Collective Portrait*, New York, 1934, 246.

39. O'Keeffe to Emily Farnham, 20 August 1968, quoted in Farnham 1971, 166.

STRAND

1. Naomi Rosenblum, in "Paul Strand: The Early Years, 1910–1932," Ph.D. diss., The City University of New York, 1978, states that Paul Strand and Rebecca Salsbury met in 1919. Belinda Rathbone, in "Portrait of a Marriage: Paul Strand's Photographs of Rebecca," in Maren Stange, ed., *Paul Strand: Essays on His Life and Work*, New York, 1990, 75, notes that they met in the spring of 1920. Because both attended the Ethical Culture School (Paul graduated in 1909 and Rebecca in 1911), it is possible they knew of each other earlier.

2. For further discussion of the importance of Strand's and Stieglitz's secular Jewish heritage, see Alan Trachtenberg in Stange 1990, 9.

3. At least in the beginning of their relationship, Stieglitz clearly saw Strand as his surrogate son. See Stieglitz to Waldo Frank, 24 August 1920, YCAL, where he writes, "Strand has matured...my 'babies' are producing good work."

4. Picasso's *The Reservoir, Horta* was reproduced in *Camera Work*, Special Number (August, 1912), 35.

5. Strand as quoted by William Innes Homer, *Alfred Stieglitz and the American Avant-Garde*, Boston, 1977, 246.

6. *New York* is reproduced in *Camera Work* 48 (October 1916), 31; *Geometric Backyards* is reproduced in Sarah Greenough, *Paul Strand: An American Vision*, Washington, 1990, 28–29, and Maria Morris Hambourg, *Paul Strand: Circa 1916*, New York, 1998, 151; *Demolition* is reproduced in Rosenblum 1978, 313.

7. During World War I many chemicals used for the creation of photographic prints, especially the highly popular platinum paper, significantly escalated in cost and manufacturers began to introduce other kinds of papers, including satista and palladium, that were different in both color and tonal range from the kinds of papers Stieglitz and Strand had used previously.

8. Marius de Zayas, "Photography," *Camera Work* 41 (January 1913), 17, and "Photography and Artistic Photography," *Camera Work* 42–43 (April–July 1913), 13–14.

9. Strand, "Photography," *Camera Work* 49–50 (June 1917), 3–4.

10. See n. 9.

11. O'Keeffe to Anita Pollitzer, 20 June 1917, as quoted in Clive Giboire, ed., *Lovingly Georgia: The Complete Correspondence of Georgia O'Keeffe and Anita Pollitzer*, New York, 1990, 256; and O'Keeffe to Strand, 12 June 1917, Paul Strand Archive, Center for Creative Photography, University of Arizona, Tucson.

12. O'Keeffe to Strand, 12 June 1917, CCP.

13. O'Keeffe to Strand, 12 June 1917, CCP.

14. O'Keeffe to Strand, 29 December 1917, CCP.

15. Strand to Stieglitz, 18 May 1918, YCAL.

16. Strand is often credited as the inspiration for O'Keeffe's close-up studies of flowers, however recent scholarship has confirmed that she made her greatly enlarged paintings of flowers before he photographed similar subjects. See Barbara Buhler Lynes, *Georgia O'Keeffe: Catalogue Raisonné*, New Haven, 1999, nos. 259, 292, 296–306. Moreover, as Sarah Peters has stated in *Becoming O'Keeffe: The Early Years*, New York, 1991, 193, O'Keeffe's 1915 compositions, made before she saw any of Strand's work, "are rife with judicious croppings."

17. While critics have often commented on the phallic nature of many of O'Keeffe's paintings of flowers, Sarah Peters was the first to suggest that many of her paintings of other subjects, including alligator pears, were derived from an examination of

Stieglitz's photographs of herself (Peters 1991). For reproductions of O'Keeffe's alligator pears, see Lynes 1999, 409–421; for Strand's *Rock, Port Lome, Nova Scotia*, 1920, and *Rock, Georgetown, Maine*, 1927, see Greenough 1990, 53, 67.

18. See Peters 1991, 183–196; Sarah Greenough, "From the Faraway Nearby," in Jack Cowart, Juan Hamilton, and Sarah Greenough, *Georgia O'Keeffe: Art and Letters*, Washington, 1987, 276–277.

19. For O'Keeffe's watercolors, see Lynes 1999, nos. 236, 237, 238, 239, 243, 244, and 245.

20. See Lynes 1999, no. 312; Peters 1991, 193–196.

21. In a letter to Dove, Stieglitz described Beck as "certainly a live young one" and someone who "knows how to laugh," while many years later Dove recalled her "good old hilarious style." Stieglitz to Dove, 15 September 1922 and 21 September 1922, and Dove to Stieglitz, 4 February 1940, as quoted in Ann Lee Morgan, ed., *Dear Stieglitz, Dear Dove*, Newark, Del., 1988, 84, 85, and 430.

22. For reproductions of Strand's portraits of Beck, see Greenough 1990, 40, 51, 61, 63, 155.

23. Strand, "Photography and the New God," *Broom* 3 (November 1922), 256.

24. Stieglitz to Rebecca Strand, 15 July 1922, YCAL.

25. Rebecca Strand to Stieglitz, 14 July 1922, YCAL.

26. Stieglitz to Nancy Newhall, as quoted in Richard Whelan, *Alfred Stieglitz: A Biography*, New York, 1995, 433.

27. Stieglitz to Rebecca Strand, 1 November 1922, YCAL.

28. Noting that Strand never allowed these photographs to be exhibited as a group, Naomi Rosenblum in Stange 1990, 273, writes that he concluded "that the similarity to Stieglitz's concept was embarrassing."

29. Stieglitz to Herbert Seligmann, 13 November 1923, and Stieglitz to Paul Rosenfeld, 4 October 1922, YCAL.

30. Strand to Naomi Rosenblum, as quoted in Rosenblum 1978, 218.

31. Naomi Rosenblum 1978, 207, notes that Strand destroyed all but one of these negatives. Several other factors also precipitated Stieglitz's photographs of clouds; see Sarah Greenough, "How Stieglitz Came to Photograph Clouds," in Peter Walch and Thomas Barrow, eds., *Perspectives in Photography: Essays in Honor of Beaumont Newhall*, Albuquerque, 1986, 151–165.

32. See "Aesthetic Criteria," *The Freeman* 2 (12 January 1921), 426–427; "The Subjective Method," *The Freeman* 2 (2 February 1921), 498; "The Independents in Theory and Practice," *The Freeman* 3 (6 April 1921), 90; "American Water Colors at the Brooklyn Museum," *The Arts* 2 (December 1921), 149–152; "John Marin," *Art Review* 1 (January 1922), 22–23; "The Forum," *The Arts* 2 (February 1922), 332–333; "Alfred Stieglitz and a Machine," *MSS* 2 (March 1922), 6–7; "Photography and the New God," *Broom* 3 (November 1922), 252–258; "News of Exhibits," *The Sun*, 31 January 1923; "The New Art of Colour," *The Freeman*

7 (18 April 1923), 137; "Photographers Criticized," *The Sun and the Globe*, 27 June 1923, 20; "The Art Motive in Photography," *British Journal of Photography* 70 (5 October 1923), 612–614; and "Georgia O'Keeffe," *Playboy* 9 (July 1924), 16–20.

33. Strand, "Photography and the New God," 1922, 252–258.

34. See n. 33.

35. Elizabeth Luther Cary, "The World of Art: Recent Pictorial Photography at the Camera Club Exhibition," *New York Times Book Review and Magazine*, 10 September 1922, 10.

36. "American Water Colors," 1921, 149–152.

37. Strand, "John Marin," 1922, 22.

38. For further discussion, see Rosenblum 1978, 91–94. See also, Strand, "Photography and the New God," 1922, 252–258.

39. Strand, unpublished press release, c. summer 1921, CCP. See also Jan-Christopher Horak, "Modernist Perspectives and Romantic Impulses: *Manhatta*," in Stange 1990, 55–71.

40. Robert Allerton Parker, "The Art of the Camera: An Experimental 'Movie,'" *Arts and Decoration* 15 (October 1921), 369.

41. Horak in Stange 1990, 55–71.

42. Strand to Stieglitz, undated, 1928, YCAL. For further discussion of the composite novel in American literature in the 1920s, see Richard Gid Powers, "Toward a New Literature: Novelistic Experimentation in America during the First Decades of the Twentieth Century," Ph.D. diss., Brown University, 1969, and Stephen Lee Sniderman, "The Composite Novel in American Literature," Ph.D. diss., University of Wisconsin, 1970. Other factors may also have influenced Strand: throughout the 1920s Stieglitz frequently exhibited both his photographs of clouds and his portraits of O'Keeffe as series.

43. Although no catalogue, brochure, or checklist has survived for this exhibition, recently discovered installation photographs have helped to identify the exact works shown (fig. 163).

44. See "American Water Colors at the Brooklyn Museum," 1921, 149–152; "John Marin," 1922, 22–23; "Alfred Stieglitz and a Machine," 1922, 6–7; "Photography and the New God," 1922, 252–258; "The Art Motive in Photography," 1923, 612–614; "Georgia O'Keeffe," 1924, 16–20; and "Marin Not an Escapist," *The New Republic* 55 (25 July 1928), 254–255.

45. "Can a Photograph have the Significance of Art?" *MSS* 4 (December 1922). In 1923 Paul and Beck also devised a plan for several wealthy people to be approached about establishing a fund to enable Stieglitz to use the Lake George property in any manner he saw fit. See Rosenblum 1978, 207; and Rebecca Strand to Stieglitz, 19 September 1923, YCAL.

46. See, for example, Lynes 1999, nos. 374, 415, 459, 492, and 578, and they purchased Dove's *Snow and Water*, 1928. See also Stieglitz to Dove, 27 March 1928 and 23 August 1928, as quoted in Ann Lee Morgan 1988, 149 and 153.

47. Strand to Samuel Kootz, 11 September 1931, CCP.

48. In 1928, after receiving a large donation to his operating fund from David Schulte, Stieglitz, in one of his more convoluted transactions, donated several of his own photographs to the Metropolitan Museum in Shulte's name, as well as those of Paul Rosenfeld, Alma Wertheim, and Rebecca Strand. For further discussion, see Whelan 1995, 498–499.

49. When thanking the Strands for the work they did in helping to launch An American Place, Stieglitz wrote, "Say, Young Lady, where did you get the notion that I didn't fully realize (& fully appreciate) the activities of Paul & yourself in connection with the new rooms idea. What I meant was I wanted the 'young ones' to keep up the activities—that is I don't want the 'new' to be a 'one man' affair." Stieglitz to Rebecca Strand, 22 October 1929, YCAL.

50. Peters 1991, 175, notes that Strand was disappointed with the *Seven Americans* show because his work was hung apart from the others. Stieglitz did include Strand's photograph in two other more minor exhibitions in the 1920s: in March 1919 he put one unidentified photograph by Strand in an *Exhibition on Modern Art* at the Young Women's Hebrew Association in New York, and on 8–10 June 1922 he included two photographs by Strand (*Bowls* and *Building*) in *A Loan Exhibition of Modern Art* he arranged at the Municipal Building in Freehold, New Jersey.

51. Strand's portrait of Stieglitz was reproduced in the catalogue that accompanied the show.

52. Whelan 1995, 507.

53. Stieglitz to Paul Strand, 31 March 1929, and 5 May 1929, CCP and YCAL. Stieglitz to Marin, 9 August 1920, box 1, folder 19, John Marin Family Archives, National Gallery of Art Library, Washington, D.C. Stieglitz to Sherwood Anderson, 1 October 1921, and Stieglitz to Seligmann, 16 October 1927.

54. Stieglitz to Seligmann, 8 October 1928, YCAL.

55. Harold Clurman, in "Photographs by Paul Strand," *Creative Art* 5 (October 1929), 735–736.

56. *The Springfield Sunday Union and Republican*, 17 April 1932.

57. McBride, "The Paul Strand Photographs," *New York Evening Sun*, 23 March 1929, Paul Strand Scrapbooks, CCP. Sterne, "Film Overtones," *New York Times*, 16 April 1932, Paul Strand Scrapbooks, CCP.

58. Strand, as quoted in Calvin Tomkins, "Profiles: Look to the Things around You," *The New Yorker* (16 September 1974), 34; and Clurman 1929, 735.

59. O'Keeffe 1978, introduction.

60. See Whelan 1995, 535.

61. Encouraged by Stieglitz and O'Keeffe, Beck Strand had begun to paint in the late 1920s, specializing in paintings on glass. For further discussion, see Suzan Campbell's essay "Women Artists of the Stieglitz Circle, 1906–1946," in *Women of the Stieglitz Circle*, Santa Fe, 1998.

62. Clurman to Strand 21 November 1932, CCP.

HARTLEY

1. Hartley to Adelaide S. Kuntz, spring 1930. This correspondence is on microfilm at the Archives of American Art, Smithsonian Institution, Washington.

2. Lee Simonson, "Hartley Exhibition," January, 1929, in the exhibition catalogue at The Intimate Gallery, New York, 1929.

3. Murdock Pemberton, "Soul Exposures," *Creative Art* (January 1929), xlviii.

4. Alfred Stieglitz to Hartley, 5 February 1929. This correspondence is in the Stieglitz Collection, YCAL.

5. See n. 4.

6. See n. 4.

7. See n. 4.

8. Henry McBride, "Attractions in the Galleries," *New York Sun*, 5 January 1929, 12.

9. Hartley to Stieglitz, 8 December 1926.

10. Hartley to Rebecca Strand, 6 March 1929. This correspondence is on microfilm at the Archives of American Art, Smithsonian Institution, Washington.

11. Hartley to Adelaide S. Kuntz, undated [1929].

12. "Marsden Hartley Returns to An American Place," *Magazine of Art* 29 (May 1936), 330.

13. "Sea-Gulls, Roses, Ikons, A Letter Never Sent," *Art News* (28 March 1936), 8.

14. Hartley to Kuntz, 22 October 1931.

15. Wallace Stevens, "The Pleasures of Merely Circulating," *Poems*, New York, 1959, 54.

16. Marsden Hartley, "Eakins, Homer, Ryder," in *On Art*, ed. Gail Scott (New York, 1982), 168–172.

17. Hartley to Kuntz, spring 1930.

18. See n. 17.

19. See n. 17.

20. Hartley to Stieglitz, 16 April 1930.

21. Hartley to Isabel and Gaston Lachaise, 7 June 1930. This correspondence is on microfilm at the Archives of American Art, Smithsonian Institution, Washington.

22. "Marsden Hartley's 'Comeback,'" *New York Sun*, 20 December 1930, 9.

23. Hartley to Stieglitz, 12 August 1931.

24. Hartley to Kuntz, 5 December 1932.

25. Hartley to Kuntz, 11 January and 5 February 1934.

26. Hartley to Norma Berger, 15 and 21 November 1934. YCAL.

27. Hartley to Rebecca Strand, 29 July 1935.

28. Hartley to Stieglitz, 1 February 1936.

29. Hartley to Kuntz, 28 April 1936.

30. Hartley to Kuntz, undated [1937].

31. Hartley to Lloyd Goodrich, two letters, spring 1937, Elizabeth McCausland papers, reel 268, Archives of American Art, Smithsonian Institution, Washington.

32. Barbara Haskell, *Marsden Hartley*, New York, 1980, 101.

33. Hartley to Hudson Walker, 1 October 1937, Archives of American Art, Smithsonian Institution, Washington.

DOVE

1. Helen Torr, diary, 10 June 1924, Arthur Dove Papers, reel N70-52, frame 068, Archives of American Art, Smithsonian Institution, Washington, and New York. The diaries were kept, alternately, by Dove and Torr, from 1924 to 1944. Hereafter cited as Torr diary or Dove diary.

2. Arthur Dove, "A Different One," in *Alfred Stieglitz: A Collective Portrait*, ed. Dorothy Norman, New York, 1934, 122.

3. Letter, Dove to Stieglitz, 9 December 1934, YCAL. This (and all other Dove-Stieglitz letters) is reprinted in *Dear Stieglitz, Dear Dove*, ed. Ann Lee Morgan, Newark, Del., 1988, 319.

4. Dove to Stieglitz, July 1916. Morgan 1988, 48.

5. For a full chronology, see Debra Balken, Elizabeth Hutton Turner, and William C. Agee, *Arthur Dove: A Retrospective* [exh. cat., Addison Gallery of American Art], Cambridge, Mass., 1998, 175–179.

6. See William Innes Homer, "Identifying Arthur Dove's 'The Ten Commandments,'" *American Art Journal* 12 (1980), 21–32.

7. Stieglitz to Dove, 28 August 1920. Morgan 1988, 70.

8. Dove to Stieglitz, August 1921. Morgan 1988, 75.

9. See Sarah Greenough, "Alfred Stieglitz and 'The Idea Photography,'" in Sarah Greenough and Juan Hamilton, *Alfred Stieglitz: Photographs and Writings*, Washington, 1983, reprinted 1998, 12–32, for an excellent study of Stieglitz, his art, and the development of modernism in America.

10. Dove to Stieglitz, 5/7 May 1931. Morgan 1988, 221.

11. Helen Torr, Notes on Arthur Dove, Dove Papers, Archives of American Art, reel 4682, frame unclear.

12. See Greenough 1983, especially 17–20.

13. William Innes Homer, *Alfred Stieglitz and the American Avant-Garde*, Boston, 1977, 77.

14. The analogy of Dove's paintings with Stieglitz's clouds was first pointed out by Sasha M. Newman, *Arthur Dove and Duncan Phillips: Artist and Patron* [exh. cat., Phillips Collection], Washington, 1981, 37, and subsequently in more detail by Sarah Greenough in her "Alfred Stieglitz's Photographs of Clouds," Ph.D. diss., University of New Mexico, 1984, 167.

15. Dove to Stieglitz, 7 July 1942; Stieglitz to Dove, 8 July and 17 July 1942. Morgan 1988, 471–472.

16. I am grateful to Sarah Greenough and Janet Blyberg at the National Gallery of Art for confirming the identification of these works. They are seen *in situ* at Dove's house in 1942 in a photograph reproduced in Anne Cohen DePietro, *Arthur Dove and*

Helen Torr/ The Huntington Years [exh. cat., Heckscher Museum], Huntington, N.Y., 1989, 57.

17. For a summary of this and how it influenced certain pioneering American modernists, see William C. Agee, *Synchromism and Color Principles in American Painting, 1910–1930* [exh. cat., M. Knoedler and Co., Inc.], New York, 1965, 28–32.

18. Greenough 1983, especially 18–20.

19. Greenough 1983, 19. I have greatly benefited from my discussions with her on this topic during December 1999–June 2000.

20. See, for example, Torr diary, 10 June 1924, and Dove to Stieglitz, 11 July 1930. Morgan 1988, 194.

21. The bulk of the late watercolors are in the collections of the National Gallery of Art; the Metropolitan Museum of Art; the Museum of Fine Arts, Boston; the Arkansas Art Center, Little Rock; the Amon Carter Museum, Fort Worth; the Wichita Art Museum; and the Wadsworth Atheneum, Hartford. Those in Wichita are published in Charles C. Eldredge, "Arthur Dove: Small Paintings," in *Reflections on Nature: Small Paintings by Arthur Dove 1942–1943* [exh. cat., Wichita Art Museum], Wichita, 1997, and are among those discussed in William C. Agee, "New Directions: The Late Work," in Balken, Turner, and Agee 1998, 142–144.

22. Stieglitz to Dove, 30 August 1922. Morgan 1988, 83.

23. Dove to Stieglitz, 19 October 1914. Morgan 1988, 43.

24. Dove to Arthur Jerome Eddy, probably November 1913. Reprinted in Arthur Jerome Eddy, *Cubists and Post-Impressionists*, Chicago, 1914, 2d ed., 1919, 48.

25. Arthur Dove, statement for *The Forum Exhibition of Modern American Painters* [exh. cat., Anderson Galleries], New York, 1916, unpaginated.

26. Dove to Stieglitz, 20 or 21 June 1928. Morgan 1988, 150.

27. Dove to Stieglitz, 3 September 1931. Morgan 1988, 230–231.

28. Arthur G. Dove, statement in *Arthur G. Dove: Paintings 1942–43* [exh. cat., An American Place], New York, 1943, unpaginated.

29. Greenough 1983, 19.

30. Homer 1977, 17.

31. Homer 1977, 67.

32. Letter, Alfred Stieglitz to Sherwood Anderson, 13 August 1923. Reprinted in Greenough 1983, 206.

33. Stieglitz to Herbert J. Seligmann, 9 August 1923. Greenough 1983, 206.

34. Dove to Stieglitz, 3 October 1924. Morgan 1988, 107.

35. See n. 34.

36. See, for example, Debra Bricker Balken, "Continuities and Digressions in the Work of Arthur Dove from 1907 to 1933," in Balken, Turner, and Agee 1998, 31.

37. Dove to Stieglitz, August 1921. Morgan 1988, 75.

38. Torr diary, 4 December 1924.

39. Torr diary, 11 March 1925.

40. Dove, c. 1930–1931, as quoted in Frederick S. Wight, *Arthur G. Dove* [exh. cat., Art Galleries, University of California, Los Angeles], Berkeley and Los Angeles, 1958, 62. Also recorded in part in Torr, Notes on Arthur Dove.

41. Dove to Stieglitz, 5/7 May 1931. Morgan 1988, 221.

42. John McCoubrey, *American Tradition in Painting*, New York, 1963, 44, and now overlooked by Wanda M. Corn, *The Great American Thing: Modern Art and National Identity, 1915–1935*, Berkeley, 1999.

43. Dove to Stieglitz, 6 September 1929. Morgan 1988, 176.

44. Miles Unger, "O Pioneer: The Art of Arthur G. Dove," *Art New England* 19, 3 (April–May 1998), 22.

45. Dove to Stieglitz, 23 January 1930. Morgan 1988, 186.

46. Torr diary, 13 August 1929.

47. Torr diary, 26 November 1929.

48. Dove to Stieglitz, early October 1929. Morgan 1988, 180.

49. See Greenough 1984, 78–83.

50. For a detailed account of the late years, see Agee in Balken, Turner, and Agee 1998, 133–153.

51. Dove to Stieglitz, 3 September 1931. Morgan 1988, 230.

52. Dove to Stieglitz, 1 February 1932. Morgan 1988, 237.

53. Dove to Stieglitz, 2 or 3 June 1932. Morgan 1988, 243.

54. Dove to Stieglitz, probably 19 June 1939. Morgan 1988, 421.

55. Discussed and illustrated in Greenough 1984, 167.

56. Dove diary, 20 August 1939, reel 40, frame 152.

57. Dove diary, 31 December 1943, reel 725, frame 1028.

58. Dove diary, 20 August 1942, reel 725, frame 795.

59. Stieglitz to Dove, 21 March 1940. Morgan 1988, 435.

60. James W. Lane, "Dove: Abstract Poet of Color," *Art News* 41 (15–31 May 1942), 21.

GEORGIA O'KEEFFE

1. Georgia O'Keeffe, *Georgia O'Keeffe: A Portrait by Alfred Stieglitz*, New York, 1976, unpaginated.

2. [Stieglitz], "Georgia O'Keeffe, C. Duncan, Réné Lafferty," *Camera Work* 48 (October 1916), 12. For further discussion, see Barbara Buhler Lynes, *Georgia O'Keeffe, Alfred Stieglitz and the Critics, 1916–1929*, Ann Arbor, 1989, 69.

3. O'Keeffe to Anita Pollitzer, late June 1915, as quoted in Jack Cowart, Juan Hamilton, and Sarah Greenough, *Georgia O'Keeffe: Art and Letters*, Washington, 1987, 142.

4. For the most thorough discussion of the critical reception of O'Keeffe's work in the late 1910s and 1920s, see Lynes 1989. See also Sarah Greenough, "From the Faraway," in Cowart, Hamilton, and Greenough 1987, 135–139; Anna C. Chave, "O'Keeffe and the Masculine Gaze," *Art in America* 78 (January 1990), 115–124.

5. Across the backing of fig. 29, Stieglitz had inscribed in pencil "Woman Supreme."

6. O'Keeffe 1976, opposite pl. 14.

7. Paul Rosenfeld, a frequent visitor at Lake George and a music critic by profession, also saw a connection between *Music—Pink and Blue No. 1* and *Music—Pink and Blue No. 2* and the visual and aural stimuli of the lake. In reviewing O'Keeffe's 1923 show at the Anderson Galleries, he made reference to these works by noting, with typically effusive language, "Veils of ineffable purity rise as the mists of the summer morning from lakewater." As quoted in Lynes 1989, 172. For further discussion of *Music—Pink and Blue No. 1*, see *Twentieth-Century American Art: The Ebsworth Collection* [exh. cat., National Gallery of Art], Washington, 1999, 191–194.

8. Stieglitz made other photographs of O'Keeffe's *Abstraction*: one in front of *Music—Pink and Blue No. 1*, National Gallery of Art accession number 1980.70.130; three of O'Keeffe holding it, 1980.70.129, 1980.70.148, and 1980.70.149; one by itself, 1980.70.122; and one resting by her feet, 1980.70.56.

9. John Tennant, "The Stieglitz Exhibition," *Photo-Miniature* 16 (July 1921), 138.

10. Tennant 1921, 137; Henry McBride, "Modern Art," *The Dial* 70 (April 1921), 480; see also Q. R., "Photography," *The Christian Science Monitor*, 21 February 1921, 12.

11. Tennant 1921, 137. For other reviews, see "Strips Mask from Life with Camera," *New York Evening Post*, 7 February 1921, 5; David Lloyd, "Stieglitz, the Pioneer Who Has Developed Photography as an Art," *New York Evening Post*, 12 February 1921, 12; Henry McBride, "Work by a Great Photographer," *The New York Herald*, 13 February 1921, section 2, 5; Hamilton Easter Field, "At the Anderson Galleries," *Brooklyn Daily Eagle*, 13 February 1921, section 3, 6; Herbert Seligmann, "A Photographer Challenges," *The Nation* 112 (16 February 1921), 268.

12. Stieglitz, "A Statement," in *An Exhibition of Photographs by Alfred Stieglitz* [exh. cat., The Anderson Galleries], New York, 1921.

13. Henry McBride, "O'Keeffe at the Museum," *New York Sun*, 18 May 1946, 9.

14. Georgia O'Keeffe, [Statement], in *Alfred Stieglitz Presents One Hundred Pictures: Oils, Watercolors, Pastels, Drawings by Georgia O'Keeffe* [exh. cat., Anderson Galleries], New York, 1923, as quoted in Lynes 1989, 184–185.

15. O'Keeffe to Mitchell Kennerley, fall 1922, as quoted by Sarah Greenough in Cowart, Hamilton, and Greenough 1987, 170; O'Keeffe as quoted by Grace Glueck, "Art Notes: It's Just What is in My Head…," *New York Times*, 18 October 1970, section 2, 24. O'Keeffe continued, "I thought I could never face the world again."

16. Marsden Hartley, [Extract from *Adventures in the Fine Arts*, 1920], in exh. cat. New York 1923, unpaginated.

17. For Paul Rosenfeld's assessment of O'Keeffe see "The Paintings of Georgia O'Keeffe: The Work of the Young Artist," *Vanity Fair* 19 (October 1922), 56, 112, and 114.

18. Helen Appleton Read, "Georgia O'Keeffe's Show an Emotional Escape," *Brooklyn Daily Eagle*, 11 February 1923, 2b.

19. H. Alexander Brook, "February Exhibitions: Georgia O'Keefe [sic]," *The Arts* 3 (February 1923), 130.

20. Herbert Seligmann, "Georgia O'Keeffe: American," *MSS* 5 (March 1923), 10.

21. O'Keeffe to Sherwood Anderson, 11 February 1924, in Cowart, Hamilton, and Greenough 1987, 176.

22. See Lynes 1989, 61, 62, 70, and 71.

23. "'I Can't Sing, So I Paint,' Says Ultra Realistic Artist: Art is not Photography—It is Expression of Inner Life," *New York Sun*, 5 December 1922, 22.

24. Lynes 1989, 73, points out that the catalogue for O'Keeffe's 1924 show includes Henry McBride's and Alan Burrough's reviews of O'Keeffe's 1923 show, however they had been edited to eliminate the passages they had quoted from Hartley's 1921 book. In addition, it is significant to note that this was contrary to Stieglitz's previous practice in *Camera Work* of printing reviews of shows, both positive and negative, in their entirety in order to stimulate debate. The fact that he acquiesced to O'Keeffe's desire to remove these offending passages indicates his growing awareness that he needed to shape and control the discourse about his artists.

25. The 1932 photographs, perhaps made in response to Edward Weston's work at the Delphic Studio in New York in 1931 and 1932, are National Gallery of Art accession numbers 1949.3.274–1949.3.281.

26. "A Second Stieglitz Exhibition," *The Amateur Photographer and Photography* 56 (23 May 1923), 466.

27. Georgia O'Keeffe, [Statement], *Alfred Stieglitz Presents Fifty-One Recent Pictures, Oils, Water-colors, Pastels, Drawings by Georgia O'Keeffe, American* [exh. cat., The Anderson Galleries], New York, 1924, unpaginated.

28. In 1909 he mounted an exhibition at 291 of Autochromes by J. N. Laurvik and drawings by de Zayas.

29. O'Keeffe to Sherwood Anderson, 11 February 1924, YCAL, as quoted in Cowart, Hamilton, and Greenough 1987, 174.

30. Stieglitz, "How I Came to Photograph Clouds," *Amateur Photographer and Photography*, 19 September 1923, 255.

31. Helen Appleton Read, "News and Views on Current Art," *Brooklyn Daily Eagle*, 9 March 1924, 2B.

32. Elizabeth Luther Cary, "Art: Exhibitions of the Week," *New York Times*, 9 March 1924, section 8, 10. For further discussion, see Lynes 1989, 79–81, and 198–199.

33. Paul Rosenfeld, "Georgia O'Keeffe," in *Port of New York*, New York, 1924, 198.

34. Richard Whelan, *Alfred Stieglitz: A Biography*, New York, 1995, 438.

35. There was no printed checklist with titles and prices, however annotated copies of the typed checklist for this exhibition indicate that Stieglitz raised the prices on O'Keeffe's works on 3 February and again on 5 February, and finally at an unspecified date thereafter. Several of the increases were dramatic: number 76 was priced at $600 on 3 February and raised to $1,000 at some point after 5 February, while number 51 was originally priced at $450, then raised to $800 on 3 February, to $900 on 5 February, and finally to $1,800 sometime before the exhibition closed on 10 February. Besides one unidentified buyer, works were sold mainly to close Stieglitz associates or their friends and family: Paul Strand, his father, Jacob Strand, and a friend Harold Greengard each bought one work, as did Paul Rosenfeld and Marion Beckett; Katharine Rhoades bought two. Annotated copies of the typed checklist are in the Georgia O'Keeffe Foundation, Abiquiu, New Mexico. Lynes 1989, 130, 340–341, notes the conflicting evidence regarding the amount of money O'Keeffe received from her 1927 show, with estimates ranging from $9,000 to $23,000.

36. Georgia O'Keeffe, [Statement], in New York 1924, unpaginated.

37. O'Keeffe to Doris McMurdo, 1 July 1922, as quoted in Cowart, Hamilton, and Greenough 1987, 170.

38. Herbert Seligmann, *Alfred Stieglitz Talking*, New Haven, 1966, 27–28.

39. Stieglitz to Paul Rosenfeld, 5 September 1923, as quoted in Sarah Greenough and Juan Hamilton, *Alfred Stieglitz: Photographs and Writings*, Washington, 1983 and 1999, 212.

40. Edmund Wilson, "The Stieglitz Exhibition," *The New Republic* 42 (18 March 1925), 97–98, as quoted in Lynes 1989, 227–229.

41. Murdock Pemberton, "The Art Galleries," *The New Yorker* 2 (22 January 1927), 62–63; Louis Kalonyme, "Scaling the Peak of the Art Season," *Arts and Decoration* 26 (March 1927), 93; and Frances O'Brien, "Americans We Like," *The Nation* 125 (12 October 1927), 361–362.

42. See O'Brien, n. 41.

43. O'Keeffe 1976, unpaginated.

44. O'Keeffe, as quoted by Blanche Matthias, "Georgia O'Keeffe and the Intimate Gallery," *Chicago Evening Post, Magazine of the Art World*, 2 March 1926, 14.

45. As quoted by Henry McBride, "O'Keeffe in Taos," *New York Sun*, 8 January 1930, reprinted in *The Flow of Art: Essays and Criticisms of Henry McBride*, ed. Daniel Catton Rich, New York, 1975, 261.

46. O'Keeffe to Blanche Matthias, April, 1929?, YCAL. In addition, see Seligmann 1966, 60, where he notes Stieglitz as saying on 22 February 1926 that "O'Keeffe had expressed a desire…to decorate a large wall." This may have been said in response to a comment by Helen Appleton Read on 21 February 1926 in the *Brooklyn Daily Eagle*, 7E, that "It would be easy to imagine a wall decorated by O'Keeffe that would show up the rather uncraftsmanlike attempts of the many would-be mural

painters who disfigure our walls....What is the matter with our architects and interior decorators that they have not singled her out as THE person to design wall panels and decorations?" Earlier that same year, Stieglitz had said that "Her work is too big for this room." Seligmann 1966, 28.

47. See Whelan 1995, 357–362; Sue Davidson Lowe, *Stieglitz: A Memoir/Biography*, New York, 1983, 317–323; Roxanna Robinson, *Georgia O'Keeffe: A Life*, New York, 1989, 370–381.

48. Lowe 1983, 319, and "Two O'Keeffe's Acquired by the Whitney Museum," *Art News* 30 (9 April 1932), 28.

49. O'Keeffe to Dorothy Brett, September?, 1932, YCAL.

50. Most accounts state that O'Keeffe quit the project on 16 November 1932: see Whelan 1995, 542; Lowe 1983, 322; Robinson 1989, 378; Laurie Lisle, *Portrait of an Artist: A Biography of*

Georgia O'Keeffe, New York, 1980, 205; Benita Eisler, *O'Keeffe and Stieglitz: An American Romance*, New York, 1991, 436. However many of O'Keeffe's own letters suggest that her decision to quit came as early as October; see O'Keeffe to Russell Vernon Hunter, October 1932, as quoted in Cowart, Hamilton, and Greenough 1987, 211. Also Barbara Lynes, *Georgia O'Keeffe: A Catalogue Raisonné*, New Haven, 1999, 1144, states that her decision came in October.

51. O'Keeffe to Henry McBride, early 1940s, as quoted in Cowart, Hamilton, and Greenough 1987, 244.

52. Georgia O'Keeffe, "Stieglitz: His Pictures Collected Him," *The New York Times Magazine*, 11 December 1949, 29.

53. See n. 52, 24.

54. See n. 52, 29 and 24.

EXHIBITED WORKS

Constantin Brancusi
Sleeping Muse, 1909–1911
marble, 17.2 × 27.6 × 21.2 (6¾ × 10⅞ × 8⅜)
Hirshhorn Museum and Sculpture Garden, Smithsonian Institution. Gift of Joseph H. Hirshhorn, 1966
(pl. 36)

Constantin Brancusi
Sleeping Muse, 1910
bronze, 17.1 × 24.1 × 15.2 (6¾ × 9½ × 6)
The Metropolitan Museum of Art, Alfred Stieglitz Collection, 1949
(pl. 39)

Constantin Brancusi
Maiastra (Bird Before It Flew), c. 1911
polished bronze, 55.9 × 18.9 × 18.7 (22 × 7½ × 7⅜)
National Gallery of Art, Washington, Gift of Katharine Graham, 1980.75.1
(pl. 38)

Constantin Brancusi
Mademoiselle Pogany, 1912
marble, 44.5 × 21 × 31.4 (17½ × 8¼ × 12⅜)
Philadelphia Museum of Art: The Alfred Stieglitz Collection
(pl. 41)

Constantin Brancusi
Muse, 1912
marble, 44.5 × 24.1 × 21.6 (17½ × 9½ × 8½)
Solomon R. Guggenheim Museum, New York
(pl. 37)

Constantin Brancusi
Danaïde, c. 1913
partly gilded bronze, 27 × 18.1 × 20 (10⅝ × 7⅛ × 7⅞)
Private Collection
(pl. 40)

Georges Braque
Untitled (Still Life), 1912–1913
charcoal, crayon, cut printed paper, and traces of graphite, 62 × 47 (24⁷⁄₁₆ × 18½)
Philadelphia Museum of Art: The Louise and Walter Arensberg Collection
(pl. 57)

Paul Cézanne
Landscape with Trees, 1880–1885
watercolor, 31.1 × 47.9 (12¼ × 18⅞)
Philadelphia Museum of Art: The Louise and Walter Arensberg Collection
(pl. 18)

Paul Cézanne
Madame Cézanne with Hydrangeas, 1882–1886
watercolor, 30.2 × 46.4 (11⅞ × 18¼)
Private Collection
(pl. 20)

Paul Cézanne
Mont Sainte-Victoire, c. 1890
watercolor and pencil, 32.8 × 50.5 (12¹⁵⁄₁₆ × 19⅞)
Courtauld Gallery, Courtauld Institute of Art, D. 1932.SC.110
(pl. 19)

Paul Cézanne
Tree Study, c. 1890
watercolor, 27.6 × 43.5 (10⅞ × 17⅛)
Kunsthaus Zürich
(pl. 21)

Paul Cézanne
Foliage, 1895–1900
watercolor and pencil, 44.8 × 56.8 (17⅝ × 22⅜)
The Museum of Modern Art, New York, Lillie P. Bliss Collection
(pl. 16)

Paul Cézanne
Well and Winding Path in the Park of Château Noir, c. 1900
watercolor over graphite on heavy cream wove paper, 53.3 × 42.9 (21 × 16⅞)
Private Collection, courtesy of Phyllis Hattis Fine Arts, New York
(pl. 17)

Charles Demuth
Poster Portrait: Dove, 1924
poster paint on board, 50.8 × 59.7 (20 × 23½)
Yale Collection of American Literature, Beinecke Rare Book and Manuscript Library
(pl. 134)

Charles Demuth
Apples (Still Life: Apples, Number 1), c. 1925
watercolor, 29.9 × 45.7 (11¾ × 18)
Sheldon Memorial Art Gallery and Sculpture Garden, University of Nebraska-Lincoln, F. M. Hall Collection
(pl. 137)

Charles Demuth
Poster Portrait: Marin, 1926
poster paint on board, 68.6 × 83.8 (27 × 33)
Yale Collection of American Literature, Beinecke Rare Book and
Manuscript Library
(pl. 135)

Charles Demuth
My Egypt, 1927
oil on composition board, 90.8 × 76.2 (35¾ × 30)
Whitney Museum of American Art, New York, Purchase, with
funds from Gertrude Vanderbilt Whitney, 31.172
(pl. 113)

Charles Demuth
Corn and Peaches, 1929
watercolor and pencil, 35 × 50.2 (13¾ × 19¾)
The Museum of Modern Art, New York, Gift of Abby Aldrich
Rockefeller
(pl. 140)

Charles Demuth
Green Pears, 1929
watercolor over black chalk, 87.9 × 100.8 (34⅝ × 39¹¹⁄₁₆)
Yale University Art Gallery, Philip L. Goodwin, B.A. 1907,
Collection, Gift of James L. Goodwin, B.A. 1905, Henry Sage
Goodwin, B.A. 1927, and Richmond L. Brown, B.A. 1907
(pl. 138)

Charles Demuth
Love, Love, Love (Homage to Gertrude Stein), 1929
oil on panel, 50.8 × 53 (20 × 20⅞)
Museo Thyssen-Bornemisza, Madrid
(pl. 136)

Charles Demuth
Red Poppies, 1929
watercolor and pencil on paper, 35.2 × 50.2 (13⅞ × 19¾)
The Metropolitan Museum of Art, Gift of Henry and Louise
Loeb, 1983
(pl. 139)

Charles Demuth
…And the Home of the Brave, 1931
oil on composition board, 74.8 × 59.7 (30 × 24)
The Art Institute of Chicago, Gift of Georgia O'Keeffe, 1948.650
(pl. 141)

Charles Demuth
Chimney and Water Tower, 1931
oil on composition board, 74.3 × 59.1 (29¼ × 23¼)
Amon Carter Museum, Fort Worth, Texas
(pl. 142)

Marius de Zayas
291 Throws Back Its Forelock

291, no. 1 (March 1915)
43.8 × 28.9 (17¼ × 11⅜)
Yale Collection of American Literature, Beinecke Rare Book and
Manuscript Library
(pl. 34)

Arthur Dove
After the Storm, Silver and Green (Vault Sky), c. 1923
oil and metallic paint on wood panel, 61 × 45.7 (24 × 18)
New Jersey State Museum, Trenton, Gift of Mr. and Mrs. L. B.
Wescott
(pl. 103)

Arthur Dove
Rain, 1924
twigs and rubber cement on metal and glass, 49.5 × 39.7 (19½ ×
15⅝)
National Gallery of Art, Washington, Avalon Fund, 1997.1.1
(pl. 108)

Arthur Dove
Goin' Fishin', 1925
assemblage of bamboo, denim shirt sleeves, buttons, wood, and
oil on panel, 54 × 65.4 (21¼ × 25½)
The Phillips Collection, Washington, D.C.
(pl. 163)

Arthur Dove
Sea II, 1925
chiffon over metal with sand, 31.8 × 52.1 (12½ × 20½)
Collection of Mr. and Mrs. Barney A. Ebsworth
(pl. 160)

Arthur Dove
Fields of Grain as Seen from Train, 1931
oil on canvas, 61 × 86.4 (24 × 34)
Collection Albright-Knox Art Gallery, Buffalo, New York. Gift of
Seymour H. Knox, Jr., 1958
(pl. 164)

Arthur Dove
Sunrise I, 1936
wax emulsion, 63.5 × 88.9 (25 × 35)
Private Collection, courtesy of Salander-O'Reilly Galleries, New
York
(pl. 161)

Arthur Dove
The Brothers, 1942
tempera and wax emulsion, 50.8 × 71.1 (20 × 28)
Collection of the McNay Art Museum, San Antonio, Gift of
Robert L. B. Tobin through the Friends of the McNay
(pl. 165)

Arthur Dove
Square on the Pond, 1942
wax-based paint on canvas, 50.8 × 71.1 (20 × 28)
Museum of Fine Arts, Boston, Gift of William H. and Saundra B. Lane and Henry and Zoë Oliver Sherman Fund, M. Theresa B. Hopkins Fund, Seth K. Sweetser Fund, Robert Jordan Fund and Museum Purchase 1990.373
(pl. 162)

Arthur Dove
That Red One, 1944
oil and wax on canvas, 68.6 × 91.4 (27 × 36)
Museum of Fine Arts, Boston, Gift of the William H. Lane Foundation 1990.408
(pl. 166)

Marcel Duchamp, Henri-Pierre Roché, and Beatrice Wood, eds.
The Blind Man, no. 2 (May 1917)
27.9 × 40.6 (11 × 16)
Collection of Francis M. Naumann, New York
(pl. 66)

Marcel Duchamp
Fountain, 1917 (1964 edition)
ready-made (porcelain), 35.6 × 49.1 × 62.6 (14 × 19⁵/₁₆ × 24⅝)
Dimitris Daskalopoulos Collection, Greece
(pl. 65)

Marsden Hartley
The Warriors, 1913
oil on canvas, 121.3 × 120.7 (47¼ × 47½)
Collection of Deborah and Halsey Minor
(pl. 68)

Marsden Hartley
The Aero, 1914
oil on canvas, 100.3 × 81.2 (39½ × 32)
National Gallery of Art, Washington, Andrew W. Mellon Fund, 1970.31.1
(pl. 69)

Marsden Hartley
Indian Fantasy, 1914
oil on canvas, 118.6 × 99.7 (46¹¹/₁₆ × 39⁵/₁₆)
North Carolina Museum of Art, Raleigh, purchased with funds from the State of North Carolina
(pl. 71)

Marsden Hartley
Portrait of a German Officer, 1914
oil on canvas, 173.4 × 105.1 (68¼ × 41⅜)
The Metropolitan Museum of Art, Alfred Stieglitz Collection, 1949
(pl. 75)

Marsden Hartley
Indian Composition, c. 1914–1915

oil on canvas, 121.3 × 121.3 (47¾ × 47¾)
Frances Lehman Loeb Art Center, Vassar College, Poughkeepsie, New York, gift of Paul Rosenfeld, 1950.1.5
(pl. 70)

Marsden Hartley
Abstraction (Military Symbols), 1914–1915
oil on canvas, 99.7 × 81.3 (39¼ × 32)
The Toledo Museum of Art, purchased with funds from the Libbey Endowment, Gift of Edward Drummond Libbey
(pl. 76)

Marsden Hartley
E. (German Officer Abstraction), 1914–1915
oil on canvas, 119.7 × 119.7 (47⅛ × 47⅛)
The University of Iowa Museum of Art, Mark Ranney Memorial Fund, 1958.1
(pl. 78)

Marsden Hartley
The Iron Cross, 1914–1915
oil on canvas, 118.7 × 118.7 (46¾ × 46¾)
Washington University Gallery of Art, Saint Louis, University purchase, Bixby Fund, 1952
(pl. 74)

Marsden Hartley
Painting No. 5, 1914–1915
oil on canvas, 100.3 × 80.7 (39½ × 31¾)
Whitney Museum of American Art, New York, Gift of an anonymous donor
(pl. 77)

Marsden Hartley
Painting No. 47, Berlin, 1914–1915
oil on canvas, 100.1 × 81 (39⁷/₁₆ × 31⅞)
Hirshhorn Museum and Sculpture Garden, Smithsonian Institution. Gift of Joseph H. Hirshhorn, 1972
(pl. 73)

Marsden Hartley
Painting No. 49, Berlin (Portrait of a German Officer or Berlin Abstraction), 1914–1915
oil on canvas, 119.4 × 99.7 (47 × 39¼)
Collection of Mr. and Mrs. Barney A. Ebsworth
(pl. 72)

Marsden Hartley
New Mexico Landscape, 1919
oil on canvas, 76.2 × 91.4 (30 × 36)
Philadelphia Museum of Art: The Alfred Stieglitz Collection
(pl. 101)

Marsden Hartley
New Mexico Recollections, No. 12, 1922–1923
oil, 76.6 × 101.7 (30³/₁₆ × 40¹/₁₆)

Jack S. Blanton Museum of Art, The University of Texas at Austin, Gift of Mari and James A. Michener, 1991
(pl. 151)

Marsden Hartley
Landscape, New Mexico, 1923
oil on canvas, 55.3 × 90.8 (21³⁄₄ × 35³⁄₄)
Collection of AXA Financial, Inc., through its subsidiary The Equitable Life Assurance Society of the United States
(pl. 110)

Marsden Hartley
Mountains in Stone, Dogtown, 1931
oil on board, 45.7 × 61 (18 × 24)
Collection of James and Barbara Palmer
(pl. 152)

Marsden Hartley
Eight Bells Folly: Memorial for Hart Crane, 1933
oil on canvas, 77.8 × 100 (30⅝ × 39⅜)
Lent by the Frederick R. Weisman Art Museum, University of Minnesota, Gift of Ione and Hudson Walker
(pl. 153)

Marsden Hartley
Mount Katahdin, Maine No. 2, 1939–1940
oil on canvas, 76.8 × 102.2 (30¼ × 40¼)
The Metropolitan Museum of Art, Edith and Milton Lowenthal Collection, Bequest of Edith Abrahamson Lowenthal, 1991
(pl. 158)

Marsden Hartley
The Wave, 1940
oil on board, 76.8 × 103.8 (30¼ × 40⅞)
Worcester Art Museum, Worcester, Massachusetts, Museum Purchase
(pl. 156)

Marsden Hartley
Crow with Ribbons, 1941–1942
oil on fiberboard, 71.1 × 56.5 (28 × 22¼)
Hirshhorn Museum and Sculpture Garden, Smithsonian Institution. Gift of Joseph H. Hirshhorn, 1966
(pl. 154)

Marsden Hartley
Mount Katahdin, Maine, 1942
oil on hardboard, 76 × 101.9 (30 × 40⅛)
National Gallery of Art, Washington, Gift of Mrs. Mellon Byers, 1970.27.1
(pl. 157)

Marsden Hartley
Summer, Sea, Window, Red Curtain, 1942
oil on masonite, 101.9 × 76.4 (40⅛ × 30¹⁄₁₆)
Addison Gallery of American Art, Phillips Academy, Andover,

Massachusetts
(pl. 155)

Wassily Kandinsky
The Garden of Love (Improvisation Number 27), 1912
oil on canvas, 120.3 × 140.3 (47⅜ × 55¼)
The Metropolitan Museum of Art, Alfred Stieglitz Collection, 1949
(pl. 23)

John Marin
Woolworth Building, No. 28, 1912
watercolor over graphite, 47 × 39.6 (18½ × 15⅝)
National Gallery of Art, Washington, Gift of Eugene and Agnes E. Meyer, 1967.13.8
(pl. 28)

John Marin
Woolworth Building, No. 31, 1912
watercolor over graphite, 47 × 39.8 (18½ × 15¹¹⁄₁₆)
National Gallery of Art, Washington, Gift of Eugene and Agnes E. Meyer, 1967.13.9
(pl. 24)

John Marin
Woolworth Building, No. 32, 1913
watercolor over graphite, 46.5 × 39.7 (18 ⁹⁄₁₆ × 15¹¹⁄₁₆)
National Gallery of Art, Washington, Gift of Eugene and Agnes E. Meyer, 1967.13.11
(pl. 29)

John Marin
Lower Manhattan (Composition Derived from Top of Woolworth Building), 1922
watercolor and charcoal with paper cut-out attached with thread on paper, 54.9 × 68.3 (21⅝ × 26⅞)
The Museum of Modern Art, New York, Acquired through the Lillie P. Bliss Bequest
(pl. 104)

John Marin
Sunset, 1922
watercolor, graphite, and charcoal, 44.5 × 54.6 (17½ × 21½)
May Family Collection, Dr. Hal Riddle and Christopher May trustees
(pl. 124)

John Marin
Movement, Autumn, 1923
watercolor and charcoal, 56.4 × 57 (22³⁄₁₆ × 22⁷⁄₁₆)
Collection of Norma Marin, courtesy of Richard York Gallery
(pl. 100)

John Marin
A Southwester, 1928
watercolor and charcoal on paper, 43.8 × 57.2 (17¼ × 22½)
Mr. and Mrs. Meredith J. Long
(pl. 129)

John Marin
Storm over Taos, 1930
watercolor over graphite, 38.2 × 53.2 (15 1/16 × 20¹⁵⁄₁₆)
National Gallery of Art, Washington, Alfred Stieglitz Collection,
1949.2.3
(pl. 131)

John Marin
Rocks and Sea, Small Point, Maine, 1931
oil on canvas, 56 × 71 (22¹⁄₁₆ × 27¹⁵⁄₁₆)
The Cleveland Museum of Art, Norman O. Stone and Ella A.
Stone Memorial Fund 1956.361
(pl. 126)

John Marin
Region of Brooklyn Bridge Fantasy, 1932
watercolor, 47.6 × 56.5 (18¾ × 22¼)
Whitney Museum of American Art, New York, purchase
(pl. 128)

John Marin
From the Bridge, New York City, 1933
watercolor, 55.6 × 68 (21⅞ × 26¾)
Wadsworth Atheneum, Hartford, Connecticut. The Ella Gallup
Sumner and Mary Catlin Sumner Collection
(pl. 125)

John Marin
Sea, Green and Brown, Maine, 1937
watercolor on white wove paper, 38.7 × 53.4 (15¼ × 21)
The Art Institute of Chicago, Alfred Stieglitz Collection
(pl. 130)

John Marin
Grey Sea, 1938
oil on canvas, 55.9 × 71.1 × 1.9 (22 × 28 x ¾)
National Gallery of Art, Washington, Gift of Mr. and Mrs. John
Marin, Jr., 1987.19.1
(pl. 132)

John Marin
My Hell Raising Sea, 1941
oil on canvas, 63.5 × 76.2 (25 × 30)
Collection of Mr. and Mrs. Barney A. Ebsworth
(pl. 127)

Henri Matisse
Standing Nude, 1901–1903
brush and ink, 26.4 × 20.3 (10⅜ × 8)

The Museum of Modern Art, New York, Gift of Edward Steichen
(pl. 9)

Henri Matisse
Half Nude, 1906
lithograph in black on cream wove simulated Japanese paper,
56.5 × 35.3 (22¼ × 13⅞)
The Art Institute of Chicago, Alfred Stieglitz Collection,
1949.927
(pl. 10)

Henri Matisse
Nude in the Forest, 1906
oil on wood, 40.6 × 32.4 (16 × 12¾)
Brooklyn Museum of Art, Gift of George F. Of
(pl. 8)

Henri Matisse
Nude, c. 1908
pencil on paper, 30.5 × 23 (12 × 9⅛)
The Metropolitan Museum of Art, Alfred Stieglitz Collection,
1949
(pl. 11)

Henri Matisse
Nude with Bracelets, c. 1909
pen and ink on paper, 32.1 × 22.5 (12⅝ × 8⅞)
The Metropolitan Museum of Art, Alfred Stieglitz Collection,
1949
(pl. 13)

Henri Matisse
The Serpentine, 1909
bronze, 56.5 × 27.9 × 19.1 (22¼ × 11 × 7½)
The Museum of Modern Art, New York, Gift of Abby Aldrich
Rockefeller, 1939
(pl. 14)

Henri Matisse
Head of Jeannette III, 1911/cast 1966
bronze, 60.1 × 23 × 29.2 (23¹¹⁄₁₆ × 9¹⁄₁₆ × 11½)
Hirshhorn Museum and Sculpture Garden, Smithsonian
Institution. Gift of Joseph H. Hirshhorn Foundation, 1972
(pl. 15)

Henri Matisse
Female Nude Lying Face Down on a Table, 1912
pen and black ink, on tan wove paper, laid down on cream
Japanese paper, 24 × 31.5 (9⁷⁄₁₆ × 12⅜)
The Art Institute of Chicago, Alfred Stieglitz Collection
(pl. 12)

Georgia O'Keeffe
No. 5 Special, 1915
charcoal on laid paper, 61 × 47 (24 × 18½)
National Gallery of Art, Washington, Alfred Stieglitz Collection,

Gift of The Georgia O'Keeffe Foundation, 1992.89.7
(pl. 87)

Georgia O'Keeffe
No. 9 Special, 1915
charcoal, 63.5 × 48.6 (25 × 19)
The Menil Collection, Houston
(pl. 86)

Georgia O'Keeffe
Blue Lines, 1916
watercolor on paper, 63.5 × 48.3 (25 × 19)
The Metropolitan Museum of Art, Alfred Stieglitz Collection,
1969
(pl. 85)

Georgia O'Keeffe
Blue No. I, 1916
watercolor over graphite on cream wove paper, 40.5 × 27.8
(15 $^{15}/_{16}$ × 10 $^{15}/_{16}$)
Brooklyn Museum of Art, Bequest of Mary T. Cockcroft, by
exchange
(pl. 89)

Georgia O'Keeffe
Blue No. IV, 1916
watercolor on cream wove paper, 40.5 × 27.8 (15 $^{15}/_{16}$ × 10 $^{15}/_{16}$)
Brooklyn Museum of Art, Dick S. Ramsay Fund
(pl. 88)

Georgia O'Keeffe
Music—Pink and Blue No. 1, 1918
oil on canvas, 88.9 × 73.7 (35 × 29)
Collection of Mr. and Mrs. Barney A. Ebsworth
(pl. 169)

Georgia O'Keeffe
Red & Orange Streak/Streak, 1919
oil on canvas, 68.6 × 58.4 (27 × 23)
Philadelphia Museum of Art: The Alfred Stieglitz Collection
(pl. 168)

Georgia O'Keeffe
Blue and Green Music, 1921
oil on canvas, 57.2 × 47 (23 × 19)
The Art Institute of Chicago, Gift of Georgia O'Keeffe to the
Alfred Stieglitz Collection, 1969.835
(pl. 102)

Georgia O'Keeffe
Autumn Trees—The Maple, 1924
oil on canvas, 91.4 × 76.2 (36 × 30)
Georgia O'Keeffe Museum, Gift of The Burnett Foundation and
Gerald and Kathleen Peters
(pl. 170)

Georgia O'Keeffe
From the Lake, No. 1, 1924
oil on canvas, 94.3 × 78.7 (37 $^{1}/_{8}$ × 31)
Purchased with funds from the Coffin Fine Arts Trust, Nathan
Emory Coffin Collection of the Des Moines Art Center
(pl. 171)

Georgia O'Keeffe
Birch Trees, 1925
oil on canvas, 91.4 × 76.2 (36 × 30)
The Saint Louis Art Museum, Saint Louis, Gift of Mrs. Ernest W.
Stix
(pl. 94)

Georgia O'Keeffe
White Flower, 1926
oil on canvas, 91.4 × 76.2 (36 × 30)
The Cleveland Museum of Art, Bequest of Leonard C. Hanna, Jr.
1958.42
(pl. 106)

Georgia O'Keeffe
Abstraction Blue, 1927
oil on canvas, 102.2 × 76.2 (40 $^{1}/_{4}$ × 30)
The Museum of Modern Art, New York, Acquired through the
Helen Acheson Bequest, 1979
(pl. 176)

Georgia O'Keeffe
The Red Hills with Sun, 1927
oil on canvas, 68.5 × 81.2 (27 × 32)
The Phillips Collection, Washington, D.C.
(pl. 172)

Georgia O'Keeffe
East River No. 1, 1927/1928
oil on canvas, 68.6 × 55.9 (27 × 22)
New Jersey State Museum, Purchased by the Association for the Arts
of the New Jersey State Museum with a gift from Mary Lea Johnson
(not in catalogue)

Georgia O'Keeffe
Wave, Night, 1928
oil on canvas, 76.2 × 91.4 (30 × 36)
Addison Gallery of American Art, Phillips Academy, Andover,
Massachusetts (purchased as the gift of Charles L. Stillman [PA
1922])
(pl. 178)

Georgia O'Keeffe
Black Cross with Stars and Blue, 1929
oil on canvas, 101.6 × 76.2 (40 × 30)
Private Collection
(pl. 173)

Georgia O'Keeffe
Farm House Window and Door, 1929
oil on canvas, 101.6 × 76.2 (40 × 30)
The Museum of Modern Art, New York, Acquired through the
Richard D. Brixey Bequest, 1945
(pl. 180)

Georgia O'Keeffe
Black White and Blue, 1930
oil on canvas, 121.9 × 76.2 (48 × 30)
National Gallery of Art, Washington, Gift (Partial and Promised)
of Mr. and Mrs. Barney A. Ebsworth, 1998.93.1
(pl. 182)

Georgia O'Keeffe
Jack-in-the-Pulpit No. IV, 1930
oil on canvas, 101.6 × 76.2 (40 × 30)
National Gallery of Art, Washington, Alfred Stieglitz Collection,
Bequest of Georgia O'Keeffe, 1987.58.3
(pl. 177)

Georgia O'Keeffe
Cow's Skull with Calico Roses, 1931
oil on canvas, 92.2 × 61.3 (36 × 24)
The Art Institute of Chicago, Gift of Georgia O'Keeffe, 1947.712
(pl. 174)

Georgia O'Keeffe
Black Place II, 1944
oil on canvas, 60.8 × 76.1 (23⅞ × 30)
The Metropolitan Museum of Art, Alfred Stieglitz Collection, 1959
(pl. 179)

Georgia O'Keeffe
Bare Tree Trunks with Snow, 1946
oil on canvas, 74.9 × 100.3 (29½ × 39½)
Dallas Museum of Art, Dallas Art Association Purchase, 1953.1
(pl. 175)

Francis Picabia
New York, 1913
gouache, 54.6 × 75.6 (21½ × 29¾)
Barbara Mathes Gallery, New York
(pl. 27)

Francis Picabia
New York, 1913
watercolor and gouache, 54.5 × 74.7 (21⁷⁄₁₆ × 29⁷⁄₁₆)
Centre Georges Pompidou, Paris, Musée national d'art mod-
erne, Legs du Docteur Robert Le Masle, 1974
(pl. 32)

Francis Picabia
Star Dancer on a Transatlantic Liner, 1913
watercolor on paper, 74.9 × 54.9 (29½ × 21⅝)

Private Collection
(pl. 33)

Francis Picabia
Comic Wedlock (Mariage comique), 1914
oil on canvas, 200 × 196.5 (78¾ × 77⅜)
The Museum of Modern Art, New York, Eugene and Agnes E.
Meyer Collection, given by their family, 1974
(pl. 60)

Francis Picabia
This Has to Do with Me (C'est du moi qu'il s'agit), 1914
oil on canvas, 199.7 × 199.1 (78⅝ × 78⅜)
The Museum of Modern Art, New York, Eugene and Agnes E.
Meyer Collection, given by their family, 1974
(pl. 61)

Francis Picabia
Here, This is Stieglitz/Faith and Love
291, nos. 5–6 (July–August 1915)
43.8 × 28.9 (17¼ × 11⅜)
National Portrait Gallery, Smithsonian Institution, Gift of
Katharine Graham
(pl. 59)

Francis Picabia
*Portrait of a Young American Girl in a State of Nudity; The Saint of
Saints/This is a Portrait About Me; De Zayas! De Zayas!*
291, nos. 5–6 (July–August 1915)
vellum, 43.8 × 86.4 (17¼ × 34)
Collection Francis M. Naumann, New York
(pls. 62–64)

Pablo Picasso
Bathers in a Forest, 1908
watercolor, gouache, and graphite on paper, 47.6 × 59.1
(18¾ ×23¼)
Philadelphia Museum of Art: The Samuel S. White 3rd and Vera
White Collection
(pl. 52)

Pablo Picasso
Head, 1909
brush and ink on paper, 62.9 × 47.9 (24¾ × 18⅞)
The Metropolitan Museum of Art, Alfred Stieglitz Collection, 1949
(pl. 56)

Pablo Picasso
Head of a Woman, 1909
brush and ink and charcoal on paper, 63.5 × 49.2 (25 × 19⅜)
The Metropolitan Museum of Art, Alfred Stieglitz Collection,
1949
(pl. 53)

Pablo Picasso
Head of Fernande Olivier, 1909

bronze, 41.3 × 22.9 × 26.7 (16¼ × 9 × 10½)
The Art Institute of Chicago, Alfred Stieglitz Collection, 1949.584
reproduced in *Camera Work*, Special Number, August 1912
(pl. 22)

Pablo Picasso
Study, 1909
watercolor on tan wove paper, 33.2 × 25.6 (13⅛₆ × 10¹⁄₁₆)
The Art Institute of Chicago, Alfred Stieglitz Collection, 1949.578
(pl. 55)

Pablo Picasso
Violin, c. 1912
charcoal on paper, 47 × 31.4 (18½ × 12⅜)
Philadelphia Museum of Art: The Louise and Walter Arensberg Collection
(pl. 58)

Pablo Picasso
Head of a Man, 1912
charcoal on paper, 62.2 × 48.2 (24½ × 19)
The Metropolitan Museum of Art, Alfred Stieglitz Collection, 1949
(pl. 54)

Auguste Rodin
Hell, c. 1900–1908
pencil and watercolor on cream paper, 31.8 × 26.7 (12½ × 10½)
André Bromberg Collection
(pl. 7)

Auguste Rodin
Kneeling Woman, c. 1900–1908
watercolor and pencil, 32.7 × 25.5 (12⅞ × 10)
The Museum of Modern Art, New York, Bequest of Mina Turner
(pl. 4)

Auguste Rodin
Nude (Woman Leaning Forward Facing Left), c. 1900–1908
pencil and watercolor, 31.8 × 24.1 (12½ × 9½)
Hope Haviland Leizear
(pl. 5)

Auguste Rodin
Female Nude from Behind, a Scarf around Her Shoulders, after 1901
charcoal, stumping, and watercolor on cream paper, 31.2 × 19.5 (12⅝₆ × 7¹¹⁄₁₆)
Musée Rodin, Paris
(pl. 6)

Edward Steichen
Rodin, "The Thinker," and "Victor Hugo," 1902
photogravure, 26 × 32.2 (10¼ × 12¹¹⁄₁₆)
Musée Rodin, Paris
(pl. 2)

Edward Steichen
Matisse—The Serpentine, c. 1910
platinum print, 29.5 × 23.3 (11⅝ × 9³⁄₁₆)
The Museum of Modern Art, New York, Gift of the photographer
(pl. 3)

Alfred Stieglitz
The Flatiron, 1902
photogravure on Japanese tissue mounted on paperboard, before 1910, 32.7 × 16.7 (12⅞ × 6½)
National Gallery of Art, Washington, Alfred Stieglitz Collection, 1949.3.272
(pl. 26)

Alfred Stieglitz
Self-Portrait, 1907
platinum print, 24.5 × 19.5 (9⅝ × 7⅝)
National Gallery of Art, Washington, Alfred Stieglitz Collection, 1949.3.303
(pl. 1)

Alfred Stieglitz
The Steerage, 1907
photogravure on Japanese vellum, before 1913, 33.2 × 26.4 (12⅞ × 10⅜)
National Gallery of Art, Washington, Alfred Stieglitz Collection, 1949.3.292
(pl. 30)

Alfred Stieglitz
The City of Ambition, 1910
photogravure on Japanese tissue mounted on paperboard, 34 × 26 (13⅜ × 10¼)
National Gallery of Art, Washington, Alfred Stieglitz Collection, 1949.3.308
(pl. 31)

Alfred Stieglitz
Old and New New York, 1910
photogravure on Japanese tissue mounted on paperboard, before 1913, 33.3 × 25.7 (13⅛ × 10⅛)
National Gallery of Art, Washington, Alfred Stieglitz Collection, 1949.3.311
(pl. 25)

Alfred Stieglitz
Arthur G. Dove, 1911–1912
platinum print, 24 × 19.2 (9⅜ × 7½)
National Gallery of Art, Washington, Alfred Stieglitz Collection, 1949.3.318
(pl. 159)

Alfred Stieglitz
Brancusi Exhibition at 291, 1914
platinum print, 19.4 × 24.4 (7⅝ × 9⅝)
National Gallery of Art, Washington, Alfred Stieglitz Collection,
1949.3.352
(pl. 35)

Alfred Stieglitz
Installation of African Art Exhibition, 1914
gelatin silver print, 18.1 × 24 (7⅛ × 9⁷/₁₆)
From the Estate of Harry H. Lunn Jr. and Myriam Lunn
(pl. 42)

Alfred Stieglitz
Charles Demuth, 1915
platinum print, 24.4 × 19.4 (9⅝ × 7⅝)
National Gallery of Art, Washington, Alfred Stieglitz Collection,
1949.3.354
(pl. 133)

Alfred Stieglitz
291—Picasso-Braque Exhibition, 1915
platinum print, 18.7 × 23.6 (7⅜ × 9⅜)
National Gallery of Art, Washington, Alfred Stieglitz Collection,
1949.3.374
(pl. 51)

Alfred Stieglitz
Marsden Hartley, 1915–1916
platinum print, 24.6 × 19.5 (9⅝ × 7⅝)
National Gallery of Art, Washington, Alfred Stieglitz Collection,
1949.3.356
(pl. 150)

Alfred Stieglitz
Marcel Duchamp, Fountain, 1917
gelatin silver print, 23.5 × 17.8 (9¼ × 7)
Private Collection
(pl. 67)

Alfred Stieglitz
Georgia O'Keeffe: A Portrait—Torso, probably 1918
palladium print, 23.6 × 19.3 (9¼ × 7⅝)
National Gallery of Art, Washington, Alfred Stieglitz Collection,
1980.70.39
(pl. 91)

Alfred Stieglitz
Georgia O'Keeffe: A Portrait—Torso, probably 1918
combination palladium and platinum print processed with gold,
23.9 × 19.3 (9⅜ × 7⅝)
National Gallery of Art, Washington, Alfred Stieglitz Collection,
1980.70.37
(pl. 117)

Alfred Stieglitz
Georgia O'Keeffe: A Portrait—Head, 1918
platinum print, 24.3 × 19.3 (9⁹/₁₆ × 7⅝)
National Gallery of Art, Washington, Alfred Stieglitz Collection,
1980.70.7
(pl. 167)

Alfred Stieglitz
Georgia O'Keeffe: A Portrait—Hands, probably 1919
palladium print, 24.4 × 19.4 (9⅝ × 7⅝)
National Gallery of Art, Washington, Alfred Stieglitz Collection,
1980.70.118
(pl. 115)

Alfred Stieglitz
Dorothy True, 1919
gelatin silver print, 24.1 × 19.1 (9½ × 7½)
National Gallery of Art, Washington, Alfred Stieglitz Collection,
1949.3.438
(pl. 99)

Alfred Stieglitz
Georgia O'Keeffe: A Portrait—Hand and Breasts, 1919
palladium print, 19.3 × 23.6 (7⅝ × 9⁹/₁₆)
National Gallery of Art, Washington, Alfred Stieglitz Collection,
1980.70.113
(pl. 118)

Alfred Stieglitz
Paul Strand, 1919
palladium print, 24.5 × 19.5 (9⅝ × 7⅝)
National Gallery of Art, Washington, Alfred Stieglitz Collection,
1949.3.411
(pl. 143)

Alfred Stieglitz
Waldo Frank, 1920
palladium print, 24.3 × 19.2 (9⅝ × 7½)
National Gallery of Art, Washington, Alfred Stieglitz Collection,
1949.3.500
(pl. 95)

Alfred Stieglitz
The Way Art Moves, 1920
gelatin silver print, 24.5 × 19.3 (9⅝ × 7⅝)
National Gallery of Art, Washington, Alfred Stieglitz Collection,
1949.3.441
(pl. 98)

Alfred Stieglitz
Georgia O'Keeffe: A Portrait—Neck, 1921
palladium print, 24.4 × 19.4 (9⅝ × 7⅝)
National Gallery of Art, Washington, Alfred Stieglitz Collection,
1980.70.159
(pl. 116)

Alfred Stieglitz
John Marin, 1922
palladium print, 23.8 × 19.1 (9⅜ × 7½)
National Gallery of Art, Washington, Alfred Stieglitz Collection,
1949.3.509
(pl. 123)

Alfred Stieglitz
Claudia O'Keeffe, 1922
gelatin silver print, 17.7 × 23.2 (6¹⁵⁄₁₆ × 9⅛)
National Gallery of Art, Washington, Alfred Stieglitz Collection,
1949.3.518
(pl. 120)

Alfred Stieglitz
Dancing Trees, 1922
palladium print, 24 × 19 (9⅜ × 7½)
National Gallery of Art, Washington, Alfred Stieglitz Collection,
1949.3.476
(pl. 90)

Alfred Stieglitz
Helen Freeman, 1922
palladium print, solarized, 1922/1923, 19.5 × 24.5 (7⅝ × 9⅝)
National Gallery of Art, Washington, Alfred Stieglitz Collection,
1949.3.461
(pl. 119)

Alfred Stieglitz
Music—A Sequence of Ten Cloud Photographs, No. I, 1922
gelatin silver print, 19.4 × 24 (7⅝ × 9⅜)
National Gallery of Art, Washington, Alfred Stieglitz Collection,
1949.3.828
(pl. 93)

Alfred Stieglitz
Music—A Sequence of Ten Cloud Photographs, No. V, 1922
gelatin silver print, 24.2 × 19.3 (9½ × 7⅝)
National Gallery of Art, Washington, Alfred Stieglitz Collection,
1949.3.833
(pl. 122)

Alfred Stieglitz
Music—A Sequence of Ten Cloud Photographs, No. VIII, 1922
gelatin silver print, 24.1 × 19 (9⅜ × 7½)
National Gallery of Art, Washington, Alfred Stieglitz Collection,
1949.3.836
(pl. 121)

Alfred Stieglitz
Music—A Sequence of Ten Cloud Photographs, No. X, 1922
gelatin silver print, 23 × 18.5 (9¹⁄₁₆ × 7⁵⁄₁₆)
National Gallery of Art, Washington, Alfred Stieglitz Collection,
1949.3.838
(pl. 109)

Alfred Stieglitz
First Snow and the Little House, 1923
gelatin silver print, 19 × 24 (7½ × 9⅜)
National Gallery of Art, Washington, Alfred Stieglitz Collection,
1949.3.624
(pl. 92)

Alfred Stieglitz
Sherwood Anderson, 1923
palladium print, 24.4 × 19.3 (9⅝ × 7⅝)
National Gallery of Art, Washington, Alfred Stieglitz Collection,
1949.3.574
(pl. 96)

Alfred Stieglitz
Spiritual America, 1923
gelatin silver print, 11.5 × 9.2 (4½ × 3⅝)
National Gallery of Art, Washington, Alfred Stieglitz Collection,
1949.3.845
(pl. 97)

Alfred Stieglitz
From My Window at An American Place, North, 1931
gelatin silver print, 24.3 × 19.1 (9½ × 7½)
National Gallery of Art, Washington, Alfred Stieglitz Collection,
1949.3.1207
(pl. 111)

Alfred Stieglitz
Lake George, probably 1931
gelatin silver print, 18.8 × 24 (7⅜ × 9⅜)
National Gallery of Art, Washington, Alfred Stieglitz Collection,
1949.3.726
(pl. 185)

Alfred Stieglitz
From My Window at The Shelton—West, 1931
gelatin silver print, 24.2 × 19.3 (9½ × 7⅝)
National Gallery of Art, Washington, Alfred Stieglitz Collection,
1949.3.1229
(pl. 189)

Alfred Stieglitz
From My Window at The Shelton, North, 1931–1932
gelatin silver print, 24.3 × 19.1 (9⁹⁄₁₆ × 7½)
National Gallery of Art, Washington, Alfred Stieglitz Collection,
1949.3.1250
(pl. 114)

Alfred Stieglitz
From My Window at An American Place, Southwest, 1932
gelatin silver print, 19.3 × 24.1 (7⅝ × 9½)
National Gallery of Art, Washington, Alfred Stieglitz Collection,
1949.3.1233
(pl. 188)

Alfred Stieglitz
From My Window at An American Place, Southwest, 1932
gelatin silver print, 23.8 × 13.4 (9⅜ × 5¼)
National Gallery of Art, Washington, Alfred Stieglitz Collection,
1949.3.1235
(pl. 190)

Alfred Stieglitz
Grass, 1933
gelatin silver print, 24.4 × 18.8 (9⅝ × 7⅜)
National Gallery of Art, Washington, Alfred Stieglitz Collection,
1949.3.736
(pl. 183)

Alfred Stieglitz
Hedge and Grasses, 1933
gelatin silver print, 18.9 × 23.9 (7⅜ × 9⅜)
National Gallery of Art, Washington, Alfred Stieglitz Collection,
1949.3.740
(pl. 184)

Alfred Stieglitz
New York from The Shelton, 1935
gelatin silver print, 24.4 × 19.2 (9⅝ × 7½)
National Gallery of Art, Washington, Alfred Stieglitz Collection,
1949.3.1253
(pl. 191)

Alfred Stieglitz
Little House, Lake George, probably 1934
gelatin silver print, 24 × 18.8 (9⅜ × 7⅜)
National Gallery of Art, Washington, Alfred Stieglitz Collection,
1949.3.771
(pl. 187)

Alfred Stieglitz
Door to Kitchen, 1934
gelatin silver print, 24.1 × 18.8 (9½ × 7⅜)
National Gallery of Art, Washington, Alfred Stieglitz Collection,
1949.3.766
(pl. 181)

Alfred Stieglitz
House and Grape Leaves, 1934
gelatin silver print, 24.3 × 19.5 (9½ × 7⅝)
National Gallery of Art, Washington, Alfred Stieglitz Collection,
1949.3.778
(pl. 186)

Paul Strand
New York (Wall Street), 1915
platinum print toned with mercury, 24.8 × 32.2 (9¾ × 12¹¹/₁₆)
Collection Centre Canadien d'Architecture/Canadian Centre for
Architecture, Montreal
(pl. 82)

Paul Strand
Bowls, 1916
silver and platinum print, 33.9 × 25 (13⅛ × 9¹³/₁₆)
The Metropolitan Museum of Art, Alfred Stieglitz Collection,
1949
(pl. 79)

Paul Strand
Blind, 1916
platinum print, 34 × 25.7 (13⅜ × 10⅛)
The Metropolitan Museum of Art, Alfred Stieglitz Collection,
1933
(pl. 83)

Paul Strand
New York (From the Viaduct), 1916
platinum print, 25.2 × 33 (9¹⁵/₁₆ × 13)
Amon Carter Museum, Fort Worth, Texas
(pl. 80)

Paul Strand
Portrait, Washington Square Park, 1916
platinum print, 34.3 × 25.1 (13½ × 9⅞)
The J. Paul Getty Museum, Los Angeles
(pl. 84)

Paul Strand
The White Fence, 1916
gelatin silver print, 24.6 × 32.5 (9¹¹/₁₆ × 12¹³/₁₆)
National Gallery of Art, Washington, Gift of Southwestern Bell
Corporation Paul Strand Collection, in Honor of the 50th
Anniversary of the National Gallery of Art, 1990.44.2
(pl. 81)

Paul Strand
Akeley Motion Picture Camera, 1923
gelatin silver print, 24.5 × 19.4 (9⅝ × 7⅝)
The Museum of Modern Art, New York, Gift of the photographer
(pl. 144)

Paul Strand
Lathe No. 1, New York, 1923
gelatin silver print, 24 × 18.9 (9½ × 7⁷/₁₆)
National Gallery of Art, Washington, Southwestern Bell Corpo-
ration Paul Strand Collection, 1991.216.8
(pl. 145)

Paul Strand
The Court, New York, 1924
gelatin silver print, 24.6 × 19.4 (9¹¹/₁₆ × 7⅝)
San Francisco Museum of Modern Art, The Helen Crocker Rus-
sell and William H. and Ethel W. Crocker Family Funds Purchase
(pl. 105)

Paul Strand
Wild Iris, Maine, 1927
gelatin silver print, 24.3 × 19.2 (9⁹⁄₁₆ × 7⁹⁄₁₆)
National Gallery of Art, Washington, Gift of Southwestern Bell
Corporation Paul Strand Collection, in Honor of the 50th
Anniversary of the National Gallery of Art, 1990.44.4.a
(pl. 107)

Paul Strand
Hacienda, near Taos, New Mexico, 1930
platinum print, 24.3 × 19.3 (9⁹⁄₁₆ × 7⁹⁄₁₆)
National Gallery of Art, Washington, Southwestern Bell Corpo-
ration Paul Strand Collection, 1991.216.20
(pl. 148)

Paul Strand
Ranchos de Taos Church, New Mexico, 1931
platinum print, 14.8 × 11.7 (5¹³⁄₁₆ × 4⅝)
Kunsthaus Zürich, The Marc Rich Collection
(pl. 149)

Paul Strand
Ranchos de Taos Church, New Mexico, 1931
gelatin silver print, 11.8 × 14.9 (4⅝ × 5⅞)
National Gallery of Art, Washington, Southwestern Bell Corpo-
ration Paul Strand Collection, 1991.216.24.a
(pl. 112)

Paul Strand
Red River, New Mexico, 1931
gelatin silver print, 19.2 × 24.5 (7⁹⁄₁₆ × 9⅝)
National Gallery of Art, Washington, Southwestern Bell Corpo-
ration Paul Strand Collection, 1991.216.25.a
(pl. 147)

Paul Strand
Near Rinconada, New Mexico, 1932
platinum print, 19.1 × 24.2 (7½ × 9½)
National Gallery of Art, Washington, Southwestern Bell Corpo-
ration Paul Strand Collection, 1991.216.26
(pl. 146)

Unknown Artist
Mask, the Baule People, Ivory Coast, 19th/early 20th century
wood, 27.9 (11)
Fisk University Galleries, Nashville, Tennessee, Alfred Stieglitz
Collection
(pl. 47)

Unknown Artist
Mask, the Guro People, Ivory Coast, 19th/early 20th century
wood, 41.6 × 16.5 × 11.4 (16⅜ × 6½ × 4½)
Anna Marie and Juan Hamilton
(pl. 49)

Unknown Artist
Mask, the We People, Ivory Coast, 19th/early 20th century
wood, 37.5 × 18.4 × 17.2 (14¾ × 7¼ × 6¾)
Anna Marie and Juan Hamilton
(pl. 43)

Unknown Artist
Mask, the Baule or Yaure People, Ivory Coast, 19th/early 20th
century
wood, 24.1 (9½)
Fisk University Galleries, Nashville, Tennessee, Alfred Stieglitz
Collection
(pl. 48)

Unknown Artist
Reliquary Figure, the Kota People, Gabon, 19th/early 20th century
wood with beaten bronze overlay, 71.1 (28)
Fisk University Galleries, Nashville, Tennessee, Alfred Stieglitz
Collection
(pl. 50)

Unknown Artist
Spoon, the Guro or Bete People, Ivory Coast, 19th/early 20th
century
wood, 24.5 × 4.6 × 5.6 (9⅝ × 1¹³⁄₁₆ × 2³⁄₁₆)
Anna Marie and Juan Hamilton
(pl. 45)

Unknown Artist
Spoon, Ivory Coast, 19th/early 20th century
wood, 18.7 × 5.2 × 4.8 (7⅜ × 2³⁄₁₆ × 1⅞)
Anna Marie and Juan Hamilton
(pl. 46)

Unknown Artist
Standing Figure with Bowl on Head, the Bete People, Ivory Coast,
19th/early 20th century
wood, 35.6 (14)
Fisk University Galleries, Nashville, Tennessee, Alfred Stieglitz
Collection
(pl. 44)

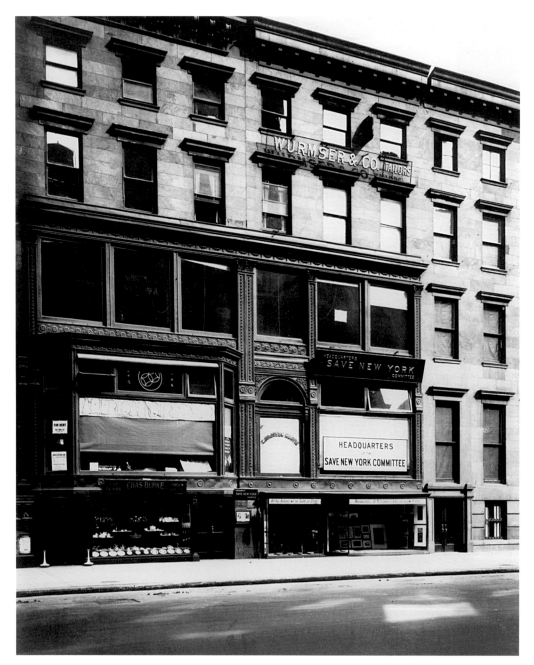

fig. 129 ALFRED STIEGLITZ OR PAUL STRAND
291: View of the Exterior, *before 1913*
Yale Collection of American Literature, Beinecke
Rare Book and Manuscript Library

EXHIBITIONS PRESENTED
BY STIEGLITZ, 1905–1946

Dates have been correlated using information gleaned from exhibition catalogues, checklists, reviews, announcements, advertisements, schedules, *Camera Work*, and the arts calendar of the *New York Evening Post*. Where dates cannot be reconciled, the source is given in parentheses.

The Little Galleries of the Photo-Secession, 291

1905–1906 SEASON

25 November 1905–4 January 1906
Exhibition of Members' Work. One hundred works from *London Salon*, *Lewis and Clark Exposition*, along with art by fellows and associates of the Secession.

10–24 January
Exhibition of French Work. Fifty photographs selected by Robert Demachy.

26 January–2 February
Exhibition of Photographs by Herbert G. French, Illustrating Portions of Tennyson's "Idylls of the King." Forty-five photographs.

5–19 February
Gertrude Käsebier and Clarence H. White. Twenty-seven photographs by each artist.

21 February–7 March
First Exhibition of British Photographers. Photographs by J. Craig Annan, architectural photographs by Frederick H. Evans, and photographic portraits by D. O. Hill and Robert Adamson.

17 March–5 April
Exhibition of Photographs by Eduard J. Steichen. Experiments in color photography. Exhibit ran concurrently with Steichen's one-man show at Glaezner Galleries.

7 April–1 May
Exhibition of Viennese and German Photographs. Multiple gum prints by German and Austrian photographers Hans Watzek, Hugo Henneberg, Heinrich Kühn, and Theodore and Oscar Hofmeister.

1906–1907 SEASON

8 November–30 December
Exhibition of Members' Work. Eighty-four photographs.

5–22 January
Exhibition of Drawings by Pamela Colman Smith. Seventy-two drawings, including a Shakespeare series and illustrations to Schumann's "Carnival."

fig. 130 ALFRED STIEGLITZ (?)
"Exhibition of Viennese and German Photographers" at 291, *1906*
Yale Collection of American Literature, Beinecke Rare Book and Manuscript Library

25 January–14 February
Baron A. de Meyer of Germany, and George H. Seeley, of Massachusetts. Twenty-three photographs by each artist.

19 February–5 March
Exhibition of Photographs by Alice Boughton, New York; by William B. Dyer, Chicago; and by C. Yarnall Abbott, Philadelphia. Twenty-three prints by each artist.

10 March–10 April
Exhibition of Photographs by Alvin Langdon Coburn. Fifty-three photographs.

27–28 September
Exhibition "reserved exclusively for the Press." Stieglitz exhibited color photographs by Steichen, Frank Eugene, and himself done in Europe using the Lumière Autochrome Process, the first to be shown in the United States.

1907–1908 SEASON

18 November–30 December
Exhibition of Members' Work. Ninety-five photographs and new color experiments shown by Stieglitz.

2–28 January
Exhibition of Drawings by M. Auguste Rodin. Fifty-eight drawings selected by Rodin and Steichen.

7–25 February
Exhibition of Photographs by George H. Seeley. Fifty-one prints.

26 February–11 March
*Exhibition of Etchings and Book-plates by Willi Geiger, of Munich;
Etchings by D. S. MacLaughlan, of Boston and Paris; Drawings by
Pamela Colman Smith.* Fourteen etchings and sixteen bookplates
by Geiger, eight etchings by MacLaughlan, and twenty-eight
drawings by Smith.

12 March–3 April
Exhibition of Photographs by Eduard J. Steichen. Forty-seven
monochromes and sixteen color Autochromes.

6–27 April
*Exhibition of Drawings, Lithographs, Water-Colors, and Etchings by
M. Henri Matisse, of Paris.* Watercolors in first room, drawings in
inner room.

1908–1909 SEASON
8–30 December
Exhibition of Members' Work. Forty-two photographs.

4–16 January
*Exhibition of Caricatures in Charcoal by Mr. Marius de Zayas; and
Autochromes by Mr. J. Nilsen Laurvik.* Twenty-five caricatures and
thirty Autochromes.

18–30 January
*Exhibition of Photographs in Monochrome and Color by Mr. Alvin
Langdon Coburn.* Thirty-three monochromes and twenty
Autochromes.

4–22 February (catalogue), or 4–28 February (*Evening Post*)
*Exhibition of Photographs in Monochrome and Color by Baron A. de
Meyer, of London and Dresden.* Twenty-four monochromes and
twelve color transparencies.

26 February–15 March
Exhibition of Etchings Dry-Points and Book-Plates by Allen Lewis.
Forty-three prints. Lewis designed and printed the catalogue.

17–27 March
*Exhibition of Drawings by Pamela Colman Smith, of London and
New York.* Twenty-six drawings, "visions evoked by music,
sketched during the concert or opera" (*Camera Work* 27, p. 27).
Secession members were allowed to view the exhibition on 16
March.

30 March–19 April
*Exhibition of Sketches in Oil by Alfred Maurer, of Paris and New York;
and Water-Colors by John Marin, of Paris and New York.* Fifteen
sketches and twenty-five watercolors.

21 April–7 May
*Exhibition of a Series of Photographs of Rodin's "Balzac" by Mr.
Eduard J. Steichen, of Paris and New York.* Eight photographs (ten
were planned, *Camera Work* 26, p. 37), the Balzac statue, and a
bronze head of Balzac done as a study, lent by Mrs. Joan W.
Simpson.

8–18 May
Exhibition of Paintings in Oil by Mr. Marsden Hartley, of Maine.
Thirty-three paintings.

18 May–2 June
*Exhibition of Japanese prints from the F. W. Hunter collection, New
York.* Twenty-one prints.

1909–1910 SEASON
24 November–17 December (catalogue), or 24 November–18
December (*Evening Post*)
Exhibition of Monotypes and Drawings of Mr. Eugene Higgins. Thirty
works.

20 December 1909–14 January 1910
Exhibition of Lithographs by Henri de Toulouse-Lautrec. Exhibit was
of "about thirty picked proofs," including the series "Elles,"
"Woman with Dog at Café," and "Truffier in Les Femmes
Savantes."

21 January–5 February
Exhibition of Color Photographs by Eduard J. Steichen.

7–19 February
Exhibition of Water-Colors, Pastels and Etchings by John Marin.
Forty-three watercolors, twenty pastels, and ten etchings.

23 February–8 March
*Exhibition of Drawings, and Photographs of Paintings by Henri
Matisse.* A show of "two dozen and more sketches," mostly nude
studies.

9–21 March
The Younger American Painters. D. Putnam Brinley, Arthur
Beecher Carles, Arthur Dove, Laurence Fellows, Marsden Hart-
ley, John Marin, Alfred Maurer, Edward Steichen, and Max
Weber, paintings and sketches.

31 March–18 April
Exhibition of Drawings by Auguste Rodin. Eleven early drawings
(1880–1890) and thirty recent drawings (1900–1910).

26 April–November
*Up and Down Fifth Avenue, A Social Satire. An Exhibition of Carica-
tures Mounted and Staged by Marius de Zayas.* Silhouettes of
prominent New Yorkers.

1910–1911 SEASON
18 November–8 December
*A Loaned Collection of Some Lithographs by Manet, Cézanne, Renoir,
and Toulouse-Lautrec; A Few Drawings by Rodin; And Smaller
Paintings and Drawings by Henri Rousseau.*

14 December 1910–12 January 1911
*Exhibition of Original Drawings; Pen-and-Ink Sketches; Etchings; by
Mr. Gordon Craig, of London.* Eighteen drawings, eight sketches,
and twenty etchings.

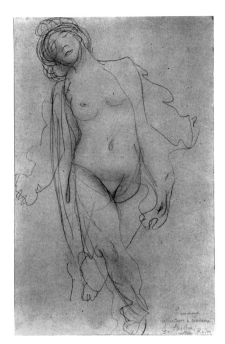

fig. 131 AUGUSTE RODIN
Dancing Female Nude, c. 1900
graphite with estompe on tan wove paper laid down
The Art Institute of Chicago, Alfred Stieglitz Collection
EXHIBITED AT 291, 1908 AND/OR 1910

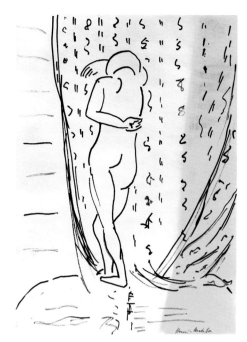

fig. 132 HENRI MATISSE
Female Nude, 1912
ink on paper
The Pierpont Morgan Library, New York
EXHIBITED AT 291, 1912

11–31 January
Exhibition of Paintings and Drawings by Mr. Max Weber, of New
York. Thirty-one pictures, "some thirty examples in oil and
watercolor, and a few pencil and crayon drawings."

2–22 February
Exhibition of Recent Water-Colors—The Tyrol and Vicinity of New
York—, By Mr. John Marin, of New York.

1–25 March
Exhibition of Water-Colors by Cézanne. Twenty watercolors.

28 March–25 April, extended to May
Exhibition of Early and Recent Drawings and Water-Colors by Pablo
Picasso, of Paris.

1911–1912 SEASON
November–8 December
Watercolors by Gelett Burgess.

18 December 1911–15 January 1912
Exhibition of Photographs by Baron Ad. de Meyer, of London. Thirty
recent photographs.

17 January–3 February
Exhibition of Paintings by Arthur B. Carles, of Philadelphia. Twenty-
six paintings from the past twelve months.

7–26 February
Exhibition of Recent Paintings and Drawings by Marsden Hartley.
Hartley's "drawings…in black and white and landscapes," also
still lifes and a portrait "of a prominent academician."

27 February–12 March
Exhibition of Paintings by Arthur G. Dove. Camera Work (38, p. 36)
also listed the show as an "Exhibition of Pastels by Arthur G.
Dove."

14 March–6 April
Exhibition of Sculpture—The First in America—and Recent Drawings
by Henri Matisse. Six bronzes, five plaster casts, one terra-cotta,
and twelve drawings.

11 April–10 May
Exhibition of Drawings, Water-Colors, and Pastels by Children, Aged
Two to Eleven. Camera Work (39, p. 47) also mentioned clay
modeling.

1912–1913 SEASON
20 November–12 December
Exhibition of Caricatures of Popular American Actors and Actresses by
Alfred J. Frueh, of New York. Forty-nine caricatures.

(?)–14 January
Exhibition of Drawings and Paintings by Walkowitz. Drawings,
water-colors, monotypes, and paintings.

20 January—15 February
Exhibition of Water-Colors—New York, Berkshire and Adirondack Series—and Oils by John Marin, of New York. Twenty-eight views of New York.

24 February—15 March
Exhibition of Photographs by Alfred Stieglitz, of New York. Prints from 1892 to 1911, with views of New York.

17 March—5 April
Exhibition of Studies Made in New York, by François Picabia, of Paris. Sixteen works.

8 April—20 May
An Exhibition of Caricatures, Absolute and Relative, by Marius de Zayas, of New York. Eighteen caricatures.

1913–1914 SEASON
19 November—10 January
Exhibition of Drawings, Pastels and Watercolors by A. Walkowitz.

12 January—14 February
Exhibition of Paintings by Marsden Hartley, of Berlin and New York. Work done in Paris and Berlin "during the past two years" (*Camera Work* 45, p. 16). Bronze Bust of Marsden Hartley, by Arnold Rönnebeck, of Berlin, was also on view.

18 February—11 March
Second Children's Exhibition. Drawings, pastels, and watercolors.

12 March—4 April
An Exhibition of Original Sculpture, in Bronze, Marble, and Wood, by Constantine Brancusi, of Paris. Eight works in maple, bronze, and wood.

6 April—6 May
Exhibition of Paintings and Drawings by Frank Burty, of Paris. Cubist works by Paul Haviland's cousin.

1914–1915 SEASON
3 November—8 December
Statuary in Wood by African Savages. The Root of Modern Art.

9 December—11 January 1915
Exhibition of Recent Drawings and Paintings by Picasso and by Braque, of Paris. Oil paintings and charcoal drawings from the collection of Francis Picabia. In the inner room, *Exhibition of Archaic Mexican Pottery and Carvings in Stone.* Works from the collection of Paul Haviland. Also, an *Exhibition of "Kalogramas," by Torres Palomar, of Mexico.*

12—26 January
Exhibition of Recent Paintings,—Never Before Exhibited Any Where— by Francis Picabia, of New York. Three oil paintings and one watercolor. In the inner room, drawings by Picasso.

27 January—22 February
Exhibition of Paintings by Marion H. Beckett, of New York, and Paintings by Katharine N. Rhoades, of New York. Ten works by each artist.

23 February—26 March
An Exhibition of Water-Colors, Oils, Etchings, Drawings, Recent and Old, by John Marin, of New York. Forty-seven works displaying "the complete evolution of Marin."

27 March—17 April
Third Exhibition of Children's Drawings. Work by boys between eight and fourteen years old under the direction of their teachers.

1915–1916 SEASON
10 November—7 December
Exhibition of Paintings and Drawings, Based Upon New Jersey Landscapes, by Oscar Bluemner, of New York.

8 December—18 January
Exhibition of Sculpture and Drawings by Eli Nadelman, of Paris. Fourteen or fifteen statues in marble, bronze, wood, and plaster, and ten drawings in wash and pen and ink.

18 January—12 February
Exhibition of John Marin's Most Recent Work—Water colors. Camera Work mentioned "twenty-odd pictures" of the Maine coast shown while Montross Gallery exhibited Cézanne watercolors, half of which were exhibited at 291 six years earlier (48, p. 10).

14 February—12 March
Exhibition of Recent Drawings and Water-Colors by A. Walkowitz, of New York. Early and recent work.

13 March—3 April
Exhibition of Photographs, of New York and Other Places, by Paul Strand, of New York. The exhibition was "shown as a natural foil to the Forum Exhibition of Modern American Painters held at the Anderson Gallery, New York at the same time" (*Camera Work* 48, p. 10).

4 April—22 May
Exhibition of Paintings by Marsden Hartley. Forty oil paintings made during Hartley's two-year stay in Berlin, "supplemented by a few examples painted since his return to New York." The exhibition had been postponed from February: "owing to blockades, war difficulties, etcetera, they have only just arrived."

23 May—5 July
Exhibition of Drawings by Georgia O'Keeffe, of Virginia; Water-Colors and Drawings, by C. Duncan, of New York; and Oils, by Réné Lafferty, of Philadelphia. O'Keeffe, ten charcoal drawings; Duncan, two watercolors; and Lafferty, one drawing, three oils.

1916–1917 SEASON
22 November—20 December
Water-Colors and Drawings by Georgia S. Engelhard, of New York, A Child Ten Years Old, Showing the Evolution from Her Fourth Year to

fig. 133 GEORGIA O'KEEFFE
No. 3—Special, *1915*
charcoal on paper
National Gallery of Art, Washington,
 Alfred Stieglitz Collection, Gift of the
Georgia O'Keeffe Foundation
EXHIBITED AT 291, 1916

fig. 134 GEORGIA O'KEEFFE
No. 12—Special, *1915*
charcoal on paper
National Gallery of Art, Washington,
Alfred Stieglitz Collection, Gift of the
Georgia O'Keeffe Foundation
EXHIBITED AT 291, 1916

Her Tenth Year. In the inner room, "in co-relation" with the above exhibit, was "A Representative Group of Paintings and Drawings by Hartley, Marin, Walkowitz, Wright, Georgia O'Keeffe."

27 December 1916—17 January 1917
Recent Water-Colors—Provincetown, Lake George, New York, Maine— By A. Walkowitz, of New York.

22 January—7 February
Marsden Hartley's Recent Work, Together with Examples of His Evolution.

14 February—3 March
John Marin's Recent Water-Colors (Country of the Delaware, and Other Exercises).

6—17 March
Paintings, Drawings, Pastels, by Gino Severini, of Paris and Italy. Twenty-five works.

20—31 March
Exhibition of Paintings and Sculpture by S. Macdonald-Wright. The eighteen works included "watercolors, oils, and a piece of statuary" (*Camera Work* 49—50, p. 33).

3 April—14 May
Exhibition of the Recent Work,—Oils, Water-Colors, Charcoal Drawings, Sculpture,—By Georgia O'Keeffe, of Canyon, Texas.

Anderson Galleries

1921

7—(?) February
An Exhibition of Photography by Alfred Stieglitz. One hundred and forty-five prints from 1886 to 1921, more than 128 of which had never been shown publicly.

10—17 May
Seventy-Five Pictures by James N. Rosenberg and 117 Pictures by Marsden Hartley. Exhibition and auction of 117 Marsden Hartley oils, pastels, and paintings on glass from 1908 to 1919, as well as seventy-five paintings by James N. Rosenberg.

1922

18—23 February
A Collection of Works by Living American Artists of the Modern Schools. Exhibition and auction of 177 paintings, drawings, and prints by more than fifty artists, including Demuth, Dove, Hartley, Marin, O'Keeffe, and Sheeler. In the catalogue introduction, Stieglitz called the show "the artist's derby."

1923

29 January—10 February
Alfred Stieglitz Presents One-Hundred Pictures, Oils, Water-colors, Pastels, Drawings by Georgia O'Keeffe, American. As of 3 February, 137 works were on the exhibition price list. Two days later, 136 works were listed.

fig. 135 MARSDEN HARTLEY
New Mexico, *1924*
oil on canvas
National Gallery of Art, Washington, Alfred Stieglitz Collection
EXHIBITED AT THE ANDERSON GALLERIES, 1925

2–(?) April
The Second Exhibition of Photography by Alfred Stieglitz. One hundred and sixteen prints, all but one of which had never been shown publicly. Exhibition included photographs of women, men, clouds, and miscellaneous subjects.

1924
3–16 March
The Third Exhibition of Photography by Alfred Stieglitz: Songs of the Sky—Secrets of the Sky as Revealed by My Camera and Other Prints. In the catalogue introduction, Stieglitz described the work as "tiny photographs, direct revelations of a man's world in the sky—documents of eternal relationship—perhaps even a philosophy."

3–16 March
Alfred Stieglitz Presents Fifty-One Recent Pictures, Oils, Water-Colors, Pastels, Drawings by Georgia O'Keeffe, American. Mounted concurrently with Stieglitz photographs, the exhibition included paintings of calla lilies, Lake George, pears, and abstractions.

1925
9–28 March
Alfred Stieglitz Presents Seven Americans: 159 Paintings, Photographs and Things, Recent and Never Before Publicly Shown by Arthur G. Dove, Marsden Hartley, John Marin, Charles Demuth, Paul Strand, Georgia O'Keeffe, Alfred Stieglitz.

The Intimate Gallery
1925–1926 SEASON
7 December 1925–11 January 1926
John Marin Exhibition. Retrospective of Marin watercolors, roughly covering 1912 to 1924.

11 January–7 February
Arthur G. Dove. Included paintings on glass and metal, and assemblages.

11 February–11 March (announcement), or 11 February–3 April (exhibition schedule)
Fifty Recent Paintings, by Georgia O'Keeffe.

5 April–2 May
Charles Demuth. Paintings, watercolors, and portrait posters.

1926–1927 SEASON
9 November 1926–9 January 1927
John Marin. Duncan Phillips bought *Back of Bear Mountain,* though he and Stieglitz argued about its price.

11 January–27 February
Georgia O'Keeffe: Paintings, 1926. Forty-seven oils, including four of the Shelton, three from the Shelton, five calla lilies, and three black petunias. Oscar Bluemner wrote "A Painter's Comment" in the catalogue.

7 March–3 April (catalogue), or 9 March–14 April (exhibition schedule)
Gaston Lachaise Sculptures. Twenty works of sculpture in alabaster, marble, bronze, and plaster, including a portrait of O'Keeffe.

1927–1928 SEASON
9 November–11 December
Forty New Water-Colors by John Marin.

12 December 1927–11 January 1928 (catalogue), or 12 December 1927–7 January 1928 (exhibition schedule)
Arthur G. Dove: Paintings, 1927. Nineteen paintings, including *Rhapsody in Blue, Part I* and *II—Gerschwin* [sic]. Introductory statement by the artist.

9 January–27 February
O'Keeffe Exhibition. A short essay by Lewis Mumford, "O'Keeffe and Matisse," which had originally been published in *The New Republic,* is reprinted in the catalogue.

28 February–27 March
Oscar Bluemner: New Paintings. Twenty-two watercolors and six oil paintings.

27 March–17 April
Peggy Bacon Exhibition. Drawings and pastels, including a caricature of Charles Sheeler. Catalogue foreword by Charles Demuth.

11 May ("for a few days")
Six Small Paintings of "Calla Lilies" by Georgia O'Keeffe. Announcement noted that the paintings were "[a]cquired by an 'Individual' and about to be sent to France." In a letter from Stieglitz, published in *The Art News,* 21 April 1928, he stated that the calla lilies recently purchased for $25,000 had been painted in 1923.

19 April–11 May

Picabia Exhibition. Eleven paintings. Catalogue noted that "[t]his exhibition of the most recent work of Francis Picabia, Paris, takes place at the initiative of Marcel Duchamp." Catalogue introduction by Meraus Michael Guinness.

1928–1929 SEASON

14 November–29 December

Marin Exhibition. Forty-seven watercolors from three series: Deer Isle, Maine (1927), White Mountain Country (summer 1927), and White Mountain Country (autumn 1927). Catalogue included an introduction by Marsden Hartley, a biography provided by the artist, and essays by Julius Meier-Graefe (reprinted from *Vanity Fair,* November 1928) and Murdock Pemberton (reprinted from *The New Yorker,* 24 November 1928).

1–31 January

Hartley Exhibition. Catalogue foreword by Lee Simonson. Works are given as "one hundred paintings in oil, watercolor, silverpoint, and pencil: still-life, landscape—mountains—trees—etc—by Marsden Hartley, painted in Paris and Aix-en-Provence—France—1924–1927."

4 February–17 March

Georgia O'Keeffe: Paintings, 1928. Thirty-five paintings. Demuth provided a short introductory quote.

19 March–7 April

Paul Strand: New Photographs. Thirty-two photographs from 1925 to 1928, mostly prints of Georgetown and Center Lovell, Maine. Catalogue introduction by Gaston Lachaise.

9–28 April

Dove Exhibition. Twenty-three paintings, all but one from 1927 to 1929. Notes by the artist in the catalogue.

29 April–18 May

Charles Demuth: Five Paintings. Watercolors and canvases, including *Provincetown* (1918), *Longhi on Broadway* (1927), *"I Saw the Figure 5 in Gold"—William Carlos Williams* (1927), an unfinished *Design for a Broadway poster* (1929), and *Cabbages & Rhubarb* (1929).

An American Place

1929–1930 SEASON

15 December 1929–30 January 1930

John Marin: 50 New Water Colors. Forty-seven watercolors from Small Point, Maine, and vicinity, and Deer Isle, Maine, and vicinity, as well as Lake George and the Adirondacks.

fig. 136 CHARLES DEMUTH
Longhi on Broadway, *1927*
oil on artist's board
Gift of the William H. Lane Foundation
Courtesy, Museum of Fine Arts, Boston
EXHIBITED AT THE INTIMATE GALLERY, 1929; AN
AMERICAN PLACE, 1931

fig. 137 ARTHUR DOVE
Flour Mill II, *1938*
wax emulsion on canvas
The Phillips Collection, Washington, D.C.
EXHIBITED AT AN AMERICAN PLACE, 1938

7 February–17 March
Georgia O'Keeffe: 27 New Paintings, New Mexico, New York, Lake George, Etc.

22 March–22 April
New Paintings by Arthur G. Dove. Twenty-six works.

April–May (?)
Group exhibition of Demuth, Dove, Hartley, Marin, and O'Keeffe. An impromptu group show, which would become common at An American Place. Because of the unstructured format of these exhibitions, there generally was no published catalogue, checklist, or announcement and thus little evidence confirming dates, titles, works exhibited, etc. Newspaper reviews often confirm that the exhibition occurred and provide other information.

1930–1931 SEASON
November
John Marin—Recent Watercolors—New Mexico and New York. Thirty-two works.

15 December 1930–18 January 1931
Marsden Hartley—New Paintings—Landscapes—New Hampshire— Still Lifes—Paris and Aix-en-Provence.

18 January–27 February
Georgia O'Keeffe: Recent Paintings, New Mexico, New York, Etc. Etc. Thirty-three paintings, including the Jack-in-the-Pulpit series and the Ranchos Church, New Mexico series.

9 March–4 April
Arthur G. Dove: 27 New Paintings—Abstractions, Landscapes, Etc.— Etc.—Etc. Checklist noted thirty-three paintings and drawings.

14 April–11 May
Charles Demuth. Only solo exhibition of Demuth's work at An American Place.

May
Group exhibition of Dove, Demuth, Hartley, Marin, and O'Keeffe.

1931–1932 SEASON
11 October–27 November
John Marin: 14 oil paintings—Maine; 30 water colors—New Mexico; 4 etchings—New York (all new).

27 December 1931–11 February 1932
Georgia O'Keeffe: 33 New Paintings (New Mexico).

15 February–5 March
127 Photographs (1892–1932) by Alfred Stieglitz. First showing of later New York subjects.

14 March–9 April
Arthur G. Dove Exhibition—1932. Nineteen paintings and twenty framed sketches.

fig. 138 **ALFRED STIEGLITZ**
Georgia O'Keeffe: A Portrait—Exhibition at An American Place, *1931–1932*
gelatin silver print
National Gallery of Art, Washington, Alfred Stieglitz Collection

10 April–May
Paul Strand. Almost one hundred photographs, including the 1929 driftwood series, New Mexican landscapes from 1930, and New Mexico and Colorado prints from 1931.
Rebecca Salsbury Strand. Paintings on glass.

16 May–14 June
Group exhibition of Dove, Marin, O'Keeffe, Demuth, and Hartley.

1932–1933 SEASON
3–29 October
Stanton Macdonald-Wright: 13 New Paintings. Thirteen paintings. Artist's statement on checklist.

7 November–17 December
John Marin: New Oil Paintings and Water Colors and Drawings.

7 January–22 February, extended until 15 March
Georgia O'Keeffe: Paintings—New and Some Old. Twenty-three paintings from 1926 to 1932, including flowers, barns, leaves, and abstractions. Catalogue included "A Woman in Flower," an introductory paragraph by Herbert J. Seligmann.

20 March–15 April
Arthur Dove and Helen Torr. Paintings and watercolors.

May
Group exhibition of Dove, Marin, and O'Keeffe.

1933–1934 SEASON
20 October–27 November (announcement), or 9 November–10 December (announcement), or 9 November–7 December (announcement)
Twenty-Five Years of John Marin, 1908–1932. Thirty-three watercolors. Catalogue published a short list of the most significant

exhibitions at the gallery, noting that the Marin exhibition "occurs in the year of the twenty-ninth anniversary of the opening of '291' and as it constitutes a part of the Progression, we here list a number of the outstanding public demonstrations at that laboratory." Three announcements exist, all written by Stieglitz. Each uses the same title but lists different dates. Exhibition reviews from late October suggest that the 9 November opening date is inaccurate, but the precise closing date remains unknown. The catalogue for this exhibition did not list specific dates.

20 December–1 February
John Marin—New Water Colors, New Oils, New Etchings. Fifteen watercolors and twelve oils.

29 January–17 March, extended until 27 March (?)
Georgia O'Keeffe: 44 Selected Paintings (1915–1927). Announcement indicated that work from 1915 to 1927 was exhibited, but reviews indicate that some paintings from as late as 1931 were also shown.

17 April–15 May, extended until 1 June (?)
Arthur G. Dove: New Oils and Watercolors. Early Dove paintings from 1922 to 1926, as well as recent oils and watercolors.

1934–1935 SEASON
3 November–1 December
John Marin: New Oil Paintings and Water Colors and Drawings. Twenty Maine watercolors from 1933, and seven Maine and New York oils from 1934. Checklist included a quotation from Duncan Phillips.

11 December 1934–17 January 1935
Alfred Stieglitz: Exhibition of Photographs (1884–1934). Sixty-nine photographs, including scenes from Europe made in the 1880s and 1890s, portraits of O'Keeffe and others, views of New York and Lake George, *Equivalents*, and the Dead Tree series. Catalogue included an introductory statement by Stieglitz.

27 January–11 March, extended until 27 March
Georgia O'Keeffe: Exhibition of Paintings (1919–1934). Twenty-eight paintings from 1919 to 1934, approximately half of which were of New Mexico. Catalogue included quotes from Henry McBride, Ralph Flint, Thomas Craven, and Lewis Mumford, as well as a short "Painter's Comment" by Oscar Bluemner.

17 March–14 April
George Grosz: Exhibition of Water Colors. Thirty-eight watercolors from 1933 and 1934. Marsden Hartley wrote the catalogue introduction.

21 April–22 May
Arthur G. Dove: Exhibition of Paintings (1934–1935). Seventeen oils and twenty-eight watercolors.

1935–1936 SEASON
27 October–15 December, exhibition extended until 1 January
John Marin: Exhibition of Water Colors, Drawings, Oils (1934–1935).

Twelve watercolors (Maine series) and six oils. Catalogue included an "Extract from a Letter from Marin, Cape Split, Maine, August 18, 1935."

7 January–27 February
Georgia O'Keeffe: Exhibition of Recent Paintings, 1935. Seventeen oils, including *Sunflower, New Mexico I* and *II*, and *Ram's Head, White Hollyhock-Hills.* Catalogue included the Marsden Hartley essay "A Second Outline in Portraiture."

29 February–20 March
Some Work by Robert C. Walker. Thirty-three works, including nineteen paintings, five wood prints, and nine drypoints.

22 March–14 April
Marsden Hartley: First Exhibition in Four Years All Pictures Shown for the First Time Publicly. Thirty paintings, including six panels "intended for use as focus motives in a convalescent pavilion," "four modern ikons for a wooden sea-chapel in the bitter north," as well as seven paintings from the artist's New England series and seven Alpine vistas.

20 April–20 May
New Paintings by Arthur G. Dove. Nineteen oils and thirty-one watercolors.

1936–1937 SEASON
27 October–25 November
Ansel Adams: Exhibition of Photographs. Forty-five photographs.
William Einstein: Paintings and Drawings.

27 November–31 December
Exhibition of Paintings: Charles Demuth, Arthur G. Dove, Marsden Hartley, John Marin, Georgia O'Keeffe, and New Paintings on Glass by Rebecca S. Strand.

5 January–3 February
John Marin: New Water Colors, Oils, and Drawings. Four drawings with color, one black-and-white drawing, sixteen watercolors (Marine series, 1935), and seven oils.

5 February–17 March
Georgia O'Keeffe: New Paintings. Twenty-one paintings from 1934 to 1936, including several of cow skulls. Annotated checklist indicates that seven other paintings may have been shown.

23 March–16 April
Arthur G. Dove: New Oils and Water Colors. Thirty-two watercolors and twenty oil-temperas. Catalogue introduction by William Einstein.

20 April–17 May
Marsden Hartley: Exhibition of Recent Paintings, 1936. Twenty-one paintings from 1936, mostly images of Nova Scotia. Catalogue included a poem by the artist, "Signing family papers," as well as an essay "On the Subject of Nativeness—a Tribute to Maine."

27 October–27 December

Beginnings and Landmarks: "291," 1905–1917. Exhibition divided into four sections: photographs shown at 291 with Julia Margaret Cameron, J. Craig Annan, Robert Demchy, Adolph de Meyer, Frank Eugene, David Octavius Hill and Robert Adamson, Gertrude Käsebier, Steichen, Stieglitz, Clarence White, and Paul Strand; paintings and sculpture at 291, including Brancusi, Cézanne, Gordon Craig, Julius Gerson, Toulouse-Lautrec, Manolo, Matisse, Utamaro, Picasso, Renoir, Rodin, Felicien Rops, Pamela Colman Smith, and Steinlen; artists influenced by 291, including Bluemner, Demuth, de Zayas, Dove, Hartley, Man Ray, Marin, Alfred Maurer, O'Keeffe, Picabia, Gino Severini, Walkowitz, Max Weber, and Macdonald-Wright; and examples of related publications by Stieglitz and others, including *Camera Work*, *291* and *391*, the Forum Exhibition catalogue, and *America and Alfred Stieglitz*. Catalogue essay by Dorothy Norman.

27 December 1937–11 February 1938

Georgia O'Keeffe: Catalogue of the 14th Annual Exhibition of Paintings. Seventeen paintings and two pastels from Ghost Ranch, New Mexico, and eight flower, shell, and rock paintings. Catalogue included letters written by O'Keeffe to Stieglitz from Ghost Ranch in late July–September 1937.

22 February–27 March

John Marin: Recent Paintings: Water Colors and Oils. Catalogue included a poem "To my Paint Children" by the artist.

29 March–10 May

Arthur G. Dove: Exhibition of Recent Paintings, 1938. Twenty-two paintings and sixteen watercolors. Catalogue essay by Duncan Phillips.

1938–1939 SEASON

7 November–27 December

John Marin: Exhibition of Oils and Water Colors. Catalogue included essays from Duncan Phillips, Justice Benjamin Cardozo, Henry McBride, Forbes Watson, and Thomas Craven.

29 December 1938–18 January 1939

Eliot Porter: Exhibition of Photographs. Twenty-nine photographs of New England, Canada, and Austrian Tyrol, dating from 1934 to 1938. Porter's first show anywhere.

29 December 1938–18 January 1939

Charles Demuth exhibition. Announcement noted that "A few DEMUTH OILS AND WATER-COLORS will be hung on the walls of the WHITE ROOM of AN AMERICAN PLACE."

22 January–17 March

Georgia O'Keeffe: Exhibition of Oils and Pastels. Twenty-two paintings, all but one from 1938. Introductory essay by William Einstein and artist's statement "About Myself."

10 April–17 May

Arthur G. Dove: Exhibition of Oils and Temperas. Twenty-one oil and tempera paintings and nine watercolors, dating from 1924 to 1939.

1939–1940 SEASON

15 October–21 November

Beyond All "Isms": 20 Selected Marins (1908–1938).

3 December 1939–17 January 1940

New Oils, New Water Colors by John Marin. Twelve watercolors and nineteen paintings.

1 February–17 March (announcement), or 3 February–17 March (catalogue)

Georgia O'Keeffe: Exhibition of Oils and Pastels. Twenty paintings from Hawaii and one from Long Island. Catalogue included introductory statement by the artist.

30 March–14 May

Arthur G. Dove: Exhibition of New Oils and Water-Colors. Twenty oils, fifteen watercolors, and one composition on plaster. Short statement by the artist.

1940–1941 SEASON

17 October–11 December

Some Marins, Some O'Keeffes, Some Doves, "Some" Show. Eight watercolors by Marin, from 1922 to 1936; nine paintings by O'Keeffe, from 1927 to 1938; and three paintings by Dove, from 1935 to 1940.

11 December 1939–21 January 1940

John Marin: 12 New Watercolors—1949; 9 New Oils—1940; Some New Drawings—1940.

27 January–11 March

Exhibition of Georgia O'Keeffes at An American Place. Thirteen oil paintings from 1940, one pastel from 1941, and two oils from 1930 and 1937; most images from New Mexico.

27 March–17 May

Exhibition of New Arthur G. Dove Paintings. Sixteen oil paintings and fourteen watercolors.

1941–1942 SEASON

17 October–27 November

Three oils by Dove, from 1938 to 1941; four watercolors and one oil by Marin, from 1926 to 1937; five oils by O'Keeffe, from 1927 to 1936; one collage (1912–1913), one etching (1904), and one charcoal (1910) by Picasso; and twelve photographs by Stieglitz, from 1894 to 1936.

9 December 1941–27 January 1942

Exhibition: John Marin (Vintage—1941). "Oils 1 to 9 inclusive, Water Colors 1 to 15 inclusive, done at Cape Split, Maine—with the exception of 3 oil figure pieces done at my home—Cliffside, New Jersey." Cata-

logue included a letter from Marin to Stieglitz, dated 10 August 1941, Addison, Maine.

2 February–17 March
Georgia O'Keeffe: Exhibition of Recent Paintings, 1941. Fourteen paintings from the series "Near Abiquiu, New Mexico" (1941), two from New Jersey, and an orchid and a shell painting.

21 March–12 April
Pertaining to New York, Circus and Pink Ladies. Marin exhibition. Thirty-seven works, including seven paintings from the Nassau Street, N.Y. series (1936).

14 April–27 May
Arthur G. Dove: Exhibition of Recent Paintings (1941–1942). Twenty paintings. Catalogue included introductory quotes from Duncan Phillips, Jerome Mellquist, and Martha Candler Cheney, as well as a Dove poem.

1942–1943 SEASON
17 November 1942–11 January 1943
Exhibition of Recent Paintings, 1942: Oils and Water Colors. Marin exhibition. Twelve watercolors and eight *Sea Movements* in oil.

11 February–17 March
Arthur G. Dove: Paintings—1942–43. Twenty-two paintings.

27 March–22 May
Georgia O'Keeffe: Paintings—1942–1943. There are several check-lists for this exhibition. Originally only fifteen paintings were to be exhibited, but subsequent annotations indicate that twenty-one were shown.

1943–1944 SEASON
5 November–9 January
John Marin: Paintings—1943. Five oils and seven watercolors painted at Cape Split, Maine (1943), as well as two other paintings and six sea paintings. Catalogue included a letter from Marin to Stieglitz, dated 29 September 1943, Cape Split, Maine.

11 January–11 March
Georgia O'Keeffe: Paintings—1943. Nineteen paintings, including seven of pelvises. Catalogue included an artist's statement "About Painting Desert Bones."

21 March–21 May
Arthur G. Dove: Paintings—1944. Twenty recent paintings.

1944–1945 SEASON
27 November 1944–10 January 1945
John Marin: Paintings—1944. Eleven oils and thirteen water-colors, primarily seascapes.

22 January–22 March
Georgia O'Keeffe: Paintings—1944. Original checklist lists thirteen paintings, including four from the pelvis series, but subsequent annotations indicate that sixteen were on view.

3 May–15 June
Arthur G. Dove: Paintings—1922–1944. Sixteen paintings.

1945–1946 SEASON
30 November 1945–17 January 1946
John Marin: Paintings—1945. Nine oils and twenty-one water-colors from Maine.

4 February–27 March
Georgia O'Keeffe. Ten oils from Abiquiu, New Mexico (1945), and four 1945 pastels. An annotated checklist indicates that three oils and one pastel were also exhibited.

April–May
John Marin exhibition of 160 drawings, primarily of New York subjects.

6 May–4 June
11 Paintings by Arthur G. Dove.

fig. 139 HERBERT J. SELIGMANN
Alfred Stieglitz Looking Over John Marin's Shoulder,
early 1930s
gelatin silver print
Museum of Fine Arts, Boston; Ellen K. Gardner Fund, 1978

GENERAL CHRONOLOGY

1864

1 JANUARY Alfred Stieglitz is born in Hoboken, New Jersey, son of Edward and Hedwig (Werner) and eldest of six children.

1871

JUNE The Stieglitz family moves to New York, where they live in a large brownstone at 14 East Sixtieth Street.

1879—1881

Stieglitz attends City College, New York.

1881

Edward Stieglitz retires and his family travels to Germany. Alfred enrolls in the Realgymnasium, Karlsruhe.

1882—1886

Stieglitz attends the Technische Hochschule in Berlin, where he first studies photography with Hermann Vogel.

1887

Stieglitz's photographs in the "Home Portraiture" competition, sponsored by *The Amateur Photographer*, are "highly commended," marking the first international recognition of his work. Stieglitz also receives first prize awarded by Peter Henry Emerson for *A Good Joke*, in the "Holiday Work" competition, also sponsored by *The Amateur Photographer*.

1890

SEPTEMBER Stieglitz returns to the United States following the death of his sister Flora. Soon he will join Louis Schubart and Joseph Obermeyer to form the Photochrome Engraving Company.

1892

MID-MARCH Protesting the commercialization of the Salon, 106 painters and sculptors resign from the Munich chapter of the Allgemeine Deutsche Kunstgenossenschaft to form the Verein bildender Künstler Münchens, known as the Munich Secession.

MAY Founding of the British photographic society "Linked Ring," which, in contrast to the Royal Photographic Society, is interested more in the aesthetics of photography than its techniques.

1893

SPRING Stieglitz becomes an editor for *The American Amateur Photographer*, the journal of the Society of Amateur Photographers.

16 NOVEMBER Stieglitz and Emmeline ("Emmy") Obermeyer marry in New York City. The couple lives at the newly opened Savoy Hotel at Fifth Avenue and Fifty-Ninth Street.

1894

SUMMER On honeymoon in Europe, Stieglitz visits Italy, Austria, Germany, Holland, France, and England.

22 SEPTEMBER–? Stieglitz exhibits two photographs in the annual exhibition of the Royal Photographic Society in London. He will exhibit with the RPS every year through 1899.

1 OCTOBER–4 NOVEMBER Stieglitz exhibits in the second Photographic Salon of the Linked Ring, to which Stieglitz and Rudolph Eickemeyer are the first Americans elected. He exhibits in the Photographic Salon through 1908.

1895

JANUARY *The American Amateur Photographer* promotes Stieglitz, noting that "Mr. Alfred Stieglitz assumes sole charge of the general management," and will serve as "the responsible editor." Stieglitz resigns in 1896.

fig. 140 ALFRED STIEGLITZ
Self-Portrait, Cortina, *1890*
platinum print processed with mercury
National Gallery of Art, Washington, Alfred Stieglitz Collection

1896

7 MAY The Society of Amateur Photographers of New York and the New York Camera Club merge to form the Camera Club of New York, with more than three hundred members. Stieglitz joins and becomes its vice president the following year.

1897

MARCH–APRIL Led by Gustav Klimt, a group of Viennese artists resigns from the Künstlerhaus Artists' Association to found the Union of the Creative Artists of Vienna, or the Viennese Secession.

JULY First issue of *Camera Notes* is published with Stieglitz as editor.

fig. 141 Cover for "Camera Notes," *published by the Camera Club of New York, 1897–1903*

1898

2 MAY Berlin Secession is formally established and Max Liebermann is elected president.

27 SEPTEMBER Stieglitz's daughter Katherine ("Kitty") is born.

24 OCTOBER–12 NOVEMBER (EXTENDED TO 18 NOVEMBER) Photographic Society of Philadelphia and the Pennsylvania Academy of the Fine Arts co-sponsor the Philadelphia Photographic Salon. Stieglitz serves on the jury, which selects one hundred photographers and 259 prints. Stieglitz is represented by ten prints.

19 NOVEMBER–1 JANUARY Munich Secession mounts an international photography exhibition, which includes nine Stieglitz photographs.

1899

1–15 MAY Retrospective of Stieglitz photographs organized by the Camera Club, New York.

1900

APRIL Edward Steichen exhibits in the Chicago Salon, where Clarence White sees his work and writes to Stieglitz about him. Steichen subsequently visits New York and meets Stieglitz at the Camera Club.

1902

17 FEBRUARY Stieglitz founds the Photo-Secession.

24 FEBRUARY Stieglitz resigns as editor of *Camera Notes*.

fig. 142 GERTRUDE KÄSEBIER
Alfred Stieglitz, *1902*
platinum on tissue
The Metropolitan Museum of Art, Alfred Stieglitz Collection, 1949

5–22 MARCH "American Pictorial Photography, Arranged by 'The Photo-Secession' " opens at the National Arts Club and introduces the Photo-Secession to the general public and arts community.

1903

JANUARY Stieglitz publishes first issue of *Camera Work*. Edward Steichen designs the cover.

APRIL *Camera Work* 2, "The Steichen Number."

1904

JANUARY Monthly meetings of the Photo-Secession begin at Mouquin's, a French restaurant on Sixth Avenue and Twenty-Eighth Street.

SUMMER Stieglitz travels to Europe, where he visits Berlin, Dresden, Munich, and London.

1905

JUNE Ernst Ludwig Kirchner, Erich Heckel, Karl Schmidt-Rotluff, and Fritz Bleyl form the German expressionist movement Die Brücke in Dresden.

OCTOBER Acting upon Steichen's suggestion, Stieglitz agrees to operate and help finance the Little Galleries of the Photo-

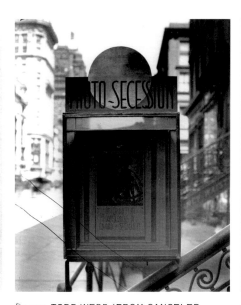

fig. 143 EDWARD STEICHEN
"Photo Secession": Broadside
for the Little Galleries,
291 Fifth Avenue, 1905
The Metropolitan Museum of Art

fig. 144 TODD WEBB (FROM CANCELED
NEGATIVE BY ALFRED STIEGLITZ)
291: Signboard for Steichen Exhibition,
1905 (printed 1963)
Yale Collection of American Literature, Beinecke
Rare Book and Manuscript Library

fig. 145 EDWARD STEICHEN
Alfred Stieglitz at 291, *1915*
gum-bichromate over platinum or gelatin silver
The Metropolitan Museum of Art, Alfred Stieglitz
Collection, 1933

Secession on the top floor of 291 Fifth Avenue in what had been Steichen's old studio and two adjoining rooms. In a letter to the members of the Photo-Secession, Stieglitz describes the new gallery "where will be shown continuous fortnightly exhibitions of from thirty to forty prints each … not only of American pictures never before publicly shown in any city in this country, but also of Austrian, German, British, French, and Belgian photographs, as well as such other art productions, other than photographic.…"

18 OCTOBER–25 NOVEMBER Salon d'Automne in Paris showcases art of Henri Matisse, as well as Charles Camoin, André Derain, Henri Manguin, Albert Marquet, and Maurice Vlaminck. Upon seeing these wildly colored and aggressively painted canvases, art critic Louis Vauxcelles exclaimed that he had seen "Donatello chez les fauves," or "Donatello among the wild beasts," thus naming the first modernist art movement of the twentieth century.

1906

APRIL *Camera Work* 14 reprints controversial George Bernard Shaw essay from the *Amateur Photographer* (October 1901), in which he compares photographic portraiture to the art of Holbein, Rembrandt, and Velázquez, declaring that "If you can not see at a glance that the old game is up, that the camera has hopelessly beaten the pencil and the paint-brush

as an instrument of artistic representation, then you will never make a true critic; you are only, like most critics, a picture-fancier."

Camera Work, special Steichen supplement.

23 OCTOBER Paul Cézanne dies.

fig. 146 EDWARD STEICHEN
View of His Studio at 103 Montparnasse, Paris, *1906*
Yale Collection of American Literature, Beinecke Rare Book and
Manuscript Library

fig. 147 FRANK EUGENE
Eugene, Stieglitz, Kühn, and Steichen Admiring
the Work of Eugene, *1907*
platinum print
Yale Collection of American Literature, Beinecke Rare Book
and Manuscript Division

1907

SPRING Marius de Zayas, forced out of Mexico by the Porfirio Díaz dictatorship, immigrates to New York, where he begins working as a caricaturist for the *New York Evening World.* Stieglitz visits de Zayas' studio and offers to show his work at 291.

JUNE–JULY Picasso paints *Les Demoiselles d'Avignon,* which marks the beginnings of cubism.

JUNE?–SEPTEMBER Stieglitz travels to Europe. In July, he meets with Steichen, Heinrich Kühn, and Frank Eugene in Tutzing, where they experiment with Lumière Autochrome plates, the first commercially viable process for color photography. In Paris, Stieglitz sees Steichen, and visits Bernheim Jeune Gallery to see work by Cézanne and Matisse.

NOVEMBER OR DECEMBER Paul Strand, a student at the Ethical Culture School, New York, studies under Lewis Hine, who takes the photography club to see 291. Photographs of the Photo-Secessionists are on view.

1908

4–25 JANUARY National Arts Club mounts a "Special Exhibition of Contemporary Art." Among the works are photographs by Stieglitz and Steichen; paintings by Mary Cassatt, William Glackens, Childe Hassam, Robert Henri, George Luks, Steichen, Henry O. Tanner, and James McNeill Whistler; and drawings by Pamela Colman Smith.

JANUARY Georgia O'Keeffe, then a student under William Merritt Chase at the Art Students League, visits 291 to see the

Rodin exhibition. Paul Haviland purchases several drawings and meets Stieglitz.

Académie Matisse opens at the Couvent des Oiseaux. During the school's three years of existence, approximately 120 students—mostly foreign—study under Matisse.

JANUARY–FEBRUARY Stieglitz is asked to resign from the Camera Club. He refuses and is expelled.

3–15 FEBRUARY Five painters of the Philadelphia-based Ashcan school—Henri, Luks, Glackens, John Sloan, and Everett Shinn—exhibit their work in New York at the Macbeth Gallery with three independent artists—Ernest Lawson, Arthur B. Davies, and Maurice Prendergast. Collectively the group becomes known as The Eight.

25 FEBRUARY Steichen, Arthur Carles, Marin, Maurer, Weber, and several other artists organize the New Society of American Artists in Paris in reaction to the conservative Society of American Artists in Paris.

MARCH After bringing suit against the Camera Club for illegal discharge, Stieglitz is reinstated as a life member. He promptly resigns.

SPRING Due to an increase in rent, 291 is forced to close its doors. With the financial assistance of Paul Haviland, the gallery is able to reopen at 293 Fifth Avenue, though Stieglitz retains the name 291. Haviland will become one of Stieglitz's closest associates, and will eventually become an editor for *Camera Work.*

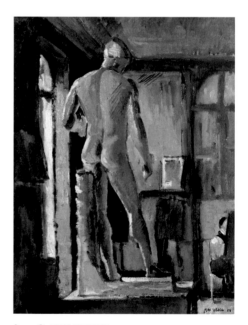

fig. 148 MAX WEBER
The Apollo in Matisse's Studio, *1908*
oil on canvas
private collection

1909

2–20 FEBRUARY Stieglitz organizes an "International Exhibition of Pictorial Photography" at the National Arts Club.

20 FEBRUARY Publication of the founding manifesto of the Italian futurists.

APRIL Poet Seumas O'Sheel introduces Marsden Hartley to Stieglitz.

MAY Stieglitz, along with Alvin Langdon Coburn, Joseph Keiley, and Clarence White, and others, resigns from the Linked Ring. The Linked Ring had suffered an internal split in 1908, when some members protested the Americanization of the organization and staged a photographic "Salon des Refusés."

24 MAY Edward Stieglitz dies at the age of seventy-six.

JUNE–EARLY OCTOBER Stieglitz travels with his family to Europe. In Paris, Steichen takes Stieglitz to visit the studio of Rodin in Meudon, and to see work of Cézanne, Matisse, and Picasso in the collections of Sarah and Michael Stein, and Leo and Gertrude Stein. Stieglitz also meets Marin sometime in June. He travels to Marienbad, Munich, Dresden, and Tutzing before returning to New York.

DECEMBER Weber returns to New York after three years in France, where he studied with Matisse and became acquainted with Picasso. Weber introduces Stieglitz to the work of Henri Rousseau, previously unknown in New York. Weber, then homeless and penniless, soon moves into the office of another tenant in 291's building, and uses 291 as a studio before business hours. Weber, along with de Zayas, will teach Stieglitz about the influences of pre-Columbian and African art on modernism.

LATE 1909 OR EARLY 1910 Stieglitz meets Dove, probably through their mutual friend Maurer.

1910

1–27 APRIL Independent Artists Exhibition is organized by Robert Henri and John Sloan, along with James Fraser, William Glackens, Walt Kuhn, Ernest Lawson, and Everett Shinn at a loft at 29 West Thirty-Fifth Street.

3 NOVEMBER–1 DECEMBER Stieglitz organizes "The International Exhibition of Pictorial Photography" at the Albright Art Gallery in Buffalo. The exhibition is a popular and critical success and marks the acceptance and recognition of the Photo-Secession within the art establishment. Ironically, it effectively marked the end of the Photo-Secession.

8 NOVEMBER–11 JANUARY Roger Fry's heavily criticized "Manet and the Post-Impressionists" exhibition is at the Grafton Galleries in London, a precursor to the Armory Show.

1911

JANUARY Weber and Stieglitz end their relationship after a dispute over pricing during Weber's solo exhibition at 291.

MARCH Man Ray visits the Cézanne watercolors exhibition at 291 and becomes a frequent visitor to the gallery.

APRIL–JULY *Camera Work* 34–35 is a double issue devoted to "the new art in Paris." Included are Steichen photographs of Rodin and his monumental Balzac sculpture, drawings by Rodin, and essays on Cézanne, Picasso, and Rodin. In response, approximately half of *Camera Work*'s six hundred subscriptions were canceled.

SUMMER Georges Braque and Picasso, working together in Céret, begin to add lettering to their canvases, signaling the transition from analytic to synthetic cubism.

MID-SEPTEMBER Stieglitz arrives in Paris. Accompanied by Steichen and de Zayas, he visits the Bernheim Jeune Gallery and is introduced to Picasso, Matisse, Rodin, Brancusi, and Vollard. Stieglitz is interested in exhibitions of Van Gogh and Gauguin for 1912, but these shows never materialize.

DECEMBER Wassily Kandinsky and Franz Marc break away from the more conservative Artists' Association of Munich to form the *Blaue Reiter*, which becomes the second branch of German expressionism.

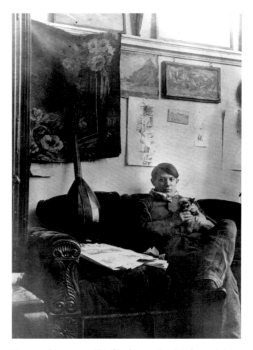

fig. 149 Picasso in His Studio on the Boulevard de Clichy (*fig. 41 is on the wall*), 1910
Musée Picasso Archives

fig. 150 Hartley onboard Ship, "First Trip Abroad," *1912*
Marsden Hartley Collection, Yale Collection of American Literature,
Beinecke Rare Book and Manuscript Library

1912

EARLY Albert Barnes gives his friend and fellow Philadel-
phian William Glackens twenty thousand dollars to purchase
modern art in Paris for his collection.

11 APRIL With Stieglitz's assistance Hartley travels to Paris,
where he visits the salon of Gertrude and Leo Stein.

14 JUNE A fire breaks out in the apartment below 291, and
Stieglitz fears that his negatives and prints, as well as his per-
sonal art collection, are destroyed. However, 291 is saved. In the
New York Globe, Hutchins Hapgood quotes Stieglitz as saying that
"if those pictures, plates, photographs, and drawings had been
destroyed, he would have gone to some pseudo art collection, to
some gallery of respectable paintings, to some museum in which
academical compromise in the way of art was stored, and would
have burnt it up."

JULY Stieglitz publishes an excerpt of Kandinsky's *On the Spir-
itual in Art* in *Camera Work* 39. The following year, Stieglitz will
purchase his *The Garden of Love (Improvisation Number 27),* the
only Kandinsky to be exhibited at Armory Show. After his pur-
chase, Stieglitz and Kandinsky exchange letters in which they
discuss the possibility of an exhibition of Kandinsky's paintings
at 291, which never materializes.

AUGUST *Camera Work,* Special Number, is "devoted to the
essays of Miss Gertrude Stein on Matisse and Picasso, illustrated
with fourteen full-page plates of the work of these artists...."

SUMMER Robert Delaunay establishes the principles of a
non-objective painting that Apollinaire would name "orphism"
and declares that "Light in Nature creates the movement of col-
ors. Movement is produced by the rapport of *odd elements,*

of the contrasts of colors between themselves which constitutes
Reality."

Cologne "Sonderbund" exhibition, a precursor to the Armory
Show.

ALSO IN THIS YEAR Albert Gleizes and Jean Metzinger
publish *Du Cubisme* in Paris; English edition will be published
the following year.

1913

JANUARY Hartley travels to Munich and meets Blue Rider
artists Kandinsky and Gabriele Münter, and sees Franz Marc's
work at the Galerie Thannhauser. Later that year he meets Marc
and keeps Stieglitz abreast of the activities of these artists.

Mabel Dodge holds her first weekly salon for the cultural
"movers and shakers" at her apartment at 23 Fifth Avenue.
Andrew Dasburg, Max Eastman, Hutchins Hapgood, Hartley,
Marin, Francis Picabia, John Reed, Lincoln Steffens, Maurice
Stern, and Carl Van Vechten become regular visitors.

14 JANUARY Picabia and his wife, Gabrielle Buffet-Picabia,
sail for New York. Soon after their arrival they become
acquainted with Stieglitz.

17 FEBRUARY–15 MARCH International Exhibition of
Modern Art exhibited at the Sixty-Ninth Regiment Armory in
New York, known colloquially as the Armory Show. More than
twelve hundred works are on view, including both American and
European (almost exclusively French) modernists. Marcel
Duchamp's *Nude Descending a Staircase* (1912) generates consid-
erable controversy. Smaller versions of the exhibition travel to
Chicago and Boston.

MARCH 291 publishes de Zayas and Paul Haviland's *A Study of
the Modern Evolution of Plastic Expression.*

3 OCTOBER John Quinn wins his fight to reform tariffs levied
against modern art.

27 OCTOBER–8 NOVEMBER Morgan Russell and Stanton
Macdonald-Wright exhibit at Bernheim Jeune Gallery in Paris.
The artists jointly issue their synchromism manifesto.

NOVEMBER *Camera Work* 42–43 (dated April–July, but not
published until November) is a double issue devoted to Stei-
chen. This also marks the first in a series of delayed publication
dates for *Camera Work.* Numbers 42/43, 44, 45, 46, and 47 were
published four to six months after the volume date.

17 DECEMBER Charles Daniel opens the Daniel Gallery at 2
West Forty-Seventh Street dedicated to modern American art.
Gallery moves to 600 Madison Avenue in 1924. It remains open
until 1932 and regularly exhibits Demuth, Hartley, Man Ray, and
Sheeler.

1914

EARLY Marcel Duchamp purchases a bottle rack in Paris and inscribes it, creating his first ready-made.

5 FEBRUARY–7 MARCH "Exhibition of Contemporary Art" at the National Arts Club.

FEBRUARY Stephane Bourgeois establishes the Bourgeois Gallery in New York.

2–16 MARCH Opening of Harriet Bryant's Carroll Galleries. The first exhibition is of the synchromists, marking their debut in the United States.

MARCH Hartley returns to Berlin (via London and Paris) and begins work on his "Amerika" series.

Founding of *The Little Review*, a literary magazine devoted to avant-garde poetry and literature. Contributors will include Ezra Pound, T. S. Eliot, and James Joyce.

MAY De Zayas travels to Paris, where Picabia introduces him to *Les Soirées de Paris* circle. Eventually copies of *Camera Work* and *Les Soirées de Paris* are exchanged between Stieglitz and Apollinaire. Apollinaire offers his poems and letters of Rousseau for publication in *Camera Work*.

SPRING Demuth returns to the United States from Europe, and with the help of a letter of introduction sent by Hartley, meets Stieglitz. Stieglitz and Demuth will become close, although Demuth will initially be represented by Charles Daniel.

Washington Square Gallery, directed by Robert Coady, opens at 47 Washington Square South. It operates until late 1916.

SUMMER Marin visits West Point, Maine, initiating the artist's long relationship with the state, which he continues to visit, and which becomes an important subject of his painting, for the rest of his life.

28 JUNE Archduke Francis Ferdinand of Austria and his wife, Sophie, are assassinated in Sarajevo, and World War I begins a month later.

FALL Walter and Louise Arensberg move to 33 West Sixty-Seventh Street, New York. Their apartment will become a meeting place for New York dadaists, and other members of the avant-garde.

O'Keeffe attends Teachers College, Columbia University, New York, where she studies with Arthur Wesley Dow. She visits 291, but does not meet Stieglitz.

SEPTEMBER Due to the threat of approaching German troops, Steichen and his family flee Paris for New York.

DECEMBER "'Cubist' Watercolors" at the Carroll Galleries.

LATE 1914 OR EARLY 1915 Strand brings a folio of his photographs to Stieglitz for his review. Impressed by their creativity, Stieglitz agrees to exhibit them at 291, and publish them in *Camera Work*.

ALSO IN THIS YEAR Duchamp completes first two American ready-mades, "Pulled at 4 Pins" and "In Advance of the Broken Arm."

Gertrude Vanderbilt Whitney establishes The Friends of the Young Artists.

Kandinsky's *The Art of Spiritual Harmony* is published in English.

Arthur Jerome Eddy publishes *Cubists and Post-Impressionism*.

1915

JANUARY *Camera Work* 47 (dated July 1914, but not published until January 1915), is dedicated to the question, "What is '291'?" Stieglitz sends letters to various persons—artists, art critics, collectors, 291 elevator operator, poets—to answer this question in written form. This becomes the first and only edition of *Camera Work* to be published without any images.

20 JANUARY–27 FEBRUARY Matisse at the Montross Gallery; first time the conservative Montross Gallery exhibits modern European art.

JANUARY–23 FEBRUARY "French Modernists and Odilon Redon" at Carroll Galleries.

MARCH–FEBRUARY 1916 Monthly publication of *291*, edited by de Zayas , Paul Haviland, and Agnes Ernst Meyer. The experimental journal publishes critical and satirical essays, poems, reviews, and artwork created especially for the journal by Apollinaire, Haviland, Max Jacob, Marin, Meyer, Picabia, de Zayas, and others. Picabia's mechano-morphic portraits of Stieglitz, Haviland, de Zayas, Meyer, and himself appear in the July–August 1915 issue.

fig. 151 **ALFRED STIEGLITZ**
Torres Palomar at 291, *c. 1915*
platinum print
New Orleans Museum of Art: Museum purchase

11 MARCH Quinn purchases six Picasso paintings from the Carroll Galleries, including representatives of the blue, rose, and cubist periods.

31 MARCH Man Ray publishes the proto-dada journal *The Ridgefield Gazook.*

EARLY JULY Paul Haviland departs for Europe.

JULY First issue of *Others* poetry magazine is published. Among the magazine's founders are Alfred Kreymborg, Wallace Stevens, Walter Arensberg, and Allen Norton. Contributors include modernist poets such as Ezra Pound, William Carlos Williams, and T.S. Eliot.

Provincetown Players theatrical troupe is established in Provincetown, Massachusetts. The group moves to New York in 1916 and continues to perform the works of American playwrights, most notably those of Eugene O'Neill, until 1929. Hartley and Demuth are active participants.

OCTOBER–3 NOVEMBER Man Ray exhibition at the Daniel Gallery.

7 OCTOBER Modern Gallery, established and run by de Zayas, opens at 500 Fifth Avenue with an inaugural exhibition of works by both European and American modernists, as well as African sculpture.

24 OCTOBER An article in the *New York Tribune*, "French Artists Spur on An American Art," argues that developments in contemporary art are shifting from Europe to America. It includes interviews with Frederick MacMonnies, Jean and Ivonne Crotti, Gleizes, Picabia, de Zayas, and Duchamp. Duchamp praised America, noting: "I adore New York....There is much about it which is like the Paris of the old days. Many artists have come over, and I think many more will come. As I said, I can paint wherever chance sets me down. I am perfectly emancipated in that regard. But I must admit the atmosphere of Paris just now is not such as to inspire artists."

1916

1 JANUARY O'Keeffe's friend, Anita Pollitzer, brings O'Keeffe's "Special" charcoal drawings to 291 for Stieglitz's review. O'Keeffe is teaching art at Columbia College in South Carolina. Impressed by her drawings, Stieglitz begins to correspond with O'Keeffe.

JANUARY Picabia and African sculpture at the Modern Gallery. Cézanne at the Montross Gallery.

JANUARY–FEBRUARY O'Keeffe receives a teaching post as head of the art department at West Texas State Normal College, Canyon, Texas, contingent upon her completion of courses with Arthur Wesley Dow at Teachers College, Columbia University. She returns to New York and begins to frequent 291.

1 FEBRUARY Hugo Ball founds the Cabaret Voltaire in Zurich, which becomes the meeting place for the Zurich dadaists.

12 FEBRUARY–1 MARCH Picabia, Cézanne, Van Gogh, Picasso, Braque, and Diego Rivera at the Modern Gallery.

8–22 MARCH Mrs. A. Roosevelt, Alice Morgan Wright, Adolf Wolff, Amedeo Modigliani, and Brancusi at the Modern Gallery.

13–25 MARCH "The Forum Exhibition of Modern American Painters" is on view at the Anderson Galleries. Stieglitz is on the exhibition committee, along with Christian Brinton, Robert Henri, W.H. de B. Nelson, John Weichsel, and Willard Huntington Wright. Many of the American modernists Stieglitz championed, including Marin, Dove, Hartley, Walkowitz, Bluemner, and Maurer, are included. Exhibition's stated purpose is "To put before the American public, in a large and complete manner, the very best examples of the more modern American art; to stimulate interest in the really good native work of this movement; and to bring serious, deserving painters in direct contact with the public without a commercial intermediary."

4–22 APRIL Jean Crotti, Duchamp, Gleizes, and Metzinger at the Montross Gallery.

29 APRIL–10 JUNE Cézanne, Van Gogh, Picasso, Picabia, and Rivera at the Modern Gallery.

fig. 152 **EDWARD STEICHEN**
Fourth of July Picnic at the Meyer Estate, Mount Kisco, New York, 1915
(clockwise from Stieglitz, at left: Agnes Meyer, Paul Haviland, Abraham Walkowitz, Marion Beckett, Francis Picabia, John Marin, Eugene Meyer, Katharine Rhoades, J. B. Kerfoot, Emmeline Stieglitz, Marius de Zayas).
Yale Collection of American Literature, Beinecke Rare Book and Manuscript Division

fig. 153 ALFRED STIEGLITZ
Kitty at 291, *1916*
platinum print
National Gallery of Art, Washington,
Alfred Stieglitz Collection

fig. 154 View from the Window
of the Modern Gallery toward
the New York Public Library,
1915
De Zayas Archives, Seville

JULY–AUGUST Hartley, along with Demuth and others, summers in Provincetown as the guest of John Reed.

AUGUST O'Keeffe moves to Canyon, Texas, to begin her teaching position at West Texas State Normal College.

11–20 SEPTEMBER Modern paintings and African sculpture at the Modern Gallery.

23 OCTOBER–11 NOVEMBER "Sculpture by Brancusi" at the Modern Gallery.

OCTOBER In *Camera Work* 48, Strand photographs are published in the first of two consecutive issues. The issue also contained article " '291' and the Modern Gallery," which represents the severing of the relationship between the two galleries.

LATE Robert Coady opens the Coady Gallery at 489 Fifth Avenue, showing works by European modernists including Cézanne, Picasso, and Juan Gris.

NOVEMBER Provincetown Players open their winter season in Greenwich Village. Stieglitz subscribes to the first season.

NOVEMBER–OCTOBER 1917 Monthly publication of *The Seven Arts*, edited by James Oppenheim, with assistance from Randolph Bourne, Van Wyck Brooks, and Waldo Frank.

26 NOVEMBER–31 DECEMBER Exhibition of African sculpture at the Modern Gallery.

5 DECEMBER Society of Independent Artists is founded by Duchamp, Man Ray, Walter Arensberg, John Covert, and others. John Quinn assists with the Society's legal work. Stieglitz is an early member.

DECEMBER–JULY 1917 Robert Coady publishes *Soil*. Coady declares in an introductory article on American art that "It is not a refined granulation nor a delicate disease—it is not an ism. It is not an illustration to a theory, it is an expression of life—a complicated life—American life."

ALSO IN THIS YEAR De Zayas publishes *African Negro Art: Its Influence on Modern Art*.

1917

JANUARY John Quinn helps organize an exhibition of the vorticists at the Penguin Gallery.

25 JANUARY–OCTOBER 1924 With obvious reference to 291, Picabia publishes *391*. Like *Camera Work*, *391* is a combination of text and image, including dada drawings, poems, critical essays, and aphorisms, with contributions by Apollinaire, Louis Aragon, Arensberg, André Breton, Duchamp, Picabia, Ezra Pound, and others.

29 MARCH–9 APRIL Sheeler, Strand, and Morton Schamberg at the Modern Gallery.

6 APRIL After an appeal by President Wilson, Congress declares war on Germany and the United States officially enters World War I.

10 APRIL–6 MAY Exhibition of the Society of Independent Artists at the Grand Central Palace opens. Although the Society's rules stipulated a "no jury—no prizes" policy, Marcel Duchamp's ready-made *Fountain* was not displayed on the grounds that it was pre-fabricated and immoral. Duchamp, Arensberg, and Stieglitz lead a protest and resign from the Society. Total membership in the Society declines by nearly fifty percent from 1,235 members in 1917 to only 628 members in 1918. Stieglitz briefly exhibits *Fountain* at 291, where he also photographs it.

MAY In *The Blind Man*, no. 2, an anonymous article about *Fountain* is accompanied by Stieglitz's photograph of the banned sculpture and Charles Demuth's comments.

LATE MAY O'Keeffe visits New York. Stieglitz rehangs her show so that she may view it.

JUNE Final issue of *Camera Work*, featuring Paul Strand's photographs.

16 JUNE First issue of the Dutch periodical *De Stijl*.

1 JULY 291 is forced to close its doors due to declining attendance and mounting financial difficulties. Stieglitz rents a small room in the same building, where he continues to receive visitors. The room, however, is not spacious enough to store unsold back issues of *Camera Work*, which Stieglitz ultimately is forced to destroy.

JULY Steichen volunteers for the U.S. Army, and soon becomes a lieutenant in the Signal Corps Photographic Division.

The publication *Rongwrong* is published, edited by Duchamp. Picabia recognizes that *391* and *Rongwrong* cannot coexist as competing proto-dadaist publications. He suggests that a chess match between a representative of each journal should determine which magazine will continue its publication. Picabia wins the match, and *Rongwrong* ceases publication.

AUGUST O'Keeffe travels to Colorado and returns through New Mexico, visiting Santa Fe for the first time.

17 NOVEMBER Rodin dies. Steichen, on assignment for the U.S. Army, returns to France just days after his death and is able to attend the funeral.

1918

1 JANUARY Mabel Dodge signs a lease for the back rooms of the largest house in Taos.

FEBRUARY Gertrude Vanderbilt Whitney establishes the Whitney Studio Club, an outgrowth of her Friends of the Young Artists.

APRIL Modern Gallery closes.

JUNE Accompanied by Paul Strand, O'Keeffe moves back to New York from Texas. Soon after her arrival in New York, Stieglitz begins to photograph O'Keeffe. Stieglitz soon separates from his wife and moves in with O'Keeffe.

Hartley visits New Mexico, first staying in Taos, then Santa Fe.

AUGUST Stieglitz and O'Keeffe go to Lake George to visit Stieglitz's family. They will return to Lake George for regular summer visits until Stieglitz's death in 1946.

11 NOVEMBER German Armistice signed. World War I will formally end with the signing of the Treaty of Versailles on 28 June 1919.

16 NOVEMBER *The Dial* 65 publishes Hartley's article "Tribal Esthetics."

ALSO IN THIS YEAR "African Negro Wood Sculpture," a folio of photographs by Charles Sheeler, is published by the Modern Gallery with an introduction by de Zayas.

Kasimir Malevich paints his *White Square on White Suprematist Composition*.

1919

EARLY Steichen returns to the United States from his tour of duty in Europe. He is stationed in Washington, D.C., for most of the year, until he retires from the Army on 31 October.

MARCH Walter Gropius merges the Weimar Art Academy with the School of Arts and Crafts to form the Bauhaus.

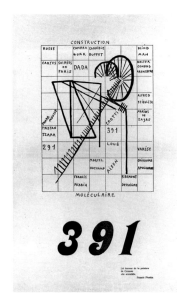

fig. 155 FRANCIS PICABIA
Construction Moléculaire,
published in 391 (February 1919)
Yale Collection of American Literature,
Beinecke Rare Book and Manuscript
Division

6–24 MARCH Stieglitz organizes an "Exhibition of Pictorial Photography, American and European," for the Young Women's Hebrew Association in New York.

APRIL–MAY Giorgio de Chirico publishes "On Metaphysical Art."

11 APRIL Edgar Varese's New Symphony Orchestra performs its first concert at Carnegie Hall.

FALL De Zayas Gallery opens at 549 Fifth Avenue. Charles Sheeler works as the assistant manager.

NOVEMBER Hartley moves back to New York and becomes active with New York dada and the Société Anonyme.

LATE Using money from two commissioned paintings, Steichen returns to France, where he immerses himself in post-war art.

ALSO IN THIS YEAR Sherwood Anderson's *Winesburg, Ohio* is published.

Weyhe Gallery opens.

1920

MARCH–10 APRIL Retrospective of Marin watercolors at the Daniel Gallery.

29 APRIL Société Anonyme founded by Katherine Dreier, Marcel Duchamp, and Man Ray. The society promotes a variety of progressive art styles. Although it focuses on modern

European artists, some Americans, including Hartley, Man Ray, Joseph Stella, and Walkowitz play an active role. In addition to numerous group exhibitions that will introduce U.S. audiences to such works as Kurt Schwitters' "Merz" collages, major solo exhibitions sponsored by the Société will include the first U.S. solo exhibitions of Alexander Archipenko (1921), Kandinsky (1923), Paul Klee (1924), and Fernand Léger (1925).

30 APRIL–15 JUNE Inaugural exhibition of the Société Anonyme opens in two rented rooms at 19 East Forty-Seventh Street. Included in this exhibition are Brancusi, Patrick Henry Bruce, James Henry Daugherty, Duchamp, Juan Gris, Picabia, Man Ray, Georges Ribemont-Dessaignes, Morton Schamberg, Joseph Stella, Van Gogh, Jacques Villon, and Heinrich Vogeler.

26 AUGUST The Nineteenth Amendment securing women's suffrage is ratified.

DECEMBER Vladimir Tatlin's model for a *Monument to the Third International* is exhibited in Moscow.

Stieglitz and O'Keeffe move to his brother's house on 30 East Sixty-Fifth Street, where they reside until 1924.

Contact, edited by William Carlos Williams and R. M. McAlmon, is issued.

ALSO IN THIS YEAR Piet Mondrian publishes his *De Stijl* essays as *Le Néo-plasticisme*.

1921

EARLY Dove leaves his wife and son and takes up residence on a houseboat on the Harlem River with Helen "Reds" Torr, whom he will marry in 1932.

JANUARY Dada manifesto published in *Little Review*.

APRIL The sole issue of Duchamp and Man Ray's *New York Dada* is published. Included in the issue were a poem by Marsden Hartley and a photograph of a woman's leg in a tight shoe by Stieglitz.

1 APRIL Société Anonyme meets to discuss "What is Dada?" Hartley, more a theorist of the movement than a practitioner, gives the keynote address.

30 APRIL De Zayas Gallery closes. The final exhibition is of Arthur B. Davies' paintings and watercolors.

3 MAY–5 SEPTEMBER "Loan Exhibition of Modern French Paintings" at the Metropolitan Museum of Art, including impressionist and post-impressionist paintings from private collections.

10–17 MAY Hartley exhibition at the Anderson Galleries. It concludes with an auction of his work, which raises $4913. Hartley uses this money to travel to Europe later that summer,

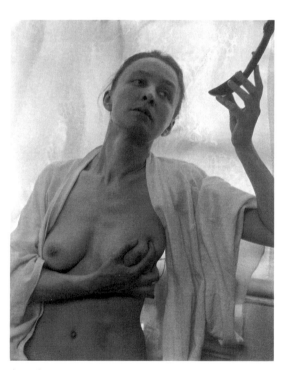

fig. 156 **ALFRED STIEGLITZ**
Georgia O'Keeffe *(holding pl. 45), 1919*
palladium print
Courtesy Vivian Horan Fine Art

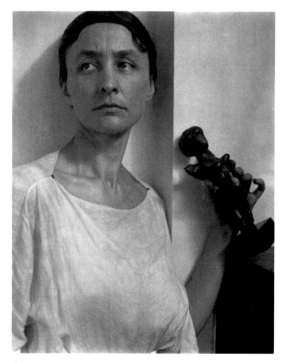

fig. 157 **ALFRED STIEGLITZ**
Georgia O'Keeffe: A Portrait—with Matisse Sculpture, *1921*
palladium print
National Gallery of Art, Washington, Alfred Stieglitz Collection

going first to Paris, and then settling in Berlin. Spends the majority of his time in Europe through early 1930.

JULY Paul Strand and Charles Sheeler's collaborative film *Manhatta* premieres at Broadway's Rialto Theater under the title *New York the Magnificent.*

AUGUST Demuth travels to Europe for the last time. While in Paris, he is hospitalized for diabetes, which eventually forces his return to the United States in November.

NOVEMBER *Broom* (1921–1924) begins publication under leadership of Harold Loeb and Alfred Kreymborg, and later Matthew Josephson and Malcolm Cowley.

LATE FALL Duncan Phillips opens his residence to the public as the Phillips Memorial Gallery.

ALSO IN THIS YEAR Sherwood Anderson publishes *Triumph of the Egg.* Anderson, who moves to New York in August 1922, will soon become friendly with Stieglitz.

A. E. Gallatin gives a Marin watercolor, "Landscape, Delaware County," to the Metropolitan Museum of Art. This is the artist's first representation within a museum's permanent collection.

Adventures in the Arts, a collection of Marsden Hartley's essays, including "The Importance of Being Dada," is published.

1922

JANUARY Strand marries Rebecca Salsbury. They will divorce in 1933.

18–23 FEBRUARY Stieglitz organizes an exhibition and auction of 177 paintings, watercolors, pastels, and drawings by American modernists at the Anderson Galleries. Total sales amount to more than $9500, with a Gaston Lachaise marble of a woman's head selling for $925. Marin's *Landscape, Maine* earned $400, and his *Tree Forms* $310; O'Keeffe's *Red Barn, Lake George* sold for $350. Many sell for far less.

fig. 158 GEORGIA O'KEEFFE
Design for cover of MSS
(December 1922)

FEBRUARY First issue of *Manuscripts (MSS)* published. Edited by Stieglitz, its contributors include Anderson, Kenneth Burke, Frank, Paul Rosenfeld, Herbert J. Seligmann, and Williams. O'Keeffe designs the cover.

FALL Stieglitz attends a soirée at the Stettheimer sisters' (Ettie, Florine, Carrie) Manhattan apartment salon for the unveiling of Florine's portrait of Carl Van Vechten.

NOVEMBER *Broom* 3, no. 4, includes Paul Strand's "Photography and the New God." Strand writes that "it is in the later work of Stieglitz, an American in America, that we find a highly-evolved crystalization of the photographic principle, the unqualified subjugation of a machine to the single purpose of expression."

21 NOVEMBER Hedwig Stieglitz dies.

DECEMBER *MSS* 4 is a special issue dedicated to the question "Can a Photograph Have the Significance of Art?" with statements by Anderson, Thomas Hart Benton, Bluemner, Charlie Chaplin, Demuth, de Zayas, Dove, Duchamp, Frank, Gaston Lachaise, Marin, O'Keeffe, Joseph Pennell, Carl Sandburg, Sheeler, Leo Stein, and others.

6 DECEMBER Barnes Foundation is chartered in Merion, Pennsylvania, outside of Philadelphia.

ALSO IN THIS YEAR Sinclair Lewis publishes *Babbitt.*

1923

EARLY Steichen moves back to New York from France. Soon after his arrival, he is offered and accepts a position as chief photographer for Condé Nast publications.

ALSO IN THIS YEAR Leon Trotsky publishes his *Literature and Revolution,* in which he offers his interpretation of the role of art in the Marxist Revolution.

Jean Toomer's collection of prose and poetry, *Cane,* is published. Toomer becomes friendly with Stieglitz and O'Keeffe at this time.

William Carlos Williams publishes *The Great American Novel.*

1924

EARLY Museum of Fine Arts, Boston, accepts twenty-seven Stieglitz photographs into their collection.

JANUARY The Royal Photographic Society of Great Britain confers upon Stieglitz its highest honor, the Progress Medal. The award is given for "services rendered in founding and fostering Pictorial Photography in America, and particularly for initiation and publication of '*Camera Work*,' the most artistic record of Photography ever attempted."

28 JULY John Quinn dies. His will directs the executors to sell all his art (except Seurat's *Le Cirque*, which was willed to the Louvre), thereby dispersing one of the great modernist art collections.

SEPTEMBER Stieglitz is divorced.

11 DECEMBER With Marin and George Engelhard serving as their witnesses, Stieglitz and O'Keeffe are married in Cliffside, New Jersey. They reside at 38 East Fifty-Eighth Street.

fig. 160 Anderson Galleries—Exterior, c. 1925
The New York Public Library, Manuscripts and Archives Division

fig. 161 **ALFRED STIEGLITZ**
Marcel Duchamp, *1923*
palladium print
National Gallery of Art, Washington,
Alfred Stieglitz Collection

ALSO IN THIS YEAR André Breton writes his *Manifesto of Surrealism.*

Sherwood Anderson's *A Story Teller's Story* is published. He dedicates the book to Stieglitz, "who has been more than father to so many puzzled, wistful children of the arts in this big, noisy, growing and groping America."

Paul Rosenfeld publishes *Port of New York: Essays on Fourteen Americans.* Included in the book are photographic portraits by Stieglitz, Strand, Alice Boughton, and Dana Desboro.

1925

FEBRUARY "The Blue Four" exhibition, featuring Lyonel Feininger, Alexej von Jawlensky, Kandinsky, and Paul Klee, is held at the Daniel Gallery.

fig. 159 Catalogue Cover for "Alfred Stieglitz Presents Seven Americans…," *1925*

MARCH Alain Locke edits a special issue of the *Survey Graphic Magazine*, entitled "Harlem: Mecca of the New Negro," symbolizing the significant cultural activities of the Harlem Renaissance.

MID-NOVEMBER Stieglitz and O'Keeffe move out of their East Fifty-Eighth Street apartment and into the Shelton Hotel at Lexington Avenue and Forty-Ninth Street, then the tallest hotel in the world.

7 DECEMBER Stieglitz opens The Intimate Gallery in Room 303 of the Anderson Galleries Building.

DECEMBER Dorothy Norman, a young volunteer for the American

Civil Liberties Union, visits The Intimate Gallery during Marin exhibition.

ALSO IN THIS YEAR F. Scott Fitzgerald publishes *The Great Gatsby.*

William Carlos Williams publishes *In the American Grain.*

1926

11 JANUARY–27 FEBRUARY Duncan Phillips visits Dove exhibition at The Intimate Gallery. Later in the year he will become Dove's patron, purchasing his first two of an eventual sixty-nine paintings.

SUMMER Strand travels to Colorado and New Mexico.

26 NOVEMBER Edith Gregor Halpert opens Our Gallery at 113 West Thirteenth Street, New York, dedicated to modern American art. It is renamed the Downtown Gallery in 1927.

19 NOVEMBER–1 JANUARY Katherine Dreier organizes the exhibition "An International Exhibition of Modern Art Assembled by the Société Anonyme" at the Brooklyn Museum. The exhibition features 106 European and American artists, representing a range of modern artistic movements, including Alexander Archipenko, Jean Arp, Brancusi, Braque, Duchamp, de Chirico, Naum Gabo, Gleizes, Juan Gris, Kandinsky, Paul Klee, El Lissitzky, Léger, Joan Miró, Moholy-Nagy, Mondrian, Gabriele Münter, Picabia, Picasso, Schwitters, and Severini. The American modernists were represented by eight Stieglitz photographs, and works by Demuth, Dove, Hartley, Marin, and O'Keeffe. Other Americans outside of Stieglitz's immediate circle included Dreier, Stuart Davis, Man Ray, Joseph Stella,

Walkowitz, and Weber. Stieglitz is invited to give one of the lectures associated with the show.

DECEMBER Duncan Phillips apparently purchases Marin's *Back of Bear Mountain* for the extraordinary sum of $6000 from his Intimate Gallery show. But Stieglitz also gives Mrs. Phillips the painting *Sunset Rockland County* and discounts two additional Marin watercolors, *Hudson River Near Bear Mountain* and *Near Great Barrington.* A public controversy ensues between Phillips and Stieglitz about the actual cost of the "$6000" Marin.

ALSO IN THIS YEAR Paul Guillaume and Thomas Munro publish *Primitive Negro Sculpture.*

1927

10 APRIL George Antheil's experimental *Ballet Mécanique* is performed at Carnegie Hall, where it is criticized for its atonality, lack of melody, and sheer cacophony.

16 MAY–28 MAY *Machine Age Exposition* organized by Jane Heap.

6 JUNE–1 SEPTEMBER Small O'Keeffe retrospective exhibition at the Brooklyn Museum.

6 OCTOBER *The Jazz Singer,* starring Al Jolson, premieres in New York, becoming the first feature-length "talkie" film.

12 DECEMBER A. E. Gallatin installs his collection of post-cubist art in a room at New York University, which he called Gallatin's Gallery of Living Art (renamed the Museum of Living Art in 1933).

1928

16 APRIL Stieglitz announces that he sold six O'Keeffe calla lily paintings for $25,000 to an anonymous collector, who was later revealed to be Mitchell Kennerley, principal owner of the Anderson Galleries. Basking in the spotlight, Stieglitz gushed "She is the Lindbergh of art.... Like Lindbergh, Miss O'Keefe [sic] typifies the alert American spirit of going after what you want and getting it!" Due, in part, to the onset of the Great Depression and related financial troubles, Kennerley is forced to return the still-unpaid-for paintings in 1931.

ALSO IN THIS YEAR Florine Stettheimer completes portrait of Stieglitz.

Metropolitan Museum of Art acquires, by gift, Stieglitz photographs.

1929

MAY The Anderson Galleries vacate 489 Park Avenue, necessitating the closure of The Intimate Gallery.

SUMMER O'Keeffe travels to Taos with Rebecca Strand and although she plans to meet Stieglitz in Lake George in July, she

fig. 162 **PAUL STRAND**
Alfred Stieglitz, *1929*
gelatin silver print
Collection Center for Creative Photography, The University of Arizona, Tucson

remains in New Mexico until the end of August. The two women stay with Mabel Dodge Luhan.

JUNE Upon the invitation of Luhan, Marin visits Taos for the first of two summers.

29 OCTOBER Stock market crashes.

8 NOVEMBER The Museum of Modern Art, founded by Lillie Bliss, Mary Sullivan, and Abby Aldrich Rockefeller, opens. Alfred H. Barr Jr. is chosen as the first director. The inaugural exhibition is of post-impressionism and the second is "Paintings by Nineteen Living Americans."

15 DECEMBER Stieglitz opens An American Place at 509 Madison Avenue, Room 1710. The Place remains open until December 1950, and during its existence it remains loyal to the exhibition of the Seven Americans—Demuth, Dove, Hartley, Marin, O'Keeffe, Stieglitz, and Strand, and especially the "Big Three"—Dove, Marin, and O'Keeffe.

1930

MID-JUNE–SEPTEMBER O'Keeffe travels to New Mexico and stays with Mabel Dodge Luhan in Taos.

SUMMER Strand travels to New Mexico and returns the following two summers.

OCTOBER Stieglitz asks Florine Stettheimer if she would be interested in exhibiting her paintings at An American Place, but she declines.

2 DECEMBER–20 JANUARY "Painting and Sculpture by Living Americans" at the Museum of Modern Art includes works borrowed from An American Place.

ALSO IN THIS YEAR Hart Crane publishes *The Bridge*, a book-length poem.

1931

MARCH Charlie Chaplin visits An American Place during an O'Keeffe exhibition. Stieglitz tells him of his idea for a movie depicting a woman's eyes.

APRIL–JULY O'Keeffe in New Mexico.

FALL Julien Levy opens a new modern gallery at 602 Madison Avenue, fourth floor, where he will exhibit photography and surrealist art. Levy's opening exhibition is billed as a "Retrospective of American Photography," with work by Annie Brigman, Gertrude Käsebier, Sheeler, Steichen, Stieglitz, Strand, and White. In lieu of original prints, Stieglitz authorized Levy to frame and hang photogravures from *Camera Work*.

NOVEMBER The Whitney Museum of American Art opens in New York. The museum was founded by Gertrude Vanderbilt Whitney after the Metropolitan Museum of Art had refused her offer to donate her collection of modern American art.

ALSO IN THIS YEAR *Letters of John Marin* is privately printed for An American Place. The volume, edited and with an introduction by Herbert J. Seligmann, consists mostly of letters to Stieglitz.

fig. 163 DOROTHY NORMAN
Paul and Rebecca Strand Exhibition at An American Place, *1932*
gelatin silver print
Collection Center for Creative Photography, The University of Arizona, Tucson

fig. 164 DOROTHY NORMAN
Alfred Stieglitz , *1930s*
gelatin silver print
Museum of Fine Arts, Boston, Gift of Francis W. Dolloff, 1991

1932

JANUARY "Surrealist Paintings, Drawings and Photographs" at Julien Levy Gallery introduces New York to the range of surrealist activities.

APRIL The Paul Strand exhibition at An American Place marks the end of his relationship with Stieglitz.

27 APRIL American modernist poet Hart Crane, who had struck up a friendship with Stieglitz a decade earlier, commits suicide by jumping overboard a steamship headed from Mexico to New York.

SPRING Hartley travels to Mexico for a year as a Guggenheim Fellow.

O'Keeffe is asked to design a mural for Radio City Music Hall, then under construction. Eager for the opportunity to decorate such a large space, she agrees to a contract paying her only $1500. When she finally sees the newly constructed room that fall, she is dismayed to find the canvas peeling off the wall and is unable to work. She demands to be released from her contract.

SUMMER O'Keeffe decides to spend the summer in Lake George with Stieglitz, rather than in New Mexico.

22 NOVEMBER–5 JANUARY Whitney Museum's First Biennial Exhibition of Contemporary American Paintings. The 157 works exhibited include paintings by Dove, O'Keeffe, Demuth, and Hartley.

1933

MARCH An American Place publishes Dorothy Norman's collected poems *Dualities*, coinciding with the end of her affair with Stieglitz.

APRIL Hartley leaves Mexico for Germany.

11 APRIL After having moved from Weimar to Dessau and then to Berlin, the Bauhaus—at odds with the Nazis political and aesthetic programs—is forced to close.

MAY While in New York, Matisse stops by An American Place, but Stieglitz is not at the gallery. Stieglitz expresses his disappointment in a 24 May, YCAL, letter to Dove: "Matisse was here while I was away. Dewey brought him. Tough luck—Fatality.—I dare not weep.—Walkowitz it seems played host!! Funny. But all right if there can be any right in such a situation. . . ."

SPRING Ansel Adams travels to New York and meets Stieglitz.

JULY Dove and Reds move back to the Dove family's property in Geneva, New York.

SUMMER Marin spends his first summer at Cape Split, Maine. He will buy a house on the bay the following year and spend his summers there.

Metropolitan Museum acquires by gift a large portion of Stieglitz's collection of work by other photographers.

1934

ALSO IN THIS YEAR Waldo Frank, Lewis Mumford, Dorothy Norman, Paul Rosenfeld, and Harold Rugg edit *America & Alfred Stieglitz: A Collective Portrait*, a book of essays with contributions from twenty-five artists and critics in celebration of Stieglitz's seventieth birthday.

11 FEBRUARY Diego Rivera's Rockefeller Center mural is destroyed after the artist refuses to adhere to Rockefeller's demand that he paint over the portrait of Lenin, which had not appeared in the approved preliminary sketch.

6 MARCH–30 APRIL "Machine Art" at the Museum of Modern Art.

SUMMER O'Keeffe returns to New Mexico after a three-year absence. She rents a small house at Ghost Ranch, near Abiquiu, and will return to New Mexico every summer except 1939. In 1940 she buys a small adobe house there.

1935

JANUARY Thomas Hart Benton, a leading practitioner of American Scene painting, attacks Stieglitz in a review entitled "American and/or Alfred Stieglitz," published in *Common Sense*. Benton criticizes Stieglitz and questions his American aesthetic, noting that it is not so much his art that is American, but rather it is within "the conception of himself as 'seer' and 'prophet' [that] lies Stieglitz' real tie to the ways of our country. America produces more of these than any land in the world. The place is full of cults led by individuals who have found the measure of all things within themselves."

18 MARCH–19 MAY "African Negro Art" at the Museum of Modern Art.

25 OCTOBER Demuth dies in Lancaster, Pennsylvania, from complications associated with diabetes.

ALSO IN THIS YEAR The Federal Farm Security Administration (FSA) is established. Roy Stryker enlists and organizes photographers to document the effects of the Great Depression throughout America. Among the FSA photographers are Walker Evans, Dorothea Lange, and Margaret Bourke-White.

Works Progress Administration's Federal Art Project (WPA/FAP) is established to assist artists who had been hard hit by the Depression. The program runs until 1943, employing more than five thousand artists and producing public artwork in more than one thousand American cities.

Cleveland Museum of Art acquires Stieglitz photographs by gift .

1936

2 MARCH–19 APRIL Landmark "Cubism and Abstract Art" exhibition at the Museum of Modern Art, New York, sets forth the canonical narrative of modern art developing progressively and inevitably toward abstraction. Included in the exhibition are many of the European artists that Stieglitz championed at 291, including Brancusi, Braque, Cézanne, Duchamp, Matisse, Picabia, Picasso, and Severini. Few Americans are exhibited.

OCTOBER Stieglitz and O'Keeffe move to a penthouse apartment at 405 East Fifty-Fourth Street.

21 OCTOBER–22 NOVEMBER Marin retrospective at the Museum of Modern Art. Notwithstanding his wariness of most arts institutions, Stieglitz selects and lends 160 watercolors, 21 oils, and 44 etchings to the museum, and supervises the hanging of the exhibition. More than twenty thousand people view the exhibition.

1937

17 MARCH–18 APRIL Museum of Modern Art mounts an exhibition "Photography 1839–1937" organized by Beaumont Newhall documenting the history of photography. The exhibition was accompanied by the catalogue *Photography: A Short Critical History*. Newhall had asked Stieglitz to chair his advisory council, but Stieglitz declined and refused to lend any of his own prints.

20 APRIL–17 MAY Hartley exhibition at An American Place marks the final collaboration between the artist and Stieglitz. After this exhibition, the Hudson Walker Gallery, and later Paul Rosenberg, will represent Hartley. Hartley will divide his time between New York and Maine.

JULY The "Degenerate 'Art' " exhibition, organized by the National Socialists, opens in Munich. On view are paintings and

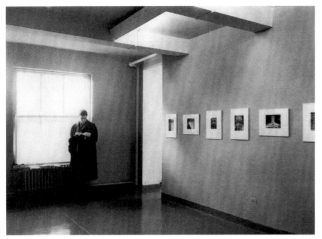

fig. 165 ALFRED STIEGLITZ (?)
Ansel Adams Exhibition at An American Place, 1936
Yale Collection of American Literature, Beinecke Rare Book and
Manuscript Library

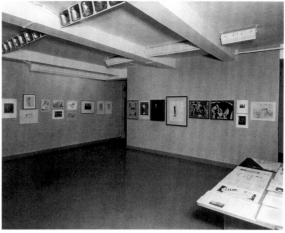

fig. 166 ALFRED STIEGLITZ (?)
"Beginnings and Landmarks" Exhibition at An American
Place, 1937
Yale Collection of American Literature, Beinecke Rare Book and
Manuscript Library

sculpture of more than one hundred modern artists, whose work is condemned on political, racial, and aesthetic grounds.

27 OCTOBER–27 DECEMBER The "Beginnings and Land-marks–291–1905–1917" exhibition at An American Place marks the twentieth anniversary of the closing of 291.

1938

APRIL Stieglitz's health continues to decline after suffering a heart attack that is followed by pneumonia.

MAY Dove and Reds move to Long Island.

MAY–JULY "Trois Siècles d'Art aux États-Unis," organized by the Museum of Modern Art in New York and including several Stieglitz artists, is at the Jeu du Paume, Paris.

SUMMER Writing from Lake George to his former secretary and family friend, Marie Rapp Boursault, Stieglitz remarks that he is "for the first time in 55 years without a camera."

FALL–WINTER 1948 Dorothy Norman publishes *Twice a Year.*

1939

LATE JANUARY–APRIL O'Keeffe travels to Hawaii as part of a commission to produce pineapple paintings for the Dole Company.

LATE MAY Museum of Non-Objective Painting opens in New York. In 1949, after the founder's death, the museum changes its name to the Solomon R. Guggenheim Museum.

AUGUST–SEPTEMBER O'Keeffe chooses to spend the summer at Lake George with Stieglitz, rather than travel to New Mexico.

1 SEPTEMBER Nazi troops invade Poland. Two days later, Britain and France declare war on Germany and World War II officially begins.

FALL Clement Greenberg publishes his polemic essay "Avant-Garde and Kitsch" in *Partisan Review.* The essay outlines the frame-work for Greenberg's formalist theories of modernist aesthetics.

ALSO IN THIS YEAR James Agee and Walker Evans publish *Let Us Now Praise Famous Men,* documenting the lives of Alabama tenant farmers.

1940

LATE Museum of Modern Art establishes a department of photography, the first such department in any art museum.

1941

JUNE Steichen writes an article for *Vogue* entitled "The Fight-ing Photo-Secession," in which he notes that contemporary photography must recognize that its heritage stems "from this Photo-Secession movement [that] stands out in bold relief, as a great tree against the sky, and the trunk of that tree is Alfred Stieglitz."

11 OCTOBER Yale University accepts the collection of the Société Anonyme, which includes 135 oils, 7 sculptures, 186 drawings, and 180 prints and photographs by 141 artists.

fig. 167 DOROTHY NORMAN
Alfred Stieglitz and Edward Steichen, 1946
gelatin silver print
Collection Center for Creative Photography, The University of Arizona,
Tucson

7 DECEMBER Japan attacks Pearl Harbor and the United States enters World War II.

ALSO IN THIS YEAR Museum of Modern Art acquires Stieglitz photographs.

1942

OCTOBER Concerned about Stieglitz's ability to travel the distance from their apartment to An American Place, O'Keeffe and Stieglitz move into a brownstone a block from the gallery at 59 East Fifty-Fourth Street.

20 OCTOBER Peggy Guggenheim opens her Art of This Century gallery in New York. The gallery remains open until 1947.

1943

21 JANUARY–22 FEBRUARY O'Keeffe retrospective exhibition of sixty-one paintings at the Art Institute of Chicago, the museum's first retrospective of a female artist. Stieglitz set the terms, insisting that the museum agree to purchase a painting from the exhibition. (The museum agreed, purchasing *Black Cross*, 1929.)

1 AUGUST–30 SEPTEMBER Retrospective Marin exhibition at the Phillips Memorial Gallery, Washington, D.C.

2 SEPTEMBER
Hartley dies in Ellsworth, Maine.

1944

1 JULY–1 NOVEMBER "History of an American: Alfred Stieglitz, 291 and After" at the Philadelphia Museum of Art. The exhibition, organized by Henry Clifford and Carl Zigrosser, presents thirty-five carbon, gelatin silver, and platinum prints, and photogravures of Stieglitz's work, as well as nearly three hundred paintings, photographs, and drawings from Stieglitz's collection.

1945

25 APRIL–10 JUNE Paul Strand solo exhibition at the Museum of Modern Art, New York.

6 AUGUST United States drops atomic bomb over Hiroshima. Three days later, another is dropped over Nagasaki. Japan unconditionally surrenders to the Allied Powers on 2 September.

DECEMBER O'Keeffe purchases abandoned house on three acres of land in Abiquiu.

1946

9 APRIL–19 MAY "Pioneers of Modern Art in America"—Demuth, Dove, Hartley, Marin, and O'Keeffe—is at the Whitney Museum of American Art. The catalogue praises Stieglitz's role in nurturing American art, noting that "Stieglitz was not one of those artistic snobs, too common a few years later, who saw no virtue outside of Paris. He believed passionately in the future of American art and specifically in certain younger men."

14 MAY–25 AUGUST O'Keeffe retrospective at the Museum of Modern Art, the museum's first major exhibition of a female artist.

SPRING Marin suffers a heart attack.

13 JULY Stieglitz dies at Doctor's Hospital in New York, several days after having suffered a major stroke. Stieglitz's ashes are buried at an undisclosed location in Lake George.

21 JULY Paul Rosenfeld dies.

22 NOVEMBER Dove dies in Huntington, Long Island.

fig. 168 DOROTHY NORMAN
Walls: An American Place, New York, *1940s*
gelatin silver print
Philadelphia Museum of Art: From the Collection
of Dorothy Norman

fig. 169 EDWARD STEICHEN
Alfred Stieglitz, 1907
Autochrome
The Metropolitan Museum of Art, Alfred Stieglitz Collection, 1955

BIBLIOGRAPHY

I. Stieglitz and His Circle

A. ARCHIVES

Ansel Adams Archive, Center for Creative Photography, University of Arizona, Tucson.

Sherwood Anderson Papers, Newberry Library, Chicago.

Oscar Bluemner Papers, Archives of American Art, Smithsonian Institution, Washington, D.C.

Arthur Dove Papers, Archives of American Art, Smithsonian Institution, Washington, D.C.

Waldo Frank Papers, Van Pelt Library, University of Pennsylvania, Philadelphia.

Marsden Hartley Papers, Archives of American Art, Smithsonian Institution, Washington, D.C.

Sadakichi Hartmann Papers, University of California at Riverside Library, Riverside, Calif.

Paul Haviland Archive, Musée d'Orsay, Paris.

T. Dudley Johnston Papers, Royal Photographic Society, Bath, England.

Mitchell Kennerley Papers, Manuscript Division, New York Public Library, New York.

Mabel Dodge Luhan Archive, Collection of American Literature, Beinecke Rare Book and Manuscript Library, Yale University, New Haven.

Henry McBride Papers, Archives of American Art, Smithsonian Institution, Washington, D.C.

Elizabeth McCausland Papers, Archives of American Art, Smithsonian Institution, Washington, D.C.

Agnes Meyer Papers, Manuscript Division, Library of Congress, Washington, D.C.

Dorothy Norman Papers, Center for Creative Photography, University of Arizona, Tucson.

Edward Steichen Archive, Museum of Modern Art, New York.

Gertrude Stein Archive, Collection of American Literature, Beinecke Rare Book and Manuscript Library, Yale University, New Haven.

Alfred Stieglitz/Georgia O'Keeffe Archive, Yale Collection of American Literature, Beinecke Rare Book and Manuscript Library, New Haven.

Paul Strand Collection, Center for Creative Photography, University of Arizona, Tucson.

Abraham Walkowitz Papers, Archives of American Art, Smithsonian Institution, Washington, D.C.

Max Weber Papers, Archives of American Art, Smithsonian Institution, Washington, D.C.

Marius de Zayas Papers, Seville.

B. PERIODICALS

The Blind Man. April–May 1917, ed. Marcel Duchamp. Two issues.

Broom. November 1921–January 1924, ed. Harold Loeb and Alfred Kreymborg; subsequent editors included Slater Brown, Malcolm Cowley, and Matthew Josephson. Twenty-one issues.

Camera Notes. Published by The Camera Club of New York, 1897–1903, ed. Alfred Stieglitz (1897–1902), Juan C. Abel (1903). Twenty-four issues.

Camera Work. January 1903–June 1917, ed. and published by Alfred Stieglitz. Fifty issues, plus two special supplements.

Contact. December 1920–June 1923, ed. W.C. Williams and R.M. McAlmon. Five issues.

The Dial. 1880–1929, ed. Scofield Thayer (1920–1925). Eighty-six volumes.

The Little Review. March 1914–May 1929, ed. Margaret Anderson and Jane Heap. Twelve volumes.

MSS [Manuscripts]. February 1922–May 1923, ed. Paul Rosenfeld. Six issues.

New York Dada. April 1921, ed. Marcel Duchamp. One issue.

Rongwrong. 1917, ed. Marcel Duchamp. One issue.

The Seven Arts. November 1916–October 1917. Twelve issues (then merged with *Dial*).

The Soil. December 1916–July 1917, ed. R.J. Coady. Five issues.

Soirées de Paris. February 1912–August 1914, ed. Guillaume Apollinaire, et al. Twenty-seven issues (some jointly published).

391. January 1917–October 1924, ed. Francis Picabia. Nineteen issues.

Twice A Year. Fall–winter 1938–fall–winter 1948, ed. Dorothy Norman. Seventeen issues (some jointly published).

291. Published by 291 gallery, March 1915–February 1916, ed. Marius de Zayas, Paul Haviland, and Agnes Ernst Meyer. Twelve issues.

C. BOOKS, ARTICLES, EXHIBITION CATALOGUES, AND DISSERTATIONS, 1903–PRESENT

Abrahams, Edward. "Alfred Stieglitz and the Metropolitan Museum of Art." *Arts Magazine* 53 (June 1979), 86–88.

———. "Alfred Stieglitz and/or Thomas Hart Benton." *Arts Magazine* 55 (June 1981), 108–113.

———. *The Lyrical Left: Randolph Bourne, Alfred Stieglitz, and the Origins of Cultural Radicalism in America.* Charlottesville, 1986.

Aisen, Maurice. "The Latest Evolution in Art and Picabia." *Camera Work*, special number (June 1913), 14–21.

"Alfred Stieglitz, Artist and His Search for the Human Soul." *New York Herald*, 8 March 1905, 5.

Alfred Stieglitz Presents One Hundred Pictures, Oils, Water-Colors, Pastels, Drawings, by Georgia O'Keeffe, American. New York, 1923.

Alfred Stieglitz Presents Seven Americans. New York, 1925.

"Alfred Stieglitz Prints." *Christian Science Monitor*, 22 December 1934, 10.

Alfred Stieglitz: The Aperture History of Photography Series. Millerton, N.Y., 1976.

Allan, Sidney, [Sadakichi Hartmann]. "A Visit to Steichen's Studio." *Camera Work* 2 (April 1903), 25–28.

——. "The Value of the Apparently Meaningless and Inaccurate." *Camera Work* 3 (July 1903), 17–21.

——. "Roaming in Thought (After Reading Maeterlinck's Letter)." *Camera Work* 4 (October 1903), 21–23.

——. "The 'Flat-Iron' Building—An Esthetical Dissertation." *Camera Work* 4 (October 1903), 36–39.

——. "The Technique of Mystery and Blurred Effects." *Camera Work* 7 (July 1904), 24–26.

Anderson, Dennis. "The Vassar Connection: Paul Rosenfeld, Edna Bryner Schwab '07, and Alfred Stieglitz." *Vassar Quarterly* (spring 1988), 26–31.

Anderson, Sherwood. *Mid American Chants.* New York, 1918.

——. *Winesburg, Ohio.* New York, 1919.

——. *Poor White.* New York, 1920.

——. *The Triumph of the Egg.* New York, 1921.

——. "Alfred Stieglitz." *New Republic* (25 October 1922).

——. *Horses and Men.* New York, 1923.

——. *A Story Teller's Story.* New York, 1924.

——. *Sherwood Anderson's Notebook.* New York, 1926.

——. *Sherwood Anderson's Memoirs.* New York, 1942.

——. *The Letters of Sherwood Anderson.* Ed. Howard Mumford Jones and Walter B. Rideout. Boston, 1953.

Annan, J. Craig. "Photography as a Means of Artistic Expression." *Camera Work* 32 (October 1910), 21–23.

Apollinaire, Guillaume. "Voyage." *291* 1 (March 1915), n.p.

Arens, Egmont. "Alfred Stieglitz: His Cloud Pictures." 9 *Playboy: A Portfolio of Art and Satire* (July 1924), 15.

Arensberg, Walter. "Dada est Americain." *Littérature* (May 1920), 15–16.

Arrowsmith, Alexandra and Thomas West, eds. *Two Lives: Georgia O'Keeffe and Alfred Stieglitz, A Conversation in Paintings and Photographs.* New York and Washington, 1992.

"Art at Home and Abroad." *New York Times*, 23 February 1913, magazine section, 15.

"Art Photographs and Cubist Painting." *The Sun*, 3 March 1913, 7.

"Attractions in Other Galleries." *New York Sun*, 20 February 1932, 8.

Baigell, Matthew. "American Landscape Painting and National Identity: The Stieglitz Circle and Emerson." *Art Criticism* 4, 1 (1987), 27–47.

Barnes, Albert. "Cubism: Requiescat in Pace." *Arts and Decoration* (January 1916), 121–124.

Barnes, Djuna. "Giving Advice on Life and Pictures...." *Morning Telegraph*, 25 February 1917.

Bell, Clive. *Art.* New York, [1913].

Bender, Thomas. *New York Intellect: A History of Intellectual Life in New York City, from 1750 to the Beginning of Our Own Time.* Baltimore, 1997.

Benson, M. "Alfred Stieglitz, The Man and the Book." *American Magazine of Art* 28 (January 1936), 36–42.

Benton, Thomas Hart. "America and/or Alfred Stieglitz." *Common Sense* 4 (January 1935), 22–24.

Bergson, Henri. "An Extract from Bergson." *Camera Work* 36 (October 1911), 20–21.

——. *Creative Evolution.* Trans. Arthur Mitchell. Reprint of 1911 edition. New York, 1944.

——. "What is the Object of Art." *Camera Work* 37 (January 1912), 22–26.

Besson, George. "Pictorial Photography—A Series of Interviews." *Camera Work* 24 (October 1908), 13–23.

Beyond a Portrait: Photographs, Dorothy Norman, Alfred Stieglitz. New York, 1984.

Birss, Ernst. " 'New York, at First, Did Not See...': Modern Art, the Public, and the Stieglitz Circle, 1913–1916." M.A. thesis, University of Alberta, 1995.

The Blind Man 2 (May 1917), on Duchamp's *Fountain* and the Richard Mutt case.

Bluemner, Oscar. "Audiator et Altera Pars: Some Plain Sense on the Modern Art Movement." *Camera Work*, special number (June 1913), 25–38.

Boughton, Alice. "Photograph, A Medium of Expression." *Camera Work* 26 (April 1909), 33–36.

Bourne, Randolph. "The War and the Intellectuals." *The Seven Arts* 2 (June 1917), 133–146.

Bragdon, Claude. *Man the Square: A Higher Space Parable.* Rochester, N.Y., 1912.

Brennan, Marcia. "Abstract Passion: Images of Embodiment and Abstraction in the Art and Criticism of the Alfred Stieglitz Circle." Ph.D. diss., Brown University, 1997.

——. "Alfred Stieglitz and New York Dada: Faith, Love and the Broken Camera." *History of Photography* 21, 2 (summer 1997), 156–161.

——. "Alfred Stieglitz and Paul Rosenfeld: An Aesthetics of Intimacy." *History of Photography* 23, 1 (spring 1999), 73–81.

——. "Corporeal Disenchantment or Aesthetic Allure? Henri Matisse's Early Critical Reception in New York." *Analecta Husserliana* 65 (2000), 235–250.

Breuning, Margaret. "The Art of Stieglitz." *New York Evening Post*, 7 April 1923, 13.

——. "Modern Photography Raises Question to Baffle Artists." *New York Evening Post*, 8 March 1924, 15.

———. "The Photographs of Alfred Stieglitz on View." *New York Post,* 29 December 1934, 24.

Brooks, Van Wyck. *America's Coming-of-Age.* New York, 1915.

———. "Young America." *The Seven Arts* 1 (December 1916), 144–151.

———. "Our Awakeners." *The Seven Arts* 2 (June 1917), 235–248.

———. "On Creating a Usable Past." *The Dial* 64 (11 April 1918), 337–341.

———. *Letters and Leadership.* New York, 1918.

———. *The Ordeal of Mark Twain.* New York, 1920.

———. *Three Essays on America.* New York, 1934.

———. *Days of the Phoenix: The Nineteen-Twenties Remember.* New York, 1957.

Brooks, Van Wyck, Alfred Kreymborg, Lewis Mumford, and Paul Rosenfeld, eds. *The American Caravan.* New York, 1927.

Bruno, Guido. "The Passing of '291.'" *Pearson's Magazine* (March 1918), 402–403.

Bry, Doris. *An Exhibition of Photographs by Alfred Stieglitz.* Washington, 1958.

———. "The Stieglitz Archive at Yale University." *Yale University Library Gazette* (April 1951).

———. *Alfred Stieglitz: Photographer.* Boston, 1965, 1996.

———. *Alfred Stieglitz and An American Place, 1929–1946.* New York, 1978.

Buffet, Gabrielle. "Modern Art and The Public." *Camera Work,* special number (June 1913), 10–14.

Bunnell, Peter C. "Alfred Stieglitz and 'Camera Work.'" *Camera* 48, 12 (December 1969), 8.

———. *A Photographic Vision: Pictorial Photography, 1889–1923.* Salt Lake City, 1980.

———. *Alfred Stieglitz: Photographs from the Collection of Georgia O'Keeffe.* New York and Santa Fe, 1993.

Burgess, Gelett. "Essays in Subjective Symbolism." *Camera Work* 37 (January 1912), 46.

Butterfield, Bruce Augustus. "Paul Rosenfeld: The Critic as Autobiographer." Ph.D. diss., University of Illinois at Urbana-Champaign, 1975.

Caffin, Charles. *Photography as a Fine Art: The Achievements and Possibilities of Photographic Art in America.* Reprint of 1901 edition. New York, 1971.

———. "Of Verities and Illusions." *Camera Work* 12 (October 1905), 25–29.

———. "Of Verities and Illusions—Part II." *Camera Work* 13 (January 1906), 41–45.

———. "Progress in Photography, with Special Reference to the Art of Eduard J. Steichen." *The Century Magazine* 64 (February 1908), 483–498.

———. "The Camera Point of View in Painting and Photography." *Camera Work* 24 (October 1908), 23–26.

———. "Henri Matisse and Isadora Duncan." *Camera Work* 25 (January 1909), 17–20.

———. "The Art 'Puffer.'" *Camera Work* 28 (October 1909), 31–32.

———. "The Art of Eduard J. Steichen." *Camera Work* 30 (April 1910), 33–36.

———. "The New Thought Which is Old." *Camera Work* 31 (July 1910), 21–24.

———. "A Fable of the Future." *Camera Work* 32 (October 1910), 20.

———. "The Exhibition at Buffalo." *Camera Work* 33 (January 1911), 21–23.

———. "A Note on Paul Cézanne." *Camera Work* 34–35 (April–July 1911), 47–51.

———. *The Story of French Painting.* New York, 1911.

———. *Art for Life's Sake: An Application of the Principles of Art to the Ideals and Conduct of Individual and Collective Life.* New York, 1913.

———. "International Exhibition is Creating a Sensation." *New York American,* 24 February 1913, 8.

———. "Picabia's Work Represents Further Abstraction in Art." *New York American,* 24 March 1913, 8.

———. "Forum Exhibition of Modern American Painting." *New York American,* 20 March 1916, 7.

———. [Review of Paul Strand exhibition at 291]. *Camera Work* 48 (October 1916), 57–58.

Caliban [Sadakichi Hartmann]. "Gessler's Hat." *The Camera* (November 1904), 431–434.

"Camera Club Ousts Alfred Stieglitz." *New York Times,* 14 February 1908, 1.

Camera Work, "What is 291?" special issue, 47 (dated July 1914, published January 1915).

Campbell, Susan. *Women of the Stieglitz Circle.* Santa Fe, 1998.

"Can a Photograph Have the Significance of Art?" *MSS* 4 (December 1922), 1–20.

Carter, Huntley. "Two-Ninety-One." *The Egoist* 3 (March 1916), 3.

de Casseres, Benjamin. "Caricature and New York." *Camera Work* 26 (April 1909), 17–18.

———. "American Indifference." *Camera Work* 27 (July 1909), 24–25.

———. "Pamela Colman Smith." *Camera Work* 27 (July 1909), 18–20.

———. "The Physiognomy of The New Yorker." *Camera Work* 29 (January 1910), 35.

———. "The Brain and the World (Dedicated to E.J. Steichen)." *Camera Work* 31 (July 1910), 27–28.

———. "Art: Life's Prismatic Glass." *Camera Work* 32 (October 1910), 33–34.

———. "Decadence and Mediocrity." *Camera Work* 32 (October 1910), 39.

———. "Rodin and The Eternality of The Pagan Soul." *Camera Work* 34–35 (April–July 1911), 13–14.

———. "The Unconscious in Art." *Camera Work* 36 (October 1911), 17.

———. "Modernity and The Decadence." *Camera Work* 37 (January 1912), 17–19.

——. "The Ironical in Art." *Camera Work* 38 (April 1912), 17–19.

——. "The Mocker." *Camera Work* 39 (July 1912), 35–36.

——. "The Renaissance of the Irrational." *Camera Work*, special number (June 1913), 22–24.

——. "Insincerity: A New Vice." *Camera Work* 42–43 (dated April–July 1913, published November 1913), 15–17.

Catalogue of the Alfred Stieglitz Collection for Fisk University, the Carl Van Vechten Gallery of Fine Arts. Nashville, 1949.

Catalogue of International Exhibition of Modern Art. New York, 1913.

Catalogue of the International Exhibition of Pictorial Photography. Organized by Alfred Stieglitz and the Photo-Secession. Buffalo, 1910.

Catalogue of a Loan Exhibition of Modern Art Assembled by Alfred Stieglitz. Freehold, N.J., 1922.

Chamberlin. "Great Photographs." *Evening Mail*, 27 February 1913, 6.

Cheney, Sheldon. *A Primer of Modern Art.* New York, 1924.

Clifford, Henry and Carl Zigrosser. *History of an American, Alfred Stieglitz: "291" and After.* Philadelphia, 1944.

Coady, R.J. [Letter]. *The Sun*, 19 March 1916, section 6, 8.

——. "American Art." *The Soil* 1 (December 1916), 3–4.

——. "American Art." *The Soil* 1 (January 1917), 54–56.

Coates, Robert M. "Alfred Stieglitz." *New Yorker* 23 (21 June 1947), 43–45.

Coburn, Alvin Langdon. "The Buffalo Show." *Camera Work* 33 (January 1911), 63–65.

——. "The Future of Pictorial Photography." *Photographic Journal of America* 54 (April 1917), 153–154.

Connor, Celeste. *Democratic Visions: Art and Theory of the Stieglitz Circle.* Berkeley, 2000.

Coomaraswamy, Ananda. "A Gift from Mr. Alfred Stieglitz." *Museum of Fine Arts Bulletin* [Boston] (April 1924).

Corn, Wanda M. "Apostles of the New American Art: Waldo Frank and Paul Rosenfeld." *Arts Magazine* 54, 6 (February 1980), 159–163.

——. *The Great American Thing: Modern Art and National Identity, 1915–1935.* Berkeley, 1999.

Cornell, Daniel. *Alfred Stieglitz and the Equivalent: Reinventing the Nature of Photography.* New Haven, 1999.

Cox, Kenyon. *The Classic Point of View.* New York, 1911.

Crane, Hart. *The Bridge.* New York, 1930.

——. *The Letters of Hart Crane, 1916–1932.* Ed. Brom Weber. Berkeley, 1965.

Craven, Thomas. "Stieglitz, Old Master of the Camera." *Saturday Evening Post* 216 (8 January 1944), 14–15.

Croly, Herbert. *The Promise of American Life.* Cambridge, Mass., 1909, 1965.

"Cubists and Futurists Are Making Insanity." *New York Times*, 16 March 1913, magazine section, 1.

"Current News of Art and the Exhibitions." *The Sun*, 20 February 1916, section 6, 8.

"Current News of Art and the Exhibitions." *The Sun*, 12 March 1916, section 6, 8.

Daniel, Malcolm. "Photography at the Metropolitan: William M. Ivins and A. Hyatt Mayor." *History of Photography* 21, 2 (summer 1997), 110–116.

Davidson, M. "Beginnings and Landmarks of a Pioneer Gallery: 291 and An American Place." *Art News* 36, 27 (1937), 13.

Demuth, Charles. "Confessions: Replies to a Questionnaire." *Little Review* 12 (May 1929), 30–31.

——. "Across a Greco is Written." *Creative Art* 5 (September 1929), 629–634.

Dessaignes, Robemont. "Musique." *291* 10–11 (December 15–January 1916), n.p.

Dijkstra, Bram. *Cubism, Stieglitz, and the Early Poetry of William Carlos Williams: The Hieroglyphics of a New Speech.* Princeton, 1969.

Dodge, Mabel. "Speculations." *Camera Work*, special number (June 1913), 6–9.

——. "On Marsden Hartley." *Camera Work* 45 (dated January 1914, published June 1914), 16.

Doty, Robert. *Photo-Secession: Photography as a Fine Art.* Rochester, 1960.

Dow, Arthur W. *Composition.* Boston, 1899.

——. "Modernism in Art." *Magazine of Art* 8 (January 1917), 113–116.

——. "The Indeps." *The Soil* 1 (July 1917), 202–205.

Dreier, Katherine. *Modern Art.* New York, 1926.

Eddy, Arthur Jerome. *Cubists and Post-Impressionism.* Chicago, 1914.

Engelhard, Georgia. "Alfred Stieglitz, Master Photographer." *American Photography* 39 (April 1945), 8–12.

——. "Master Photographer." *American Photography* 39 (April 1945), 8–12.

——. "The Face of Alfred Stieglitz." *Popular Photography* (September 1946), 52–55, 120–126.

——. "Grand Old Man." *American Photography* 44 (May 1950), 18–19.

Ernst, Agnes. "New School of the Camera." *New York Sun*, 26 April 1908.

"Exhibitions at '291.' " *Camera Work* 45 (dated January 1914, published June 1914), 16–26, 37–43.

"Exhibitions at '291'—Season 1916–1917." *Camera Work* 49–50 (June 1917), 33–36.

Exhibition on Modern Art Arranged by Alfred Stieglitz. New York, 1919.

Exhibition of Photographs by Alfred Stieglitz. Washington, 1958.

The Eye of Stieglitz. New York, 1978.

Fahlman, Betsy. "Arnold Rönnebeck and Alfred Stieglitz: Remembering the Hill." *History of Photography* 20, 4 (winter 1996), 304–311.

Field, Hamilton Easter. "At the Anderson Galleries." *Brooklyn Daily Eagle*, 13 February 1921, section 2, 5.

"The Fifth-Month Poet." *The Seven Arts* 2 (May 1917), 117.

Fisher, William Murrell. "The Georgia O'Keeffe Drawings and Paintings at '291.'" *Camera Work* 49–50 (June 1917), 5.

Flint, R. "Alfred Stieglitz." *Art News* 30 (20 February 1932), 9.

———. "What is 291? Alfred Stieglitz and Modern Art in the United States." *Christian Science Monitor Weekly Magazine*, 17 November 1937.

Forum Exhibition of Modern American Painters. New York, 1916.

Frank, Waldo. "Vicarious Fiction." *The Seven Arts* 1 (January 1917), 294–303.

———. *Our America*. New York, 1919.

———. *Salvos*. New York, 1924.

———. "The Poetry of Hart Crane." *New Republic* 50 (16 March 1927), 116–117.

———. "Alfred Stieglitz—The World's Greatest Photographer." *McCall's Magazine* 54 (May 1927), 24, 107–108.

———. *The Re-discovery of America*. New York and London, 1929.

———. *Memoirs of Waldo Frank*. Ed. Alan Trachtenberg. Amherst, Mass., 1973.

Frank, Waldo, et al. *America and Alfred Stieglitz: A Collective Portrait*. New York, 1934, 1975.

Freed, Clarence. "Alfred Stieglitz: Genius of the Camera." *The American Hebrew*, 18 January 1924.

"French Artists Spur on an American Art." *New York Tribune*, 24 October 1915, part 4, 2–3.

Fry, Roger. "The Grafton Gallery." *The Nation* 8 (19 November 1910), 331–332.

———. "A Postscript on Post-Impressionism." *The Nation* 8 (24 December 1910), 536–537.

———. "Preface to the Second Exhibition of Post-Impressionist Art, Grafton Galleries" [1912]. Reprinted in Roger Fry, *Vision and Design*. Middlesex, England, 1920, 1940.

Fulton, Deogh. "Cabbages and Kings." *International Studio* 81 (May 1925), 144–147.

Gallup, Donald. "The Weaving of a Pattern: Marsden Hartley and Gertrude Stein." *Magazine of Art* 41, 7 (November 1948), 256–261.

Garfield, George and Frances O'Brien. "Stieglitz, Apostle of American Culture." *Reflex Magazine* 3 (September 1928), 24–29.

Gee, Helen. *Stieglitz and the Photo-Secession*. Trenton, 1975.

Georgia O'Keeffe: A Portrait by Alfred Stieglitz. New York, 1978.

Gleizes, Albert and Jean Metzinger. *Cubism*. 1st English ed. London, 1913.

van Gogh, Vincent. "From Van Gogh's Letters." *Camera Work* 40 (October 1912), 37–41.

Goodrich, Lloyd. *Pioneers of Modern Art in America, The Decade of the Armory Show, 1910–1920*. New York, 1963.

Gray, Andrea. *Ansel Adams: An American Place*. Tucson, 1982.

Green, Jonathan, ed. *Camera Work: A Critical Anthology*. New York, 1973.

Greenough, Sarah. "From the American Earth: Alfred Stieglitz's Photographs of Apples." *Art Journal* 41, 1 (spring 1981), 46–54.

———. "Alfred Stieglitz's Photographs of Clouds." Ph.D. diss., University of New Mexico, 1984.

———. "How Stieglitz Came to Photograph Clouds." In *Perspectives on Photography: Essays in Honor of Beaumont Newhall*, 151–165. Ed. Peter Walch and Thomas Barrow. Albuquerque, 1986.

Greenough, Sarah and Juan Hamilton. *Alfred Stieglitz: Photographs and Writings*. Washington, 1983, 1999.

Gregory, Horace. "Alfred Stieglitz, Pioneer in American Art." *New York Herald Tribune Books*, 16 December 1934, section 7, 1–2.

Guillaume, Paul and Thomas Munro. *Primitive Negro Sculpture*. New York, 1926.

Guimond, James. *The Art of William Carlos Williams: A Discovery and Possession of America*. Urbana, 1968.

H., S. [Sadakichi Hartmann]. "To the 'Flat-Iron.'" *Camera Work* 4 (October 1903), 40.

———. "That Toulouse-Lautrec Print!" *Camera Work* 29 (January 1910), 36–38.

———. "De Zayas." *Camera Work* 31 (July 1910), 31–33.

———. "Puritanism, Its Grandeur and Shame." *Camera Work* 32 (October 1910), 17–19.

———. "Rodin's Balzac." *Camera Work* 34–35 (April–July 1911), 19–21.

Haines, Robert E. "Image and Idea: The Literary Relationships of Alfred Stieglitz." Ph.D. diss., Stanford University, 1967.

———. "Alfred Stieglitz and the New Order of Consciousness in American Literature." *Pacific Coast Philology* 6 (April 1971), 26–34.

———. *The Inner Eye of Alfred Stieglitz*. Washington, 1982.

Hamilton, George Heard. "The Alfred Stieglitz Collection." *Metropolitan Museum of Art Journal* 3 (1970), 371–392.

Hannum, Gillian Greenhill. "Photographic Politics: The First American Photographic Salon and the Stieglitz Response." *History of Photography* 14, 3 (July–September 1990), 285–295.

Hapgood, Hutchins. "Fire and Revolution." *New York Globe*, 11 July 1913.

———. *A Victorian in the Modern World*. New York, 1939.

Hartley, Marsden. "Epitaph for Alfred Stieglitz." *Camera Work* 48 (October 1916), 70.

———. "Tribal Esthetics." *The Dial* 65 (16 November 1918), 399–401.

———. "Red Man Ceremonials: An American Plea for American Aesthetics." *Art and Archaeology* (1920).

———. "Vaudeville." *The Dial* (March 1920), 339.

———. *Adventures in the Arts: Informal Chapters on Painters, Vaudeville, and Poets*. New York, 1921.

———. "Dissertation on Modern Painting." *The Nation* 112 (9 February 1921), 235–236.

———. *Twenty-Five Poems*. Paris, 1923.

———. "Art and the Personal Life." *Creative Art* 2 (June 1928), 31–37.

Hartmann, Sadakichi. "A Plea for Straight Photography." *American Amateur Photographer* 16 (March 1904), 101–109.

———. "Aesthetic Activity in Photography." *Brush and Pencil* 14 (April 1904), 24–40.

———. "On the Lack of Culture." *Camera Work* 6 (April 1904), 19–22.

———. "The Photo-Secession, A New Pictorial Movement." *The Craftsman* 6 (April 1904), 30–37.

———. "The Photo-Secession Exhibition at the Carnegie Art Galleries, Pittsburgh, Pa." *Camera Work* 6 (April 1904), 47–50.

———. "Structural Units." *Camera Work* 36 (October 1911), 18–20.

———. "On Originality." *Camera Work* 37 (January 1912), 19–21.

———. "The Esthetic Significance of The Motion Picture." *Camera Work* 38 (April 1912), 19–21.

———. "The Exhibition of Children's Drawings." *Camera Work* 39 (July 1912), 45–46.

———. "One More Matisse." *Camera Work* 39 (July 1912), 22, 33.

———. "An Open Letter." *Camera Work* 41 (January 1913), 42–43.

[Sadakichi Hartmann]. "Unphotographic Paint—The Texture of Impressionism." *Camera Work* 28 (October 1909), 20–23.

Haviland, Paul B. "The Home of the Golden Disk." *Camera Work* 25 (January 1909), 21–22.

———. "The Photo-Secession Gallery." *Camera Work* 26 (April 1909), 36–37.

———. "Accomplishments of Photography and Contributions of the Medium to the Arts." *Camera Work* 33 (January 1911), 65–67.

———. "Conception and Expression." *Camera Work* 33 (January 1911), 33–34.

———. "Art as a Commodity." *Camera Work* 34–35 (April–July 1911), 68–69.

———. "Marius De Zayas—Material, Relative, and Absolute Caricatures." *Camera Work* 46 (dated April 1914, published October 1914), 33–34.

———. "291." *291* (March 1915), n.p.

———. "Man, the Machine and Their Product, the Photographic Print." *291* 7–8 (September 1915), n.p.

Haz, Nicholas. "Alfred Stieglitz, Photographer." *American Annual of Photography* (1936).

Heilbrun, Françoise. *Camera Work: Stieglitz, Steichen, and Their Contemporaries.* Trans. Ruth Sharman. New York, 1991.

Heilbrun, Françoise and Quentin Bajac. *Paul Burty Haviland (1880–1950), photographe.* Paris, 1996.

Henderson, Archibald. "Bernard Shaw on Photography." *Camera Work* 37 (January 1912), 37–41.

Henderson, Linda Dalrymple. "Mabel Dodge, Gertrude Stein, and Max Weber; a Four-Dimensional Trio." *Arts Magazine* 57 (September 1982), 106–111.

Hind, C. Lewis. *The Post-Impressionists.* London, 1911.

Hinton, Horsley A. "The Work and Attitude of the Photo-Secession of America." *Amateur Photographer* (2 June 1904), 426–428.

History of an American: Alfred Stieglitz, "291," and After: Selections from the Artists Shown by Him from 1900 to 1925. Cincinnati, 1951.

History of Photography 20, 4 (winter 1996). Special Stieglitz issue.

Homer, William Innes. "Stieglitz and 291." *Art in America* 61, 4 (July–August 1973), 50–57.

———. "Alfred Stieglitz and an American Aesthete." *Arts Magazine* 49 (September 1974), 25–28.

———. "Stieglitz, 291, and Paul Strand's Early Photography." *Image* 19 (June 1976), 6–10.

———. *Alfred Stieglitz and the American Avant-Garde.* Boston, 1977.

———. *Alfred Stieglitz and the Photo-Secession.* Boston, 1983.

Hyland, Douglas. "Agnes Ernst Meyer and Modern Art in America, 1907–1918." M.A. thesis, University of Delaware, 1976.

———. "Agnes Ernst Meyer, Patron of American Modernism." *American Art Journal* 12 (winter 1980), 64–81.

In Focus: Alfred Stieglitz. Malibu, 1995.

The Intimate Gallery. New York, 1978.

"Is Photography a New Art?" *Camera Work* 21 (January 1908), 17–22.

Ivins, Jr., William. "Photography of Alfred Stieglitz." *Bulletin of the Metropolitan Museum of Art* 24, 2 (February 1929), 44–45.

Jacob, C. Max. "La Vie Artistique." *291* 10–11 (December 1915–January 1916), n.p.

———. "La Vie Artistique." *291* 12 (February 1916), n.p.

Jewell, Edward Alden. "Stieglitz in Retrospect." *New York Times,* 16 December 1934, section 11, 9.

———. "Alfred Stieglitz." *New York Times,* 14 July 1946, 38.

———. "Hail and Farewell." *New York Times,* 15 June 1947.

Jussim, Estelle. "Technology or Aesthetics: Alfred Stieglitz and Photogravure." *History of Photography* 3 (January 1979), 81–92.

Kalonyme, Louis. "Georgia O'Keeffe: A Woman in Painting." *Creative Art* 2 (January 1928), xxxv–xxxix.

Kandinsky, Wassily. "Extracts from 'The Spiritual in Art.'" *Camera Work* 39 (July 1912), 34.

———. *The Art of Spiritual Harmony.* First published 1912; London, 1914.

———. *Concerning the Spiritual in Art.* Ed. Hilla Rebay, trans. M.T.H. Sadler. New York, 1946.

Keiley, Joseph T. "The Photo-Secession Exhibition at the Pennsylvania Academy of Fine Arts—Its Place and Significance in the Progress of Pictorial Photography." *Camera Work* 16 (October 1906), 45–51.

———. "The Buffalo Exhibition." *Camera Work* 33 (January 1911), 23–29.

Kerfoot, J.B. "Henri Matisse: A Retrospect." *Camera Work* 25 (January 1909), 45–46.

———. "The Game at the 'Little Galleries.'" *Camera Work* 33 (January 1911), 45.

———. "A Bunch of Keys." *291* 3 (May 1915), n.p.

Kiefer, Geraldine Wojno. "The Leitmotifs of *Camera Notes,* 1897–1908." *History of Photography* 14, 4 (October–December 1990), 349–360.

——. *Alfred Stieglitz: Scientist, Photographer, and Avatar of Modernism, 1880–1913.* New York and London, 1991.

——. "Alfred Stieglitz, *Camera Work*, and Cultural Radicalism." *Art Criticism* 17, 2 (1992), 1–20.

Kootz, Samuel. *Modern American Painters.* New York, 1930.

Kornhauser, Elizabeth Mankin and Amy Ellis, with Maura Lyons. *Stieglitz, O'Keeffe and American Modernism.* Hartford, 1999.

Krauss, Rosalind. "Stieglitz/*Equivalents*." *October* 11 (winter 1979), 129–140.

——. "Alfred Stieglitz's 'Equivalents.' " *Arts Magazine* 54, 6 (February 1980), 134–137.

Kreymborg, Alfred. *Troubadour: An Autobiography.* New York, 1925.

Kruty, Paul. "Arthur Jerome Eddy and His Collection: Prelude and Postscript to the Armory Show." *Arts Magazine* 61 (February 1987), 40–47.

Larkin, Oliver W. "Alfred Stieglitz and 291." *Magazine of Art* 40 (May 1947), 179–183.

Laurvik, J. Nilsen. "New Color Photography." *Century* (January 1908), 323–330.

——. "New Tendencies in Art." *Camera Work* 22 (April 1908), 33–34.

——. "Alfred Stieglitz, Pictorial Photographer." *The International Studio* 44, 174 (August 1911), xxi–xxviii.

——. *Is It Art? Post-Impressionism, Cubism, Futurism.* New York, 1913.

Lawrence, D.H. *Studies in Classic American Literature.* Reprint of 1923 ed. New York, 1968.

Leavens, Ileana. *From "291" to Zurich: The Birth of Dada.* Ann Arbor, 1983.

Leonard, Neil. "Alfred Stieglitz and Realism." *Art Quarterly* 29 (1966), 277–286.

Leonard, Sandra E. *Henri Rousseau and Max Weber.* New York, 1970.

Levin, Gail. "Andrew Dasburg: Recollections of the Avant-Garde." *Arts Magazine* 52, 10 (June 1978), 126–130.

——. "Konrad Cramer: Link from the German to the American Avant-Garde." *Arts Magazine* 56, 6 (February 1982), 145–149.

Levin, Gail and Marianne Lorenz. *Theme and Improvisation: Kandinsky and the American Avant-Garde, 1912–1950.* Boston, 1992.

Lewis, Sinclair. *Main Street.* New York, 1920.

——. *Babbitt.* New York, 1922.

Lewis, Stephen E. "The Modern Gallery and American Commodity Culture." *MODERNISM/modernity* 4, 3 (September 1997), 67–91.

Long, Rose-Carol Washton. "Kandinsky and Abstraction: The Role of the Hidden Image." *Artforum* 10 (June 1972), 42–49.

——. *Kandinsky: The Development of an Abstract Style.* Oxford, 1980.

Longwell, Dennis. "Alfred Stieglitz vs. the Camera Club of New York." *Image* 14, 5–6 (December 1971), 21–23.

Loughery, John. "Charles Caffin and Willard Huntington Wright, Advocates of Modern Art." *Arts Magazine* 59 (January 1985), 103–109.

Lowe, Sue Davidson. *Stieglitz: A Memoir/Biography.* New York, 1983.

Loy, Mina. "Aphorisms on Futurism." *Camera Work* 45 (dated January 1914, published June 1914), 13–15.

——. "There is No Life or Death." *Camera Work* 46 (dated April 1914, published October 1914), 18.

Luhan, Mabel Dodge. *Movers and Shakers.* New York, 1936.

Lukach, Joan J. "Severini's 1917 Exhibition at Stieglitz's '291.' " *Burlington Magazine* 113 (April 1971), 196–209.

Lynes, Barbara Buhler. *O'Keeffe, Stieglitz, and the Critics, 1916–1929.* Ann Arbor, 1989.

MacColl, William D. "Some Reflections of the Functions and Limitations of Art Criticism—Especially in Relation to Modern Art." *Camera Work* 30 (April 1910), 17–21.

Macmonnies, Frederick. "French Artists Spur on American Art." *New York Tribune*, 24 October 1915, part 4, 2.

Maeterlinck, Maurice. "Je Crois." *Camera Work* 2 (April 1903), supplement.

——. "I Believe." *Camera Work*, special Steichen supplement (April 1906), 1.

——. "Maeterlinck On Photography." *Camera Work* 37 (January 1912), 41–42.

MSS [Manuscripts] 4 (December 1922), special issue, "Can a Photograph Have the Significance of Art."

Margolis, Marianne Fulton. *Camera Work: A Pictorial Guide.* New York, 1978.

Marin, John. "Foreword." *MSS* 2 (March 1922), 3–4.

——. "Notes." *MSS* 2 (March 1922), 5.

——. *Letters.* Ed. Herbert Seligmann. New York, 1931.

Marks, Robert W. "Man With a Cause." *Coronet* (September 1938), 161–170.

——. "Peaceful Warrior." *Coronet* (October 1938), 161–171.

——. "Stieglitz—Patriarch of Photography." *Popular Photography* 6 (April 1940), 20–21, 76–79.

——. "Alfred Stieglitz." *Gentry* 7 (summer 1953), 66–72.

Mather, F.J. "The New Painting and the Musical Fallacy." *The Nation* 99 (12 November 1914), 588–590.

——. "Photographer and Champion of Art." *Saturday Review* 11 (8 December 1934), 337.

May, Henry F. *The End of American Innocence: A Study of the First Years of Our Own Time.* New York, 1959.

McBride, Henry. "Work by a Great Photographer." *New York Herald*, 13 February 1921, section 2, 5.

——. "Modern Art." *The Dial* 70 (April 1921), 480–482.

——. "The Paul Strand Photographs." *New York Sun*, 23 March 1929, 34.

[McBride, Henry]. "Art Photographs and Cubist Painting." *Sun*, 3 March 1913, 7.

McCausland, Elizabeth. "Forty Years' War for Artists Leaves Stieglitz Still Valiant." *Springfield Sunday Union and Republican*, 28 February 1932, section E, 2.

——. "America, Alfred Stieglitz." *Springfield Sunday Union and Republic*, 2 December 1934, section E, 6.

——. "Retrospective Show of Modernist Pioneers." *Springfield Sunday Union and Republic*, 7 November 1937, section E, 6.

[McCausland, Elizabeth]. "Stieglitz's 50-year Fight for Photography Triumphant." *Springfield Sunday Union and Republican*, 14 May 1933.

——. "Photographs by Stieglitz Now at an American Place." *Springfield Sunday Union and Republican*, 16 December 1934, section E, 6.

Mellquist, Jerome. *The Emergence of an American Art*. New York, 1942.

——. "Eulogy to Paul Rosenfeld." *Twice A Year* 14–15 (fall–winter 1946–1947), 206–207.

——. "Pertaining to Deaths of Stieglitz and Rosenfeld." *Twice A Year* 14–15 (fall–winter 1946–1947), 211–212.

Mellquist, Jerome and Lucie Wiese, eds. *Paul Rosenfeld: Voyager in the Arts*. New York, 1948.

Messer, Thomas M. "Kandinsky en Amerique." In "Wassily Kandinsky, 1966–1944: Centenaire de Kandinsky." *XXe Siècle* 37 (December 1966), 11–17.

Meyer, Agnes Ernst. "Some Recollections of Rodin." *Camera Work* 34–35 (April–July 1911), 15–19.

——. "How Versus Why." *291* 1 (March 1915), n.p.

——. "Mental Reactions." *291* 2 (April 1915), n.p.

——. "Woman." *291* 3 (May 1915), n.p.

——. "Marion H. Beckett and Katharine N. Rhoades." *Camera Work* 48 (October 1916), 8.

Miller, Henry. "Stieglitz and John Marin." *Twice A Year* 8–9 (spring–summer 1942–fall–winter 1942), 146–155.

Minuit, Peter [Paul Rosenfeld]. "291." *The Seven Arts* 1 (November 1916), 61–65.

"Miss Georgia O'Keeffe Explains Subjective Aspect of Her Work." *The Sun*, 5 December 1922, 22.

Moffatt, Frederick C. *Arthur Wesley Dow*. Washington, 1977.

Muir, Ward. "Alfred Stieglitz: An Impression." *Amateur Photographer and Photographic News* (24 March 1913), 285–286.

——. "Photographic Days." *The Amateur Photographer and Photography* (14 August 1918), 187–188.

——. "'Camera Work' and its Creator." *The Amateur Photographer and Photography* 56 (28 November 1923), 465–466.

Mulligan, Therese, ed. *The Photography of Alfred Stieglitz: Georgia O'Keeffe's Enduring Legacy*. Rochester, 2000.

Mullin, Glen. "Alfred Stieglitz Presents Seven Americans." *The Nation* 120 (20 May 1925), 577–578.

Mumford, Lewis. *The Brown Decades*. New York, 1931.

——. "A Camera and Alfred Stieglitz." *New Yorker* (22 December 1934).

Munson, Gorham. "291: A Creative Source of the Twenties." *Forum* 3 (fall–winter 1960), 4–9.

Naef, Weston J. *The Art of Seeing: Photographs from the Alfred Stieglitz Collection*. New York, 1978.

——. *The Collection of Alfred Stieglitz*. New York, 1978.

Nathanson, Carol Arnold. "The American Response, in 1900–1913, to the French Modern Art Movements after Impressionism." Ph.D. diss., The Johns Hopkins University, 1973.

Nevison, Henry W. "The Impulse to Futurism." *Atlantic Monthly* 114 (November 1914), 626–633.

Newhall, Beaumont. *Photography: A Short Critical History*. New York, 1937.

——. "Stieglitz and 291." *Art in America* 51 (February 1963), 49–51.

Newhall, Nancy. "What Is Pictorialism?" *Camera Craft* 48 (November 1941), 653–663.

Nietzsche, Friedrich. "To the Artist Who is Eager for Fame, His Work Finally Becomes But a Magnifying Glass Which He Offers to Everyone Who Happens to Look His Way." *Camera Work* 28 (October 1909), 39.

Norman, Dorothy. "Marin Speaks, and Stieglitz." *Magazine of Art* 30 (March 1937), 151.

——. "Alfred Stieglitz: From the Writings and Conversations." *Twice A Year* 1 (fall–winter 1938), 77–110.

——. "Alfred Stieglitz: Ten Stories." *Twice A Year* 5–6 (spring–summer 1941), 135–163.

——. "Alfred Stieglitz: Six Happenings." *Twice A Year* 14–15 (fall–winter 1946–1947), 188–202.

——. "Was Stieglitz a Dealer?" *Atlantic Monthly* 179 (May 1947), 22–23.

——. "Alfred Stieglitz on Photography." *The Magazine of Art* 43 (December 1950), 298–301.

——. "Alfred Stieglitz—Seer." *Aperture* 3, 4 (1955), 3–24.

——. *Alfred Stieglitz: An Introduction to an American Seer*. New York, 1960.

——. "Stieglitz and Cartier-Bresson." *Saturday Review* 45 (22 September 1962), 52–56.

——. "Stieglitz's Experiments in Life." *New York Times*, 29 December 1963, magazine section, 12–13.

——. *Alfred Stieglitz: An American Seer*. Reprint of 1973 ed. New York, 1990.

Norman, Dorothy, ed. *Stieglitz Memorial Portfolio*. New York, 1947.

——. *Encounters: A Memoir*. New York, San Diego, and London, 1987.

North, Percy. "Turmoil at 291." *Archives of American Art* 30, 1–4 (1990), 76–83. [Special retrospective volumes.] Originally published under the same title in *Archives of American Art* 24, 1 (1984).

North, Phylis Burkley. "Max Weber: The Early Paintings, 1905–1920." Ph.D. diss., University of Delaware, 1975.

"Notes on the Exhibitions at '291.'" *Camera Work* 37 (January 1912), 46.

"Notes on '291.'" *Camera Work* 42–43 (dated April–July 1913, published November 1913), 18–26, 41–54, 65.

O'Keeffe, Georgia. "Stieglitz: His Pictures Collected Him." *New York Times*, 11 December 1949, magazine section, 24–26.

Oliver, Maude I.G. "The Photo-Secession in America." *The International Studio* 32 (September 1907), 199–215.

Oppenheim, James. "From the Foreword to Randolph Bourne's *Untimely Papers* (1919)." *Twice A Year* 1 (fall–winter 1938), 38.

Oppenheim, James and Waldo Frank. [Editorial]. *The Seven Arts* 1 (November 1916), 47–51.

Parsons, Melinda Boyd. *To All Believers—The Art of Pamela Colman Smith*. Wilmington, 1975.

———. "Pamela Colman Smith and Alfred Stieglitz." *History of Photography* 20, 4 (winter 1996), 285–292.

Peeler, David P. "Alfred Stieglitz: From Nudes to Clouds." *History of Photography* 20, 4 (winter 1996), 312–319.

Peterson, Christian A. *Alfred Stieglitz's "Camera Notes."* New York and London, 1993.

Philippi, Simone and Ute Kieseyer, eds. *Alfred Stieglitz: Camera Work: The Complete Illustrations, 1903–1917*. Cologne, 1997.

Photosammlung Stieglitz aus dem Metropolitan Museum New York. Cologne, 1980.

"Photo-Secession Exhibitions." *Camera Work* 29 (January 1910), 51–53.

"Photo-Secession Notes." *Camera Work* 30 (April 1910), 54.

"Photo-Secession Notes." *Camera Work* 41 (January 1913), 24–30, 41.

"Photo-Secession Notes." *Camera Work* 44 (October 1913), 39–43.

"Photograph Show Spans Fifty Years." *New York Times*, 11 December 1934, 21.

"Picabia, Art Rebel, Here to Teach New Movement." *New York Times*, 16 February 1913, part 5, 9.

Picabia, Francis. "How New York Looks to Me." *New York American*, 30 March 1913, magazine section, 11.

———. "We Live in a World." *291* 12 (February 1916), n.p.

"Pictured Music." *Current Literature* 45 (August 1908), 174–177.

Pisano, Ronald G. *An American Place*. Southampton, 1981.

Plagens, Peter. "The Critics: Hartmann, Huneker, De Casseres." *Art in America* 61, 4 (July–August 1973), 66–71.

Poore, H. R. "The Photo-Secession." *The Camera* (1903).

———. *The New Tendency in Art: Post-Impressionism, Futurism, Cubism*. Garden City, N.Y., 1913.

"A Post-Cubist's Impression of New York." *New York Tribune*, 9 March 1913, part 2, 1.

Potter, Hugh M. *False Dawn: Paul Rosenfeld and Art in America, 1916–1946*. Ann Arbor, 1980.

Pultz, John. "Equivalence, Symbolism, and Minor White's Way into the Language of Photography." *Record of the Art Museum, Princeton University* 39 (1980), 28–39.

Read, Helen Appleton. "Alfred Stieglitz Shows Recent Photographs." *Brooklyn Daily Eagle*, 8 April 1923, 2B.

Rhoades, Katherine. "I Walked into a Moment of Greatness." *291* 3 (May 1915), n.p.

———. "Flip-Flap." *291* 4 (June 1915), n.p.

Rich, Daniel Catton. "The Stieglitz Collection." *Bulletin of the Art Institute of Chicago* 43 (15 November 1949), 64.

Rich, Daniel Catton, ed. *Flow of Art: Essays and Criticisms of Henry McBride*. New Haven, 1997.

Ringel, Fred J., ed. *America as Americans See It*. New York, 1932.

———. "Stieglitz: Done by Mirrors." *The New Republic* 81 (6 February 1935), 365–366.

Rodgers, Timothy Robert. "Alfred Stieglitz, Duncan Phillips and the '$6000 Marin.'" *Oxford Art Journal* 15, 1 (1992), 54–66.

———. "Making the American Artist: John Marin, Alfred Stieglitz, and Their Critics, 1909–1936." Ph.D. diss., Brown University, 1994.

"The Rodin Drawings at the Photo-Secession Galleries." *Camera Work* 22 (April 1908), 35–40.

Rolland, Romain. "America and the Arts." *The Seven Arts* 1 (November 1916), 47–51.

Rood, Roland. "The Three Factors in American Pictorial Photography." *American Amateur Photographer* 17 (December 1905), 506–509.

———. "Edward J. Steichen…" *American Amateur Photographer* 18 (March 1906), 99–102.

Rosenfeld, Paul. "The Novels of Waldo Frank." *The Dial* 70 (January 1921), 115–119.

———. "Stieglitz." *The Dial* 70 (April 1921), 397–409.

———. "American Painting." *The Dial* 71 (December 1921), 649–670.

———. "The Watercolors of John Marin." *Vanity Fair* 18 (April 1922), 48, 88, 92, 110.

———. "The Paintings of Marsden Hartley." *Vanity Fair* 18 (August 1922), 47, 84, 94, 96.

———. "The Paintings of Georgia O'Keeffe." *Vanity Fair* 19 (October 1922), 56, 112, 114.

———. *Port of New York*. New York, 1924.

———. *Men Seen*. New York, 1925.

———. *By Way of Art*. New York, 1928.

———. "Photography of Alfred Stieglitz." *The Nation* 134 (23 March 1932), 350–351.

———. "Marsden Hartley." *The Nation* 157 (18 September 1943), 326.

———. "Alfred Stieglitz." *Twice A Year* 14–15 (fall–winter 1946–1947), 203–205.

Rozaitis, William. "The Joke at the Heart of Things: Francis Picabia's Machine Drawings and the Little Magazine 291." *American Art* 8 (summer–fall 1994), 42–59.

Rudnick, Lois Palken. *Utopian Vistas: The Mabel Dodge Luhan House and the American Counterculture*. Albuquerque, 1996.

Sacks, Claire. "The 'Seven Arts' Critics: A Study of Cultural Nationalism on America, 1910–1930." Ph.D. diss., University of Wisconsin, 1955.

Sadler, Michael T.H. "After Gauguin." *Rhythm, Art, Music, and Literature* 1 (spring 1912), 23–29.

Savinio, Alberto. "Dammi L'Anatema, Cosa Lasciva." *291* 4 (June 1915), n.p.

Sayag, Alain. "Stieglitz: Un Fantôme au Musée." *Les Cahiers du Musée national d'art moderne* 35 (spring 1991), 49–57.

Search-Light [Waldo Frank]. *Time Exposures.* New York, 1926.

Selections from the Dorothy Norman Collection. Philadelphia, 1968.

Seligmann, Herbert J. "A Photographer Challenges." *The Nation* 112 (16 February 1921), 268.

——. "Why 'Modern' Art?" *Vogue* 62 (15 October 1923), 76–77, 110, 112.

——. "Music and Words." *New York Tribune*, 18 November 1923, magazines and books section, 20.

——. "Alfred Stieglitz and His Work at 291." *American Mercury* (May 1924), 83–84.

——. *D.H. Lawrence: An American Interpretation.* New York, 1924.

——. [Letter]. *New York Times*, 28 February 1932, section 8, 11.

——. *Alfred Stieglitz Talking: Notes on Some of His Conversations, 1925–1931.* New Haven, 1966.

Seven Americans. New York, 1974.

Shaw, George Bernard. "Evans—An Appreciation." *Camera Work* 4 (October 1903), 13–16.

——. "G. Bernard Shaw on the London Exhibitions." *Camera Work* 14 (April 1906), 57–62.

——. "The Unmechanicalness of Photography." *Camera Work* 14 (April 1906), 18–25.

——. "Bernard Shaw's Appreciation of Coburn." *Camera Work* 15 (July 1906), 33–35.

——. "A Page from Shaw." *Camera Work* 34–35 (April–July 1911), 22.

Sheeler, Charles. "Recent Photographs by Alfred Stieglitz." *The Arts* 3 (May 1923), 345.

Shiffman, Joseph. "The Alienation of the Artist: Alfred Stieglitz." *American Quarterly* 3 (fall 1951), 244–258.

"Show Recent Photographs from Stieglitz Studio." *New York Herald*, 8 April 1923, section 7, 7.

Silet, Charles L.P. "The Seven Arts: The Artist and the Community." Ph.D. diss., University of Indiana, 1973.

Smelstor, Marjorie Rose. "*Broom* and American Cultural Nationalism in the 1920s." Ph.D. diss., University of Wisconsin, 1975.

Smith, Joel. "How Stieglitz Came to Photograph Cityscapes." *History of Photography* 20, 4 (winter 1996), 320–331.

Smith, Pamela Colman. [Portfolio of Prints]. New York, 1907.

Soby, James Thrall. "Alfred Stieglitz." *Saturday Review of Literature* 29 (28 September 1946), 22–23.

"Spirit of An American Place: An Exhibition of Photographs by Alfred Stieglitz." *Bulletin of the Philadelphia Museum of Art* 76, 331 (1981).

Stearns, Harold E., ed. *Civilization in the United States: An Enquiry by Thirty Americans.* New York, 1922.

Steichen, Edward J. "Ye Fakers." *Camera Work* 1 (January 1903), 48.

——. [The Steichen Book]. New York, 1906.

——. "Color Photography." *Camera Work* 22 (April 1908), 13–24.

——. "Painting and Photography." *Camera Work* 23 (July 1908), 3–5.

——. "The Lusha Nelson Photographs of Alfred Stieglitz." *U.S. Camera* 1 (February–March 1940), 16–19.

——. "The Fighting Photo-Secession." *Vogue* (15 June 1941), 22, 74.

Stein, Gertrude. "Henri Matisse." *Camera Work*, special number (August 1912), 23–25.

——. "Pablo Picasso." *Camera Work*, special number (August 1912), 29–30.

——. "Portrait of Mabel Dodge at The Villa Curonia." *Camera Work*, special number (June 1913), 3–5.

——. "From a Play by Gertrude Stein on Marsden Hartley." *Camera Work* 45 (dated January 1914, published June 1914), 17–18.

——. *The Autobiography of Alice B. Toklas.* New York, 1933.

Stieglitz, Alfred. "An Apology." *Camera Work* 1 (January 1903), 15.

——. "The Photo-Secession." *Bausch and Lomb Lens Souvenir* (Rochester, N.Y., 1903), 3.

——. "Photo-Secession—Its Objectives." *Camera Craft* 7 (August 1903), 81–83.

——. "The Fiasco at St. Louis." *Photographer* (20 August 1904).

——. "Some Impressions of Foreign Exhibitions." *Camera Work* 8 (October 1904), 34–36.

——. "The Photo-Secession." *The American Annual Photography and Photographic Times-Bulletin Almanac 1904*, 41–44.

——. "The 'First American Salon at New York.' Reprinted articles by Fitzgerald, DeKay, Moser." *Camera Work* 9 (January 1905), 50–52.

——. "Camera Work, 1906: An Announcement." *Camera Work* 11 (July 1905), supplement.

——. "Simplicity in Composition." *The Modern Way in Picture Making* (1905).

——. "The New Color Photography—A Bit of History." *Camera Work* 20 (October 1907), 20–25.

——. "Frilling and Autochromes." *Camera Work* 23 (July 1908), 49–50.

——. "Exhibition of Pictorial Photography." *Academy Notes* (Journal of the Albright Art Gallery) 6 (January 1911), 11–13.

——. [Letter to the Editors]. *The Evening Sun*, 18 December 1911, editorial page.

——. "The First Great 'Clinic to Revitalize Art.'" *New York American*, 26 January 1913, 5-CE.

——. [Untitled]. *Photo Miniature* 124 (March 1913), 220–221.

——. [Untitled]. *Camera Work* 47 (July 1914), n.p.

——. "One Hour's Sleep—Three Dreams." *291* 1 (March 1915), n.p.

——. "Foreword." *The Forum Exhibition of Modern American Painters.* New York, 1916.

——. "Photographs by Paul Strand." *Camera Work* 48 (October 1916), 11–12.

——. [Letter]. *Blind Man* 2 (1917), 15.

——. "A Statement." *Exhibition of Photography by Alfred Stieglitz.* New York, 1921.

——. "Regarding the Modern French Masters Exhibition." *Brooklyn Museum Quarterly* 8 (July 1921), 105–113.

——. [Letter]. *The Arts* 2 (August–September 1921), 61.

——. "Portrait—1918." *MSS* 2 (March 1922), 9.

——. "Portrait—1918." *MSS* 2 (March 1922), 10.

——. "Portrait: 1910–1921." *MSS* 2 (March 1922), 10.

——. "Is Photography a Failure?" *The Sun,* 14 March 1922, 20.

——. [Untitled]. *Second Exhibition of Photography by Alfred Stieglitz.* New York, 1923, n.p.

——. "How I Came to Photograph Clouds." *Amateur Photographer and Photography* 56 (1923), 255.

——. "Chapter III." *Third Exhibition of Photography by Alfred Stieglitz.* New York, 1924, n.p.

——. "Sky-Songs." *The Nation* 118 (1924), 561–562.

——. [Untitled]. *Alfred Stieglitz Presents Seven Americans.* New York, 1925, 2.

——. [Untitled]. *Marin Exhibition.* New York, 1927, n.p.

——. "Stieglitz." *Art Digest* 1 (March 1927), 20.

——. "To the Art Editor." *Creative Art* 12 (February 1933), 152.

——. "Not a Dealer." *American Magazine of Art* 27 (1934), 4.

——. [Untitled]. *Alfred Stieglitz: An Exhibition of Photographs.* New York, 1935, n.p.

——. "Ten Stories." *Twice A Year* 5–6 (fall–winter 1940–spring–summer 1941), 135–163.

——. "Four Happenings." *Twice A Year* 8–9 (spring–summer 1942–fall–winter 1942), 105–136.

——. "Four Marin Stories." *Twice A Year* 8–9 (spring–summer 1942–fall–winter 1942), 156–162.

——. "Thoroughly Unprepared." *Twice A Year* 10–11 (spring–summer 1943), 245–253.

——. "Is It Wastefulness Or Is It Destruction." *Twice A Year* 10–11 (spring–summer 1943), 254–255.

——. "Random Thoughts—1942." *Twice A Year* 10–11 (spring–summer 1943), 261–264.

——. "Scissors Grinder." *Twice A Year* 10–11 (spring–summer 1943), 256–260.

——. *Stieglitz on Photography: His Selected Essays and Notes.* Ed. Richard Whelan with an afterword by Sarah Greenough. New York, 2000.

"Stieglitz and His Influence." *Christian Science Monitor,* 21 February 1921, 12.

"Stieglitz Assails W.P.A. Art as 'Wall Smears.'" *New York Herald Tribune,* 3 December 1936, 9.

"Stieglitz at Seventy Recalls Birth of Modern Art." *New York Herald Tribune,* 1 January 1934, 17.

"Stieglitz of '291' Begins Again in Room 303." *The World,* 20 December 1925, section 3, 9.

Stone, Gray. "The Influence of Alfred Stieglitz on Modern Photographic Illustration." *American Photography* 30 (April 1936), 199–206.

Strand, Paul. "Stieglitz." *Conservator* 27 (December 1916), 137.

——. "Photography." *The Seven Arts* (August 1917), 524–526.

——. "Aesthetic Criteria." *The Freeman* 2 (12 January 1921), 426–427.

——. "American Water Colors at the Brooklyn Museum." *The Arts* 2 (December 1921), 148–152.

——. "The Forum." *The Arts* 2 (February 1922), 332–333.

——. "Alfred Stieglitz and a Machine." *MSS* 2 (March 1922), 6–7.

——. "Photography and the New God." *Broom* 3 (November 1922), 252–258.

——. "Photographers Criticized." *New York Sun,* 27 June 1923, 20.

——. "The Art Motive in Photography." *British Journal of Photography* 70 (October 1923), 613–615.

——. "Georgia O'Keeffe." *Playboy* 9 (July 1924), 16–20.

——. "Steichen and Commercial Art." *New Republic* 62 (19 February 1930), 21.

——. "Alfred Stieglitz 1864–1946." *New Masses* 60 (6 August 1945), 6–7.

——. "Stieglitz: An Appraisal." *Popular Photography* 21 (July 1947), 62.

Sweeney, James Johnson. "Rebel with a Camera." *New York Times,* 8 June 1947, magazine section, 20.

——. "Stieglitz." *Vogue* 109 (15 June 1947), 58–59, 93.

Sweeney, James Johnson, ed. *African Negro Art.* New York, 1935.

Symons, Arthur. *Studies in the Seven Arts.* London, 1906.

——. "Arthur Symons on Rodin's Drawings." *Camera Work* 34–35 (April–July 1911), 63–64.

Szarkowski, John. *Alfred Stieglitz at Lake George.* New York, 1995.

Szekely, Gilliam. "The Beginnings of Abstraction in America: Art and Theory in Alfred Stieglitz's New York Circle." Ph.D. diss., University of Edinburgh, 1971.

Tashjian, Dickran. *William Carlos Williams and the American Scene, 1920–1940.* New York, 1978.

Taylor, Francis Henry. "America and Alfred Stieglitz." *The Atlantic Monthly* 155 (January 1935), 8, 10.

Temple, Scott. "Fifth Avenue and the Boulevard Saint-Michel." *Forum* 28 (December 1910), 665–685.

Thissen, John Hughes. "Sherwood Anderson and Painting." Ph.D. diss., Northwestern University, 1974.

Thomas, F. Richard. *Literary Admirers of Alfred Stieglitz.* Carbondale and Edwardsville, Ill., 1983.

"To the Friends of The Seven Arts." *The Seven Arts* 2 (October 1917), n.p.

Toomer, Jean. *Cane.* New York, 1923.

Turner, Elizabeth. *In the American Grain: Arthur Dove, Marsden Hartley, John Marin, Georgia O'Keeffe, and Alfred Stieglitz.* Washington, 1995.

"291." *The New Yorker* (18 April 1925), 9–10.

"'291'—A New Publication." *Camera Work* 48 (October 1916), 62.

"'291' and The Modern Gallery." *Camera Work* 48 (October 1916), 63–64.

"'291' Exhibitions: 1914–1916." *Camera Work* 48 (October 1916), 7–22, 37–46, 53–61.

"'291'—the Mecca and the Mystery of Art in a Fifth Avenue Attic." *New York Sun*, 24 October 1915, 6.

Tyrell, Henry. "What Is Stieglitz." *The World*, 15 April 1923, metropolitan section, 11.

Vollard, Ambroise. *Cézanne's Studio.* Trans. Robert J. Coady. New York, 1915.

Weaver, Mike. "Alfred Stieglitz and Ernest Bloch: Art and Hypnosis." *History of Photography* 20, 4 (winter 1996), 293–303.

Weber, Max. "Chinese Dolls and Modern Colorists." *Camera Work* 31 (July 1910), 51.

——. "The Fourth Dimension from a Plastic Point of View." *Camera Work* 31 (July 1910), 25.

——. "To Xochipilli, Lord of Flowers." *Camera Work* 33 (January 1911), 34.

——. *Cubist Poems.* London, 1914.

——. *Essays on Art.* New York, 1916.

Weichsel, John. "Ecce Homo." *Camera Work*, special number (June 1913), 58–59.

——. "Cosmism or Amorphism?" *Camera Work* 42–43 (dated April–July 1913, published November 1913), 69–82.

——. "The Rampant Zeitgeist." *Camera Work* 44 (dated October 1913, published March 1914), 20–24.

——. "Artists and Others." *Camera Work* 46 (dated April 1914, published October 1914), 13–17.

Weiss, Peg. *Kandinsky in Munich: The Formative Jugendstil Years.* Princeton, 1979.

Wells, H.G. "On Beauty." *Camera Work* 27 (July 1909), 17.

Werner, Alfred. *Max Weber.* New York, 1974.

"'What Is 291?' The Cosmos, Answers Alfred Stieglitz." *New York Evening Post*, 14 April 1925, 2.

Whelan, Richard. *Alfred Stieglitz: A Biography.* New York, 1995.

Whistler, J. McNeill. "From Whistler's 'Ten O'Clock.'" *Camera Work* 5 (January 1904), 52–53.

Wilde, Oscar. "The Artist." *Camera Work* 26 (April 1909), 26.

——. "From 'The Critic as Artist.'" *Camera Work* 27 (July 1909), 46.

Williams, William Carlos. *The Great American Novel.* Paris, 1923.

——. *In the American Grain.* Reprint of 1925 ed. New York, 1956.

——. *The Autobiography of William Carlos Williams.* New York, 1959.

Wilson, Edmund. "Greatest Triumphs: The Stieglitz Exhibition." *The New Republic* 42 (18 March 1925), 97–98.

Wright, Willard Huntington. *Modern Painting, Its Tendency and Meaning.* New York and London, 1915.

——. "The Aesthetic Struggle in America." *Forum* 55 (February 1916), 201–220.

——. "The Forum Exhibition." *Forum* 55 (April 1916), 457–471.

Young, Mahonri Sharp. *Early American Moderns: Painters of the Stieglitz Group.* New York, 1974.

de Zayas, Marius. "The New Art in Paris (Salon d'Automne)." *Camera Work* 34–35 (April–July 1911), 29–34.

——. "Pablo Picasso." *Camera Work* 34–35 (April–July 1911), 65–67.

——. "The Sun Has Set." *Camera Work* 39 (July 1912), 17–21.

——. "The Evolution of Form—Introduction." *Camera Work* 41 (January 1913), 44–48.

——. "Photography." *Camera Work* 41 (January 1913), 17–20.

——. "De Zayas Charts Your Soul Force." *New York Sun*, 22 April 1913, 7.

——. "Photography and Artistic-Photography." *Camera Work* 42–43 (dated April–July 1913, published November 1913), 13–14.

——. "Modern Art—Theories and Representations." *Camera Work* 44 (October 1914), 13–19.

——. "Caricature: Absolute and Relative." *Camera Work* 46 (dated April 1914, published October 1914), 19–21.

——. "New York n'a pas vu d'abord." *291* 5–6 (July–August 1915), n.p.

——. [Untitled]. *291* 7–8 (September–October 1915), n.p.

——. "Femme!" *291* 9 (November 1915), n.p.

——. "Modern Art…Negro Art…." *291* 12 (February 1916), n.p.

——. "The Steerage." *American Photography* 10 (March 1916), 120–121.

——. "Cubism." *Arts and Decoration* 6 (April 1916), 284–286, 308.

——. "Modern Art in Connection with Negro Art." *Camera Work* 48 (October 1916), 7–9.

——. *African Negro Art.* New York, 1916.

——. "Clouds: Photographs by Stieglitz." *The World*, 1 April 1923, 11.

——. *How, When, and Why Modern Art Came to New York.* Ed. Francis M. Naumann. Cambridge, Mass., and London, 1996.

de Zayas, Marius and Paul Haviland. *A Study of the Modern Evolution of Plastic Expression.* New York, 1913.

——. "Comments on 'The Steerage.'" *291* 7–8 (September–October 1915), n.p.

Zigrosser, Carl. "Alfred Stieglitz." *New Democracy* 4 (April 1935), 65–67.

——. "Alfred Stieglitz." *Twice A Year* 8–9 (spring–summer 1942–fall–winter 1942), 137–145.

Zilczer, Judith Katy. "The Aesthetic Struggle in America, 1913–1918: Abstract Art and Theory in the Stieglitz Circle." Ph.D. diss., University of Delaware, 1975.

——. *The Noble Buyer: John Quinn, Patron of the Avant-Garde.* Washington, 1978.

———. "John Quinn and Modern Art Collectors in America, 1913–1924." *American Art Journal* 14 (winter 1982), 57–71.

———. "Alfred Stieglitz and John Quinn: Allies in the American Avant-Garde." *American Art Journal* 16 (summer 1985), 18–33.

II. European and American Modernism

A. GENERAL

Ades, Dawn, et al. *In the Mind's Eye: Dada and Surrealism.* Chicago and New York, 1985.

Agee, William C. "Willard Huntington Wright and the Synchromists: Notes on the Forum Exhibition." *Archives of American Art Journal* 24, 2 (1984), 10–44.

Altshuler, Bruce. *The Avant-Garde in Exhibition: New Art in the 20th Century.* New York, 1994.

Arauz, Rachael. "Articulating 'American': Text and Image in American Modernism." Ph.D. diss., University of Pennsylvania, May 2000.

The Armory Show: International Exhibition of Modern Art, 1913. New York, 1972.

Art in America 51, 1 (February 1963), special issue commemorating the fiftieth anniversary of the Armory Show.

Baigell, Matthew. *The American Scene: American Painting of the 1930's.* New York and Washington, 1974.

———. *A Concise History of American Painting and Sculpture.* New York, 1984.

Baker, Houston A., Jr. *Modernism and the Harlem Renaissance.* Chicago, 1987.

Ball, Hugo. *Flight Out of Time: A Dada Diary.* Ed. John Elderfield, trans. Ann Raimes. Berkeley, 1996.

Barr, Alfred H., Jr. *Defining Modern Art: Selected Writings of Alfred H. Barr.* Ed. I. Sandler and A. Newman. New York, 1986.

Bohan, Ruth L. *The Société Anonyme's Brooklyn Exhibition— Katherine Dreier and Modernism in America.* Ann Arbor, 1983.

Bois, Yves Alain. "La Leçon de Kahnweiler: Cubist Art and African Sources." *Cahiers du Musée National d'Art Moderne* 23 (spring 1988), 29–56.

Brown, Milton W. *American Painting from the Armory Show to the Depression.* Princeton, 1955.

———. *The Modern Spirit: American Painting, 1908–1935.* London, 1977.

———. *The Story of the Armory Show.* 2d ed. New York, 1988.

Bunnell, Peter C., ed. *A Photographic Vision: Pictorial Photography, 1889–1923.* Salt Lake City, 1980.

Chipp, Herschel B. *Theories of Modern Art.* Berkeley, 1968.

Coben, Stanley. *Rebellion against Victorianism: The Impetus for Cultural Change in 1920s America.* New York, 1991.

Coke, Van Deren. *The Painter and the Photograph: From Delacroix to Warhol.* Albuquerque, 1972.

The Color of Modernism: The American Fauves. New York, 1997.

Corn, Wanda M. *The Color of Mood: American Tonalism, 1880–1910.* San Francisco, 1972.

Craven, Wayne. *American Art: History and Culture.* Madison, 1994.

Crunden, Robert M. *American Salons: Encounters with European Modernism, 1885–1917.* New York, 1993.

———. *Body and Soul: The Making of American Modernism.* New York, 2000.

Davidson, Abraham A. *Early American Modernist Painting, 1910–1935.* New York, 1981.

Davis, Keith F. *An American Century of Photography: From Dry-Plate to Digital.* Kansas City, 1995.

The Decade of the Armory Show: New Directions in American Art, 1910–1920. New York, 1963.

Donne, John. "L'Art negre dans les ateliers de l'ecole de Paris, 1905–1920." *Arts d'Afrique noire* 71 (autumn 1989), 21–28.

Doty, Robert. *Photo-Secession: Photography as a Fine Art.* Rochester, 1960.

Douglas, Ann. *Terrible Honesty: Mongrel Manhattan in the 1920s.* New York, 1995.

Eldredge, Charles C. *American Imagination and Symbolist Painting.* New York, 1979.

———. "The Arrival of European Modernism." *Art in America* 61, 4 (July–August 1973), 35–41.

Flam, Jack. "The Spell of the Primitive; in Africa and Oceania Artists Found a New Vocabulary." *Connoisseur* 214 (September 1984), 124–131.

Foster, Stephen C., ed. *Crisis and the Arts: The History of Dada.* New York and London, 1996.

Foster, Stephen C. and Rudolf E. Kuenzli, eds. *Dada Spectrum: The Dialectics of Revolt.* Madison and Iowa City, 1979.

Four Americans in Paris: The Collections of Gertrude Stein and Her Family. New York, 1970.

Frascina, Francis and Jonathan Harris, eds. *Art in Modern Culture: An Anthology of Critical Texts.* New York, 1992.

Goddard, Donald. *American Painting.* New York, 1990.

Golding, John. *Visions of the Modern.* Berkeley, 1997.

Goldwater, Robert. *Symbolism.* New York, 1979.

———. *Primitivism in Modern Art.* Cambridge, Mass., 1986.

Greenough, Sarah, et al. *On the Art of Fixing a Shadow: One Hundred and Fifty Years of Photography.* Washington and Chicago, 1989.

Hambourg, Maria Morris and Christopher Phillips. *The New Vision: Photography Between the World Wars.* Reprint ed. New York, 1994.

Harper, Margaret F. *The Linked Ring.* London, 1979.

Harrison, Charles. *Modernism.* Cambridge, 1997.

Harrison, Charles, et al. *Primitivism, Cubism, Abstraction: The Early Twentieth Century.* New Haven, 1993.

Hartmann, Sadakichi. *The Valiant Knights of Daguerre: Selected Critical Essays on Photography.* Ed. Harry W. Lawton and George Knox. Berkeley, 1978.

Haskell, Barbara. *The American Century: Art and Culture 1900–1950.* New York, 1999.

Heller, Adele and Lois Rudnick, eds. *1915, The Cultural Moment: The New Politics, The New Woman, The New Psychology, The New Art and The New Theatre in America.* New Brunswick, 1991.

Henderson, Linda Dalrymple. "A New Facet of Cubism: 'The Fourth Dimension' and 'Non-Euclidean Geometry' Reinterpreted." *Art Quarterly* 34 (1971), 411–433.

———. *The Fourth Dimension and Non-Euclidean Geometry in Modern Art.* Princeton, 1983.

Hiller, Susan, ed. *The Myth of Primitivism: Perspectives on Art.* London and New York, 1991.

Hills, Patricia. *Turn-of-the-Century America: Paintings, Graphics, Photographs, 1890–1917.* New York, 1977.

Homer, William Innes. *Avant-Garde: Painting and Sculpture in America, 1910–25.* Wilmington, 1975.

Huelsenbeck, Richard. *Dada Almanach.* New York, 1966.

———. *Memoirs of a Dada Drummer.* Ed. Hans J. Kleinschmidt, trans. Joachim Neugroschel. Berkeley, 1991.

Hunter, Sam. *American Art of the 20th Century.* New York, 1972.

Hunter, Sam and John Jacobue. *Modern Art: Painting, Sculpture, Architecture.* 3d ed. New York, 1992.

Joachimides, Christos and Norman Rosenthal, eds. *American Art in the 20th Century: Painting and Sculpture, 1913–1933.* London and Munich, 1993.

Knight, Christopher. "On Native Ground: U.S. Modern." *Art in America* 71, 9 (October 1983), 166–174.

Kosinski, Dorothy. *The Artist and the Camera: Degas to Picasso.* New Haven and London, 1999.

Lane, John R. and Susan C. Larsen, eds. *Abstract Painting and Sculpture in America, 1927–1944.* New York, 1983.

Lears, T.J. Jackson. *No Place of Grace: Anti-Modernism and the Transformation of American Culture, 1880–1920.* Chicago, 1984.

Lehman, A.G. *The Symbolist Aesthetic in France, 1885–1895.* Oxford, 1950.

Levin, Gail. *Synchromism and American Color Abstraction, 1910–1925.* New York, 1978.

———. "Primitivism in American Art: Some Literary Parallels of the 1910s and 1920s." *Arts Magazine* 59 (November 1984), 101–105.

Lewis, Stephen E. "The Modern Gallery and American Commodity Culture." *MODERNISM/modernity* 4, 3 (September 1997), 67–92.

Martinez, Andrew. "A Mixed Reception for Modernism: The 1913 Armory Show at the Art Institute of Chicago." *Museum Studies* 19, 1 (1993), 30–57.

McDonnell, Patricia Joan. "American Artists in Expressionist Berlin: Ideological Crosscurrents in the Early Modernism of America and Germany, 1905–1915." Ph.D. diss., Brown University, 1991.

Moak, Peter van der Huyden. "Cubism and the New World: The Influence of Cubism on American Painting, 1910–1920." Ph.D. diss., University of Pennsylvania, 1970.

Morrin, Peter, Judith Zilczer, and William C. Agee. *The Advent of Modernism: Post-Impressionism and North American Art, 1900–1918.* Atlanta, 1986.

Motherwell, Robert, ed. *The Dada Painters and Poets: An Anthology.* Cambridge, Mass., and London, 1989.

Naumann, Francis. "The New York Dada Movement: Better Late than Never." *Arts Magazine* 54, 6 (February 1980), 143–149.

———. "Walter Conrad Arensburg: Poet, Patron, and Participant in the New York Avant Garde, 1915–1920." *Bulletin of the Philadelphia Museum of Art* 76 (spring 1980), 2–32.

———. *New York Dada, 1915–23.* New York, 1994.

———. *Making Mischief: Dada Invades New York.* New York, 1996.

The New Society of American Artists in Paris, 1908–1912. Flushing, 1986.

Newhall, Beaumont. *On Photography.* Watkins Glen, N.Y., 1956.

———. "Photography as Art in America." *Perspectives, USA* 15 (1956), 122–133.

———. *Photography: Essays and Images.* New York, 1980.

———. *The History of Photography: From 1839 to Present.* 5th ed. New York and Boston, 1994.

Newhall, Nancy. *From Adams to Stieglitz: Pioneers of Modern Photography.* New York, 1989.

1913 Armory Show; 50th Anniversary Exhibition, 1963. New York, 1963.

Olson, Arlene R. *Art Critics and the Avant-Garde, New York, 1900–1913.* Ann Arbor, 1980.

Paris—New York. Paris, 1977.

Peterson, Christian A. *After the Photo-Secession: American Pictorial Photography, 1910–1955.* New York, 1997.

Pohlmann, Ulrich. "The Dream of Beauty, or Truth Is Beauty, Beauty Truth, Photography and Symbolism, 1890–1914." In *Lost Paradise: Symbolist Europe.* Montreal, 1995.

Potter, Hugh McClellan. "The 'Romantic Naturalists' of the 1920s." Ph.D. diss., University of Minnesota, 1964.

Powell, Richard J. and David A. Bailey. *Rhapsodies in Black: Art of the Harlem Renaissance.* London, 1997.

Pultz, John and Catherine B. Scallen. *Cubism and American Photography, 1910–1930.* Williamstown, 1981.

Rhodes, Colin. *Primitivism and Modern Art.* New York, 1994.

Richter, Hans. *Dada: Art and Anti-Art.* New York, 1997.

Ringbom, Sixten. "Art in the Epoch of the Great Spiritual." *Journal of the Warburg and Courtauld Institute* 29 (1966), 386–419.

Risatti, Howard. "American Critical Reaction to European Modernism, 1908 to 1917." Ph.D. diss., University of Illinois at Urbana-Champaign, 1978.

———. "Music and the Development of Abstraction in America: The Decade Surrounding the Armory Show." *Art Journal* 39 (fall 1979), 8–13.

Ritchie, Andrew C. *Abstract Painting and Sculpture in America.* New York, 1951.

Robbins, Warren M. *African Art in American Collections, Survey 1989.* Washington, 1989.

Roeder, George H., Jr. *Forum of Uncertainty: Confrontations with Modern Painting in Twentieth-Century American Thought.* Ann Arbor, 1980.

Rookmaaker, H.R. *Gauguin and 19th Century Art Theory.* Amsterdam, 1972.

Rose, Barbara. *Readings on American Art since 1900.* New York, 1968.

——. *American Art since 1900.* Revised ed. New York, 1975.

Rubin, William, ed. *"Primitivism" in 20th Century Art: Affinity of the Tribal and the Modern.* New York, 1984.

Le Salon de photographie: Les Ecoles pictorialistes en Europe et aux Etats-Unis vers 1900. Paris, 1993.

Schimmel, Julie, William H. Truettner, and Charles C. Eldredge. *Art in New Mexico, 1900–1945: Paths to Taos and Santa Fe.* Washington, 1986.

Sekula, Allan. "On the Invention of Photographic Meaning." *Artforum* 13 (January 1975), 37–45.

Selz, Peter. *Beyond the Mainstream: Essays on Modern and Contemporary Art.* Cambridge and New York, 1997.

Shannon, Helen. "From 'African Savages' to 'Ancestral Legacy': Race and Cultural Nationalism in the American Modernist Reception of African Art." Ph.D. diss., Institute of Fine Arts, New York, 1999.

Sheon, Aaron. "1913: Forgotten Cubist Exhibitions in America." *Arts Magazine* 57 (March 1983), 93–107.

Smith, Bernard. *Modernism's History: A Study in Twentieth-Century Art and Ideas.* New Haven, 1998.

Solomon-Godeau, Abigail. *Photography at the Dock: Essays on Photographic History, Institutions, and Practices.* Minneapolis, 1991.

Stavitsky, Gail. *Gertrude Stein: The American Connection.* New York, 1990.

Udall, Sharyn Rohlfsen. *Modernist Painting in New Mexico, 1913–1935.* Albuquerque, 1984.

Tashjian, Dickran. *Skyscraper Primitivism: Dada and the American Avant-Garde, 1910–1925.* Middletown, Conn., 1975.

——. *A Boatload of Madmen: Surrealism and the American Avant-Garde, 1920–1950.* New York, 1995.

Travis, David. *Photography Rediscovered: American Photographs, 1900–1930.* New York, 1979.

Tsujimoto, Karen. *Images of America: Precisionist Painting and Modern Photography.* San Francisco, 1982.

Versaci, Nancy and Judith Tolnick. *Over Here: Modernism, the First Exile, 1914–1919.* Providence, 1989.

Watson, Steven. *Strange Bedfellows: The First American Avant-Garde.* New York, 1991.

Webb, Virginia-Lee. *Perfect Documents: Walker Evans and African Art, 1935.* New York, 2000.

Wechsler, Jeffrey with Jack J. Spector. *Surrealism and American Art, 1931–1947.* New Brunswick, 1976.

Weinberg, Barbara H., Doreen Bolger, and David Park Curry. *American Impressionism and Realism: The Painting of Modern Life, 1885–1915.* New York, 1994.

Wertheim, Arthur Frank. *The New York Little Renaissance: Iconoclasm, Modernism, and Nationalism in American Culture, 1908–1917.* New York, 1976.

Wilson, Richard Guy, Dianne H. Pilgrim, and Dickran Tashjian. *The Machine Age in America, 1918–1941.* New York, 1986.

Zabel, Barbara. "The Machine as Metaphor, Model, and Microcosm: Technology in American Art, 1915–1930." *Arts Magazine* 57 (December 1982), 100–105.

Zilczer, Judith. "'The World's New Art Center': Modern Art Exhibitions in New York City, 1913–1918." *Archives of American Art Journal* 14, 3 (1974), 2–7.

——. "Primitivism and New York Dada." *Arts Magazine* 51 (May 1977), 140–142.

B. ARTISTS

CONSTANTIN BRANCUSI

L'Atelier Brancusi. Paris, 1997.

Bach, Friedrich Teja, Margit Rowell, and Ann Temkin. *Constantin Brancusi, 1876–1957.* Philadelphia, 1995.

Brown, Elizabeth A. *Constantin Brancusi: Photographer.* Paris, 1995.

Chave, Anna. *Brancusi: Shifting the Bases of Art.* New Haven, 1993.

Frizot, Michel. "Les Photographies de Brancusi, une sculpture de la surface." *Les Cahiers du Musée National d'Art Moderne* 54 (winter 1995), 35–49.

Geist, Sidney. *Constantin Brancusi, 1876–1957: A Retrospective Exhibition.* New York, 1969.

——. "Brancusi, the Meyers, and Portrait of Mrs. Eugene Meyer, Jr." *Studies in the History of Art* 6 (1974), 188–212.

——. *Brancusi: The Sculpture and Drawings.* New York, 1975.

——. *Brancusi: A Study of the Sculpture.* New York, 1983.

Hulten, Pontus, Marielle Tabart, and Isabelle Monod-Fontaine. *Brancusi, Photographer.* Trans. Kim Sichel. New York, 1979.

Hulten, Pontus, et al. *Brancusi.* New York, 1987.

Kramer, Hilton. *Brancusi: The Sculptor as Photographer.* Lyme, Conn., 1979.

Miller, Sandra. "Constantin Brancusi's Photographs." *Artforum* 19 (March 1981), 38–44.

——. *Constantin Brancusi: A Survey of His Work.* Oxford and New York, 1995.

Shanes, Eric. *Constantin Brancusi.* New York, 1989.

Varia, Radu. *Brancusi.* New York, 1996.

Vetrocq, Marcia E. "Re-reading Brancusi: The Philadelphia Story." *Art in America* 84 (January 1996), 60–63+.

GEORGES BRAQUE

Cafritz, Robert. *Georges Braque.* Ed. Jan Lancaster. Washington, 1982.

Clement, Russell T. *Georges Braque: A Bio-Bibliography.* Westport, Conn., 1994.

Cooper, Douglas. *The Essential Cubism: Braque, Picasso and Their Friends, 1907–1920.* London, 1983.

Fauchereau, Serge. *Braque.* Trans. Kenneth Lyons. New York, 1987.

Poggi, Christine. *In Defiance of Painting: Cubism, Futurism, and the Invention of Collage.* New Haven, 1992.

Rubin, William. *Picasso and Braque: Pioneering Cubism.* New York, 1989.

Wilkin, Karen. *Georges Braque.* New York, 1991.

Zurcher, Bernard. *Georges Braque, Life and Work.* Trans. Simon Nye. New York, 1988.

PAUL CÉZANNE

Cachin, Françoise, et al. *Cézanne.* Trans. John Goodman. New York, 1996.

Cézanne, Paul. *A Cézanne Sketchbook: Figures, Portraits, Landscapes, and Still Lifes.* New York, 1985.

Fry, Roger. *Cézanne: A Study of His Development.* Chicago, 1989.

Geist, Sidney. *Interpreting Cézanne.* Cambridge, Mass., 1988.

Gowing, Lawrence. *Cézanne: The Early Years, 1859–1872.* New York, 1988.

Kendall, Richard, ed. *Cézanne by Himself: Drawings, Paintings, Writings.* London, 1988.

Kyle, Jill Anderson. "Cézanne and American Painting, 1900 to 1920." Ph.D. diss., University of Texas, Austin, 1995.

Lewis, Mary Tomkins. *Cézanne's Early Imagery.* Berkeley, 1989.

Machotka, Pavel. *Cézanne: Landscape into Art.* New Haven, 1996.

Rewald, John. *Paul Cézanne, the Watercolors: A Catalogue Raisonné.* Boston, 1983.

———. *Cézanne, the Steins and Their Circle.* New York, 1987.

———. *Cézanne and America: Dealers, Collectors, Artists and Critics, 1891–1921.* Princeton, 1989.

Rewald, John, ed. *Paul Cézanne, Letters.* Trans. Marguerite Kay. New York, 1995.

Rewald, John with Walter Feilchenfeldt and Jayne Warman. *The Paintings of Paul Cézanne: A Catalogue Raisonné.* New York, 1996.

Rilke, Rainer Maria. *Letters on Cézanne.* Ed. Clara Rilke, trans. Joel Agee. New York, 1985.

Shiff, Richard. *Cézanne and the End of Impressionism: A Study of the Theory, Technique, and Critical Evaluation of Modern Art.* Chicago, 1984.

———. *Paul Cézanne.* New York, 1994.

Yount, Sylvia and Elizabeth Johns. *To Be Modern: American Encounters with Cézanne and Company.* Philadelphia, 1996.

CHARLES DEMUTH

Corn, Wanda M. *In the American Grain: The Billboard Poetics of Charles Demuth.* Poughkeepsie, N.Y., 1991.

Eiseman, Alvord L. "A Study of the Development of an Artist: Charles Demuth." Ph.D. diss., New York University, 1976.

———. *Charles Demuth.* New York, 1982.

Fahlman, Betsy. *Pennsylvania Modern: Charles Demuth of Lancaster.* Philadelphia, 1983.

Farnham, Emily. *Charles Demuth: Behind a Laughing Mask.* Norman, Okla., 1971.

Frank, Robin Jaffee. *Charles Demuth: Poster Portraits, 1923–1929.* New Haven, 1994.

Gallatin, A.E. *Charles Demuth.* New York, 1927.

Gebhard, David and Phyllis Plous, eds. *Charles Demuth: The Mechanical Encrusted on the Living.* Santa Barbara, 1971.

Haskell, Barbara. *Charles Demuth.* New York, 1988.

Murrell, William. *Charles Demuth.* New York, 1931.

Norton, Thomas E., ed. *Homage to Charles Demuth: Still Life Painter of Lancaster.* Ephrata, Pa., 1978.

Ritchie, Andrew Carnduff. *Charles Demuth.* New York, 1950.

Weinberg, Jonathan. *Speaking for Vice: Homosexuality in the Art of Charles Demuth, Marsden Hartley, and the First American Avant-Garde.* New Haven and London, 1993.

ARTHUR DOVE

Arthur G. Dove, 1880–1946: A Retrospective Exhibition. Ithaca, 1954.

Balken, Debra Bricker. *Arthur Dove: A Retrospective.* Andover, Cambridge, Mass., and Washington, 1998.

Cohn, Sherrye. "The Dialectical Vision of Arthur Dove: The Impact of Science and Occultism on His Modern American Art." Ph.D. diss., University of Washington, 1982.

———. "The Image and the Imagination of Space in the Art of Arthur Dove; Part I: Dove's 'Force Lines, Growth Lines' as Emblems of Energy." *Arts Magazine* 58 (December 1983), 90–93.

Fillin-Yeh, Susan. "Innovative Moderns: Arthur G. Dove and Georgia O'Keeffe." *Arts Magazine* 56 (June 1982), 68–72.

Haskell, Barbara. *Arthur Dove.* San Francisco and Boston, 1975.

Johnson, Dorothy Rylander. *Arthur Dove: The Years of Collage.* College Park, Md., 1967.

Morgan, Ann Lee. "Toward the Definition of Early Modernism in America: A Study of Arthur Dove." Ph.D. diss., University of Iowa, 1973.

———. *Arthur Dove: Life and Work: With a Catalogue Raisonné.* Newark, Del., London, and Toronto, 1984.

Morgan, Ann Lee, ed. *Dear Stieglitz, Dear Dove.* Newark, Del., 1988.

Newman, Sasha M. *Arthur Dove and Duncan Phillips: Artist and Patron.* Washington and New York, 1981.

Wight, Frederick S. *Arthur G. Dove.* Berkeley, 1958.

MARCEL DUCHAMP

Ades, Dawn. *Marcel Duchamp.* New York, 1999.

Camfield, William A. *Marcel Duchamp, Fountain.* Houston, 1989.

Duchamp, Marcel. *Marcel Duchamp, Notes.* Ed. Paul Matisse with Pontus Hulten. Paris, 1999.

de Duve, Thierry. *Kant after Duchamp.* Cambridge, Mass., and London, 1996.

Fillin-Yeh, Susan. "Dandies, Marginality and Modernism: Georgia O'Keeffe, Marcel Duchamp and Other Cross-Dressers." *The Oxford Art Journal* 18, 2 (1995), 33–44.

d'Harnoncourt, Anne and Kynaston McShine, eds. *Marcel Duchamp.* New York and Philadelphia, 1973.

Jones, Amelia. *Postmodernism and the En-gendering of Marcel Duchamp.* Cambridge and New York, 1994.

Joselit, David. *Infinite Regress: Marcel Duchamp, 1910–1941*. Cambridge, 1998.

Kuenzli, Rudolf and Francis M. Naumann. *Marcel Duchamp: Artist of the Century*. Cambridge, Mass., and London, 1989.

Naumann, Francis. *Marcel Duchamp: The Art of Making Art in the Age of Mechanical Reproduction*. London, 1999.

Ramírez, Juan Antonio. *Duchamp: Love and Death, Even*. Trans. Alexander R. Tulloch. London, 1998.

Tomkins, Calvin. *Duchamp: A Biography*. New York, 1996.

Weiss, Jeffrey. *The Popular Culture of Modern Art: Picasso, Duchamp, and Avant-Gardism*. New Haven, 1994.

MARSDEN HARTLEY

Burlingame, Robert. "Marsden Hartley." Ph.D. diss., Brown University, 1954.

Ferguson, Gerald, ed. *Marsden Hartley and Nova Scotia*. Halifax, 1987.

Gallup, Donald. "Hartley and Stein." *Magazine of Art* 41 (1948), 256–261.

Harithas, James. "Marsden Hartley's German Period Abstractions." *Corcoran Gallery of Art Bulletin* 16 (November 1967), 22–26.

Hartley, Marsden. *Cleophas and His Own: A North Atlantic Tragedy*. Halifax, 1982.

——. *On Art*. Ed. Gail Scott. New York, 1982.

——. *Somehow a Past: The Autobiography of Marsden Hartley*. Ed. Susan Elizabeth Ryan. Cambridge, Mass., and London, 1995.

Haskell, Barbara. *Marsden Hartley*. New York, 1980.

Hokin, Jeanne. *Pinnacles and Pyramids: The Art of Marsden Hartley*. Albuquerque, 1993.

Homer, William Innes, ed. *Heart's Gate: Letters between Marsden Hartley and Horace Traubel, 1906–1915*. Highlands, N.C., 1982.

Levin, Gail. "Marsden Hartley, Kandinsky, and Der Blaue Reiter." *Arts Magazine* 52 (November 1977), 156–160.

——. "Marsden Hartley and the European Avant-Garde." *Arts Magazine* 54 (September 1979), 158–163.

——. "Hidden Symbolism in Marsden Hartley's Military Pictures." *Arts Magazine* 54, 2 (October 1979), 154–158.

——. *Marsden Hartley: Six Berlin Paintings, 1913–1915*. New York, 1992.

——. "Photography's Appeal to Marsden Hartley." *Yale University Library Gazette* 68, 1–2 (1993), 12–42.

Ludington, Townsend. *Marsden Hartley: The Biography of an American Artist*. Boston, 1992.

Marsden Hartley, 1877–1943. Long Island, 1977.

Marsden Hartley, 1908–1942: The Ione and Hudson D. Walker Collection. Minneapolis, 1984.

Marsden Hartley: Painter/Poet 1877–1943. Los Angeles and Austin, 1969.

Marsden Hartley: A Retrospective Exhibition. New York, 1969.

McCausland, Elizabeth. *Marsden Hartley*. Minneapolis, 1952.

——. "The Return of the Native: Marsden Hartley." *Art in America* 40 (September 1952), 55–79.

McDonnell, Patricia. " 'Dictated by Life': Spirituality in the Art of Marsden Hartley and Wassily Kandinsky, 1910–1915." *Archives of American Art Journal* 29, 1–2 (1989), 27–34.

——. *Marsden Hartley: American Modern*. Minneapolis and Seattle, 1997.

Robertson, Bruce. *Marsden Hartley*. New York and Washington, 1995.

Scott, Gail. *Marsden Hartley*. New York, 1988.

Scott, Gail, ed. *On Art by Marsden Hartley*. New York, 1982.

——. *The Collected Poems of Marsden Hartley, 1904–1943*. Santa Rosa, 1987.

"Seventy-Five Pictures by James N. Rosenberg and 117 Pictures by Marsden Hartley." Auction catalogue. New York, 1921.

Tashjian, Dickran. "Marsden Hartley and the Southwest: A Ceremony for Our Vision, A Fiction for the Eye." *Arts Magazine* 54 (April 1980), 127–131.

Weinberg, Jonathan. *Speaking for Vice: Homosexuality in the Art of Charles Demuth, Marsden Hartley, and the First American Avant-Garde*. New Haven and London, 1993.

JOHN MARIN

Fine, Ruth E. *John Marin*. Washington and New York, 1990.

Gray, Cleve. *John Marin by John Marin*. New York, 1970.

Helm, MacKinley. *John Marin*. New York and Boston, 1948.

John Marin: Memorial Exhibition. Los Angeles, 1955.

John Marin in Retrospect. Washington, 1962.

Norman, Dorothy, ed. *The Selected Writings of John Marin*. New York, 1949.

Reich, Sheldon. *John Marin: Oils, Watercolors, and Drawings*. Philadelphia, 1969.

——. *John Marin: A Stylistic Analysis and Catalogue Raisonné*. 2 vols. Tucson, 1970.

Zigrosser, Carl. *The Complete Etchings of John Marin*. Philadelphia, 1969.

HENRI MATISSE

Barr, Alfred H., Jr. *Henri Matisse*. New York, 1931.

——. *Matisse, His Art and His Public*. New York, 1951.

Cauman, John H. "Matisse and America, 1905–1933." Ph.D. diss., The City University of New York, 2000.

Duthuit, Claude with Wanda de Guébriant. *Henri Matisse: Catalogue Raisonné de l'Oeuvre Sculpté*. Paris, 1997.

Elderfield, John, ed. *Henri Matisse: A Retrospective*. New York, 1993.

Elsen, Albert. *The Sculpture of Henri Matisse*. New York, 1972.

Flam, Jack. *Matisse: The Man and His Art, 1869–1918*. Ithaca and London, 1986.

——. *Matisse: A Retrospective*. New York, 1988.

Gilot, Françoise. *Matisse and Picasso, A Friendship in the Arts*. New York, 1990.

Golding, John. *Matisse and Cubism*. Glasgow, 1978.

Gowing, Lawrence. *Matisse.* London and New York, 1979.

Herbert, James D. *Fauve Painting: The Making of Cultural Politics.* New Haven and London, 1992.

Matisse, Henri. *Matisse on Art.* Ed. Jack Flam. New York, 1973.

Mezzatesta, Michael. *Henri Matisse—Sculptor/Painter.* Fort Worth, 1984, 74–79.

Monod-Fontaine, Isabelle. *The Sculpture of Henri Matisse.* London, 1984, 9–17.

——. *Matisse.* Paris, 1989.

Schneider, Pierre. *Matisse.* Trans. Michael Taylor and Bridget Stevens Romer. New York, 1984.

GEORGIA O'KEEFFE

Castro, Jan Garden. *The Art and Life of Georgia O'Keeffe.* New York, 1985.

Cowart, Jack and Juan Hamilton with Sarah Greenough. *Georgia O'Keeffe: Art and Letters.* Washington and Boston, 1988.

Dijkstra, Bram. *Georgia O'Keeffe and the Eros of Place.* Princeton, 1998.

Eldredge, Charles C. *Georgia O'Keeffe.* New York, 1991.

——. *Georgia O'Keeffe: American and Modern.* New Haven and London, 1993.

Fillin-Yeh, Susan. "Innovative Moderns: Arthur G. Dove and Georgia O'Keeffe." *Arts Magazine* 56 (June 1982), 68–72.

——. "Dandies, Marginality and Modernism: Georgia O'Keeffe, Marcel Duchamp and Other Cross-Dressers." *The Oxford Art Journal* 18, 2 (1995), 33–44.

Fine, Ruth E. and Barbara Buhler Lynes. *O'Keeffe on Paper.* Washington and Santa Fe, 2000.

Fine, Ruth E., et al. *The Book Room: Georgia O'Keeffe's Library in Abiquiu.* New York, 1997.

Georgia O'Keeffe and Her Contemporaries. Amarillo, 1985.

Gherman, Beverly. *Georgia O'Keeffe: The "Wideness and Wonder" of Her World.* New York, 1986.

Giboire, Clive, ed. *Lovingly, Georgia: The Complete Correspondence of Georgia O'Keeffe and Anita Pollitzer.* New York, 1990.

Goethals, Marion M. *Georgia O'Keeffe: Natural Issues, 1918–1924.* Williamstown, 1992.

Goodrich, Lloyd and Doris Bry. *Georgia O'Keeffe.* New York, 1970.

Greenough, Sarah, ed. With Jack Cowart and Juan Hamilton. *Georgia O'Keeffe: Art and Letters.* Washington and Boston, 1988.

Hassrick, Peter H., ed. *The Georgia O'Keeffe Museum.* New York and Santa Fe, 1997.

Hoffman, Katherine. *An Enduring Spirit: The Art of Georgia O'Keeffe.* Metuchen, N.J., and London, 1984.

Kornhauser, Elizabeth Mankin and Amy Ellis, with Maura Lyons. *Stieglitz, O'Keeffe and American Modernism.* Hartford, 1999.

Lisle, Laurie. *Portrait of an Artist: A Biography of Georgia O'Keeffe.* New York, 1980.

Loengard, John. *Georgia O'Keeffe at Ghost Ranch: A Photo Essay.* New York, 1994.

Lynes, Barbara Buhler. *Georgia O'Keeffe: Catalogue Raisonné.* 2 vols. New Haven, London, Washington, and Abiquiu, 1999.

Messinger, Lisa Mintz. *Georgia O'Keeffe.* New York, 1988.

O'Keeffe, Georgia. *Georgia O'Keeffe.* New York, 1976.

Patten, Christine Taylor and Alvaro Cardona-Hine. *Miss O'Keeffe.* Albuquerque, 1992.

Patten, Christine Taylor and Myron Wood. *O'Keeffe at Abiquiu.* New York, 1995.

Peters, Sarah Whitaker. *Becoming O'Keeffe: The Early Years.* New York, 1991.

Pincus-Witten, Robert. *Georgia O'Keeffe: Selected Paintings and Works on Paper.* New York, 1986.

Pollitzer, Anita. "That's Georgia." *Saturday Review of Literature* 4 (November 1950), 41–43.

——. *A Woman on Paper: Georgia O'Keeffe.* New York, 1988.

Robinson, Roxana. *Georgia O'Keeffe: A Life.* New York, 1989.

Turner, Elizabeth. *Georgia O'Keeffe: The Poetry of Things.* Washington and New Haven, 1999.

Udall, Sharyn R. *O'Keeffe and Texas.* San Antonio, 1998.

Wagner, Anne Middleton. *Three Artists (Three Women): Modernism and the Art of Hesse, Krasner, and O'Keeffe.* Berkeley, 1996.

Wilder, Mitchell A. *Georgia O'Keeffe: An Exhibition of the Work of the Artist from 1915 to 1966.* Fort Worth, 1966.

FRANCIS PICABIA

Borràs, Maria Lluïsa. *Picabia.* New York, 1985.

Camfield, William A. *Francis Picabia.* New York, 1970.

——. *Francis Picabia: His Art, Life and Times.* Princeton, 1979.

Francis Picabia: Máquinas y Españolas. Valencia, 1995.

Homer, William Innes. "Picabia's *Jeune fille américaine dans l'état de nudité* and Her Friends." *The Art Bulletin* 57 (March 1975), 110–115.

LeBot, Marc. *Francis Picabia et la crise des valeurs figuratives, 1900–1920.* Paris, 1969.

Picabia, Francis. *Écrits, 1913–1920.* Ed. Olivier Revault d'Allonnes. Paris, 1975.

——. *Who Knows: Poems and Aphorisms.* Trans. Remy Hall. Madras and New York, 1986.

——. *Yes no: Poems and Sayings.* Trans. Remy Hall. New York, 1990.

Rozaitis, William. "The Joke at the Heart of Things: Francis Picabia's Machine Drawings and the Little Magazine 291." *American Art* 8, 3–4 (summer–fall 1994), 42–60.

391 25 (January 1917–November 1924).

291 5–6 (July–August 1915).

Wilson, Sarah. *Francis Picabia: Accommodations of Desire.* New York, 1989.

PABLO PICASSO

Baldassari, Anne. *Picasso Photographe, 1901–1916.* Paris, 1994.

——. *Picasso et la photographie: "À plus grande vitesse que les images."* Paris, 1995.

——. *Le Miroir noir, Picasso sources photographiques, 1900–28.* Paris, 1997.

———. *Picasso and Photography: The Dark Mirror.* Paris and Houston, 1997.

Cooper, Douglas. *The Essential Cubism: Braque, Picasso and Their Friends, 1907–1920.* London, 1983.

Daix, Pierre. *Picasso: Life and Art.* Trans. Olivia Emmet. New York, 1994.

Fontcuberta, Joan. "Señor Pablo's Unseen Photographs." *Aperture* 142 (winter 1996), 92–93.

Green, Christopher. "Zervos, Picasso and Brassaï, Ethnographers in the Field: A Critical Collaboration." In Malcolm Gee, ed., *Art Criticism since 1900,* 116–139. Manchester and New York, 1993.

Karmel, Joseph Low [Pepe]. "Picasso's Laboratory: The Role of His Drawings in the Development of Cubism, 1910–14." Ph.D. diss., Institute of Fine Arts, New York, 1993.

Leighten, Patricia. "The White Peril and L'Art Negre: Picasso, Primitivism, and Anti-Colonialism." *The Art Bulletin* 72 (December 1990), 609–630.

Poggi, Christine. *In Defiance of Painting: Cubism, Futurism, and the Invention of Collage.* New Haven, 1992.

Richardson, John, with Marilyn McCully. *A Life of Picasso.* Vols. 1 (1881–1906) and 2 (1907–1917). New York, 1991–1996.

Rubin, William, ed. *Pablo Picasso: A Retrospective.* New York and Boston, 1980.

———. *Picasso and Braque: Pioneering Cubism.* New York, 1989.

Stein, Gertrude. *Picasso: The Complete Writings.* Ed. Edward Burns. Boston, 1985.

Tucker, Paul Hayes. "Picasso, Photography, and the Development of Cubism." *The Art Bulletin* 64 (June 1982), 288–299.

Weiss, Jeffrey. *The Popular Culture of Modern Art: Picasso, Duchamp, and Avant-Gardism.* New Haven, 1994.

Zervos, Christian. *Pablo Picasso.* Paris, 1942–.

AUGUSTE RODIN

Alexandre, Arsène. *L'Oeuvre de Rodin.* Paris, 1900.

Butler, Ruth. *Rodin: The Shape of Genius.* New Haven, 1993.

Crone, Rainer and Siegfried Salzmann, eds. *Rodin: Eros and Creativity.* New York, 1997.

Daix, Pierre. *Rodin.* Paris, 1988.

Elsen, Albert. *In Rodin's Studio: A Photographic Record of Sculpture in the Making.* Oxford, 1980.

———. *Rodin's Thinker and the Dilemmas of Modern Public Sculpture.* New Haven, 1985.

Elsen, Albert E., ed. *Rodin Rediscovered.* Washington, 1981.

Grunfeld, Frederic. *Rodin, A Biography.* New York, 1998.

Jarrassé, Dominique. *Rodin: A Passion for Movement.* Paris, 1995.

Pinet, Hélène. *Les Photographes de Rodin.* Paris, 1986.

———. *Rodin: The Hands of Genius.* Trans. Caroline Palmer. New York, 1992.

Sillevis, John. "Rodin's First One-Man Show." *The Burlington Magazine* 137, 1113 (December 1995), 832–837.

EDWARD STEICHEN

Camera Work (April 1906). Special Steichen supplement.

Gedrim, Ronald J. *Edward Steichen: Selected Texts and Bibliography.* New York, 1996.

Harley, Ralph L., Jr. "Eduard Steichen's Modernist Art-Space." *History of Photography* 14, 1 (January–March 1990), 1–22.

Haskell, Barbara. *Edward Steichen.* New York, 2000.

History of Photography 17, 4 (winter 1993). Special Steichen issue.

Homer, William Innes. "Eduard Steichen as Painter and Photographer, 1897–1908." *American Art Journal* 6, 2 (November 1974), 45–55.

Johnston, Patricia. *Real Fantasies: Edward Steichen's Advertising Photography.* Berkeley, 1997.

Longwell, Dennis. *Steichen, The Master Prints 1895–1914: The Symbolist Years.* New York, 1978.

Niven, Penelope. *Steichen: A Biography.* New York, 1997.

Peterson, Christian. *Edward Steichen: The Portraits.* San Francisco, 1984.

Phillips, Christopher. *Steichen at War.* New York, 1981.

Sandeen, Eric J. *Picturing an Exhibition: The Family of Man and 1950s America.* Albuquerque, 1995.

Sekula, Allan. "The Instrumental Image: Steichen at War." *Artforum* 14, 4 (December 1975), 26–35.

Smith, Joel. *Edward Steichen: The Early Years.* Princeton and New York, 1999.

Steichen, Edward. *The Family of Man: 30th Anniversary Edition of the Classic Book of Photography.* New York, 1983.

———. *A Life in Photography.* New York, 1984.

Steichen, Joanna. *Steichen's Legacy: Photographs, 1879–1973.* New York, 2000.

Steichen the Photographer. New York, 1961.

Tuggle, Catherine. "Steichen and the Photography-as-Art Debate: Silencing the Cuckoo's Call." *History of Photography* 17, 4 (winter 1993), 343–350.

PAUL STRAND

Coke, Van Deren. "The Cubist Photographs of Paul Strand and Morton Schamberg." In *One Hundred Years of Photographic History: Essays in Honor of Beaumont Newhall,* 35–52. Albuquerque, 1975.

Denton, Sharon. *Paul Strand Archive.* Center for Creative Photography, University of Arizona, Tucson, 1980.

Greenough, Sarah. *Paul Strand.* Washington, 1990.

Hambourg, Maria Morris. *Paul Strand: Circa 1916.* New York, 1998.

Newhall, Nancy. *Paul Strand: Photographs 1915–1945.* New York, 1945.

———. *Time in New England.* New York, 1950.

Paul Strand. New York, 1987.

Paul Strand. 2 vols. Zurich, 1987–1990.

Paul Strand: An Extraordinary Vision. Santa Fe, 1994.

Paul Strand: Rebecca. New York, 1996.

Paul Strand: A Retrospective Monograph, The Years 1915–1968. New York, 1971.

Paul Strand: The Stieglitz Years at 291 (1915–1917). New York, 1978.

Rathbone, Belinda. "Portrait of a Marriage: Paul Strand's Photographs of Rebecca." *The J. Paul Getty Museum Journal* 17 (1989), 83–98.

Rosenblum, Naomi. "Paul Strand: The Early Years, 1910–1932." Ph.D. diss., City University of New York, 1978.

Tomkins, Calvin. *Paul Strand: Sixty Years of Photographs.* New York, 1976.

Yates, Steve. *The Transition Years: Paul Strand in New Mexico.* Santa Fe, 1989.

Zavattini, Cesare and Paul Strand. *Un Paese: Portrait of an Italian Village.* New York, 1997.

MARIUS DE ZAYAS

Bailey, Craig R. "The Art of Marius de Zayas." *Arts Magazine* 53 (September 1978), 136–143.

Bohn, Willard. "The Abstract Vision of Marius de Zayas." *The Art Bulletin* 62 (September 1980), 434–452.

——. "Marius de Zayas and Visual Poetry: 'Mental Reactions.' " *Arts Magazine* 55 (June 1981), 114–117.

Hyland, Douglas. *Marius de Zayas: Conjurer of Souls.* Lawrence, Kans., 1981.

Schneider, Luis Mario. *M. de Zayas: Acopio Mexicano.* Xalapa, 1992.

de Zayas, Marius. *African Negro Art.* New York, 1916.

——. "How, When, and Why Modern Art Came to New York." *Arts Magazine* 54 (April 1980), 96–125.

——. *How, When, and Why Modern Art Came to New York.* Ed. Francis M. Naumann. Cambridge, Mass., and London, 1996.

——. *La evolución del arte moderno.* Mexico City, Breve Fondo Editorial, 1997.

de Zayas, Marius and Paul Haviland. *A Study of the Modern Evolution of Plastic Expression.* New York, 1913.

ACKNOWLEDGMENTS

We have been actively working on this exhibition and book for five years and talking about it for almost twice as long, and since the beginning have asked many people to accomplish difficult tasks and to give time and energy to the project. That so many have responded with enthusiasm and good spirit is a testament to their great generosity. The brief acknowledgments that follow cannot convey the full extent of our gratitude.

From its inception this project has had the enthusiastic support of Earl A. Powell III, director, National Gallery of Art, and Alan Shestack, deputy director and chief curator. Their insightful contributions, as well as those of D. Dodge Thompson, chief of exhibitions, and Mark Leithauser, chief of design, have immensely aided this undertaking, helping to clarify ideas and strengthen the argument. With great sadness and respect, we also acknowledge the critical roles played in the formulation of both the exhibition and its accompanying catalogue by the late Gaillard F. Ravenel and Frances P. Smyth, the former heads and guiding lights, respectively, of the department of installation and design and editors office. Their passionate and infectious commitment to beauty, scholarship, and ideas enriched not just this project but countless others during their long tenures.

The staff of the department of photographs worked long and hard. A very special note of thanks is owed to Charles Brock, research associate, for his critical contributions to all phases of the planning, organization, and execution of the project. It is no exaggeration to say that without his work it could not have been done. In addition, April Watson, curatorial assistant, immeasurably helped our efforts through her thorough and meticulous organization of many aspects of the catalogue. Janet Blyberg, assistant for the Alfred Stieglitz Project, conducted early research that proved invaluable. Julia Thompson, assistant curator, also provided great help with her knowledge of the Gallery's photography collection. In addition, we thank our former staff assistants Laura Prochnow and Noelle Giguerre for the support they gave us. Because this project includes such a wide variety of mediums—paintings, photographs, sculpture, drawings, and prints—from Europe, America, and Africa, we have also drawn often and frequently on the expertise of fellow curators here at the Gallery who have shared their insights and expertise concerning individual artists, collections, and collectors. In this regard, Mr. Brock and I are particularly indebted to Nancy Anderson, Judith Brodie, Nicolai Cikovsky, Philip Conisbee, Ruth E. Fine, Franklin Kelly, Andrew Robison, and Jeffrey Weiss.

The book is the result of the collaborative efforts of several people. Mary Yakush, senior editor, deserves special recognition and deep thanks for helping to conceptualize and edit its contents so that it forms a cohesive whole. In the editors office now headed by Judy Metro, Susan Higman and Chris Vogel are to be thanked profusely for their sensitive editing and beautiful production, as are Laura Lindgren and Celia Fuller of Lindgren/Fuller Design for their thoughtful design and willingness to accommodate our many and often last-minute changes. We are once again indebted to photographer Robert Hennessey for his unmatched expertise in creating the films from which the reproductions of the photographs are printed.

The task of gathering the more than 190 works in the exhibition has required the concerted effort of many on the Gallery staff, particularly Jessica Stewart, Abbie Sprague, Kathleen McCleery Wagner, Jennifer Fletcher Cipriano, and Jonathan Walz, department of exhibitions, who expertly coordinated the loans; and Sally Freitag, Michelle Fondas, and Daniel Shay, registrar's office, who worked long hours to ensure the safe transport of all exhibited works. Carol Kelley, director's office; Joseph Krakora, external and international affairs; Chris Myers and Sandy Masur, corporate relations office; Ruth Anderson Coggeshall, Cathryn Scoville, and Patty Donovan, development office, have all supported the project in myriad ways, as have Deborah Ziska and Lisa Knapp of the information office; Elizabeth Croog and Nancy Robinson Breuer, office of the secretary-general counsel; Nancy Hoffmann of the treasurer's office; and Susan MacMillan Arensberg, exhibition programs. In addition, we thank Hugh Phibbs, Ann Hoenigswald, Constance McCabe, Shelley G. Sturman, Judith Walsh, and Stephan Wilcox, conservation department; Ava Lambert, Carlotta Owens, and Charles Ritchie, modern prints and drawings; Genevra O. Higginson, special events; Faya Causey and Rachel Schulze, academic programs; and Ted Dalziel and Thomas McGill, Jr., library. Neal Turtell, executive librarian, is to be thanked for many things, especially his efforts to locate copies of *291*. We are grateful to Ira Bartfield and Sara Sanders-Buell, photographic services, for assembling photographs of all exhibited works. A special debt is owed to Gordon Anson, Barbara Keyes, Linda Heinrich, and John Olson, installation and design, for enabling us to convey the spirit of Stieglitz's original exhibitions.

Several interns have made substantial contributions to our efforts and infused this project with their enthusiasm. We enjoyed the time we spent with all of them, and Mr. Brock and I would especially like to thank Lee Bickerstaff, Leah Dickerson, Amy Fowler, Barbara Goldstein, Laura Groves, David Hart, Lynn Matheny, Anne Mitzen, Medha Patel, Nathalie Ryan, and Emily Shapiro.

The project rests upon the foundation laid by earlier scholars who have studied Stieglitz and the artists, photographers, intellectuals, and others associated with

him. In addition to the authors cited in the bibliography, early accounts by Dorothy Norman and Herbert Seligmann and the subsequent work of Edward Abrahams, Doris Bry, Wanda Corn, Bram Dijkstra, Robert Doty, Benita Eisler, Charles Eldredge, William Innes Homer, Laurie Lisle, Sue Davidson Lowe, Ann Lee Morgan, Francis M. Naumann, Sarah W. Peters, Roxanna Robinson, Anne Wagner, and Richard Whelan have been of immense help. We thank all of the catalogue authors—William C. Agee, Charles Brock, John Cauman, Ruth E. Fine, Pepe Karmel, Jill Kyle, Barbara Buhler Lynes, Townsend Ludington, Anne McCauley, Bruce Robertson, Helen M. Shannon, and Ann Temkin—who have enriched this project not only through their essays, but also with advice.

Several museums have each lent many works, and without their support this exhibition would not have been possible. We would like to pay special recognition to Jay Clarke, Douglas Druick, Mark Pascale, and Daniel Schulman at The Art Institute of Chicago; Maria Morris Hambourg, William Lieberman, and Nan Rosenthal at the Metropolitan Museum of Art; Peter Galassi, Margit Rowell, and Kirk Varnedoe at the Museum of Modern Art; Ann Percy, Joseph Rishel, Innis Howe Shoemaker, and Katherine Ware at the Philadelphia Museum of Art; and Barbara Haskell at the Whitney Museum of American Art. Numerous other independent scholars, curators, and librarians have also made important contributions to this project, as have individuals in auction houses and galleries. We would like to thank David Acton; Henry Adams; M. Darsie Alexander; Ida Balboul; Anne Baldassari; Opal K.C. Baker; Laurence Berthon; Danielle Blanchette; Jay Bochner; Helen Braham; Marcia Brennan; Peter Bunnell; Leslie Calmes; Beverly Calté; William Camfield; Andrea Caratsch; Annette DiMeo Carlozzi; Victor Carlson; May Castleberry; Christa J. Clarke; Melanie Clore; Ann Cohen de Pietro; Francesca Consagra; Desmond Corcoran; Judith Cousins; Guy-Patrice Dauberville; Michel Dauberville; Diane De Grazia; Rodrigo de Zayas; Gertrude Weyhe Dennis; Virginia Dodier; Toni Dove; John Driscoll; Lynn Dynas; Alison de Lima Greene; Lynn Dubard; Kathleen Ewing; Betsy Fahlman; Susan Faxon; Richard Feigen; Walter Feilchenfeldt; Linda Ferber; Evelyne Ferlay; John H. Field; Michael Fitzgerald; Kaspar Fleischmann; Martha J. Fleischman; Dominique Fourcade; Sylvie Fresnault; Bryna Freyer; Pie Friendly; Jean Fritts; Marianne Fulton; Barbara Galatti; Robert J. Gedrim; William Gerdts; Mary Ann Goley; Kevin Grogan; Wendy Grossman; Wanda de Guébriant; Karen Haas; Emily Hage; Linda Hardberger; Phyllis Hattis; Françoise Heilbrun; Norine Hendricks; Elizabeth Hilton; Tom Hinson; Erica E. Hirshler; Lisa Hodermarsky; Walter Hopps; David Johnson; Isobel Johnstone; Vance Jordon; Claudie Judrin; Mary Kalish-Johnson; Jacque Kerchache; David Kiehl; Susan Kloman; Elizabeth Kornhauser; Quentin Laurens; Rebecca Lawton; Sylvia Lecat; Deborah Leveton; Gail Levin; Elizabeth Loder;

Christophe Lunn; Flo Lunn; Barbara McCandless; Nanette Maciejunes; Peter MacGill; Guido Magnaguagno; Sandra Markham; Lynn McCary; Suzanne Folds McCullagh; Marilyn McCully; Patricia McDonnell; Grete Meilman; Lisa Messinger; Charles Moffett; Isabelle Monod-Fontaine; Alexis Morgan; Ann Lee Morgan; Anthony Montoya; Leigh Morse; Therese Mulligan; Laura Muir; Weston J. Naef; Peter Nathan; Carol Nathanson; Dianne Nilsen; Patrick Noon; Percy North; John D. O'Hern; Margaret M. O'Reilly; Perry Ottenberg; Jean-Louis Paudrat; Julie Pearson; Maria Antonella Pelizzari; Sandra Phillips; Hélène Pinet; Harold Porcher; Marla Prather; Jussi Pylkkänen; Philip Ravenhill; Wendy Reaves; Jock Reynolds; John Rohrbach; Shelly Roman; Jeff Rosen; Naomi Rosenblum; Cora Rosevear; Roy Sieber; Daniel Siedell; William Siegmann; Theodore Stebbins; Claudia Steinfels; Jeremy Strick; Dale Stultz; Kurt Sundstrom; Elizabeth Hutton Turner; Caroline Turner; Claire Vincent; Jim Voorhies; Jayne Warman; Joan T. Washburn; Virginia-Lee Webb; Joy S. Weber; Adam Weinberg; Stephanie Wiles; Matthew Witkovsky; Barbara Wolanin; Richard T. York; Virginia Zabriskie; and Judith Zilczer. This exhibition would also not have been possible without the assistance and able skills of the registrars at all of the lending institutions and collections and we extend to them our deepest thanks.

In addition to our many lenders, several private collectors were also enormously helpful, sharing with us their great knowledge about this field. We would especially like to thank Timothy Baum; Aaron Fleischman; Celeste Hadis; Mr. and Mrs. Ted Haviland; Mrs. William Janss; Maurice Katz; Mr. and Mrs. Jules Kay; Dr. Ronald Klar; Mr. and Mrs. Myron Kunin; Nicole Maritch-Haviland; Mr. and Mrs. Meyer Potamkin; Michael Scharf; Ed Shein; and Joanna Steichen.

Special thanks are owed to the many libraries and archives, and their staffs, for permission to publish material from their holdings. We are especially indebted to the late Donald Gallup and Patricia C. Willis, Alfred Stieglitz/Georgia O'Keeffe Archive, Yale Collection of American Literature, Beinecke Rare Book and Manuscript Library. We thank also the Georgia O'Keeffe Foundation, especially Agapita Judy Lopez and Elizabeth Glassman, and Raymond R. Krueger, Juan Hamilton, and June O'Keeffe Sebring.

Finally, and by no means least, thanks are owed to Nicolai and Sophia Cikovsky and Caroline and Walker Brock, who through every phase of this project offered patience, humor, and wise counsel.

SARAH GREENOUGH

PHOTOGRAPHIC CREDITS